Kunstwissenschaftliche

Bibliothek

Series Editor Christian Posthofen

Volume 37

Verlag der Buchhandlung
Walther König, Köln

Variantology 3

On Deep Time Relations of Arts, Sciences and Technologies in China and Elsewhere

Edited by Siegfried Zielinski and Eckhard Fürlus
in cooperation with Nadine Minkwitz

Text Editor: Gloria Custance

© 2008 Siegfried Zielinski, Eckhard Fürlus, the authors and
Verlag der Buchhandlung Walther König, Köln

Text Editor: Gloria Custance
Design: Silke Fahnert, Uwe Koch, Köln
Production Printmanagement Plitt, Oberhausen

Cover illustration:
"U (Segment Yokohama)", 2005, Ingo Günther
For complete image sequence and text see pages 212–222.

Frontispiece: Irit Batsry, © 2007

Die Deutsche Bibliothek – CIP-Einheitsaufnahme
Ein Titelsatz für diese Publikation ist bei
Der Deutschen Bibliothek erhältlich.

ISBN 978-3-86560-366-1

Research on archaeology/variantology of the media in 2006 has been
generously supported by the Ministry of Science of Northrhine-Westfalia
and the Kunsthochschule für Medien Köln, since 2007 by the Universität
der Künste Berlin.

Contents

* page nos. 15, 35, 73, 91, 115, 151, 189, 223, 255, 293, 305, 331, 347, 367, 391, 451

SIEGFRIED ZIELINSKI

& ECKHARD FÜRLUS

Introduction: *Ars brevis umbrae et lucis*

Seeing and comprehending are complementary fields. They complement each other in the various modes of thought and action with which we learn about and appropriate the world. "The history of vision and knowledge" are "closely intertwined",[1] writes Gérard Simon in his study on optical concepts in ancient Greece. When Simon wrote this book, his research field was to lay the foundations of the classical age of science through a new *physics of the visible* (Johannes Kepler, Galileo Galilei, René Descartes). Irritated by the way in which the texts written by ancient Greek theorists of the gaze had been handed down, which were also of great importance for pre-modern concepts, Simon plunged ever further into the deep time of ancient theories of optics, particularly into the texts by Euclid and Ptolemy. What especially went against his grain was that histories of science appeared to map their contemporary ideas of the subject of optics and the gaze onto ancient history—they literally forced the modern view upon these ancient authors.

Inspired also by Michel Foucault's archaeologies of knowledge and power, Simon's intention was to uncover what precisely was being discussed when the ancient Greeks wrote about the complexity of the relationships between the person who sees and that which is seen; that is, he endeavoured to get behind and beyond the comfortable separation into subjective and objective, and active and passive, with which we are familiar today. Meticulous and critical re-reading of the translations, transcriptions, and copies of the ancient texts produced a clear result—contrary to the established conclusions of research: the beam of vision coming from the eye, that fascinating phenomenon to which was ascribed multifarious meanings and of which the "ancient geometers" had spoken repeatedly and tried to research intensively, must not be imagined as a physical quantity, "is not the same as a ray of light [...]. The object of their

1 Gérard Simon, *Der Blick, das Sein und die Erscheinung in der antiken Optik* (Munich, 1992), p. 24. The French original was published in 1988 by the Paris publisher Éditions du Seuil. See also Simon's essay: Science de la vision et représentation du visible. *Les Cahiers du Musée National d'Art Moderne* 37 (1991): 5–21.

[the ancient Greeks] research is not light, but sight."[2] Therefore, in the history of science the research field of the ancient texts does not belong to physics or mathematics or geometry, not to the field of *techné*; instead, it belongs to the field of the *psyché*, to work on a "theory of the soul". Classical Greek research was articulated first and foremost as questions about the particular nature of the "seeing human, his relation to the visible".[3]

For Western philosophy, Plato's allegory about the prisoners in the cave is the master text that looks at the relationship between those who see, and that which is seen, from philosophical angles.[4] Unable to free themselves, or even move their heads, the captives think that the shadows of objects and figures, which are passed in front of a fire behind their backs, are real. They are real of necessity because the shadows are the only visible things that the prisoners are allowed to experience; they cannot even turn their heads to see the person next to them. If they could cast off their chains, turn away from the shadows, leave the firelight made by humans behind, and go out into the sunlight they would overcome the view associated with the cave. They would begin to recognise truth, first the reflections of things in water, then the reflections which divine light throws from the things to the eye of the observer, and ultimately they are able to see the pure light of knowledge.

Epistemologically the shadows in Plato's allegory have the status of things that are specious, misleading, *negative*. They are bloodless like the denizens of Hades. In the late 1960s Jean-Louis Baudry took the cave allegory and applied it to the theory of the cinematographic apparatus and its effects, and at the same time, without attracting much attention, Baudry utilised some of the psychoanalytical ideas of Jacques Lacan, the mirror stage and formation of the ego, for media theory.[5] In *A Short History of the Shadow* Victor I. Stoichita discusses Plato's cave allegory, with very similar implications, in connection with the

2 Ibid., p. 13.

3 Ibid., p. 23.

4 Plato, *Politeia*, Pol 514a–517a; English edition, e.g., *The Republic of Plato*, trans. Allan Bloom (New York, 1991).

5 See in particular the two essays: Jean-Louis Baudry, Effets idéologiques produits par l'appareil de base. *Cinéthique* 7/8 (1970): 1–8; Le dispositif: Approches metapsychologiques de l'impression de réalité. *Communications* 23 (1975): 56–72; English trans.: Ideological Effects of the Basic Cinematographic Apparatus, in: *Film Theory and Criticism. Introductory Readings*, ed. Gerald Mast, Marshall Cohen, and Leo Braudy, 4th edition (Oxford, 1992), pp. 302–312; The Apparatus: Metaphysical Approaches to the Impression of Reality in Cinema, in: *Film Theory and Criticism: Introductory Readings*, ed. Leo Braudy and Marshall Cohen, 6th edition (Oxford, 2004).

origin of painting and photography with reference to the famous story recounted by Pliny the Elder in *Naturalis historia*: the projected shadow image of the absent lover who had gone away to war.[6] Theory and artistic praxis of the mass media have been profoundly influenced by both master texts. In his highly original *Histoire(s) du cinéma*, the god of the European post-war film avant-garde, Jean-Luc Godard, speaks in a breathy voice-over from the blackness of off-screen about the white screen and its status as a winding-sheet upon which dark shadows are thrown: cinematographic life as a reflection of death, combined with a quantum of hope when in its text the dark shadows change into "ombres blanches", which technically they are on the film's negative.[7]

These can be counted as scholarly and artistic farewells to the hierarchies that the modern age erected in connection with (visual) perception. On the historic eve of modernism there were clear declarations of belief in Platonic dualism. Francis Bacon called the twelve members of his "house of Salomon", who bring knowledge and inventions from foreign lands to *The New Atlantis*, "merchants of light" and he divided them into four groups of three: "depredators", "mystery-men", "pioneers or miners", and "dowry-men or benefactors".[8] They are merchants of light who trade in the results of work that produces knowledge.

From the perspective of media archaeology a high point was the discriminational judgement of shadow and everything that resided in its neighbourhood semantically, which is expressed in the light metaphysics of the seventeenth-century master of the affective and effective arts of sound and image, Athanasius Kircher. His *Great Art of Light and Shadow*, which was first published in 1645, contains a wealth of artefacts and apparatus for projection and technical visualisation. At the end of Book 10 Kircher formulates in a condensed and schematic form the horizontal and vertical coordinates from a visual perspective out of which the cross of Western knowledge may be constructed. His "metaphysica lucis et umbrae"[9] has as its base the four Empedoclean elements,

6 Victor I. Stoichita, *Brève histoire de l'ombre*, originally published as *A Short History of the Shadow* (London, 1997).

7 Jean-Luc Godard, *Histoire(s) du cinéma*, video film in eight parts for French television (Canal Plus), 1988–1998, quotation from Part 2. The complete soundtrack appeared on ECM Records, New Series, Munich, 2000, text inserts and still images in two volumes at Gallimard-Gaumont, Paris, 1998.

8 Francis Bacon, *Neu-Atlantis* (Stuttgart, 1982), pp. 54–55; quotation in an excerpt from *The New Atlantis* online: http://www.uvawise.edu/history/wciv2/bacon.html.

9 Athanasius Kircher, *Ars magna lucis et umbrae* (Rome, 1645), pp. 917–929; the schema is on p. 924. From an art-historical perspective see also: Fabio Barry, Lux and lumen. *kritische berichte* 4 (2002): 22–37.

fire, air, water, and earth. At the level of living creatures these elements correspond to God, the angels, humans, and animals; to these Kircher assigns the quintessential cognitive faculty of thought *(mens)*, the intellect, reason, and sensory perception. Beneath this, he arranges the qualities horizontally in a range from brilliantly light to abysmally dark:

Lux is the light of light *(lume di lume)*, the divine light, which has no corporeal presence, and of which all other light phenomena can be but a pale reflection. *Lumen* refers to the light that is tied to shining or reflecting bodies; etymologically it is also lightning or the gleam of gold, in Kircher's hierarchy it is the bodies of angels that propagate light. Humans represent the second-order medium *(secundum speculum)* that reflects divine light. To humankind he assigns the quality of shadows *(umbrae)*, which defines life—negatively—from death; non-human animals are assigned in their entirety to the realm of darkness *(tenebrae)*. In the middle plateau of his classifications Kircher even provides the corresponding colour scale: divine light is colourless; it simply shines and represents pure brightness. To the angels belongs *albedo*, the pale white that we are familiar with, for example, from polished white marble statuary. Humans, creatures with blood, are *rubedo*, deep red, and the lowest order, the animal kingdom, is *nigredo*, which corresponds to the black of unstructured matter, as depicted by Robert Fludd in a copperplate engraving of 1617.[10]

Deus.	Angelus.	Homo.	Animal.
Mens.	Intellectus.	Ratio.	Senfus.
Lux.	Lumen.	Vmbræ.	Tenebræ.
Lux.	Albedo.	Rubedo.	Nigredo.
Supercœleſtia.	Cœlum.	Nubes.	Terra.
Lux perpetua.	Meridiana.	Crepuſculum.	Tenebræ noĉturnæ.
Ignis.	Aër.	Aqua.	Terra.

Fig. 1 *"Deus sons lucis est, & Angelus primae lucis speculum; secundum speculum, homo."*[11] In: *Athanasius Kircher,* Ars magna lucis et umbrae *(1645), Epichirema V., p. 924.*

10 See also the chapter on Kircher in S. Zielinski, *Deep Time of the Media* (Cambridge, MA, 2006), pp. 101–157; on Robert Fludd's black square, see pp. 111–113.

11 "God is the source of light, the angel is the reflection of this primary light, and the human is the second reflection".

If one flies towards the sun in regions of the Earth where the sun rises in the morning one encounters a different view of the complementary relationship between light and shadow. When Plato wrote his allegory of the prisoners in the cave it is possible that he had seen a performance of a (Near) Eastern shadow play, a cultural practice which was most probably known in Ancient Greece. Or at least this is one of our favourite speculations in media archaeology, for Plato's detailed description of the *dispositif* of projection reads in places like a manual for putting on such a shadow play. In this cultural and technical practise the shadow thrown by a three-dimensional body when illuminated by artificial light has a meaning opposite to that in Western philosophy: the shadow is an object of enjoyment, contemplation, instruction, religious ritual, and only sometimes of fear or terror.

And the shadow in this tradition is above all an object of longing. It is generally held that Chinese shadow play originated in the Western Han dynasty (206 B.C.–A.D. 8). Like the myth concerning the origins of painting written down by Pliny the Elder mentioned above, the origin of the shadow play, too, is associated with a tragic love story. When Emperor Wu's favourite concubine died, a magician named Shao Weng put up a white cloth screen at night and made an illuminated female figure dance behind it whose shape resembled exactly the emperor's departed loved one.[12]

From ancient times—that is, from the deep time of Chinese knowledge culture—knowledge concerning calculation of the passage of time, from day to night and light to dark, was not dubbed heliology or heliologics, but was known as *gnomonics*. The name comes from the *gnomon*, a perpendicular rod that was driven into the ground or a many metres-tall obelisk, which then cast a shadow upon the even plane around it showing the passage of the hours. The *gnomon* is the artificial agent positioned between the natural light of the sun and the abstract measurement result that can be read off the graduation: the shadow rod functioned as the medium in gnomonic projection.

A master text from the deep time of Chinese natural philosophy that expressly engages with optical phenomena is the so-called *Mohist Canon*, which is named after its founder Mo-tzu and was written between the late fifth and the mid third century B.C. The *Later Mohist Canon* consists of a great number of short *propositions* on various themes, particularly of a philosophical nature. The Can-

12 According to Clara B. Wilpert in her book *Schattentheater* (Hamburg, 1973), p. 59; on the modern history of Chinese shadow theatre and its many cultural meanings see particularly Fan Pen Li Chen, *Chinese Shadow Theatre. History, Popular Religion, and Women Warriors* (Montreal, 2007).

on is regarded as an early thought system that competed with Confucianism.[13] Eight of the highly condensed statements are devoted to optics.

Even a superficial reading of the propositions leaves an astounding impression. The character for *kuang* (light) appears only a few times, whereas the character for *yin* (shadow) appears in all eight propositions and several times in each one. Nathan Sivin, whose work is as ground-breaking in the field of the deep time of optics in China as Simon's studies on classical European antiquity's concepts of the gaze and optics, sums up the import of this distribution thus: "The Mohist optics is primarily the study of shadows."[14]

Already the first proposition regarding the physics of the visible celebrates shadows in a very special way, namely, as *positive*. Here the question under consideration is whether a shadow can move under its own volition. "A shadow does not shift", says the Mohist canon and propagates the view that a shadow is a product of the moment and constantly renews itself. It is a sensational event of an instant, which the text explains in spatial terms: "Where the light reaches, the shadow disappears", and, vice versa, "where the shadow is born the light disappears".[15] The moment that light falls on the shadow it destroys the shadow, which then ceases to exist. For example, the shadow of a bird flying past the sun, which appears a little further on, is a new shadow wrested from the light and also only exists for a very short moment.

The second proposition about optics concerns the phenomenon of the double shadow, which is produced through two sources of light that illuminate an object. The definitions that follow engage succinctly with the inversion of a projected object, with the use of planar, convex, and concave mirrors as well as the size of shadow silhouettes in relation to the size and distance of the light source.

According to many modern commentators these physical definitions are probably the result of experiments with artificial experimental apparatus, which in the history of optics we know as the *camera obscura*, or pin-hole camera. Nathan Sivin has reservations about drawing this conclusion; in his opinion the descriptions are not precise enough to allow any definite statement. Notwithstanding,

13 For a thorough and systematic analysis see: Angus Charles Graham, *Later Mohist Logic, Ethics and Science* (Hong Kong, 1978), which also contains meticulous translations of the traditional texts.

14 Here we follow primarily the essay by Nathan Sivin and A.C. Graham, A systematic approach to the Mohist optics (ca. 300 B.C.), in: *Chinese Science*, ed. N. Sivin and Shigeru Nakayama (Cambridge, MA, 1973), pp. 105–152, quotation p. 113.

15 All three short quotations: ibid., p. 116.

the clarity of the propositions and definitions of the Mohist Canon is infinitely superior to the extremely vague circumlocutions of Aristotle, who from a European perspective was the inventor of this instrument for studying optical phenomena. Aristotle's observations were not made with a constructed *camera obscura*. They derive from watching light rays fall through foliage, a sieve, and the intertwined fingers of both hands; with a lot of good will they can be interpreted such that Aristotle knew these optical effects or tried to describe them himself. Further, the observations do not occupy a central position in his philosophical work, but are among the mixture of news about physics.[16]

Without question, observations in connection with the phenomenon of shadows attained a high degree of precision in the Chinese scientific tradition long before the advent of the Italian Renaissance. This is due in no small part to the work of the polymath and outstanding astronomer, Shen Kua (1031–1095) from Ch'ien-t'ang, today's Hangchow in Chekiang province. His *Dream Book* (*Meng ch'i pi t'an*) of 1086 contains the discovery of what we know today as the focus (or focal point), the exact centre mid-way between the object and the projection surface. Shen Kua described its function for seeing via optical instruments giving impressive and also beautiful examples of flying birds and moving clouds, whose shadows were already included in the propositions of the *Later Mohist Canon*.[17]

Shen Kua was the contemporary of another great polymath and optics researcher from a region where the sun stands high at its zenith, Ibn al-Haytham from Baghdad, who spent much of his life in Cairo in Egypt. Like Shen Kua, Ibn al-Haytham was also a passionate observer of the two principal celestial light sources for terrestrial life, sun and moon. Also like Shen Kua, he defined more precisely the collected optical knowledge of the previous 1500 years, up to and including its technical objectification as a dark room in which the realm of shadows could be scientifically investigated. Ibn al-Haytham, in fact, wrote his studies on optics some decades before Shen Kua's *Dream Book*—in the early eleventh century. He will play a prominent role in the Fourth Volume of our *Variantology* series, together with other polymaths, natural philosophers, and engineers with which we shall celebrate the *l'âge d'or* of Arab-Islamic science, an epoch that we Europeans have too long regarded as the dismal and science-less Dark Ages.

16 Aristotle, *Problemata physica*, trans. Hellmut Flashar, in: Aristoteles, *Werke*, vol. 19 (Darmstadt, 1975), esp. pp. 140–141.

17 Nathan Sivins published a lexical essay devoted to Shen Kua in 1975, which appeared in *Sung Studies Newsletter* 13 (1977): 31–56.

But first we invite the reader with this Third Volume in our series to embark on an exploration of the deep time relations between the arts, sciences, and technologies, which takes us f. e. to Bulgaria, England, France, India, Italy, The Netherlands, Spain, and with a special focus on China. To all who came from far away to Germany in order to make these imaginary expeditions into their research areas possible we extend our heartfelt thanks. And that from our discussions came texts, which we had the privilege of editing, is a great gift. We thank all the authors for their work and for the patience and assistance they gave us in preparing the manuscripts for publication, which for us contained most unfamiliar material. Mareile Flitsch and Dagmar Schäfer were invaluable mediators in the discussions with our Chinese guests; Jens Bleiber translated in the widest sense the essay by Xu Fei; Christoph Zeller assisted with the contribution of Dai Nianzu, and he also helped us tremendously with all the final editing of the sections in Chinese. The author's individual variants of transcriptions, symbols, and for time periods have been retained.

One of the first to formulate fragments of a future theory of tele-communication in twentieth-century Europe was not a scientist, but a poet and dramatist. In 1927 Bertolt Brecht published a short provocative text with the title "Radio—An Antediluvian Invention?" As so often in his theoretical writings, he used a parable to illustrate what he meant:

"I recall an old story in which the superiority of Western culture is supposed to be made clear to a Chinese man. He says, 'What have you got?' They reply, 'Railways, automobiles, telephones.' 'I am sorry to have to tell you,' replies the Chinese man politely, 'that those are things *we* have already forgotten.' I immediately had the terrible impression with regard to radio that it was an unbelievably old institution, which had sunk into oblivion because of the deluge."[18]

Translated from German by Gloria Custance

[18] The short text appears in vol. 18 of Brecht's *Gesammelte Werke* (Schriften zur Literatur und Kunst I.) (Frankfurt, 1967) pp. 119 ff; for an English translation of the text see: *Brecht on Film and Radio*, ed. Marc Silberman (London, 2000), p. 37.

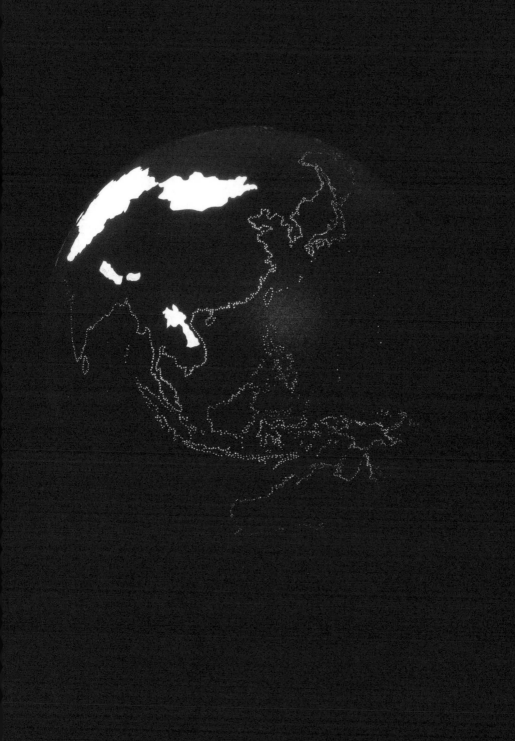

Worldprocessor [#7]

SIMON WERRETT

"The Finest Fireworks in the World": Chinese Pyrotechnics in Early Modern Europe

Fireworks originated in writing. Before there was paper in China, writing was done on green bamboo stalks, and dried over a fire to make the marks endure. In the fire, air-pockets in the bamboo stalks burst, making a cracking sound. In the second or third century A.D., the *Shen I Ching* explained how such cracking bamboo was cast onto a fire to scare away ten-foot tall mountain men (*shan shan*) and evil spirits. The first gunpowder fireworks were made to imitate these burning bamboos.[1]

Despite many historians noting the ancient origins of gunpowder and fireworks in China, little attention has been paid to the place of Chinese fireworks in Western culture in more recent centuries. This essay explores the attitudes of Europeans to Chinese pyrotechnics between the sixteenth and nineteenth centuries, and sets these attitudes within the context of changing European relations with and conceptions of China in this period. Historians have offered a variety of interpretations of such relations and their changing evaluations of Chinese politics, religion, and society.[2] I propose that judgements about fireworks followed their own distinctive trajectory, by considering what kinds of intelligence Europeans had about Chinese fireworks, and how this influenced European pyrotechnic traditions. I ask how Europeans valued Chinese fireworks, and examine the ways in which they compared eastern pyrotechny with their own. There was no uniform answer to these questions, and throughout

1 Joseph Needham, *Science and Civilisation in China, vol. 5: Chemistry and Chemical Technology. Part 7: Military Technology: The Gunpowder Epic* (Cambridge, 1986), p. 130; on the history of gunpowder and fireworks in China, see also J.R. Partington, *A History of Greek Fire and Gunpowder* (Cambridge, 1960), pp. 237–97; Wang Ling, On the invention and use of gunpowder and firearms in China. *Isis* 37 (1947): 160–178.

2 See, e.g., Basil Guy, *The French Image of China before and after Voltaire* (Geneva, 1963); Louis Dermigny, *La Chine et l'occident*, 4 vols. (Paris, 1964), vol. 1, pp. 11–80; Ho-Fung Hung, Orientalist knowledge and social theories. *Sociological Theory* 21 (2003): 254–280; Jonathan D. Spence, *The Chan's Great Continent* (London, 1998).

the period Chinese fireworks prompted a diversity of responses. Europeans did not always assume Chinese fireworks surpassed their own, and even praise of Chinese fireworks could carry implicitly condescending meanings. Europeans also imitated Chinese fireworks, but the means by which they did so changed significantly between the eighteenth and nineteenth centuries. While the eighteenth-century taste for *chinoiserie* encouraged efforts to discover the secrets and recipes of Chinese fireworks, the growth of science in Europe led to a more critical "technical Orientalism" in the early nineteenth century, as men of science claimed to be able to surpass Chinese pyrotechnics using experimental physics and chemistry. Nevertheless, Chinese fireworks came to dominate western markets for pyrotechnics in subsequent years.

The Earliest Fireworks
in China and Europe

The first festive fireworks display in China took place in Kaifeng in the early decades of the twelfth century, for a visit of the emperor to the Pao-chin Lou pavilion, "Suddenly a noise like thunder (*phi li*) was heard, the setting off of *pao chang* (fire-crackers), and then the fireworks (*yen huo*) began."[3] Any strict chronology is impossible, however, since Chinese pyrotechnic vocabulary used earlier terms to describe new effects. Thus *yen huo*, the term for fireworks, originally meant "smoke-fires", which produced coloured smokes and were older than gunpowder fireworks, though *pao chang* (exploding crackers) very probably used gunpowder, the term replacing the earlier non-pyrotechnic *pao kan* and *pao chu*, meaning exploding stem or bamboo.

From the mid-twelfth century, references to festive displays multiply, referring, for example, to fireworks (*yen huo*) for New Year's Eve, attached to frames, and shown with "abundance of lanterns" circa 1185, or fireworks set off from boats on New Year's Eve on a lake in Hangchow in the mid-thirteenth century.[4] Already by the late twelfth century, these events included fire-crackers, coloured smoke-balls, revolving wheels, fireworks that played on the water or flew like kites, and probably rockets (*huo chien*). Like Europeans later, the Chinese presented fireworks in structured performances, or "fire-plays" (*huo hsi erh*),

3 Mêng Yuan-Lao, *Tung Ching Mêng Hua Lu* (Dreams of the Glories of the Eastern Capital), quoted in Needham, *Science and Civilisation*, vol. 5, p. 131.

4 Needham, *Science and Civilisation*, vol. 5, p. 132.

and compared them to celestial and meteorological phenomena, being "like thunder" and "like comets".[5]

By the sixteenth century, with gunpowder now widely available, both festive and military pyrotechnics were highly developed in China. A multitude of different fireworks made explosions and noise, showered different tints of fire and sizes of sparks into the air, ran about on the ground and water, or ignited one after another in complex pieces linked together with fuses. Joseph Needham proposed that "earth rats" (*ti lao shu*), which ran erratically about on the ground, were the origin of rocket propulsion. First recorded circa 1264, in their original form the earth rats probably consisted of a powder-filled bamboo stick.[6] The use of rockets in warfare began with incendiary fire-arrows employed by the Chinese and Mongols in the early thirteenth century; for example, at the siege of Kaifeng in 1232. By the end of that century, these had evolved into gunpowder projectiles, knowledge of which soon spread, recorded in manuscripts such as the *Treatise on Horsemanship and Stratagems of War* by the Syrian Al-Hasan al-Rammah after 1280.[7]

Fireworks in Europe are unlikely to have developed independently of connections to China. They began—as in the East—with a form of cracker, already described by Roger Bacon in 1267 as a global commodity: "that toy of children which is made in many parts of the world".[8] The Mongols may have brought gunpowder weapons and rockets to Europe in their attacks on eastern cities such as Buda, but it was not until 1380 that the first use of gunpowder fireworks and rockets in Europe are recorded.[9] In that year, the *rochetta*, as it was now called, was used in battles between the Venetians and Genoese in the war of Chioggia (1378–1380), while a dove made to sparkle with gunpowder was sent flying down a string in Vicenza as part of a church mystery play in front of the local bishop's palace at Pentecost in 1379.[10]

5 See the accounts in Needham, *Science and Civilisation*, vol. 5, pp. 132–133; Wang Ling, On the invention, p. 164.

6 Needham, *Science and Civilisation*, vol. 5, pp. 135–136; Jixing Pan, The origin of rockets in China, in: *Gunpowder. The History of an International Technology*, ed. Brenda J. Buchanan (Bath, 1996), pp. 25–32; Jixing Pan, On the origin of rockets. *T'oung Pao* 73 (1987): 2–15.

7 Partington, *History of Greek Fire*, pp. 200–204, 241–246.

8 Roger Bacon, *The Opus Maius of Roger Bacon*, trans. Robert Belle Burke, 2 vols. [1928] (Bristol, 2000), vol. 2, pp. 629–630.

9 On the Mongols in Buda, see Partington, *History of Greek Fire*, p. 250.

10 On Chioggia, see Partington, *History of Greek Fire*, p. 174; A spectacle at Pentecost, Vicenza, 1379, in: *The Medieval European Stage 500–1550*, ed. William Tydeman, Glynne Wickham, John Northam, and W.D. Howarth (Cambridge, 2001), pp. 432–433, especially p. 432.

The Catholic church, then, presided over the development of festive fireworks displays in Europe before the first Jesuit missionaries reported on Chinese fireworks in the sixteenth century. Like the Chinese, Europeans imagined fireworks in celestial and meteoric terms, and divided festivals of light between fireworks, rockets, shells, wheels, etc., and illuminations, in which thousands of lamps lit up a building or city square. In 1540, the Sienese Vannoccio Biringuccio described the spectacular pyrotechnics of the Girandola festival, held at the Castel Sant' Angelo in Rome for the election of Popes and the feast-days of Saint Peter and Paul.[11] A model for subsequent displays in Europe, it began with illuminations of the castle walls. Biringuccio explained how lanterns of paper and tallow candles were set in "many rows as far as the eye can reach" creating "a very beautiful thing to see".[12] Then came cannon salutes and the lighting of burning tar barrels. The centrepiece was a vast explosion of thousands of rockets above the castle tower, their spreading "wheat sheaf" shape giving the spectacle its title by analogy to "girandola"—fountain sprays. By the 1570s, the Roman fireworks were seen as imitating a meteoric tempest. Thus the engraver Giovanni Brambilla described how the rockets "burst in the air in the shapes of stars". It seemed "as if the sky has opened [...] it seems as if all the air in the world is filled with fireworks, and all the stars in the heavens are falling to Earth."[13]

Many subsequent fireworks in Europe imitated the Girandola, although in the course of the sixteenth century princely courts became the principle patrons of pyrotechny, staging fireworks to celebrate military victories and state occasions, such as royal births, weddings, and coronations. In the late sixteenth and early seventeenth century, new forms of fireworks proliferated in Europe. These echoed the various motions and types already evident in Chinese displays, with fiery wheels, artificial suns, stars, comets, and aquatic fireworks becoming popular, though no Chinese influence on these designs is recorded. Most were staged as a form of theatrical performance, with allegorical narratives and elaborate stage scenery. A new genre of technical manuals on pyrotechny explained how these effects were to be achieved.[14] There was also exchange between the learned and

11 Vannoccio Biringuccio, *The Pirotechnia of Vannoccio Biringuccio* [Venice, 1540] (New York, 1990), pp. 442–443. On the history of the Girandola, see Lucia Cavazzi, *"Fochi d'allegrezza" a Roma dal Cinquecento all'Ottocento* (Rome, 1982), pp. 83–97; Kevin Salatino, *Incendiary Art* (Santa Monica, CA, 1997), pp. 76–83.

12 Biringuccio, *Pirotechnia*, p. 442.

13 Quoted in Salatino, *Incendiary Art*, p. 78.

14 See, e.g., Francis Malthus, *A treatise of artificial fire-vvorks both for vvarres and recreation.* (London, 1629); Jean Appier, dit Hanzelet, *La pyrotechnie de Hanzelet Lorrain où sont représentés les plus*

pyrotechnists. Natural magicians in particular were fascinated by the "strange fires" of the gunners. The Neapolitan magus Giambattista Della Porta and the Jesuit Athanasius Kircher in Rome both included discussions of fireworks in their works on magic. Della Porta, whose *Magia naturalis* in its extended version from 1589 included a whole book of "artificial fires", witnessed the Girandola and enquired after pyrotechnic skills.[15] He thought fireworks a powerful medium with which to urge the Christian message, "The matter is very useful and wonderful, and there is nothing in the world that more frights and terrifies the mindes of men. God is coming to judge the world by Fire."[16]

The Jesuit Kircher was very interested in both fireworks and China, his voluminous works including compendiums of Jesuit accounts of China and the *Ars pyrobolica*.[17] For his information, Kircher relied on a growing number of first-hand reports on China from Portuguese prisoners and priests, Jesuit missionaries, and Dutch merchants travelling to the east. The Jesuit accounts were the most systematic, ranging from the authoritative journals of Father Matteo Ricci, who was in Peking from 1601 until his death in 1610, to the encyclopaedic atlas, history, and geography of China by Father Martin Martini appearing in the 1650s.[18] A number of these works provided Europeans with their first glimpse of Chinese pyrotechnics and the festival of lanterns. The Jesuits also joined a growing debate in Europe which contrasted "ancient" backwardness and "modern" civilisation by the latter's invention and use of gunpowder.[19] In their descriptions, the Jesuits rarely failed to judge China's pyrotechnics, as a useful indicator of Chinese character and civilisation in comparison to the Europeans. This judgemental and comparative mode of

rares [...] secrets des machines et des feux artificiels propres pour assieger [...] toutes places (Pont-à-Mousson, 1630).

15 Engl. transl.: Della Porta, *Natural Magick [...] in Twenty Books* (London, 1658), pp. 289–304.

16 Della Porta, *Natural Magick*, p. 289.

17 Athanasius Kircher, *China illustrata* (Amsterdam, 1667); Athanasius Kircher, *Ars magna lucis et umbrae* (Rome, 1645/1646) Pt. 2, pp. 826–827; Athanasius Kircher, *Mundus subterraneus, in XII libros digestus*, 2 vols. in one (Amsterdam, 1665), vol. 2, pp. 467–480 (Book 9, section 5, part 4, Ars pyrabolica).

18 On the Jesuits in China, see Liam Matthew Brockey, *Journey to the East. The Jesuit Mission to China, 1579–1724* (Cambridge, MA, 2007); Charles E. Ronan and Bonnie B.C. Oh, eds., *East Meets West: The Jesuits in China, 1582–1773* (Chicago, 1988); Filippo Mignini, *Matteo Ricci. Europa am Hofe der Ming* (Milan, 2005).

19 Roy S. Wolper, The rhetoric of gunpowder and the idea of progress. *Journal of the History of Ideas* 31 (1970): 589–598.

observation would endure for a long time when Europeans considered China's fireworks. However, there was no typical line in seventeenth-century accounts. The English compiler of travel accounts Richard Hakluyt's record of Jesuit missions in China praised Chinese industry in the art of military and festive pyrotechny, "Their industry doth no less appear in founding of guns and in making of gun-powder, whereof are made many rare and artificiall fireworks."[20] However, even though Matteo Ricci agreed that "their skill in the manufacture of fireworks is really extraordinary", producing "ingenious" and "wonderful" displays, he nevertheless took the alleged preference of the Chinese for using gunpowder in festive rather than military fireworks as a sign of their lack of belligerence and hence military weakness.[21] The Portuguese Jesuit Alvaro Semedo made a similar argument: "the use of powder is very ancient in China: and in fire-works, wherein they are excellently skilful, they spend more powder in a year, than in their Armies, at this time, in five." In contrast, while cannon, bombards, mortars, and muskets were all in evidence in China after the arrival of Europeans, "now they know not how to make use of them, and keep them only for ostentation."[22]

Others considered the Chinese equal, or even inferior, in pyrotechny compared to Europeans. Thus Johann Nieuhof's account of the Dutch embassy to China in 1665 noted, "Though we acknowledge they had the Invention of Gunpowder before us [...] yet they never arriv'd to our Perfection, being unskill'd in Fire-works."[23] Henry Middleton, writing of his voyages at the beginning of the seventeenth century, chose to recount how *European* travellers had impressed the Chinese with fireworks. When his men took fireworks to the Chinese court, the "women cried out for feare they would set the court on fier", but on moving to another venue, "they fired all they had, and made the King and his traine very good sport."[24]

20 Richard Hakluyt, *Voyages and Discoveries. Principal Navigations, Voyages, Traffiques and Discoveries of the English Nation* [1599–1600] (London, 1972), p. 332.

21 See Jonathan D. Spence, *The Memory Palace of Matteo Ricci* (London; New York, 1985), p. 45; *China in the Sixteenth Century. The Journals of Matthew Ricci, 1583–1610*, ed. Louis J. Gallagher, S.J. (New York, 1953), pp. 18, 77, 321.

22 Alvaro Semedo, *The history of that great and renowned monarchy of China* [...] [1642] (London, 1655), p. 99.

23 Johannes Nieuhof, *An embassy from the East-India Company of the United Provinces, to the Grand Tartar Cham* [...] (London, 1673), pp. 426–427.

24 Henry Middleton, *The Voyage of Henry Middleton to the Moluccas, 1604–1606*, ed. Sir William Foster (London, 1943), p. 158.

Fireworks and Chinoiserie

Thus, there was no consensus that Chinese fireworks were superior in the seventeenth century, although the argument that the Chinese taste for fireworks showed a weakness in war seems to have been the most common opinion emerging from these accounts. "Gun-powder is of most ancient standing among them; of it they make curious and costly Fire-works; they have some Cannon, but no Skill in the use of it, only shoot at random."[25]

Nor, in the seventeenth century, is there any clear indication that accounts of Chinese fireworks and illuminations (since the festival of lanterns was also described by the Jesuits) had any influence on the styles of pyrotechnics fashionable in the European courts.[26] This contrasted with European attitudes to other Chinese arts. From the mid-seventeenth century, European elites became enthralled by Chinese culture, and began imitating and adapting Chinese arts and decorative styles to create the fantastical genre of *Chinoiserie*.[27] Chinese lacquers, porcelain, filigree, the *façon de la chine* textiles, and silk were all imported and emulated, while courtly artists and architects designed pavilions, palaces, and gardens *à la chinoise*. Writers depicted China as a harmonious and orderly society, rationally managed, luxurious, and happy. Politics and philosophy also had their *chinoiserie*, in the fascination of figures such as G.W. Leibniz and Christian Wolff with Chinese language and writing, the philosophy of Confucius, and Chinese science.[28] There would also be a vogue for Chinese fireworks, but it is only evident from the very end of the seventeenth century. After the 1690s, attitudes to Chinese pyrotechnics coalesced into a generally favourable

25 Manuel de Faria e Sousa, *The Portugues Asia* (London, 1695), pp. 498–499. This was also the view of John Webb, *An historical essay endeavoring a probability that the language of the empire of China is the primitive language* (London, 1669), p. 111; Joanna-Waley Cohen, *The Culture of War in China* (London; New York, 2006) has described the centrality of warfare to Qing China.

26 Besides the account of Gabriel de Magalhães, the festival was described at length by Louis Le Comte, *Memoirs and observations typographical, physical, mathematica* […] (London, 1697), pp. 150–153.

27 Hugh Honour, *Chinoiserie. The Vision of Cathay* (New York, 1973); Oliver Impey, *Chinoiserie. The Impact of Oriental Styles on Western Art and Decoration* (London, 1977); Madeleine Jarry, *Chinoiserie. Chinese Influence on European Decorative Art. 17th and 18th Centuries* (New York, 1981); Dawn Jacobson, *Chinoiserie* (London, 1993).

28 Julia Ching and Willard Oxtoby, eds., *Discovering China. European Interpretations in the Enlightenment* (Rochester, 1992); R.F. Merkel, *Leibniz und China* (Berlin, 1952); David E. Mungello, *Leibniz and Confucianism. The Search for Accord* (Honolulu, Hawaii, 1977); Arnold H. Rowbotham, The impact of Confucianism on seventeenth-century Europe. *The Far Eastern Quarterly* 4 (1945): 224–242.

opinion, while performers sought to emulate Chinese fireworks, and to discover Chinese pyrotechnic recipes. However before this time, perhaps because Chinese fireworks, unlike silks or porcelain, were not available for Europeans to experience directly, there were few efforts to imitate them.

Even so, in the eighteenth century, consensus grew that Chinese fireworks were superlative, and there was more interest in imitating them. Commentators now praised Chinese fireworks even if they had never seen them. In 1696 Father Louis Le Comte claimed the Chinese made "the finest fireworks in the world" though he had not seen any while visiting China, fireworks there being "not so ordinary as People imagine".[29] Similarly, the European-bound historian Jean-Baptiste Du Halde's 1735 *Déscription* [...] *de la Chine*, a survey of missionary and other sources on China, included detailed accounts of Chinese fireworks, in which he thought "the Chinese excel".[30] Of particular interest in these accounts were pyrotechnic "trees" or "vine arbours" which used brilliantly coloured fire to represent flowers, wood, leaves, grapes, and fruits. Reports or observations of these fireworks now led authors to compare Chinese and European pyrotechnic skills on specific grounds. Joseph de la Porte, the abbé de Fontenai, recalled witnessing fireworks in Canton in 1744, "One sees entire trees, covered with leaves and fruits; grapes, apples, oranges, with their particular colour [...] This is something our French artificers have not yet been able to do."[31]

Such accounts led Europeans to seek out the recipes for Chinese fireworks with a view to imitating them in displays for the courts and a growing number of public venues for fireworks which flourished in the eighteenth century. The latter included the theatres of Paris and the pleasure gardens of London. Fireworks had long been used to add drama to scenic effects in the theatre in Europe, and had partly evolved as an independent genre of spectacle after pyrotechnics were used for the *intermezzi* of theatrical performances. Initially, these performances served the court, but by the eighteenth century they also entertained the public. Many of the artisans responsible for these shows were itinerant Italians. The Ruggieri family, for example, showed complex fireworks at the Paris *Comédie Italienne*, where they arrived around 1740 from their native

29 Le Comte, *Memoirs and observations*, p. 151.

30 Jean-Baptiste Du Halde, *The general history of China. Containing a geographical, historical, chronological, political and physical description of the Empire of China*, 4 vols. [1735] (London, 1741), vol. 2, pp. 166–169.

31 Joseph de La Porte, abbé de Fontenai, *Le voyageur françois, ou Le connoissance de l'Ancien et du Nouveau monde* (Paris, 1769), vol. 5, p. 123.

Bologna.[32] The Ruggieri and another Italian, Giovanni Battista Torré, set up pleasure gardens or "Wauxhalls" in Paris in the 1760s, imitating the gardens of Marylebone, Ranelagh, and Vauxhall established earlier in the century in London, which regularly showed fireworks to paying audiences.[33]

Within this context of courtly and commercial pyrotechny, imitation and elaboration of Chinese arts and decorations grew steadily during the eighteenth century. Before the mid-century, Chinese settings for fireworks were only occasionally employed. In 1722, for example, the duc de Bourbon gave a fête for the young Louis XV at Versailles, which consisted of a mock sea-battle between "Chinese" in dragon-shaped warships and "Turks" in crescent-shaped ships. Fireworks simulated the exchange of fire between the boats.[34] In most cases, however, the scenery accompanying fireworks was classical in inspiration, consisting of temporary edifices representing Roman temples, triumphal arches, obelisks, or columns. Nevertheless, there was much interest in imitating the brilliant fires and coloured trees and fruits recounted in the missionaries' and other accounts of China.

The name most associated with this interest is that of Father Pierre Le Chéron d'Incarville, a Jesuit missionary who spent many years in China.[35] Born at Rouen in 1706, d'Incarville trained as a Jesuit in Paris before undertaking missions to Quebec, and from 1739, to Peking, where he remained until his death in September 1757. From Peking, d'Incarville sent numerous reports on Chinese botany and arts to the Paris Royal Academy of Sciences and to fellows of London's Royal Society, including accounts of Chinese lacquers, paper, wax, paints, and dyes.[36] D'Incarville also sent a detailed description of the

32 Patrick Bracco and Elisabeth Lebovici, *Ruggieri. 250 ans de feux d'artifice* (Paris, 1988); Henri de Chennevières, Les Ruggieri. Artificiers, 1730–1885. *Gazette des beaux-arts* 36 (1887): 132–140.

33 Warwick Wroth, *The London Pleasure Gardens of the Eighteenth Century* (London, 1896); Gilles-Antoine Langlois, *Folies, tivolis et attractions. Les premiers parcs de loisirs parisiens* (Paris, 1991).

34 Simon Harcourt-Smith, An exhibition of Chinoiserie. *Burlington Magazine* 68 (1936): 90–92, here p. 92.

35 Renèe Simon, Voyage de P. N. Le Chéron d'Incarville en Chine sur le Jason 1740. *Archivum Historicum Societatis Iesu* XL, 80 (1971): 423–436; Henri Bernard, Un correspondant de Bernard de Jussieu en Chine. Le Père Le Chéron d'Incarville, missionnaire français de Pékin. *Archives Internationales d'Histoire des Sciences* 6 (1949): 333–362 and 692–717.

36 P[ierre]. N[icolas]. Le Chéron d'Incarville, A Letter from Father D'Incarville, of the Society of Jesus, at Peking in China, to the Late Cromwell Mortimer, M.D.R.S. Secr. *Philosophical Transactions of the Royal Society* 48 (1753): 253–260; Mémoire sur les vernis de la Chine. *Mémoires de Mathématique et de Physique présentés à l'Académie Royale des Sciences* 3 (1760): 117–142.

manufacture of Chinese fireworks, with recipes and instructions for making the pyrotechnics that previous missionaries had often described. It is not clear when this information reached the Paris Academy of Sciences, but it was published in the Academy's *Mémoires* in 1763, and appeared in an English summary in the *Universal Magazine* the following year.[37] The principle intelligence in the article concerned the recipe for "Chinese Fire", explaining that this brilliant composition lay at the foundation of Chinese fireworks, and was made by crushing old iron pots and scraps into sand and adding the sand to gunpowder, to make what the Chinese called "thieh ê" (iron moths); "thieh sha" (iron sand), or "thieh hsieh" (iron granules).[38] D'Incarville also listed recipes for Chinese "flowers" made with the iron sand composition, and explained how the coloured figures of flowers, fruits, and wood were made with the Chinese fire or gunpowder pastes of powdered sulphur and plant extracts, applied to bamboo frames. D'Incarville also described Chinese methods of manufacturing saltpetre, sulphur, matches, and cartridges; and gave an account of the "Chinese Drum", a remarkable effect in which series of illuminated figures dropped in succession from a drum.[39]

Since the appearance of this article in 1763, d'Incarville has always been identified as the person responsible for bringing "Chinese fire" to Europe, where it immediately proved popular and became a standard component of pyrotechnic performances across the continent thereafter.[40] However, some evidence suggests d'Incarville may not have been the first, and certainly not the only European privy to the secrets of Chinese fireworks. The Russians, for example, had good access to China, and exploited trade links to gain pyrotechnic intelligence. In 1712, Tsar Peter the Great requested the commissar in Peking,

37 P.N. Le Chéron d'Incarville, Manière De faire les fleurs dans les Feux d'Artifice Chinois. *Mémoires de mathématique et de physique Présentés à l'Académie Royale des Sciences, par divers Savans, & lus dans ses Assemblées* 4 (1763): 66–94; Manner of making Flowers in the Chinese Fire-works, illustrated with an elegantly engraved Copper-Plate. *Universal Magazine* 34 (1764): 20–23.

38 Needham, *Science and Civilisation*, vol. 5, p. 141, proposes that the practice of using iron filings in China as an incendiary composition was probably ancient, dating to at least the seventh century, and predating the invention of gunpowder.

39 Le Chéron d'Incarville, Manière De faire les fleurs, pp. 74–87.

40 Many authors subsequently provided recipes and instructions for making Chinese fire, e.g., Jean-Charles Perrinet d'Orval, *Manuel de l'artificier* (Paris, 1757), pp. 27–30, 98–100, 119–120; Captain Robert Jones, *Artificial Fire-works* (London, 1765), pp. 44, 104, 162, 193, 196; A.M. Th[omas] Morel, *Traité pratique des feux d'artifice pour le spectacle et pour la guerre, avec les petits Feux de table, et l'Artifice à l'usage des Théâtres* (Paris, 1818), p. 79; James Cutbush, *A System of Pyrotechny* (Philadelphia, 1825), p. 265.

Lorens Lang, to "obtain and dispatch the secret of the composition of Chinese firework fountains."[41] Peter tried out Chinese fireworks for himself in 1722 after his guards captain Lev Izmailov brought samples from China. Izmailov reported that in China, "they make such fireworks that no-one in Europe has ever seen."[42] There was also interest in more westerly locales. In exile in Paris, Lord Bolingbroke sought the "secret of Chinese fireworks" in 1721, though no details are known of his efforts.[43]

The Ruggieri brothers at the *Comédie Italienne* knew the secret of Chinese fire in the early 1750s. A later descendent of the Ruggieri claimed fireworks presented for the birth of the duc d'Aquitaine in Paris on September 16th 1753 were the first in France to include rockets "of the Chinese composition" and a forty-foot high cascade "also in Chinese fire".[44] In August 1754 the Ruggieri showed a *feu chinois* at the Jesuit theatre of the Collège Louis-le-Grand, and a year later the brothers displayed a "Feu d'artifice, Chinois" at the *Comédie Italienne*: "it gives more brilliance to artifice, is less subject to smoke, and since it goes out very promptly, it is communicated without danger."[45] At Versailles that year, the Marquis de Gesvres gave "une petite fête à la maréchale de Duras: grand souper, cavagnole et petit feu d'artifice chinois."[46]

The source of the Ruggieri's new fire was probably a report sent from d'Incarville in Peking.[47] However, one report suggested otherwise, since, "The *Sieurs* Ruggieri, authors of fireworks which have been seen up to now in the *Théatre Italien*... bought from an artificer who for a long time exercised his art in China, the secret of this composition."[48] The nationality of this artificer is not

41 Ivan Ivanovich Golikov, *Dopolneniia k Deianiam Petra Velikogo*, 18 vols. (Moscow, 1790–1797), vol. 13 (Moscow, 1794), p. 294.

42 V.N. Vasil'iev, *Starinnye feierverki v Rossii (XVII–pervaia chetvert' XVIII veka)* (Leningrad, 1960), p. 55.

43 Thomas Macknight, *The Life of Henry St. John, Viscount Bolingbroke, Secretary of State in the Reign of Queen Anne* (London, 1863), p. 531.

44 Claude-Fortuné Ruggieri, *Précis historique sur les fêtes, les spectacles et les réjouissances publiques* (Paris, 1830), p. 282.

45 Ernest Boysse, *Le théâtre des Jésuites* (Paris, 1880), pp. 327–329, 332; Claude Parfaict and François Parfaict, *Dictionnaire des théâtres de Paris*, 7 vols. (Paris, 1767), vol. 7, pp. 521–522; L.V. Gofflot, *Théâtre au Collège du moyen âge à nos jours* [1907] (New York, 1964), pp. 297–298.

46 Charles Philippe d'Albert, duc de Luynes, *Mémoires du duc de Luynes sur la cour de Louis XV (1735–1758)*, vol. 14 (Paris, 1864), p. 223.

47 Boysse, *Le théâtre des Jésuites*, p. 329.

48 Parfaict and Parfaict, *Dictionnaire des théâtres*, p. 521.

mentioned but it is perhaps possible that a Chinese fireworks master supplied the information, and certainly this would not be the only record of a Chinese fireworker appearing in early modern Europe.[49] At the very least it suggests there were artisanal exchanges between China and Europe taking place outside the sphere of literate or official culture. The Chinese were evidently willing to divulge recipes, since d'Incarville himself claimed, "I have the secret of the Emperor's artificer, who comes to see me from time to time."[50]

Chinese Fireworks and the Progress of Natural Philosophy

The second half of the eighteenth century saw a flourishing of Chinese-styled fireworks in Europe. A trade card from the late eighteenth century, for example, indicates the value placed on Chinese fireworks, explaining how the pyrotechnist, named Clitherow, sold "the Real True & Genuine China fire that Represents a Beautifull Fruit tree in full Bloom, will Throw its Flowers from 10, to 30 feet High [...] Sold by no one else in England."[51] Alongside the growing use of Chinese fire, Chinese-style scenery also proliferated in fireworks of this period. Prince Heinrich of Prussia and Catherine II of Russia were thus treated to the vision of an illuminated Chinese temple on the road to Tsarskoe Selo in October 1770.[52] Two years later, the architect Paolo Possi presented a magnificent *chinoiserie* temple or "Luogo dedicato alla Cinese filosofia" for Pope Clement XIV at the annual *Chinea* fireworks festival in Rome.[53] The following year at Marylebone Gardens in London there was a "Chinese procession" with fireworks, and in 1780 a Mr. Flockton's theatre at Highgate showed a "Chinese Bridge" and "Chinese Temple" in fireworks.[54] The Prince of Wales was

49 J.E. Varey, Les spectacles pyrotechniques en Espagne (XVIe–XVIIe siècles), in: *Les Fêtes de la Renaissance*, ed. Jean Jacquot, 2nd. edition, 3 vols. (Paris, 1975), vol. 3, pp. 619–634, here p. 631.

50 Le Chéron d'Incarville, Maniére De faire les fleurs, pp. 74–87.

51 Trade Card of Benjamin Clitherow, British Museum, Department of Prints and Drawings, Sarah Banks collection, item 62.6.

52 M.A. Alekseeva, Yu.A. Vinogradov, Yu.A. Piatnitskii, B.V. Levshin, eds., *Gravirovalnaia palata Akademii nauk XVIII veka: sbornik dokumentov* (Leningrad, 1985), p. 161.

53 Lucia Cavazzi, *"Fochi d'allegrezza"*, p. 60.

54 Mr. Flockton's Theatre. At the [hand-written White Lyen Highgate] *in this town. This present evening, will be exhibited His Grand Exhibition, in the same Manner as Performed before the Royal Family and most of the Nobility in the Kingdom*. (London, ca. 1780).

entertained with "bouquets" of the Chinese fire in August 1783, while the same "brilliant and Chinese fire" was shown at Ranelagh Gardens for the summer season.[55] Chinese fireworks fitted both the enlightened and romantic sensibilities of the second half of the eighteenth century. In *Julie, or the New Heloise*, Jean-Jacques Rousseau thus had Julie entertained with "rockets I had brought from China, which made quite an impression".[56] William Chambers, extolling the virtues of studied irregularity in gardening based on Chinese models, gave one of the most enthusiastic judgements of Chinese fireworks in the eighteenth century, "they are more splendid, and more expert than the Europeans [...] a more magnificent sight cannot be seen. Even the Girandola, and illumination of St. Peter's of the Vatican, tho' far the most splendid exhibitions of that sort in Europe, are trifles, when compared to these of China."[57]

As European pyrotechnists increasingly displayed Chinese-styled fireworks, so assessments of their skills compared to those of the Chinese became more favourable. However many Europeans still assumed the Chinese superior in pyrotechny to Europeans. As *homme de lettres* François-Alexandre de La Chenaye-Aubert wrote in 1767, "We have had in France for some years artificers who are at least equal to those of the Chinese and Italians." Nevertheless, "Chinese and Italian fireworks have over some time become better than one of our spectacles."[58] Claude-Fortuné Ruggieri, France's best pyrotechnist at the turn of the nineteenth century concurred with this view, but qualified it by explaining away Chinese skills. "The Chinese are perhaps to-day superior in this art, to the French and Italians; partly by the minuteness of their work and more by the possession of materials which we lack."[59]

These views began to change in the 1790s, when Europeans began to place a new importance on historical development, representing Europe's rapid industrialisation and the growth of science and technology as a process of improvement and progress that was unmatched by non-Europeans, including notably

55 *Disposition of the fireworks, ordered by the Honourable Artillery Company, to be displayed in the Artillery-Ground, on Tuesday night, August 12, 1783, on his Royal Highness George Prince of Wales, Captain-General of the Company, coming of age* (London, 1783); *Ranelagh. On Friday next, May 4, 1798, will be exhibited a grand fire-work. By Signors Rossi and Tessier. Order of firing* [...] (London, 1798).

56 Jean-Jacques Rousseau, *Julie, or the New Heloise* (Hanover, 1997), p. 491.

57 William Chambers, *A Dissertation on Oriental Gardening* [1772] (Dublin, 1773), p. 48.

58 François-Alexandre de La Chenaye-Aubert, *Dictionnaire historique des mœurs, usages et coutumes des Français* [...], 3 vols. (Paris, 1767), vol. 1, p. 133–134.

59 Claude-Fortuné Ruggieri, *Elémens de pyrotechnie* (Paris, 1801), p. xix.

the Chinese, who rather appeared caught in a static and unproductive social order.[60] The popular enlightenment image of Chinese philosopher-kings and orderly social hierarchy was now re-imagined by critics of absolutism as a corrupt system of "oriental tyranny".[61] These changes are apparent in attitudes to Chinese pyrotechny at the turn of the nineteenth century, which began to echo earlier arguments of the seventeenth century claiming China's fireworks were impressive, but also signs of a failing in Chinese culture. The embassy of Lord George Macartney to Peking in 1793 represented the Chinese in this manner. Macartney approached the Chinese on the assumption that gifts of scientific and artisanal goods from Europe would be highly valued by the Emperor as superior to local Chinese commodities. James Dinwiddie, mechanic to the embassy, even planned to show the Emperor European fireworks.[62] Macartney thus assumed Chinese inferiority in the arts and sciences, including pyrotechnics.[63] The gifts, however, did not impress the Emperor, who refused them, an act which Macartney's embassy represented as evidence not of European inferiority but of Chinese backwardness and conservatism. As Dinwiddie wrote, "Their prejudices are invincible."[64] This condescending attitude was also implicit in embassy accounts of China's fireworks, which were presented as impressive but ultimately trivial and the limit of Chinese ingenuity, "the fireworks [in China] [...] exceeded any thing of the kind I had ever seen... however meanly we must think of the taste and delicacy of the court of China, whose most refined amusements seem to be [fireworks] [...] it must be confessed that there was something grand and imposing in the general effect."[65]

Macartney's accounts of Chinese intransigence and pyrotechnics were widely publicised, and likely contributed to a change in the nature of pyrotechnic *chinoiserie* in Europe in the early nineteenth century. Europeans still favoured *chinoiserie*, but now saw it as a sign of European superiority and ingenuity. Thus

60 Joanna Waley-Cohen, China and western technology in the late eighteenth century. *American Historical Review* 98 (1993): 1525–1544.

61 Donald F. Lach, China in western thought and culture, in: *Dictionary of the History of Ideas. Studies of Selected Pivotal Ideas*, ed. Philip P. Wiener, 4 vols. (New York, 1973), vol. 1, pp. 353–373, pp. 364–365; Hung, Orientalist knowledge, p. 262.

62 William Jardine Proudfoot, *Biographical Memoir of James Dinwiddie [...] embracing some account of his travels in China* (Liverpool, 1868), p. 50, 54.

63 Simon Schaffer, Instruments as cargo in the China trade. *History of Science* 44 (2006): 217–246.

64 James Dinwiddie, quoted in Proudfoot, *Biographical Memoir*, p. 50.

65 John Barrow, ed., *Some Account of the Public Life, and a Selection from the Unpublished Writings, of the Earl of Macartney*, 2 vols. (London, 1807), vol. 2, p. 285.

Claude-Fortuné Ruggieri, who had been willing to grant the Chinese were superior to French and Italian pyrotechnists in 1801, changed his mind two decades later, on the basis that the Chinese failed to progress,

"Some people imagine that the Chinese are still today superior to the French and the Italians in this art, partly by their workmanship, partly by the possession of materials which we lack. Nevertheless, I have just had occasion to observe the contrary. A merchant arriving here a year ago [ca. 1820] managed to bring back a dozen cases of Chinese fireworks. These fireworks turned out to be no different from what the Chinese have made for the last three or four centuries. That convinced me that we in Europe are much superior to the Chinese."[66]

Key to this sense of superiority was European science. Ruggieri argued that physics and chemistry were critical to improving fireworks, and this was typical of the broader attitude. In the eighteenth century, those who wished, like the previous generation of Ruggieri, to include Chinese fireworks in their displays had sought out recipes from knowledgeable artisans or Chinese masters themselves. But in the early nineteenth century, Europeans instead sought to imitate Chinese fireworks using the supposedly superior methods of European science. Confident in, and increasingly nationalistic about their own scientific and technological progress, Europeans now believed they could imitate and surpass Chinese fireworks, together with many other Eastern arts, using physics and chemistry. In many cases these projects failed.

An exemplary instance was the work of English gentleman-inventor, Sir William Congreve. Congreve is best known as the inventor, around 1805, of "Congreve rockets", huge iron-cased incendiary missiles which were employed in the British artillery between the Napoleonic and Crimean Wars.[67] In making these rockets, Congreve was imitating an eastern art, since their inspiration came from efforts to reproduce Indian war rockets employed against British forces by Hydar Ali and Tipu Sultan of Mysore in the eighteenth century. Congreve, who saw himself as a "man of science", presented his rockets as progressing through experiment and systematic trials, so that while his rockets did not resemble those of India, they were in principle superior. Congreve also applied this logic, a kind of "technical Orientalism", to Chinese fireworks, setting out to surpass them using the latest scientific techniques. In 1814 Congreve

66 Claude-Fortuné Ruggieri, *Principles of Pyrotechnics*, [1821] (Buena Vista, CA, 1994), p. 46–47.

67 Frank H. Winter, *The First Golden Age of Rocketry* (Washington D.C., 1990).

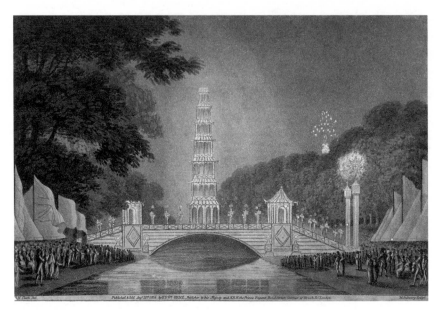

Fig. 1: J. H. Clark (painter), M. Dubourg (engraver), Night-time view of the Chinese pagoda and bridge, St James's Park, with crowds gathered to watch fireworks, aquatint *(London, 1814). With kind permission of Guildhall Library, City of London.*

presented a "Chinese pagoda and bridge" in St. James's Park at celebrations for the short-lived peace of Amiens (Figure 1).

Instead of using Chinese fire or other pyrotechnics to illuminate the pagoda, Congreve chose new-fangled hydrogen gas, product of recent experiments in the natural philosophy of "airs". But the experiment was a spectacular failure, since the pagoda caught fire and burned to the ground; another instance, like the Macartney embassy, of British over-optimism concerning the power of its science.[68]

68 Anon., Grand National Jubilee on the First of August, 1814. *Belle Assemblée, or Court and Fashionable Magazine* (September 1814): 88–95; Suzanne Boorsch, Fireworks on paper. Celebration of the "Glorious Peace". London 1814. *Art On Paper* 4 (2000): 54–59.

Conclusion

Failures such as Congreve's gas illumination did not prevent Europeans from asserting the superiority of their fireworks over those of the Chinese in the early nineteenth century. Claude-Fortuné Ruggieri even went a step further and denied that the Chinese had invented gunpowder. "It is remarkable that immediately upon the appearance of some new discovery there is a willingness to attribute it to these settled people [...] Europeans deprive their compatriots [...] of inventing those things which are most useful and ingenious."[69] For Ruggieri, only Europeans were ingenious and innovative, while the Chinese were "settled", living in an unchanging world and lacking progress.

Europeans thus returned to the mixed opinions which had characterised the attitudes of the seventeenth century, when Chinese fireworks were praised but taken as evidence of a different kind of failing, a lack of military ambition. In the interval, Europe witnessed a great vogue for Chinese pyrotechny, which nevertheless developed differently to other arts and sciences of European *chinoiserie*. Starting around 1700, Europeans sought to imitate Chinese fireworks, and succeeded when recipes were brought from China by artisans and missionaries. From about 1770, fireworks were also decorated with Chinese scenery—pagodas, temples, and gardens—which flourished at a time when other elements of *chinoiserie* were in decline. After the Macartney embassy interest in Chinese fireworks redoubled, but now took on a different form, as Europeans used science, rather than informants from China, to replicate Chinese pyrotechnics. This coincided with an increasingly condescending view of Chinese art and culture.

Nevertheless, while European pyrotechnists came to dismiss Chinese fireworks, the consuming public did not. Fireworks originated in print and just as the trajectory of Chinese fireworks in Europe did not follow the line of other arts of *chinoiserie*, so the public taste for fireworks did not follow the criticisms of Chinese fireworks in the pyrotechnic literature. The nineteenth century thus witnessed the growth of a public and commercial market for fireworks, as individuals chose to set off their own small-scale spectaculars instead of attending grand, centrally organised state displays of the kind in which the Ruggieri specialised. With this "democratisation" of fireworks, a market grew for cheap, quality pyrotechnics, and these the Chinese supplied in abundance. The public became very favourable to Chinese fireworks and imports grew rapidly. The

69 Ruggieri, *Principles of Pyrotechnics*, p. 62.

trade appears to have begun in 1787, when the first commercial ship to sail from the new United States to China arrived home in Massachusetts.[70] On board were several boxes of firecrackers, which the captain had picked up after seeing them fired off in the streets in China. As Lord Macartney was dismissing Chinese fireworks in Peking, these crackers began selling well in America, prompting merchants to buy more Chinese fireworks on subsequent trading voyages. By 1848, five thousand packs of Chinese fireworks valued at $ 20,000 were being shipped to Britain annually, and by 1899 a million pounds of crackers reached England while 30 million were annually exported to the USA. China continues to dominate the fireworks export trade today.[71]

70 Warren Dotz, Jack Mingo, and George Moyer, *Firecrackers* (Berkeley, CA, 2000), p. 39.

71 J.R. Morrison, *A Chinese Commercial Guide* (Canton, 1848), p. 167; Joseph Schafer, *The History of North America* 10. *The Pacific Slope and Alaska* (Philadelphia, 1904), p. 216; Anon., Crackers for the Fourth. *Massachusetts Ploughman and New England Journal of Agriculture* 58 (1899): 4.

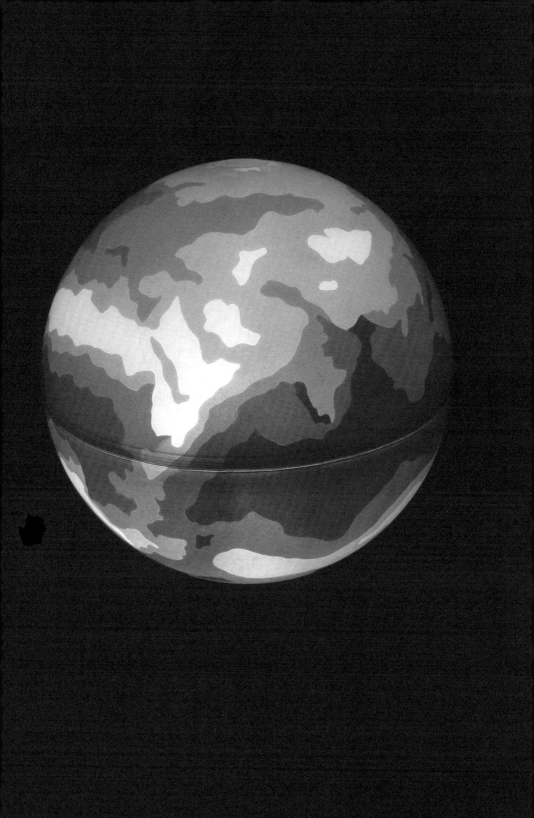

Worldprocessor [#233]

ARIANNA BORRELLI

Pneumatics and the Alchemy of Weather: What Is Wind and Why Does It Blow?

In Renaissance Europe, in the years between 1530 and 1620, a number of pre-existing traditions about wind, spirit, the element air, and pneumatic devices resonated with each other, giving rise to new views on the nature and origin of wind. Eventually, winds came to be regarded as resulting from the air's tendency to rarefy and expand under the influence of heat. This is essentially the same opinion that is held today.

Simple as this explanation may seem, it was—and still is—highly non-trivial, both because of the complexity of wind phenomena and the general difficulty of conceptualising the motive force of heat. Moreover, in the Renaissance much more was at stake in connection with this subject than merely the application of a known principle to a new field. Explaining winds—or wind—might be an opportunity to demonstrate how rational thought could grasp the inner principles according to which nature produced its most complex phenomena. For some philosophers, understanding the origin of winds even meant understanding how divine power descended to Earth, bringing movement, change, and life. Thus, behind the complexity of wind the greatest mystery of all lay hidden.

For Renaissance Europeans, the main feature of wind was its variety, represented by the long-standing tradition of the wind rose. However, during the sixteenth century philosophers took an increasing interest in discussing the possible common nature and origin of all winds, and I shall present an overview of their opinions.[1] In doing so, I will focus on the role—or better: roles—played by technical artefacts in the attempts at conceptualising wind and its motive force. The devices we shall encounter most frequently will be pneumatic engines; that is, machines in which motion was generated by allowing air (or sometimes steam) to expand and contract. Springs will be mentioned, too, as well as some (al)chemical products, notably gunpowder. No machines made of gears, weights, levers, or pulleys entered late Renaissance discussions on the

1 I consciously use the term "origin" here because although authors of the period often spoke of "cause" or "causes" of wind, their notions of causality cannot be employed without a long discussion.

origin of wind, although this period saw the emergence of a natural philosophy that often interpreted even living bodies in mechanical terms. At the end of my overview, I shall offer some remarks on this point.

I shall present Renaissance theories of wind making use, as far as possible, of the notions employed by Renaissance authors, which were extremely varied. While devoting more space to a few selected authors, I shall also try to give an impression of the general panorama of more and less traditional views, as well as how the subject of wind attracted increasing attention. My overview does not offer evidence of a linear development in any one direction; rather, it demonstrates different traditions could combine and transform in very many ways.

One final remark on priority: recognition of the thermal expansion of air as the motor of global atmospheric circulation is usually associated with the name of Edmond Halley (1656–1742), or with some contemporary of his.[2] However, as we shall see, this notion was already present in late Renaissance meteorology. Before that, the thermal expansion of air had already been mentioned as a cause of wind by the Arabic-Islamic philosopher and physician Ya'q b ibn Is q al-Kind (ca. 800 – after 864), thus no Renaissance scholar is entitled to claim priority.[3]

Prologue: Wind and Wind Roses in the Renaissance

Can the regional and seasonal variety of wind be explained simply as moving air? For Aristotle the answer to this question was negative. Pre-modern natural philosophers often showed more interest in exploring and classifying varieties of winds and their effects than in seeking a common cause of them all. Modern meteorologists define wind as flowing air, but regard it as a highly complex phenomenon whose individual occurrences cannot be explained in terms of a single cause.[4]

2 For example: Harold L. Burstyn, Early explanations of the role of the Earth's rotation in the circulation of the atmosphere and the ocean. *Isis* 57 (1966): 167–187, here pp. 170–178; Alfred Fierro, *Histoire de la météorologie* (Paris, 1991), pp. 69–70; Anders O. Persson, Hadley's principle: Understanding and misunderstanding the trade winds. *History of Meteorology* 3 (2006): 17–42, here pp. 18–19; Karl Schneider-Carius, *Wetterkunde—Wetterforschung* (Freiburg, 1955), pp. 58–60.

3 Fuat Sezgin, *Geschichte des arabischen Schrifttums*, vol. 7 (Leiden, 1979), pp. 242–243.

4 David E. Newton, Wind, in: *Encyclopedia of Air*, ed. D.E. Newton (Westport, 2003), pp. 208–213.

In ancient times, the various types of wind phenomena—from pleasant cooling breezes to destructive whirlwinds—were not only evident to the senses: they were also essential factors that made orientation at sea possible.[5] Seamen would recognise a wind from its temperature, humidity, intensity, regularity, or smell, all features perceptible to trained senses, and they decided accordingly whether or not the particular wind would bring them to their desired destination. Knowledge of astronomy and geography was a necessary component of the art of navigation, but ancient sailing instructions often took such forms as: "from Chios to Lesbos 200 stadia with Notus [the south wind]".[6] Winds were thought to bring rain or good weather; they were believed to affect health, which assumed particular importance in medieval Galenic medicine; and, in the Renaissance, winds were integrated into the fourfold system of temperaments.[7]

All these traditions converged in the wind rose, whose description was of primary importance to all natural philosophers from antiquity to the Renaissance who discussed wind. Describing the wind rose did not mean simply listing names and directions of winds, it meant portraying—and eventually explaining—their different qualities, for example, the weather they would bring, the way they could affect health, and the time of the year in which they blew.[8] The variety of winds was often related to—and sometimes explained in terms of—the characteristics of the lands they (seemingly) came from and of the peoples

5 My remarks on wind and navigation are based on: Hans-Christian Freiesleben, *Geschichte der Navigation* (Wiesbaden, 1978), especially pp. 4–27 and 36–41; Arend Wilhelm Lang, *Seekarten der südlichen Nord- und Ostsee* (Berlin, 1968), especially pp. 3–7; Stefano Medas, *De rebus nauticis* (Rome, 2004), especially pp. 48–61; Eva Germaine Rimington Taylor, *The Haven-finding Art* (New York, 1957), pp. 37–40, 52–55 and 97–113.

6 Taylor, *Haven-finding Art*, p. 53.

7 The connection between wind and health is discussed in: Hippocrates, Airs, waters, places, in: *Hippocrates*, vol. 1, trans. William Henry Samuel Jones, (Cambridge, MA, 1962), pp. 65–137, here pp. 72–83 (Hp. Aër. 2–6); Pliny, *Natural history*, trans. Harris Rackham, 10 vols. (Cambridge, MA, 1938–1964), here vol.1, pp. 266–268 (Plin. Nat. 2, 48); Vitruvius, *On Architecture*, ed. and trans. Frank Granger, 2 vols. (Cambridge, MA, 1931–1934), here vol. 1, pp. 54–56 (Vitr. 1, 6). On the continuation of this tradition in the Middle Ages, Renaissance, and beyond: Joëlle Ducos, *La météorologie en français au Moyen Age* (Paris, 1998), pp. 161–165; Caroline Hannaway, Environment and miasmata, in: *Companion Encyclopedia of the History of Medicine*, ed. William F. Bynum and Roy Porter, 2 vols. (London, 1993), here vol. 1, pp. 292–308; Simeon Kahn Heninger, jr., *A Handbook of Renaissance Meteorology* (Durham, NC, 1960), here pp. 110–112.

8 On the qualities of individual winds: Ducos, *Météorologie*, pp. 161–177; Otto Gilbert, *Die meteorologischen Theorien des griechischen Altertums* (Leipzig, 1907), here pp. 568–584; Heninger, *Renaissance Meteorology*, pp. 107–128.

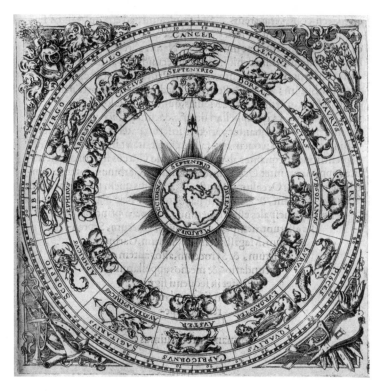

Fig. 1: F. Padovani, Tractato de ventis *(Treatise on winds, 1601) p. 23. The wind rose is represented here as a pattern of cosmic order related to the zodiac signs. In the lower corners: musical wind instruments (left) and pneumatic or wind-driven devices (right). Image from the Library Collection of the National Oceanic and Atmospheric Administration/ Department of Commerce (NOAA), archival photograph by Sean Linehan, NOS, NGS.*

that inhabited them. At the same time, winds could also be regarded as due to astrological influences. The wind rose represented a connection between celestial, astronomical order, and terrestrial variety of lands and living creatures.

On medieval portulan charts and Renaissance sea maps, wind roses were always present with their prolonged lines criss-crossing the chart. Geography, astronomy, and the magnetic compass could indicate the direction in which one wished to travel, but the direction in which travel was actually possible depended on the wind. In long ocean voyages on the high seas a small difference in wind direction could mean a large deviation from the desired course. Therefore, a finer determination of both wind direction and wind intensity became necessary: wind roses with thirty-two points were developed and combined

with the magnetic compass. The speed of a ship could be estimated by throwing a log with a rope attached to it overboard, and measuring how much rope went overboard within a given period of time.[9]

Between the end of the sixteenth and the beginning of the seventeenth century, there were also notable developments in the construction and employment of windmills, through which the motive force of wind was harnessed to serve on land.[10] In this case, too, an exact determination of the direction and intensity of wind became increasingly important.

Is Wind Moving Air or Not? Ancient and Medieval Inheritance in the Renaissance

Along with the wind rose, Renaissance scholars inherited from the past a wide range of opinions on the nature and origin of winds.[11] Many ancient Greek philosophers stated that wind was moving air: Anaximander of Miletus (fl. 547–546 B.C.), Anaximenes of Miletus (fl. 546–525 B.C.), Hippocrates of Cos (ca. 460–375), and the Stoics. Their opinions reached the Latin medieval world through Pliny the Elder's (23–79) *Historia naturalis* and Seneca's (4 B.C.–A.D. 65) *Naturales quaestiones*, and by the late Middle Ages, the notion that wind was moving air was commonly accepted.[12] As to why air should move, Pliny, Seneca, and other classical authors had listed a number of different reasons, but only Seneca had committed himself to choosing one as the "most convincing and most correct", namely, that "air had a natural power of moving itself".[13]

9 To measure length easily, seamen's ropes were knotted at regular intervals, so that speed was ultimately estimated in "knots" per time unit (Taylor, *Haven-finding Art*, pp. 200–201 and 230–231).

10 Ulrich Troitzsch, Technischer Wandel in Staat und Gesellschaft zwischen 1600 und 1750, in: *Mechanisierung und Maschinisierung. 1600 bis 1840*, ed. Akos Paulinyi and Ulrich Troitzsch (Berlin, 1997), pp. 9–267, here pp. 41–44.

11 On ancient theories about the nature and origin of winds, see: Robert Böker, Winde. B. Die geographischen Windtheorien im Altertum, *Paulys Realenziclopädie der classischen Altertumswissenschaft* 8A2 (1958), cc. 2215–2265; Gilbert, *Meteorologische Theorien*, pp. 511–539; Liba Taub, *Ancient Meteorology* (London, 2003). For the reception of ancient theories in medieval times: Ducos, *Météorologie*, especially pp. 25–31, 156–165, 254–268 and 323–324.

12 Seneca, *Natural Questions*, trans. Thomas H. Corcoran, 2 vols. (London, 1971–1972), on winds: vol. 2, pp. 74–123 (Sen. Nat. 5); Pliny the Elder, *Natural History*, on winds: vol. 1, pp. 244–273 (Plin. Nat. 2, 38–50).

13 "Ceterum illa [causa] est longe valentior veriorque, habere aerem naturalem vim movendi se." (Seneca, *Natural Questions*, vol. 2, p. 82 (Sen. Nat. 5, 5).

Between the late twelfth and the thirteenth century, Latin Europe rediscovered Aristotle's meteorology, which explained weather phenomena in terms of two exhalations drawn up by the sun from earth and water: a humid and cold one, responsible for rain, snow, and hail, and a hot and dry one, which caused thunder, lightning, shooting stars, and winds, amongst other things.[14] In Aristotle's opinion to regard wind as moving air did not do justice to the wide variety of wind phenomena: the dry and hot exhalations, he explained, rose up in the air and were then dragged along by the circular movement of the celestial spheres so that they ended up moving horizontally.[15]

Around 1500, meteorology was dominated by this Aristotelian framework of the two exhalations, but in the meantime medieval philosophers had modified and expanded the structure in many ways. The explanation of the nature and origin of winds which we encounter most often in Renaissance meteorological works is in a sense "Aristotelian", but its salient features can be traced back to Albertus Magnus (approx. 1200–1280) and to his *Liber meteororum*.[16] In this long and detailed discussion of winds, Albertus accepted Aristotle's theory of exhalations, but stated that the hot and dry exhalations, when they reached the higher, colder layers of air, were not dragged along by celestial motion, but rather repelled by the cold. Being fiery, they could not sink, and therefore kept on moving horizontally. For want of a better name, I will refer to this model as "Albertus Magnus' theory of wind formation". Albertus also struck a compromise between Aristotle's theory of exhalations and the pre-existing view that wind was moving air by concluding that wind was due to exhalations, which in turn moved air. This opinion, too, was be endorsed by many Renaissance authors.

Although Aristotelianism prevailed, other ancient and medieval theories on winds were not forgotten, or, if forgotten, were soon rediscovered. Particularly important were theories that assigned a prominent role to the element air. Seneca's notion of air moving by itself was part of his Stoic worldview, which conceived the cosmic principle of all life and movement (the "pneuma") as a subtle substance pervading everything and giving rise, among other things, to

14 For a short summary of Aristotle's meteorology, see: H. Howard Frisinger, *The History of Meteorology: To 1800* (Boston, 1983), pp. 15–23. For a more detailed discussion: Taub, *Ancient Meteorology*, pp. 77–115.

15 Aristotle, *Meteorologica*, trans. Henry Desmond Pritchard Lee (Cambridge, MA, 1987), pp. 86–101 and 162–173 (Arist. Mete. 1, 13 and 2, 4).

16 Albertus Magnus, *Opera omnia. Vol. 6, part 1: Meteora*, ed. Paul Hossefeld (Münster, 2003), on winds: pp. 104–128, here especially p. 107, 115 and pp. 109–110. On Albertus' meteorology: Ducos, *Météorologie*, pp. 59–63 and 158–161.

all weather phenomena.[17] Air was an expression of "pneuma", and was both alive and life-giving. Isidor of Seville (approx. 560–636) had also regarded all weather manifestations as transmutations of air, and the idea that weather was a kind of alchemy of air was often found in late medieval encyclopaedic works.[18] Thus, when we encounter this notion again in the late Renaissance, it is hardly possible to regard it as an entirely novel development. The same holds true for the idea that winds were cosmic, perhaps divine, powers blowing from the celestial sphere onto Earth. According to a fascinating study by Barbara Obrist, this idea was already expressed in late medieval wind diagrams.[19]

Renaissance authors were also not the first to employ machines to demonstrate how wind was generated: an example can be found in Vitruvius' *De architectura* (approx. 33–22 B.C.)[20]. Vitruvius stated:

"Wind is wave of air flowing with uncertain currents of motion. It is born when heat excites humour and the impulse of the action presses out the force of the spirit of the breath."[21]

This view was demonstrated by the "aeolipila", a hollow metal sphere (usually shaped like the face of Aeolus) with a single tiny hole in it. The sphere was filled with a small quantity of water and then heated on a fire, so that the steam blew violently out of the hole, resembling wind. Vitruvius' few lines defining wind were quoted quite often in late Renaissance meteorological works, possibly because they expressed the idea well that air possessed a force ("vis") that heat could awaken.

Finally, I should like to stress that, although Renaissance philosophers often quoted ancient authorities, and although there are many similarities between Renaissance and ancient speculations on wind and weather, one should be wary of speaking of influences, and I shall avoid doing so.[22]

17 Seneca, *Natural Questions*, vol. 1, p. 104 (Sen. Nat. 2, 4). On Stoic "pneuma" and Renaissance philosophy, see: Peter Barker, Stoic contributions to early modern science, in: *Atoms, "Pneuma" and Tranquillity*, ed. Margaret J. Osler (Cambridge, 1991), pp. 135–154.

18 Ducos, *Météorologie*, pp. 371–394, especially p. 376 on weather as "alchimie de l'air".

19 Barbara Obrist, Wind diagrams and medieval cosmology. *Speculum* 72 (1997): 33–84.

20 Vitruvius, *On Architecture*, vol. 1, p. 54 (Vitr. 1, 6).

21 "Ventus autem est aeris fluens unda cum incerta motus redundantia. Nascitur cum fervor offendit umorem et impetus factionis exprimit vim spiritus flatus." (Vitruvius, *On Architecture*. p. 54 (Vitr. 1, 6)). This and all further translations from the Latin and other languages are mine.

22 In this respect, I fully agree with: Martin Mulsow, *Frühneuzeitliche Selbsterhaltung* (Tübingen, 1998), here p. 271.

Wind Theories in Meteorological Treatises
from the First Half of the Sixteenth Century

The European Renaissance was characterised by a growing interest in meteorology.[23] By this point in history weather predictions and the interpretation of extraordinary weather events already had a long tradition, but during the sixteenth century interest in systematic explanations of meteorological phenomena increased, too.[24] A number of works on the subject were published; initially, they remained within the Aristotelian framework, but after the middle of the century original contributions were made.[25]

One of the first summaries of meteorology to be printed in the Renaissance was written in the early fifteenth century by Pierre d'Ailly (1350–1420), and reprinted several times between 1500 and 1524.[26] D'Ailly based his work on Aristotle's theory of exhalations and explained winds according to Albertus Magnus's theory, with hot/dry exhalations being "reflected or thrown back" ("[vapor] reflectitur vel repercutirur") by cold air or, alternatively, by clouds. Thus, the interaction between cold air and hot exhalations, which in principle was only a repulsion between their forms, took on the character of a violent collision. D'Ailly also accepted Albertus' idea that exhalations moved air.

Albertus Magnus' theory, with its simple, quasi-mechanical explanation for the horizontal motion of wind, clearly had a special appeal for those who wanted to offer compact summaries of meteorology. Between 1500 and 1550, it was endorsed by:

23 I have collected evidence of this growth of interest in: Arianna Borrelli, The weatherglass and its observers in the early seventeenth century, in: *Philosophies of Technology*, ed. Claus Zittel, Gisela Engel, Nicole C. Karafyllis and Romano Nanni (Leiden, 2008) [forthcoming], on which some parts of this contribution are based.

24 Christoph Daxelmüller and Gundolf Keil, Prognose, Prognostik, *Lexikon des Mittelalters* 7 (2002), cc. 242–243; Gustav Hellmann, Wetterprognosen und Wetterberichte des XV. und XVI. Jahrhunderts, in: *Neudrucke von Schriften und Karten über Meteorologie und Erdmagnetismus* 12 (Berlin, 1969), pp. 7–26.

25 G. Hellmann, Entwicklungsgeschichte des meteorologischen Lehrbuches, in: *Beiträge zur Geschichte der Meteorologie*, ed. G. Hellmann, vol. 2 (Berlin, 1917), pp. 1–134 and Heninger, *Renaissance Meteorology*, pp. 16–23 and 225–240. Hellmann's text is my main reference for locating Renaissance treatises on meteorology.

26 Pierre d'Ailly, *Tractatus super libros metheororum* (Leipzig, 1506), on wind formation: ff. 13r–13v. On the editions of the treatise: Hellmann, *Lehrbuch*, pp. 68–71.

- Johannes Pontano (1426–1503) in his Latin poem on weather (approx.1500), which described the repulsion between exhalations and air as an epic battle;
- Vitus Amerbach (1504–1557) in his commentary to Pontano's verses (1539);
- Fausto da Longiano (1512–1560) in his Italian *Meteorologia* (1542);
- Antoine Mizauld (approx. 1510–1578), a famous French astrologer, in his Latin *Meteorologia* (1547; French translation 1548);
- Jobst Willich (1501–1552) in his *Introduction to the Meteorology of Aristotle, Albertus Magnus, and Pontano* (1549). Willich explicitly refuted Seneca's statement that wind was moving air.[27]

Interestingly, both Amerbach and Willich belonged to the circle of Philipp Melanchthon (1497–1560), whose members were interested in astrology and other occult sciences.[28] Melanchthon himself wrote an introduction to Pontano's poem and the theologian Joachim Camerarius (1500–1574), a friend of Melanchthon's, composed a Latin poem on winds (1536).[29]

Meanwhile, old and new Aristotelian commentaries on the philosopher's *Meteorologia* were being printed and in such works there were very few attempts to offer simple, general explanations for complex phenomena.[30] I only mention one of them:

- Francesco Vimercati (1474–1570), in his commentary on Aristotle's *Meteorologia* (1556), accepted the theory of exhalations, but was very critical of all opinions on the horizontal motion of wind, and pointed out how they often would contradict experience.[31]

27 Johannes Pontano and Vitus Amerbach, *Liber de meteoris* (Strassburg, 1539), here pp. 49–52; Pontano and Amerbach, *De meteoris*, here pp. 146–147; Fausto [Sebastiano] da Longiano, *Meteorologia* (Venice, 1542), here ff. 28v–30r; Antoine Mizauld, *Meteorologia* (Paris, 1547), here p. 17; Jobst Willich, *Isagoge in Aristotelis, Alberti Magni et Pontani meteora* (Frankfurt an der Oder, 1549), here pp. 18–19.

28 Hellmann, *Lehrbuch*, pp. 70–71. On Melanchthon's circle: Lynn Thorndike, *A History of Magic and Experimental Science*, 8 vols. (New York, 1923–1970), here vol. 5, pp. 378–405, on Camerarius: pp. 383–384; on Amerbach p. 394. On Willich: R. Schwarze, Jodocus Willich. *Allgemeine Deutsche Biographie* 43 (1898): 278–282.

29 Joachim Camerarius, Aeolia, in: J. Camerarius, *Opuscola aliquot elegantissima* (Basel, 1536), ff. 17v–23r.

30 A list of commentaries on Aristotle's meteorology published in the Renaissance can be found in: Hellmann, *Lehrbuch*, pp. 16–39. On Renaissance Aristotelianism and its flexibility: Mulsow, *Selbsterhaltung*, pp. 30–35. Specifically on Aristotelian meteorology: Craig Thomas, Experience of the New World and Aristotelian revisions of the Earth's climates during the Renaissance. *History of Meteorology* 3 (2006): 1–16.

31 I used the later edition: Francesco Vimercati, *In quattuor libros Aristotleis meteorologicorum commentarii* (Rome, 1570), here pp. 212–213 and 218–219.

Finally, around the middle of the century, non-Aristotelian views on air and wind began to be expressed. Many employed a notion that was of seminal importance in the Renaissance: "spirit".

Spirit and Spirits in the Renaissance

A recurrent feature of Renaissance thought was the idea of a middle instance intervening between matter and soul.[32] This third instance was usually thought of as a subtle substance, neither fully corporeal nor fully incorporeal. It was variously referred to as "spiritus", "pneuma" or "quintessence"—some chose to call it simply fire or air. It is impossible to give a general definition of Renaissance theories of spirit; however, what is of importance for the following analysis is the schematic, abstract structure body–spirit–soul, where the body is entirely material, the soul entirely immaterial, and the spirit is somewhere in between, mediating between the two. Regardless of whether they accepted it or not, this schematic was present in the minds of Renaissance philosophers as much as the Aristotelian distinction between matter and form.

The body–spirit–soul schematic could be employed both at the level of individual beings and in a cosmic sense, with the "soul of the world" ruling matter by means of the "spirit of the world". Such notions were central to natural magic and alchemical thought, but also played an important role in discussions on the existence of vacuum and on the properties of matter.[33]

Renaissance conceptions of spirit and spirits are important for our subject here because they were often linked with the element air. First of all, spirit was thought of as an air-like substance, and second, air was regarded as a preferred vehicle of spirit(s). Air conveyed the breath of life and was utilised by demonic spirits as a means to produce material effects.[34] Highly relevant for our discus-

32 On the various concepts of "spirit" and their interaction and assimilation in the late Renaissance: Allan G. Debus, Chemistry and the quest for a material spirit of life in the seventeenth century, in: *Spiritus. IV° colloquio internazionale*, ed. Marta Fattori and Massimo Bianchi (Rome, 1984), pp. 245–263; Eugenio Garin, Relazione introduttiva, in: Fattori and Bianchi, *Spiritus*, pp. 3–14; Gerhardt Klier, *Die drei Geister des Menschen*. (Stuttgart, 2002); Marielene Putscher, *Pneuma, Spiritus, Geist* (Wiesbaden, 1973); Daniel Pickering Walker, *Spiritual and Demonic Magic from Ficino to Campanella* (Leiden, 1958).

33 Cornelis de Waard, *L'expérience barométrique, ses antécédents et ses explications* (Thouars (Deux-Sèvres), 1936), pp. 9–10 and 25–33.

34 Michael Cole, The demonic arts and the origin of the medium. *The Art Bulletin* 84 (2002): 621–640, especially pp. 623–628; Ducos, *Météorologie*, pp. 389–394.

sion is also the linkage connecting a "spirit" of celestial origin to the "innate heat" ("calidum innatum") of living creatures.[35] This connection was made by physicians, both by those belonging to the Galenic school and by those who criticised it, like Girolamo Cardano. It is important for our subject because, in this context, it was possible to conceive the effect of solar heat on air as an act of vitalisation.

Notions of spirit and spirits can be traced back to various ancient traditions, which in the Renaissance were often assimilated by each other: the "pneuma" of the Stoics, the astral body of Neoplatonic philosophy, and the medical spirits of Galenic medicine. The same traditions also contributed to shape the Christian notion of the Holy Ghost, and the idea of a close connection between wind and divine power is certainly present in the Bible.[36] A more recent contribution came from the alchemical idea of "quintessences", that is, subtle substances that that be distilled out of material bodies, just as alcohol, a fiery spirit, could be distilled from wine.[37] Moreover, in the alchemical view spirits were somehow connected to air because quintessences were often separated from raw substances in the form of vapours. This alchemical aspect of the spiritual activity of air-like substances must be kept in mind because, when coupled with pneumatic experiences, it could be very helpful in making sense of meteorological phenomena, which depend so much on humidity.

Wind and Spirit

Agrippa von Nettesheim (1486–1535), a very influential writer on natural magic, had this to say on air and wind:
"[Air] is a vital spirit, passing through all beings, giving life and subsistence to all things, binding, moving, and filling all things. Hence it is that the Hebrew doctors reckon it not amongst the elements, but count it as a medium or glue,

35 Mulsow, *Selbsterhaltung*, pp. 201–276.

36 Sabatino Moscati, The wind in Biblical and Phoenician cosmogony. *Journal of Biblical Literature* 66 (1947): 305–310; Gérard Verbeke, *L'évolution de la doctrine du pneuma du stoicisme à S. Augustin* (New York, Inc. 1987).

37 On spirit and quintessence in alchemy: F. Sherwood Taylor, The idea of the quintessence, in: *Science, Medicine and History*, ed. Edgar Ashworth Underwood, vol. 1 (London, 1953), pp. 247–265; Karin Figala, Quintessenz, in: *Alchemie*, ed. Claus Priesner and K. Figala (Munich, 1998), pp. 300–302; Heike Hild, Geist, in: Priesner and Figala, *Alchemie*, pp. 147–148; Bernard Joly, Pneuma, in: Priesner and Figala, *Alchemie*, pp. 284–285.

which joins things together, and as the resounding spirit of the world instrument. [...] There are also from the airy element winds. For they are nothing else, but air moved and stirred up."[38]

For Agrippa, the four winds gave rise to all other weather phenomena, as well as to seasonal changes.

In his highly original *Liber meteororum* (printed in 1566), the first meteorological treatise in the German language, Paracelsus (1493–1541) explained that winds blew from the celestial sphere through the element air towards Earth, and that their different qualities depended on celestial influences.[39] Paracelsus' works are important for our subject, because they contain the seeds of what later became the Paracelsian theory of "aerial niter", an active principle which was (roughly speaking) an aerial version of earthly gunpowder, and was allegedly responsible for life, combustion, thunder and lightning, as well as a number of illnesses.[40] This theory offered an additional framework connecting the activity of air, life, and weather phenomena.

In the year 1546, the Hippocratic-Galenian physician and prolific writer Michelangelo Biondo (1500– after 1565) published a *Booklet on wind and navigation, containing learned knowledge very useful to navigation, as well as a new wind rose and a careful examination of winds and weather*.[41] It was not an original work, but rather a collection of material taken from various sources. Biondo began by stating that wind was moving air, and quoted Vitruvius. He then went on to describe Aristotle's theory of exhalations and Albertus Magnus' theory of wind formation, but in the end stated: "However, it is general opinion that wind is moving air, as everyone knows."[42] The next section was "On spirit", and its contents were taken from Galenic and Hippocratic writings:

38 "[Aer] spiritus est vitalis, cuncta permeans entia, omnibus vitam et consistentiam praebens, ligans, movens, et implens omnia. Hinc Hebraeorum doctores illum non inter elementa numerant, sed velut medium et glutinum, diversa insimul coniungens, et tanquam spiritum mundani instrumenti reboantem habent. [...] Ex aereo elemento fiunt etiam venti: ipsi enim nihil aliud sunt, quam motus aer, et concitatus." (Henricus Cornelius Agrippa von Nettesheim, *De occulta philosophia* (Cologne, 1533), p. 8 and 10).

39 Paracelsus (Theophrast von Hohenheim), *De meteoris*, in: Paracelsus, *Sämtliche Werke*, vol. I, 13 (Munich, 1996), pp. 125–206, here p. 160.

40 For an overview and further references on this subject, see: Allen G. Debus, The Paracelsian aerial niter. *Isis* 55 (1964): 43–61.

41 Michele Angelo Biondo, *De ventis et navigatione libellus, in quo navigationis utilisima continetur doctrina cum pixide novo, et diligenti examine ventorum et tempestatum* (Venice, 1546); on Biondo's life and work, see: Giorgio Stabile, Michelangelo Biondo, *Dizionario biografico degli italiani* 10 (1968): 560–563.

42 "Sed aerem motum ventum esse res est utique vulgaris, quia notum est omnibus." (Biondo, *De ventis*, f. 3v).

"Both older and more recent philosophers say that spirit and breeze are a sort of breath, which they declared to be air, by which and through which all animated creatures breathe. [...] Everything which is between heaven and earth is full of spirit, and therefore spirit is the cause of cold and hot weather. [...] Moreover, I believe that spirit steers the course of sun and moon [...] gives life to animated creatures and is also the cause of illnesses."[43]

Using words taken from ancient medical authors, here Biondo expressed views similar to those of natural magicians and alchemists. The rest of his treatise was devoted to more practical matters: names and qualities of winds, their effects on human health, and, finally, the importance of a precise determination of wind direction in marine navigation. To this end, Biondo proposed a wind rose with twenty-six points, and at the end he briefly discussed the utility of the magnetic compass.[44] Thus, in this treatise, at least three different aspects of wind stood side by side: wind as the expression of a cosmic spirit, wind in its irreducible qualitative variety, and wind as a motive force to be accurately estimated. The author, however, made no attempt to provide a closer fit or any direct connection between these aspects. Later, some philosophers would discover this connection in the form of pneumatic devices.

Girolamo Cardano and Pneumatic Machines

In the year 1550, the Milanese physician and astrologer Girolamo Cardano (1501–1576) published the first edition of his treatise *De subtilitate*, which became very popular and was expanded in two further editions (1554, 1560).[45] Cardano was an original if rather unsystematic thinker, and in this work he expressed his

43 "Et prisci philosophi recentiores, spiritum et flatum dicunt esse alitum quandam, quem enuntiaverunt esse aerem, quo, et in quem universa animalia spirant. [...] Quicquid autem est infra terra ac coelum spiritu plenum est, quare spiritus est causa frigoris et aestus [...] propterea arbitror quod spiritus diriget cursum solis et lunae. [...][spiritus] praestat vitam animalibus et quoque est morborum causa." (Biondo, *De ventis* f. 4r–4v). The author states he is quoting Galen and Hippocrates; I was only able to identify his quote from Hippocrates in: *On breaths*, in: *Hippocrates*, vol. 2, trans. William Henry Samuel Jones (Cambridge, MA, 1967), pp. 226–253, here pp. 230–231 (Hp. Flat. 3–4).

44 Biondo, *De ventis*, pp. 14r–16v.

45 For my analysis I used : Girolamo Cardano, *De subtilitate*, ed. Elio Nenci, vol. 1 (Milan, 2004). A complete edition can be found in: G. Cardano, *Opera omnia*, vol. 3 (Stuttgart, 1966), pp. 353–672. For a general discussion of its contents, see: E. Nenci, Introduzione, in: Cardano, *De subtilitate*, pp. 13–42. On Cardano's life and work, see: Giuliano Gliozzi, Girolamo Cardano. *Dizionario biografico degli italiani* 19 (1976): 758–763.

views on natural philosophy. Both his ideas on motion and his theory of air and wind are of interest for our subject.

Cardano was one of the first Renaissance scholars to embed in his natural philosophical discussions long descriptions of the structure and workings of technological artefacts, for example, gunpowder and hydraulic and pneumatic devices. He had read at least parts of *Pneumatics* by Hero of Alexandria (ca. A.D. 62), which was available at the time in Latin translation in manuscript form.[46] Cardano was certainly familiar with Hero's introduction to the work, which is one of the very few ancient texts where the workings of rather complex machines—mostly pneumatic devices—are used as a starting point to reflect upon matter and motion.

As an engineer, Hero knew how important it was for the workings of his machines that air should be capable of expanding and contracting, a property that, according to him, was only possible because air was made out of corpuscles separated by voids, which could increase and decrease in volume.[47] Cardano refuted the existence of vacuum, but he followed Hero in placing much importance on expansion and contraction. He closely scrutinised the working of devices such as suction pumps, bellows, and spring-driven clocks, and used their operations to conceptualise well-known phenomena in new terms, namely, as effects of the bodies' resistance to excessive expansion and contraction. There were, he explained, three kinds of natural motion:

"The first one, and the most powerful, is due to the avoidance of vacuum, but more truly to the form of an element, when this does not admit further rarefaction and when the parts of matter, as always, refuse to be separated. Thus, when [obstructed] bellows are extended more than what the little bit of air [they contain] can stand, that air at first rarefies, but then, since basic matter does not admit separation and the air is unable to sustain further rarefaction, it either attracts something to itself, or completely destroys the bellows. Therefore, motion does not derive from vacuum, but mainly from the form of that portion of air, when it does not want to be either expanded further or separated [from other matter]."[48]

46 Cardano, *De subtilitate*, pp. 61–63. On the importance of Hero's *Pneumatics* for early modern natural philosophy, see: Marie Boas, Hero's Pneumatica: A study of its transmission and influence, *Isis* 40 (1949): 38–48.

47 Hero of Alexandria, *Opera omnia. Vol. 1. Pneumatica et automata*, ed. Wilhelm Schmidt, 2 vols. (Leipzig, 1899), here pp. 4–8 (Hero Spir. 1, 147).

48 "Ergo in universum tres erunt motus naturales. Primus quidem ac validissimus a vacui fuga, sed verius a forma elementi, cum maiorem raritatem non admittat, nec materiae partes separari

From the viewpoint of modern science, this shift in explanatory perspective does not provide a more correct explanation than the Aristotelian one. However, its importance should not be underestimated for it indicated that the motion of pneumatic devices was no longer seen as a consequence of a generic principle of nature to which the machine obeyed as a whole, the "horror vacui". Instead, here motion was regarded as due to a property of a specific part of the machine—in the bellows, air—which was viewed as providing the motive force for the entire system.

For Cardano the second kind of natural motion was a symmetrical complement to the first, and originated from resistance to excessive compression:

"[The second kind of motion] seems to happen to prevent bodies from penetrating each other, but is more truly due to the reason opposite to that of the first motion, namely, to the fact that the form of basic matter should not become less than what is right for it, while in the previous case it should not become more."[49]

The third kind of natural motion was the tendency of heavy things to descend and of light things to rise, and Cardano added: "Everyone says it is clearly natural, so that I will not delve much into it."[50] He went on to describe the workings of various devices, explaining them in terms of his three kinds of natural motion. The first examples were descriptions of two elaborated pneumatic machines to raise water, followed by a discussion of how springs were used to drive mechanical clocks and how the tension of strings and ropes was exploited in throw-weapons.[51] Many more machines followed, but this short presentation should suffice to show how Cardano, reflecting in terms of machines and their motive forces, regarded expansion and contraction of air as symmetrical phenomena, both constituting a source of motive force.[52] This was a different

unquam queant. Cum igitur in follibus apertio maior fit quam paucus ille aer ferre possit, primum rarior redditus, cum materia prima separationem non admittat, aer ille non sustinens maiorem raritatem, aut aliquid ad se trahit, aut folles omnino disrumpit. Non igitur a vacuo motus ullus, sed a formis ipsis maxime aeris, dum amplius divelli nequit nec separari, fieri consuevit." (Cardano, *De subtilitate*, p. 66).

49 "[Secundus motus fit] ne corpora se mutuo penetrent factus videtur, sed verius oppositam priori ob rationem, ne scilicet forma plus iusto quam debeat materiae primae consequatur, sicut in priore ne iusto minus." (Cardano, *De subtilitate*, p. 66).

50 "Tertius autem motus [...] quem plane omnes naturalem esse fatentur, quo minus de eo laboro." (Cardano, *De subtilitate*, p. 67).

51 Cardano, *De subtilitate*, pp. 67–72.

52 Later, Cardano also explained the propelling force of gunpowder in terms of a tendency to expand (Cardano, *De subtilitate*, pp. 151–152). However, Cardano did not discuss any machine in

position to Hero's, who had attributed the air's tendency to expand when compressed to the elasticity of its particles, but had considered the suction power of pumps as due to the speed with which matter could move in a vacuum.[53] Cardano, instead, somehow attributed to air properties similar to those of a spring. In fact, at the time springs and air were the two most common means of making a machine move, along with the descent of weights or water.

For pneumatic engineers, distinguishing between moving and moved components was important to evoke motive forces and manipulate them into producing desired effects.[54] For natural philosophers, the approach could contribute to shape theory, conceptualising expansion and contraction of air not primarily in terms of a change of volume, but rather of the air's capability to actively resist rarefaction and condensation, a capability that could eventually express itself in mechanical motion. This kind of conceptualisation could be extended to open-air phenomena such as wind, whose motive force was evident to everyone, whereas changes in volume were not.

Later, Cardano stated that in the universe, the element air had the function of receiving and conveying fiery, celestial influences to Earth, providing health and well-being for living creatures.[55] For air to remain pure and healthy, however, it was necessary for it to move continually, sometimes in a strong wind, sometimes in a gentle breeze. A proof of the perennial natural motion of air was the fact that, in narrow spaces, there was always a breeze blowing, a phenomenon often exploited by architects. This effect resulted from the air's resistance to compression, which was therefore instrumental in generating winds of different intensity and direction. However, for the Italian astrologer Cardano, the details of wind formation ultimately depended upon celestial influences.[56]

which expansion and contraction were due to heating or cooling, even though Hero of Alexandria had devoted much attention to the subject in his Introduction to the *Pneumatics*.

53 Hero, *Pneumatica*, pp. 8–9.

54 On the speculative interest of engineers in air and its force, see: Graham Hollister-Short, The formation of knowledge concerning atmospheric pressure and team power in Europe from Aleotti (1589) to Papin (1690), *History of Technology* 25 (2004): 137–150; Matteo Valleriani, From "condensation" to "compression": How Renaissance Italian engineers approached Hero's "Pneumatics", in: *Weight, Motion and Force*, Max Planck Institute for the History of Science, Preprint 320 (2006), pp. 43–61.

55 Cardano, *De subtilitate*, pp. 125–128 and 197–200.

56 G. Cardano, *De rerum varietate*, in: G. Cardano, *Opera Omnia*, vol. 3, pp. 1–351, here pp. 5–7. In this text, Cardano assented that certain winds were due to exhalations, but still regarded normal winds as moving air (Cardano, *De rerum varietate*, p. 6).

Winds in the Meteorology of Bernardino Telesio

Bernardino Telesio (1509–1588) was one of the most original and influential natural philosophers of the Italian Renaissance.[57] His main work was the treatise *De rerum natura*, (three eds. 1565, 1570, 1586), but he also wrote a number of booklets on individual subjects, and one of them was *On those things, which happen in the air, and on earthquakes* (1570), in which he presented a systematic treatment of meteorological phenomena based on the principles of his own philosophy of nature.[58]

As the starting points for his natural philosophy Telesio employed some Aristotelian notions as well as the structure body–spirit–soul. In the earliest version of *De rerum natura*, soul and spirit were identified with each other as a very subtle, material substance pervading all bodies and making them capable of sensing and reacting to each other with pleasure or pain. In later works, Telesio corrected himself, explaining that men also had an immaterial, immortal soul, which however did not play any role in determining natural phenomena. In his system, there were two active principles in nature: heat and cold. Heat made bodies larger and thinner, while cold thickened and contracted them. Thanks to the spirit pervading them, all bodies reacted to these actions with pleasure or pain. According to the analysis of Martin Mulsow, Telesio's notion of heat was an elaboration of the idea of "innate heat" of living bodies developed by Renaissance physicians.[59]

Telesio began his meteorology by refuting Aristotle's theory of the two exhalations, and claiming that only humid vapours were drawn up by solar heat both from earth and from water.[60] Therefore, winds, too, were simply humid vapours flowing through the air. The only difference between rain vapours and wind vapours was that the latter were incapable of condensing into rain, hail, or snow:

"Thus, we have to assume that this kind [of vapour] can neither thicken in an open and free space, nor be constrained by our cold so much, that they condense into [rain, snow, or hail]. In fact, we never see air condense into water

57 As reference for my overview on Telesio's natural philosophy I used: Roberto Bondì, *Introduzione a Telesio* (Rome and Bari, 1997), especially pp. 13–39 and 74–93.

58 I used the second edition of this work: Bernardino Telesio, *De his quae in aere fiunt*, in: B. Telesio, *Varii de naturalbus rebus libelli* (Venice, 1590).

59 Mulsow, *Selbsterhaltung*, especially pp. 234–246 and 251–266.

60 Telesio, *De his quae in aere fiunt*, f. 14r–14v.

or snow, no matter how much it is pressed together by a leather sack, or by the direst cold, and the thinnest winds, as for example Boreas seems to be, do not seem to ever condense into water or snow."[61]

According to Telesio, the "thinness" of wind vapours was not simply a state they happened to be in, it was a property that determined the way they would react to attempts at making them thicker:

"[The vapours] diffuse in winds, sometimes of their own motion, and they move out of their own will in horizontal direction. [...] But even when they do not want to move spontaneously, they can be seen to be moved and pushed. Being thin by nature, they hate and greatly resist being compressed in themselves, or condensing into a completely different substance. Sometimes it happens that they have increased so much that the space in which they are cannot contain a larger number or a greater volume of them—either because new ones are coming up under them, constantly emerging from earth and see, or because the same vapours need a larger space, having been made thinner by the sun, or in any circumstance in which they cannot preserve their thinness, but are compressed and made smaller. In these cases, they move horizontally with a light, peaceful motion, if by doing this they can avoid compression."[62]

When easy escape was not possible, the vapours began to move faster and faster locally, using their motive force to destroy all obstacles.[63] For Telesio, the inherent "thinness" of some vapours, that is, their aversion to compression and condensation, expressed itself in the motive force of wind. This notion recalls Cardano's ideas, but unlike Cardano, Telesio also took into account the rarefying effect of heat, which could provoke vapours into reacting with motion.

61 "Huismodi enim qui sunt nec in aperto liberoque loco adeo in seipsos conspissari, at neque adeo a nostro frigore compingi posse videti debent, ut in illorum ullum crassescant. Siquidem neque aer ullus quantumvis in utrem coniectus et frigoribus saevientibus quantumvis, nec tenuissimi qui sunt venti, cuiusmodi Boreas ipse videtur, vel in aquas unquam, vel in nives crassescere apparent." (Telesio, *De his quae in aeris fiunt*, f. 14v).

62 "Qui vere in ventos diffunduntur, proprio forte motu, sponteque sua in obliquum feruntur, bene enim propria natura mobiles [...] At vel nihil moveri appetentes a seipsis moveri tamen, impellique videri possint. Quoniam enim tenues sui natura in seipsis spissari, densarique in alienam omnino agi substantiam, summe odio habent summeque aversantur, ubi tanti facti sunt, ut locus in quo continentur plures, aut ampliores eos capere non possit, si vel novi, qui assidue a terra, marique emergunt, eos subeunt, vel amplius ipsi a sole attenuati ampliore indigeant loco, quacunque omnino occasione in propria ibi servari tenuitate non possint, sed comprimantur, inque angustius agantur, id ut vitent in obliquum feruntur, et levi quidem, placidoque motu, si eo compressionem vitant." (Telesio, *De his quae in aeris fiunt*, f. 15v–16r).

63 Telesio, *De his quae in aere fiunt*, f. 16r.

In my opinion, Telesio also conceived of the wind's motive force in analogy to the one displayed by air or steam in pneumatic devices. In his meteorological treatise, he did not mention any machine, but he did so in other works, and he is usually regarded as having valued experiment—at least in theory.[64] For example, he argued in favour of the existence of a vacuum by questioning the idealised technical premises of the experiments that allegedly proved its impossibility, and proposed modifying the apparatus in new ways. As stressed by Charles Schmitt, this was an important step, regardless of whether or not the modifications were, or could ever be, carried out in practice.[65] The verbally encoded features of artefacts of greater or lesser complexity were being used to create new, hypothetical natural philosophical scenarios upon which to reflect.

Wind and Wind Theories
in the Second Half of the Sixteenth Century

In the second half of the sixteenth century, the number of original meteorological treatises increased still further. Some were written for university lectures, others addressed a broader, learned public; however, it is not possible to make a clear-cut distinction between "learned" and "popular" treatises. Most authors continued to base their work on the Aristotelian theory of exhalations, but there is increasing mention of the opinions of other authors. Albertus Magnus' theory of wind formation remained popular, but a considerable number of authors also questioned or rejected it. In Germany, treatises continued to be written mainly in Latin.

- Michael Stanhuf (d. 1608), in his *De meteoris* (1554), quoted non-Aristotelian opinions, but endorsed Albertus Magnus' theory; [66]
- Marcus Frytsche, in his *Meteororum* (1555), agreed with Albertus Magnus, but quoted Vitruvius's statement that heat would press the force of wind

64 On Telesio's attitude to experiment, see: Charles B. Schmitt, Experimental evidence for and against a void: The sixteenth-century arguments. *Isis* 58 (1967): 352–366, here pp. 355–357 and 360–364; de Waard, *L'expérience barométrique*, pp. 27–28.

65 Charles B. Schmitt, Changing conceptions of vacuum (1500–1650), in: *Actes du XIe congrès international d'histoire des sciences*, vol. 3 (Wrocław, 1968), pp. 340–343, here p. 341.

66 Michael Stanhuf, *De meteoris libri duo* (Wittenberg, 1554), no pagination.

out of humour and mentioned with some respect Seneca's idea of the air's capability of moving by itself; [67]

- Johannes Garcaeus the Younger (1530–1574), in his *Meteorologia conscripta* (1568), adopted Albertus Magnus' theory of wind, but stated that "by this same meteorological phenomenon [i.e., wind] does man live, namely through expiration and inspiration of the lungs."[68] Further, he explained that "in the Holy Scriptures, the Holy Spirit is expressed in the nature of winds".[69]
- Wolfgang Meuerer (1513–1585), in his *Commentarii meteorologici* (published posthumously in 1592), only offered Albertus Magnus' opinion.[70]

Wittenberg continued to be a centre of the meteorologically interested: two of these treatises were published there (Stanhuf and Garcaeus), and a third was written by a former student of Wittenberg University (Meurer). In England, only one treatise appeared, but it rapidly became very popular:

- William Fulke's (1538–1589) *Goodly gallery with a most pleasant prospect, into the garden of naturall causes of all kind of meteors* (1563) combined Aristotle's opinions with those of other authorities, and devoted only three pages to wind.[71] Fulke stated that, while "general winds" were exhalations, "particular winds" could also have other origins: some came from caves, and some were simply moving air.

In Italy, between 1550 and 1600, at least four dialogues and four treatises on weather were published, all in the vernacular. The treatises were more systematic than the dialogues, which were written by: Tomaso Tomai (d. 1593) (1566), Francesco Guidani (1578), Francesco Camillo Agrippa (d. after 1595) (1584), and Vitale Zuccolo (1556–1630) (1590).[72] Agrippa, an engineer from Milan, was

67 I used a later edition of this work: Marcus Frytsche, *Meteororum* (Nuremberg, 1563), on winds ff. 130v–141r.

68 Joahnnes Garcaeus, *Meteorologia conscripta* (Wittenberg, 1568), on winds ff. 232r–298v, quote from f. 234v.

69 Garcaeus, *Meteorologia*, f. 279r.

70 Wolfgang Meurer, *Commentarii meteorologici* (Leipzig, 1592), on winds pp. 186–233.

71 William Fulke, *A goodly gallery*, ed. Theodore Hornberger (Philadelphia, 1979), on winds pp. 48–50.

72 Tomaso Tomai, *Dialogo meteorologico* (Ancona, 1566), on winds p. [13–14] (no pagination: I count

the only author who did not mention exhalations; instead, he explained that celestial influences changed the qualities of the elements, causing air to move. Guidani and Zuccolo endorsed Albertus Magnus' theory, while Tomai only said that earthly, hot exhalation moved air.

Of the treatises, some demonstrated that authors now felt it was necessary to defend Aristotelian positions on wind and its origin:

- Bartolomeo Arnigio (1523–1577), in his *Meteoria* (1568), took over word for word Frytsche's statements on Albertus Magnus's theory and on Vitruvius;[73]
- Stefano Breventano (d. 1577) wrote a treatise on weather as well as a *Treatise of the origin of winds, of their names and of their properites, [a treatise] useful and necessary to sailors and to any kind of people* (1571).[74] He quoted Vitruvius on heat pressing force out of humour and Seneca on air being full of spirit, but then explicitly endorsed Albertus Magnus' theory;
- Francesco de' Vieri (1524–1591), in his *Trattato delle meteore* (1573), debated at length whether wind was made out of air, dry exhalation, or humid vapour, and argued for the Aristotelian view, but not for Albertus Magnus' opinion;[75]
- Cesare Rao (fl. 1560–1585), in *I meteori* (1582), accepted exhalations, but offered various possibilities as to what kind of exhalations wind might be made of.[76] He, too, did not endorse Albertus Magnus' opinion.

During the sixteenth century, interest in wind and weather was kindled by reports reaching Europe from the East and West Indies about hitherto unknown meteorological phenomena:

- The *Historia natural y moral de las Indias* (1590) by the Jesuit Father Joseph de Acosta (1540–1600) described tropical weather and the trade winds that

from the beginning of the table of contents); Francesco Guidani, *Dialogo* (Venice, 1578), on winds ff. 14v–19r; Camillo Agrippa, *Dialogo* (Rome, 1584), on winds pp. 5–31; Vitale Zuccolo, *Discorso delle cose meteorologiche* (Venice, 1590), pp. 31–45.

73 Bartolomeo Arnigio, *Meteoria* (Brescia, 1568), f. 96v–97v.

74 Stefano Breventano, *Trattato delle impressioni dell'aere* (Pavia, 1571); S. Breventano, *Trattato dell'origine delli venti, nomi et proprieta' loro utile, et necessario a marinari et ogni qualità di persone* (Venice, 1571), here especially pp. 3v–5r.

75 Francesco de' Vieri, *Trattato delle meteore* (Florence, 1573), on winds pp. 67–82.

76 Cesare Rao, *I meteorii* (Venice, 1582), on winds ff. 109v–120r.

blew in tropical regions the whole year in an east–west direction.[77] Acosta interpreted the trade winds as evidence in favour of Aristotle's idea that exhalations were dragged along by the east–west rotation of the celestial sphere.

The many aspects of wind, all of them important to Renaissance culture, were collected in:

- the Latin "Treatise on wind" (1601) by Fabrizio Padovani (fl. 1605), who quoted many opinions on the origin of wind, but ultimately opted for Aristotelian views, although not exactly in Albertus Magnus' form.[78] Padovani discussed wind in architecture, agriculture, and navigation, and the final chapter dealt with *The mechanics of winds*. It contained descriptions and images of "various instruments moved by the work of wind": flags, windsocks, ships, windmills of various kinds, pneumatic machines, bellows, "aeolipilae" and, finally, musical wind instruments.[79]

Meanwhile, discussions on winds and their origin appeared in literature that was not primarily concerned with meteorology:

- Jean Bodin (1529–1596), a jurist who was a firm believer in and opponent of demonic magic, published in 1596 a *Theatre of the whole nature*.[80] He explained that winds were merely moving air and that the "reason of wind" ("ratio ventorum") could be of two kinds: an ordinary one, which had its origin in the sun, and a singular one, which was characteristic of each region and was due to the impulse ("impulsus") of angels or demons;
- Francesco Pifferi (b. approx. 1548) discussed winds in an addition to his commentary to the "Sphere" of Sacrobosco (1604), an astronomical work.[81]

77 Joseph de Acosta, *Historia natural y moral de las Indias* [1590], 2 vols. (Madrid, 1894), here vol. 2, pp. 180–185 and 192–197.

78 Fabrizio Padovani, *Tractato duo alter de ventis alter perbrevis de terraemotu* (Bologna, 1601), pp. 3–7.

79 "Varia instrumenta ope ventorum mota." (Padovani, *De ventis*, p. 128).

80 Jean Bodin, *Universae naturae theatrum* (London, 1596), on the causes of winds pp. 159–165. On Jean Bodin's attitude to demonic magic, see: Walker, *Magic*, pp. 171–177.

81 Francesco Pifferi, *La sfera di Giovanni Sacrobosco, tradotta e dichiarata* (Siena, 1604), on winds pp. 354–365. I thank Matteo Valleriani for pointing out this reference to me. Pifferi presents this discussion as new material, and in fact winds were not discussed, for example, in the treatises on

He quoted Vitruvius' definition of wind, but rejected it to endorse the Aristotelian theory of exhalations. As to the winds' motion, it was due to the varying qualities of exhalations and linked to celestial influences;

- the physician William Gilbert (1540–1603), best known for his treatise *De magnete* (1600), in the years 1601–1602 completed his *New philosophy of our sublunar world* (published 1651), which included new explanations for all meteorological phenomena.[82] Wind was moving air, and its motion was due to thermal expansion. However, what expanded was not air, but very compact, earthy matter from underground, whose expansion was so fast that it moved large masses of air, like "salniter in fire or gunpowder which has caught fire".[83]

Making Air Visible: The Inverted Glass Experiment and Giovanni Battista Benedetti

Expansion and contraction of air are not visible under normal circumstances, but they can be made visible using a glass. In the last decade of the sixteenth century, a very simple experiment doing precisely this became popular in Europe.[84] It involved an inverted glass flask and a basin of water. To perform the experience: (1) take an empty glass flask and heat it by putting it near a fire; (2) turn it upside down and dip its neck into a small basin full of water; (3) watch the water slowly climb up the neck of the inverted flask.

The effect was not new; it had been used for suction cups since antiquity. The experimental set-up described above, which I shall refer to as the "Inverted Glass Experiment", was made popular in Europe by the first edition of Giambattista Della Porta's *Magia naturalis* (1558).[85] However, Della Porta gave the

the sphere by Alessandro Piccolomini (1540), Francesco Giuntini (1564), or Christophoros Clavius (1570).

82 William Gilbert, *De mundo nostro sublunari philosopha nova* (Amsterdam, 1651), on winds pp. 254–266. On its date of composition: Richard A. Jarrell, The latest date of composition of Gilbert's "De mundo". *Isis* 63 (1972): 94–95.

83 "Perinde atque halnitrum in igne, aut pulvis bombardicus cum jam ignem conceperit." (Gilbert, *De mundo*, p. 255).

84 I discuss the history of this experiment in more detail in: Borrelli, Weatherglass.

85 I used the second reprint of this work: Giambattista Della Porta, *Magiae naturalis* (Anverse, 1560), here f. 59r. On the diffusion and influence of this work, see: Laura Balbiani, *La 'magia naturalis' di Giovan Battista Della Porta* (Bern, 2001), pp. 78–85 and 212–218.

traditional Aristotelian interpretation of the phenomenon: heat attracted water. A few years later, in his *Disputationes de quibusdam placitis Aristotelis* (printed in 1585), Giovanni Battista Benedetti (1530–1590) explained that the Aristotelian interpretation was wrong: what happened was that air contracted as it cooled, and the water had to rise "to prevent space from remaining empty".[86]

From the point of view of modern science, this explanation is more correct than the Aristotelian one, but it must be noted that Benedetti ultimately attributed the motion of the water to the impossibility of vacuum, and not to some property of the contracting air, as for example Cardano had done. Nevertheless, in the same short essay as well as in a letter, Benedetti took the very important step of linking thermal expansion and contraction of pure air to wind formation.[87] As a proof of his opinion, he pointed out that a cloud covering the sun immediately gave rise to a breeze.

Cornelis Drebbel, Giambattista Della Porta, and the Activity of Air

Benedetti's remarks were actually only an aside in his discussion of rarefaction and condensation, but during the first decade of the seventeenth century, the Inverted Glass Experiment took centre stage in the discussion on the origin not only of winds, but of all meteors. In two treatises on meteorology the experiment was presented as demonstrating how the element air, under the influence of celestial fire, could become alive and active, acquiring motive force. The first was Cornelis Drebbel's (approx. 1572–1633) *Short treatise on the nature of the elements and how they cause wind, rain, lightning and thunder and to what they are useful*, published in Dutch in 1604 and soon translated and reprinted in many languages.[88] The second was Giambattista Della Porta's (about 1535–1615)

86 On the life and work of Giovanni Battista Benedetti, see: Stillman Drake, Giovanni Battista Benedetti. *Dictionary of Scientific Biography* 1 (1970): 604–609. Benedetti's *Disputationes de quibusdam placitis Aristotelis* were printed as part of a larger work: Giovanni Battista Benedetti, *Diversarum speculationum mathematicarum et physicarum liber* (Turin, 1585), the Inverted Glass Experiment is described on pp. 193–194, the quote "ne aliquis locus vacuus remaneat" is on p. 193.

87 Benedetti, *Diversarum speculationum*, p. 192 and pp. 416–417 (letter to Pancrazio Mellano).

88 Cornelis Drebbel, *Een kort tractaet van de natuere der elementen, ende hoe sy veroorsaecken, den wind, reghen, blixem, donder, ende waromme dienstlich zijn* (1604). The earliest edition of the treatise that was accessible to me was the German translation: C. Drebbel, *Ein kurzer Tractat von der Natur der Elementen und wie sie den Wind, Regen, Blitz und Donner verursachen und war zu sie nutzen* (Leiden,

Fig. 2: C. Drebbel, Kurzer Tractat von der Natur der Elemente *(Short treatise on the nature of the elements, 1608) p. 15. The Inverted Glass Experiment is shown here as not taking place in a laboratory, but in a natural environment, with an alchemist's retort hanging from a tree. Image from the Library of the Max Planck Institute for the History of Science (Berlin).*

book *On the transmutations of air*, which was published in Latin in 1610 and never translated or reprinted.[89]

Historically, Drebbel's meteorology was much more influential than Della Porta's. However, I will discuss the two works together, because their statements

1608), from which all my references and quotes are taken. On the dates of the various editions of the book: Hellmann, *Lehrbuch*, p. 77. On Drebbel's life and work: Gerrit Tierie, *Cornelis Drebbel (1572–1633)* (Amsterdam, 1932).

89 G.B. Della Porta, *De aeris transmutationibus*, ed. Alfonso Paolella (Naples, 2000). On Della Porta, see for example: William Eamon, *Science and the Secrets of Nature. Books of Secrets in Medieval and Early Modern Culture* (Princeton, 1994), pp. 195–233.

on wind generation and their general views of meteorological phenomena exhibit extraordinary similarities, even though they are expressed in very different terms. Drebbel wrote in Dutch, using a language of Paracelsian inspiration and stressing the religious significance of the study of nature; the Italian scholar cast his thoughts in the Latin words of ancient and medieval authorities and made use of geometrical arguments. Della Porta argued explicitly against Aristotle; whereas Drebbel quoted neither friend nor foe. However, both authors explained thunder according to the Paracelsian "gunpowder" theory mentioned above.[90]

Both Drebbel and Della Porta postulated a cosmic subtle substance—a "spirit"—which was both recipient and vehicle of celestial influences, allowed elements to transmute into each other, made air alive and life-bringing, and gave rise to all meteorological phenomena. Drebbel's cosmic spirit was fire; the "clearest" of all elements and top of the hierarchical order of elements— fire, air, water, and earth. [91] Fire "clarified" the other elements, making them capable of sustaining life: thus air became similar to fire, water to air, and so on. Della Porta explained meteorological phenomena as "transmutations of the air" in a literal sense and quoted Isidor of Seville, explaining that the element air, by becoming thinner or thicker, could give rise to winds, thunder, clouds, rain, or snow.[92] In the words of Seneca, he then explained that air had the function of linking heaven and Earth and of bringing life to all animated creatures.[93]

Drebbel's and Della Porta's statements on the origin of wind are very similar in content, and begin with a description and a depiction of the Inverted Glass Experiment. They said: if you take an empty glass flask, dip its neck into water, and then heat up the belly of the flask, you will see bubbles of air violently escaping through the water.[94] These were "winds rising up from the mouth of the retort", stated Drebbel, while Della Porta remarked that it looked "as

90 Della Porta, *De aeris transmutationibus*, pp. 146–149; Drebbel, *Kurzer Tractat*, pp. [21–22]. This edition is unpaginated; I count from the title page.

91 Drebbel, *Kurzer Tractat*, p. [8].

92 Della Porta, *De aeris transmutationibus*, p. 14, ll. 5–9, corresponding to Isidor of Seville, *Etimologie. Libro XIII: De mundo et partibus*, ed. and trans. Giovanni Gasparotto (Paris, 2004), p. 38 (Book 13, 7,1).

93 Della Porta, *De aeris transmutationibus*, p. 14.

94 The experiment is described in: Della Porta, *De aeris transmutationibus*, pp. 43–45; Drebbel, *Kurzer Tractat*, pp. [15–16].

though we were blowing into a tube immersed in the water".[95] The same set-up was then used in a visual demonstration that air increased its volume when heated, and that it contracted again during cooling. Neither Della Porta nor Drebbel mentioned here the "horror vacui", and the Italian scholar stated that in contracting, the air attracted the water.

After presenting the Inverted Glass Experiment, both authors described the "aeolipila" as an example of how stronger winds are produced by thicker substances (water for Drebbel, humid air for Della Porta) under the action of fire.[96] Next, Della Porta—but not Drebbel—specified that wind happened when air expanded with solar heat, pushing away any colder air in its vicinity. He then attempted to explain the seasonal and geographical variations of winds according to this model.[97] Drebbel, however, seemed to be aware that a simple explanation of winds in terms of hot air pushing away cold one might be problematic, and remained quite vague on the subject.[98]

Although both Drebbel and Della Porta conceived of wind—and weather in general—in vitalistic terms, neither employed the notion of the resistance of air to expansion and contraction to explain the process of wind formation, as Telesio had done. Drebbel concentrated on the alchemical interplay between water, air, and fire, which provoked wind, humidity, or rain. Della Porta, as noted above, conceptualised expansion in somewhat mechanical terms, with hot air pushing away cold, but without taking changes in density and weight into account.

For both authors, the Inverted Glass Experiment primarily had the function of demonstrating how heat endowed air with motive force. In this sense, the experiment was similar to the "aeolipila", and it is not surprising to find both experiments mentioned side by side, although very different artefacts were involved. Notably, the "aeolipila" was presented as only of secondary relevance to a demonstration of wind, even though it actually simulated it. The Inverted Glass Experiment was the most important demonstration, because it made the motive force of air visible, although it did not provide a sensually perceptible simulacrum of wind.

95 "[Wir sehen] winde steigen aus dem mund der Retorten." (Drebbel, *Kurzer Tractat*, p. [16]); "quamadmodum eveniret si cava harundine sub aquis mersa insufflamus." (Della Porta, *De aeris transmutationibus*, p. 43).

96 Della Porta, *De aeris transmutationibus*, p. 45; Drebbel, *Kurzer Tractat*, p. [16]. Della Porta quotes Vitruvius and mentions his name; Drebbel does not.

97 Della Porta, *De aeris transmutationibus*, pp. 49–51.

98 See, for example, his questions and answers (or lack of) in: Drebbel, *Kurzer Tractat*, pp. [19–20].

The Weatherglass, Galileo Galilei, and Robert Fludd

In the following years the Inverted Glass Experiment gained great popularity, and by the 1620s, the glass apparatus necessary to perform it was being sold by instrument makers in The Netherlands and in England.[99] The device often went under the name of "weatherglass", for it was discovered that it could also predict weather. Around 1610, Aristotelian philosophers began to use it as a "thermometer", that is, to quantify the "temperature" of heat and cold in the air, and Galileian philosophers followed their example soon after.[100]

In the meantime, Drebbel had become famous in Europe by presenting to the public a "perpetuum mobile" based on expansion and contraction of air, which he claimed demonstrated the force behind all movement and life.[101] For Galileo Galilei (1564–1642) and his followers, Drebbel's perpetual motion was only a trick based on a well-known effect, to which they apparently did not attach any particular natural philosophical significance.

However, the weatherglass (and the "aeolipila", too) demonstrated a highly non-trivial natural phenomenon, which we conceptualise today as a transformation of energy from heat into mechanical motion. As is well known, the study of steam engines in the late eighteenth and early nineteenth centuries was instrumental in the development of this kind of conceptualisation, whose importance for modern science can hardly be overestimated. Thus it is legitimate to wonder why Galileo and his friends were not fascinated by the motive power of heat. Below, I shall offer a tentative answer to this question.

Galileo never proposed any general theory about the origin of wind, and instead claimed that "the causes of wind generation are many and different".[102] Yet in his

99 The set-up could be turned into a permanent instrument by fixing the inverted glass on top of the water vessel. Since the water also rose and fell in response to changes in atmospheric pressure, the device worked as a barometer. For an overview, see: F.S. Taylor, The origin of the thermometer. *Annals of Science* 5 (1942): 129–156.

100 The term "temperature" comes from Aristotelian philosophy, where it indicated the balance of heat and cold in a body.

101 For a discussion of Drebbel's device, see: Jennifer Drake-Brockman, The "perpetuum mobile" of Cornelis Drebbel, in: *Learning, Language, and Invention*, ed. Willem D. Hackmann and Anthony J. Turner (Ashgate, 1994), pp. 124–147.

102 "delle quali generazioni di venti molte e diverse son le cause." (G. Galilei, *Dialogo sopra i due massimi sistemi del mondo tolemaico e copernicano*, ed. Ottavio Besomi and Mario Helbing, 2 vols. (Padova, 1998), here vol. 1, p. 479). Trade winds are discussed in Galileo, *Dialogo*, vol. 1, pp. 477–481, commentary in vol. 2, pp. 868–870.

Dialogo dei massimi sistemi (1632), he presented the existence of the trade winds as evidence of the Earth's rotation. Air, he explained, was usually full of earthly exhalations, which, being thicker than air, were drawn along by the Earth's rotation. By contrast, pure air, like the air over the tropical oceans, tended to remain still, and therefore seemed to be moving from east to west. With this, winds also became involved in the most famous dispute of the age, about the Copernican system.

In 1622, Francis Bacon (1561–1626) published his *Historia ventorum*, a fact that in itself bore witness to the growing importance of the subject.[103] Bacon did not regard the existence of a common cause of all winds as proven, and acknowledged winds made of air alone, as well as winds made of exhalations together with air. As to the causes of their motion, these were various: trade winds, for example, were due to Earth's rotation, while other winds were caused by rarefaction and expansion of air, or by exhalations drawn up by the sun. Bacon briefly mentioned the weatherglass, but he did not give it prominence in discussing wind formation.[104]

In the meantime, the Inverted Glass Experiment attracted the attention of the physician and Rosicrucian philosopher Robert Fludd (1574–1637).[105] In his *Meteorologia cosmica* (1626), Fludd explained that winds were the principal meteorological phenomenon ("princeps meteororum") and the closest to God:[106]

"Wind is an aerial spirit, of middle consistence, inspired or animated by the breath of Iehova, which He extracts from his treasure-case according to His will, to effect either a punishment or a benediction."[107]

Supporting his opinions with a large number of Biblical quotations, Fludd explained that angels were the efficient cause of winds acting both in the macro- and microcosmos, so that changes in the air corresponded to changes in the state

103 Francis Bacon, *Historia ventorum*, in: F. Bacon, *Works*, ed. James Spedding, Robert Leslie Ellis, and Douglas Denan Heath, vol. 2 (London, 1859), pp. 13–78. On the causes of winds, for example, pp. 20–21, 26–27 and 46–50.

104 Bacon, *Historia ventorum*, p. 47.

105 On Robert Fludd's chemical philosophy, see: Allen G. Debus, *The Chemical Philosophy*, 2 vols. (New York, 1977), here vol. 2, pp. 205–293; specifically on his use of the weatherglass: A.G. Debus, Key to two worlds: Robert Fludd's weather-glass. *Annali dell'istituto e museo di storia della scienza di Firenze* 7 (1982): 109–143.

106 Robert Fludd, *Philosophia sacra et vere christiana seu meteorologia cosmica* (Frankfurt am Main, 1626), here pp. 38–44.

107 "Ventus est spiritus aereus, mediocris consistentiae, flatu Iehovae inspiratus, seu animatus, quem e thesauris ad voluntatem suam, sive ad flagellum, sive ad bene dictionem exequendam, depromit ipse." (Fludd, *Meteorologia cosmica*, p. 42).

Fig. 3: R. Fludd, Integrum morborum mysterium *(Whole mystery of illnesses, 1631) p. 53. The scale of the weatherglass is related here to the four elements (left), and to the humours characterising the human temperament (right). Image from: University Library, Humboldt University Berlin,* Integrum morborum mysterium; *Med Na 35.*

and temperament of living creatures, especially man.[108] Winds gave rise to all other weather phenomena. In the appendix to this work, Fludd described the weatherglass, which in later works became for him a three-dimensional, mobile structure on which to inscribe his entire philosophy.[109] This was possible because, in Fludd's opinion, the workings of the weatherglass corresponded to the workings of the macrocosmos and microcosmos: of man and the universe. For example, he drew a parallel between the thermal expansion and contraction of air in the weatherglass and the pulse of the heart caused by the spirit of life.[110]

108 Fludd, *Meteorologia cosmica*, pp.191–207.

109 Fludd, *Meteorologia cosmica*, pp. 283–303.

110 Debus, Fludd's weather-glass, pp. 130–138.

In the *Integrum morborum mysterium* (1631), Fludd used a number of devices and experiments involving thermal expansion and contraction of air as well as vaporisation and condensation of water to explain various illnesses.[111] Most of the machines were taken from the works on pneumatics by Philo of Byzantium (c. 200 B.C.) and Hero of Alexandria, but one image was a copy of the drawing of the Inverted Glass Experiment that had appeared in Drebbel's meteorological treatise.[112]

Reactions to the Activity of Air:
Libert Froidmont and René Descartes

Thanks to Drebbel's and Fludd's work, and probably also to the popularity of the weatherglass as a material artefact, the theory associating winds with the thermal expansion and contraction of air became well known in Europe. However, the theory was far from being generally accepted because it contradicted Aristotelian physics and was also difficult to reconcile with a mechanistic-corpuscular view of matter. Moreover, by then the theory had become embedded in—and probably was even a symbol of—a vitalistic-alchemical, Rosicrucian conception of meteorology and cosmology, which did not appeal to everyone.

As a reaction to this view of meteorological phenomena, two works offering alternatives were published: the *Meteorologicorum libri sex* (1627) by Libert Froidmont (1587–1653) and *Les Météores* (1637) by René Descartes (1596–1650).[113] Froidmont made an earnest, well-informed attempt at showing how a flexible Aristotelian framework could provide the most reliable answers to questions concerning weather, while Descartes boldly offered the first systematic treatment of meteorological phenomena within a strictly mechanical-corpuscular view of nature.

Froidmont endorsed the opinion that winds were made of dry and hot exhalations, criticised those modern philosophers who had claimed that wind was

111 Debus, Fludd's weather-glass, pp. 138–142, quote from p. 142.

112 R. Fludd, *Integrum morborum mysterium* (Frankfurt am Main, 1931), p. 462, almost identical with: Drebbel, *Kurzer Tractat*, p. [15].

113 Libert Froidmont, *Meteorologicorum libri sex* (Antwerpen, 1627); René Descartes, *Les Météores/ Die Meteore*, ed. Claus Zittel (Frankfurt am Main, 2006). On these works, see: Christoph Meinel, Les "Météores" de Froidmont et les "Météores" de Descartes, in: *Libert Froidmont et les resistances aux revolutions scientifiques*, ed. Anne-Catherine Bernès (Haccourt, 1988), pp. 105–129.

moving air, and fiercely rejected the idea that air could be animated, "as the Stoics dream".[114] In a section entitled: "Neither rarefaction nor condensation of air are the efficient cause of all winds. Against Vitruvius and G.B. Benedetti", he correctly pointed out how Benedetti's theory in most cases failed to explain or even plainly contradicted observation. Froidmont also refuted a number of well-known Aristotelian views on the motion of winds, among them Albertus Magnus' theory, and argued against those who used biblical quotes to claim that winds were a direct expression of celestial power and were caused by God's angels. He finally stated his own opinion in a section entitled: "Winds flow towards Earth because of their gravity, like streams and rivers in their beds", which started, however, with the rather cautious words: "As it is, after a long reflection, I was not able to find any other cause."[115]

For Froidmont, it was important that theories should not contradict observed phenomena, whereas Descartes had a more a priori approach to meteorology.[116] His discussion of winds was inspired by Vitruvius, although Descartes did not mention him by name.[117] While acknowledging that people were inclined to refer to moving air as "wind", Descartes explained that real winds were actually made of vapours drawn up from earth and water by solar heat. This could be seen in (Vitruvius') "aeolipila": in the open air, as in the "aeolipila", vapours expanded when heated and, when they encountered the opposition of other vapours, clouds, or mountains, they ended up escaping in the one free direction, causing wind. Air could participate in this motion, but its contribution was negligible.

Although the general lines of this explanation may seem similar to Telesio's theory of wind generation, Descartes conceptualised expansion and contraction in strictly mechanical-corpuscular terms. For him, vapours—as all matter— were made out of small corpuscles together with even smaller particles filling the gaps between the corpuscles.[118] Heat was nothing other than the movement of the latter, smaller particles, and it made the body expand. Exactly how expansion could take place under these conditions without creating a vacuum (whose

114 I summarise here the contents of: Froidmont, *Meteorologicorum*, p. 146–158. The quote "ut somniant Stoici" is on p. 148.

115 "Ventos gravitate sua in terram defluere, ut torrentes et flumina per alveos"; "Causam enim aliam, post longam meditationem, reperire nullam valui." (Froidmont, *Meteorologicorum*, p. 158).

116 Meinel, Météores, p. 129.

117 Descartes, *Les Météores*, on wind formation: pp. 94–103.

118 Descartes, *Les Météores*, pp. 35–47.

existence Descartes denied) remained unclear, and this unsatisfactory aspect of his meteorology was criticised, among others, by Libert Froidmont.[119]

A Thought-experiment with Churches

One of the names most often associated with the birth of scientific meteorology is that of Evangelista Torricelli (1608–1647). In his lectures (published 1715), Torricelli also addressed the question of wind generation:[120]

"If a very large church were full of water up to its highest point, what would happen? The answer is easy: if the doors were open, the water would flow out of them with great force, and, through the highest windows, as much air would flow in, as water flows out. And if the church should have the hidden virtue of transforming that air immediately into water, the flow from the doors would go on and on, and would never end, as long as the hypothetical transformation of air into water continues."[121]

One could now hypothetically substitute the water in the church with cold air, noting the following phenomenon:

"The most venerable church of Santa Maria del Fiore sometimes, and the main basilica of Rome much more often, are both capable, on the hottest summer days, of emanating out of their doors a very fresh wind, exactly at that time in which the air is very quiet with no wind whatsoever. The reason is the following: the air enclosed inside the great building, for whatever reason, is cooler than the air outside, scorched by rays and reflexes of the sun. Being cooler, it is also denser and shall therefore be heavier. And if this is true, a flow of air shall have to come out of the doors similar to the flow of water, which we have exemplified above."[122]

119 Meinel, Météores, p. 125.

120 Evangelista Torricelli, Del vento, in: E. Torricelli, *Lezioni accademiche* (Milan, 1823), pp. 149–165. On the date of publication, see: Burstyn, Early explantions, p. 171.

121 "Se un grandissimo tempio fusse pieno tutto d'acqua fino alla sua più alta sommità, che farebbe? La risposta è pronta. Se le porte fussero aperte, l'acqua per esse se n'uscirebbe con grandissimo impeto, e per le finestre più sublimi, succederebbe nel tempio altrettant'aria per l'appunto quanta acqua per le porte se ne partisse; e se il tempio avesse un'occulta virtù di convertire subito in acqua quell'aria succeduta, il profluvio delle porte sarebbe continuo, e non finirebbe mai, fin tanto che durasse la supposta metamorfosi dell'aria in acqua." (Torricelli, Del vento, p. 158).

122 "L'augustissimo tempio di Santa Maria del Fiore qualche volta, ma molto più spesso la maggiore basilica di Roma, hanno questa proprietà, di esalare ne' giorni più caldi della state un vento

This statement is correct: at ground level, it is cold air that pushes away hot air, and not the reverse. Torricelli conceptualised the motion of hot and cold air masses by thinking them as separated by the walls of a building and, in this way, he ignored the air's life-like tendency to expand when heated. Instead, he reasoned in terms of change of weight, applying Archimedes' principle.[123]

Meteorological Machines

As this overview has shown, technical artefacts entered the discourse on the origin of wind in many different ways: some philosophical notions were based on actual devices, other reflections grounded on literary descriptions of ancient artefacts, and some experiments looked like the result of abstract reflections that might or might not have ever become reality. In the case of Fludd and the weatherglass, a device became a new formal language to express a new natural philosophy. Moreover, I would also like to suggest that the development of techniques for exploiting the motive force of air and winds ran parallel to a modification of the way in which wind was perceived: no longer as a phenomenon of potentially infinite quality, but primarily as a source of a potentially infinite quantity of motive force.

This analysis has also made it clear that pneumatic devices acquired natural philosophical relevance within a specific meteorological-cosmological context in which wind and weather were seen as the multiform expression of a single cosmic principle animating air. The devices themselves were certainly not the source of this view, but it is undeniable that they provided new patterns to for connecting wind, air, and celestial power. In this process, the notions of wind and air—and possibly also that of celestial power—were transformed, while the Inverted Glass Experiment became a demonstration—perhaps a simulacrum—of celestial motive force. At the same time, among Aristotelian and Galileian

assai fresco, fuor delle proprie porte, in tempo proprio quando l'aria si trova tranquillissima e senza vento alcuno: la ragione è questa, perchè l'aria dentro la vasta fabbrica racchiusa, qualunque sia la cagione, si trova più fresca dell'esterna infiammata da tanti raggi e reflessi del sole; però se più fresca, è anco più densa; adunque sarà anco più grave. E se questo è vero, dovrà dalle porte uscir quel profluvio d'aria che nell'acqua abbiamo esemplificato." (Torricelli, Del vento, p. 159).

123 Harold L. Burstyn states that Torricelli applied here "the notion of varying atmospheric pressure", but, as can be clearly seen from the text, he was thinking in traditional hydrostatical terms (Burstyn, Early explanations, p. 171).

philosophers, the same instrument achieved fame as a thermometer, providing patterns for a very different kind of reflection.

Discussing the relationship between mechanical devices and mechanistic philosophy, Derek de Solla Price stated that seeing the former as a pre-existing inspiration for the latter would be putting "the cart before the horses", and suggested that "some strong innate urge toward mechanistic explanations led to the making of automata".[124] Although he defined automata simply as "devices that move by themselves", de Solla Price considered almost exclusively artefacts—or parts thereof—whose workings lent themselves to mathematical-mechanical conceptualisation: astronomical clocks, clockwork automata, computing machines, even optical tricks.[125] If we accept his idea of a symbiosis—as I would suggest to call it—between mechanistic philosophy and mathematical-mechanical automata, then it is hardly surprising that Galileo and Descartes did not show any particular fascination for the weatherglass, whose behaviour resisted—and still resists—any mechanistic explanation. The weatherglass only became interesting when considered as a means of quantifying phenomena.

At the same time, one could postulate an affinity between vitalistic-minded philosophers and those artefacts and artificial processes that lent themselves to conceptualisation in vitalistic terms. For example, (al)chemical experiments, the magnetic compass, or pneumatic engines, where the life-like, spring-like resistance of air to expansion and contraction could be regarded as a primary feature, without looking for mechanical reductions. For the same reasons, these philosophers might have preferred to speculate on wind and weather rather than on falling bodies or the pendulum.

Epilogue: Edmond Halley's Map of Winds

In 1686, Edmond Halley published an essay describing tropical winds, particularly the trade winds, which blow regularly towards south-west above the equator and towards north-west below it while the air at the equator remains

124 Derek J. de Solla Price, Automata and the origins of mechanism and mechanistic philosophy. *Technology and Culture* 5 (1964): 9–23, quotes on p. 9 and 10.

125 Some automata described by de Solla Price were driven by pneumatics, but the parts he related to the "innate urge" towards mechanism were the parts mechanically simulating astronomical or biological motion, and not the ultimate source of motion (for example: de Solla Price, Automata, pp. 13–15, 18–20, quote from p. 9).

calm.[126] Halley correctly explained that the air at the equator, which is steadily heated by the sun, becomes thinner and rises up, while the colder air of the tropical regions rushes in from north and south.[127] The explanation for the additional east–west drift only came much later, and need not interest us here.[128]

In the same essay, Halley also drew up a map of the tropical oceans in which he represented winds as successions of strokes indicating the direction in which a ship would travel under the influence of the wind blowing at that specific point of the sea. In this map, winds did not represent direction any longer; instead, they were themselves represented as the direction of a virtual, invisible motive force.

126 Edmond Halley, An historical account of the trade winds, and monsoons. *Philosophical Transactions* 16 (1686): 153–168.

127 Halley, Trade winds and monsoons, p. 165.

128 Persson, Hadley's principle.

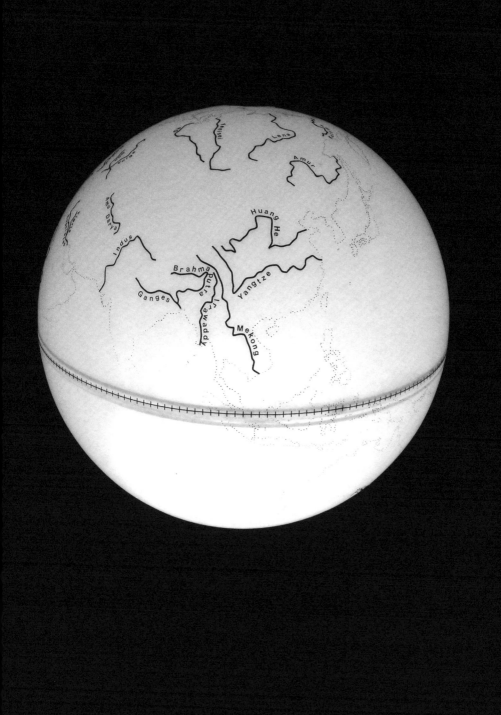

Worldprocessor [#111]

RAMON GUARDANS

[General View of Water Control]
On the Book *He fang yilan* 河防一覽
Published by Pan Jixun[1] 潘季馴
in 1590

Preliminary

This paper might as well start on a personal note that will help us organise the material to be presented and develop the right tone to deal with it. I first became aware of the existence of the *He fang yilan* through a long note in a book I read in 1978.[2] At that time I was, and still am, working on mathematical and physical models of biological processes occurring over a wide range of scales, from bacteria to multinational corporations and the history of the solar system.

The note described the story of Pan Jixun (1521–1595) who was responsible for the management of the Huanghe ("The Yellow River") and the Grand Canal in the late sixteenth century. By the end of his career he had written an eleven-volume treatise on water control at the scale of a 4000-km-long river and a watershed of 752,000 km^2. I had to see that book, and made many friends over two decades trying to find it. In 2002, in the archives of Academia Sinica in Taipei, I finally had the opportunity to see a copy of the 1590 edition of the *He fang yilan* that Pan Jixun had supervised.[3] The great surprise was that the first volume contained a series of 48 maps—96

1 All Romanisation will be changed to Pinyin except for modern authors' own Romanisations of their names.

2 Chi Ch'ao-Ting, *Key Economic Areas in Chinese History* (London, 1936). The Italian translation I read is: *Le zone Economiche Chiave Nella Storia della Cina* (Torino, 1972), p. 164.

3 It was thanks to Chi Hua Tsou of the Institute of Botany, Regina Llamas and John Kieshnick of the Institute of History and Philosophy at Academia Sinica, and Dr. Tsai Tai-Bing of the National Changhua University in Taiwan that a functional illiterate like myself could gain some insight on the work of Pan Jixun and the *He fang yilan*. All mistakes are mine.

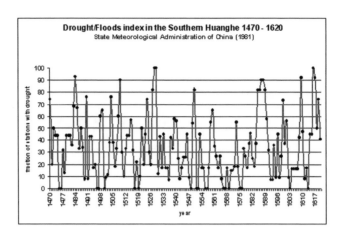

Fig. 1: Drought/floods index for the southern Huanghe region in the years that preceded and included the work of Pan Jixun. High values indicate that many stations report dry years while low values indicate that few stations are in drought and many are flooded. Redrawn from the drought/floods index as published by the State Meteorological Administration of China in 1981 in the Yearly Charts of Drought/ Floods in China for the last 500 years (1470–1979) based on reports of more than 100 stations where records were kept.

pages in the way they are printed in that edition—of the Huanghe with detailed annotations. The work is a magnificent compilation of historical, geographical, and hydraulic information relying on long and detailed historical records and a network of monitoring stations connected by fast communication lines.

The way things were done and the way they are described in the *He fang yilan* represent a cooperative dynamic operation at a scale in space and time that has few or no precedents in any other part of the world, and that predates by several centuries anything comparable in scope and detailed coverage in Europe. I am a biologist and have been following the work of some sinologists, but I am definitely not a professional sinologist. My intention in this paper is to introduce the *He fang yilan*, of which no translation or complete edition exists beyond the 1783 printing in Volume 576 of the *Siku quanshu* (Imperial Collectanea),[4] in the hope that more systematic work might be stimulated by this publication.

4 Jingyin wenyuan siku quanshu 景印文淵四庫全書, ed. Ji Yun 紀昀 et al. (Taipei, 1983–1986).

Fig. 2: Map 144b. The squares with four turrets (there are four altogether in this image) represent major cities or the administrative centres of prefectures. Squares with four unconnected brackets represent cities or the administrative centres of districts. The boxed characters describe the course of the Yellow River and the rising point, course, and confluence point of its tributaries.

Introduction

There are two big rivers in China, the Changjiang[5] in central China, and further north the Huanghe. The Changjiang carries a much larger amount of water. Most of its upper course is in mountainous areas, while several thousand kilometres of the lower courses of the Huanghe and the Changjiang are in very low terrain.

In the words of Xu Jiongxin:

"The Yellow River is famous for its heavy sediment load and for its high suspended sediment concentration. The mean annual suspended sediment

5 "Yangzi" is the name given in the "West" to the river that is called in China Changjiang (the long river). Yangzijiang was the local name for the lower course of the river Changjiang. European visitors in the seventeenth century took that name for the name of the whole river and successfully exported this confusion.

load at the Shanxian hydrological station is 1,600 million tonnes, and the mean suspended sediment concentration is 37.3 kg/m³. Due to the serious on-going aggradation the river channel of the Lower Yellow River is very unstable. Frequently in history the river has busted its banks and even completely changed its course. According to historical records bank-failures and course-changes have occurred at least 1500 times. Seven of these were major course-changes".[6]

The process involving the building of dykes or levees, is described as follows:

"Since levees confine sediment deposition to a narrow area, the rate of river bed rise by sedimentation may be greatly speeded up. Due to the heavy sediment load the Yellow River will inevitably become a 'hanging river', which means that the river bed between the two levees will grow much higher than the ground surface outside. In the present situation, the height difference can amount to 3–10 m […] The larger the height difference between the river bed and the ground surface, the higher is the risk for the river to burst the levee and cause course-changes during flood events. In case the river changes its course, the former hanging river bed will be abandoned and become an elongate micro-highland with a height of 3–10 m above the ground surface. […] After a period of time [following a levee burst and course change] the diverted water flow becomes more concentrated again, and a new channel takes shape gradually. Then the local people start to build levees alongside the new river course for flood protection. Many years later, a hanging river bed will be formed again. Afterwards, the preceding process may be repeated once again, and so forth."

As the *Historical Atlas of the Huanghe*[7] recapitulates:

"For thousands of years since the time of Yu, the reputed founder of the Xia Dynasty (21st–16th century B.C.), harnessing and development of the Huanghe have followed the rises and falls of various dynasties. Prior to the Sui and Tang dynasties (4–8th century A.D.), much attention had been devoted to the transport of grains via waterways to the capital besides construction of

6 Xu Jiongxin, A study of long-term environmental effects of river regulation on the Yellow River of China in historical perspective. *Geografiska Annaler* 75 (1993): 61–72, here 62–64.

7 *Historical Atlas of the Huanghe*, (Beijing, 1986), p. 54.

water conservancy works for farming. The creation of the Honggou and Caoqu Canals and the North-South Grand Canal formed a navigation network, linking up the four large rivers of Haihe, Huanghe, Huaihe, and Changjiang, which played a very important role in transporting grain from south to north and from east to west, and also in promoting economic prosperity in these areas. Stress was gradually laid on flood prevention in the lower reaches along with the shifting of the political centre in the Northern Song Dynasty (960–1127 A.D.). Later, the 1500-km-long Grand Canal from Beijing to Hangzhou was completed during the period of Yuan-Ming-Qing dynasties (13–20th century A.D.), when great efforts were persistently exerted on maintaining navigation along the Canal and harnessing the lower reaches of the Huanghe."

There is a vast literature on the several thousand years of water management of the northeast China plains. The detailed technical literature dealing with the very large spatial and temporal scales on which this cognitive model operated was brilliantly reviewed in the book by Chi Ch'ao-Ting (1936), *Key Economic Areas in Chinese History. As Revealed in the Development of Public Works for Water*

Fig. 3: Map 145a. *The large crenelated circle represents the capital. Along the river that emerges from the capital, the five sets of brackets represent locks (just before them is a bridge). The large river at the top of the frame is the Yellow River.*

Control. This work presents a detailed review of the vast literature on water management in China over 30 centuries, and also a very interesting compilation and description of some relevant gazetteers. Gazetteers were, and are, kept as local chronicles and they often include valuable hydrologic and climatic information. There are thousands of very complete gazetteers over many centuries and locations.[8] There is also abundant literature investigating problem solving in water management on smaller scales.[9] A very rich review of the history of texts on agriculture in China can be found in Bray (1984).[10] Several recent works provide updated views of the available scholarship.[11]

The textual background to the work of Pan Jixun can be summarised citing Needham et al.:

"From the Song dynasty (10th to 13th centuries A.D.) quite a number of relevant books survive. In 1059 the *Wu zhong shuili shu* 吳中水利書 [Water-Conservancy of the Wu District], by Shan E 單鍔, appeared; it was the result of many years' study of the canals of Jiangsu. In 1242, Wei Xian 魏峴 produced the *Siming tuoshan shuili beilan* 四明它山水利 備覽 [Irrigation of the Mount Tuo District], a historical account of their development in the neighborhood of

8 "Modern research of historic climatic fluctuation in China may be traced back to Chu Co-Chen [Zhu Kezhen in Pinyin Romanisation] (1926). Chu's last paper (Chu, 1973) on this topic summarises the long time scale fluctuation of temperature in China during the last 5000 years. The State Meteorological Administration of China (1981) used historic documents from provinces and counties to establish "Yearly Charts of Drought / Floods in China for the Last 500 Years (1470–1979)" and provide a data set of annual wetness grades presented in five numbers (1 to 5) at 120 stations for the China mainland for the same period. Since then a considerable number of analyses have been performed based on these data [...]. Noteworthy are also Gong and Hameed (1991) reconstructing the history of conditions of wetness in East China for the last 2000 years in terms of 5-year means; Wang et al. (1991) reconstructing a series of the seasonal temperature grades for the last 500 years in 10-year resolution; and Fang (1992) establishing a data bank from records of climatic disasters and anomalies in ancient Chinese documents describing the earliest record of a great flood in 2597 B.C. and frequent records after 659 B.C.". Jiang Jianmin et al., Historic climate variability of wetness in east China (960–1992). A wavelet analysis. *International Journal of Climatology* 17 (1997): 969–981.

9 For example Christian Lamouroux, Gestion de l'eau et organisation communautaire. L'exemple de la rivière Yeyu Shaanxi. *Bulletin de L'Ecole Francaise D'Extreme-Orient* 85 (1998): 187–225, which indicates also the very general nature of the problem and possible comparative interest (e.g., with Crawford David, Arranging the bones. *Ethnos* 68 (2003): 463–486).

10 Francesca Bray, *Science and Civilisation in China*, vol. 6, Part II, *Agriculture*, ed. Joseph Needham (Cambridge, 1984), pp. 47–85.

11 Mark Elvin, *The Retreat of the Elephants. An Environmental History of China* (Yale, 2004); Mark Elvin and T.-J. Liu, eds., *Sediments of Time* (Cambridge, 1998); Randall A. Dodgen, *Controlling the Dragon* (Honolulu, 2001).

Ningbo. Also from the Song, though not all easy to date exactly, are the following (among others):

Shuili shu 水利書 [Treatise on Water Conservacy] by Fan Zhongyan 范仲淹 (about 1030);

Qingli hefang tongyi 慶曆河防通議 *[General Discussion of the Flood-Protection Works in the Qingli reign-period] by Shen Li* 沈立 *(between 1041 and 1048);*

Shuili tujing 水利圖經 *[Illustrated Manual of Civil Engineering] by Cheng Shimeng* 程師孟 *(1060);*

He shi ji 河事集 [Collected Materials on River Control Works] by Zhou Jun 周俊 (1128);

Zhihe ce 治河策 [The Planning of River Control] by Li Wei 李渭;

Caoyun fuku cangyu 漕運府庫倉庾 *[Tax-grain Water Transport and Granaries] by Wang Yinglin* 王應麟 *(about 1270)*."[12]

Such are some of the works which remain to mark a period exceptionally rich in civil engineers. From the Yuan may be mentioned an important book, the *Hefang tongyi* 河防通議 [A General Discussion of the Protection Works along the Yellow River], dated 1321, and contributed by a Persian or Arab scholar in the Mongolian service, Sha Keshi 沙克什, whose Chinese name was Shan Si 贍思. Shan Si was an excellent mathematician and geographer, who used the Tian Yuan algebraic methods in his engineering calculations. His book was really a revision and enlargement of two of the older texts that I have just mentioned, those by Shen Li and Zhou Jun. The fourteenth century gave, as further examples:

Zhizheng hefang ji 至正河防記 [Memoir on the Repair of the Yellow River Dykes in the Zhizheng Reign-period] by Ouyang Xuan 歐陽玄 (about 1350);

Zhihe tulüe 治河圖略 [Illustrated Account of Yellow River Floods and Measures against Them] by Wang Xi 王喜.

Many efforts were made to manage the flow of communication between the capital and the field administration. In 1370 an Office of Reports inspection (*Chayan si*) was set up. In August 1377 this office was expanded and upgraded under the new name of the Office of Transmission (*Tongzheng si*). To handle the very large volume of information and goods that the state desired to collect and circulate, the Ming state activated three partially

12 Joseph Needham, Wang Ling, and Lu Gwei-Djen, *Science and Civilisation in China*, vol. 4, Part III, *Civil Engineering and Nautics. The Literature on Civil Engineering and Water Conservancy* (Cambridge, 1971), pp. 323–325. The Chinese characters given as footnotes in Needham et al. and the current Pinyin transliteration have been added to the text substituting the wade gilles notation in the original.

integrated services: the courier service, the postal service, and the transport service.[13]

Chi Ch'ao-Ting (1936) and Needham, Ling and Lu Gwei-Djen (1971) agree in their review of the literature on hydraulic engineering:[14]

> "The first great compendium dates from the Ming. Pan Jixun served four terms of office between 1522 and 1620[15] as Director-General of the Yellow River Works and Grand Canal, becoming the greatest authority of his age on hydraulic engineering. His book, the *He fang juanshu* (or *He fang yilan*, General View of Water Control), includes many maps, copies of memorials, edicts and other official documents, and many interesting discussions by the author, written in the form of dialogues with imaginary opponents.[16] Pan's own preface is dated 1590. The *Siku quanshu* catalogue of the late 18th century says that 'although changes in methods were afterwards necessary to fit changing circumstances, yet experts in river control always take this book as standard guide'."

I would argue that these works with titles that include words such as "water conservancy", "flood-protection works", "river control works" "planning of river control", and "account of Yellow River floods and measures against them" show the existence of what could be called today an epistemic position, where processes at very large scales were conceived in terms of risk management strategies based on physical monitoring of the environment and inference.

The actual books where this knowledge was noted and explained provide a basis for imagining the procedures, the material practice of consultation of the books and the short-term and long-term response to contemporary problems. Conceptual scaffolds gave the problems names, dimensions, and positions in space and time. The procedural, problem-based approach to organising knowledge in the He fang yilan has many precedents, and has been studied in detail in a recent edition of the Jiuzhang suanshu "Nine Chapters of mathematical

13 Timothy Brook, *The Confusions of Pleasure* (Berkeley, 1998), pp. 33–34.

14 This paragraph comes from the note in Chi Ch'ao-Ting's book (1936, p. 164 of the 1972 Italian translation mentioned above) and is literally retaken by Needham et al. (1971, p. 325) and many other authors after them. Pan Jixun lived from 1521 to 1595 and was in office four times between 1565 and 1592.

15 From the Jiajing (1522–1566) to the Wanli (1573–1620) reign periods.

16 Like, e.g., Galileo Galilei, *Dialogo sopra i due massimi sistemi del mondo*. 1632.

procedures".[17] Chapter 5 of the Jiuzhang suanshu is dedicated to "discussion of construction works" and solves problems of moving earth, building dykes, and estimating the volume of large bodies of water.

A recent work dealing with *tu* 圖, technical images, and exploring "their relationship with written text in the production of technical knowledge"[18] is obviously relevant here in terms of understanding the book and positioning it both within the technical environment where it was produced and today. "Pan's use of sophisticated maps and charts has seldom been the focus of analysis in the various studies that refer to his work" and "Clearly they would merit further study given the impressive impact of Pan's technical analysis."[19]

The *He fang yilan*

Several copies of the original printing are available, and the complete work was newly printed with carefully redrawn maps in the *Siku quanshu* edition of 1782[20] and then reprinted in 1986. A steady scholarship in Chinese has studied this work.[21] However, this masterpiece of water management has not yet been published in any other language than Chinese. The *Guide to the Management of the Yellow River and the Grand Canal* published in 1590 by Pan Jixun is a unique work of large-scale environmental management, properly a geographic

17 Karine Chemla and Guo Shuchun, *Les Neufs Chapitres, le classique mathématique de la Chine ancienne et ses commentaires*. Édition critique bilingue (Paris, 2004).

18 Francesca Bray, Introduction: The powers of tu, in: *Graphics and Text in the Production of Technical Knowledge in China*, ed. Francesca Bray, Vera Dorofeeva-Lichtmann, and Georges Métailié (Leiden, 2007), pp. 1–78.

19 Bray, Introduction, p. 32.

20 "The most famous and enduring of the [Emperor Qianlong's] ventures to preserve and present the past was his enterprise to collect all the great texts of his empire in the *Siku quanshu* (*complete library of the four treasures*). The *Siku quanshu* has four sections: classics, history, miscellaneous philosophy, and belles-lettres. A large bureaucracy, set up in 1773, was responsible for bringing together texts from throughout the empire and for organising their reproduction in seven handwritten copies, to make seven sets of the entire compilation. Eleven thousand texts were examined, and 3500 were included in the final version. Works came from private individuals as well as from libraries of high officials". Jessica Rawson, The Qianlong emperor: Virtue and the possession of antiquity, in: *China: The Three Emperors, 1662–1795*, ed. Evelyn Rawski and Jessica Rawson (London, 2005), p. 275.

21 Tsai Tai-Bing, *Yellow Sorrow and Pan Ji-xun's Water Management in Late Ming* (Taipei, 1998).

information system, a model and a database, an interdisciplinary summary presented in multimedia. It includes a detailed map of the 4000-km-long river, an historical account, and the anatomy of the problem and proposals for integrated management of the Huanghe and the Grand Canal[22] as well as calculations about dyke building, giving results in material, labour, and time.

The *He fang yilan* is a compendium of information on the administration and appropriation of the resources of the land and the establishment of large-scale priorities, preparing the ground for very material performances of construction and disaster.

The philosophical, political, historical, and physical dynamics that play out in Pan Jixun's work and in his text are interestingly dissected in Chi Ch'ao-Ting

Fig. 4: The characters in the upper left corner of the map document the history of breaks in the river at that point, stating that major breaks in the river took place in 1448 and 1489, after which it repeatedly broke until, in 1590 a long dyke was built to control the overflow. The characters on the left-hand side of the map describe a similar dyke built there, also in 1590.

22 Water supply for the 1500-km-long Grand Canal (China's Guanhe, "official waterway") came mostly from rivers, but some elevated sections depended on humanmade reservoirs or lakes; see: E.B. Vermeer, *The Rise and Fall of a Man-made Lake* (Nankai, 2005).

(1936), who suggests that the alternative was water management for transport, for taxes and appropriation by the elite, or flood control for public welfare. One of Pan's central points seems to be that integrating—dealing with the Huanghe and the Grand Canal at once—is a way to achieve both objectives. Many pages of the map in his book display both watercourses to make the point. Another alternative frequently discussed in the book is building wide dykes with low walls to avoid flooding, or narrow dykes with higher walls to "confine the water in restricted waterway so as to flush the sands". Pan Jixun argued forcibly for the latter option and introduced the "moon dykes" in order to achieve this objective.

Some of the hydraulic tools and terms that appear in the *He fang yilan* concern the different types of dykes. The *Lu* dyke is at about 1 km from the river in low water times, and provides the first defence; the lower *Yao* dykes can be some 10 km away from the *Lu* dyke and help contain the overflow, avoiding more extensive flooding and water loss (see map 146b in Figure 4); the *Gouti* dykes (not shown here but visible on maps 154b and 155a) are perpendicular to and joining the *Lu* and *Yao* dykes and were used to slow the water flow and clean the waters of the river. The "moon dykes", that Pan Jixun promoted, are semi-circular dykes that reinforce the *Lu* dyke and allow it to be higher, thus helping to provoke strong currents to flush the sediments in the river bed; the "moon dyke" is also effective in containing overflow, and can be seen in the upper left corner of map 146b in Figure 4.

It can be argued that the *He fang yilan* is, in today's terminology, an integrated model of the watershed. The first volume of the *He fang yilan* contains the preface and a map in which the first few pages present a general view of the Huanghe and the Grand Canal, and then a series of some 40 maps depict different areas of interest in detail showing the river and the dykes as well as annotations concerning the problems, responsibilities for gates and dykes, and historical background.

The paper by E.B. Vermeer[23] provides, to my knowledge, the only detailed account of the *He fang yilan* in English and translates some sections of the book.

"Pan Jixun had written a negative report in 1571 which concluded that attempts under previous dynasties had failed, because of the shallowness and rapid

23 E.B. Vermeer, 'P'an Chi-Hsün's solution for the Yellow River problems of the late sixteenth century. *T'oung Pao* LXXIII (1987): 33–67, here p. 44.

siltation of the rivers in Shandong and because of sand deposits by the sea at the river mouth. (*He fang yilan* Ch. 6, pp. 152–156). Again in 1576, while out of office, he memorialized that the project could not be successful: the channel would be too high to hold water well and too shallow for the 300–400 picul-carrying sea-going ships; the seatide (which went inland over 20 li[24] in the Southern and 60 li in the Northern river) might clog the entrances with sand, and it would be very costly: one million silver taels. He concluded that work should be stopped to save labour and expenses." (*He fang yilan* Chapter 6, pp. 157–159).

According to Vermeer, the circumstances under which Pan was appointed to his third term (1578–1580) as vice minister of public works and supervisor of the authority over the Yellow River and the Grand Canal were described in an imperial edict.

"In recent years the Yellow River and the Huai River have inflicted great damage by inundation. The Grand Canal has been obstructed. The people cannot live in safety. There have been repeated orders to local officials to regulate it [...] At the court, opinions differ [...] No successes have been achieved [...] We command that all Governors of Zhili, Shandong and Henan Provinces should obey you as Provincial Commander-in Chief [...] Everyone is searching for the causes of the damage."[25]

And the problems to be tackled were summed up:

"Why has the mouth at Zao Wan silted up after having been opened and which drainage should be opened now? Why has the entire Huai River flow wandered southward without returning, and which bed should be dredged for it now?

In Xu (zhou) and Bi (xian) the river bed has the same height as the cities. Where should we dredge and flatten it? The gaps at Huang Bu and Zui Zhen have been stopped long ago without success. Why should we construct them as permanent (spillways)? Should the old route of the Yellow River be restored? Should the original bed at Jing Dao be cleared out? Should the Gaojia dyke and the Baoying dyke be built or not? Will the new throughcut

24 One li amounts to 584 metres, one picul about 60 kg.

25 Vermeer, P'an Chi-Hsün's solution, p. 45.

at Xia Fo Jiao help navigation, and should it be cleared out further? Upstream from Xu (zhou) and Bi (xian) the terrain is high in the south and low in the north, so that once the break occurs, the Yellow River would go northwards, thereby obstructing the Grand Canal; you must investigate which is the main channel, which is the branch channel, and which is a combined channel, and whether we should reinforce the dykes of the main channel or reduce its flow through a branch channel or separate the streams of the combined channel. All proposals must be investigated and you should report in detail to us."[26]

So much for a dynamic process and a stack of problems.

How did Pan Jixun cope with this mandate? The incidence of floods and droughts in his time have been documented in multiple sources. A complete series of yearly dryness/wetness indexes for over a hundred sites in China (1470–1979) integrated in 6 regions was compiled in the late 1970s from observations in gazeteers and other careful records, and the results were published by the State Meteorological Administration of China in 1981,[27] so it includes the period in which Pan Jixun was active. These data have been widely studied[28] and do provide, in combination with other sources such as the *He fang yilan*, an extraordinary insight into the precedents of large-scale management of risk.

The *He fang yilan* is based on a rich precedent of texts and technical wisdom and it made of them an original compilation, integrating available information in a framework that could help people who studied his work to understand and do things in a more effective way at very large spatial and temporal scales.

Pan Jixun was active from 1565 to 1592. In Figure 1 one can see that, in the lower Huanghe the early years of his career included many floods, while the later years are more of a dry spell.

The following maps belong to the collection of 48 maps in the first volume of the *He fang yilan*. These are published on pages 141 to 164 in Volume 576 of the *Siku quanshu* (1782/1986) edition that prints two drawings on each page. We identify the maps by the page in this edition and the position in the page, (a) for top.

26 Edict 10/3/1578 in *He fang yilan* Chapter 1, pp. 25–26.

27 State Meterological Administration of China. *Yearly Charts of Drought/Floods in China for the last 500 Years (1470–1979)* (Beijing, 1981).

28 Cf. note 9 and also: Jie Song, Changes in dryness/wetness in China during the last 529 years. *International Journal of Climatology* 20 (2000): 1003–1015; and W.H. Qian, D. Chen, Y. Zhu, and H.Y. Shen, Temporal and spatial variability of dryness/wetness in China during the last 530 years. *Theoretical and Applied Climatology* 76 (2003): 13–29.

In the 1590 edition each map is folded and shown as two sides of one page. The first 9 drawings present the river in a large scale and general terms. Figure 2 (map 144b) and Figure 3 (map 145a) are examples of this section. From map 146a on (Figures 4 to 6) the collection describes with a much higher resolution sections of the Huanghe and the Grand Canal where major works had been undertaken, and included important cities (Figures 3 and 4), or classical problems that had to be addressed (e.g., the Nanwang Lake in map 148b in Figure 5).

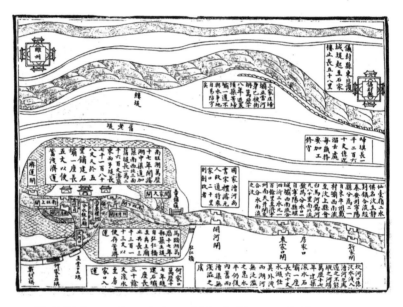

Fig. 5: The large section at the bottom left hand of the map is the Nanwang Lake 南旺湖. This was a key trouble spot, since the Grand Canal ran through it and it was on very high ground. Hence, intensive works were constructed in and around this area. A dam and a series of gates regulated water levels in the lake to prevent flooding.

The final maps in the collection (e.g., map 161b in Figure 6) describe the upper ranges of the watershed, where the rivers are confined by terrain and the works described are not dykes but bridges and early warning stations to signal strong currents that can yield floods.

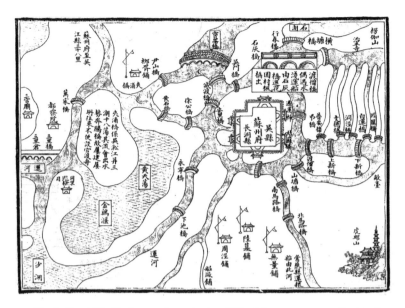

Fig. 6: Map 161b. The large enclosure in the middle of the map represents the city of Suzhou, itself famous for its canals. The large number of arcs, representing bridges, on the waterways surrounding the city reflect the extensive bridge building in the area. The three houses with flags outside of them at the bottom of the map (there is another in the upper left corner) are signal stations distributed along major arteries in order to quickly pass on warnings.

Concluding Remarks

It is hard to overestimate the creative effort that is embedded in the history of the cultures of the world in the exercise of testing and transmitting procedures that lead to correct results in such varied activities as mathematics,[29] music,[30] agriculture, food, and water management.

What is the anatomy or internal structure of the problems the *He fang yilan* faces, and how does it deal with them, being still considered "a standard guide for experts in river control" in 1783? What role did the information in the

29 Marcia Ascher, *Mathématiques d'ailleurs (nombres, formes et jeux dans les sociétés traditionnelles)* (Paris, 1998); S. Arom et al., *La science sauvage* (Paris, 1993).

30 Rulan Chao Pian, *Song Dynasty Musical Sources and Their Interpretation* (Hong Kong, 2003).

book play in its own time and over the following centuries in the actual daily management of the river? What are the criteria to choose a procedure to solve a given problem or find the answer to a question? What types of errors and what type of correct results are found? How can we compare errors in mathematical calculations and errors in water management?

Facing and focusing on the challenges and difficulties in reading these texts can help refine and orient questions relevant for very contemporary technical and philosophical issues, including the phenomenon of "misreading" the place of an ancient or foreign discipline[31] and overlooking its relevance in history or its potential today as a source of useful ideas.

How does this text work for the reader, how does the text come to the reader? How does the reader work through a problem with the text, how does the reader go to the problem?

Today, much useful research is interested in the composition of environments, where texts, images, and numerical values can interact. This interaction is mediated by models, projections, networks of metaphors described in a formal language and produced by moving material objects on a screen, sheet, or calculating board.

The *He fang yilan* and the collections of texts, images, and numerical data that it is based on are a good example of this kind of integrated environment.

Over the three decades that I have been trying to understand what the *He fang yilan* was in its own times and in the present, my day job has been in research on the effects on health and the environment of long-range transport of air pollution.[32] The problems of integrating information cast in multiple formats and about many different processes has thus been part of my work, and my respect for Pan Jixun and his team has only grown.

31 Fu Daiwei, Higher taxonomy in scientific communities and higher incommensurability, in: *Mind and Cognition*, ed. Y. Houng and J. Ho (Taipei, 1995), pp. 95–116.

32 J. Alcamo, P. Mayerhofer, R. Guardans, T. van Harmelen, J. van Minnen, J. Onigkeit, M. Posch, and B. de Vries, An integrated assessment of regional air pollution and climate change in Europe. *Environmental Science & Policy* 5 (2002): 257–272; Nuria Castells and Ramon Guardans, The development of Multilateral Environmental Agreements (MEAs) on toxic chemicals, in: *Handbook of Transdisciplinary Research*, ed. G.H. Hadorn (Berlin, 2007).

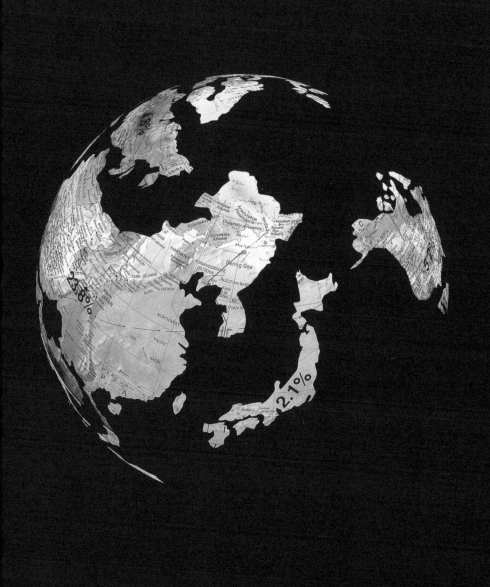

Worldprocessor [#78]

FRANCESCA BRAY

Tales of Fertility:
Reproductive Narratives in Late
Imperial Medical Cases

In *The Woman Beneath the Skin*, widely considered a conceptual milestone in the
history of medicine, Barbara Duden complained that the techniques of histori-
cal demography "silence the body":

"To social historians of my generation historical demography has become a
primary source of statements about body-mediated phenomena [in which] the
characteristics of the body within a statistical population are [...] perceived as
probable attributes of an object: as rates of birth, morbidity, reproduction, and
mortality."[1]

In recent years demographic historians of China have been striving to recap-
ture the *demographic mentalities* of the people whose individual births and
marriages, pregnancies and deaths coalesced into the grand ebbs and flows of
population change that they seek to trace and to explain. "Eventually we will
understand not just how frequently individuals marry and give birth, but why."[2]
Is this optimism justified?

The new demographic history of China is part of a broader revisionist project.
Earlier Malthusian interpretations held that in contrast to early modern Europe,
where families operated deliberate preventive checks (such as late marriage)
to reduce the number of children women bore, thus increasing the resources
available to individual offspring in an increasingly competitive society, in impe-
rial China population growth was limited only by the positive check of death.
There was a cultural explanation, a rationality, underlying this statistical pat-
tern, but it was distinctly non-modern: namely, families were driven by the
imperatives of patrilineal descent to have as many sons as possible.[3] However,

1 Barbara Duden, *The Woman Beneath the Skin: A Doctor's Patients in Eighteenth Century Germany*
(Cambridge, MA, 1991), p. 192, emphasis added.

2 William Lavely, James Lee, and Wang Feng, Chinese demography. *Journal of Asian Studies* 49
(1990): 807–834, here p. 818.

3 This view is still current among leading demographers in China; see James Lee, Cameron Camp-

over the last decade a new image of late imperial China has been fashioned. The main thrust of recent comparative, economic, intellectual, and cultural history has been to argue that late Ming and Qing society (ca. 1550–1800) was working its way, just as Europe was, towards modernity. Late imperial China was modern not in a European but in a distinctively Chinese mode, and it contributed in ways hitherto insufficiently scrutinised to the shaping of the emerging modern world, its international relations, statecraft practices, commercial institutions, and patterns of consumption.[4] Not surprisingly, demographic historians have been anxious to demonstrate that late imperial population history fits the same mould.

The demographic historians of China work with large collections of individual-level data sets such as lineage documents. First, they propose a stylised model of a demographic system. Then they seek to identify the behavioural patterns revealed by statistical analyses of these data sets, and propose corresponding rationales for reproductive practices.[5] Although critics still contest their use of the admittedly difficult and partial sources, the new demographers now confidently assert that marital fertility rates in late imperial China were significantly lower than those in contemporary Europe, while births were evenly spaced across a woman's fertile period, indicating that families took deliberate measures to space their children.[6] Referring to studies by social or cultural

bell, and Wang Feng, Positive check or Chinese checks? *Journal of Asian Studies* 61 (2002): 591–607. Arthur Wolf is probably the most passionate proponent of this view in the West today; e.g., Arthur P. Wolf, Is there evidence of birth control in late imperial China? *Population and Development Review* 27 (2001): 133–154.

4 André Gunder Frank, *Re-Orient: Global Economy in the Asian Age* (Berkeley, 1998); Wong R. Bin, *China Transformed* (Ithaca, 1997); Kenneth Pomeranz, *The Great Divergence* (Princeton, 2000); Gary G. Hamilton and Wei-an Chang, The importance of commerce in the organization of China's late imperial economy, in: *The Resurgence of East Asia: 500, 150, and 50-year Perspectives*, ed. Giovanni Arrighi, Takeshi Hamashita, and Mark Selden (New York, 2003), pp. 173–213; Benjamin A. Elman, *On Their Own Terms: Science in China, 1550–1900* (Cambridge, MA, 2005); Timothy Brook, *The Confusions of Pleasure: Commerce and Culture in Ming China* (Berkeley, 1998); Craig Clunas, Modernity global and local. *American Historical Review* 104 (1999): 1497–1511.

5 Cameron D. Campbell, Wang Feng, and James Z. Lee, Pretransitional fertility in China. *Population and Development Review* 28 (2002): 735–750; Lee, Campbell, and Wang, Positive check or Chinese checks? *Journal of Asien Studies* 61 (2002): 591–607.

6 William Lavely and R. Bin Wong, Revising the Malthusian narrative: The comparative study of population dynamics in late imperial China. *Journal of Asian Studies* 57 (1998): 714–748; James Lee and Wang Feng, *One Quarter of Humanity: Malthusian Mythology and Chinese Realities, 1700–2000* (Cambridge, MA, 1999); Zhao Zhongwei, Fertility control in China's past. *Population and Development Review* 28 (2002): 751–757.

historians, including myself, the demographic historians note as part of "the context in which individuals made decisions" a range of social and biological techniques for controlling the number of offspring, including infanticide; contraception, or abortion; adopting in or out; and perhaps low rates of coital frequency following prevailing medical wisdom.[7] They point to the late imperial expansion of gynaecology and paediatrics as an indication that families were prepared to invest in the health and future of individual children, rather than trying for as many male offspring as possible in the hope that some would survive. They link such imputed attitudes to a broader context of social and economic competition and higher levels of affluence—in other words they see here a form of "modern" rationality framing reproductive decisions.[8]

Yet this approach to demographic mentalities silences not only the bodies, but also the persons most intimately involved. First, the genealogies, which are among the principal sources for Chinese demographic history, record patrilineal descent. Since Chinese women were incorporated into their husband's lineage on marriage, daughters were not usually included in these documents; wives were sometimes recorded, sometimes not; concubines were omitted. Even sons were often not registered until they had survived the first years of infancy. What womanly experiences of barrenness and miscarriage, of bearing nameless daughters or sons who perished in infancy, lie behind the bare facts of names and years noted in a genealogy?

In other words, how did a woman's fecundity, the number of pregnancies she experienced, translate into fertility, the number of children who were born, survived, and made it into the records? Demographic historians are able to test sta-

7 Drawing, for instance, in: Charlotte Furth, Producing medical knowledge through cases, in: *Thinking with Cases: Specialist Knowledge in Chinese Cultural History*, ed. Charlotte Furth, Judith T. Zeitlin, and Ping-chen Hsiung (Honolulu, 2007), pp. 125–151; Charlotte Furth, *A Flourishing Yin: Gender in China's Medical History, 960–1665* (Berkeley, 1999); Francesca Bray, *Technology and Gender: Fabrics of Power in Late Imperial China* (Berkeley, 1997); Hsiung Ping-chen, *A Tender Voyage: Children and Childhood in Late Imperial China* (Stanford, 2005); Hsiung P., Facts in the tale: Case records and pediatric medicine in late imperial China, in: *Thinking with Cases*, ed. Furth, Zeitlin, and Hsiung, pp. 152–168.

8 Campbell, Wang, and Lee, Pretransitional fertility in China, p. 742; Li Bozhong, Kongzhi zengchang, yi bao fuyu: Qingdai qianzhongqi Jiangnan de renkou xingwei [Controlling growth to protect wealth: Population behavior in Jiangnan during the early and mid Qing period]. *Xin Shixue* 5 (1994): 25–70; Li, Duotai, biyun, yu jueyu: Song Yuan Ming Qing Jiangzhe diqu de jieyu fangfa jiqi yunyong chuanbo [Abortion, contraception, and sterilisation: Birth control methods and their dissemination in Song-Yuan-Ming-Qing Jiangsu and Zhejiang], in: *Hunying, Jiating yu Renkou Xingwei: Dongxi Bijiao* [Marriage, family formation, and population behaviour: East–West comparisons], ed. James Lee, Songyi Guo, and Yizhuang Ding (Beijing, 2000), pp. 71–99.

Fig. 1: The childbirth chamber.
Shinzoku kibun 清俗記聞
[Recorded accounts of Qing customs], 1800. The new mother is sitting on her bed, propped up between piles of quilts. This posture was supposed to precent hemorrhaging. A maid or perhaps the wet-nurse is holding the new baby.

tistically whether certain practices or clusters of practices, (such as infanticide and/or abortion) are consistent with their general model.[9] This means, however, that they can account only for actions that were efficacious in modern terms. What they cannot test for is intentions, beliefs, and partial efficacy—fundamental components of the "why" and the "how" of reproductive behaviour.[10]

As an alternative source of insights into demographic mentalities, or what I prefer to call reproductive cultures,[11] here I offer a brief exploration of medical cases describing the treatment of reproductive problems. I agree with scholars

9 For example, Campbell, Wang, and Lee, Pretransitional fertility in China.

10 Nina L. Etkin, Cultural constructions of efficacy, in: *The Context of Medicine in Developing Countries*, ed. Siaak van der Geest and Susan R. Whyte (Dordrecht, 1988), pp. 299–326; Bray, *Technology and Gender*, pp. 290–296.

11 The term *mentality*, developed by *Annales* historians in the Durkheimian tradition, denotes common ways of thinking or cases of mind that prevail throughout a society. Anthropologists and social or cultural historians today treat *culture* as a constantly shifting arena of contested definitions and conflicts over power.

like James Lee that the information, which such qualitative sources offer, resists easy incorporation into demographic models, being highly circumstantial and concerned principally with anomalies rather than routines. At the opposite end of the analytical spectrum from abstract models, these medical cases focus on the experiences of individual women, recapturing the bodily experiences, the aches and palpitations, the yearning, elation, and fears surrounding fertility and childbirth. Sometimes they span the few hours of an acute crisis; sometimes they chart constitutional changes over many years. As narratives with deliberately selected beginnings and ends, they offer insights into how female health and fertility were construed, and what was considered the desirable outcome of a reproductive disorder. Furthermore they incorporate the supernatural explanations and the social expectations, which were as important as economic rationalities in shaping reproductive choices and reproductive cultures.

Medical Cases in Late Imperial China

The late imperial period saw the emergence and spread of a prosperous, literate urban culture, which supported a burgeoning of medical practice and medical publishing. Literati had always had some familiarity with medical theories as applications of general cosmological principles. Furthermore it was the duty of a good Confucian to prepare medicines for ailing parents, and many famous literati physicians through the ages first learned their skills in order to treat sick family members. By the late Ming many ordinary families could afford to consult doctors. The competition between physicians, both for clients and for clinical authority, was intense. Some identified themselves as hereditary physicians, *shiyi* 世醫, claiming generations of skilful doctors as forebears; others identified themselves as *ruyi* 儒醫, literati physicians, their virtuosity rooted in superior learning. Religious and magical beliefs produced variations on or alternatives to medical images and interpretations of the body, and orthodox physicians competed not only with each other but also with folk healers, midwives, diviners, bonesetters, priests, and herbalists.[12] Most people who consulted doctors had at least a smattering of medical theory, gleaned from the medical sections of almanacs or household encyclopaedias, or from cheap primers on medical

12 Chao Yuan-ling, *Medicine and Society in Late Imperial China* (unpublished Ph.D. thesis, Department of History, UCLA, 1995), here chapter 1; Christopher Cullen, Patients and healers in late imperial China. *History of Science* xxxi (1993): 91–150.

Fig. 2: A man with his wife in front of her bed. Lu Ban jing 魯班經
*[Carpenter's canon], edition of ca. 1600. Numerological and geomantic
calculations to ensure fertility figured prominently in the construction of the
marital bed; geomantic calculations for the siting of ancestral graves were
also considered a fundamental technique for generating offspring.*

topics written in accessible language. Many felt competent to question a doc-
tor's decisions and call in a rival. There was a huge market for every kind of
medical work, and new editions were sometimes pirated within days.[13]

The Ming publishing industry contributed significantly to the professionali-
sation of medicine: a dense web of technical debate and argument over claims to

13 Chao Y., *Medicine and Society in Late Imperial China* (unpublished, UCLA, 1995), p. 28; Lucille
Chia, *Printing for Profit: The Commercial Publishers of Jianyang, Fujian (11th–17th Centuries)* (Cam-
bridge, MA, 2002).

truth was made open to public scrutiny.[14] Argument through cases had played a key role in the construction of knowledge in both law and medicine from early times, in China as in Europe, but individually authored collections of medical cases, *yian* 醫案, were a Ming innovation, closely connected to the rise of the *ruyi* or literati physicians.[15] Collections of medical case histories, with their tales of subtle diagnoses and inspired cures, fascinated fellow literati and the wider public.[16] They sold well as literature,[17] while helping physicians to establish convincing claims for their preferred theories and therapies: they "turned attention away from inherited canon and ancient masters, locating medical authority in the individual".[18]

Medical cases speak primarily through the authoritative voice of the doctor. But they are also narratives of sickness and treatment that allow the sick persons and their bodies to speak, even if indirectly. Some physicians recorded cases in very concise terms, occasionally reducing them simply to a set of symptoms and prescriptions. More commonly, cases told a human as well as a medical story. Most late imperial cases highlight the experiences of individuals embedded in their social circle: physicians did not have surgeries, but visited clients in their homes (often in between visits from rivals); they consulted with husbands, mothers, maids, and family friends; they made repeated visits; they recorded not only the details of bodily sufferings, but also the emotional triggers to which they attributed physical dysfunction, and their negotiations with family members as the treatment progressed. Many cases describe a patient who has undergone previous diagnosis and treatment by other physicians or healers—naturally, the earlier treatment was mistaken and unsuccessful, while the virtuosity or subtlety of the physician who recorded the case brings about a

14 Chao Y., *Medicine and Society in Late Imperial China* (unpublished, UCLA, 1995); Furth, *A Flourishing Yin*, pp. 224–265; C. Furth, Introduction: Thinking with cases, in: *Thinking with Cases*, ed. Furth, Zeitlin, and Hsiung, pp. 1–27.; Furth, Producing medical knowledge.

15 Furth, Zeitlin, and Hsiung, eds., *Thinking with Cases*; Christopher Cullen, Yi'an (case statements): The origins of a genre of Chinese medical literature, in: *Innovation in Chinese Medicine*, ed. Elisabeth Hsu (Cambridge, 2001), pp. 297–323; Joanna Grant, *A Chinese Physician: Wang Ji and the "Stone Mountain medical case histories"* (London, 2003).

16 On the similarities in structure and allure between medical cases and detective stories, another genre which became wildly popular in the late Ming, see Judith Zeitlin, The literary fashioning of medical authority: A study of Sun Yikui's case histories, in: *Thinking with Cases*, ed. Furth, Zeitlin, and Hsiung, pp. 169–202.

17 Furth, *A Flourishing Yin*.

18 Furth, Producing medical knowledge, p. 226.

cure. In some cases the patient or their family ignore the advice of the recorder of the case; the results tend to be fatal.

A case is a professional construction, a selective narrative that retrospectively imposes order upon confusion, that disentangles essential from coincidental, primary from secondary. Where do the roots of the sickness lie? What does the patient think is wrong, and does it coincide with the doctor's understanding? What are the stages of treatment, and at what point has the problem been resolved? The choice of where a case begins and ends is not arbitrary, and may well require us to reflect upon the distinction that anthropologists make between *curing* and *healing*. Curing is defined from the practitioner's perspective as the elimination of a pathogen or the repair of a lesion; healing is defined from the perspective of the patient, as the resolution of the disorder from which they perceive themselves to suffer. Thus, if someone has a raging fever which they attribute to possession by a demon, a biomedical doctor would expect to *cure* them by administering antibiotics to eliminate the infecting virus, while the sufferer would consider this step to be the suppression of a mere symptom, believing that the fundamental problem of possession could only be *healed* by an exorcism.[19] Medical theories in late imperial China varied considerably, and none had the degree of authority claimed by biomedical science today; cases sometimes show prolonged negotiations between physician and client about what exactly was wrong. Most medical cases were written up for public as well as professional readerships, and were thus crafted to demonstrate that the doctor could bring about happy endings for his patients—as long as they were wise enough to follow his advice. Those who foolishly ignored it suffered the unanswerable alternative to a happy ending: death.

Womanly Health

One medical specialism that expanded rapidly during the late imperial period was "wives' medicine", *fuke* 婦科 (or "women's medicine", *nüke* 女科). The notion of a specialised female medicine first emerged in the writings of some Song dynasty physicians like Chen Ziming 陳自明 (1190–1270), in response to the idea that the different endowments of *yin* and *yang* characteristic of male and female constitutions produced a sexual difference in the responses and

19 Mark Nichter, Of ticks, kings, spirits, and the promise of vaccines, in: *Paths to Asian Medical Knowledge*, ed. Charles Leslie and Allen Young (Berkeley, 1992), pp. 224–255.

Fig. 3: First page of an eighteenth-century book on gynaecology. Wu Daoyuan 吳道源, Nüke qieyao 女科切要 [Absolute essentials of gynaecology], 1773. This section on Tiaojing men 調經門 [menstrual regulation] is the first of the seven sections of the book. The first sentence reads: "The reason why jingbi 經閉 [menstrual blockage] causes women's disorders is that women are ruled by Blood."

processes that patterned a disorder, and required corresponding differences in prescription. The earliest works of *fuke* therefore included a full range of general disorders as they affected women, as well as special sections on what from a biomedical perspective we would think of as gynaecology or reproductive medicine.[20] By the later Ming, however, the category of *fuke* was devoted almost exclusively to the disorders of menstruation, conception, pregnancy, birth and its aftermath; in other words it coincides rather closely to the modern biomedical category of gynaecology. Sections on *fuke* feature prominently in late imperial collections of cases, and here I present cases from several well-known Ming and Qing specialists. By charting anomalous experiences that warranted medical attention, *fuke* cases offer insights into what kinds of reproductive experiences women or their families felt were normal, desirable, or tolerable—at least among the comfortably-off or rich urban families who formed the bulk of the *fuke* physicians' clientele.

20 Furth, *A Flourishing Yin*, pp. 59–93.

Most of the cases I present here come from the chapter on *fuke* in a critical compendium of cases published in the Qianlong reign (1736–1796) by Xu Dachun 徐大春 (1693–1771). Xu was an archetypal *ruyi* or literati doctor. He began to study medicine because many of his relatives fell sick, and although he gained renown as a practitioner, he was still more famous during his lifetime and after his death as a learned scholar and prolific writer. The chapter on *fuke*, the thirty-second in the work, is long (thirty-nine double pages of small print). It includes numerous cases from Xu's own practice, and many from famous Ming physicians including Wang Ji 汪機 (1463–1539)[21] and Xue Ji 薛己 (1487–1559).[22] I also cite a few examples from Ye Gui 葉圭 (1667–1746), whose cases were collected and published posthumously by his disciples in 1776. Ye and Xu were both natives of cities in the prosperous Lower Yangzi region. Unlike Xu, however, Ye considered himself a hereditary physician; he started learning from his father and apprenticed himself to seventeen masters before setting up his own practice. Wang Ji and Xue Ji also learned their craft from their fathers.[23] The roughly 300 cases in Xu Dachun's *fuke* section vary in length from a couple of columns to almost a page. Ye Gui's cases are unusually long and detailed. In both collections the patient is usually not named, although age and marital status are almost invariably included; not surprisingly, the great majority concern married women of child-bearing age, though pubescent girls and older women also feature. One difficulty with assessing the cases from the perspective of reproductive cultures is that sometimes the term son, *nan* 男, or daughter, *nü* 女, is used for a baby, but more often the physician simply uses the term child, *zi* 子, a term which in principle does not denote sex, yet in the context of patriliny often implies a male child or heir.

The *fuke* cases offer some interesting insights into how female fertility was construed by non-specialists. It was standard medical wisdom, dating back to the ancient *Yellow Emperor's Classic of Internal Medicine*, that a girl's fertile energies come through at twice seven years, *sui* 歲, and a boy's at twice eight; at that point both are able to procreate. Women's fertility is exhausted at seven

21 See the study by Grant, *A Chinese Physician*.

22 The renowned author of numerous works, including theoretical treatises on *fuke*.

23 Ou Ming, *Chinese–English Dictionary of Traditional Medicine* (Hong Kong, 1988), pp. 354, 361; Li Jingwei, ed. *Zhongyi Renwu Cidian* [Dictionary of Chinese physicians] (Shanghai, 1988), pp. 97, 281, 668.

times seven *sui*, men's at eight times eight.[24] The Song physician Chen Ziming had advised that a woman should not bear children before twenty *sui* for fear of damaging her internal organs, while a man should wait till thirty so that his *yang* energies were firm; Chen's arguments were elaborated by Ming medical specialists and were much in vogue among physicians in the eighteenth century.[25] The *fuke* cases appear to confirm that in late imperial times nice families did not set girls to child-bearing as soon as they were physically ready. Out of all Xu Dachun's cases involving pregnancy, if age is mentioned at all we find that the woman is at least twenty *sui*; only in a single case (included in the section on menarche, *tiangui* 天癸) is it implied that the pregnant woman is a very young girl—indeed, probably unmarried. A woman brings her daughter (age not given) to Xu Dachun who examines her and finds a pulse which indicates pregnancy. He suggests that the young lady has had no period for over a month, and is told he is correct. He provides intensive care throughout the duration of the pregnancy; first, to encourage the healthy formation of the foetus, later, to avoid miscarriage, and finally, to help the young lady give birth easily. "And indeed she gave birth to a boy, who was bouncy, bright, and easy to raise."[26]

At the onset of menarche, it is interesting to note that physicians were likely to qualify a girl who started menstruating at fourteen *sui* (the classical twice seven) as reaching menarche unusually early. Other cases indicate that most mothers did not start worrying unduly about the absence of menses until a girl was about seventeen *sui*,[27] and that scrupulous physicians tried to calm over-anxious parents:

"A woman brought in one of her daughters, fifteen *sui*, to be examined. She said that when the girl was fourteen her menses started to flow on their own,

24 Bray, *Technology and Gender*, p. 318. A child entered its first *sui* at birth, and its second at the passage of the lunar New Year; thus a child of four *sui* would be about two years old in Western reckoning. The multiples of seven years for women and eight for men clearly have a numerological touch; nevertheless, twelve Western-style for menarche and forty-seven for menopause seem reasonable approximations.

25 Charlotte Furth, Rethinking van Gulik: Sexuality and reproduction in traditional Chinese medicine, in: *Engendering China*, ed. Christina K. Gilmartin, Gail Hershatter, Lisa Rofel, and Tyrene White (Cambridge, MA, 1994), pp. 125–146.

26 Xu Dachun, *Yilüe Liushu, Nüke Zhiyan* [Medical compendium in six books, experiences in gynaecology], first published eighteenth century (Beijing, 1988), p. 32/12a–b.

27 For example, Ye Gui, *Linzheng zhinan yi'an* [Medical records as a guide to diagnosis], preface 1776 (Taipei, 1984), p. 6/14a; Xu, *Yilüe Liushu*, p. 32/3a.

but now on the contrary they had stopped. The mother told me this with fear. I said: 'Madam, this is your daughter and your menses must have begun at fourteen too. The reason that they have stopped is that they have skipped a year and you find this strange, but later they will start again. However I still fear that as to True *qi* 氣 [the body's protective and growth force] her natural endowment is both irregular and weak. If you want to treat it with drugs, that would be appropriate.' I thus secured the innate True *qi* to make Water rise and Fire descend, so that the Five Viscera were in harmony with each other and the pulses were in communication."[28]

This case is typical in that the negotiation takes place between the person socially responsible for the patient and the physician, rather than directly between physician and patient (a mother speaks for her unmarried daughter, a husband will usually negotiate with the physician on behalf of his wife). At the level of diagnostic virtuosity, the case illustrates that sometimes the interruption of a natural process may in itself be a natural event. The physician tries to allay the mother's fears (well supported by classical medical theory) that a disruption of the menses signals the onset of some profound disorder[29] by appealing to specific personal circumstances: the mother herself probably started menstruation early, but here she is alive and well and with a pubescent daughter. Probably nature can be left to take its course. However, the mother obviously wishes to take action, and perhaps there is some slight weakness in the girl's vital force. Prescribing a tonic to replenish *qi* and Blood would certainly do no harm, ensuring the balanced physiological flows that signalled female health and fertility. It was also a means to retain mother and daughter as satisfied clients,[30] whereas refusing to prescribe in response to what they perceived as a life-threatening problem would probably have sent them to another more obliging physician, as in the case treated by Xue Ji which Xu cites immediately previously:

28 Xu, *Yilüe Liushu*, p. 32/3b.

29 See Francesca Bray, A deathly disorder: Understanding women's health in late imperial China, in: *Knowledge and the Scholarly Medical Traditions*, ed. Donald Bates (Cambridge, 1995), pp. 235–50, and Bray, *Technology and Gender*, pp. 326–334 on the lay and medical obsession with menstrual regularity, and the often fatal consequences of neglecting amenorrhea.

30 At the time that Xu Dachun and Ye Gui were practising, the city-dwellers of the Lower Yangzi cities, both women and men, were apparently avid for tonic drugs that would replenish *yin* and were apt to refuse other types of prescription, even though—as Xu Dachun sourly remarked in his essay "On patients" [*Bingjia lun* 病家論]—they had not the slightest understanding of *yin yang* theory; Chao Y., *Medicine and Society in Late Imperial China* (unpublished, UCLA, 1995), pp. 39–40.

"A virgin, seventeen *sui*, ill for a long time without cure. Her reproductive powers had not come through [i.e., she had not yet begun to menstruate]. She developed a fever and a cough and ate and drank little. They considered using emmenagogues, but Xue [Ji] said: 'This is because her natural endowment is not sufficient and the *yin* Blood hasn't yet come through. This is the only reason. We must simply nourish Blood and *qi* and increase the bodily secretions, and the menses will flow on their own.' The others doubted that this would lead to quick results and used the emmenagogues as first intended. But [Xue] said: 'This is not the way to treat this disorder. It is a very violent remedy. It will drastically build up the *yang* Fire, and the *yin* Blood will be affected and will flow wildly; if Spleen and Stomach are affected they will waste.' The result was that her menstrual Blood wouldn't stop flowing, she couldn't eat or drink, and although Xue was called in he couldn't save her."[31]

A young woman was expected to reach reproductive maturity in her third seven-year cycle, and at this point the failure to conceive or to carry a child to term became a medical problem. In reconstructing what we might call the ethnobiology of reproduction in late imperial China, it is important to note the essential ambiguity of some crucial concepts or conditions. I have discussed elsewhere the ambiguities inherent in the practice of *tiaojing* 調經, menstrual regulation.[32] Because menstrual regularity was at the root of female health and fertility, whereas blocked menses were believed to lead quickly to debility or even death, women whose menses were delayed felt justified in using drugs to bring on the menses—although it was also recognised that even skilled physicians found it almost impossible to distinguish between the physical characteristics of early pregnancy and blocked menses. In the *fuke* cases, blocked menses, *jingbi* 經閉, figure as the cause of life-threatening syndromes, as in the case of a woman of twenty-four *sui* treated by Xu Dachun. She had tried countless remedies to no avail. By the time Xu was called in she was unable to eat and her family were at their wits' end. Over several days he gave her a series of prescriptions to loosen the phlegm which he had diagnosed as blocking her system; soon a menstruation was brought on which expelled waste matter from her womb; within a month regular, spontaneous menstruation was re-established and the woman regained her health and vigour.[33] The happy

31 Xu, *Yilüe Liushu*, pp. 32/3a–b.

32 Bray, A deathly disorder; Bray, *Technology and Gender*, pp. 326–334.

33 Xu, *Yilüe Liushu*, pp. 32/3b.

ending recorded here is not the birth of a baby: the woman's restoration to health, vitality, and menstrual regularity implied to any Chinese reader that her fertility had also been restored.

Other causes of menstrual irregularity or barriers to conception noted in Xu Dachun's cases include vaginal discharges, often triggered by depression or anxiety; fevers; and obesity. Xu records the case of a woman whose womb's membranes were clogged with fat, so that although she was menstruating regularly she was unable to conceive. Xu treated her with twenty or thirty courses of drugs to disperse the fat and open the womb, and the next year she finally gave birth to a child.[34] Knots, *jie* 結, or accumulations, *juji* 聚集, which hampered healthy physiological flows, also caused infertility:[35]

"I met a soldier who said to me: 'When my foolish wife was as yet unmarried she had a cold accumulation under her heart like the cover of a cup. When touched it made a sound like water; if stroked with a hot hand it felt like ice. She has now been married fifteen years and I fear my line will be cut off, so I wish to divorce her.' I stopped him, saying: 'If you use the drugs I give you her illness can be cured and a pregnancy achieved.' So the soldier brought her for consultation [...] Her pulse did not have the cast of infertility (*wuzi zhi hou* 無子之候) and I said she could be pregnant in under a year. The soldier laughed and said his old woman would try it [...] [Prescriptions listed] [...] In less than two months her Blood and *qi* were harmonised, and within not many months she was pregnant twice; both children lived."[36]

Although the sex of the children is not given their birth signals a satisfactory conclusion of the case, so probably at least one was a boy.

Knots and accumulations were associated with the repression of strong emotions. Body and spirit were weakened when natural circulation was impeded, and this could cause a "ghost pregnancy", *guitai* 鬼胎:[37]

"A woman over thirty, whose periods had stopped for eight or nine months; her abdomen was distended and grew daily, her complexion was sometimes dark, sometimes yellow. She took drugs to test for pregnancy [see below] but without response. I examined her. Her pulse was thready. When her complexion was dark she alternated between hot and cold; the disorder was located in

34 Ibid., pp. 33/11a.

35 Charlotte Furth, Concepts of pregnancy (1987); Zeitlin, The literary fashioning.

36 Xu, *Yilüe Liushu*, pp. 32/10a.

37 Wu Yi-Li, Ghost fetuses, false pregnancies, and the parameters of medical uncertainty in classical Chinese gynecology. *Nan Nü* 4 (2002): 170–206; Zeitlin, The literary fashioning.

Liver and Gallbladder. When her complexion was yellow her intestines ached dreadfully, she felt tired and resisted eating; the disorder was located in Spleen and Stomach. This was not a true pregnancy. Melancholy had caused a knot (*jie* 结), damaging Liver and Spleen so the *qi* of Gallbladder and Stomach was not able to process and cleanse properly. *Evil spirits had thus been able to possess her—this is called a ghost pregnancy.* I boiled together the two decoctions *guipi* 歸脾 ["restore Spleen"] and *xiaoyao* 逍遙 [a gentle prescription for building up female vitality], with 3 scruples of "spirit-beheading cinnabar" (*zhanguidan* 斬鬼丹); she discharged great quantities of dirty Blood and turbid water in which was a [kind of] womb, and in this womb was a clot of Blood which closely resembled a ghost's face. *So I have noted this to signal a curious event.*"[38]

Here Xu attributes the pseudo-pregnancy to possession by a ghost, rendered possible by melancholy and its physiological effects. Ghost pregnancies were an acknowledged medical phenomenon, sometimes attributed by physicians to supernatural causes (possession by spirits), sometimes explained as natural if abnormal outcome of emotional or physiological ill-health disrupting the processes of pregnancy:[39]

"A woman whose abdomen gradually grew bigger as if she were pregnant. When she reached the tenth month she asked for drugs for an easy birth.[40] I examined her: her spirit [*shen* 神, one of the body's vital forces] was in difficulty and her pulse was very weak; clearly this was not a foetus in good shape and it would be difficult to give her drugs. Not many days later she indeed gave birth to half a bucketful of white worms. This was because the woman's original *qi* was extremely depleted, so although semen and Blood had congealed[41] she was unable to form a foetus and they formed a rotten, dirty mass; after a while dampness was transformed into heat, and heat and dampness together produced

38 Xu, *Yilüe Liushu*, p. 32/22a–b, emphases added.

39 Wu, Ghost fetuses.

40 It was common to try to control the size of the fetus in late pregnancy to avoid difficulties in childbirth. "Thin fetus drugs", based on sweet orange peel, are mentioned in *materia medica* as early as the ninth century as a way to avoid difficult childbirth, and were taken from the end of the fifth month. However, the drugs had a tendency to weaken the *qi* energy of both mother and child, so the mother had less strength to deliver and the child would be weak and difficult to raise. As an alternative, physicians recommended "life-sustaining drinks" to increase energy; Fang Lüe, *Shangyou tang yian* [Medical cases from the Hall of Honoured Friendship], preface 1846 (Shanghai, 1983), p. 6/38b.

41 Conception occurred when male and female generative essences (semen and Blood) mingled harmoniously and congealed in the womb to form the solid mass that would develop into the fetus.

the worms so that she appeared pregnant. This woman died less than a month afterwards."[42]

Here the mass of worms of which the sick woman is delivered is explained by the physician not as a monstrous phenomenon but as the product of a natural transformation of Blood and semen under conditions of poor health. Yi-Li Wu reminds us that nothing could be taken for granted about what the womb contained even in the last stages of pregnancy: in a society lacking the certainties implied by chemical pregnancy tests, ultrasound, and foetal testing, human reproduction was experienced as infinitely mutable.[43] Some physicians claimed to be able to diagnose pregnancy by pulse after a month or two, others felt they could not be sure until at least three months had passed. A number of well-known pregnancy tests existed, prescriptions consisting of drugs such as Buddha's hand and *xiaoyao* powder which nourished and mildly activated the Blood.[44] If the woman who used such a test was not pregnant it would stimulate a menstrual flow; if nothing happened, or if there was a movement in the abdomen, the chances were that she was pregnant. A physician might prescribe such a drug to confirm his diagnosis; a woman could easily obtain it herself from a herbalist or pharmacy. When a woman missed one or two periods, then, she might simply presume she was pregnant, she might procure a mild drug to test for pregnancy, or she might construe her amenorrhea as the dangerous condition of "blocked menses" and resort to one of the emmenagogues referred to earlier—prescriptions of violent, heating Blood-activating drugs which were well-known to double as abortifacients.

If a woman suspected that she was pregnant but hoped that she was not, the uncertainties of early diagnosis together with the imperative of "regulated menses", *tiaojing*, without which long-term health and fertility were impossible, offered legitimate prescriptions to resolve the issue without even framing it as a step to terminate a possible pregnancy. After all, "if a spontaneous miscarriage takes pace in the first month, nobody realises that it is a miscarriage—they simply say they were not pregnant; they do not realise that they were already pregnant and have miscarried, *anchan* 暗產".[45] The medical cases only tell us when things went badly wrong, as they did for "Wang Guo's 汪鍋 wife, thirty-

42 Xu, *Yilüe Liushu*, p. 32/21a.

43 Wu, Ghost fetuses.

44 Bray, *Technology and Gender*, p. 320.

45 Ye Gui, quoted in Huang Shengwu, ed., *Zhongguo yixue baike quanshu. Zhongyi fukexue* [Chinese medical encyclopaedia. Traditional Chinese gynaecology] (Shanghai, 1983), p. 23.

five *sui*, who detested giving birth" and mistakenly dosed herself with very powerful abortifacients, provoking a violent haemorrhage; or the woman in her fifth month who dosed herself with a home-made abortifacient of "boiled-red pills", *jianhong wan* 煎紅丸; or the woman of almost forty with a weak constitution who induced abortion herself. The second case concludes, after a series of subtle prescriptions, with the foetus being gradually calmed, *jian an* 漸安 (implying that both the patient and the pregnancy were saved); in the first and third cases the foetus is lost but the patients are completely cured, *quan chou yi* 全瘳矣.[46]

Abortion was not illegal in late imperial China, although the law punished doctors or midwives who caused a woman's death by prescribing dangerous drugs.[47] Most medical case histories offered no moralising comments on women who tried to end their pregnancies, although they were scathing about physicians who ignorantly or unscrupulously prescribed dangerous Blood-moving drugs. Physicians present themselves as giving priority not to the foetus but to the woman's survival and long-term health. Not surprisingly, however, their recorded cases usually show how their exceptional skills enabled them to save both mother and child. The case collections include long sections on the health problems of pregnant women, and equally long sections on "calming the foetus", *antai* 安胎, reducing foetal movement or agitation, preventing miscarriages, and ensuring healthy foetal growth. The disorders of pregnancy often pitted the survival of the foetus against that of the mother, and treatment required a carefully planned sequence of therapeutic tactics, as in a case of heat damaging the *yin* of the Lung recorded by Ye Gui:

"First cold then hot, coughing and irrigation: this is a Lung disorder of the spring months and warming wind. The wind constitutes a *yang* pathogen, and the warming is gradually transformed to heating; this alien *qi* which causes an infection is the diurnal, seasonal *qi* [...] The use [of the bitter, heating drugs normally prescribed for Lung complaints] before the foetus is formed [in the third or fourth month] is forbidden because they produce great heat and agitation, conditions which endanger [the pregnancy]. [In this case] one is recommended to clear away the Lung agitation and to moisten the Lung parchedness. If the foetus is given cooling drugs then it will be calmed, if the disorder is

46 Xu, *Yilüe Liushu*, pp. 32/21b; 32/21b; 32/21a–b, taken from the sections on *fang tai zi zhui* 防胎自墜 [preventing miscarriage] and on *taizhui men* 胎墜門 [miscarriage].

47 Bernard H.K. Luk, Abortion in Chinese law. *American Journal of Comparative Law* 25 (1977): 372–392.

dispelled the patient herself will be calmed—this is what I call non-replenishing replenishing. The physicians of old first cured the repletion [which generally manifests in heat], for the repletion is the pathogen. [Prescription includes a series of drugs for clearing heat.]

Then: Gasping and fever diminished by half, four limbs slightly chilly, uncomfortable feeling in abdomen. There is the worry that the *qi* of the foetus may be affected above. Yesterday she took the clearing and moistening prescription and broke out in beads of sweat: one could see that the bitter and parched were exhausting the Blood which then helped the fever. Today however the agitation and thirst have stopped. *I ask the original cause of the disorder. The damage caused by sorrow and fear* had nourished the Liver *yin*. *The cure* is to stimulate the Kidney secretions, to stabilise and preserve the embryo while regulating the sick body. Prescription for Restoring the Pulse, omitting [the warm drugs and those that dispel cold Wind] and adding [cooling, heat-dispersing drugs from the previous prescription]."[48]

In a vicious circle, fear and anxiety about the risks of pregnancy often made a woman ill. Some cases tell us of a husband pleading with a doctor to give drugs that will expel the foetus in order to save his wife:

"The wife [of a junior official]: her foetus was leaking [slight but continuous bleeding]; doctors had treated her but the leaking did not stop. Her husband, given the circumstances, wished to have her abort and consulted me. I prescribed Buddha's hand powder so that if the foetus could be calmed it would, and if not it would abort, but in a natural fashion."

This case has an unhappy ending: Xu goes away to visit his in-laws, and while he is absent the anxious husband resorts to another physician who administers powerful Blood-moving drugs. The unfortunate woman haemorrhages and dies.[49]

In the numerous cases of sickness during pregnancy, excessive morning sickness, or threatened miscarriage the author of the case usually records the happy outcome of his ministrations as including the "calming" of the foetus, *antai*; sometimes, but not always, he also records a successful birth.[50] Sometimes the foetus is dead in the womb, and the happy outcome is a successful diagnosis of this tricky condition, followed by a prescription of drugs to expel the dead

48 Ye Gui, *Linzheng zhinan yi'an*, p. 9/35b–36a, emphasis added.

49 Xu, *Yilüe Liushu*, p. 32/20a–b.

50 Ibid., 32/13a and 32/15a are just two of many such cases.

foetus and restore the women to health.[51] Occasionally we are given a narrative which shows that the physician has followed his patient over a period of many years, as in the following case treated by Wang Ji and included by Xu Dachun in his section on "Menstrual regulation", *tiaojing*:

"A married woman, twenty-one *sui*: for six months at her period her abdomen hurt as if it was being scraped; the pain was so bad she wanted to die [...] [prescription]. After nine years she had a child, and afterwards she took the medicine several times with success, but after fifteen years the prescription lost its effectiveness and Wang examined her once more [...] [concluding that it is no longer the same disorder]. When she first became ill her form was thin and small but now it is fat and large. The classics say that when a thin person has much Blood they suffer from heat [which produced repletion], but when a fat person has much Blood they suffer from depletion [the opposite of repletion], so how could the cure be the same?"[52]

From the standpoint of reconstructing demographic mentalities or reproductive cultures, one might have hoped that a case of this kind would tell us how many pregnancies and live births the woman experienced during her long-term treatment for painful menstruation. But the point which Wang Ji is arguing is that constitution changes with age; we cannot tell if his patient had one child or several during the course of his successful management of her dysmenorrhoea. Some cases, like the one by Master Han 韓, included by Xu Dachun in his section on leucorrhoea, give far more detail of a demographic kind:

"A woman in the mountains, over thirty, who had been pregnant eighteen times: nine were premature or stillbirths, seven infants joined their ancestors young [...] The woman's fright and depression were so extreme that she became totally confused and unaware of human affairs. Her mouth, lips and tongue were all ulcerated; sometimes her gullet would become blocked although the lower part was empty, and she suffered from leucorrhoea. She was in this state for more than forty days; sometimes she became slightly conscious, desiring to hang herself in unbearable grief at her condition. A physician gave her a cold course of treatment [a prescription lasting several doses] to cut off the upper heat but then below the symptom of leucorrhoea became even more serious. Another gave a hot prescription together with a syrup of aromatic drugs, and

51 For example, the two cases described, ibid., 13b.

52 Xu, *Yilüe Liushu*, p. 32/1a.

111

then a fever began to mount in her lower body, she became dizzy, and wished for death. I took her pulse and recognised the symptoms of the extinction of *yang* [i.e., she was near to death]. [The family] wept bitterly, saying: 'The ancestors' descent has not yet been established yet they are near to mistakenly killing our elder brother's wife.' I hastily took salt and boiled up 9 scruples of aconite [a powerful and poisonous drug for dispelling inner heat] as the principal drug, compounded with the juice of peppermint [dispels fever] and assisted with ginger ash, asparagus and the like of Schizandra sinensis seeds simmered in water and then cooled in a well. I administered it, and before she had finished the dose she fell into a heavy snoring slumber and slept through the night, after which she was fully conscious again. But after some time there still was no heir though two daughters followed each other in quick succession. She wept for the pain, and all her relatives distant and near grieved. A friend, Zhao Xianchang 趙憲長, was alarmed and asked me, 'Sir, what method do you have for dealing with this?' I said: 'In the books of prescription true must be matched with true and false matched with false. Outside we had a false heat and therefore I followed it with a falsely cold drug; but inside we had a true cold and therefore I countered it with a truly hot drug. Thus inner and outer were brought to harmony and the disorder was resolved. If I treat her continuously with 'female gold elixir pills' then the confusion [of true and false symptoms] will be transformed: not only will her symptoms be dispelled but her original *qi* [vital forces] will be regulated.' And in her thirty-seventh year she gave birth to a son who has now inherited."[53]

This woman had been pregnant eighteen times by her early thirties (a vastly greater conception rate than I have seen mentioned in any other case); only half the pregnancies resulted in live births and seven of the nine infants died; the two who did survive were daughters. After treatment she gave birth to two more daughters, and eventually, at thirty-seven, to a son who lived; since no pregnancy problems are mentioned in the later part of the case, we may assume there were no further miscarriages or infant deaths. So here we have five live children—or, as far as the family was concerned, a single son—at the cost of twenty-one pregnancies. It was sorrow and desperation about the lack of a son that brought the woman to the edge of death in the first place. The immediate cure was effected with drugs; however, it was recognised by all involved that the only final cure, which would restore the woman not only to health but also to happiness, was the birth and survival of a son and heir. This healed both the

53 Ibid., p. 32/7a.

woman and the family; a happy ending was thus achieved and the case could at last be considered closed.

Concluding Remarks

I began this paper by suggesting that medical case studies might illuminate the demographic mentalities, or reproductive cultures, which demographic historians hope to recover as context for reproductive choices, or even to incorporate into their models. Yet clearly it is no simple task to integrate the quantitative and qualitative approaches.

If more *fuke* cases were as explicit about an individual's complete reproductive history as the last case I described, they might offer real possibilities for relating fecundity to fertility. Much more typical, however, are the narratives which conclude by informing us that "the foetus was secured and the woman gave birth to two children in a row", or "a child was born within a year", or "she gave birth to a succession of sons and daughters".[54]

What might medical cases reveal about the context in which people made reproductive decisions? The new demographic historians argue the late imperial period was marked by low marital fertility rates and flat fertility curves characteristic of a society using some form of birth control, most likely selective infanticide. They propose that families preferred to invest in a few children rather than to maximise the number of sons at any price. Medical cases say nothing of infanticide. In other respects, they support demographers' suggestions that late imperial families, or at least the families likely to consult physicians, were not interested in babies, or even boys, at any price. The structuring of the medical narratives shows that many physicians and their clients put the long-term health of the mother before the life of an individual foetus, and that they considered menstrual regulation an indispensable precondition for female health and fertility. We can also infer from *fuke* theory and cases that women not infrequently terminated early pregnancies with drugs which we would term abortifacients, but which in late imperial terms were pregnancy tests.

So the medical cases indicate that women had means and rationales for achieving what in our terms would be a degree of control over their own fertility, and show us social contexts in which such control was apparently condoned. Yet they also show us the heavy price many women had to pay in order to produce a socially

54 Ibid., pp. 32/21a; 32/10b–11a; 32/8a.

desirable family. They tell us tales of agitated foetuses; of women exhausted by child-bearing; worn out by miscarriages; driven mad by their failure to produce a son; or dying in childbirth. They describe how sickness can curdle the contents of a woman's womb and turn it into worms. In contrast to the image of conscious decisions and rational planning proposed by the demographers, the medical case histories of late imperial China remind us of the perpetual ambiguities and uncertainties surrounding pregnancy, and the unfathomable mutability attributed to natural reproductive processes.

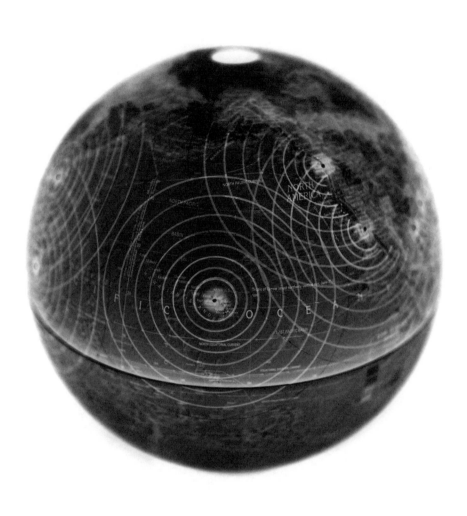

Worldprocessor [#243]

DAI NIANZU

Electricity, Magnetism, and Culture in Ancient China

This article gives an outline of Chinese knowledge about electricity and magnetism in ancient times[1] focusing on four aspects:

(a) static electricity; (b) thunder and lightning; (c) magnetism; and (d) the lodestone spoon and the compass.

The Chinese discovered static electric attraction and that many kinds of materials become electrically charged when rubbed: also that there is a flash and a noise when they discharge.

In history, for a long time people thought that thunder and lightning were expressions of the mood of the gods. Most philosophers and thinkers explained their causes with the Qi of the Yin and Yang. The philosopher Wang Chong [王充] of the Han Dynasty was the first to put forward the idea that thunder and lightning consist of fire. Apart from line lightning, many reports about ball lightning and bead lightning can be found in classical texts. There are innumerable observations of metal melting and lacquer ware remaining unscorched when struck by lightning; thus people acquired their first knowledge about conductors and insulators. The phenomenon of point discharge led the missionary Gabriel de Magalhães to believe that Chinese buildings were equipped with lightning conductors. In the sixteenth century, a group of soldiers tried to protect their camp from thunder and lightning by firing their rifles into the air.

In ancient China the attracting and repelling forces of magnetism and the polarity of magnets were known. This article highlights the knowledge of Liu An [刘安], King of Huainan in the Han Dynasty, and his followers about magnetism, especially the fact that they were the first to succeed in producing magnetic bars. Further, there are many stories about magic and conjuring tricks that employed magnetism.

The form of the compass in ancient times is discussed, and the genesis of the compass in ancient China. The compass whose needle points south was

1 I should like to point out that the term "ancient" is not used by Chinese and Western historians in the same way. Chinese historians refer to the time before the Opium Wars of 1840 as "ancient", whereas for Western historians the period before the fifth century, when the Roman Empire withered away, is "ancient". In this chapter the Chinese convention is used.

invented in the mid-ninth century; the compass and geomagnetic declination in a modern sense were discovered in the first half of the eleventh century; the compass was developed further and was used in navigation from the beginning of the twelfth century.

Additionally, this essay includes cultural questions related to magnetism. Besides magic and conjuring, Taoists, alchemists, doctors, and the military had a great interest in electromagnetism. It is a cultural phenomenon that many schools of thought participated in advancing knowledge about magnetism, which was also an important factor in driving the development of science in ancient China. Even before Kepler's system of the universe and Isaac Newton's thoughts about gravitation were introduced to China, the Chinese already explained the tides and the movement of celestial bodies in terms of magnetism and gravitation.

Introduction

According to Siegfried Zielinski, the science of electricity is the "soul" of the new media.[2] This is a penetrating insight by a scholar who thoroughly understands the history of media. Long before the birth of the science of electromagnetism, flat media like newspapers and other print media were commonly used. Only after the birth of the science of electromagnetism and the development of radio and microwave technology did today's stereoscopic media like TV broadcasting, mobile phones, and the World Wide Web become possible, as well as the transmission of information for today's aviation and the remote control of spacecraft. In the history of science in modern times, the seventeenth and the eighteenth centuries were the prehistoric period of electricity and magnetism. In the first thirty years of the nineteenth century, electricity and magnetism were put together by the work of Hans Christian Oersted (1777–1851), Joseph Henry (1799–1878), and Michael Faraday (1791–1851). The combination of electromagnetism and optics in 1862 was the contribution of James Clerk Maxwell (1831–1879). It must be pointed out that the concept of the "field" raised by Faraday in his old age is extremely important for today's media. If there were not such a field in the air, it would be hard to imagine how today's media and

2 Siegfried Zielinski, *Archäologie der Medien*. Preface of Chinese Edition (Beijing, 2006); German original: *Archäologie der Medien* (Reinbek, 2002); English translation: *Deep Time of the Media*, trans. Gloria Custance (Cambridge, MA, 2006).

their technology could have been discussed or how they could have become established. In 1888, Heinrich Rudolf Hertz (1875–1894) demonstrated by experiment that electromagnetic waves also have all the specific characteristics of light, which shows that electricity, magnetism, and light are essentially of the same kind. This discovery opened up a new chapter in the history of electromagnetism and media.

In the period when the science of electromagnetism became established, one could not speak of a specific Chinese contribution. The Chinese had only made certain important discoveries about static electricity and static magnetism. It can be said that between 1600, when William Gilbert (1540–1603) published his book *De magnete* and 1792, when Luigi Galvani (1737–1798) discovered galvanism through an experiment, the ancient Chinese of that period were also aware to some extent and also discussed the phenomena of static electricity and static magnetism.

Static Electricity

The Chinese discovered the phenomenon of attraction caused by static electricity after rubbing amber later than Thales of Miletus (642–547 B.C.) of Greece, but they discovered the same phenomenon in connection with rubbing the shell of the hawksbill turtle earlier, and they always mentioned the attraction caused by static electricity together with that caused by magnets. The book *Apocryphal Treatise on the Spring and Autumn Annals; Investigation of the Strange and Extreme Penetration* 春秋考异邮, written during the last years of the western Han Dynasty (206 B.C.–A.D. 25) states: "The lodestone attracts iron, the hawksbill turtle attracts mustard seeds."[3] Eastern Han Dynasty scholar Wang Chong (27– ca. 97) wrote in the book *Discourses Weighed in the Balance* 论衡: "Amber picks up mustard seeds and the lodestone attracts needles. This is because of their genuineness, for such a power cannot be conferred on other things; other things may resemble them but they will have no power of attraction. Why? Because when the nature of the *Chhi* is different, things cannot mutually influence one another."[4] In the years after the Han Dynasty, the Chinese discovered

3 Chin: 磁石吸铁，玳瑁吸诺。Anonymous, *Apocryphal Treatise on the Spring and Autumn Annals; Investigation of the Strange and Extreme Penetration* 春秋纬考异邮 (Han Dynasty).

4 Chin: 顿牟缀芥，磁石引针，皆以其真是，不假他类。他类肖似，不能缀取者，何也? 气性异殊，不能相感动也。Wang Chong, vol. 16, chapter 47, in: *Discourses Weighed in the Balance* 论衡 (Han-Dynasty),

more and more materials, such as amber, lacquer, human hair, cats, peacock feathers, chicken feathers, silk, and animal fur, that exhibited the phenomena of attraction, flash discharge, and sound of discharge after they had been rubbed.[5] Interestingly, the ancient Chinese did not regard this as "electricity"; rather, they thought it was a kind of "fire", "unusual fire", or "light", although thunder and lightning in the air were regarded as electricity. In this period Western scholars regarded the phenomena of static electricity as "electrum" (the term "electricity" derives from this word), but not thunder and lightning as electricity. However, regardless of being in the west or the east, it took the courageous Benjamin Franklin (1706–1790) to unify the electrum on the ground and the thunder and lighting in the sky.

The hawksbill turtle and amber were materials commonly used in traditional Chinese medicine (Fig. 1). Physicians always tested whether they were genuine by using the attraction phenomena of static electricity. Lei Xue 雷斅 (date of birth and death unknown) of the Liu Song Dynasty (420–479) wrote in his book *Treatise on the Decoction and Preparation of Drugs* 炮炙论: "Amber has the colour of blood. Rub it with a cloth to warm it up; if it attracts mustard seeds it is genuine."[6] Tao Hongjing [陶弘景] (456–536) wrote in *Informal Records of Famous Physicians* 名医别录: "But only that kind which, when rubbed with the palm of the hand, and thus made warm, attracts mustard seeds, is genuine."[7]

In the period of the Western Han Dynasty, the wives of rich feudal lords often used amber clasps to fix their hair. When the clasps were taken off suddenly, there was a flash caused by static electricity. People at the time did not understand the phenomena of static electricity and were scared; they took this light to be "phosphorescence". The King of Huainan, Liu An (179–122), and one of his over thousand advisors observed this flash and noted it down in their co-authored book *The Book of the Prince of Huainan* 淮南子: "Taking off a clasp

trans. Joseph Needham, *Science and Civilisation in China*, vol. 4, part 1 (Cambridge, 1962), p. 233; note that *Qi* 气 is transcribed here as *chhi*.

5 See also: Dai Nianzu, *A Series of Books on History of Physics in China* (Changsha, 2002), pp. 30–58.

6 Chin: 琥珀血色, 以布试热, 吸得芥子者其也 Li Shizhen 李时珍, *The Great Pharmacopoeia* (Beijing, 1982), pp. 2152–2153. This quotes the books of Lei Xue 雷斅, *Treatise on the Decoction and Preparation of Drugs* 炮炙论, (Liu Song Dynasty, 420–479), and Tao Hongjing (陶弘景), *Informal Records of Famous Physicians* (名医别录), (Xiaoliang Dynasty, 555–587).

7 Chin: 琥珀惟以手心摩热拾芥为真 Tao Hongjing 陶弘景, *Informal Records of Famous Physicians* 名医别录; see also fn. 5; trans. J. Needham, *Science and Civilisation*, vol. 4, part 1, p. 238.

causes phosphorescence. What is it that we are scared of?"[8] This is the first record about a flash caused by static electricity.

There is another story in a historical book, which is of great significance for the history of media. In the year 300, Sima Zhong 司马衷, also known as Emperor Hui of Jin 晋惠帝, took Yangshi 羊氏 as his queen. Yangshi entered the palace and a maidservant helped her to take off her silk clothes. Perhaps because they took the clothes off very quickly, or perhaps because the maidservant shook them—whatever the cause, "the clothes were suddenly on fire". The scared maidservant secretly spread this story around in the palace. Neither the government official who got wind of the story, nor the Confucian scholars could explain this strange occurrence, and they whispered secretly to each other about it, but finally the rumour spread across the entire country. Historians like Fang Xuanling 房玄龄 (579–648) recounted the event in *The History of the Jin Dynasty* 晋书.[9] This story is just like a scene from one of today's television plays or movies.

A discharge produces not only a flash but also a sound. Zhang Hua 张华 of the western Jin Dynasty was the first to write down this phenomenon: "When people comb their hair or take off their clothes, then there is something following the comb and by opening the bun of hair there will be a flash and also a sound like when you smack your lips."[10]

Guo Tuan 郭彖 (date of birth and death unknown), who lived at the beginning of the southern Song Dynasty (1127–1279), reported another story about static electricity. The main character of the story is called "Mister Liu". He was on his way home when he was caught in the rain, sought shelter in a tomb by the wayside, and being tired he fell asleep. When he awoke a horrible scene occurred:

"Mr. Liu, a more than 60-year-old man living at the foot of Mount Heng in Heshuo (area in the north of the Yellow river), climbed once to the temple of Shangfeng [...] on his way back home, he was caught in the rain. He saw the opening of a tomb alongside the way and entered it to seek shelter from the rain. At nightfall he fell asleep. In the middle of the night, Mr. Liu awoke. The rain had stopped and the bright moon shone thorough the opening so the whole grave came clearly into view. The wall of bricks was very bright and clean. At

8 Chin: 抽簪招磷, 有何为惊 Liu An 刘安, *Huainanzi* 淮南子, chapter on Shuilinxun 说林训.

9 Fang Xuanling, *Jin Shu* 晋书, vol. 27, in: *Records of Five Elements* (Beijing, 1974), p. 805.

10 Chin: 今人梳头, 脱着衣时, 有随梳, , 解结而有光者, 亦有咤声 Zhang Hua, *Bo Wu Zhi* (*Record of the Investigation of Things* 博物志), vol. 9 (Beijing, 1980), p. 106.

Fig. 1: Amber used for medicinal purposes during the Tang Dynasty, found in 1972 in Hejia village in Xian province

Fig. 2: Amber clasp, found in 1999 in Nanjing in the tomb of Mu Rui 沐睿 (?–1609), duke of the county Qian 黔 during the Ming Dynasty (1368–1644).

the north wall there was a white skeleton, which was complete from head to feet, not a single piece was missing. Mr. Liu stood up and came a little closer to look at the bones when the skeleton suddenly rose up and embraced Mr. Liu. Liu hit it forcefully and the white bones fell apart down to the ground and didn't move again. Liu got out of the tomb and told the story to others. Someone said: This is not an odd thing. Mister Liu's Qi was so strong that it was able to attract the bones. Today's children pull out feathers of chicken and hold them to their bosoms. They draw them up and down with his fingers and the feathers responded to the movement of the fingers. If the feather is slightly broken up then it will not respond. This is just the same principle."[11]

Obviously, the main character of the story, Mr. Liu (it seems as though it is the author Guo Tuan himself) had a quite profound knowledge of static electricity, and he was probably a materialist.

[11] Chin: 刘先生，河朔人，年六十余，居衡岳紫盖峰下。……尝至上峰，归路遇雨，视途边一家有穴，遂入以避。会昏暮，因就寝。夜将半，睡觉雨止，月明透穴，照圹中历历可见。觉甍甚光洁。北壁唯白骨一具，自顶至足俱全，余无一物。刘方坐起，少近视之，白骨倏然而起，急前抱刘。刘极力奋击，乃零落坠地，不复动也。刘出，每与人谈此异。或曰：此非怪业，刘真气壮盛，足以翁附枯骨耳。今儿童拔鸡羽置之怀，以手指上下引之，随应：羽稍折断，即不应，亦此类也: Guo Tuan 郭彖, *Kui Che Zhi*, vol. 6 (*A Cartload of Queer Phenomena* 睽车志, 卷6。四库全书本).

Thunder and Lightning

The two Chinese characters *lei* 雷 for thunder and *dian* 电 for lightning are used separately to describe the sound and the flash of electrical discharges in the air. The earliest occurrence of the character for thunder is on oracle bone inscriptions of the Shang Dynasty (1300–1028 B.C.). The earliest occurrence of the character for lightning, *dian*, is on bronze objects of the western Zhou Dynasty (1027–771 B.C.) (Fig. 3). During the early period of cultural history, people believed thunder was the sound made by "Lei Gong [雷 公]", the god who controls thunder, when pushing a cart through the sky, and lightning was the light sent out by "Dian Mu [电 母]" (the goddess who controls lightning).[12] People thought that thunder and lightning were expressions of the mood of the deities; this belief is still remembered by people today.

In the period of the western Zhou Dynasty, the cause of thunder and lightning was already being explained by the clash of the two Qi of Yin and Yang. It is noted in *The Book of Changes* 周易 that "A strong 刚 and a weak line 柔 were manipulated together (until there were the eight trigrams), and those eight trigrams were added, each to itself and to all the others, (till the sixty-four hexagrams were formed). We have exiting forces of thunder and lightning; the fertilising influences of wind and rain; and the revolutions of the sun and the moon, which give rise to cold and warmth."[13] Here the "strong" 刚 and the "weak" 柔 refer to the Qi of the Yang (sun) and the Qi of the Yin (moon). The book *Zhuangzi* 庄子, which was written during the Warring States Period (480–220 B.C) states: "When Yin and Yang are in disharmony, the heavens and the Earth will be greatly disturbed. Thunder will crash and rain will come with lightning",[14] and *The Book of the Prince of Huainan* says: "When Yin and Yang clash, this causes thunder and excites lightning."[15] The Qi of Yin and the Qi of Yang do not have the same character. When they collide in the air, thunder and lightning ensue. This way of philosophical thinking and this ingenious guess retained their validity up to the explanations of modern science: two kinds of

12 See also: Wang Chong, *Discourses*, vol. 6, chapter 23, p. 103.

13 Chin: 刚柔相摩，八卦相荡，鼓之以雷霆，润之以风雨，日月运行，一寒一暑 Translation from: *The Chinese–English Bilingual Series of Chinese Classics, Book of Changes: The Great Treatise* (Changsha, 1993), p. 291.

14 Chin: 阴阳错行，则天地大骇，于是乎有雷有霆 Translation from: *The Chinese–English Bilingual Series, Zhuangzi*, chapter 26, External Things (Changsha, 1997), p. 547.

15 Chin: 阴阳相薄，感而为雷，激而为电 *Huainanzi*, chapter 3.

clouds with different electrical charges clash in the sky, which leads to electrical discharges. Liu Xiang 刘向 (77 B.C.–A.D. 6) was the first to relate thunder to lightning. To use his words in his book, *The General Meaning of the Five Classic Books* 五经通义, "Lightning is what you call the ray of a thunder."[16]

With regard to reports of thunder and lightning, people frequently observed line lightning but less frequently ball lightning or pearl lightning. Yao Kuan 姚宽 (date of birth and death unknown, successful candidate in the highest imperial examination in 1097, he was an assistant minister in the Ministry of Revenue when the court of the Song Dynasty moved southwards) wrote about ball lightning striking people:

"In the Ansheng-temple of Taizhou [now Linhai, Zhejiang province], the monk Shi Zhao was sitting in daytime in front of other Buddhist monks. It was the day of the Dragon Boat Festival. Suddenly they heard noise coming from the tiles of the roof and straightaway a light of fire struck the ground. After a brief moment, it became as big as the wheel of a vehicle. It first burned Shi Zhao's left arm, then spread to the right arm and his back before it disappeared. After quite a while it reappeared again, forming line lightning, and then left the room with a booming thunder. The monk was barely alive, and lifted his clothes to look upon it. On the back of his Kasaya [Sanskrit, long robe in yellow and red, worn by Buddhist priests] was a hole in the form of a coin, on his underwear was a hole, as large as a bowl, and a big sore was under his backbones, which caused him much pain. Everybody thought that because the fire came from heaven he couldn't be cured. However, by giving him hot water with dissolved medicine in it, he completely recovered in a little more than a month. What a strange phenomenon this was."[17]

This flame, which was as big as a wheel, was surely ball lightning. Yao Kuan described its sound, form, and size as well as its various movements. The passage is written just like an article in *Nature* magazine. The common people did not believe the monk could be cured, because it was "heavenly fire". But Yao Kuan cured him, and the people were astonished by this.

16 Chin: 电谓之雷光也 compiled by Ma Guohan 马国翰, *Yu Han Shanfang Jiyishu* 玉函山房辑佚书, (Qing Dynasty).

17 Chin: 台州 (浙江天台山等地, 今临海县) 杜渎监之北, 安圣院僧师肇, 端午日, 昼与僧对坐, 忽闻屋瓦有声, 火光一线下至地。少顷, 遂大如车轮, 先燎僧之左臂, 次及右臂, 忽入于背, 不见。久之, 复为一线飞去, 出屋即震雷一声。其僧仅有气, 且举衣视之, 背后袈裟一圆孔如钱, 中单圆孔如碗, 脊下烧一圆疮, 疮楚甚。皆以为天火, 不可治。予以汤火药涂之, 月余遂无事, 怪异如此 Yao Kuan, *Xixicongyu* 西溪丛语, vol. 1 (Song Dynasty).

The philosopher Wang Chong, who had his doubts about Confucianism, strongly opposed the theory that thunder and lightning were caused by the anger of the gods. He argued that these phenomena were "fire" and offered five pieces of evidence for this. For instance: If someone was hit by thunder "his corpse has the smell of fire [sulphur]", a stone hit by a thunder "turns red and gets warm", thunder and lightning in the air "are shining like fire", and thunder and lightning "burn down houses, trees, plants", etc.[18]

Wang Chong's way of thinking was the same as that of Benjamin Franklin, whose experiments with a kite in 1749 proved that man-made lightning on Earth and the lightning occurring in the sky have twelve kinds of similarities, including sending out light, killing animals, making combustibles catch fire, having a sulphurous smell, etc.[19]

The people of ancient times made detailed records about observed strange happenings involving thunder and lightning. In 490 lightning struck a temple and "burned the face of Buddha, but left the windows unchanged."[20] A naturalist of the Song Dynasty, Shen Kuo 沈括 (1031–1095), recorded an event when lightning struck a private residence: all the gold and silver jewellery inside a wooden box were melted, but the lacquer ware was not. There was also a sword which melted but its leather sheath was unharmed.[21] Zhang Zhou 庄绰 also named Jiyu 季裕 (lived in the eleventh and twelfth centuries), wrote about an incident when lightning struck a temple. The golden decorations on the head and body of the Bodhisattva completely melted away, but those in other colours did not.[22] Liu Xianting 刘献廷 (1648–1695), who lived at the time of the Song Dynasty, recorded lightning striking boats and stores. The wood and lacquer ware on the boats was safe, but the copper mirrors and plates stored in a bag were melted. In the stores, all the golden and iron objects were lost, but the leather wrapping around them and the lacquer ware remained unharmed.[23] Based on the wealth of historical documents, Fang Yizhi 方以智 (1611–1671) summarised in *Wuli*

18 Wang Chong, *Discourses*, vol. 6, chapter 23, p. 97.

19 Florian Cajori, *A History of Physics* (New York, 1919), p. 129.

20 Chin: 永明八年四月六日, 雷震会稽山阴恒山保林寺, 刹上四破, 电火烧塔下佛面, 窗户不异也 Xiaozi Xian 萧子显, *The History of Southern Qi Dynasty*, vol. 19, *Records of Five Elements* (Beijing, 1972), p. 379.

21 Shen Kuo, *Dream Pool Essays*, vol. 20, para. 10; see also: J. Needham, *Science and Civilisation in China*, vol. 3 (Cambridge, 1959), p. 482.

22 Zhang Zhou 庄绰, *Ji Lei Pian* 鸡肋篇, vol. 1 (Song Dynasty).

23 Liu Xianting 刘献廷, *Guang Yang Zaji* 广阳杂记, vol. 1, (Beijing, 1957), p. 14.

Xiaoshi: "When lightning-fire comes into contact with metal and lacquer ware, then metal will melt but lacquer ware will remain unharmed."[24] This is the basis for the concept of inductors and isolators in modern science.

Beginning with the western Han Dynasty (206 B.C.– A.D. 8), classical books contain many records about point discharge. For example, on the battlefield on some nights soldiers saw thunder and lightning where "fire appears at the end of spears"[25] and "there are flames on the top of halberds; seen from a distance, it seems as though candles are hanging in the air."[26] Others observed that the golden peak of a pagoda "emitted golden rays, scattering in all directions like shooting stars."[27] Others saw that at the two ends of the ridge of a roof, "the ornaments with the shape of legendary animals spit out fire."[28] On the basis of the vast number of historical records relating to this topic and the characteristics of Chinese architecture, the Portuguese missionary Gabriel de Magalhães believed Chinese buildings had lightning conductors. Magalhães was a Jesuit who was sent to India in 1636 where he taught philosophy in Goa; he was also proficient in mechanics. In 1640 he came to China and did missionary work. He finally settled down in Sichuan. The emperor Shunzhi 顺治 (ruled 1644–1661) held him in high esteem and bestowed upon him a church and money for his missionary work. After Shunzhi died, Magalhães received physical punishment twice because he was accused of bribery. His sentence was remitted because of a major earthquake. Afterwards he spent his latter years peacefully under the protection of Emperor Kangxi 康熙 (ruled 1662–1722). When Magalhães died, Emperor Kangxi wrote the epigraph on his gravestone and performed a solemn funeral for him. Magalhães finished two books in 1668: *Traitre des lettres et de la langue Chinoise* and *Les Douze excellences de la Chine*. The latter was translated into French and into English in 1688—French title: *Nouvelle relation de la Chine, contentant le description des particularités les plus remarquables de ce grand empire* (Paris, 1688); English title: *A New History of China, Containing a description of the most considerable particulars of that vast empire* (London, 1688, 4 volumes). These books became classic works for European understanding of China.

24 Chin: 雷火所及, 金石销熔, 而漆器不坏 Fang Yizhi, *Wuli Xiaoshi* 物理小识, vol. 2 (Ming dynasty).

25 Chin: 矛端生火 Han Shu 汉书, in: *Records of Five Elements*, vol. 96 (Beijing, 1962) p. 3924.

26 Chin: 戟锋有火光, 遥望如悬烛, Jin Shu, in: *Records of Five Elements*, vol. 27 (Beijing, 1974), p. 810.

27 Chin: 放金光, 若流星四散 *Jiaxingfu Zhi* 嘉兴府志, vol. 35, Xiangyi 祥异 (1879).

28 Song Lian, History of Yuan Dynasty, in: *Records of Five Elements*, vol. 51 (Beijing, 1976), p. 1101.

Fig. 3: Old Chinese characters for thunder and lightning. The first two lines are the word thunder as it can be found in oracle bones inscriptions. They show line lightning, raindrops, and a wheel to represent the sound of a thunder. In the third line, A is the character for lightning as it can be seen in inscriptions on bronze objects (tenth century B.C), B is the character for lightning used by Xu Shen in his dictionary Shuowenjiezi *(Han Dynasty), and C is the seal character for lightning. They show a cloud in the sky, raindrops, and line lightning.*

In *Les Douze excellences de la Chine* Magalhães wrote about Chinese architecture:

"The roofs of their buildings, which are built with lacquered tiles, are shining like the pane of plate glass. The corners of the roofs are aiming the sky and are formed like horns decorated with dragons which are highly venerated in the empire. This shape of the roofs is similar to the tents where the ancient Han lived. Every corner of the tents was fixed with a lance which lifts up the tent to the sky. This is now imitated by the stones and the tiles of the roof. The monsters, whose tongues stick out towards space, are traversed with metallic entrails which end up in the ground. That is why if a lightning strikes their flats or the palace it chooses the way offered by the tongues of the dragons and gets engulfed to the ground without having made something bad at all. It is well to be seen that through the wisdom of this people; they were able to unify beauty and utility by the fruits of their industry and it is sagacious by being all exquisite."[29]

29 Gabriel de Magalhães, *Nouvelle relation de la Chine* (Paris, 1688); quotation from: Claude Roy, *La Chine dans un miroir* (Lausanne, 1953), p. 47. English translation by Christoph Zeller.

Fig. 4: (A) Wooden pagoda built in the eleventh century, Ying county in Shanxi province.
(B) The top of the pagoda.

Magalhães lived in China for thirty-seven years and travelled to many places in China. He had extensive contacts with Chinese scholars and visited many palaces, temples, and pagodas by himself. His records ought to be accurate. However, I made enquiries in the field of contemporary archaeological studies in China about his writings, particularly to ascertain whether the iron bars reached the ground or not, and the result was negative. These writings originated in China and although they are not accurate, they were written 60–80 years before Benjamin Franklin developed his lightning rod theory. I wonder if they could have influenced the invention of the lightning rod.

An interesting incident was separately recorded by both local and central government, although its scientific value and significance was beyond the recorders' imagination. In the *History of the Ming Dynasty* 明史 there is the following account: One night in April 1512 in the Jiangxi province, there were tempestuous winds and heavy thunder and lightning. In the camp Xianju 仙居 in the county Yugan 余干 "there were lights like arrows, striking the flagpole, looking like a dragon and illuminating the whole countryside. The soldiers shook their flags and the fire on the top of the flags dispersed in all directions. From out of the top of their spears came a light like a star."[30] The *General Records of History and*

30 Chin: 有光如箭，坠旗杆上,俄如烛龙,光照四野。士卒撼其旗,飞上竿首,既而其火四散。枪首皆有光如星 Zhang Tingyu et al., *Ming Shi*, in: *Records of Five Elements*, vol. 29 (Beijing, 1974), p. 479.

Topography of Jiangxi 江西通志 records that: "The soldiers of the camp attacked it with their blunderbusses and the fire scattered."[31] Such a magnificent example of atmospheric electricity has rarely been seen in history. Whether the soldiers' nerves were set on edge by the noise of the thunder, or whether they became excited by the shine of the electric discharge at the top of the flagpoles, they even forgot their ancestors' belief in the gods Lei Gong 雷公 [god of thunder] and Dian Mu 电母 [goddess of lightning]; little did they suspect that their actions would lead to exclamations of admiration by scholars of later generations. Firing with their blunderbusses into the sky was not only daring, it also prefigured twentieth-century man's dispersal of thunder—firing missiles through thunderclouds to disperse them as is practised today.

 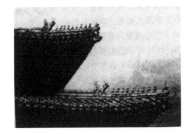

Fig. 5: Decorative animals at the two ends of the roof ridge of the Qianqing Palace in the Forbidden City, Beijing.

On Chinese Knowledge about Magnetism

Which magnetic phenomena did the ancient Chinese know about? Before the thirteenth century they understood that (a) natural lodestones attract iron filings and iron ingots, and that lodestones can be classified by the weight of the iron they can attract; (b) big metal ingots can also attract small lodestones and magnetic powder; (c) there can be a certain distance between the lodestone and the iron and they will still attract each other—there is no need for direct contact; (d) two lodestones both attract and repel each other; (e) iron that has already been attracted by a lodestone can attract other iron; (f) lodestones do not

31 Chin: 守寨士卒固发铳冲之, 其火四散 *Jiangxi Tongzhi* 江西通志, vol. 107, *Jixiang* 祥异 (1732).

129

attract copper, gold, tiles, or stone; (g) adhering metallic powder to non-magnetic substances will make them magnetic; (h) lodestones with certain shapes can indicate the direction of attraction; (i) the invention of the compass, the discovery of geomagnetic declination, and the use of the compass for marine navigation; (j) there is a geomagnetic dip; and (k) they analysed the function of magnetism using Qi and the principle of Yin and Yang. This knowledge was recorded by scholars of all dynasties and schools of thought and is found in various classical books. In the seventeenth century people already knew how to inhibit magnetism—magnetic action can be shut off with iron.[32]

Already in the Chunqiu Period 春秋 (770–481 B.C.) people knew that natural lodestones attract iron. The *Book of Master Guan* 管子 called the lodestone *Cishi* 慈石. The character *Ci* 慈 shows the love between mother and son. Lü Buwei's 呂 不韦 (?–235 B.C.) *Master Lu's Spring and Autumn Annals (Compendium of natural philosophy)* 呂氏春秋 says: "The lodestone calls the iron to itself, or attracts it."[33]

This chapter will not elaborate on the enormous quantity of records in classical books concerning knowledge about magnetism; rather, it will focus on several incidents which have a quite profound cultural meaning.

During the first years of the western Han Dynasty 西汉 (206 B.C.–A.D. 8) Liu An 刘安 (179–122 B.C.), the king of Huainan 淮南, and his thousands of followers contributed a great deal to the development of knowledge about magnetism. Liu An was the grandson of Liu Bang 刘邦 also known as the Emperor Han Gaozu 汉高祖, and the first son of the younger brother of Liu Heng (Emperor Wen of the Han 汉文帝刘恒). In 164 B.C. (the sixteenth year of Liu Heng's regency) Liu An succeeded his father as King of Huainan. In his younger years he liked to read books and play music, but was bad at riding and archery, which led him to become a philosopher and writer of the western Han Dynasty with an agile imagination. He treated the common people well and gained a high reputation in his country. He also liked the occult arts and his home was full of thousands of "guests" sponging off him 门客—many were occultists. Under his leadership, the *Nai Shu* 内书 was compiled, which is today called *The Book of the Prince of Huainan* 淮南鸿烈 or 淮南子, and the *Wai Shu* 外书, known today as *The Ten Thousand Infallible Arts of the Prince of Huainan* 淮南万毕术; together the two works are titled the *Book on Huainanzi* 淮南王书. *The Book of the Prince of Huainan* is a book written by masters on various topics, which mixes together Confucians, writers on legislation, and geomancers. In *The Ten Thousand*

32 Dai Nianzu, *A Series of Books*, p. 40.

33 Chin: 慈石召铁，或引之也, trans. J. Needham, *Science and Civilisation*, vol. 4, part 1, p. 232.

Infallible Arts of the Prince of Huainan much space is devoted to concocting pills for immortality, conjuring, occultism, and alchemy—and it contains much knowledge concerning magnetism. Liu An lived during the regency of the emperors Wen 文, Jing 景, and Wu 武. At the beginning of his regency Emperor Wu (ruled 140–87 B.C., grandson of Emperor Wen and nephew of Liu An) had no son and heir to the throne. Liu An, seduced by the seditious talk of his "guests", started to plot a rebellion against him. He cast weapons in his residence, accumulated money, bribed various other kings and his beloved daughter to the capital Chang'an 长安, collaborated with upper class officials, and spied out the political circumstances. Fearing that there could be a leakage of information about his secret plot of rebellion, he used a cunning trick to force his son, who was already married to the dowager empress' granddaughter, to divorce. In 122 B.C. the plot backfired; Liu An was arrested and taken to prison where he ultimately committed suicide. The number of people involved in this case was in the region of several thousand.[34] Among them were a number of gifted diviners, alchemists, and occultists who were either killed, banished, or had to flee the country. It is regrettable that a group with such extensive knowledge was dispersed in this manner.

There are many passages in *The Book of the Prince of Huainan* where one reads about the action of magnetism:

"If you think that because the lodestone can attract iron you can also make it attract pieces of pottery, then you will find yourself mistaken. Things cannot be judged merely in terms of weight. Fire is obtained from the sun by the burning mirror, the lodestone attracts iron, crabs spoil lacquer, the mallow turns its face to the sun. Such effects are very hard to understand."[35]

"Some effects are more pronounced at short range and others at long range. Rice grows in water but not in running water. The purple fungus grows on mountains but not in stony valleys. The lodestone can attract iron but has no effect on copper."

34 Sima Qian, *Shi Ji*, vol. 118, *Huainan Wang Zhuan* (Beijing, 1959), p. 3082, or: Ban Gu, *Han Shu*, vol. 44, *Huainan Wang Zhuan* vol. 44 (Beijing, 1962), p. 2145.

35 Chin: 若以慈石之能连铁也，而求其引瓦则难矣。物固不可以轻重论之。夫燧之取火日,慈石之引铁, 蟹之败漆，葵之响日，虽有明智，弗能然也。故耳目之察，不足以分物理；心意之论，不足以定是非 Liu An, *Huananzi*, chapter 6 *Lan Ming Xun* 览冥训, trans. J. Needham, *Science and Civilisation*, vol. 4, part 1, p. 232.

"The lodestone flies upwards."[36] This observation of Liu An's is different from many others. Obviously, when a heavier iron ingot was uplifted, a smaller lodestone or small pieces of magnetite jumped. Perhaps the records quoted above were reports that Liu An and his followers inherited from their forefathers. The following one, however, contained in the *Ten Thousand Infallible Arts of the Prince of Huainan* was their own discovery. It is a description about magnetic attraction and repulsion: "The lodestone lifts chess-men." "The lodestone pushes the chess-man away."[37]

These two sentences demonstrate the meaning of magnetic polarity. The ends of magnet bars with different polarity attract and ends with the same polarity repel, as is well known today. There is also a description about the polarity and directivity of magnets: "Put a lodestone into a well and lost persons will find back home by themselves".[38] Gao You 高诱 (lived in the Han Period, date of birth and death unknown) commented on this sentence: "Put into a well" means "hang into a room".[39] "Well" should be understood as a low place where people can take shelter from wind. "Lost person" means someone who left the house and lost their bearings. The lodestone here would be a long magnet bar. Therefore, hanging a lodestone in a "well" or in a room is merely to avoid the influence of the wind blowing in the direction of the magnet bar; the lost person is able to find the right direction and can finally return home. It can be seen that people's knowledge in the period of the Han Dynasty was a mixture of science and conjuring; maybe the conjuring part was the major portion of it. This record also suggests that originally, it was magic that led to the discovery of the compass' deflexion.

A record about a man-made lodestone: "The blood of a cock is rubbed up with needle-iron [filings] and pounded to mix. [Then when] lodestone chess-men are set up on the board, they will move of themselves and bump against each other."[40] This record has annotations by Gao You of the Han Dynasty

36 Chin: 磁石上飞 Liu An, *Huainanzi*, chapter 4 *Di Xing Xun* 墜形训 , trans. J. Needham, *Science and Civilisation*, vol. 4 part 1, p. 233.

37 Chin: 磁石提棋 磁石拒棋 Liu An, *Huainan Wanbishu* 淮南万毕术 The Ten Thousand Infallible Arts of the Prince of Huai-Nan) excerpts from: Li Fang 李昉, *Tai Ping Yu Lan* 太平御览 chapters 736 and 988; see also J. Needham, *Science and Civilisation*, vol. 4 part 1, p. 316.

38 Chin: 磁石悬入井, 亡人自归 Liu An, *Huainan Wanbishu* 淮南万毕术 (*Ten Thousand Infallible Arts*), excerpts from: Li Fang 李昉, *Tai Ping Yu Lan* 太平御览, chapter 988.

39 Chin: 悬室中 Liu An, *Huainan Wanbishu* 淮南万毕术 (*Ten Thousand Infallible Arts*), excerpts from: Li Fang 李昉, *Tai Ping Yu Lan* 太平御览, chapter 736.

40 Chin: 取鸡血, 杂磨针铁, 和磁石, 用涂棋头, 曝干之, 置局上, 即自相抵击也 Liu An, *Huainan*

*Fig. 6: Wooden figurines playing chess on a chessboard.
Excavated in the 1970s from tomb no. 48, Han Dynasty,
in Wuwei county, Gansu province.*

and is also recorded in works such as *Index of Historical Records* by Sima Zhen 司马贞 (Tang Dynasty, date of birth and death unknown),[41] *Amended Text of Historical Records* 史记正义 by Zhang Shoujie 张守节 (Tang Dynasty, date of birth and death unknown),[42] and *Tai-Ping Reign-Period Imperial Encyclopaedia* 太平御览, edited by Li Fang 李昉 (Song Dynasty, 925–996).[43] The entries in these books differ slightly for a few characters are not completely equivalent. During the Ming Dynasty, Fang Yizhi 方以智 (1611–1671) a scholar of natural science, quoted the relevant characters in his book.[44]

As can be seen, Chinese scholars of all dynasties were greatly interested in man-made magnets and furthermore, they all took this to be a mystical technique. The production process was as follows: When making steel needles the point of the needle was ground with a file; naturally, the steel powder which falls to the floor is magnetic. The blood of chickens is a mixture with adhesive properties. They used the blood as a binding agent for the metal powder and pasted it onto the two ends of rectangular chess-men. These became positively

Wanbishu, version edited by Wang Renjun 王仁俊, in: *Yuhan shanfang ji yishu* (玉函山房辑佚书), trans. J. Needham, *Science and Civilisation*, vol. 4, part 1, p. 316.

41 Same as fn. 33, p. 1390.

42 Same as fn. 33, p. 463.

43 Same as fn. 37 and 38.

44 Fang Yizhi, *Wuli Xiaoshi* 物理小识, chapter 12.

Fig. 7: Painting on silk of a woman playing Go. From a Tang Dynasty tomb in Asitana, Xinjiang province.

charged at one end and negatively charged at the other. Of course, these chess-men either repelled or attracted one other on the chessboard. This kind of chess was also called "the fighting chess-men"[45] (Figs. 6, 7).

According to the historical records, not only Liu An and his followers played "the fighting chess-men", but also the magician Luan Da 栾大 (Han Dynasty, date of birth and death unknown) demonstrated the technique of "the fighting chess-men" to entertain Emperor Wu of Han (156–87 B.C.), who then often called for Luan Da to see the chess-men fighting by themselves, which gave him much pleasure. During the southern Song Dynasty (1127–1279), a man who had been influenced by *The Ten Thousand Infallible Arts of the Prince of Huainan* produced magnetic ladles (which were made of gourds) and performed "the fighting ladles" at a marketplace and took money for it. Soon after, another man accused him of "deluding the masses with sorcery" and the performer was sent to jail by the local authorities, where they poured pigs' blood over him (it was believed that the blood of pigs could wipe out demons). The performer finally came out with the truth, whereupon he was released.[46] In this period people no longer used a mixture of chicken blood but glue for the binder. This method of

45 Chin: 斗棋; same as fn. 41.

46 Zhang Zhou 庄绰, *Ji Lei Pian* 鸡肋篇, vol. 2.

134

producing magnets exhibits some similarities to the coated tape that was used for tape-recorders from the second half of the last century.

Historically, the specific properties of magnetism were often used for magic or conjuring tricks. For example, by using three of the magnetic ladles mentioned above one could perform the "fight of the calabashes",[47] and by gluing magnetic powder onto the wooden figure of a dog and hiding a magnet up your sleeve one could "send the dog to fetch".[48] The conjuring tricks called "the wooden horse runs by itself, the paper figure dances by itself"[49] were also tricks using the technique of "at one place steel is used and at another place magnets are used".[50] Another magic trick was "putting iron in one's mouth and a knife cannot hurt the body".[51]

Like Liu An and his followers, a handful of magicians had greater and more profound knowledge than other people; they pretended it was magic but after revealing the truth, people understood the principle behind it. The scholar Xie Zaihang 谢在杭 (1573–1619) of the Ming Dynasty (1368–1644) recorded such an event:

"All these magical tricks, they are often false and absurd. In Jinling [金陵 today's Nanjing] there was a medicine seller who used a statue of a Bodhisattva to ask his patients for symptoms. He gave the medicine to his patients through the hand of the statue; if the medicine didn't fall down and stayed in the hand of the Bodhisattva then the patients took it. He earned a lot of money each day. A young man saw this and wanted to know how the seller was doing this trick. He waited until the patients were gone and invited the seller for a drink. Afterwards they left the tavern without paying but the innkeeper didn't take any notice. They repeated this three times. The medicine seller asked for the reason why they could leave without paying. The young man answered: This is just an easy trick and I would be very happy if we could exchange our knowledge. The seller said: That's nothing special. The hand of the wooden statue is a magnet and there are iron filings adhering to the medicine. The young man said: I already paid before you arrived. Both men laughed loudly."[52]

47 Chin: 葫芦相打 Cheng Yuanjing 陈元靓, *Guide through the Forest of Affairs* 事林广记 *Gui* 癸 *Collection*, vol. 12, The Supernatural Beings and Necromancies 神仙幻术 (Song Dynasty).

48 Chin: 唤狗子走; same as fn. 47.

49 Chin: 木马自走, 纸人自舞; same as fn. 44.

50 Chin: 一处用铁浆, 一处用磁吸也; same as fn. 44.

51 Chin: 嘬铁于口, 刀刃不能伤其身 Tao Zongyi 陶宗仪, *Talks (at South Village) while the Plough Is Resting* 南村辍耕录, vol. 23.

52 Chin: 凡幻戏之术, 多系伪妄。金陵人有卖药者, 车载大士像问病。将药从大士手中过, 有留于手不

And certainly the readers laughed too after reading this story.

The lodestone was widely used by the ancient Chinese. When the first emperor of Qin 秦始皇 (ruled 246–210 B.C.) built the Epang palace, it is recorded in historical books that the entrance was built with lodestones to prevent people with knives and swords entering.[53] The high-ranking officer Ma Long 马隆 (date of birth and death unknown) of the western Jin Dynasty (265–317 B.C.) fought against an army of the Qiang 羌 in north-western China. He built up great piles of lodestones in a narrow lane and then lured the enemy into this trap where they were immobilised.[54] In the manufacture of white porcelain, magnets were used to stir the liquid glaze. Iron material was attracted and removed; thus spotlessly white porcelain was guaranteed.[55] For alchemists, the lodestone was an indispensable material. They selected lodestones that would "attract iron needles", the more the better.[56] Also, in Chinese traditional medicine the lodestone was in widespread use. Amongst others, physicians produced substances similar to today's magnetic water, they used magnetic pillows to cure insomnia, and employed smooth and small lodestones to extract small iron objects that had been swallowed by children or adults.[57]

The Compass and
Magnetic Declination

The ancient form of the compass is called *sinan* 司南 [south-pointer]; it was made out of a natural lodestone and had the shape of a spoon. Records relating to this form of compass can be found in the *Book of Master Han Fei* 韩非子, a book from the Warring States Period (480–222 B.C), and the *Discourses Weighed in the Balance* 论衡 by Wang Chong. The *Book of Master Han Fei* states:

下者，则许人服之。日获千钱。有少年子傍观，欲得其术，俟人散后，邀饮酒家。不付酒钱，饮毕竟出，酒家各不见也。如是者三。卖药者扣其法。曰：'此小术耳，君许相易，幸甚'。卖药者曰：'我无它，大木偶手是磁石，药有铁屑则粘矣。'少年曰：'我更无它，不过先以钱付酒家，约客到，绝不相问耳。'彼此大笑而罢。，Xie Zaihang 谢在杭, *Wu Za Zu* 五杂俎, chapter 6.

53 Anonymous, *San Fu Huang Tu* 三辅黄图, chapter 1, edition in the Sikuquanshu.

54 *Jin Shu* 晋书, vol. 27, *Records of Five Elements* (Beijing, 1974), p. 1555.

55 Zhu Yan 朱琰, *Tao Shuo* 陶说 *The Theory of Pottery and Porcelain*, vol. 3, Manufacturing Methods (Tianjin, 1988), pp. 32–33.

56 Chu Ze 楚泽, *The Records in the Rock Chamber: A Taiqing Scripture*, vol. 1 太清石壁记 (Sui Dynasty).

57 Dai Nianzu, *A Series of Books*, pp. 119–124

"Subjects encroach upon the ruler and infringe his prerogatives like creeping dunes and piled-up slopes. This makes the prince to forget his position and to confuse west and east until he really does not know where he stands. So the ancient kings set up a south-pointer, in order to distinguish between the directions of dawn and sunset."[58]

Here "directions of dawn and sunset" means the directions of east and west. The *Discourses Weighed in the Balance* says:

"As for the chhü-yi [the indicator-plant] it is probable that there was never any such thing, and that it is just a fable. Or even if there was such a herb, it was probably only a fable that it had the faculty of pointing [at people]. Or even if it could point, it was probably the nature of that herb to move when it felt the presence of men. Ancient people, being rather simple-minded, probably thought that it was pointing when they really only saw it moving. And so they imagined that it pointed to deceitful persons.

But when the south-controlling spoon is thrown upon the ground, it comes to rest pointing at the south.

So also certain "maggots which arise from fish and meat" 鱼肉虫, placed on the ground, move northward. This is the nature of these maggots. If indeed the "indicator-plant" moved or pointed, that also was its nature given to it by Heaven."[59]

That which is referred to here as *chhü-yi* 屈轶之草 is a legendary plant. The so-called "maggots which arise from fish and meat" 鱼肉之虫 were probably the larvae of an insect with strong phototaxis. Wang Chong mentioned them together with the original "south-controlling spoon" 司南之杓 for the purpose of showing that the characteristic of pointing towards something was their natural character. The "spoon" 杓 refers to the shape of the "south-pointer"; the "rest" 柢 is the root of a tree, which functioned as spoon handle. *Di* 地 [earth, ground] means *dipan* 地盘 [earth-plate], a part of a tray used for divination called *shipan* 式盘 [diviner's board], which consisted of two trays: the outer one was called *dipan* 地盘 [earth-plate], and the one in the middle was called *tianpan* 天盘 [heaven-plate]. The earth-plate was used together with the *sinan* 司南 [south-controller], and the points of the compass were marked on it. In

58 Chin: 夫人臣之侵其主也，如地形焉，即渐以往，使人主失端，东西易面，而不自知。故先王主司南以端朝夕 *Hanfeizi* 韩非子, chapter 6 有度, trans. J. Needham, p. 270.

59 故夫屈轶之草，或时无有，而空言生；或时实有，而虚言能指。……古者质朴，见草之动，则言能指。能指，则言指佞人。司南之杓，投之于地，其柢指南。鱼肉之虫，集地北行，夫虫之性然也。今草能指，亦天性也 Wang Chong, *Discourses* 论衡, vol. 17, chapter 52, p. 270, trans. J. Needham, pp. 261–262.

Fig. 8: Lodestone spoon restored
by Wang Zhenduo.

Fig. 9: Lodestone spoon sketched
by the author.

the 1940s, the naturalist Wang Zhenduo 王振铎 (1913–1992) made numerous text researches on the south-controller, and also reconstructed the lodestone spoon[60] (Fig. 8). The south-controller (or south-pointer) he reconstructed lost the function of the lodestone spoon of pointing south for a long period, because too much attention was paid to art. In fact, it is an extremely simple lodestone spoon; its form is similar to a spoon with a simple, long and tapered handle (Fig. 9). Before the south-pointing needle was invented, from the Han Dynasty up to the Tang Dynasty (206 B.C.–A.D. 907) the south-pointer was produced and used extensively, especially by magicians for divination and forecasting family matters, human affairs, government and national affairs.[61]

In the process of the development of the "south-pointer" into today's compass we should ascertain the following: (a) When did the magnetic needle appear? (b) How did the disk marked with the points of the compass change from the earth-plate used for divination into today's compass?

Alchemists of the Sui Dynasty (581–618) had already discovered that ordinary iron needles could be magnetised by magnetic induction. The book *Taiqing*

60 Wang Zhenduo 王振铎, *Discovery and Application of Magnetic Phenomena in China. Collection of Science, Technology and Archaeology* (Beijing, 1989), pp. 50–218.

61 Dai Nianzu, *Notes on Discovery and Application of Magnetic Phenomena in China* (Taiyuan, 2004), pp. 82–111.

Shibiji says that "Only a lodestone which can attract five or six needles is a good one."[62] During the Xian Qing era 显庆 (656–661) of Emperor Gaozong of Tang 唐高宗, the medical scholar Su Gong 苏恭 (date of birth and death unknown) also discovered that a lodestone of good quality could attract ten needles.[63] This indicates that it will not be much longer before south-pointing needles are invented. Approximately two hundred years later, in 843, Duan Chengshi 段成式 (803–863) and some of his friends visited a temple in Chang'an (today's Xi'an). Among the poetry and lyrics which he wrote down in his travel notes are the following remarks: "A soldier carries magnetic needles and stones", "I saw an alms bowl and put needles into it."[64] These are the first records about needles pointing toward the south; perhaps the south-pointing needle that floats on water (the water compass) already existed.

At the beginning of the eleventh century, there were at least three works which described both the compass and magnetic declination. One is the *The General Records on the Tenets of Tombs* 茔原总录, which the astronomer and geomancer Yang Weide 杨维德 (date of birth and death unknown; he was a low-ranking government official for astronomy at the imperial court) finished writing in 1041. Almost at the same time as Yang Weide, the geomancer Wang Ji 王伋 (about 988–1058) wrote his *Zhenfa Shi* 针法诗 [poem on the methods of the needle], which contains an account of geomagnetic declination. From 1040–1044, the military scientist and strategist Zeng Gongliang 曾公亮 (999–1078) wrote his book *Collection of the Most Important Military Techniques* [Wu Jing Zongyao 武经总要]. The naturalist Shen Kuo 沈括 (1031–1095) finished his *Dream Pool Essays* 梦溪笔谈 before 1090. There are so many books related to this topic that were published after these that to summarise them is beyond the scope of this brief chapter.

Yang Weide wrote:

"When researchers want to find out the proper four directions without deviations, they should take a needle which points to the directions Bing and Wu. Make sure that it is in the correct position in the middle of the two directions and you get the correct directions. [...] Bing-Wu is indistinct but gives a general

62 Chin: 磁石但取引针相连五六者为良 Chu Ze 楚泽, *The Records in the Rock Chamber*, vol. 1 (Sui Dynasty).

63 Su Gong 苏恭, *Notes on Pharmacopoeia of the Tang Dynasty*, in: Tang Shenwei 唐慎微, *Reorganized Pharmacopoeia*, vol. 4 *Yu Shi Bu* 玉石部 (Song Dynasty).

64 Chin: 勇带磁针石, 遇钵更投针 Duan Chengshi 段成式, *Miscellany of the Yu-Yang Mountain, Continuative Collectanea*, vol. 5, Records on the Temples (Beijing, 1981), pp. 246–253.

idea. To pinpoint it more precisely, fix the needle on a cord, let it hang down and the right angle will be displayed."[65]

From these words we can deduce that already at that time south-pointing needles and disks marked with the directions existed, and that when the two are combined the result is a compass; furthermore, they had knowledge about geomantic declination. In Wang Ji's "Poem on the Magnetic Needle" he says:

"Between Hsü and Wei points clearly the needle's part. [But] to the south there is Chang, which 'rides upon all three' [The kua] Khan and Li stand due north and south, though people cannot recognise [their subtleties].

And if there is the slightest mistake there will be no correct predictions".[66]

This poem clearly describes geomantic declination. What is more, because words like *Hsü* 虚, *Wei* 危, *Khan* 坎, *Li* 离 stand for certain directions, the compass undoubtedly already existed.

Zeng Gongliang wrote:

"When troops encountered gloomy weather or dark nights, and the directions of space could not be distinguished, they let an old horse go on before to lead them, or else they made use of the south-pointing carriage, or the south-pointing fish to identify the directions. Now the carriage method has not been handed down, but in the fish method a thin leaf of iron is cut into the shape of a fish two inches long and half an inch broad, having a pointed head and tail. This is then heated in charcoal fire, and when it has become thoroughly red-hot, it is taken out by the head with iron tongs and placed so that its tail points due north (lit. in the Tzu direction). In this position it is quenched with water in a basin, so that its tail is submerged for several tenths of an inch. It is then kept in a tightly closed box. To use it, a small bowl filled with water is set up in a windless place, and the fish is laid as flat as possible upon the water-surface so that it floats, whereupon its head will point south (lit. in the Wu direction)".[67]

65 Chin: 客主取的, 宜匡四正以无差, 当取丙午针, 于其正处, 中而格之, 取方直之正也。……丙午约而取于大概, 若究详密, 宜曲表垂绳 Yang Weide 杨维德, *Ying Yuan Zongmu* 茔原总录, vol. 1 *Zhu Shan Lun* 主山论.

66 Chin: 虚危之间针路明, 南方张度上三乘。坎离正位人不识, 差却毫厘断不灵。, Anonymous, recorded in *Master Kuan's Geomantic Instructor, The Chapter of the Explained Middle*, see: *Imperial Encyclopedia*, vol. 655, ed. Chen Menglei 陈梦雷 et al. (Qing Dynasty).

67 Chin: 若遇天景瞳霾, 夜色暝黑, 又不能辨方向, 则当纵老马前行, 令识道路, 或出指南车及指南鱼, 以辨所向。指南车世法不传。鱼法以薄铁叶剪裁, 长二寸, 阔五分, 首尾锐如鱼形, 置炭火中烧之, 候通赤, 以铁钳钳鱼首出火, 以尾正对子位, 蘸水盆中。没尾数分则止。以密器收之。用时置水碗于无风处, 平放鱼在水面令浮, 其首常南向午也。Zeng Gongliang, *Collection of the Most Important Military Techniques* (武经总要前集), vol. 15, trans. J. Needham, p. 252.

Thus, by heating up a fish-shaped iron leaf and quenching it afterwards, because of the geomagnetic field the ferromagnetic domain arranged from chaos to order forms an iron leaf with magnetic characteristics. It is quenched while "its tail points due north", 以尾正对子位; this method of inserting the fish into water at a slant exactly uses the geomagnetic dip angle. This kind of magnetisation is relatively weak; however, in this way one can induct magnetic iron leaves even without having a lodestone. In times of war, this may have been very useful.

Shen Kuo wrote:

"Magicians rub the point of a needle with the lodestone; then it is able to point to the south. But it always inclines slightly to the east, and does not point directly to the south."[68]

"When the point of a needle is rubbed with the lodestone, then the sharp end always points south, but some needles point to the north. I suppose that the natures of the stones are not all alike. Just so, at the summer solstice the deer shed their horns, and the winter solstice the elks do so. Since the south and the north are two opposites, there must be a fundamental difference between them. This has not yet been investigated deeply enough."[69]

Shen Kuo is clearly referring to geomagnetic declination in combination with the method of induction that causes an iron needle to become magnetised. Actually, this kind of magnetic induction was discovered by an alchemist and scholar of herbal medicine who lived at the time of the Sui Dynasty, 400–500 years before Shen Kuo.

We have found out about the south-pointing needle, but how did the plate of the Chinese compass evolve? As mentioned above, a plate showing the directions [fangweipan 方位盘] developed from the diviner's board [shipan 式盘], which was used for divination (Fig. 10). When the south-pointing needle was developed, the plate was naturally replaced by the earth plate [dipan 地盘]. From archaeological discoveries and according to records in historical documents, the earth plate was first a rectangle, but later changed to a round form and, along with the needs of professional geomancers, the graduation marks became increasingly complex. In the meantime, the compass used for maritime naviga-

68 Chin: 方家以磁石磨针锋, 则能指南, 然常微偏东, 不全南也。Shen Kuo, *Dream Pool Essays*, vol. 24, trans. J. Needham, p. 249.

69 Chin: 以磁石磨针锋, 则锐处常指南, 亦有指北者。恐石性亦不同, 如夏至鹿角解, 冬至麋角解, 南北相反, 理应有异, 未深考耳。Shen Kuo, *Dream Pool Essays, Supplement to the Essays*, vol. 3, Opinions of Medicine, trans. J. Needham, p. 250.

Fig. 10: Wooden board used for Liuren divination, unearthed 1972 from Han Dynasty tomb no. 61 in Mojuzi, city of Wuwei, Gansu province.

tion still retained simple graduated markings showing the points of the compass. There were many kinds of compasses, for example, water compasses, dry compasses, wooden and porcelain compasses. In the military book *Huqian Jing* 虎钤经 [Tiger Seal Manual] by Xu Dong 许洞 (980–1011), written in the early Song Dynasty, are pictures of a square and a circular compass (Fig. 11). The book *The Nine-Heaven Mysterious Girl Blue-Bag Sea Angle Manual*, written during the southern Song Dynasty (1127–1279), contains a picture of a quite com-

Fig. 11: Square compass (A) and circular compass (B) drawn by Xu Dong in the book Huqian Jing.

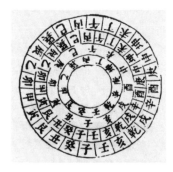

Fig. 12: Picture of a water compass from the book The Nine-Heaven Mysterious Girl Blue-Bag Sea Angle Manual 九天玄女青囊海角经.

142

Fig. 13: Porcelain compass used for navigation. A. Porcelain bowl unearthed 1966 from tombs of the Jin and Yuan dynasties, city of Dalian, district Ganjingzi. B. Sketch of a compass in the form of a bowl. C. Porcelain tray of the Ming Dynasty with the picture of the Eight Trigrams stored in the Palace Museum in Beijing and a sketch of the compass at its centre.

plex compass for geomantic purposes[70] (Fig. 12). Many porcelain compasses used by mariners have come to light in archaeological excavations (Fig. 13). In 1988, a 22.2 cm-tall figurine of a geomancer placed in a grave was unearthed from a grave of the southern Song Dynasty in Linchuang county (Jiangxi province). In his right hand the figure holds a compass in front of the left side of his chest. The occupant of the tomb is Zhu Jinan 朱济南 (unkown–ca. 1197)[71], a Song Dynasty military officer of the city Shao Wu 邵武. This proves that both dry and water compasses were first produced in China (Figs. 15, 16, 17). The compass of this porcelain figurine is obviously mounted on a magnetic needle, which functions as a fulcrum.

After the compass was developed, it was first used by diviners, but soon—end of the eleventh century, beginning of the twelfth—it was also used in navigation. The very first records about its use by mariners are from Zhu Yu 朱彧. He finished writing his book *Pingzhou Table-Talk* 萍洲可谈 in 1119. In this book he describes what his father Zhu Fu 朱服 saw and heard when he was the chief official of the province Guangzhou from 1095 to 1102:

"According to the government regulations concerning sea-going ships, the

70 Anonymous, *The Nine-Heaven Mysterious Girl Blue-Bag Sea Angle Manual* 九天玄女青囊海角经, recorded in: *Master Kuan's Geomantic Instructor, The Chapter of the Explained Middle.* See: *Imperial Encyclopedia*, ed. Chen Menglei 陈梦雷 et al.

71 Chen Dingrong 陈定荣 and Xu Jianchang 徐建昌, The tomb of Song Dynasty in Linchuan country of the Jiangxi province. *Archaeology* 4 (1988): 329.

larger ones can carry several hundred men and the smaller ones may have more than a hundred men on board. One of the most important merchants is chosen to be the leader, another is deputy leader and a third is Business manager. The Superintendent of Merchant Shipping gives them an officially sealed red certificate permitting them to use the light bamboo for punishing their company when necessary. Should anyone die at sea, his property becomes forfeit to the government [...] The ships' pilots are acquainted with the configuration of the coasts; at night they steer by the stars, and in the day-time by the sun. In dark weather they look at the south-pointing needle. They also use a line a hundred feet long with a hook at the end, which they let down to take samples of mud from the sea-bottom; by its (appearance and) smell they can determine their whereabouts."[72]

This record about a compass being used in navigation was written around one hundred years before the first description of a compass in Europe.[73] A short time later, a member of the royal clan Zhao Rukuo 赵汝适 (date of birth and death unknown) wrote in his book *Records of Foreign Peoples* 诸藩志:

"To the east (of Hainan Island) are the 'Thousand-Li-Sandbanks' and the 'Myriad-Li-Rocks', and (beyond them) is the boundless ocean, where the sea and sky blend their colours, and the passing ships sail only by means of the south-pointing needle. This has to be watched closely by day and night, for life or death depends on the slightest fraction of an error."[74]

Zhao Rukuo was an official at the overseas trade office in Fujian in 1127. He wrote this book during this time, which describes the situation of China's coastal trade relations. It should be noted that all the ships mentioned in this book are Chinese.

There are a vast number of records concerning maritime navigation and the compass up to the time of Zheng He 郑和 (1371–1435), the seafarer. Zhang He commanded huge fleets with up to twenty-seven thousand people, embarked on seven ocean-going voyages, and even reached the east coast of Africa. This is common knowledge today.

72 Chin: 甲令, 海舶大者数百人, 小者百余人, 以巨商为纲首, 副纲首, 杂事。市舶司给朱记, 许用笞治其徒。有死亡者籍其财。……舟师识地理, 夜则观星, 昼则观日, 阴晦观指南针, 或以十丈绳钩取海底泥嗅之, 便知所至。Zhu Yu 朱彧, *Pingzhou Table-Talk* 萍州可谈, vol. 2 (Song Dynasty), trans. J. Needham, p. 279.

73 Ibid.

74 Chin: 东则千里长河, 万里石床, 渺茫无际, 天水一色。舟舶来往, 惟以指南针为则, 昼夜守视唯谨, 毫厘之差, 生死系矣。Zhao Rukuo 赵汝适, *Records of Foreign Peoples* 诸藩志, vol. 2 (Song Dynasty), trans. J. Needham, p. 284.

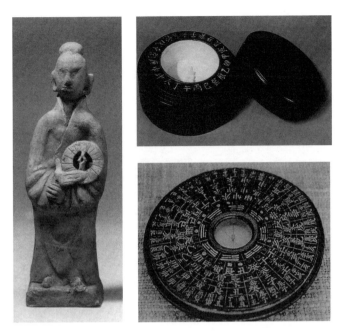

Fig. 14: Figurine of a geomancer unearthed 1988 from graves of the southern Song Dynasty in Linchuan county, Jianxi province.
Fig. 15: Water compass of the Ming Dynasty, Museum of Chinese History in Beijing.
Fig. 16: Geomancer's compass, Qing Dynasty, Museum of Chinese History in Beijing.

For a long time, the majority of European historians looked at history from a contemporary point of view. They thought that these ships couldn't possibly have been Chinese ships and therefore, the compass does not originate from China, but is "a western invention".[75] However, they were unable to find any European historical documents of these periods which mentioned a compass. Naturally, once the compass had gone on board, it spread around the world at the speed of the ships.

75 R.J. Forbes, *Man the Maker. A History of Technology and Engineering* (New York, 1950), pp. 101, 108, 132.

145

Fig. 17: Picture from the book Shu Jing Tu Shuo 书经图说*, named Taibao Xiang Zhai Tu* 太保相宅图*. In this picture you can see a man scrutinising his compass.*

The Culture of Electromagnetism

Ancient Chinese knowledge about electromagnetism includes the origin and development of the compass. This invention has an extremely complex cultural background. All kinds of people, elements of society, and schools of thought contributed to it. In the beginning the south-pointer and the diviner's board were related to the soothsayers 日者 of the Qin and Han Period, who were referred to afterwards as "masters of esoterica" 方士 or magicians 术士. They looked up to the sky and down to earth, they read the future from the clouds and diagnosed a disease from the patient's appearance, practised glyphomancy (fortune-telling by analysing the parts of Chinese characters) and listened to voices. From this they conjectured about the fate of the state, the emperor, and even common people. Their divinatory activities extended to the highest echelons of the nation's government and military. Obviously, the soothsayers' knowledge of nature was better than that of ordinary people.

"Masters": The masters were a huge army; there was a coming and going in the corridors of the imperial palace, and they made a great noise at the market. Following the changing dynasties, the soothsayers of the old days split up into various professions. Some cast horoscopes or forecast the fate of a person by

146

their physiognomy, others practiced divination, magic arts, or geomancy (using methods of feng shui for the architecture of houses and graves), for example. Others were engaged in the art of healing or shamanism. In general, people who did not embrace Confucianism but had profound knowledge of certain kinds of sorcery were all called "masters". Those among them, who dealt in the art of becoming immortal, or concocting drinks or pills for longevity or immortality, were called "masters of esoterica" 方士. Those who practised divination, physiognomy, or geomancy were called "Masters of the Yin and Yang" 阴阳家, and to a certain extent they participated in the discovery of electromagnetism. Luan Da, who gave a performance of the fighting chess-men for Emperor Han Wudi, was a famous master of esoterica and he was often invited to the imperial court. Among the thousands of guests of the Prince of Huainan, Liu An, a considerable number were masters with certain kinds of specialist knowledge. People who used magnetic games and magnetic conjuring tricks to cheat and obtain money were also masters with a profound knowledge of static electricity. During the Tang and the Song dynasties geomancers made an outstanding contribution to the development of the study of magnetism—they were the "midwives" at the birth of the compass. The porcelain figurine holding a compass from Jiangxi province mentioned above has the lettering "Zhang, the celestial being" 张仙人 . He was a famous geomancer of that region, and perhaps even an early inventor of the compass. The discovery of magnetic declination was also the geomancers' contribution. Last but not least, they bequeathed a body of geomantic writings on how to use the compass.

Taoists: Among the guests of Liu An there were many Taoists. They made a huge contribution to the study of electromagnetism in the early phase. Tao Hongjing 陶弘景 (456–536) of the Xiaoliang Dynasty (502–559) was a physician as well as a Taoist. Yu Fan 虞翻 (164–233) of the later Han Dynasty, and Tan Qiao 谭峭 lived in the tenth century of the Southern Tang Dynasty (937–975) were Taoists. Xu Dong, Chen Xianwei 陈显微 (date of birth and death unknown), Yu Yan 俞琰 (lived in the thirteenth century) were all hermits who lived in the mountains and were also probably Taoists. The man named Shen Shang Ren 昇上人, who travelled with Duan Chengshi to Chang'an, was also a Taoist.

"The lodestone is free of selfishness. You can see his great power."[76] This is a famous dictum of the Taoists.

76 Chin: 磁石无我, 能见大力 *The Book of Master Guanyin* 关尹, *Chapter Six Daggers*, (Jin Dynasty or Tang Dynasty).

Physicians: Lodestones, amber and the hawksbill turtle, all three were indispensable medicinal ingredients in traditional Chinese medicine. Physicians had to know how to tell whether these substances were genuine or not to guarantee that the medicine would have the desired effect. Therefore, knowledge about static electricity and static magnetism became common knowledge for physicians.

In addition, there were also members of the military like Zeng Gongliang, the author of the *Collection of the Most Important Military Techniques* [Wu Jing Zongyao 武经总要]. Army officers were the first to observe the phenomenon that electricity discharges from sharp metallic objects. Seafarers made the experience that magnetic declination is not the same everywhere.

Potters and weavers: Potters manufactured porcelain compasses, and weavers discovered that rubbing silk clothes leads to a light flash that discharges with a sound. Furthermore, there were many Confucianists, such as Zhang Hua 张华, Duan Chengshi, and Shen Kuo, who conducted experiments on electricity and lightning and put this down in their writings or recorded the information they gained about these phenomena. Without their records, the history of electromagnetism in ancient times would lose much of its splendour.

Not to be forgotten is also the part that Chinese philosophy played: the Taoist vigour theory and the concepts of Yin and Yang helped to explicate the phenomenon of electromagnetism. The different Qi of Yin and Yang was employed as a satisfying explanation for electric and magnetic attraction and repulsion and the cause of thunder and lightning, and this influenced the development of knowledge about electromagnetism in ancient times.

Finally, I want to talk about how the Chinese used their knowledge about electromagnetism in philosophy, and how they visualised the action of tides and celestial bodies. In the seventeenth century, Jiexuan 揭暄, a student of Fang Yizhi argued: "The relationship of the moon and water is like magnetic attraction, like amber picks up mustard seeds."[77] This idea was expanded by You Yi 游艺, a student of Xiong Mingyu 熊明遇 (1579–1649), who drew the illustration 两月对摄潮汐图[78] (Fig. 18). In this picture, there is a "real moon" 实月, a "false moon" 气月, a "correct attraction" 正吸, and an "opposing attraction" 反吸, as well as curving lines. This looks very similar to a picture describing the attraction force of a magnet bar. Through this they attempted to explain the phenomenon of tides.

77 Chin: 月与水, 如磁之吸引, 珀之拾芥 Fang Yizhi, *Wuli Xiaoshi* 物理小识, vol. 2.

78 Youyi 游艺 *Latter Collection of the Problems on Astronomy, The Chapter of Universal Movement* (Qing Dynasty).

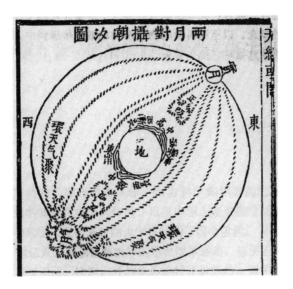

Fig. 18: The picture drawn by You Yi in the seventeenth century.

After Tycho Brahe's (1546–1601) model of the universe was introduced to China in the first half of the seventeenth century, the European missionaries in China and Chinese scholars used the attraction force of the lodestone to explain the movement of celestial bodies. Originally, Brahe's model of the universe did not contain the idea of gravitation. However, the missionary Jacques Rho (1590–1638), and Chinese scholars like Wang Xichan 王锡阐 (1628–1682), Mei Wending 梅文鼎 (1633–1721), and Jiang Yong 江永 (1681–1762) expressed the opinion that celestial bodies possess the attraction power of lodestones. At that time, the universal systems of Kepler and Newton had yet not been introduced to China. The theories of the Chinese, that celestial bodies have the attraction force of lodestones, were chaotic and had contradictions; nevertheless, they introduced the idea of gravitation to the world.

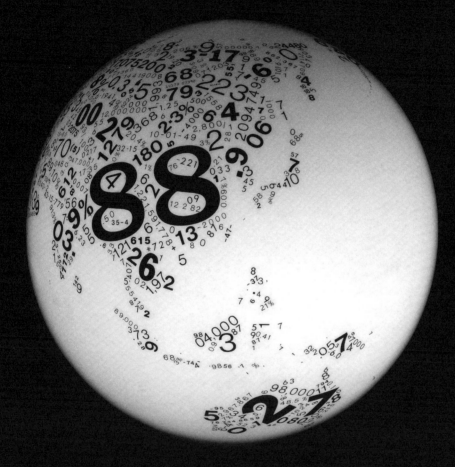

Worldprocessor [#33]

Contents

CHEN (JOSEPH) CHENG-YIH

Cultural Diversities:
Complementarity in Opposites

1. Cultural Diversities and Complementarity

History provides ample examples of cultural diversities in humankind's assimilation of knowledge and in humankind's creativity in the humanities. Such diversities produced a rich global variation among early civilisations. The cultural diversities between China and the West, for example, were well manifested by the contrast in their approaches to knowledge and creativity. We see the contrast in their languages, as exemplified by the Western alphabetic principle and the Chinese logographic principle. We see the contrast in their logic, as exemplified by the formal Aristotelian syllogism and the pragmatic Mohist model thinking. We see the contrast in their mathematical proofs, as exemplified by the Greek axiomatic deductive proof and the Chinese derivative proof. We see the contrast in their views of time and space, as exemplified by the Greek finite-crystalline universe and the Chinese infinite empty-space universe. We see the contrast in their views of building elements of the world, as exemplified by the Greek view that the world is made of *atomos* [atoms] and the Chinese view that the world is made of *qi* 氣 [energy]. Such contrast in approaches and views arising from cultural diversities were often found to be complementary.

In a paper, entitled "Equal Temperament: An Ethnomusicological Study", submitted for discussion at our Third Variantology Workshop (December, 2006), I provided a comparative study on the development of equal temperament in China and in Europe as an explicit example of complementary in contrast. It is shown there that the two approaches differ not only in thought process but also in methodology. Due to their contrast in approaches, we have an enriched understanding of tonal structures and a diversified view of tuning and harmony, in addition to the equal temperament.

In fact, complementarities among cultural diversities have facilitated human understanding of nature and promoted human creativity. They played an important role in the progress of world knowledge. Only with a better appreciation of cultural diversities can one avoid the imposition of value judgement and the traditions of one civilisation upon others and provide a better evaluation of the multicultural roots of science and humanity.

2. Views on Complementarity in Ancient China

To the early Chinese thinkers, it seems to be self-evident that complementarity is one of the natural processes governing the ever-changing world, not only in humanity but also in nature. The complementarity approaches allow one to analyse social, ethical, or psychological issues from various opposite perspectives and bring to light the underlying harmony of human experiences. The well-known *zhongyong* 中庸 principle [the doctrine of mean] was formulated for negotiating settlements in confrontations and for avoiding extreme behaviours.[1] It has been one of the central teachings of the Ru Jia 儒家 throughout Chinese civilisation for well-being and social harmony.

In China, complementarity has also been one of the central concepts in attempts to understand the phenomena of changes in nature. From the ancient Chinese classics, it is seen that the occurrences of natural phenomena have often been interpreted and explained as the interaction of opposing elements in nature. Over the course of time, abstract terms, *yin* 陰 and *yang* 陽, were coined to denote such opposites.[2] A number of formulations were proposed, using the *yin* and *yang* concepts, to interpret and explain processes of nature. Perhaps the best-known formulations are the *yin-yang* 陰陽 theory, the *dao-sheng-yi* 道生一 model, and the *tai-ji* 太極 model.

In this section, I will devote my study only to the early Chinese works on complementarity relating to nature.

1 The Book *Zhong Yong* 中庸 was first translated into Latin by Prosperus Intorcetta and published in 1667 with the title *Sinarum Scientia Politico-Moralis*.

2 The *yin* 陰 and *yang* 陽 terms have often been translated simply as "female" and "male". However, the Chinese terms for designating genders or sex are as follows:

Female	Male	Specifications
nü 女	*nan* 男	for human beings only
pin 牝	*mu* 牡	for animals
ci 雌	*xiong* 雄	for birds
mu 母	*gong* 公	for general usages
yin 陰	*yang* 陽	for philosophical and scientific usages

Therefore, it is seen that the *yin* and *yang* terms are not used to specify genders in the biological sense. They designate a pair which manifest opposite natures or contrary perspectives in an abstract sense.

154

2.1 The *Yin–Yang* Theory

The *yin-yang* theory has its foundation based on dialectic logic, a logic which exploits the opposites for discussion and reasoning. The dialectic logic behind the *yin–yang* theory had a profound influence on the Chinese system of thought.[3] The great Chinese philosopher Confucius (ca. 551–479 B.C.) suggested that thoroughly examining a matter from opposite perspectives allows one to gain new insights and to achieve a deeper understanding of the matter. As recorded by his disciples, Confucius once said:

"吾有知乎哉? 無知也。 有鄙夫問於我空空如也, 我扣其兩端而竭焉。

Am I knowledgeable? I am not knowledgeable. When I was asked for an answer, I am often empty, knowing nothing about it. I seek [the answer] by analysing the matter from its opposing perspectives."[4]

The description given by Confucius is a dialectical approach to reasoning, seeking complementarity of the opposites.[5]

2.1.1 The *Yin–Yang* Principle

The basic principle of the *yin–yang* theory as stated in the *Yi Jing* 易經 [Book of Changes] is:

一 陰 一 陽 之 謂 道。

"One *yin* 陰 and one *yang* 陽 constitute the *dao* 道."

Here the terms *yin* and *yang* stand for the two opposing elements whose interaction gives rise to the process of changes in nature. This *yin–yang* principle is accepted as one of the basic *dao* 道, the principles of nature. In this simple statement, the ancient Chinese intended to summarise the basic secret of nature. Throughout history, creative attempts were tried out to interpret and explain various processes in nature in accordance with the *yin–yang* principle.

3 In Chinese spoken language, it is common to express a concept in terms of its opposite sides of limits. For example, they use *chang* 長 [long] and *duan* 短 [short] as in *changduan* 長短 to express length [*changdu* 長度]; the use of *leng* 冷 [cold] and *re* 熱 [hot] as in *lengre* 冷熱 to express temperature [*wendu* 溫度].

4 See Chapter 9 of the *Lun-Yu* 論語 [Analects].

5 It is of interest to note that a similar practice was also advocated by the Greek philosopher Socrates (ca. 469–399 B.C.). Just like Confucius, Socrates also claimed that he was not knowledgeable. He used the question-and-answer technique to expose false and true in discussion and reasoning.

Let us consider an early attempt to explain the natural phenomena of thunder and lightning during thunderstorms in terms of the *yin–yang* 陰陽 principle. A description dating from the fifth century B.C. is reproduced below:[6]

地氣上齊, 天氣下降, 陰陽相摩。

天地相盪, 鼓之雷霆, 奮之以風雨。

"The *qi* ascends from the earth and the *qi* descends from the sky. The interaction of these *yin–yang* opposites gives rise to the mutual frictions and the mutual undulation between the earth and sky, resulting in the drumming of thunder and lightning and the rushing of wind and rain."

Here, the opposite processes of ascending *qi* from the earth and the descending *qi* from the sky are visualised to be the *yin* and *yang* opposites. The phenomena of thunder and lightning were explained as being caused by the frictional interaction between the ascending and descending *qi*. It is significant that, at this early time, the interpretation of nature's grand display was based entirely on naturalistic mechanisms, without any mysticism.

In this account, one encounters the important character *qi*. The meaning of the character *qi* is not well defined by the context of its use here. However, it is unambiguous that the character *qi* as it is used here mediates the *yin–yang* interaction. At this early stage in human assimilation of knowledge, a quantitative description of a dynamic process has not yet been developed. I have left the character *qi* untranslated, and defer its discussion to the Appendix at the end.

In the next three subsections, I provide an account on the nature of the *yin–yang* opposites and their interactions as envisioned by the ancient Chinese.

2.1.2 The *Tai-Ji* 太極 Diagram

In the Chinese conceptualisation, the *yin* 陰 and *yang* 陽, though opposite, are not completely separable. The *yin* 陰 contains *yang* 陽 and the *yang* 陽 also contains *yin* 陰. In the Daoists' terminology, the *yin* 陰 embraces the *yang* 陽 and the *yang* embraces the *yin*. Their interaction is dynamic and spontaneous. A graphic representation of such characteristics utilising symmetry can be found in the *tai-ji* diagram given in Figure 1. The term *tai-ji* was coined to denote the concept of an ultimate source in nature.

6 From the *Yue Ji* 樂記 [Records of Ritual Music], fifth century B.C.

Fig. 1: The tai-ji *diagram illustrates the concept of an ultimate source in nature composed entirely of the* yin *and* yang *opposites whose interactions give rise to the process of changes in nature.*

In this diagram, the totality of the *tai-ji* is composed of the *yin* and *yang* opposites, given in black and white colours, respectively. The dynamic of the interaction is expressed through the spiral configuration of the *yin* and *yang*. The concept of inseparability is expressed by the small black circle in the white and the small white circle in the black.

This simple yet suggestive image of the *tai-ji* represents the dynamic of complementarity. It has also been widely adopted as the symbol of the ultimate source of the universe.

2.1.3 The *Yin–Yang* Complementarity

A challenging problem in the application of the *yin–yang* principle is in the proper identification of the *yin* and *yang* opposites, and in understanding how they interact with each other. This is certainly dependent on the nature of the *yin–yang* opposites and on the specific process under study. There are no universal mechanisms or laws to account for all interactions in nature. However, some general features, based on symmetry and pattern, were proposed by the ancient Chinese.

One school of thought viewed the *yin–yang* interactions as complementary in a way that was capable of achieving balance and harmony in the system. Hence,

157

they assumed that the qualities and characteristics of a system can be established and maintained by the proper adjustment of the *yin–yang* opposites in the system. In their view the system could be any system, such as the universe or one's body.

Thus, the behaviour of seasons and the occurrence of abnormalities were viewed by the ancients as a matter of balance between the *yin* and the *yang* opposites of the heaven and earth system. We have, for example, the following statement:

天地之和, 陰陽之調也。

"The harmony between the heaven and the earth is the result of balance between the *yin* and the *yang*."[7]

That is, when the *yin* and the *yang* are balanced, heaven and the earth are harmonious and free from abnormalities.

Applications based upon such considerations are found, for example, in works on alchemy, biology, and medicine. As an example, let us examine how sickness was interpreted from the balance of the *yin* and *yang* in one's body. A passage dating from the fifth century B.C. is reproduced below:

陰淫寒疾, 陽淫熱疾。

"When *yin* is in excess, one gets sick due to cold;
When *yang* is in excess, one gets sick due to hot."[8]

It is in Chinese medicine that the concept of balance took on great theoretical importance.

Another school of thought views the *yin–yang* interactions as complementary in a cyclic pattern. Reproduced below from Chinese texts are such pattern-like descriptions:

陽極反陰, 陰極反陽。

"As the *yang* attains its maximum, it returns towards the *yin*; as the *yin* attains its maximum, it returns toward the *yang*."[9]

陽還終始, 陰極反陽。

The *yang* moves cyclically between the end and the beginning, as the *yin* attains its maximum and returns towards the *yang*.[10]

Such a synthesis based on symmetry brought the cyclic pattern into the binary *yin–yang* principle. Binary and cyclic patterns were considered to be the most significant patterns in nature by the early Chinese students of nature.

7 See the Da Yue 大樂 chapter of vol. 20 of the *Lü-Shi Chun-Qiu* 呂氏春秋.

8 See *Zuo Zhuan* 左傳 [Master Zuo's Commentary on the Spring-Autumn Annals].

9 See *Lun Heng* 論衡 [Discourse Weighed in Balance], ca. 82.

10 See *Gui Gu Zi* 鬼谷子 [Book of the Devil Valley Master].

In retrospect, one realises that the different *yin–yang* behaviours envisioned by the ancient Chinese were very creative and not improbable. Later science has revealed that there exist in nature a number of such systems. Consider, for example, the pH concentration of a solution: the neutrality of the solution can be maintained by adjusting the acidity and alkalinity characteristics of the system to yield 7 for the pH number. For systems with the cyclic *yin–yang* behaviours, we have, for example, the harmonic oscillation with its potential energy and kinetic energy exhibiting a cyclic pattern, and the electromagnetic wave with its electric field and magnetic field exhibiting a cyclic pattern.[11]

2.1.4 *Yin–Yang* Interaction over a Distance

Among the early systems exhibiting the *yin–yang* behaviours that were considered by the ancient Chinese, the most important ones are the amber and mustard seeds system and the lodestone and iron system, which correspond, respectively, to the electric and magnetic systems in modern terminology. In investigating electrostatic interactions, the *yin–yang* opposites were identified with the *qi* of the amber and the *qi* of the mustard seeds. Similarly, the *qi* of the lodestone and the *qi* of the iron were taken to be the *yin–yang* opposites in investigating magnetic interactions. In a paper entitled "Magnetism in Chinese Civilisation", submitted to our Third Variantology Workshop for discussion, I provided a review of studies of electricity and magnetism in ancient China. Here, I will just discuss the salient features of their analyses of such interactions over a distance.

It is apparent from observations that both electrostatic and magnetic interactions can proceed over a distance without contact; a phenomenon that reminded the ancient Chinese of resonance in sound, first discovered by Lu Ju 魯遽 of Western Zhou 周.[12] In interpreting the phenomenon of resonance, the term *gan-ying* 感應 [literally "sympathetic respond"] was coined to denote resonance

11 One should not misconstrue the discussion given in this paragraph as implying that the ancient Chinese predicted or anticipated such systems. Of course, they did not. The discussion intends to point out the complementary nature of different thought systems in humankind's assimilation of knowledge. The *yin–yang* theory formulated by the ancient Chinese should be evaluated by its contents within its historical time frame, and not be dismissed as superstitious and non-scientific, as advocated by certain historians of science.

12 The demonstration of this phenomenon is recounted by Zhuang Zhou 莊周 as recorded in the Luan Long Pian 雜篇 volume (vol. 8) of the *Zhuang Zi* 莊子 [The Book of Master Zhuang].

over a distance. By analogy, the term *xiang-gan* 相感, mutual influence, was coined to describe both electrostatic and magnetic interactions over a distance without contact.

From the first-century work of Wang Chong 王充 (27–97), we have the following passage on the description of such interactions:[13]

頓牟掇芥, 磁石引針, 皆以其真是, 不假他類。

他類肖似, 不能掇者, 何也? 氣性異殊, 不能相感動也。

"Amber picks up mustard seeds and the lodestone attracts needles. These are their genuine properties, not derived from others. Other things though similar do not possess such properties. Why? Because the nature of their *qi* is different and consequently they cannot undergo such interactions by mutual influence."

Here, Wang Chong pointed out that *qi* is an attribute of the object not derived from the others. Whether two objects can undergo interactions by mutual influence depends on the nature of the *qi* possessed by the two objects.

From the second-century work of Guo Pu 郭璞, we have the following account of electrostatic and magnetic interactions:[14]

磁石吸鐵, 玳瑁(瑁)取芥。 氣有潛通, 數亦冥會, 物之相感。

"The lodestone draws iron and amber collects mustard seeds. This is because their *qi* are invisibly interconnected [*qian-tong* 潛通] and their numerical measures are properly met, the mutual influence between them consequently occurred."

In Guo Pu's description, he further pointed out that two objects would undergo interaction over a distance only if the *qi* possessed by the two objects are invisibly interconnected and their numerical measures are properly met.

Guo Pu's interpretation of the role of *qi* in electrostatic and magnetic interactions is of great significance. It touched on two key features of interaction over a distance; namely, how the interaction extends between the two objects, and how the interaction could be initiated. It is the proposed interconnectivity of their *qi* that allows the interaction to extend between the two objects, and the proposed measurability of their *qi* that allows the interaction to proceed when their numerical measures are met. From these descriptions, it is apparent that, by the second century, the technical meaning of the character *qi* had become better defined through the context of its usage in interpreting electrostatic and magnetic interactions.

13 From the Luan Long Pian 亂龍篇 chapter of the *Lun-Heng* 論衡 [Discourse Weighed in Balance], ca. 82.

14 See his *Ci-Shi-Zan* 磁石贊 of 300 C.E., and his commentary on the *Shan-Hai Jing* 山海經 [Classic of the Mountains and Rivers], ch. 3, p. 6a.

In further study of magnetic interactions, the ancient Chinese observed that the interactions could also proceed through certain material barriers. This led to the view that *qi* should also possess penetrating ability. We have, from the eleventh century onward, descriptions such as: "concealed influence through barrier" [*jian-ge qian-ying* 間隔潛應], "interconnection through barrier" [*ge-he xiang-tong* 隔闊相通],[15] "interconnection through obstacle" [*zu-ai xiang-tong* 阻礙相通],[16] and "concealed interconnection through obstacle" [*ge-ai qian-tong* 隔礙潛通][17] for magnetic interactions over a distance with barriers.

Through studying electrostatic and magnetic interactions the ancient Chinese acquired a remarkable understanding of the phenomena of interactions over a distance. The concept of *qi* anticipated the concept of "field" in classic science.[18] This suggests that the term "*qi*" could be identified with the term "field" (for further discussion of the character "*qi*", see the Appendix).

In retrospect, it was the lack of the ability to carry out adequate quantitative analysis of electricity and magnetism that prevented further progress of the ancient Chinese. The general level of knowledge assimilated by then was not conducive. However, their interpretations of reaction over a distance were certainly very advanced. One had to wait nearly two millennia before an adequate quantitative analysis of electricity and magnetism was developed in Europe.

Another mechanism for the *yin–yang* interaction over a distance proposed by the ancient Chinese again involves the concept of *qi*. In this mechanism, the *yin–yang* interactions are visualised to proceed by exchange of *qi*. One of the best descriptions of such a type of *yin–yang* interaction is found in the *Zeng Zi* 曾子 [The Book of Master Zeng]:

吐氣者施, 而含氣者化。 是以陽施而陰化也。

"The one that emits *qi* is active [*shi* 施]; the one that absorbs *qi* is reactive [*hua* 化]. This is the principle of *yang* active and *yin* reactive."[19]

15 See the *Yun-Ji Qi-Qian* 雲笈七籤 [Yun-Ji Seven Tablets], ca. 1019–1025, by Zhang Jun-Fang 張君房.

16 See the works by thirteenth-century Song 宋 commentators Chen Xian-Wei 陳顯微 and Yu Yan 俞琰.

17 See the *Guang-Yang Za-Ji* 廣陽雜記 [Guang-Yang Collected Miscellanea] by Liu Xian-Ting 劉獻廷 of the Ming 明 dynasty.

18 Here, classic science refers to the science developed since the Galilei era of the seventeenth century up to the end of the nineteenth century.

19 The work was incorporated in the *Zhou Li* 周禮 [The Book of Zhou Institutions].

According to this interactive mechanism, the *qi* carries the interaction from the *yang* element to the *yin* element as it is emitted from the *yang* and absorbed by the *yin*. This is to say that each element senses the presence of the other element over a distance by exchange of the *qi*. This is an extraordinary description of interactions between *yin* and *yang* opposites over a distance, using the *qi* as the mediacy.

From certain perspectives, the *qi*-exchange mechanism for the *yin–yang* interaction described by Zeng Can 曾參 of the ca. fifth century B.C. is remarkably modern. Zeng Can would be amazed to learn that in quantum electrodynamics the interaction between charged particles is viewed as due to the exchange of virtual photons. This exchange mechanism was first introduced in 1930 by a Japanese physicist, Tomanaga Shin'ichirô (1905–1979), who shared the credit with Julian Schwinger (1918–1994) and Richard Feynman (1918–1988) for the development of quantum electrodynamics, a theory which accounts for both the wave and particle behaviour (see Section 3.1).

In 1935, the Japanese physicist Yukawa Hideki (1907–1981) proposed the meson-exchange mechanism for interpreting short-range strong nuclear interactions. Yukawa argued that the strong nuclear force can interact through a medium mass acting as the mediacy. This led to the seminal meson-exchange mechanism for nucleon interactions. Using the Feynman diagram, the meson-exchange mechanism proposed by Yukawa can be conveniently illustrated. Figure 2a illustrates a meson carrying strong force between a proton and a neutron as they interact.

Fig. 2: (a) A Feynman diagram showing the meson exchange when a proton and neutron interact via the strong nuclear force. (b) A diagram illustrating the qi *exchange as it is emitted from the* yang *and absorbed by the* yin *over a distance during a* yin–yang *interaction.*

If we adopt the modern scheme to represent the *qi*-exchange mechanism for the interaction between a *yin* element and a *yang* element as described by Zeng Can 曾參, we get a diagram as shown in Figure 2b. It shows that the *yang* element emits the *qi* and the *yin* element absorbs the *qi* as the *yin* and the *yang* interact over a distance. Despite the fact that the *qi*-exchange mechanism proposed by Zeng Can was for an arbitrary reaction between unspecified *yin* and *yang* elements and the meson-exchange mechanism proposed by Yukawa was intended for strong nuclear interactions, one can see certain similarities between these two mechanisms, proposed more than 2500 years apart. The physics contents between the two reactions are obviously at entirely different levels, but both of the proposed mechanisms were intended for reactions occurring in nature.

2.2 The *Dao-Sheng-Yi* Model

According to the Daoism, the instant when earth and heaven came into existence from the state of non-existence [*wu* 無, nothingness], there was complete chaos [*hun* 混] in the state of existence [*you* 有, being].[20] The question is how, at this instant of existence, did changes began to occur, giving rise to the production of things in nature. The *dao-sheng-yi* model was proposed by the Daoists for interpreting the process of changes in accordance with the *yin–yang* principle. From the *Dao-De-Jing* 道德經 [Canon of the Virtue of Dao], we have a description of the model as follows:

道生一, 一生二, 二生三, 三生萬物。

萬物負陰而抱陽, 沖氣以為和。

"The *dao* produced one, the one produced two, the two produced three, and the three produced all things. All things backed by the *yin*, embraced by the *yang*, and saturated with *qi* in a state of harmony."

Here, the model suggests that things in nature are produced in a linear chain progression as the *yang* embraces the *yin* in interaction. A state of harmony is reached when the system is saturated with *qi*.

20 See the Daoist book, *Dao-De-Jing* 道德經 [Canon of the Virtue of Dao].

2.3 The *Tai-Ji* Model

2.3.1 The Binary Expansion

The *tai-ji* model formulated by Ru Jia represents the Ruist view of the process of changes in accordance with the *yin–yang* principle. A familiar version of the *tai-ji* model can be found in the Xi-Ci-Zhuan 繫辭傳 appendix of the *Book of Changes*:[21]

> 是故易有太極, 是生兩儀,
>
> 兩儀生四象, 四象生八卦。

"Therefore, in changes [*yi* 易], there is the *tai-ji* 太極,

which produces *liang-yi* 兩儀 [i.e., the *yin* 陰 and *yang* 陽 opposites].

The *yin* 陰 and *yang* 陽 produce *si-xiang* 四象 [four symbols],

and the four symbols produce the *ba-gua* 八卦 [eight trigrams]."[22]

In terms of the *tai-ji* diagram given in Figure 1 and the *yao* 爻 symbols, "– –" and "—", of the *Book of Changes* for the *yin* and *yang* opposites, respectively, the *tai-ji* 太極 model can be represented by the diagram below:

Fig. 3: The binary expansion of the tai-ji *model expressed in terms of the* yin-yao 陰爻 *"– –" and* yang-yao 陽爻 *"—" of the* Book of Changes.

The diagram in Figure 3 projects a binary progression for the generation of *gua* 卦 elements. This expansion is evidently algebraic in nature since the *gua*

21 This appendix of the *Book of Changes* was a work of the Ru Jia.

22 See the Xi-Ci-Zhuan 繫辭傳 appendix of the *Book of Changes*.

elements at each stage of the expansion are open elements and may be variously substituted and interpreted in accordance with the matter under consideration. This algebraic nature allows the *tai-ji* model to be applied to a number of fields with a variety of interpretations.

The naturalistic *tai-ji* model was intended to express a production process in nature. The use of symbols to simplify the complexity of nature is of significance in logic. Unlike the *dao-sheng-yi* model of the Dao Jia 道家 given in linear chain progression, the *tai-ji* model visualises a creation process in binary progression. This model set the stage for the ancient Chinese to regard the *tai-ji* as containing the ultimate germs of truth in nature. One finds such deductions, for example, in the search for the origin of the universe and in the attribution of the origin of mathematics (see Section 2.3.3 below).

It is now common knowledge that the *gua* elements generated at the n^{th} stage of the binary progression can be obtained based on the combinatorial properties of the *gua*. Allowing all possible permutations, the total number of the *n-yao gua* n-爻 卦 that one can construct from various mixtures of the *yin-yao* 陰爻 "– –" and *yang-yao* 陽爻 "—" is 2^n. Figure 3 illustrates a three-stage binary progression, leading to a set of 8 trigrams [3-*yao gua*]. In the *Book of Changes*, a set of 64 hexagrams [6-*yao gua*] are explicitly listed, indicating a six-stage binary progression.

A characteristic feature of this method for generating the *gua* elements lies in its randomness. From each *gua*, there is a fifty–fifty chance of reaching either one of the next two *gua*. Thus, it is governed by pure chance.

2.3.2 Application in Divination

One of the early applications of the *tai-ji* model was in divination. Over time, consultation of *gua* became a formal practice in Zhou 周 ceremonies. In the *Zuo Zhuan* 左傳 [Master Zuoqiu's Commentary on the Spring-Autumn Annals] of the fifth century B.C., there are records of *gua* consultations for affairs such as military campaigns, hunting expeditions, etc. It is of interest to note that these records indicate that, more than often, an action was taken as originally planned, in opposition to the outcome of the consultation.[23] An eminent Chinese philosopher Xun Qing 荀卿 (313–238 B.C.) once commented:

[23] It should be noted that the probability of reaching certain *gua* in the binary progression of the *tai-ji* model as well as for the *da-yan* procedure discussed in this section can be calculated, unlike the probability in predicting the outcome of a military campaign or a hunting expedition.

卜筮然後絕大事, 非以為得求也, 以文之也。

"To make important decisions after a divination is not because it provides the required prediction but because it is a cultural expression."[24]

The practice of *gua* consultation often provides moral support.[25]

It is interesting to note that a mathematical procedure was developed later, probably also by Ru Jia, to alter the probability in generating the *gua*. The procedure is known as the *da-yan* 大衍 [great expansion] procedure.[26] After the divinatory rhetoric is removed, the *da-yan* procedure may be stated as follows:

1. Divide the total of 49 sticks into two portions arbitrarily and then remove one stick from one of the two portions.

2. Count the sticks in each portion by fours, and then remove the remainders. [For the portion by fours evenly, take the remainder to be four.]

3. Take the remaining sticks [i.e., the total number of sticks minus those removed] to be the new total.

4. Repeat the procedure two more times.[27]

In current algebraic notation, the *da-yan* procedure may be presented in terms of the following equations:[28]

$$x = 4n_1 + R_1 + 1, \qquad 4 \geq R_1 > 0; \qquad (1)$$
$$y = 4n_2 + R_2, \qquad 4 \geq R_2 > 0; \qquad (2)$$

where n_1 and n_2 are positive integers, R_1 and R_2 are the remainders to be removed, and the sum $x + y$ is the total number subject to the procedure.

Beginning with the number 49, we have $x + y = 49$. Equations (1) and (2) then reduce to

$$4n + R = 48, \qquad 8 \geq R > 0 \qquad (3)$$

where $n \equiv n_1 + n_2$ and $R \equiv R_1 + R_2$. Equation (3) yields two solutions:

$$n = 10, R = 8;$$
$$n = 11, R = 4.$$

24 See the *Xun Zi* 荀子 [The Book of Master Xun] of 240 B.C.

25 Fortune-telling in different forms, including the use of *gua*, are common human practices found in all civilisations. The comment here refers exclusively to the practice of *gua* consultation in a formal ceremony among institutions and intellectuals.

26 See the *Xi-Ci-Zhuan* appendix of the *Book of Changes*.

27 For a discussion of the procedure, see Chen Shih-Chuan 程石泉, How to form a hexagram and consult the *I Ching. J. Am. Oriental Soc.* 92 (1972): 237.

28 Chen (Joseph) Cheng-Yih, *Early Chinese Work in Natural Science* (Hong Kong, 1996), p. 208.

This gives two possible paths: the path given by the first solution with the number 40, and the path given by the second solution with the number 44. The procedure is then repeated, with one of the two numbers, to generate the next possible paths. From number 40, one obtains the paths with numbers 32 and 36, and from number 44, one obtains the paths with numbers 36 and 40, as illustrated in Figure 4.

Fig. 4: The da-yan *[great expansion] procedure for simulating the binary expansion of the* tai-ji *model with the* gua *elements expressed in terms of numbers instead of the* yao 爻 *symbols.*

Apparently, the *da-yan* procedure was invented to simulate the binary expansion. From the branching ratios given in the diagram, one sees that the procedure allows a random generation of paths but with a different probability. From one *gua* element, the probability of reaching either one of the next two *gua* is no longer a fifty–fifty chance.[29] The *da-yan* procedure favours the *yang* component. In this divination procedure, we find one of the earliest roots of the mathematic indeterminate theory in ancient China (see Section 2.3.3).[30]

29 The probability of reaching the final *gua* element can be calculated exactly in principle.

30 For other related indeterminate problems that are found later in Chinese mathematics books, see the Chinese Remainder Theorem from the *Sun-Zi Suan-Jing* 孫子算經 [Master Sun's Mathematical Manual] of ca. 280 and the Hundred Fowls Problem from the *Zhang-Qiu-Jian Suan-Jing* 張邱建算經 [Zhang Qiu-Jian's Mathematical Book], written between 468 and 486.

2.3.3 Application in Mathematics

The algebraic nature of the *tai-ji* model allows a number of different substitutions and interpretations. It is instructive to examine its application to topics other than divinations. In this section, we consider the application of the *tai-ji* model in mathematics.

The influence of the *tai-ji* model in mathematics was profound. Well-known mathematicians such as Liu Hui 劉徽 (third century), and Qin Jiu-Shao 秦九詔 (1202–1261) attributed to the *tai-ji* the origin of mathematics. Qin stated in his mathematics treatise, *Shu-Shu Jiu-Zhang* 數書九章 [Mathematics Treatise in Nine Sections] of 1247 that he devoted much time to the *Yi Jing* for his research in mathematics. Qin Jiu-Shao 秦九紹 appreciated well the mathematical significance of the *da-yan* [great expansion] procedure for the generation of the *gua* system (see Section 2.3.2). He named his new method the *da-yan* method after the *da-yan* procedure.

The *da-yan* method is given in Chapter 1 of his mathematics treatise. After solving the first problem taking from the *da-yan* procedure of the *Book of Changes*, Qin Jiu-Shao provided a general rule for solving systems of simultaneous congruencies. The algorithm described in the rule has a complexity and sophistication advanced for his time. In 1973, Libbrecht commented:

"We should not underestimate this revolutionary advance, because from this single remainder problem, we come at once to the general procedure for solving the remainder problem, even more advanced (from the algorithmical point of view) than Gauss's method, and there is not the slightest indication of gradual evolution."[31]

Libbrect concluded that Sarton did not exaggerate when he called Qin Jiu-Shao "one of the greatest mathematicians of his race, of his time, and indeed, of all times".[32]

Another important contribution of the *tai-ji* model to mathematics was the role it played in the discovery of the binomial coefficients. From the analysis of the paths that a *gua* can be reached, it is evident that the path to reach a *gua* is not unique since some of the *gua* can be reached by a number of different paths.[33] It is not difficult to see that the number of equivalent paths is related to the multiplicity of the equivalent *yao* permutations in a *gua*.

31 Ulrich Libbrecht, *Chinese Mathematics in the Thirteenth Century* (Cambridge, MA, 1973) p. 183.

32 George Sarton, *Introduction to the History of Science*, vol. III (Baltimore, 1947), p. 626.

33 See the number of paths given in the parenthesis in Figure 3.

Through such analyses of the multipath and multiplicity of the *gua*, the ancient Chinese discovered the distinct triangular number pattern of the binomial coefficients. It was in the great work of the Northern Song mathematician, Jia Xian 賈憲 (fl. 1010–1025), that one found binomial coefficients were explicitly used in root-extraction. According to the book *Xiang-Jie Jiu-Zhang Suan-Fa* 詳解九章算法 [A Detailed Analysis of the Mathematical Methods in the Nine Chapters] of 1261 by Yang Hui 楊輝, the triangular tabulation of the binomial coefficients [reproduced in Figure 5 below] came from Jia Xian's 賈憲 description of the *zeng-cheng* 增乘 method for root-extraction.[34]

Fig. 5: The Jia Xian 賈憲 *triangular tabulation of binomial coefficients reproduced from Yang Hui's* 楊輝 Xiang-Jie Jiu-Zhang Suan-Fa 詳解九章算法 *[A Detailed Analysis of the Mathematical Methods in the Nine Chapters] of 1261.[35] In the text, it is noted that this tabulation (left) came from the* Shi-Suo Suan-Shu 釋鎖算書 *and Jia Xian* 賈憲 *made use of the method.*

This work by Jia Xian was of major importance in numerical equations since the work broke free from the traditional geometrical interpretation of root-

34 According to Yang Hui 楊輝 (fl. thirteenth century), the triangular tabulation of the binomial coefficients came from Jia Xian's 賈憲 book entitled the *Shi-Suo Suan-Shu* 釋鎖算書 [Mathematics Book on the Method of Unlocking by Binomial Coefficients], a book which is now lost.

35 Such a triangular tabulation of binomial coefficients is known as the Pascal triangle in the West, named after the French mathematician and philosopher Blaise Pascal (1623–1662).

extraction and set the stage for an algebraic development of numerical equations of higher degrees by thirteenth-century mathematicians such as Qin Jiu-Shao 秦九韶 and Yang Hui 楊輝. In Figure 6, the triangular tabulation of binomial coefficients marked with recurrence relations is reproduced from the 1303 work of the Zhu Shi-Jie 朱世傑 (fl. 1290–1310).[36]

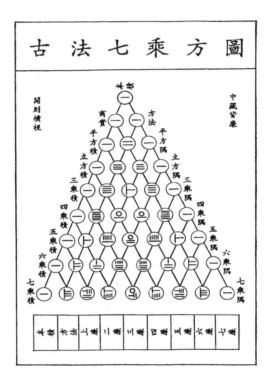

Fig. 6: A triangular tabulation of binomial coefficients reproduced from Si-Yuan Yu-Jian 四元玉鑑 *[Reflections in Mathematics up to Four Variables] of 1303 by Zhu Shi-Jie* 朱世傑.

Zhu Shi-Jie 朱世傑 referred to the diagram as the seven-fold chart for the "old" method of raising binomials.

36 From the first chapter of volume I of the *Si-Yuan Yu-Jian* 四元玉鑑 [Reflections in Mathematics up to Four Variables] of 1303 by Zhu Shi-Jie 朱世傑.

2.3.4 Western Views of the *Tai-Ji* Model

Historical evidence indicates that by the late thirteenth century there was a great increase in cross-cultural interaction between China and the West over and above the high level of Silk Road interactions that had been reached during the Tang and Song periods. This increase was brought on by the rise and westward campaigns of the Mongols in the thirteenth century, then by the Zheng He 鄭和 maritime expeditions in the early fifteenth century,[37] and followed by the rise of European maritime activities in the sixteenth century. With such multilateral confrontations, more channels for cross-cultural interactions became available for the transmission of ideas and knowledge, with speeds beyond the historical diffusion process. Here, we examine the Western views of the *tai-ji* model.

Before Matteo Ricci (Li Ma-Dou 利瑪竇, 1552–1610), an influential Jesuit missionary, entered Peking in 1601, he devoted much of his time in China to studying Chinese classics in order to familiarise himself with Chinese culture.[38] His Latin translation of the *Si-Shu* 四書 [Four Classics] was completed and sent back to Europe in 1593.[39] In his studies of Chinese classics, Ricci interpreted the *tai-ji* as the "*prima materia* of the Scholastics".[40]

Based on this interpretation, John Rodriguez, later in 1631, made the following comments on the *tai-ji* model:

"According to the Occidental interpretation, the Great Ultimate [i.e., the *tai-ji*] is something material, is matter without intelligence and without consciousness. Unless there is the infinite, omnipotent, wise, and intelligent factor, how could it ever produce things?"[41]

[37] For early accounts of the expeditions in Western languages see, for example, articles in *China Review* 3 (1874–1875); 4 (1875–1876), and the *T'oung Pao* 30 (1933): 230–452; 31 (1935): 3–4; 32 (1936): 4; 34 (1938): 5.

[38] See Fang Hao 方豪 (1964), vol. 5, ch. 6, p.183, and Louis Pfister, *Notices Biographiques et Bibliographiques sur les Jésuites de l'Ancienne Mission de Chine* (1552 to 1773), 2 vols. (Shanghai, 1932).

[39] See L. Pfister, ibid.

[40] See Fonti Ricciane, *Storia dell'Introduzione del Cristianesimo in China*, pt. II (Rome, 1949), p. 297, note b sqq.

[41] These comments are from a letter written by John Rodriquez in 1631. The letter is still preserved at the library of the University of Seoul and has been published in the *Shigaku Zasshi* 史學雜誌 [The Historical Journal of Japan], vol. XLIV. The translation into English is by Rufus Suter and Matthew Sciascia, see Pasquale M. d'Elia, *Galileo in China* (1960), p. 43.

The fact that the *tai-ji* model does not contain elements of creationism was the major source of Rodriguez's objection. This comment is based essentially on the premise that, without supernatural power, it is not possible to create things. On the other hand, the *tai-ji* model was formulated based on the premise that things in nature are produced spontaneously from *tai-ji* according to the principles of nature. The model makes no comment on the intelligence or the origins of *tai-ji* itself.[42]

In 1703, German mathematician Gottfried W. Leibniz (1646–1716) pointed out that the binary number system is contained in the Chinese binary *gua* system of the *Yi Jing* [Book of Changes].[43] He stated that "qui se sert des seuls caracteres 0 et 1, avec des Remarques sur son Utilite, et sur ce qu'elle donne les sens anciennes Figures Chinoises de Fohy." This is apparent if one takes the *yin-yao* "– –" symbol to be that for the numeral 0, and the *yang-yao* "—" symbol to be that for the numeral 1, as illustrated in Table 1 for the trigrams.

Trigram *Gua*	Binary Numerals "– –" = 0, "—" = 1, scale 2
	$(0 \times 2^2) + (0 \times 2^1) + 0 = 0$
	$(0 \times 2^2) + (0 \times 2^1) + 1 = 1$
	$(0 \times 2^2) + (1 \times 2^1) + 0 = 2$
	$(0 \times 2^2) + (1 \times 2^1) + 1 = 3$
	$(1 \times 2^2) + (0 \times 2^1) + 0 = 4$
	$(1 \times 2^2) + (0 \times 2^1) + 1 = 5$
	$(1 \times 2^2) + (1 \times 2^1) + 0 = 6$
	$(1 \times 2^2) + (1 \times 2^1) + 1 = 7$

Table 1. The relation between the trigram *Gua* and binary numerals.

42 Rodriguez's objection can be equally applied to the big-bang model of the universe in modern science. In the big-bang model, the basic view is that immediately after the big bang, the universe expands spontaneously, governed by certain basic principles, from an initial volume of extremely dense mass. The model does not tell us anything about the intelligence and origin of the initial dense mass from which the expansion began.

43 Gottfried Wilhelm Leibniz, Explication de l'arithmétique binaire, in: *Mémoires de l'Academie Royale des Sciences* (Paris, 1703).

The relations between the trigram *gua* and binary numerals illustrated in Table 1 can be applied to all *gua*.

Thus, with the substitution of – – = 0 and —— = 1, and the interpretation of the permutation operation as to set place value for the *yao* in the *gua*, the *tai-ji* model can be expressed in terms of the binary numerals in Figure 7.

Generation of Binary Numerals in the *Tàijí* 太 極 Model.

Identification: – – = 0, —— = 1,
Operation: Setting Positional Values
1703, G. W. Leibniz (1646–1716)

Fig. 7: The binary expansion of the tai-ji *model expressed in terms of binary numerals.*

It is known that Leibniz first discussed the binary numerals in 1679; however, a full account of the numerals was not published until 1703, after a long period of correspondence (beginning no later than 1697) with the Jesuit Joachim Bouvet in China on the *Yi Jing*.[44]

There were many debates among historians of science on the question whether Leibniz's work on binary numerals was inspired or influenced in any way by

44 The *Yi Jing* [Book of Changes] was available in Europe long before 1679 (see, for example, the work of Nicolaus Trigault of 1615), but there is no known record indicating that Leibniz knew the book before 1697.

the Chinese system of *gua*.[45] The fact that the *gua* systems can be interpreted as binary numerals is not at all surprising since the *gua* system is an abstract representation of the general combinatorial principle of binary systems. However, it should also be noted that the fact that the binary numerical principle is a part of the general binary concept represented by the *gua* does not necessarily imply that the early Chinese recognised the numeral properties of the *gua*. On the other hand, even if the binary numerical principle in the *gua* was not recognised by the early Chinese, it would not prevent a reader of the *Yi Jing* from realising, or even gaining further insights into the binary numerals through the *gua* systems.

The point which is of interest to us here is not the debate itself, but the observation that the merit of the abstract *gua* system depended on the user and the context in which it was used.[46] In 1912, Masson-Oursel made the following remarks about the *gua* systems:

"It supposes a kind of translation of all natural phenomena into a mathematical language by means of a set of graphic symbols, germs of what Leibniz would have called a 'universal character'; thus constituting a dictionary permitting men to read Nature like an open book, whether with intellectual or practical aims in view."[47]

From the different views and the various applications of the *tai-ji* model discussed above, it is not difficult to see the complementary interplay between the opposite views of naturalism and creationism.

In fact, Leibniz also interpreted the binary numeral system in terms of religious significance. He assigned 1 to represent God and 0 to represent nothing and attempted to use these binary numbers to prove that God could create the universe out of nothing. Joseph Needham (1900–1995) suggested that Leibniz had sent his table of binary numerals to Bouvet in China in 1701 because he had hoped that "the Chinese might be induced to accept Christianity by such quasi-mathematical demonstrations."[48] However, the Chinese can easily re-interpret Leibniz's concepts of "nothing" and of "God" to be associated with the Daoist

45 For a discussion of these debates, see Joseph Needham, *Science and Civilisation in China* (Cambridge, 1956), vol. 2, pp. 340–345.

46 It is interesting to speculate whether modern knowledge of binary expansion process in the cleavage of a fertilised egg cell (i.e., a zygote) was available to the ancient Chinese working on the binary expansion process.

47 Paul Masson-Oursel, Études de Logique Comparée. *Revue de Métaphysique et de Morale* 20 (1912): 811; 23 (1916): 343.

48 Needham, *Science and Civilisation*, vol. 2, p. 341, footnote d.

concepts of *wu* [nothingness, the state of non-existence] and *you* [being, state of existence] for the creation process (see Section 2.2).

In retrospect, we see that the *tai-ji* model was formulated at a time when religion and mysticism dominated people's views. The merit of the *tai-ji* model lies in its naturalistic approach. When the *Yi Jing* found its way into Europe, the scientific revolution was at its beginning stage. It was the period which saw the publication of the *Sidereus nuncius* [Starry Messenger] in 1610 by Galileo Galilei (1564–1642), based on observations that he made with his re-designed telescope.[49] And it was also the period which saw the movement of scientific naturalism and the struggle to be free from the Church's view of science. In fact, it is the complementarity between the opposite views of naturalism and creationism that has facilitated the progress of science and technology.

The influence of the *Yi Jing* in Chinese civilisation has been profound. Mathematician Qin Jiu-Shao 秦九韶 claimed that from his study of the *Yi Jing*, he realised that mathematics would help us to comprehend the miraculous universe and to understand the process of life, in addition to managing business and to analysing various things. In 1247, he stated:

數與道非二本也。

"Mathematics and *dao* are not from two different bases."[50]

This is a premise of great scientific merit, advanced for his time. Mote in 1971 made the following observation:

"*I Ching* 易經 [i.e., *Yi Jing*] has remained a bottomless well from which each age of Chinese thought has drawn provocative insight."[51]

As noted by Jung[52] and by Mote,[53] the ancient Chinese minds with their unique conceptualisations led to the development of cosmology and cosmogony, which appear closer to the explanations offered by modern physics than those we find in myths and religious systems.[54]

49 It is relevant to note that, at this juncture, neither Galilei's *Discourses Concerning Two New Sciences* (1638) nor Newton's *Philosophiae Naturalis Principia Mathematica* (1687) were as yet in existence.

50 See the Preface of his book *Shu-Shu Jiu-Zhang* 數書九章 [Mathematics Treatise in Nine Sections] of 1247.

51 Frederick W. Mote, *Intellectual Foundations of China* (New York, 1971), p. 15.

52 See the Foreword by Carl Jung in Richard Wilhelm's *I Ging. Das Buch der Wandlungen* (Jena, 1924), English trans. C.F. Baynes (New York, 1950).

53 F.W. Mote, *Intellectual Foundations*, p. 19.

54 This is contrary to the claims of some sinologists and historians of science that the Chinese *gua* system was in itself inhibitive to the development of science in ancient China.

3. Complementarity in Modern Science[55]

3.1 The Nature and Propagation of Light

3.1.1 The Traditional Views of Light

In classic physics, light can be viewed as rays and as waves. These two opposite views complement each other. Up until the time of Isaac Newton (1643–1727), most scientists thought that light was a ray of corpuscles emitted by a light source. The ray model of light provides adequate explanations for reflection, refraction, transmission, and dispersion phenomena of light. Evidence of wave properties of light began to emerge around 1665. By 1678, Christiaan Huygens (1629–1695) had proposed a creditable argument for interpreting waves. The wave model of light explains adequately the diffraction, interference, and polarisation phenomena of light.

The fact that light reveals both a wave nature and a particle nature is fascinating. Such a dichotomy in light is what the ancient Chinese would like to look for in their *yin–yang* theory. In the subsequent sections, I examine how the interplay of these two opposite natures of light helped in the progress of modern physics and, in the meantime, shook the thought system influenced by Aristotelian logic to its roots. The dilemma led the eminent physicist Niels Bohr (1885–1962) to postulate the complementarity principle (see Section 3.2.3).

3.1.2 Contact Medium for Propagation

Because light can travel from the sun to the Earth through nearly empty space, the question of a propagation medium became significant if one was to accept the wave model for light, for in traditional thinking a contact medium is necessary for waves to propagate. A medium called "ether", borrowed from the Latin word "aether" [Greek *aither*], was proposed to provide the contact medium for light to propagate. It was assumed that the ether permeated all space. Since ether cannot be detected, it must be transparent and tenuous. It should also

55 I adopt the terminology that sciences developed before the seventeenth century are referred to as traditional sciences, and sciences developed up to the end of the nineteenth century, since the Galilei era, are referred to as classic sciences. The new sciences developed at the turn of the nineteenth century are now referred to as modern sciences.

produce no resistance to the motion of material objects; otherwise, planets in space would soon lose their energy and spiral into the sun.

In the 1860s, James Clerk Maxwell (1831–1876) predicted theoretically the existence of electromagnetic waves composed of changing electric and magnetic fields, each alternating at frequency f. Furthermore, he demonstrated that such waves can travel in a vacuum at the speed of light $c = 299{,}792{,}458$ m/s, depending only on the electric and magnetic constants ε_0 and μ_0. The existence of such electromagnetic waves was later confirmed experimentally. In addition, it was identified that light is actually also an electromagnetic wave, occupying the narrow visible band in the electromagnetic spectrum.

This distinguished work, which laid the foundations of electromagnetic technology, raised new questions, which were contrary to traditional thinking. How could electromagnetic waves travel at the speed of light c independent of the speed of the source and the observer? If light propagates through the ether, then the speed c should be defined relative to the ether medium. From 1881 to 1887, Albert Michelson (1952–1931) and Edward Morley carried out a series of experiments using an interferometer to determine Earth's speed relative to the ether. Their experiments showed that the Earth does not move relative to the ether. This negative result is contrary to the traditional and Newtonian views but is consistent with Maxwell's prediction of a constant speed c. An observer on the Earth, independent of the Earth's speed, should measure the same speed for light in all directions.

In fact, Maxwell had shown that an electromagnetic wave propagates by the interaction between the changing electric and magnetic fields within themselves. This implies that there is actually no need for a contact medium for the propagation of electromagnetic waves in free space. In interpreting Maxwell's predictions, Albert Einstein (1897–1955) abandoned ether and, thus, abolished the notion that propagation of all waves requires a contact medium.

In analysing Maxwell's results, in 1905 Albert Einstein postulated that (a) the laws of physics are the same in every inertial frame of reference, and (b) that light propagates through empty space with a definite speed c independent of the speed of the source or observer. In these postulations, Einstein accepted Maxwell's predictions by interpreting that the speed of light is the ultimate speed in nature. This complementary approach allowed Einstein to resolve the contradiction by deriving the special theory of relativity, which brought us to a universe that transcends our ordinary experience.[56] The theory of relativity

56 Einstein's "Special theory of relativity" dealing with inertial reference frames. In his later "General theory of relativity", Einstein extended relativity to deal with accelerating reference frames.

broadened our view of space and time and revealed the relation between mass and energy, $E = mc^2$. It was through the propagation speed of electromagnetic waves that nature revealed relativity to Einstein.

3.1.3 Wave–Particle Duality of Light

In the same year, 1905, Einstein also made a substantial advance concerning the particle nature of light. In interpreting the phenomenon why light will only knock out electrons from a clear metal surface when the frequency of a light wave is at, or higher than a characteristic frequency set by the metal, independent of the intensity of light, Einstein proposed that the energy transmitted to the metal from light is in the form of a discrete "lumps" of energy, not in a smooth continuous fashion. The term "photons" was later coined in 1926 to denote such lumps of energy. Einstein used the Planck constant h to specify the discrete nature of the photon energy $E = hf$, where f is the frequency of the light wave.[57] A photon is a massless particle whose momentum is related to its wavelength by $p = h/\lambda$. In visualising light as a stream of photons, Einstein explained the photoelectric effect convincingly.

The two celebrated works of Einstein of 1905 illustrate that Einstein accepted both the wave nature and particle nature of light. The wave nature of light has been demonstrated conclusively by the interference and diffraction experiments of Young and others. The particle nature of light has been well demonstrated by the Compton scattering and photoelectric experiments. The propagation of light is best described by a wave model, but the particle model approach provides the best understanding of emission and absorption. Thus, we see that both aspects of light have validity. The wave–particle duality is probably a more complex a phenomenon in nature than just for light.

3.2 Dilemmas in Quantum Theory

In 1912, Niels Bohr constructed the first viable argument on the stability of the electronic structure of atoms, using the newly devised "massive nuclear"

[57] The Planck constant, which has the value, $h = 6.63 \times 10^{-34}$ j.s, was determined by Max Planck (1858–1947) who in 1900 first proposed the concept of energy quanta in his study of blackbody radiation.

model of the atom by Ernest Rutherford (1871–1937) of 1911. Bohr argued that electrons in an atom each move in an orbit of a stationary state with a definite energy. An electron would lose energy only by emitting a quantum of energy as it jumps from its stationary state to another stationary state of lower energy. By energy conservation, the quantum of energy released is given by $hf = E_{\bar{n}} E_{l}$, where E_n and E_l refer to the energy of the upper and lower states, respectively.

The Bohr model of an atom provided an adequate explanation for why the emission and absorption of light by atoms occur only at certain wavelengths. The predicted values for the line spectra and ionisation energy of a one-electron atom, such as the hydrogen atom or helium ion, are in excellent agreement with experiment, despite some important limitations. However, it was this seminal work of Bohr that led us to the quantum description of atomic structure and the development of quantum mechanics.

3.2.1 Wave–Particle Duality of Matter

The wave–particle duality encountered in the study of light involves massless particle photons travelling at the speed of light c. For a particle, such as an electron, which has a mass and, according to relativity, can never attain the speed c, does one expect wave–particle duality? In 1923, Louis Victor de Broglie (1892–1987) predicted the existence of matter waves based on the simple argument of symmetry: if a light wave has particle nature, then a mass particle should also have wave nature. De Broglie proposed that the wavelength of a material particle would be related to its momentum in the same way as for a photon. Thus, for a particle having linear momentum $p = mv$, the wavelength is given by $\lambda = h/p$.[58]

If a particle has a wave nature, one should expect to have wave equations to provide its description of the special and temporal behaviour of a wave function. In 1926, Erwin Schrödinger (1887–1961) derived such a wave equation for matter waves, known as the Schrödinger equations. Schrödinger's formulation developed quantum mechanics, which successfully dealt with atomic-scale phenomena, such as the spectra emitted by atoms, and resolved certain difficulties of Bohr's model of atoms.[59] Independently, Werner Heisenberg (1901–1976)

[58] For a relativistic particle, the momentum would be given by $p = m_0v/(\sqrt{1-v^2/c^2}\,)$.

[59] It is necessary to add the concept of electron spin to Schrödinger's formulation of quantum mechanics to explain atomic spectra satisfactorily.

developed a matrix formulation of quantum mechanics. In 1927, the existence of a matter wave was verified experimentally by C.J. Davison (1881–1958), L.H. Germer, and George P. Thomson (1892–1975). These works and others firmly established matter waves, and thus revealed that the wave–particle duality is a general phenomenon, not exclusively limited to electromagnetic waves.

3.2.2 Probability and Uncertainty

Treating particles as waves, we have the wave function Ψ from the Schrödinger equations, which represents the displacement of the mass wave [the wave amplitude] as a function of time and position. Such a wave function Ψ can be viewed as the mass field in analogy with the electric field, or magnetic field in electromagnetic waves. If we ask, Where are the particles? then we need to treat the problem on a probabilistic basis. Max Born (1882–1970) first suggested, in 1927, the probability of finding the particles is given by the square of the wave function Ψ^2. Consider, for example, the case that Ψ represents a single electron in an atom. Then, Ψ^2 at a certain space-time point represents the probability of finding the electron at that space-time point. One can no longer determine the exact position of the electron, let alone follow the motion of the electron through space and time as in classic mechanics.

The probability imposed by quantum mechanics is different from the probability one encounters in dealing with a large number of particles. In quantum mechanics, the probability is inherent in nature. In this development, one actually witnesses the rise of a revolutionary idea that is culturally alien to the characteristic thought system of the West. Due to wave–particle duality, one is forced to replace determinism with probability in dealing with the microscopic world. In the classical Newtonian view, the path of a particle is precisely predictable from the initial position and velocity and the forces exerted upon it. However, in quantum mechanics certain probabilities always exist that the particle will take on different positions.

The quantum nature of interaction adds additional uncertainties in one's ability to determine the position of a particle. To determine any property of a system, one needs to interact with the system to take measurements. This interaction will inevitably disturb the energy of the system. For a classic system, the disturbance in energy can be made arbitrarily small. But for a quantum system, the minimum disturbance in energy would be a single quantum, such as a photon of light. Thus, the uncertainty in measurement is limited by the Planck constant h of quantisation.

In 1927, Werner Heisenberg proposed the uncertainty principle. He argued that the act of observing a quantum-mechanical system necessarily disturbs the

system. As a result, it is impossible to measure simultaneously a particle's exact position and momentum, or a particle's energy and the time of measurement. These uncertainties in position Δx and in momentum Δp can be expressed mathematically as $\Delta x\, \Delta p \geq h/(2\pi)$. Similarly, the uncertainties in energy ΔE and in time Δt can be expressed mathematically as $\Delta E\, \Delta t \geq h/(2\pi)$. These uncertainty statements express the probabilistic view of quantum mechanics that there is some inherent unpredictability in nature; this is very different from the deterministic view of classical mechanics.

This inherent unpredictability in quantum theory is a cause of concern. Why should determinacy of a physical quantity govern by statistical laws based on probability instead of by deterministic laws? Why should the emission of a photon from atomic systems be random? Why should the choice of measurement of one physical quantity affect the determinacy of the other? Why cannot the wave nature and particle nature be observed simultaneously? Is the foundation of physics built on chance and choice? Such unsettling questions inspired the famous debates on the foundations of physics, led by Einstein and Bohr. In relating this debate, Einstein has often been quoted for his statement "God does not play dice." This tends to misrepresent the nature of the debate. The debate was to seek for a conceptual basis to accommodate the apparent contradictory behaviours of light and quantum systems. Bohr dealt with these dilemmas by appealing to the principle of complementarity.

3.2.3 Bohr's Complementarity Principle

In 1927 Bohr proposed to view the wave characteristics and the particle characteristics as being complementary. In interpreting experiments, sometimes we need the wave descriptions and sometimes the particle descriptions; this is because we need both descriptions to complete our model. Here, Bohr viewed the wave and particle nature as the opposites of the whole in one's approach to the understanding of wave–particle duality.

The principle of complementarity proposed by Bohr is logically incompatible with the deterministic view. There is no question that by 1927 the wave–particle duality had been accepted by most physicists. If one is to have a full understanding of light and quantum systems, one must accept both their wave and particle properties. Einstein's equation $E = hf$ is in itself an acknowledgement of both the wave and particle nature of light, since the equation links their properties. It equals the energy of a particle with the frequency of the wave though the Planck constant h of quantisation.

The ongoing debate is to seek a further understanding of the duality, since it is difficult to visualise a combination of the wave and particle natures. One view of the difficulty stems from our reliance on concepts of waves and particles conceived in the macroscopic world to study light and quantum systems. All our experiments have been designed to be interpreted either in terms of the wave properties or in terms of the particle properties conceived in the macroscopic world. These are indirect experiments. From this point of view, the wave–particle duality is probably two different manifestations of one physical property.

Bohr's principle of complementarity accepts the duality as a natural behaviour of nature and directs us toward a dialectic approach to the wave–particle duality. It was the acceptance of the wave–particle duality of light as a natural phenomenon that helped one to conceive and discover the matter waves and to the development of quantum mechanics. Apparently, there is still much to be learned from the duality behaviour of nature.

During his trip to China in 1937, Bohr had the opportunity to discuss his complementarity principle with Chinese scientists. During these discussions, he developed a better understanding of the *yin–yang* principle and the *tai-ji* model. Later, Bohr adopted the *tai-ji* diagram (see Figure 1) for his coat of arms (see Figure 8) when he was knighted for his outstanding achievements in science and important contributions to Danish cultural life.

Fig. 8: Niels Bohr's coat of arms with the tai-ji *symbol and the inscription* "Contraria Sunt Complementa" *designed in 1947 when he was awarded the Danish Order of the Elephant.*

Bohr's adoption of the *tai-ji* symbol with the inscription "Contraria sunt complementa" [contraries are complementary] in Latin for his coat-of-arms acknowledges that the symbol illustrates the concept of complementarity.

Yukawa Hideki was once asked whether Japanese scientists had as much conceptual difficulties with Bohr's principle of complementarity as the scientists in the West. He was quoted as saying: "We in Japan have not been corrupted by Aristotle."[60] To Japanese scientists, the complementarity principle appears to be self-evident. Yukawa was best known for his 1935 prediction of the meson as the mediacy for strong nuclear interactions. Five years earlier, Tomanaga proposed the photon-exchange mechanism for the interaction between charged particles (see Section 2.1.4). In such mechanisms, the interacting partners sense the presence of each other over a distance by exchange of mediacy. It is of interest that, in quantum electrodynamics and in elementary particle physics, the exchange mechanisms for interaction over a distance without contact were both first proposed by physicists with a cultural background that was not significantly influenced by determinism. Can this be entirely coincidental? Perhaps, in these achievements in modern physics, one finds complementarity between the different thought systems of East and West?

Appendix: On the Concept of *Qi*

In this appendix, I provide an account of the character *qi*, which appeared in the earlier sections. I am aware of the different meanings of the character as discussed at the Third Variantology Workshop (December 2006). Here, I confine my discussion to its use in the early natural sciences.

The character *qi* is an important technical term in the early development of philosophy and science in China. The character is an ideogram representing the dynamic process of transforming water into steam in cooking. Archaeological excavations revealed that using steam for cooking began very early in Chinese civilisation as indicated by the unearthed Neolithic pottery cooking vessels *yan* 甗 [steamer].[61] This suggests that an awareness of the water–steam conversion

60 I learned of this quotation during a conversation with colleagues in 1970 while I was a NODITA visiting professor in Denmark and Norway. I am indebted to the Nordisk Institut for Teoretisk Atomfysik for the visiting appointment. At the Institute, I had an opportunity to view some of Bohr's documents on his view of wave–particle duality.

61 A *yan* 甗 is composed of two vessels, a *zeng* 甑 with a perforated floor surmounted on a pot or a cauldron (often with a tripod base) and a top cover. Pottery *yan* [steamer] has been unearthed at

must also have begun very early. It was probably through this awareness that the ancients in China first realised the dynamic phenomenon of "power" transfer, exemplified by the transfer of power from fire to steam in water–steam conversion. An older version of the character is 氣, which has, within the steam radical (气), the explicit appearance of the fire (火) radical, instead of the rice radical (米).[62] This was probably one of the reasons that the character *qi* was used to denote the concepts associated with the phenomena of dynamic interactions and their abstractions. This eventually led to the idea of visualising *qi* as the mediate for the *yin–yang* interactions (see Section 2.1.4).

In the course of nearly three millennia of its use,[63] the character *qi* has acquired multiple meanings relating to concepts associated with "force", "power", "energy", "field", and "dynamic process". Its use spread widely both in the humanities and in early sciences. Consequently, the character *qi* has acquired multilayers of meanings from its use in different fields. For example, the meanings acquired by the character from its use in Chinese medicine are certainly different from the meanings acquired from its use in astronomy. To avoid ambiguities arising from different meanings of the same character in different fields, one can visualise the multilayer structure in terms of a Riemann surface. Thus, the different layers of meanings of the character can be visualised to exist on the different planes of a Riemann surface. In any case, one should always interpret the character according to the context in which it is used.

In this paper, the character *qi* first appears in Section 2.1.1, in the fifth century B.C. interpretation of the phenomena of thunder and lightning in thunderstorms. Although the meaning of the character was not well defined by the context of its use there, it is unambiguous that the character *qi* was used to represent the mediate of the *yin–yang* interaction in producing thunder and lightning. I have left the character untranslated. Readers can certainly draw their own interpretation. However, by the first to the second century, when the character *qi* was used in interpreting the phenomena of electrostatic and magnetic interactions given in Section 2.1.4, its meaning was much better defined by the context of its use there.

a number of Neolithic sites, see, for example, the Yangshao 仰韶 cultural stratum at Banpo 半坡 Neolithic site in Xi'an 西安, carbon-dated to ca. the fifth millennium B.C.

62 See, for example, the *Han-Yu Da-Zi-Dian* 漢語大字典 [Dictionary of Chinese Characters] (Sichuan Publishing House 四川辭書出版社, 1988), vol. 3, p. 2011.

63 The character *qi* 氣 first appeared in the *jia-gu-wen* 甲古文 [Shell-born Inscriptions] of the Shang dynasty.

In Section 2.1.4, I quoted the works of Wang Chong 王充 and of Guo Pu 郭璞 and analysed their interpretation of the role of *qi* in electrostatic and magnetic interactions. In their works, the *qi* is identified to be the physical attribute of the objects engaged in the electrostatic or magnetic interactions. According to their interpretations, two objects would undergo interaction over a distance if their *qi* has the interconnectivity and measurability characteristics. This explanation covered the key features of interaction over a distance; namely, how the interaction extends between the two objects and how the interaction could be initiated. Such an interpretation anticipates the modern concept of field and the term *qi* could be identified with the concept of "field". However, strong objections were voiced by some sinologists and historians of science when the term *qi* was translated as "field".

Here one encounters difficulties in translating ancient Chinese technical terms. Unlike the technical terms in the Western tradition, the Chinese technical terms suffered certain discontinuity when China made her transition from traditional to classic science. This gives rise to an impression that the old technical terms in Chinese tradition do not bear much relation to the technical terms in classic and modern science. For the technical terms in the Western tradition, the situation is different since the transition to classic science first began in Europe. There were conscious attempts to adopt, where possible, the early Greek terms to denote newly developed concepts. This gives rise to an impression of continuity from the old Greek tradition to classic and modern science.

Consider, for example, the term "atom", which in modern science stands for the smallest unit of an element that can exist either alone or in combination and is composed of electrons and a massive nucleus. The term "atom" was adopted from the ancient Greek term *atomos*. It denotes the minute indivisible particles of the universe envisioned by the ancient Greek philosopher Democritus. It seems natural for historians of science to give certain credit to the ancient Greeks for the development of the atom in modern science. For the case of "*qi*", as it is used in the electrostatic and magnetic interactions, the views of historians of science is not as generous. Yet from the point of view of physics, the relation between the Chinese term "*qi*" and the term "field" in classic and modern science is closer than the relation between the Greek *atomos* (Latin *atomus*) and the "atom" in modern science.

In fact, when the classic theory of electricity and magnetism was first introduced into Japan from Europe in the nineteenth century, the technical concepts such as electron with its negative charge and positron with its positive charge were interpreted by the Japanese scholars in terms of the

Chinese *yin* and *yang* 陽 concepts, respectively, resulting to the following translations:[64]

negative charge	*yin dian-he* 陰電荷
positive charge	*yang dian-he* 陽電荷
electron	*yin dian-zi* 陰電子
positron	*yang dian-zi* 陽電子

Technical terms such as "electricity", "magnetism", "electric field", and "magnetic field" were translated by Japanese scholars, based not on their pronunciations but on their meanings, using the corresponding Chinese characters found in early Chinese works on electricity and magnetism as follows:

electricity	*dian-qi xue* 電氣學
magnetism	*ci-qi xue* 磁氣學
electric field	*dian-qi chang* 電氣場
magnetic field	*ci-qi chang* 磁氣場

The same translations were later accepted by the Chinese scholars when the new theory of electricity and magnetism reached China.

It appeared to the Chinese scholars that such identifications by the Japanese scholars were natural and appropriate. However, adjectives such as "hallucination" and "childish" were used by Western scholars to rebut such identifications and translations by the Chinese.[65] It is probably worthwhile to examine the term "field" in physics. Although the word "field" is a Middle English word, its use in physics as in magnetic field (1845) and electric field (1889) was fairly

64 The term "positron" appeared later and is included here for completeness.

65 See, for example, James Legge, trans., *The Texts of Confucianism*, part 2, *The Yi King* (Oxford, 1899).

late. It is used there for us to better perceive how the electrostatic and magnetic interactions can act over a distance. From this perspective, there is no difference to the use of the character "*qi*" by the ancient Chinese in their investigation of electrostatic and magnetic interactions as discussed in Section 2.1.4.

Since its use in physics, the concept of "field" has been modified and enriched as our understanding of such interactions advances. In the traditional understanding, fields are perceived as forces coming from the interacting objects. Not until the eighteenth century, through the work of scientists such as Charles Coulomb (1736–1806) and Carl Friedrich Gauss (1777–1855), could the electric and magnetic fields be quantitatively pictured in terms of theoretical field lines. From the brilliant work of Maxwell, one learned that electric and magnetic fields can travel through space as waves, such as light (see Section 3.1.2). In 1905, Einstein introduced the concept of photons and visualised the travelling fields as a collection of photons. This led to the photon-exchange mechanism for the interpretation of interactions between charged particles in quantum electrodynamics (see Section 2.1.4).

Let us now examine the use of the character *qi* in astronomy in ancient China. In his account of the Huntian 渾天 sky–earth model, the well-known Han astronomer Zhang Heng 張衡 (78–139) provided in his "Hunyi Zhu" 渾儀注 [Commentary on the Armillary Sphere] the following passage:

渾天如雞子, 天體圓如彈丸, 地如雞子中黃, 孤居于內。

天大而地小, 天表裏有水, 天之包地猶殼之裏黃。

天地各乘氣而立, 載水而浮。

"The celestial sphere is like a hen's egg in which the sky is round like a spherical shell and the earth is like the yolk of the egg lying alone in the centre. The sky is large and the earth is small. The layer of sky in itself contains water. The sky is wrapping around the earth just as the shell layer wraps around the yolk. The sky and the earth, each carrying water and floating [in space], rely on *qi* to sustain [their configurations]."[66]

This passage provides a clear description that the Earth is a sphere, like the yolk of an egg, and the sky is a spherical shell, wrapping around the Earth, but in order to establish and to sustain their configurations they rely on "*qi*".

What is the meaning of *qi* as it is used here? It is apparent that here the term "*qi*" has a somewhat different meaning to its usage in the electrostatic and

[66] It is incorrect to translation the sentence "天地各乘氣而立, 載水而浮." as "The heavens are supported by *chhi* [vapour], the earth floats on the waters", see Needham, *Science and Civilisation*, vol. 3, p. 217.

magnetic interaction discussed above. To have a better sense of the meaning of *qi*, it is advisable to decipher the meaning in conjunction with its use in other texts in astronomy.

Let us examine the use of the character *qi* in the teachings of the Xuan-Ye 宣夜 [Infinite Universe] astronomical school. The Xuan-Ye teaching, as recovered from the recollections of a Han officer Qie Meng 郗萌, is found in the "Tian Wen Zhi" [天文志] section of the *Jin Shu* 晉書 [History of the Jin Dynasty] of 635. The relevant passages run as follows:

天了無質, 仰而瞻之, 高遠無極。 眼瞀精絕, 故蒼蒼然也。 譬之旁望遠道之黃山而皆青, 俯察千仞之深谷而窈黑, 夫青非真色, 而黑非有體也。 日月眾星, 自然浮生虛空之中, 其行其止, 皆須氣焉。 是以七曜, 或逝或住, 或順或逆, 伏見無常, 進退不同, 由乎無所根繫, 故各異也。

"The sky is empty and void of substance [*wu-zhi* 無質]. When one looks up at it, one can see that it is immensely high and far away, having no bounds [*wu-ji* 無極]. It is the limitation of one's eye-sight that causes the sky to appear as a vast blue. Just as if one looks horizontally at the yellow mountains at a great distance, and sees grey blue. Or as if one gazes down into a valley a thousand fathoms deep, one sees solid black. But the blue of the mountain is not the true colour, nor does the black indicate substance. The sun, the moon, and all the stars float naturally in the empty space, and their motions all need the *qi*. Thus the seven luminaries [*qiyao* 七曜][67] sometimes appear and sometimes disappear, sometimes move forward, and sometimes retrograde. Their presence does not have a common regularity and their motions are not the same. Since they are not interconnected, they each have a different behaviour."[68]

Here, we find a naturalistic account of the motions of planets in the solar system which is advanced for its time. In the text, it is explicitly stated that the motion of the celestial objects in space requires *qi*. Based on the context of its use here, together with its use in the Huntian 渾天 astronomical school quoted above, it is reasonable to associate the term *qi* with energy. It is now common knowledge that if a planet in the solar system loses its energy, it spirals into the sun. It is also of interest to note that field and energy are interrelated, since electric field and magnetic field are different forms of energy.

[67] The term *qi-yao* 七曜 refers to the sun, moon, and the five planets: *Jin* 金 [Venus], Mu 木 [Jupiter], Shui 水 [Mercury], Huo 火 [Mars], and Tu 土 [Saturn].

[68] Similar passages are also found in the Tian Wen Zhi 天文志 section of the *Sui Shu* 隋書, vol. 14, p. 5.

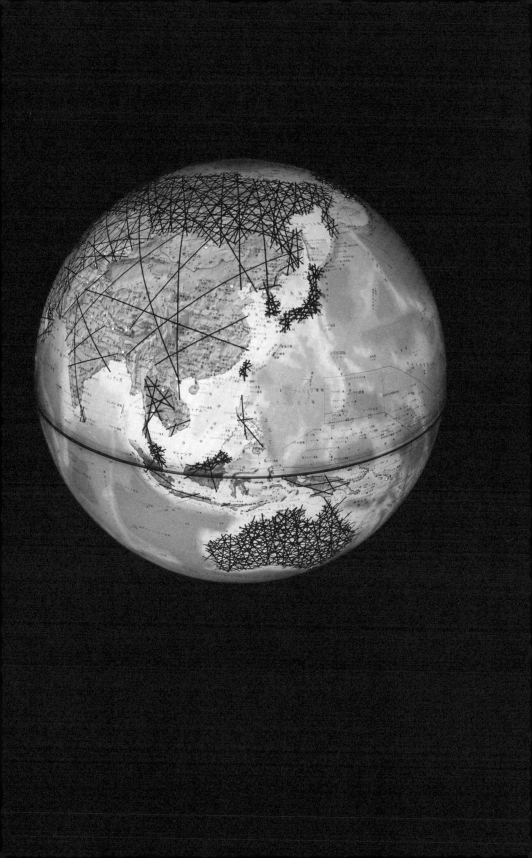

Worldprocessor [#164]

MAREILE FLITSCH

Body—Posture—Tool
Anthropological Reflections on the Depiction
of Body–Artefact Relationships
in Chinese Folk Art

For some years now, there has been popular literature on the Chinese book mar-
ket, which can be described as *Zhengzai xiaoshi de*: literature about "becoming
insignificant".[1] The subject of these mostly illustrated volumes is the disappear-
ance of hitherto familiar elements of everyday life in modern China: objects, cus-
toms and traditions, games, arts, trades, textiles, foods, residential buildings, and
characteristic idioms of local speech or dialect.

Fig. 1: A look into the mirror. HYm IX–25.

1 Books whose titles begin with *Zhengzai xiaoshi de*, are published since the beginning of 2000 in
the *Gugu Shidai tuwen xilie* 古古时代图文系列 [Illustrated texts of an epoch series] by the Gugu
Publishing House in Shanghai; cf. also Mareile Flitsch, "Zeigt her eure Füße ...". *Das neue China* 1
(2003): 29. A further book series has the title *Jijiang shiqu de shenghuo* 即将逝去的生活 (Vanishing
everyday life) and is currently published by the Chinese Tourism Publishing House (*Zhongguo lüyou
chubanshe*).

Among the vanishing art forms cited is paper-cutting.[2]

Paper-cutting in rural areas, in particular, is today a deeply non-synchronous art. Layers of time and elements of knowledge co-exist, whose handing-down, amid consumer orientation and school education, amid the mechanisation of everyday life and the decline in the daily household competence of women, is becoming obsolete. The transformation of this folk art from a multi-layered medium of social, religious, ideological, and individual content into a mere wall decoration, a commodity, is taking place insidiously. Contemporary collection campaigns and pronounced public interest in the art will not stop the process:

"It remains to remark that folk art may have more to fear from admirers than from those that denigrate it. Through seeking to save it artificially, we may destroy its flavour and originality, its very roots and style, and reduce it to a caricature of itself—a caricature with an appeal for hurried travellers only."[3]

Paper-cutting in Everyday Life in China:
The State of Research and Documentation

For some years now, an extensive body of Chinese and non-Chinese literature has been devoted to the art of Chinese paper-cutting, in which its diversity is extolled time and again:

"Paper-cutting constitutes an unrivalled museum of living cultural fossils. [...] The art originated from the patterns on clothes worn by the ancient Huaxia tribes (ancestors of the Chinese nation) in the valley of the Yellow River, is a living fossil of a totem-worshipping culture. [...] As a whole, the art of paper-cutting created by woman workers is a reflection of Chinese philosophical ideas, cultural awareness, and Chinese indigenous philosophy."[4]

Today, thanks to the Chinese folk art research led by academics such as Jin Zhilin and Pan Lusheng, we know a great deal about the history, techniques, forms, and functions of paper-cutting. Researchers have investigated the various regional styles of paper-cutting and have classified them. Much

2 Gu Yan, *Zhengzai xiaoshi de yishu* (Shanghai, 2001), p. 174.

3 Jacques Pimpaneau, Introduction, in: Jin Zhilin, *L'esthétique de l'art populaire chinois* (Paris, 1989), pp. 1–12, here p. 12.

4 Jin Zhilin, Preface, in: *Life and Arts of Folk Paper-cutting Genius Inheritors in China*, ed. Qiao Xiaoguang (Taiwan, 2004), pp. 7–8, here p. 8.

has been written about the religious content of paper-cuts, their function as a type of amulet, the religious motifs preserved in them, and their use in healing rituals. Over and above that, it is well known that paper-cuts in China are a medium in which motifs from popular and folk literature, proverbs and sayings, homonyms, lucky symbols, and much more are transmitted through time.

"Anonymous and without claim to realistic portrayal": Consequences of a Specific Point of View

In the course of the research on and documentation of paper-cutting, two opinions on the art have become established which, in the face of our current state of research, require reconsideration. One is the view that folk art is a collective art:

"Genuine folk art is anonymous. [...] The folk artist seeks neither to innovate nor to imitate, but simply to preserve a high, old tradition", wrote Pimpaneau as late as 1989, in accord with most of his colleagues, including his colleagues in China.[5]

The other point of view which we encounter time and again is that the form of composition used in paper-cuts follows an aesthetic other than that of reality:

"The perception of reality of these 'paper-cut artists' is quite specific also. [...] they seek to conjugate the different significant elements regardless of whether these may or may not be simultaneously visible to the normal observer. Folk art, more perhaps than any other art form, has no concern for reproducing reality as we see it or might see it, but seeks with total disregard for visual realism to make that reality as meaningful as possible."[6]

Correspondingly, for a long time paper-cuts were collected without supplementary information, often without even the name of the artist. They were chosen for collections according to aesthetic aspects, arranged according to major themes, given short, concise titles; "Happy Rabbits", "On a Long Journey", "A Monkey Playing with a Tiger", and "Herding Sheep" are examples of these insipid titles.[7]

5 Pimpaneau, Introduction, in: Jin, *L'esthétique*, p. 9.

6 Ibid., p. 10.

7 Qiao Xiaoguang, ed., *Life and Arts of Folk Paper-cutting*.

Research became aware relatively late that this restricted point of view was a problem. Today, the new perception of folk art as local *and* individual art makes this field extremely exciting. Perhaps we have UNESCO to thank for this; the importance which UNESCO attaches to this filigree heritage in China had led to the circumstance that now even the biographies of the artists (both men and women) are presented.[8] Nevertheless, despite all efforts and progress, established art is still so much to the fore that the artists are still barely visible as individual personalities. Passages, such as the following one, at the end of a portrait of the peasant Gao Fenglian from Yanchuan in Shaanxi speak for themselves:

"Her paper-cutting is unique in style. It includes not only rugged and simple rural connotations and mysterious primitive meanings, but also restive vital energy as expressed in the idea of Yin and Yang. In 2000, at the China Exhibition of Paper-cutting in the Past Century, her work "Episodes in Northern Shaanxi" won a special award and was collected by the China National Museum of Fine Art. Pursuit of arts is not easy and she will not give up."[9]

In this way the zeal to collect and document folk art—which today, incidentally, often reaches high prices on the art market—leads to a range of essential aspects of paper-cutting being overlooked.

Observations on the Relatedness
of Paper-cutting to Biography

More than twenty years ago I began to be interested in folk art as a part of the daily handing-down of practical everyday knowledge in China. I have made the experience repeatedly that the personal relationship between peasant women and the motifs of their paper-cuts is more multi-layered than is assumed in the literature on the subject.[10]

8 Ibid.

9 Ibid., p. 519.

10 Deng Yanfang, for example, described in 1990 a total of thirty paper-cuts by her illiterate mother, who, with the help of paper-cuts, explained the events of her life. The name of the old lady is not mentioned in the article and her paper-cuts were later anonymously reproduced elsewhere; Mareile Flitsch, Papercut stories of the Manchu woman artist Hou Yumei. *Asian Folklore Studies* LVIII-2 (1999): 369.

About twenty years ago, in the province of Jilin, I encountered the peasant Hou Yumei.[11] When her children were small, Hou Yumei cut out for them in paper objects and scenes from her own life, family history, and the history of the Manchus, to whom she considered herself as belonging. This she had inherited from her mother. In addition, Hou Yumei reported that in her case, a series of pictures would virtually come into being in her head, how she then sat down with paper and scissors and the pictures in her head then "flowed" via hand and scissors into the paper. When this happened, she would shut herself away. Any disturbance interrupted her creativity and frustrated her. She cuts, said Hou Yumei, as if in a trance.

If one engages with the biographical elements in paper-cuts, it quickly becomes clear that they are self-evident and a matter of course. Thus paper-cut motifs can easily be read differently. In one and the same motif—beyond all stylistic similarities of local motifs, there is always the specific creation of a peasant woman—people recognise motifs from folk literature and/or particular experiences from their own lives. If one reads paper-cuts from this perspective, it becomes clear that in their paper-cuts, the artists also position themselves in the world. Moreover, shining through in their portrayals in so many diverse ways are the references to practical, rural everyday knowledge, so that one can speak with complete justification of paper-cuts as a mirror of individual repertoires of knowledge. Thus the question ought to be: which kinds of knowledge are stored in paper-cuts?

When trying to discover autobiographical traces in the comprehensive literature on paper-cutting, one can indeed occasionally find what one is looking for. Taking the book *Zhiren ji* (Notes on paper figures) by the artist Guo Qingfeng as one example, and aspects of the portrayal of rural labour and of spatial orientation of the body in paper-cutting as another, the following demonstrates that looking at paper-cuts with regard to biographies and to both individual and local repertoires of knowledge can be a much more valuable approach.

The artist Guo Qingfeng is probably not well known outside of China. Born in the province of Shaanxi in 1967, he belongs to a generation of artists and intellectuals who grew up during the Cultural Revolution, and when the economic reforms began in the early 1980s, he was forced to totally re-orient himself. At the age of twenty-two, Guo went on a trek along the Wuding River, which flows into the Yellow River, and began to be interested in folk culture. He later studied

11 Mareile Flitsch, Manjurische Scherenschnitt-Erzählungen. *Deutsche Gesellschaft für Ostasia-tische Kunst. Mitteilungen* 6, (1994); Flitsch, Papercut stories.

Fig. 2: The cover of Guo Qingfeng's book Zhiren ji.

painting, and today works as a professional artist. In his artworks, as well as in his academic papers, Guo Qingfeng analyses the folk culture of the Loess Highlands in north-western China. He is involved in the research, documentation, and preservation of this cultural heritage and warns urgently about the consequences of its loss.[12] In his book *Zhiren ji*, Guo Qingfeng links the richness of Chinese folk culture with the personal fates of the individuals who produce it. By doing so, he opens his eyes to the autobiographical references in folk culture.

12 Guo Qingfeng became well-known through activities such as the award winning project *Qian-jia xiu* 千家绣 (Embroidered by a thousand families). The embroideries, whose motifs were designed by living peasant women from along the Yellow River, were made into a 350-metre-long patchwork quilt. Cf. http://www.shanghaiview.com/en_detail.php?Log_1d=114 (26.02.2008).

Example I: Memories of Pain:
Cao Xiuying and Her Paper-cuts

Anyone born as a girl in the Loess Highlands in Shaanxi in 1929 would only be lucky if born into a well-off family, a family with enough sons, and in a part of the region spared the turmoil of war. Apart from anything else a girl might suffer the fate of foot-binding or being a child bride, and certainly that of forced marriage. Cao Xiuying, who was born in 1929 in the mountain village of Caojiashan on the River Huai in the municipality of Laojundian in the Zizhou district, had more bad luck than good. After a short and happy childhood, she experienced the early loss of her father, was sold by her stepfather, forced to beg and, finally, was sold into a forced marriage to a man older than herself. The marriage was childless.

In her paper-cuts, Cao Xiuying depicted scenes from the history of her life. She used motifs that were handed down from mother to daughter and thus renewed, "re-grown", each generation. Cao Xiuying's mother taught her to always look at the world as though she was cutting it in paper. "The way that the scissors both destroyed and formed the paper, she was not aware of at the beginning. But later she felt like a sheet of paper herself. She experienced a deep pain at being cut up and cut to a pattern". As soon as she took the scissors in her hand, Cao Xiuying cut "her internal world in paper".[13]

One paper-cut was of a soldier, a motif which, in the time in which Cao Xiuying was born, embodied both fear and hope. Riding out of the picture, hurrying away or hurrying past, the absent-minded posture, the serious look: all personified Cao Xiuying's numerous war experiences, as well as the loss of her father, who left her in order to become a "Red" soldier. For three years the family received no news of him. In this as in so many other cases it was accepted that he would not come back. In contrast, a self-portrait paper-cut depicts the artist as a child riding on her goat. The cuts are similar, but the body's posture and facial expression could not be more different.

The loss of her father was dramatic for Cao Xiuying in every respect. He left to his parents "only" a daughter-in-law and her two daughters, and thus no male heir. Cao Xiuying's mother was married off to a man in the village of Yunyan in the Yichuan district. This man could not or did not want to keep the two young girls in his house, and insisted that Cao Xiuying, who was then ten years old, be given to her mother's younger sister.

13 Guo Qingfeng, *Zhiren ji* (Shanghai, 2006), p. 54.

Fig. 3: A soldier, in: Guo, Zhiren ji. (Shanghai, 2006), p.52.

In reality Cao Xiuying was sold by her stepfather. Her aunt and her aunt's husband were involved in the opium trade, were themselves opium addicts, and made Cao Xiuying go begging for them. During the attacks by the Japanese army, the young Cao Xiuying experienced terrible things. She was frequently left alone by her aunt and uncle, and was so cold and hungry that she thought she saw ghosts. A second paper-cut depicts an old woman with a walking stick and a second figure, Cao Xiuying herself. In the image of this old woman, still with bound feet, who could only laboriously move about with a stick, and who saved Cao Xiuying and took care of her for a time, both pain and hope are portrayed. Further, the paper-cut is also a memorial to the practice of foot-binding with its attendant severe curtailment of physical activity, which was mandatory up to and beyond the generation before Cao Xiuying's. A further paper-cut by Cao Xiuying combines the positive folk-literature motif of the rescuing dog with another experience from her own childhood. The approximately 11-year-old girl flees one day to a dog where, snuggled up to the animal in its den, she finds an unforgettable sense of warmth and security.

Finally, Cao Xiuying was sold to a man seventeen years her senior to whom she was officially married at the age of thirteen. The marriage was unhappy

Fig. 4: Cao Xiuying hiding in the dog hole, in: Guo, Zhiren ji. (Shanghai, 2006), p. 62.

and childless. A positive outcome of her marriage was that a strong relationship developed between Cao Xiuying and her mother-in-law, who, herself much in demand in the village as a person skilled in folk art, supported Cao Xiuying's talent for paper-cutting. Never, according to Cao Xiuying, did she work so much with paper and scissors as she did in the years of her unhappy marriage. After the death of her mother-in-law, Cao Xiuying took her place as *huajiang popo*, the village's "old master of the paper flowers".

When her husband died in 1982, Cao Xiuying buried him in due form. She left the village in 1985 and moved to the village of Hujiahe to be together with a man who "could read a few characters". A fourth paper-cut depicts Cao Xiuying in one of the frequently encountered motifs in the art of northern China: a woman lighting her husband's pipe.[14]

14 Guo Qingfeng, *Zhiren ji*, pp. 52–65.

Fig. 5: The old couple, in: Guo, Zhiren ji. *(Shanghai, 2006), p. 65.*

Example II: Li Yu and Her *zhiren* "Paper People" as Mediators with Other Worlds

The peasant Li Yu, born around 1917, epitomises the well-known belief, which exists in many regions of China, in mediators or ambassadors between the living and the worlds of the souls of the dead. Mostly mentioned in connection with the ritual of *zhaohun*, "to summon the souls", this corresponds to the proven existence of "mediums" in very early China—a kind of vocational calling of metaphysically gifted people for carrying out healing rituals and divining.[15]

In an impressive chapter, Guo Qingfeng describes the peasant Li Yu, who cuts out her paper mediators with other worlds with her hands. She is part of a long tradition of popular religious rites and beliefs—with elements of northern Chinese shamanism—in which paper-cuts have a key function.

15 Jin Zhilin, L'esthétique, p. 19; Jin Zhilin, Zhonghua minzu de baohushen yu fanyan zhi shen
– Zhuaji wawa (Beijing, 1989), pp. 4–6.

Li Yu is the only daughter of a *yinyang*, a healer and seer named Li. When travelling at night, it was said that Li always cut four paper people out of hempen paper—the material that must be used in matters concerning demons (*gui* 鬼)—murmured some magic formulas, blew once, and then four demons carried him the rest of the way. As soon as he arrived at his destination, he folded up the paper people and put them in his pocket.

Her father had practised this art in the third generation, and it was clear that his daughter, who suffered from an imprecisely described mental illness from birth, would not be allowed to continue his calling. After three generations, this would have brought disaster to the fourth.

Her father left his daughter just a pair of scissors. Li Yu's mother told her that, after the death of her parents, she would only have the possibility to contact them through paper. Therefore, after her father's death, Li Yu began to cut out paper people with her scissors. A breath of wind made one of the figures stand up, and Li Yu had the feeling that her father was standing next to her.

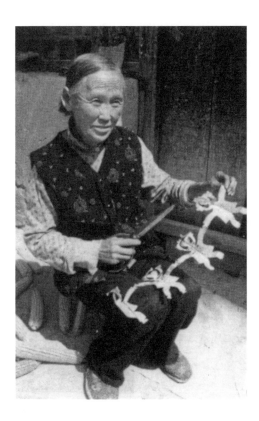

Fig. 6: Li Yu and her paper figures, in: Guo, Zhiren ji. (Shanghai, 2006), p. 195.

Through paper and scissors, Li Yu had made contact with the souls of both the living and the dead and she has been cutting paper people ever since—in 2003 she was eighty-six years old. Because of her slight "madness", she is considered particularly effective at holding all types of healing rituals.

As can be gathered from Guo Qingfeng's account Li Yu differentiates between the types of paper she uses according to quality. Yellow paper is for spirits, and hempen paper for demons—one must not confuse the two. Handmade paper, which is made from remnants of textiles and paper scraps boiled up to a paper mixture, then formed and dried on the wall, Li Yu regards as a special mixture. It is special because of its material origin in its everyday use by people, and thus its elements are socially charged which, as fluff, dissolves in liquid. In the process of these tufts aggregating and being scooped up, for Li Yu numerous roads are structured—this we also know from other sources: "That is why one can, by means of this kind of paper, both leave the world of spirits and cross over the border into it. The colour of the paper, on the other hand, decides about birth and annihilation as well as about the direction of the roads". Thus each type of paper has its own characteristics. In reality there is only a very thin layer of paper between the worlds of *Yin* and *Yang*. If scissors cut paper into the form of people, then the border between *Yin* and *Yang* is cut in two and another world is cut open. The paper people are sometimes just vessels, they are just houses.[16]

By means of this knowledge, Li Yu creates in her paper-cuts the types of roads by which she leads the souls, spirits, and demons back into their own worlds. Every cut in her paper offers Li Yu a view into another world, contact with her deceased, and advice as to the course of action for a healing. When she does not know what to do in a particular matter, she first cuts a slit in the paper. By doing so, the world opens and she finds a solution:

"Before the cutting of the paper, in the eyes of Li Yu the paper is, regardless of whether it is white or red, a still unknown world. She is in the position of being able to seriously and conscientiously cut herself into it, and that which she allows to become visible to us, is a mysterious and vast history in space. She measures the *hun* and *po* of your soul, cuts a paper person for you, and when she burns it, it takes the pain out. Her scissors are her authentic experience with the world."[17]

Li Yu told Guo Qingfeng about a case, which is cited many times in a similar way in the literature on the subject; for example, in Jin Zhilin. A schnapps

16 Guo Qingfeng, *Zhiren ji*, p. 182.

17 Ibid., p. 197.

demon pursued a drunken young man in the village who, as a result fell ill. With the help of a paper person and a formula, she lured the schnapps demon into the paper, burnt it, and by immersing the paper, locked him into a bowl of water. She then had someone empty the bowl of water at a crossroads. After she had sent the lost demon back to his own world in this manner, the young man recovered quickly.

The crossroads is an important place in Chinese folk religion, a type of multiple crossing-place for people, souls, spirits, and demons. According to Li Yu, the four directions that people see at crossroads are not the only possible directions. There are many more that lead upward, downward, and in other directions, which people of this world cannot see, except for such people as her father, her grandfather, and her great-grandfather. The people of this world take the visible roads; other beings take the others. Li Yu regards it as her task to help direct the right souls, spirits, and demons to the right paths, and thus to re-establish the conditions that are necessary for the cure of suffering.

Li Yu's knowledge, according to Guo Qingfeng, only survived because her village was so remote that even during the Cultural Revolution it was totally forgotten. Additionally, it was preserved because of the lack of medical care: the villagers had nothing else except the belief in skills such as those of Li Yu.

The Work of Peasants and the Spatial Orientation of the Body in Paper-cuts

The references to life in Cao Xiuying's paper-cut motifs demonstrate that conventions in the portrayal of people also express the physical experiences of the artist. Expressed in the motifs is a sensitive physical portrayal of emotional states, for example, in the image of the mounted soldier, the child lying next to the dog, or the old woman lighting the pipe.

The physical form of Li Yu's paper people derives from a knowledge level which is not that of physical knowledge of everyday life. The rigid posture of the spirits—which artists like Li Yu internalise in the end because they memorise them through cutting—and their raised or open hands must be understood in reference to a religious iconography, which is investigated, for example, by Eleanor von Erdberg in her 1987 article "Hand and Gesture in Chinese Art".[18] In her paper-cut stories, as I have pointed out elsewhere, Hou Yumei makes use

18 I should like to thank Ingo Nentwig for information about this publication.

Fig. 7: In Hou Yumei's Paper-cut stories, spirits depict the shapes and gestures of Li Yu's paper figures. HYm VII–2.

of the Manchurian counterparts of the paper people, the *mamaren*, to differentiate between the spirits and the people in the picture.[19]

Therefore, it is not surprising that the peasants' knowledge as a whole flows into the paper-cuts, which must be understood as embodied knowledge. Further, time and again the artists use motifs of what concerns them on a daily basis, that which their hands coordinate when they are not working with paper and scissors. This embodied knowledge, which the artists have learned and internalised in the course of their lives to cope with daily life, can be read in their paper-cuts. Thus it is also not surprising that in paper-cuts space is made for innovations in everyday life; a circumstance which renders them an

19 Flitsch, Papercut stories (1999), here 367–368. The meanings of the gestures and body postures of the paper people have, to my knowledge, not yet been researched. A glance at Jin Zhilin's 1989 work about the *Zhuaji wawa* figures shows how interesting this would be.

interesting indicator of how new knowledge is integrated into the repertoire of everyday life.[20]

Tragically, the situation described above where paper-cutting is perceived as anonymous and an art that takes no pains to be realistic, has the result that in collections, scant attention is paid to the fact that this kind of paper-cut reflects the practical everyday knowledge of their artists. They were either hardly collected at all or they vanished behind generalised titles in published anthologies. Without informants, the reconstruction of what is portrayed in such paper-cuts is difficult.

The *Kang* in Paper-cutting

Encountering Hou Yumei and the way she tells stories with paper-cuts is a stroke of luck for research. By taking this example, it is possible to demonstrate some characteristics of the notions of body posture embedded in paper-cutting.

Hou Yumei comes from Tonghua in the province of Jilin. In this region in the south of Jilin many different peoples—Koreans, Manchus, Hui, and Han Chinese—live side by side. Hou Yumei believes herself to be a Manchu, a fact which explains the elements and stereotypes of Manchurian identity such as clothing, headdresses, the men's pigtails, and certain gestures in her paper-cuts.

Characteristic for the region in which Hou Yumei lives is the use of the *kang*,[21] a heated platform for living and sleeping use by all the peoples of northern China. The *kang* is an essential component of the living space as well as a socio-technological orientation in everyday life.[22] Hou Yumei grew up on such a *kang* herself, and so her paper-cut figures also sit on a *kang*.

The kang is technically a closed incinerator. The oven's waste heat circulates through the *kang*'s interior cavity and warms the inner walls and top of the *kang*. The smoke and last remaining heat are channelled to the outside through a flue or chimney.

20 Cf. Jin Zhilin, *L'esthétique*, p. 121, "The Byre" with a complex depiction of the circadian rhythm of cattle feeding, and p. 155, "The Apple Trees" on a new technique of planting fruit trees.

21 Cf. Mareile Flitsch, *Der Kang. Eine Studie zur materiellen Alltagskultur bäuerlicher Gehöfte in der Manjurei* (Wiesbaden, 2004).

22 The differences in the *kang* cultures of the various ethnic groups are only briefly touched upon here.

5. 财迷进屋后，对姐姐说："姐姐，参室这么大了，让他跟我去放山，来许挖着大货(太人参)，您娘俩的日子也会宽裕些"。

Fig. 8: Inside a Manchurian house. The hero of the tale, his mother and her younger brother are depicted sitting on the wooden edge of the kang. To the left, cushions and bedclothes are piled on a low wooden closet. A small kang table with a lamp stand is behind the kang. The mother's brother has taken off his shoes and placed them in front of the kang. HYm I–3.

It is important to know that in China there are regional variations in *kang* technology. The *kang* in the cave houses of the Loess Highlands in Shaanxi is a coherent structure, similar to a heatable bed and independent of the other structures in the house, whereas the *kang* in northern and north-eastern China is a sort of heating axis, with the stove in the kitchen, the actual *kang* in the living area, and the chimney outside the house. Thus the *kang* itself has both a warm and a cold end. As a result, a dichotomous space is characterised in which—not least as a consequence of the extremely cold winters—the whole of everyday life takes place. The development of temperature in the *kang* is essential for domestic work. People depend upon its heat: the housewife germinates cereals on it, nurses children and old people on it, lets ducks' and hens' eggs hatch on it, feeds up young animals on it, lets the dough rise and food ferment on it, and, in addition, uses the sunlight that falls on the *kang*'s mat to dry textiles. Cooking a meal or just boiling water for tea for guests heats up the *kang*, whether intended or not. A strong gust of wind down the chimney can cover

39、推门进屋一看、娘亲躺在冰冷的炕上、紧闭着双眼、已经剩下一点点气了。爹亲泪如雨下、哽咽着、哭叫着:"娘亲、娘亲、我回来了、您醒醒啊……!"

40、无论怎样喊叫、娘亲就像死去了一样、爹亲忽然想起爹姑给的药、忙拿出来给娘亲倒进嘴点、又往眼睛里倒点、娘亲一点点把眼睛睁开了。

Fig. 9 and 10: On returning home the son finds his sick mother lying on the cold kang. *He takes out his medicine and cures his mother's eye disease. (HYm I–39, 40).*

the living area in soot. Consequently, the *kang* axis is an object of permanent consideration, of concern about supplies of heating fuel, or unplanned progressions of temperature.

In all of China's *kang* regions, the *kang* is portrayed in paper-cutting. In contrast to paper-cuts from the Loess Highlands where the *kang* is shown as a small area, in paper-cuts from north-eastern China the *kang* frequently dominates the picture. Even when it is not explicitly indicated or depicted, the *kang* is so internalised by the people of the region they recognise that the *kang* area is meant by the sitting posture of a woman, or simply by a particular accessory. Details depicted in paper-cuts include, for example, the recess for storing one's shoes before climbing onto the *kang*, on which one moves about carefully and barefoot. Mats appear in paper-cuts upon which people lie in the correct position. As mentioned above, there is both a warm and a cold end to the *kang*. In paper-cuts cushions mark the head end of the *kang*, an oil lamp the time of

Fig. 11: *The rich man lying on his* kang *dreams of becoming wealthier. The cat indicates the warm side of the* kang.
HYm VI–23.

208

day. Decorations on the walls of the *kang* indicate the occasion for the depicted scene, for example, the character for double happiness/luck stands for a marriage. In short: without knowledge of the local technology and utilisation of the *kang*, it is virtually impossible to interpret the paper-cuts.

Conclusions

What kinds of knowledge are thus stored in paper-cuts and what knowledge will be lost if the predictions are correct?

The phenotypic disappearance of distinctive cultural features due to the accelerating rate of change in everyday life in China frequently only marks the end of a long process of fundamental genotypic change. To possess precise details about the knowledge that is represented, transported, and handed down through cultural features, such as everyday objects, customs and traditions, games, arts, handicrafts, textiles, food, and local characteristics of speech, is essential for understanding the how processes leading to the loss of cultural competence, to de-skilling, proceed. This is the focus of my own research interests, and I am convinced that slumbering within this topic are important insights into China's socio-technical transformation in the twenty-first century. If one understands paper-cutting as a mirror of repertoires of knowledge, then one also recognises them as a sensitive medium for documenting change.

In 1989 Pimpaneau sharply criticised the consequences of the loss of folk culture:

"Uprooted from its native spiritual soil, it becomes just one more sales product to be used, like traditional paintings, for decorating the walls and head-scarves of the illiterate."[23]

Guo Qingfeng comes from the province of Shaanxi. He is an artist and, as such, is deeply impressed by the folk art of the region. This also finds expression in his own art. Thus it appears justified to ask whether Guo Qingfeng is simply satisfying a personal passion or whether there is a vision behind his endeavours to protect rural Chinese folk art.

After reading his book and some other texts, one has the impression that Guo Qingfeng is not primarily interested in the close relationship of folk art to the portrayal of practical everyday knowledge in the art objects themselves.[24]

23 Pimpaneau, Introduction, pp. 6, 12.

24 In the meantime, in the rural regions of China in which urbanisation is already under way, a

Guo Qingfeng appears to be searching for something quite different: the roots of Chinese cultural identity. He is interested in the processes of fundamental change—above all, with regard to the loss for the future orientation of China—which is linked to the disappearance of this cultural heritage, which he sees as originating in an ancient autochthonous Chinese culture. At the end of his chapter about Li Yu, which is also the last chapter of his book, Guo Qingfeng formulates somewhat enigmatically his idea of what could be learnt by China from the art of the people of the Loess Highlands. According to Guo, for the modern person paper is merely a material in different colours, which can only lead them back to the places where it was manufactured, to the factory or the firm:

"These are places where one can perhaps work intensively, but they are places where the power of the imagination will always be lacking and where one cannot be conscientious. At such crossroads, even when they are three-dimensional crossroads linked with one another in the form of the character *mi* 米, we shall not be in a position to find the way back home."[25]

Translated from German by Jim Sullivan

semi-professional paper-cutting art has developed which, at first glance, appears disconcertingly more perfect than the rural paper-cuts that this article is concerned with. What is shocking about this old–new art of paper-cutting, is the stereotyping of everyday practical behaviour as well as the loss of the formerly naturally cut spatial references and the density of motifs.

25 Guo Qingfeng, *Zhiren ji*, p. 197.

INGO GÜNTHER

U (Segment Yokohama)

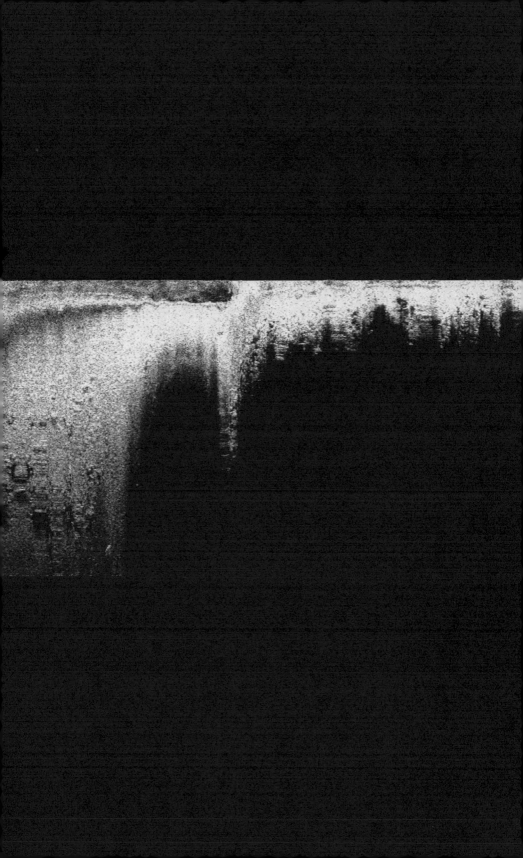

"U" refers to "under water" as in U-boat. Using advanced imaging sonar Ingo Günther has recorded underwater phanomena since 2005 at various depths and locations around the planet. "U" was first shown as a 2-hour long movie at the Yokohama Triennale, Japan.

Sonar technology is similar to the more familiar ultrasound imaging technology commonly used in medical diagnostics. Essentially, a continuous high frequency sound is transduced in the water and the resulting echo is recorded by a sensor next to the transducer. Pulse by pulse, slices of what becomes a sound image, are recorded. Commercially so-called Sonar Side Scanners have been used for ocean floor mapping and exploration as well as rescue and recovery operations. The resonance and density of the water and objects reflecting sound registers in different shades of grey. The long continuous black and white images are the result of endless hours of underwater scanning of the Yokohama Bay, where Admiral Perry landed about a century and half ago forcing the Japanese to end their self-imposed isolation and awoke a country from its sleep—changing the global balance forever. No traces of objects or formations that can be attributed to that event were found.

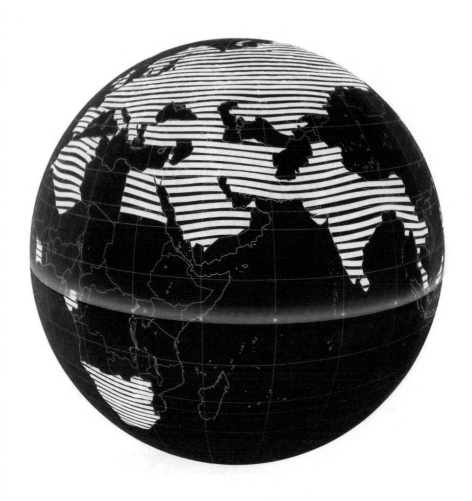

Worldprocessor [#255]

DAGMAR SCHÄFER

Ganying—Resonance in Seventeenth-century China: The Examples of Wang Fuzhi 王夫之 (1609–1696) and Song Yingxing 宋應星 (1589–ca. 1666)

"Bringing things very remote, and independent on one another, into one view, the better to contemplate and discourse of them, united into one conception, and signified by one name. For there are no things so remote, or so contrary, which the mind cannot, by this art of composition, bring into one idea; as is visible in that signified by the name universe."

John Locke, *An Essay Concerning Human Understanding.*
Book II, Chapter XXIV, 3, Of Collective Ideas of Substances

This chapter engages with the difficulty of interpreting scientific knowledge beyond terminological translation and with the issue of "concept formation".[1] In modern psychology a concept is understood as a mental category to identify objects, events, or ideas in relation to others.[2] The idea of modern science ultimately relates to the notion that things and affairs can be grouped together to form a class of ideas or objects with a set of common features or attributes.

1 Carl Gustav Hempel, *Aspects of Scientific Explanation* (New York, 1965), and *Fundamentals of Concept Formation in Empirical Science* (Chicago, 1972); see also Richard Bevan Braithwaite's viewpoint as published in *Scientific Explanation* (Cambridge, 1953).

2 For a more sophisticated tripartite definition of concept see Charles Kay Ogden and Ivor Armstrong Richards, *The Meaning of Meaning* [1923] (San Diego, 1989), and, more directly, Giovanni Sartori, Guidelines for concept analysis, in: *Social Science Concepts*, ed. G. Sartori (Beverly Hills, 1984), p. 22. On conceptual change through history, see Terence Ball, *Transforming Political Discourse. Political Theory and Critical Conceptual History* (Oxford, 1988); and on the framing of information regarding concepts and classification ideals, see *Knowledge, Concepts, and Categories*, ed. Ken Lamberts and David Shanks (Cambridge, MA, 1997).

Despite the fact that the sciences present these features and their relation to others often as of universal validity, as a mental category and in its historical genesis a concept is subject to cultural and local specifics at a given time. Conceptual agreement underlies each grouping as to what defines commonality and the relationship among items of interest.

A concept that brought things very remote, and independent of one another, together in pre-modern Chinese scholarly understanding was the notion of *ganying*. *Ganying* identifies a structural relationship in a cosmological approach that identifies all things and affairs as part of an isomorphic entity. Charles Le Blanc's research on the *Huainanzi* 淮南子 [The Book of Master Huainan],[3] an early third-century text that gives voice to various schools of thought, emphasises the centrality of *ganying* in pre-modern Chinese thinking. Taking Charles Le Blanc's research results, I ask how later generations applied *ganying* to make sense of a huge range of things and issues. Specifically I refer to approaches by the seventeenth-century thinkers Wang Fuzhi 王夫之 (1609–1696) and Song Yingxing 宋應星 (1589–ca. 1666).

The seventeenth century was a period of great social and political upheaval that saw the fall of the Chinese Ming dynasty (1368–1644) and the rise of Manchurian Qing rule (1645–1912). The two scholars that my investigation focuses on were trained for official careers, but never took up their respective positions. Song Yingxing failed the metropolitan exam several times and had little chance of pursuing an official career even before the fall of the Ming. Wang Fuzhi's career was disrupted by the Manchu conquest. Both scholars belonged to the constantly growing stratum of highly educated, but somewhat "redundant" intellectuals—people who were in search of ideals and ideas that would give them an eligible place in society. The two scholars also shared other common ground: both based their philosophy on *Qi* and both were critical of orthodox political and philosophical ideals. In this case orthodoxy refers to the actual Ming dynastic implementation of Cheng-Zhu Neo-Confucianism, and especially its application of the *tianren ganying* paradigm as opposed to the original Song Dynastic school of thought.[4] I suggest *ganying* became an important

3 Charles Le Blanc, *Huai-nan Tzu: Philosophical Synthesis in Early Han Thought. The Idea of Resonance (Kan-Ying)* (Hong Kong, 1985).

4 I here refer to Ming dynastic reflections on the *Taishang ganying pian* 太上感應篇 [Chapters on Action and Response According to the Most High] [Lord Lao]: DZ 1167. Abbreviated as *Ganying pian* 感應篇, one of the most famous morality books (*shanshu* 善書), believed to be a revelation of Taishang laojun 太上老君 [Great High Lord Lao]. The text emphasises the supreme ability to reward and punish combining Confucian ethics with Buddhist concepts of karma and Daoist beliefs

point of argument for both thinkers, Song Yingxing and Wang Fuzhi. They applied the concept of *ganying* to explain action and reaction on more practical levels: Song Yingxing, who was interested in technical issues, admits resonance to his approach to verify the world as one in *Qi* via a survey of sound phenomena. The polymath and poet Wang Fuzhi based his art and literature theory on resonance, making it a central topic in his philosophical discourse on the interaction between an objet d'art and its observer.

Despite the disparate context in which the two authors applied *ganying*, my contribution stresses that both proceeded from the same basis and with a similar purpose in mind. A major point of their critique was the fatal effect that the orthodox moral concept of the mutual resonance between heaven and humankind (*tianren ganying*) had on the essential notion of resonance as a working principle. Both attempted to resurrect the cosmological roots of resonance, and in this way substantiate its ultimate validity.

The Concept

> When shameless sounds affect people, their rebellious *Qi* responds to them;
> the rebellious *Qi* manifests itself and thus licentious music arises.
> When correct sounds affect people, their obedient *Qi* responds to them;
> the obedient *Qi* manifests itself and harmonious music arises.
>
> (*Yue ji*, 579).

The search for relationships that remain effectively constant within the complexity of change and transformation in our environment plays an important

in longevity and immortality. It re-gained importance among educated merchants and intellectuals during the early and mid-Qing period. Translated by James Legge, *The Texts of Taoism* 2 [1891] (New York, 1962), pp. 235–46, and by Frederic Balfour, *Taoist Texts* (London, 1894). Daisetz Teitaro Suzuki and Paul Carus, *Treatise on Response and Retribution*, [1906] (La Salle, 1973). More recent translations are by Eva Wong, *Lao-tzu's Treatise on the Response of the Tao* (San Francisco, 1994). For its role during the Late Imperial Period I refer to Cynthia J. Brokaw, *The Ledgers of Merit and Demerit. Social Change and Moral Order in Late Imperial China* (Princeton, 1991).

role in the human quest for knowledge. What causes things to happen and what ties them together? For Chinese intellectuals *ganying* was part of this discourse. Basically *ganying* is part of a cosmological approach that sees all things and affairs as part of an isomorphic structural entity. Construing phenomena as sensitive, perhaps perceptive in a rudimentary sense, it stresses the interdependence of things in that those things and events/phenomena are identified as parallel with respect to their forms and with affinities between their *Qi*. As such *ganying* is a working principle and provides a model to perceive, explain, and define all kinds of things, phenomena, and events, and the properties or attributes that define these things (the intention, connotation, or definition) in relation to each other.[5] The importance of relational definition is also evident in Charles Le Blanc's analysis of the idea of resonance in the *Huainan zi*:

"As a preliminary definition, the idea of resonance means all things in the universe are interrelated and influence each other according to pre-set patterns, so that interaction appears as spontaneous and not as caused by an external agent. The idea of resonance thus plays the role of a cosmological principle, that is, a rational device with which to understand the universe as a totality, man being part of that totality."[6]

Le Blanc's definition stresses another important point for a proper understanding of *ganying*: it is a concept that is based on a holistic worldview, which conceives of everything as internal to a given system.[7] What the definition does not state, but which I add here, is that the system in which *ganying* interacts is reliant on harmony from the beginning and as its ultimate end. All Chinese applications of *ganying* proceed from this basis.

Epistemologically *ganying* can be seen as a counterpart to the concept of causation and change in Western science and philosophy. However, in general the perspective was vitalistic rather than mechanical throughout the varied range of its applications.[8] Several scholars, among them Kim Yung

5 John Gerring, What makes a concept good? A criterial framework for understanding concept formation in the social sciences. *Polity* 31 [3] (1999): 357.

6 Le Blanc, *Huai-nan Tzu*, pp. 8, 114.

7 Richard von Glahn mentions that resonance "mediated between different orders of reality". It is not apparent that Chinese intellectuals, even in religion, conceived humans and gods as two forms of reality. Richard von Glahn, *The Sinister Way. The Divine and the Demonic in Chinese Religious Culture* (Berkeley, 2004), pp. 14–15.

8 Joseph Needham has called Chinese thought in sum "organicistic", mentioning that the mechanistic and quantitative was largely absent in Chinese thinking. *Science and Civilisation in China,*

Sik, have suggested that this thwarted a search for purely mechanical causes and effects that typify scientific exploration and explanation in Western traditions. However, this only reflects upon *ganying* in the most general sense and value.

Translations of *ganying:* Stimulus (*gan*) and Response (*ying*) or Resonance?

An important issue when translating is to be aware that concepts are employed differently in different fields and sub fields, and within different intellectual traditions. In general translations select a term with the intention of implying the same or, at least to a considerable extent, similar connotations. Yet even within single sub fields or intellectual traditions there is a good deal of ambiguity surrounding certain terms that cannot be covered in translations. John Gerring points out that "concepts are routinely stretched to cover instances that lie quite a bit outside their normal range of use. Or they are scrunched to cover only a few instances ignoring others. Older concepts are redeployed leaving etymological trails that confuse the unwitting reader. New words are created to refer to things that were perhaps poorly articulated through existing concepts, leaving a highly complex lexical terrain, for the old concepts continue to circulate."[9] To translate the term alone thus "restricts" the concept considerably—in some cases to an extent that it is misinterpreted.

Chinese intellectual "concept formation" was vitally reliant upon the philological approach. Therefore, it is important to realise that *ganying* derives from a "binominal expression of two semantically and grammatically independent words". Hence the translation of *ganying* as "resonance" obstructs the concept insofar as it ignores that the concept initially consisted of two discrete entities, each with a fully independent meaning. Philological approaches by Western scholars to classical sources take this Chinese concept formation into account

vol. 2 (London, 1962), pp. 91–92; 248, 281. I use the term vitalistic here in its Western usage as a counterpart to mechanistic worldviews of the seventeenth and eighteenth centuries. Diderot, for example, had ideas about resonance and the dynamics of matter that are described as "vitalistic materialism and sensitivity" by Matthew Riley, Straying from nature. The labyrinthine harmonic theory of Diderot and Bemetzrieder's "Leçons de clavecin" (1771). *The Journal of Musicology* 19 [1] (2002): 3–38, here p. 25.

9 Gerring, What makes a concept good?, pp. 357–393.

by rendering *ganying* as a theory of two aspects rather than one term. James Legge, for example, in his translations of Chinese classics addressed *gan* as influence and *ying* as response.[10] Mary Lelia Makra preferred "evocation and response".[11]

The philological approach also dominated later applications and understandings of *ganying*. In general, China's classically trained scholars developed their particular understanding by investigating the historical roots and preceding philosophical and philological features of such imperative terms. We can take it for granted that even if scholars rendered *ganying* as a *terminus technicus*, they had initially, based on historical precedents, analysed it as two before admitting it as one. On this basis we can retrace each individual's interpretation of *ganying*. Angus Charles Graham, for example, proposed that the two philosophers Cheng Mingdao 程明道 (1032–1085) and Cheng Yichuan 程伊川 (1033–1107/8) understood *ganying* as "stimulation and response".[12] Anne Birdwhistell gives Shao Yong's 邵雍 (1011–1077) interpretation of *ganying* as "movement and response".[13] Clearly these nuances are not only the result of the translators' efforts but inherent in the individual thinkers' descriptions. However, it would be erroneous to neglect the common ground. Different interpretations are in congruence with the general understanding. It seems that there existed a general cognitive image and various specific understandings of *ganying*, *gan*, and *ying*.

Western interpretations and translations of *ganying* reveal a general disagreement about the sense of *gan*, whereas there is mainly consensus about translating *ying* as response. Joseph Wu explains this peculiarity by the fact that "to translate *gan* as influence is to emphasise the external or objective aspect of the *gan* process. If we translate it with English terms such as receptiveness, being sensitive to, or being moved, our emphasis would be shifted to the subjective aspect." [14] In fact, such a distinction was at least beyond a lexicographical definition of *gan* as demonstrated in the *Shuowen jiezi* 說文解

10 James Legge (trans.), Xiaojing, ch. 16, 3a, in: *Sacred Books of the East* 3 (New York, 1966).

11 Cf. Mary Lelia Makra and Paul K.T. Sih, *The Hsiao Ching* (New York, 1961), p. 35.

12 Angus Charles Graham, *Two Chinese Philosophers Cheng Mingdao and Cheng Yichuan* (London, 1958), p. 38.

13 Shao Yung on Knowledge and Symbols of Reality, in: *Shao Yung on Knowledge and Symbols of Reality*, ed. Anne D. Birdwhistell (Stanford, 1989), p. 114.

14 Cf. Antonio S. Cua, Practical causation and Confucian ethics. *Philosophy East and West* 25 [1] (1975): 1–10, here: 9.

字 [Analytical Dictionary of Characters] of the year 121 B.C. by Xu Shen 許慎, an interpretation that was generally referred to during the Ming period. Here *gan* is simply explained by "it moves (*dong* 動) a person's heart-soul" (*gan, dongren xin* 感, 動人心).[15] This interpretation is connected with a commentary in the *Yijing* 已經 [Book of Changes] that explains how sages stimulate a person's heart-soul (*shengren gan renxin* 聖人感人心) to pacify the world: "Sages establish teachings [that] stimulate-move (*gan*) the people's heart-soul. This makes them change their evil and follow benevolence. Afterwards all under heaven is pacified. (*shengren shejiao, gandong renxin, shi bian e cong shan. Ranhou tianxia heping* 聖人設教, 感動人心,使變惡從善. 然後天下和平.)"[16] The *Yijing* also explains that a gentleman (*junzi*) needs to stimulate emotions to change people's behaviour, and thus the gentleman has to take action so "that what is silent/lonesome and does not move, is stimulated (*gan*) and subsequently accords with the causes of all under heaven (*jiran bu dong gan er zhu tong tianxia zhi gu* 寂然不動感而逐通天下之故)".[17] Both early texts emphasise that *gan* de facto moves (*dong* 動) something that is metaphorical/abstract, that is, the heart-soul and "that which is silent/lonesome". Hence they match an internal state of motion, that is, to feel (*gan*), with an external state of motion, that is, to move literally (*dong*).

Another important aspect of Chinese understanding of the *ganying* concept is the fact that "to respond" in the context of the *Yijing* expresses the reflection of things and affairs as apparent in the outer world.[18] In this context, the text emphasises sequences, that is, that *gan* creates the primary movement and stimulus whereas the second absorbs or accepts this in reflection. Four hundred years later the commentator Kong Yingda 孔穎達 (574–645 A.D.) explains this passage in the *Yijing* and suggests that "*gan* is movement (*dong* 動) and *ying* is compensation of this movement. For all that, first there is the motion, and afterwards there is that which resonates".[19] Thus Kong Yingda considers

15 Character 6874, *Shuowen jiezi quanwen jiansuo shiban* 說文解字全文檢索試版, http://shuowen.chinese99.com/index.php.

16 *Yijing*, Xici xia, 12, 12a.

17 *Yijing*, Xici xia, 16, 1a.

18 The *Dayou gua* section of the *Yijing* says that *ying* "to resonate/accept" [means]: call heaven and the periods/seasons (*shi* 時) continue. It accepts emotion (*gan*) and resonates (*ying*) concomitant to the periods/seasons.

19 From the Tang to the Ming, Kong Yingda's interpretation was the standard *Yijing* text. The *Zhouyi zhengyi* 周易正義 [Rectified Meanings of the Zhou Changes] was chiefly compiled by Kong Yingda under imperial edict at the beginning of the Tang Dynasty. Reprint Beijing, 1999.

gan ying within the context of action and reaction and adds to this the idea of sequence (before and after).

As Charles Le Blanc's definition points out, Chinese intellectuals presumed that resonance is spontaneous. They also drew this notion from the *Yijing*: "after a movement, there is a resonance/echo (*ying*), there is nothing that establishes it." In its original understanding resonance required no external agent: unique and animated particulars interact; they integrate spontaneously and generate a discernible regularity and cadence through their mutuality, an emergent rather than a given order.[20]

Qi and Resonance

Since the third century B.C. thinkers and statesmen, such as Lü Buwei 呂不韋, Liu An 劉安 (180–122? B.C.), and Dong Zhongshu 董仲舒 (175–105 B.C.), employed *Qi* systematically to erect a philosophy that linked state, humanity, and cosmos. Thus although the stimulus–response was in use much earlier, this development also ultimately influenced the concept formation of *ganying*. Ultimately it became linked with the idea of *Qi. Qi* thinkers saw *Qi as* the universal origin. *Ganying*, as Charles Le Blanc puts it, preserved "the ontological memory".[21] For thinkers of *Qi* resonance is therefore not merely objective contemplation or mirror reflection, it actually transforms and re-transforms. [22]

The key to understanding the idea of resonance in later periods in its connection to *Qi* lies in the epistemological concept of *yin* and *yang. Yin* and *yang* may be best considered as relational phases: "Something is *yin* or *yang* only in reference to an ensemble of which it is a part."[23] The five phases are a finer cyclical texture of the *yin* and *yang* qualities in which "water and fire stood for the most intensive aspects of *yin* and *yang*, metal and wood stood for the less intensive

20 Le Blanc, *Huai-nan Tzu*, p. 208.

21 Le Blanc, *Huai-nan Tzu*, p. 67.

22 Dong Zhongshu 董仲舒, *Chunqiu fanlu* 春秋繁露 [Abundant Dew, Interpretations of the Spring and Autumn Annals] of the year 135. 12:13b. For an interpretation of the cosmological aspects in this text I refer to Gary Arbuckle's Inevitable treason. Dong Zhongshu theory of historical cycles and early attempts to invalidate the Han Mandate. *Journal of Asian and Oriental Society* 115 [4] (1995): 585–97. See also Derk Bodde's summary of attempts at interpreting *wuxing* and *Qi*, in: Derk Bodde, *Chinese Thought, Society, and Science* (Honolulu, 1991), pp. 100–103. Cf. John H. Knoblock and Jeffrey Riegel, trans., *The Annals of Lü Buwei* (Stanford, 2000).

23 Nathan Sivin, *Science, Medicine and Technology in East Asia*, vol. 2 (Ann Arbor, 1988), p. 203.

aspects, and earth stood for the aspect in which the opposed tendencies were balanced and in effect neutralized by each other."[24] Thus all things and affairs had one origin, while *yin* and *yang* characteristics furnished all things with a basic behaviour. No matter how a scholar defined and applied them in his discourse, he would recognise them as phases, as conditions that explain change and structure.

Resonance—A Qualifier for Categories

Resonance preserved harmony by providing linkage among things and affairs whose attributes were defined by their *yin* and *yang* qualities. From this perspective *ying* and *yang's* respective positions in the ever-moving cyclical universe demonstrated that they were endowed with intrinsic natures, which made such behaviour inevitable for them. If they did not behave in those particular ways they would lose their relational positions to the whole (which made them what they were). Thus they were organic parts in a state of existential inter-dependence with the whole world-organism.

The notion of "intrinsic nature", which Joseph Needham and Ho Peng-Yoke have delineated, refers to the fact that *ganying* qualifies gradually on the basis of relationships: conclusive, marked out, and closed groups of things and affairs with respective *yin* and *yang* qualities react with others that are thus identified as being of the same category (*tonglei* 同類).[25] The idea that relationship classifies is apparent in many texts of this period. The *Lüshi chunqiu* 呂氏春秋 [Master Lü's Spring and Autumn Annals] mentions that: "Kinds that solidify, convene one another. Their *Qi* is similar and their criteria suit one another." This was also true for sounds that "emulate/match and their criteria resonate."[26] Dong Zhongshu 董仲舒 (175–105 B.C.) explains that "beautiful affairs attract beautiful categories, evil affairs attract evil categories. This is how a mutual resonance/stimulus-response (*ganying*) of categories arises."[27] Sound is mentioned

24 Nathan Sivin, *Science in Ancient China* (Aldershot, 1995), p. 179.

25 Joseph Needham, *Science and Civilisation*, vol. 2 (Cambridge, 1956), p. 281.

26 *Lüshi chunqiu* 呂氏春秋 [Master Lü's Spring and Autumn Annals] of the year 239, written and compiled by Lü Buwei 呂不韋, ed. Chen Qiyou 陳奇猷 (Shanghai: 1995), p. 345.

27 This refers to the expression "Those of one kind, move another (*tonglei xiangdong* 同類相動)" in *Chunqiu fanlu* 春秋繁露 [Luxuriant Dew of the Spring and Autumn Annals] by Dong Zhongshu 董仲舒 (179–104 B.C.). *Sibu beiyao*-edition, ch. 57, 13:3.

explicitly in these texts because it explains how the invisible, yet audible realm is governed by the same principle as the visible world.

Resonance and Musical Roots

Charles Le Blanc mentions that the notion of resonance first appeared in the *Yueji* 樂記 [Record of Music].

Two things can be deduced from this passage. First, it is clear that the non-visible realm is considered as classifiable by sound phenomena in the same way as materially sensitive attributes classify the visible world. Second, sound and emotion, although invisible, are sensible in other ways, are correlated in behaviour, and can even be considered as being reliant on the same attributes. Clearly, *ganying* is dependent on the intrinsic nature of things: shameless sounds react with rebellious *Qi*; correct sounds react with obedient *Qi*. The application of *ganying* in the *Yue ji* (record of music) is elementary for later theories of art, because it associates artistic quality with ethical issues—an association that would become obligatory in ritual, social, and political contexts.[28] One point to keep in mind with regard to the identification of *ganying* in the context of music is that the *Yue ji* makes a methodological distinction between *sheng* (here translated as "sound") and *yin* ("tone"): "sounds" are considered as the raw material of music, "tones" are music's elaborated, systematised, calculated, and ethicised components.

In the *Yue ji* "all sounds emerge from the human heart",[29] so the tones made by musicians *express*, in the technical sense of the word, what is in the heart.[30] Music expresses behaviour *in potential*, governed by the same overall principle as all other things, that is *ganying*. In the *Yue ji* resonance travels both from inner to outer (expression), and from outer to inner (reception). However, in this enlargement of musical resonance, the movement from inner to outer clearly dominates. Music is thus a way to domesticate the inner reception by the outer expression because one understands the principle by which both interact.

28 The *Yue ji* and its relation to poetry is discussed by Haun Saussy, *The Problem of a Chinese Aesthetic* (Stanford, 1993), pp. 85–101.

29 *Li ji*, "*Yue ji*," in Zhu Bin (1753–1843), comm., *Li ji xun cuan* (rpt., Shisan jing Qing ren zhushu series, Beijing, 1988), 2:559.

30 I understand "express" here technically and in its philosophical sense, that is, with connotations developed by a series of writers from Spinoza to Leibniz, Pierce, and Susanne Langer.

The *Yijing* explains "similar sounds echo (*ying* 應) and similar *Qi* support another (*xiang qu* 相取)". Zhuangzi 庄子 mentions "similar categories follow one another (*xiangcong* 想従), similar sounds mutually resonate (*xiangying* 相應). This is a sturdy principle of heaven." According to the *Lüshi chunqiu* "categories call another similarly, if the *Qi* is similar, then it unites. Sounds that are close together/next to each other resonate."[31] It is interesting to note how subtly these early texts explain qualities and assign them: sounds resonate, and *Qi* supports. Similar sounds resonate because they relate to each other. This is because *Qis* with the same quality support one another. In Zhuangzi categories follow one another, which is why sounds resonate. The basis of this suggestion is to accept *ganying* as a theoretical cognitive image.

Many scholars, like John Henderson, see these explanations as based on correlation, suggesting that correlative thinking is separate from cosmological resonance (*ganying*). Modern historians of Chinese thought have sometimes written as if almost any two items that could be correlated in Chinese cosmology could also be made to interact at a distance to affect one another by virtue of their mutual sympathy [i.e., resonance]; if not by way of any specific mechanism then at least by virtue of the allegedly organic structure of the traditional Chinese cosmos.[32]

The question Henderson poses is: Do things and affairs actually interact or intercommunicate in a sense that is implied by *ganying*, if in fact what we see and what is mentioned is a mere correlation? The answer to this question is that if the concept defines *ganying* as a modus operandi that is generally effective in nature, it is not necessary to make it explicit. There is another point that needs to be mentioned here. Correlative thinking in general draws systematic correspondences between aspects of various orders of realities or realms, such as the body politic and the heavenly cosmos. Yet it is not always apparent that *Qi* thinkers, who explain sound as reliant on *Qi*, see those various orders and thus draw a correlation. When the various orders of realities remain obscure, as is the case in this passage, the argument is not based on correlation, but rather aims at expressing interdependence. Reading it in this way Song presumes that sounds resonate *because Qi* reacts to the surrounding *Qi*.[33] Sound is thus an evidence of

31 This refers to the Chinese expression "call in categories (*zhaolei* 昭類) [of a kind]".

32 John B. Henderson, *The Development and Decline of Chinese Cosmology* (New York, 1984), p. 22.

33 In this context the reader needs to be aware that there are not two *Qi* as such. The distinction is merely one of placement, not of kind.

Qi and *Qi* the reason of sound. His explanation does, however, not correlate *Qi* and sound.

For Peterson, correlative thinking generally does not work without *ganying*. Yet he abstains charily from any claim to absoluteness, pointing out that Chinese scholars themselves were far from agreeing on this point: "We have to go case by case to determine where an actor or author is adopting a descriptive or metaphoric mode and where he is implying the possibility that effective *ganying* correlates and perhaps their manipulation by humans."[34] Yet correlation subjects to a descriptive mode, whereas *ganying* as a basic cognitive image may have led to a mimesis in which the concept was acknowledged implicitly.[35]

In my view, however, both correlation and *ganying* are two aspects that need to be clearly distinguished: correlation establishes and indicates a mutual or reciprocal relation. It is an argumentative mode to explain relationships. As such we can consider it as the device to substantiate *ganying*/resonance as the working principle. Resonance, however, is the epistemological model that underlies the structural relationship explained by correlation.[36] Hence *ganying* is not reliant on correlation, but leads to it.

Resonance—Historical Implications

The idea of *ganying* was obviously the product of a period of great political unrest and competing social systems that characterised the period in China before the third century B.C. At this time the axiom that heaven and earth, the divine and the human world, were one isomorphic body was deeply implanted in Chinese thinking. "As a spatial cosmology this projected in the mind and eyes of the Yin and Shang people towards a deep-rooted component of a ritus that searched for a parallelism between heaven and earth. They correlated the centralised state with the ruler as its core to the heavenly realm with the pole-star as the centre of stars. All this could be located in a rectangular China covered by a circular heaven in the orderly (*chaxu* 差序) pattern of heaven and

34 See Willard J. Peterson's review of Henderson. *Harvard Journal of Asian Studies* 46 [2] (1986): 660.

35 Henderson, *Development*, p. 94.

36 Karl S.Y. Kao, Self-reflexivity, epistemology, and rhetorical figures. *Chinese Literature: Essays, Articles, Reviews (CLEAR)* 19 (1997): 59–83, 74.

earth."[37] For both periods, the Yin and the Shang, heaven–human interconnectedness became the prevailing prerequisite of cosmological endeavours. It gave them a valuable origin while the orderly pattern (*chaxu geju*) gave them security in predictability. Whereas the gods and spirits possessed the power to intervene in mundane affairs (*ling*), humans could influence the divine realm through sacrifice and mantic arts. Thus gods were esteemed in proportion to their responsiveness to human entreaties. This quality was referred to as a "potency of stimulus (*linggan*)".[38] During the Warring States Period both the *yin yang* and *wuxing* theories had merged with the *ganying* concept to form one system in which the separate theories were hardly discernible. The stimulus of *yin* and *yang* and the conquest–creation cycle of the five phases progressively expressed and proved the resonance concept. Resonance offered further support to the idea that heaven and humankind were interconnected in the context of *yin yang* and *wuxing*.

Whereas the Huainanzi integrates a fundamentally Daoist-oriented viewpoint toward resonance as part of an organic system, the generation of Zou Yan 鄒衍, Lü Buwei 呂不韋, Liu An 劉安, and Dong Zhongshu assigned political and social purposes to it. To put it simply, Dong added to Han orthodox Confucianism the idea of heaven–human resonance (*Tianren ganying*) by defining that humankind and heaven had to be of the same category (*tonglei* 同類). This characterised their relationship because only on this basis were they able to resonate with one another. This also gave humans an equal status with heaven. Like people who became ill, heaven changed the weather or produced natural disasters. In this subtle argumentation we can see that *ganying* meant more than the basis to justify correlation—it identified interdependence. This interdependence was *the prerequisite for political control*: heaven could express approval or disapproval of human actions and especially of the rulers of the people, that is, the sons of heaven. In the hands of statesmen, such as Zou Yan and Lü Buwei, the concept of resonance between heaven and humankind primarily became a method by which eminent court theorists assured political control.

This development was viewed critically from its very inception. One of its most fervent opponents was the philosophical maverick Wang Chong. Wang Chong's ideas were not very well received until the early nineteenth century, a circumstance which ensured that his philosophical ideas remained socially and

37 Le Blanc, *Huai-nan Tzu*, p. 67.

38 Von Glahn, *Sinister Way*, pp. 34–41.

politically inconsequential. Yet his critique exemplifies how politicians wilfully employed *ganying* for their purposes:

"Heaven is many thousand miles (*li* 里) away from man. Now, in case heaven had ears and could listen, [one has to consider] that words [spoken] at the distance of several thousand miles, could not be heard [any more] (*fou nengwen* 弗能聞). If a man was sitting on a high podium tower, looking out for the ants on the ground, he would not be able to distinguish their forms any more. How, then should he hear their sounds even when complete silence is prevailed? The bodies of cranes are so minute. They cannot transcend the vast expanse of void *Qi* (*kong Qi* 空氣) similar to that of human form. Now the altitude of heaven cannot at all be compared to that of a [small] podium and the proportion of the human body compared to heaven cannot be compared to the ratio of cranes and men. They say that heaven hears man's words and subsequently good and bad [behaviour] (*shan e* 善惡) are presumed as auspicious and inauspicious (*jixiong* 吉凶). That is a misconception."[39]

Here Wang Chong disproves the most anthropocentric version of the mutual sympathy between the heavens and humans that would become the prevailing state orthodoxy. It would, however, be misleading to interpret Wang Chong's arguments as reducing resonance to a mere mechanical principle in which things need to be at a certain distance from each other in order to be mutually influenced. His argument is simply against the idea that natural events can be seen per se as actual or potential factors that express *ganying*: not all events in nature are on principle related to the moral behaviour of humans. Nor is it the case that some influences call for an engagement and response, while others do not. Wang Chong was offended by the Confucian interpretation of *ganying* because it no longer pretended to offer an explanation of the nature of the world, but imagined a schema for guiding actions toward the Confucian vision of central harmony.[40] In this scenario, the sage recognises the heavens' will and responds to it through action. He can understand heavenly portents and react, so that they bring no harm to him or the people.

Wang Chong is a meaningful example of one who firmly believed in the unity of heaven and humankind, but at the same time refused to accept that heaven affects the life of humans directly. He vigorously attacked the Confucian

39 Wang Chong, *Lun Heng* (Beijing, 1999), ch. 4 bianxu 17, p. 341.

40 Cf. Kant's notion of a "typical critique of practical reason"; Paul Dietrichson, Kant's criteria of universalizability, in: *Kant Foundations of the Metaphysics of Morals*, ed. R.P. Wolff (Indianapolis, 1969), pp. 163–207.

agenda that related resonance to moral life, but he did not reject resonance as a working concept underlying cosmological structure. The fact that humans had to follow ethics meant that they triggered further reactions by what they did, or did not do. Thus the moralists of this period used the idea of stimulus (*gan*) and response (*ying*) to explain that humans were such a trigger. In the hands of these philosophers *ganying* thus became a moral issue rather than a theory that purported to explain the nature of the world or a theory of practice.

Li Zehou has pointed out that whereas for thinkers of the third century Dong Zhongshu (176–104 B.C.) ethics is subordinate to cosmology, later generations, especially after Zhu Xi, the Neo-Confucian ideal par excellence of the tenth century, already viewed cosmology as absolutely subordinate to ethics.[41] During the Song Dynasty, and again during the last period of the Ming, the belief that resonance could be translated into a mechanism of retribution became very popular.[42] These periods of political and social upheaval required some comfortable message that made fate accountable, or at least provided a method of directing one's fate beyond the chaos of one's environment to remedy unsettled conditions.[43] This was all the more true for the interpretation of *omina* as aspects of heaven–human resonance. In this we recognise a substantial point of dispute between orthodox Confucians, that is, state doctrine and the intellectuals that were retrospectively grouped under the label of *Qi* thinkers of the Ming Dynasty.[44]

41 Li Zehou, Some thoughts on Ming-Qing Neo-Confucianism, in: *Chu Hsi and Neo-Confucianism*, ed. Wing-Tsit Chan (Honolulu, 1986), p. 553. This is an allusion to the *ganying* [in this context translated as "sympathetic responses"] section of the *Xiao jing* [Classic of Filial Piety]. See *Xiao jing zhu shu*, (ed. Tabei 1988) 8, Ia.

42 The tract of *Taishang* on action and response (*taishang ganying bian*), a brief work of only 1280 characters, describes the mechanism of retribution; see Brokaw, *The Ledgers of Merit and Dementi* (Princeton, 1991).

43 Karl S.Y. Kao, Bao and Baoying. Narrative causality and external motivations in Chinese fiction. *Chinese Literature: Essays, Articles, Reviews (CLEAR)* 11 (1989): 115–138, here 128. These conceptions were, however, a popular belief that were manifested in such works as the *Taishang ganying bian* or the *Gongguo ge* [Ledgers of Merit and Demerit]. Basically they expressed the idea that virtue is rewarded and vice punished.

44 This grouping is anachronistic as these thinkers mainly saw themselves as individuals and were reluctant to embrace particular school traditions or tutoring systems; Li Shuzeng 李書增; Sun Yujie 孫玉杰; Ren Jinjian 任金鑒 (eds.), *Zhongguo mingdai zhexue* 中國明代哲學 [Philosophy in China during the Ming Dynasty] (Zhengzhou, 2002), pp. 1438–1456. During the late 1980s a group close to Ge Rongjin already published a book together with others which he named accordingly. Chen Guying 陳鼓應, Xin Kouhao 辛寇浩, Ge Rongjin 葛榮晉 (ed.), *Ming Qing shixue sichao shi* 明情實學思潮史 [The History of the Trend of Practical Learning during the Ming and Qing Dynasty]

During the Song and after the Ming Dynasty an anti-*ganying* movement became one of the major influences on the idea of nature and its epistemological embedment, and it initiated a new approach to the subject of *ganying*. John Henderson comments that Chinese intellectuals of the Qing dynastic period identified the cosmos as one of irregularity and anomaly, lacking definite demarcation and not amenable to being understood precisely by humans.[45] The intellectual scene in the sixteenth and seventeenth centuries presents instances of Ming and Qing commentators' criticism of Chinese cosmology, which then changed to prevailing literati ideas about heaven and earth after the transformation. Although scepticism about the traditional correlative cosmology, and especially the *ganying* concept, existed between the Han and Qing, anticipating the sceptical views of the seventeenth century, it is only in the late Ming and early Qing that scholars scrutinised the Han and Song cosmological structural assumptions (the latter basically built upon the former) critically and in doing so, referred to resonance. The two thinkers Wang Fuzhi and Song Yingxing belong to this context.[46]

Resonance during the Ming Dynasty

Song Yingxing (1589–1666?) and Wang Fuzhi (1619–1692) represent a social stratum that may be best characterised as a great, but somewhat unused, potential of well-educated academics—people who were trained to serve the government, but did not. Both can be considered as unorthodox thinkers. Song Yingxing was a minor scholar of the late Ming dynasty. He is popular as the author of a technical encyclopaedia titled *Tiangong kaiwu* [The Works of Heaven and the Inception of Things]. This work comprises the craft knowledge of its era and is unique in its approach until the nineteenth century. Wang Fuzhi passed the *juren* examination in 1642, but after the fall of the Ming three years later, he declined all contacts with the new Qing dynasty and devoted himself to scholarship. Both thinkers approached the universe and its governing principles consistently as a world of *Qi*.[47] They believed that

(Beijing, 1988). This collection enumerates more than 60 thinkers from the mid-Ming until the mid-Qing dynasty.

45 Henderson, *Development*, p. 141.

46 Henderson, *Development*, p. 45.

47 Yeeloo Liu, Is human history predestined in Wang Fuzhi's cosmology? *Journal of Chinese Philosophy* 28 [3] (2001): 321–338.

China. Instead, he suggested this phenomenon was a result of *Qi* collision, in which the *Qi* scattered at one edge would attempt to get to its 'natural place' to contact harmoniously the surrounding *Qi* of the void. In this concept the fact that certain materials could not be penetrated by *Qi* was a vital prerequisite for the production of musical instruments and for the explanation of all further inconsistencies with the general rule. Song Yingxing's idea also provided a suitable and convenient model to explain the phenomenon of sound:

"Regarding this, when one takes the high swinging bell (*xuanzhong* 悬鍾) and the stretched drum (*mangu* 漫鼓), the *Qi*, which is contained (*han* 涵) in their interior, and the *Qi*, which rushes about (*mao* 冒) their exterior, bear each other in mind and are aware of each other (*xiangyi xiangsi* 相億相思). They both feel mutual anger (*hen* 恨) about the barrier (*gemo* 隔膜)."[58]

Although this explanation is admittedly philosophical, it clearly illustrates the idea of echoing reverberation. One *Qi* echoed or answered the other *Qi*, and both attempted to harmonise into an entirety. Moreover, we can assume that *Qi* was the ontological basis for sound emanation—which in Song Yingxing's case was the *Qi* of the void. Due to this, a bell "filled with earth could not produce a sound". Even in the case of the freely hanging *Qing* (*xuanqing* 悬磬) instrument,[59] for Song Yingxing the principle could still be fully explained by these guidelines.

"*Qi* as a harmonious whole (*hunlun*) is separated and broken into (*jiege* 界隔) two areas (*liangfang* 兩方) by/through the dangling *Qing* instrument."[60]

This passage indicates that the separation of *Qi* entities is still the focus of Song Yingxing's theories. In this regard he may have considered that his own thoughts were not at all disparate to those of ancient thinkers such as Wang Chong and Tan Qiao, except for the fact that Song Yingxing placed greater emphasis on the notion that sound required no other basis than *Qi*. This autocracy of *Qi* in Song Yingxing's metaphysical world is without parallel and is repeatedly stressed by Song Yingxing in its various appearances.

"Referring to the bell-shaped percussion instrument (*zheng* 鉦), which is struck by a hammer or the leather stretched drum (*tang* 鐋), neither the copper nor the strained leather are of different qualities, i.e., they both do not possess

58 *Gemo* is the separating skin, i.e. a membrane. *Lun Qi* (1976), ch. Qi Sheng 6, p. 73.

59 The instrument is first mentioned in *Lunyu*, ch. 14 xianwen 憲問 14, weizi 微子 22, *Lunyu zhengyi* (1990), p. 132.

60 Song Yingxing, *Lun Qi*, in *YeYi, Lun Qi, Tan Tian, Silan Shi* (Shanghai, 1975), ch. Qi Sheng 4, p. 69.

sound of a *Qing* instrument set up next to a wall would be clearly heard [which is not the case, or is it?]"[55]

If resonance of *Qi* was not able to resound, then no sound would be heard, and hence a bell filled with earth would not ring. The same principle provided the theoretical background for the idea that the sages constructed round-shaped musical instruments in order to facilitate a quicker re-harmonisation of *Qi* after a collision. In this case it was subtly combined with the assumption that *Qi* at rest was equally distributed and that an accumulation of *Qi* in one place caused disharmony:

"[The question is:] The sages (*shengren* 聖人) manufactured (*zhi* 制) musical instruments, whose forms by and large were circular/round (*yuan* 圓) and not angular (*wufang* 無方). What is the inherent sense?/What is the sense of that?

I say: talking about this concerns the accumulation (*ju* 聚) and inclusion (*han* 涵) of *Qi*. If to enable the *Qi* of the internal emptiness (*zhongxu* 中虛) to echo the outside, it requires/ presupposes, that everything desires to be in a state of harmony/ order/ balance (*jizhi* 齊至) and consistency (*junji* 均集). As soon as there is an angle (*fang' a* 方隅), [the *Qi*] will hurry to one angle and rest at the other angle (*xi* 息), at that angle [the *Qi*] is fast (*ji* 急) and in the other angle it is slow (*huan*). In the core/centre there is confusion and *Qi* is wandering about unsystematically/chaotically. Hence the sound heard is very unsatisfactory, i.e., it cannot be properly heard (*buzu wen* 不足問)."[56]

Here Song Yingxing clearly introduced the idea that *Qi* had intensified in one corner and thus was in a state of imbalance. In the same text he also referred to an unbalanced relationship of water and fire agents in the atmosphere. In the case of water and fire agents, Song Yingxing called this accumulation (*ju*) or inclusion (*han*). I suggest the principle was that sound, that is, the collision of *Qi* or any other disturbance of *Qi*, always strives for harmonious suspension. The same principle underlies the notion in Chapter 10 of the *Tiangong kaiwu* where Song Yingxing argues, "all musical instruments must be round-shaped and without any solders (*han* 銲)."[57]

Song Yingxing thus dismantled the relationship between sound production and material that normally governed the respective theories in pre-modern

55 Song Yingxing, *Lun Qi* in *YeYi, Lun Qi, Tan Tian, Silan Shi* (Shanghai, 1975), ch. Qi Sheng 4, pp. 69–70.

56 *Lun Qi* (1976), ch. Qi Sheng 6, p. 73.

57 *Tiangong kaiwu* (1997), ch. 10, p. 297.

Most prominent thinkers of *Qi*, such as Zhang Zai, all agreed on the notion that an "intuitive capacity in things for response (*ying* 應)" was a vital prerequisite for the production of sound—a notion which for Zhang Zai required no further explanation for it was firmly embedded in the Chinese code of knowledge. More than five hundred years later Wang Fuzhi added a commentary to Zhang Zai's text, in which he explained that Zhang Zai had a vibrating, a shaking (*zhen* 振) *Qi* in mind. Zhang Zai established this impression of *Qi* agitation as the key factor in sound production. The motion of things [or *Qi*] transforms *Qi* into "*Qi* in a state of agitation". Consequently, *Qi* in a state of agitation is explained as the reason for the production of sound.

The idea of reciprocal correspondence (*ying* 應 and *ganying* 感應) in China at this time was so intimately embedded in a moralistic paradigm that it is hard to believe that Song Yingxing actually attempted to trace it back to its substantial or 'natural' origin. Obviously, he must have found a corresponding idea in the ancient classical texts on music and cosmological issues that induced him to make resonance a vital principle in his theory of harmonising the universe of *Qi*. *Qi* thus represents the organic basis of the human mind's continuity with nature in both Huang-Lao Daoism and Neo-Confucianism.[53] Song Yingxing's notion of resonance was thus amenable to references to actual experience:

"Let us just ask the [following] question: the freely dangling *Qing* (*xuanqing* 悬 磬) instrument is hit.[54] There is no *Qi* enclosed (*han* 涵) within [the instrument], but its sound is clear and high-swinging (*jingyue* 清越). Why though?

I say: In this case *Qi* as a harmonious whole (*hunlun* is separated and broken into (*jiege* 界隔) two areas (*liangfang* 兩方) by/through the dangling *Qing* instrument. So as soon as it is hit from the southern direction (*nan* 南), the *Qi* north (*bei* 北) of the *Qing* stone echoes. If it is knocked from the east (*dong* 東), thus the *Qi* west (*xi* 西) of the *Qing* echoes. This seems to be the intrinsic sense of the bell and the drum, analogously. Assuming the sound was originally created by the stone (*shi* 石) and was not a resonance [product] (*ying* 應) of *Qi*, the

[53] For the "Daoist flavour" of the concept of responsiveness in Zhou Dunyi's ideas I refer to Joseph A. Adler, Response and responsibility. Chou Tun-i and Neo-Confucian resources for environmental ethics, in: *Confucianism and Ecology*, ed. Mary Evelyn Tucker and John Berthrong (Cambridge, 1998), pp. 123–149, here p. 130.

[54] The instrument is first mentioned in *Lunyu* [Analects], ch. 14 xianwen 憲問 16, *Lunyu zhengyi* (1990), p. 4b.

Qi governs the totality of nature.[48] And in this view, all of human history with its vicious circle of flourishing and decline is governed by the principle of the two *Qi* of *yin* and *yang*.[49] Moreover, both thinkers had a particular interest in practical things and developed sophisticated theories about natural phenomena and sound. Wang Fuzhi, who is generally considered to have developed Zhang Zai's metaphysics of *Qi* "with great persuasive power",[50] stresses that all things and affairs "are the result of the moving power of *Qi*. It fills the universe. And as it completely provides for the flourishing and transformation of all things, it is all the more spatially unrestricted." In its essential import and implications this claim corresponds to Song's theoretical approach and also adheres to the universality of Song Yingxing's demand concerning *Qi*.[51] Here the cognitive structure of resonance *ultima pro res* provides for unity. As an example to illustrate both the common ground and subtle differences in Chinese scholarly approaches to *ganying*, I shall give an overview of Song Yingxing's notion of sound, followed by a survey of Wang Fuzhi's theory of literature and arts. In acoustic theory *ganying* is a perennial subject, and allegedly the origin of the concept of *ganying* also derives from this context. Wang Fuzhi perceived resonance as a working principle in poetical language, identifying relationships on various levels.[52] Both thinkers considered *ganying*, that is, stimulation and response, but not in the literal sense of the words as abstract terms: for Song Yingxing and Wang Fuzhi *ganying* moved and reacted, practically and literally.

48 According to Nathan Sivin, nature is not the appropriate concept as it was not introduced into Chinese thought until the late eighteenth century. Chinese scholars distinguished an entity that existed or is so "out-of-itself (*ziran* 自然)".

49 For works available in English, see Wong Siu-Kit, *Notes on Poetry from the Ginger Studio* (Hong Kong, 1987); on Luo Qinshun see: Youngmin Kim, Luo Qinshun (1465–1547) and his intellectual context. *T'oung Pao* 89 (2003): 367–441.

50 Tu Wei-ming, *Confucian Thought: Selfhood as Creative Transformation* (New York, 1984), p. 22.

51 The translation is from Wing–tsit Chan, trans. and comp., *A Source Book on Chinese Philosophy* (Princeton, 1963), pp. 698–699.

52 Wang Fuzhi also exhibits a particular interest in acoustic phenomena that is obvious in all his writings. His comments are often quoted in Chinese historical accounts of scientific thinking after 1900. However, his views on sound have to be extracted from his various writings and commentaries; they are less systematically presented than his ideas on poetry or Song's notion of sound.

two [different] attributes. The drumstick hits [the centre] (*tang* 湯) and the bum bum sound (*keng* 硿), which is heard coincides with the two first notes of music *gong* 宮 and *shang* 商. When the four edges (*siyan* 四沿) are clattered and rattled, the tones *jiao* 角 and *yu* 羽 resound."[61]

Sound was thus a transformational appearance of *Qi*, which occurred because of the resonance potential of the *Qi* of the void. As long as the *Qi* of the void was present, sound could emerge. Only if the barrier between the two *Qi* was too thick in its formal quality or the water and fire agents had built an impenetrable barrier, for example, a solid layer of leather or earth or a wet brick wall, then the two *Qi* could no longer harmonise and were even hindered in resonating with the opposite *Qi*. In these cases either no emanation of sound was possible, or the sound would quickly die away.

Although Song Yingxing's ideas and conclusions appear strange to modern scholars, it can be assumed that it was possible to work with such a principle and that contemporary investigators would have benefited from this theory to make further proposals. Undeniably, Song Yingxing's attempt is a unique approach in Chinese history to give a feasible and objective theoretical background for the explanation of the physical world. Song Yingxing's approach to *Qi* and sound indicates clearly that Chinese scholars were most certainly interested in the natural world. At the same time it also demonstrates that he saw his approach embedded in and founded on traditional Chinese scholarly paradigms and explanatory models and that he did not move out of this framework. Song Yingxing provides, in his own estimation, a coherent theoretical modus operandi; one which was in harmony with ancient ideas presented in the classics, such as *Lunyu* and *Shangshu*, and was in accordance with the traditional ideas of the five phases. Although he harshly criticised certain features and current developments, Song Yingxing's appraisal of his cultural environment indicates a high potential for social and cultural assimilation in China's ancient world, where the scholar did not attempt to destroy ancient knowledge but rather verified a universal principle by re-examining it and putting it back into its essential context.

61 *Lun Qi* (1976), ch. Qi Sheng 6, p. 73. A *tang* 鐋 belongs to the category of *jinge* instruments. Like *gong* and *shang*, Song Yingxing does not consider *jiao* 角 and *yu* as definite tones but just describes a sound quality. A lengthy discourse about sound in relation to the material of the instrument that produces it is found in the entries for the musical officials in the *Zhouli*, entry *Diantong*. The material–sound quality relation is also the subject of the *Kaogong ji*'s section about bell making, which states that "bells with thick (*hou* 厚) walls produce heavy (*shi* 石) sounds, whereas those with thin walls (*bo* 薄) produce scattered (*bo* 播) sounds."

"That is the reason why heaven created (*sheng*) the five phases (*wuxing* 五行) and as five phases exist, each of the five phases owns a sound (*sheng*) And the tone/pitch (*yin* 音) of fire and water is entrusted with/deposited (*jituo* 寄托) in metal (*jin*) and earth (*tu*). That is how to deduce (*tui* 推) [the principle/sense] of the five sounds/ tones and that is it."[62]

The notion of a *yin–yang* complement eventually became mixed with modern scientific concepts and was then falsely alluded to as a mechanical balancing of natural forces. The *yin yang* theory has even been compared to atomic models or generative energy, both of which are far from the way *yin* and *yang* were comprehended by people like Song Yingxing.[63] For them, *yin* and *yang* did not act each as a self-referential force, they were part of a cosmological principle of resonance, responsiveness (*ying* 應), and "stimulus response (*ganying* 感應)"[64]— stages in a process. However, the context in which Song Yingxing applied this idea was ultimately related to an investigation of his natural surroundings and not, as in his colleagues' approaches, to any reduction to a question of morality and ethnicity. He probably took this idea from its very beginnings, the *Yijing*, which says that "identical sounds respond mutually (*tongsheng xiangying* 同聲相 應)".[65] The variability of the resonance concept manifests its universality. As a root metaphor it could be observed in nature and interpreted in issues of ethics.[66]

62 *Lun Qi* (1976), ch. Qi Sheng 5, pp. 72. For the expression *wu yin zhiyi*, please note that in the original the last two characters of the final sentence are completely illegible and their sense can only be guessed at.

63 For a discussion of the lack of interest in China in an atomic approach, see Joseph Needham, Wang Ling, and Kenneth G. Robinson, *Science and Civilisation*, vol. 4, Part I (Cambridge, 1962), pp. 3–6.

64 The centrality of responsiveness and resonance in early Chinese culture is described by Charles Le Blanc in Résonance: Une interprétation chinoise de la réalité, in: *Mythe et philosophie à l'aube de la Chine impériale*, ed. Charles Le Blanc and Rémi Mathieu (1992), pp. 91–111, 95. Another early source for these ideas is the *Lüshi chunqiu*. A good overview of the philosophical implications of responsiveness during the Song dynasty by Zhou Dunyi, which influenced later and especially Ming dynastic conceptions, is given in Joseph A. Adler, *Response and responsibility: Chou Tun-i and Confucian resources for environmental ethics*, in: *Confucianism and Ecology*, ed. Tucker and Berthrong (1998), pp. 123–149.

65 *Yijing, Sishu wujing*–edition, *wenyan* 文言, p. 31.

66 For a survey of the ethical concerns of Song dynastic thinkers and their moral interpretation of human–heaven totality see: Robert Weller, and Peter Bol, From heaven-and-earth to nature: Chinese concepts of the environment and their influence on policy implementation, in: *Confucianism and Ecology*, ed. Tucker and Berthrong, pp. 313–342, 314.

In Song Yingxing's concept resonance explains the energising appearance and results of *Qi*, which is located in the context of nature, the physical world. We may also put it in the context of cosmology, "an all enfolding harmony of impersonal cosmic function", and in this connection I understand *ziran*, too, as an organic process in the sense used by Tu Weiming, who describes its initial feature as "a spontaneous self-generating life process, which exhibits three basic motifs: continuity, wholeness, and dynamism". Tu Weiming also argues that:

"to say that self-so is all inclusive is to posit a non-discriminatory and non-judgemental position, to allow all modalities of being to display themselves as they are. This is possible, however, only if competitiveness, domination, and aggression are thoroughly transformed. Thus, all-enfolding harmony also means that internal resonance underlies the things in the universe. Despite conflict and tension, which are like waves of the ocean, the deep structure is always tranquil. The great transformation of which nature is the concrete manifestation is the result of concord rather than discord and convergence."[67]

The three aspects of continuity, wholeness, and dynamism are also vital incentives for Song Yingxing's recognition of his physical surroundings. Responsiveness is thus part of a cosmology of harmonious interaction, which fosters the ultimate linking of all things with an inner logic—in Song Yingxing's theory, this is ultimately reliant on *Qi*.

Literature and *ganying*

From the Late Warring States Period until several centuries after the Han, all writers concurred that mimesis was the highest goal of painting, sculpture, and even, in certain cases, architecture. Artists and artisans who were able to simulate their subjects realistically deserved the greatest praise. One thousand years later, in the Song dynasty and Yuan period, attitudes changed considerably and painters as well as calligraphers defined self-expression as the ultimate aim of the arts. This generation denigrated realism as a mannered trick of professionals and academy painters. Some researchers see a relationship between the commercialisation of the environment and the supposed emergence of an individualism that had not been apparent in other periods. This is especially true

67 Tu Weiming, The continuity of being: Chinese visions of nature, in: *On Nature*, vol. 6, ed. Leroy R. Rouner (Paris, 1984), pp. 113–129, 115.

in the arts. In fact, Chinese literature during this period exhibits emotional revelations/exposure (*Zhenqing shixing* 真情實性), individualism, and an aversion to the previous movement of the Song dynasty to revive antiquity (*fugu* 復古). This was an attack on the vital essence of *ganying* and a great qualitative leap distinguishes this era. From the tenth to the twelfth century the relationship between object and subject had widely dominated discussions in the arts. Against this background Ming literati developed their theories of art and literature. The classical epistemology, which had been changed by the Song (if not earlier), and the canonical expressive theory of language was again tempered by a theory of mimesis and realism in Ming fiction and fiction criticism, where literary language attempted to represent reality rather than expressing the author's intention or feeling.[68] Michelle Yeh points out that thinkers during the Ming essentially drew on the literary criticism of the third century B.C., recovering various aspects of people like Lu Ji 陸機 (261–303). A line can be drawn from the Tang poet Liu Xie (465–523), to Shi Tao 石濤, and Liu Xizai 劉熙載, Fan Xiwen 范細文 of the Song Dynasty, Fang Hui 方回 of the Yuan dynasty to Xie Zou 謝榛 of the Ming dynasty.[69] All of them applied *ganying* as an explanatory framework to provide symmetry and structural unity. For them, resonance was manifested in devices such as parallelism, juxtaposition, alternation of contrasts, and the linking of elements. As a universal principle, in the arts resonance negotiated the idea of an interrelated paradox between the object and the subject, the perceiver and the perceived object. This relationship existed despite periodical and cultural borders. They all saw written culture as dominated by the same cosmic principle as all other things.[70]

68 See Earl Miner, *Comparative Poetics* (Princeton, 1990), p. 45; Stephen Owen, *Readings in Chinese Literary Thought* (Cambridge, 1992), p. 37–45.

69 This refers to the style *wenfu* 文賦. A new orientation to poetry: The transition from traditional to modern, (in essays and articles by) Michelle Yeh, *Chinese Literature: Essays, Articles, Reviews (CLEAR)* 12 (1990): 83–105.

70 Liu Xie (465–532) is quite explicit on this point. He perceives literature (*wen* 文) as a repetition of cosmic patterns and justifies parallelism as a natural evolution from symmetry in nature. See his *Wenxin diaolong* 文心雕龍 chapters yuandao 原道 and lici 麗辭, Huang Shulin 黃叔琳. Shanghai: Gudian wenxue 1958, pp. 1–235. Chen Kui 陳騤 (1128–1203) suggests that parallelism is desirable even in nonparallel prose to connect meanings and to group similar categories; see his work *Wenze* 文則 (*Baoyantang miji*) 1, 5a/b. Li Yong (1627–1705) is an excellent example of the universality of resonance *ganying*. He often uses medicine as a metaphor both to convey particular ideas in his literature and to establish the theoretical framework of his thinking. Anne D. Birdwhistell, Medicine and history as theoretical tools in a Confucian pragmatism. *Philosophy East and West* 45 [1] (1995): 1–28.

Wang Fuzhi bases his theory of arts on a monistic *Qi*. Hence Wang Fuzhi forms a rather subjective viewpoint to construct his famous theory of a "mutual creation between scene and emotion" in the appreciation of beauty on the basis of a resonance model. His notion of scenes and feelings has two senses. On the one hand there is the objectively present natural scenery. Herein one has to distinguish between the thing itself and the scenery that is in the heart-soul. On the other hand there exists talk about scenery which is present in poetry and music/songs (*jingyu* 景語). This is the "emotion of scenery creation". In the sense of a scenic phenomenon (*jingxiang* 景象) or the sketch (*tujing* 圖景) the idea of "emotion of scenery creation" is subject to the concrete aspect of a song or a poem.

Wang Fuzhi believes that when the heart-soul (*xin* 心) and the concrete object interact, only the heart-soul resonates, whereas the object does not change at all. It merely carries and contains the sense that a person gives to it. However, he does not distinguish between mental and physical resonance in way that we would expect: The objective mental phenomenon of a heart-soul and a thing that move in resonance results for Wang Fuzhi from a transformational process of the *yin–yang Qi*. The man who moves encounters the respective object. As a result the object resonates and this qualifies their relationship. Things and affairs, object, scene and motion can accordingly be arranged in categories, which he comprehends as an extension that enfolds *Qi* and the "transformation by *Qi* (*Qi hua* 氣化)". Thus ultimately the relationship between the heart-soul and things is also a sublime creation of the "*Qi* transformation" process. Accordingly, motions are not simply subjectively produced things neither are they just a subjective reflection or mirror to the outside. For Wang Fuzhi "the subtle/incipient of *yin* and *yang* is motion (*dong* 動). Things are a product/offspring (*chan* 產) of heaven and earth. For this reason, on the outside we have its thingness and in the inside there can be its emotion (*gan*). If emotion exists inside, the outside must have thingness [...]. All things under heaven and their reciprocal/corresponding motion/emotion are never in want (i.e., all things and affairs have a corresponding sense)."[71]

The crucial point in Wang Fuzhi's interpretation is that the decision about the existence or non-existence of things (*wu*) and the heart-soul (*xin*) depends on and is structured by *Qi*. Emotion is therefore a mutual reflection towards

71 See Wang Fuzhi's discussion of the Shijing 論詩經 Beifeng Nai you kuye 邶風豝有苦葉, Shiguang zhuan 詩廣傳, ch. 1. Chu Meng-ting 朱孟庭, Wang Fuzhi lun Shi de wenxue tanyi 王夫之論《詩》的文學闡釋 [Wang Fu Chih's Interpretation on "The Book of Odes"]. *Dong Wu Zhongwen xuebao* 11 (2005): 191–220, 196.

the existence of things as an isomorphic body in which "motion (*dong*) is an incipient/subtlety (*ji* 幾) of *yin* and *yang*". The term subtlety here again refers to the *Yijing*, which defines *ji* as the "minute/micron of motion (*jizhe dong zhi wei* 幾者, 動之微)".[72] In the context of the *Yijing* motion is thus for Wang Fuzhi the subtle and fine sign and symbol of a transformational movement by the two *Qi* of *yin* and *yang*. The indications produced by this transformation of *yin* and *yang* are expressed on a mental level as emotion (*gan*). To the outside scenes appear or are displayed as things, i.e., they have a transformational form. Language is hence expressive-active or embodies what the speaker feels or thinks; yet, it imitates or even directly presents one's intention. Wang Fuzhi identifies this as *gan*. For him language aims to move emotionally and intellectually; ultimately these two aspects cannot be distinguished because both realms are equally governed by *Qi*. Thus, if language moves, it does so because it moves the *Qi*; if something resonates or echoes to it, it does so, because in fact all things and affairs are of one *Qi*; stimulating one means that others of the same kind respond. However, it is important to understand this as a spontaneous rather than a mechanistic reaction, which is reliant on the idea that all affairs under heaven, including humankind, are sympathetic products of the *yin yang Qi*:

"Stimulus (*gan* 感) delivers mutual resonance (*jiao xianggan* 交相感). The *yin* resonates to *yang* and form (*xing* 形) can be created, the *yang* resonates the *yin* and a phenomenon is marked."[73]

From a qualitative viewpoint object relations decide about the relations between feelings and scenes.

"To compare meaningful things/affairs to meaningless things/affairs is also not easily done. The scene watches over emotions. That what-is-so-by-itself and emotion mutually interact/react with/to another like amber–mustard (*po jie* 珀芥). Emotion and scene can be divided, because one belongs to the heart-soul while the other belongs to things. Scenes create emotions and emotions create scenes: the touch of grief and joy, the face to face of glory and criticism is mutually stored in its eaves. The heavenly emotion and the principle of things can be grief and joyful. It can be infinitely applied. It flows and is not stagnant. It does neither know poverty nor stagnancy."[74]

72 *Yijing*, Ch. Xici shang 3b.

73 Zhang Zai, *Zhengmeng*, 12:4b.

74 Liu Xingbang 劉興邦, Lun Wang Fuzhi de Tianren zhi xue 論王夫之的 天人之學 [On Wang Chuanshan's Study of the Relation between Heaven and Man]. *Chuanshan xuekan* 3 (2004): 32–45,

The scene to which Wang Fuzhi refers in this context are the affairs and things of the outer world as opposed to the inner self. Emotion and scene, both from an objective and a subjective viewpoint structure the art motif and the art object: that which cares for emotion is the scene, that what is out of itself and emotion act as amber and mustard, two things that stand as a symbol for things having mutual effects on another. For him, the blending/harmony of scene and emotion in poetry and music is an undivided process. This is a vital progress to Liu Xie's notion of the resonance concept in its ontological sense: for Liu Xie, objects and colours may be exhausted, but the inspired emotions are boundless (*wuse jin er qing youyu*).[75]

According to Wang Fuzhi resonance between scene and emotion can be classified into two general types that either generate or elicit a reaction:

1. Actor's category or etic view:[76] Scene creates emotions such as a face to face with glorification or criticism. The up and down, the flourishing and decline of things and affairs effects people's feelings. Wang Fuzhi authorises this interpretation with a reference to the Book of Rites (Liji) "the movements of a man's heart-soul is that which is employed in a thing".[77] The classical source assumes that the thing is the origin. Wang Fuzhi extends this idea, suggesting that the thing comes first and the emotion evolves afterwards. In his interpretation the thing decides the emotion.

2. Analyst's category or emic view: According to Wang Fuzhi poets first have feelings and consider things sensitively, therefore the surrounding things and affairs do not offer the same kind of stimulus. Joyous poets see the moon as a laughing face, while sad people see a mask of pity. This theory of Wang Fuzhi again draws on the third-century poet Liu Xie who claimed that things were watched through emotion.[78] For Wang Fuzhi this kind of resonance is most appreciated in the arts and thus he gives it the special terminology "scenery in

36. Ng On-Cho, Religious hermeneutics: Text and truth in Neo-Confucian readings of the Yijing. *Journal of Chinese Philosophy* 34 [1] (2007): 5–24 (20).

75 Liu Xie, *Wenxin diaolong* (1958), wuse 46:552.

76 For discussion and coining of the terms etic and emic see Marvin Harris, History and significance of eti/emic distinction. *Annual Review of Anthropology* 5 (1976): 329–350. I mainly use it here in the definition of Ward Goodenough, *Description and Comparison in Cultural Anthropology* (Chicago, 1970).

77 Liu Xie writes in the Wenxian diaolong/ wuse 文心調龍 (1958), ch. Wuse 物色 46:559: "Emotion as to things removing that is what Zhong Rong 鍾嶸 in Shipin 詩品 calls the resonance of things in man."

78 Wenxin diaolong, ch. 46 wuse, p. 555.

emotion (qing zhong jing)" to stress that the emotion colours the scene. Emotion thus decides the thing. Wang Fuzhi commented, "the scene in emotion is the weirdest thing to write about", which seems to imply that he considers the etic view as more common as the emic.

However, it would be misleading to see these two aspects as separate issues. Furthermore, they cannot be differentiated with regard to process; instead, they differ with regard to aspects of bias. The idea that a scene creates emotions stresses the object, whereas the "emotion creates scene" notion of resonance stresses the motif. The former is a resonance concept of a mutual relation between scene and emotion with its roots in the objective. The second type is a heart-soul based resonance concept of the scene and emotion with its roots in the subjective.

Summary

Beginning with Wang Chong and continuing with Zhang Zai, thinkers who applied *Qi* can usually be categorised as unorthodox thinkers, or they even considered themselves as belonging to the active political opposition. For up to the Ming dynasty any occupation with *Qi* inevitably expressed a political purpose. I suggest that scholars who dealt with *Qi* primarily did so to express their political convictions as well as a distinct philosophical belief. In any case the two issues cannot be separated from one another.

The triumph of Zhu Xi's theory of *li* during the following periods had the result that Zhang Zai's philosophy remained of secondary importance in state indoctrinated systems—education and office holding. When the Ming house made Zhu Xi's philosophy a state doctrine, its canon became mandatory for state examinations and in intellectual discourse. Towards the end of the Ming dynasty and under the Qing dynasty, philosophers progressively opposed the domination of principle (*li*) as a philosophical principle. Naturally, the successive constriction of doctrinal ideals to the one extreme brought forth thinkers who reconfirmed its philosophical *parem esse*. But due to this political support and within the realm of political and philosophical classification of Zhang Zai, any individual interest in *Qi* was automatically marked as being at variance with the Ming Neo-Confucian propagation of principle as its state doctrine. Thus any interest in *Qi* was quickly associated with the motive of political opposition. Besides Song Yingxing and Wang Fuzhi, people like Wang Tingxiang 王廷相 (1474–1544), Luo Qinshun, Liu Zongzhou 劉宗周 (1578–1645), Tang Hezheng 唐鶴徵 (1538–1619), and Dai Zhen 戴震 (1723–1777) determined further that

the nature of morality and principle was the very nature of the *Qi* quality (*Qi zhi*), and hereby resurrected resonance as a cosmological issue.[79] To a considerable degree all of these men opposed the contemporary doctrinaire attitude and concurring state politics.

It is interesting that during the Ming dynasty people like Song Yingxing and Wang Fuzhi use *ganying* with a concrete issue in mind. Although they seemingly deal with different contexts, their concern is similar in that both agree upon *ganying* as a structural formula of relationships. Both come to a quite different conclusion from the mainstream scholars who reflected on *ganying* only as a formula of moral connotation. In both approaches *ganying* equally establishes in itself the order of the universe. Song claims that people react to sound *ganying* because of a shattered or damaged harmonious *Qi* that attempts to resurrect harmony. Shattered *Qi* means chaos. It is thus the opposite of a non-desirable state striving after harmony. Harmony is per definition *Qi* in a state of rest, i.e., when things and events have reassumed their natural order after stimulation and response. Consequently sound is the abrupt dissolution of order that is attempting to get back to its initial stage. By this straightforward application Song Yingxing turns the moralistic connotation that Confucian scholars had attributed to *ganying* back into a cosmological principle, in which sound serves as a proof that the world was one of *Qi*.

Song's notion of *ganying* draws essentially on the classical Lüshi chunqiu, arguing that "things of the same category are certain to attract each other. When their *Qi* is the same they are in harmony, when sounds are matched, they resonate." In this regard the political and somatic microcosm can only harmonise with the macrocosm because the ensemble of dynamic processes circulates *Qi* (as the material basis of change) throughout all realms equally. Thus all levels echo another. Wang Fuzhi's understanding, although he deals with art, corresponds to this. In his theory about art and reflection he draws on a dualistic *Qi* concept with *yin* and *yang* attributes. His worldview is as holistic as Song's when he claims that "emotion and scene are given two terms, but in reality one cannot divide them. The Divine that is in the poem, subtly unites

79 Ding Yidong 丁易東 (Tang Hezheng) of the Song dynasty (end of the thirteenth century), for example, related most of his *Qi* studies to the investigation of the *Yijing* prevalent in his study *Zhou Yi Xiangyi* 周易象義 [The Sense of the Phenomenon in the Zhou Yi]. Ho Peng Yoke, Chinese science: The traditional Chinese view. *Bulletin of the School of Oriental and African Studies, University of London* 54 [3] (1991): 506–519, 511.

without a boundary/shore."[80] For Wang Fuzhi the scene–emotion relation is in ultimately a relation between motif and object. This concept structuralises art phenomena seeing *ganying* as the unifying reason of object–motif. The idea that emotion and scene create one another as a resonance concept produces an art phenomenon in which motif and object meld together and act upon each other in an interplay of stimulus and response, reaching the peak of perfection at the point where stimulus and response disintegrate harmoniously.

80 Wang Fuzhi, *Jiang Zhai shihua* 姜斋詩話 [Poetry and prosa of Jiang Zhai] (Beijing: Renmin wenxue chubanshe, 1981), 2:14b.

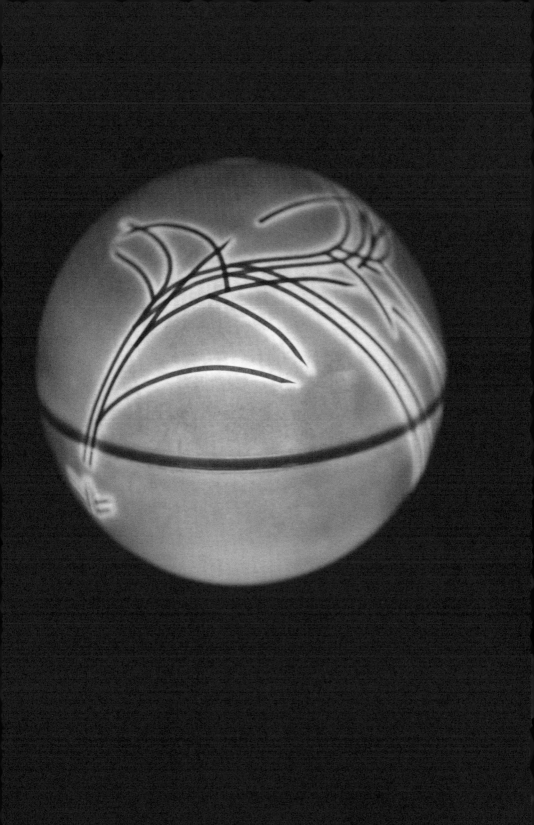

Worldprocessor [#231]

XU FEI

Exploration and Achievements of the Acoustics of *Yuelü*, the Theory of the Tone System in Ancient China

In the history of Chinese science, the theory of the tone system in ancient China is a specific field that is one of the most abundant in content; it has the longest history, and is the closest to modern science in interrelated results. This text investigates the historical evolution of *Yuelü* 乐律, the theory of the tone system in ancient China, from the perspective of and by means of media archaeology. Some of its outstanding results are presented. Theoretical thinking as well as technological methods that Zhu Zaiyu 朱载堉 (1536–1611) adopted to create equal temperament are illustrated and discussed. Further, the intrinsic relationship between arts, sciences, and technologies and its important influence on innovation in the arts is revealed.

Introduction

Sound is probably the earliest medium that humankind made direct use of because humans possess vocal organs. Assuming that spoken and written language required the progress of civilisation, these were probably preceded by the medium of sound based on simple music to fulfil the important task of exchanging emotions and even information between people. A survey of the relations between art, science, and technology in ancient times by means of media archaeology must not neglect the important field of the very long and unique tradition of the theory of the tone system in ancient China, which is called *Yuelü Shengxue* 乐律声学 or simply *Yuelü* 乐律,[1] and its evolution. In the history of Chinese learning this theory is a specific field, which is one of the most abundant in content, has one of the longest histories, and is closest to modern science in interrelated results. Since prehistoric times, the Chinese have attached great importance to knowledge of acoustics, and all Chinese dynasties

1 Translator's note: Both terms are translated here as "theory of the tone system in ancient China".

assigned a very high position to music. Ritualised official ceremonies with music and dance, the *Zhili Zuoyue* 制礼作乐,[2] were a national institution, and officials paid much attention to the systematic study of tone system theory and of musical instruments and achieved great success in this. These circumstances motivated research on the nature of sound and related acoustic phenomena. Beginning with the *Shiji* 史记 [Records of the Grand Historian] of Sima Qian 司马迁 (145–? B.C.) until the *Qingshi Gao* 清史稿 [Draft History of Qing], ancient China preserved complete, continuous historical documentation collected historically in the *Ershisi Shi* 二十四史 [Twenty-Four Histories]. Sixteen of these twenty-four books discuss theoretical problems of the study of the ritual tone system, which are classified into special sections and chapters or merged with the science of astronomical calculation of calendars. Data on the theory of the tone system were also standardised on a national level. Thus the only field of ancient Chinese natural science that goes back several thousands of years without interruption and that has maintained its advanced level throughout the ages is the study of the ritual tone system, for which the ancient term is *Lüxue* 律学.[3] This is not only demonstrated by the fact that the Chinese were the first to discover the regular pattern for the length-correction of pitch-pipes, which were constructed according to the system of *Sanfen Sunyi Lü* 三分损益律 [principle of superior and inferior generation, see Section 3, but also by Zhu Zaiyu 朱载堉 (1536–1611) of the Ming dynasty (1368–1644), who systematically invented the theory of equal temperament and a tuning instrument that conforms to physical laws. What needs to be mentioned here especially is that during the Qing dynasty (1644–1911), through the aid of a Western researcher who had come to China, the Chinese researcher Xu Shou 徐寿 (1818–1884) was able to publish a treatise on "Correction of the Acoustics of Pitch-pipes by Adjustment of

2 Translator's note: *Zhili Zuoyue* 制礼作乐 were ritualised official ceremonies with music and dance instituted and ordered by the highest political leaders since the Western Zhou dynasty (11th century–771 B.C.), and held regularly under the feudal system at different political levels in all parts of the kingdom or empire.

3 As Chen (Joseph) Cheng-Yih wrote in the introduction to his book, *Early Chinese Work in Natural Science* (Hong Kong, 1996), "the areas of early acoustics that were of interest to the ancient Chinese, known as *Lüxue* 律学, has been translated by some scholars as 'temperament', but the scope and interest of *lü-xue* are not well represented by those of the temperament. The term *Lüxue* literally means the study of Lü 律. It would probably be better not to translate the term at all. If it is necessary, one probably may coin the term 'Lüology' to represent this branch of early science in Chinese civilisation." Translator's note: in this text, *Lüxue* will be translated by "study of the ritual tone system" or just "*Lüxue*".

their Length Measures" [translated below by "length-correction of pipe", see Section 3] in the famous British science journal *Nature*. This was the first scientific article published by a Chinese in *Nature*. This fact demonstrates that the theory of the tone system in ancient China is an academic discipline that was able to maintain a dialogue with the advanced natural sciences of the world during a period when modern Chinese sciences and technologies lagged far behind developments in the West.

Over the past ten thousand years, the influence of the overlapping of acoustics and arts that emerged in the theory of the tone system in ancient China had attained several high points. The development of this theory even exerted an important influence on the political system of China. The following review and study of its history will help us to reconsider the great creations achieved by humankind through the combination of arts, science, and technology.

1. Tracing the Roots
of the Theory of the Tone System
in Ancient China

In the past musical acoustics had an important influence and effect on the formation and evolution of Chinese civilisation. However, when it comes to dating its actual historical starting point, which extends back several thousands of years, we are confronted with unusual and confusing depths in which it is easy to get lost. Thanks to ancient artefacts unearthed by archaeologists, currently the earliest origins of Chinese musical acoustics can be traced back to a *Gudi* 骨笛 (a Jiahu bone flute), dated to 5000 B.C., that was found at the excavation site in Hemudu (located in the flatland south of the Bay of Hangzhou in Jiangsu Province), which produces a single pitch when blown. Another find is a *Xun* 埙, a wind pipe made of pottery discovered at the archaeological excavation site of Banpo near the city of Xi'an, which has only one sound hole. It seems that these earliest artefacts are in stark contrast to the theory of the tone system in ancient China that developed in later times. The discovery of bone flutes at the excavation site of Jiahu in Henan Province, which are estimated to be about 8000 years old, has thoroughly rewritten the history of the origin of Chinese primitive musical acoustics. In 1987, several dozens of bone flutes were found at the Jiahu early Neolithic site in Wuyang, Henan Province. In 1999, *Nature* published some basic information about the Jiahu bone flutes under the heading "Oldest playable musical instruments found at Jiahu early Neolithic site

Fig. 1: 7-hole bone flute (Gudi) M511:4, excavated from Jiahu Neolithic site, which can still play amazing music.

in China".[4] From April 16 to June 10, 2001, the author and his research team carried out the seventh excavation at Jiahu archaeological site. One of the main results of this excavation was another batch of bone flutes. Among these, the basically intact Gudi M511:4 provided us with the conditions for a further thorough examination of the Jiahu bone flute.

Acoustic measurements showed that the musical acoustics of the Jiahu bone flute were successful. Further possible interpretations include at least the following:

(1) Originally the Gudi was an end-blown flute held vertically and inclined for playing. In this way, it is possible to get the same music results as with today's musical instruments. It does not sound, as maintained in the past, like some kind of weak breath.

(2) Most of the 6- and 7-hole Gudis can perform two true octaves when played by the old technique of vertical and inclined end-blowing. This result of actual measurements affirms that Jiahu bone flutes actually served as functioning musical instruments. Furthermore, when it comes to discussing the relationship between arts, science, and technology, a practical demonstration of the flute's musical acoustics astounds people: even at that time, humans had obviously already mastered suitable technologies for making musical instruments.

(3) Experimental acoustic measurements have shown that with appropriate adjustment of the fingering technique, most of the 7-hole bone flutes can perform a largely exact 7-tone scale and not a 5- or 6-tone scale. Of course, performing a 5-tone scale only will show even better musical accurateness.

4 Zhang Juzhong, Garman Harbottle, Wang Changsui, and Kong Zhaocheng, Oldest playable musical instruments found at Jiahu early Neolithic site in China. *Nature* 401 (1999): 366–368.

(4) With reference to the 12-tone equal temperament that is generally adopted in the world today, the different Gudis diverge considerably in their musical accurateness, but of those that are still playable, almost all are able to produce sweet-sounding music that is pleasing the ear. This illustrates that long-established musical practice permitted the inhabitants of Jiahu to conceive basic musical aesthetic feelings, and furthermore, they had discovered and executed the regular patterns for drilling holes and producing sounds that were pleasant to human ears. Engravings found on several of the Gudis are also evidence that this technology was already evolving quickly towards sophistication in this period. This is the reason why the inhabitants of Jiahu were able to make Gudi bone flutes in such large numbers, and also helped this type of musical instrument to become an important utensil for religious practice and entertainment. Considering that only about 5% of the entire Jiahu area has been excavated so far, but that nearly 30 bone flutes have already been found, this large quantity inevitably suggests that the Jiahu bone flute must have been a very popular musical instrument or utensil for sacrificial offerings in that period.[5]

2. Examination and Explanation of Standard Pitch Instruments Used in the Han Dynasty (206 B.C.–220 A.D.)

The making of standard pitch instruments is an important indication of humans combining arts, science, and technology. Preserved documents and archaeological excavations indicate that as early as in the sixth century B.C. and even earlier, the Chinese began to make typical musical pipe instruments like the Jiahu Gudi described above. Not later than at the end of the Yin dynasty (another name for the Shang dynasty, ca. 1600 – ca. 1046 B.C.) and the beginning of the Zhou dynasty (1122–256 B.C.), the ancient Chinese invented pitch-pipes (*Lüguan* 律管) for the fixation of tones to regulate the pitches of bell chimes. During Spring and Autumn Period (770–467 B.C.) and the Warring States Period (475–221 B.C.), the pitch-pipe had already become a commonly used tuning instrument. The widespread utilisation of pipe-tuning instruments in ancient times met its own social demand: Very early in ancient China, people

5 Xu Fei, Xia Ji, and Wang Changsui, *Jiahu Gudi Yinyue Shengxue Texing de xin Tansuo* 贾湖骨笛音乐声学特性的新探索 [New research of acoustics characteristic of Jiahu bone flute], *Yinyue Yanjiu* 音乐研究 [Music Research] 112 [1] (2004): 30–35.

practised a type of musical form where many people gathered to make music and sing together. In order to realise the joint performance of music by a large number of people, one condition is first to establish and to fix an absolute pitch as a common norm, which requires a pipe-type tuning instrument. This is one of the reasons why in ancient China, research on pitch-pipes persisted for such a long time without declining.

In China, the *Yingao Biaozhunqi* 音高标准器 [standard pitch instrument or simply tuning instrument] used for musical practise was also called Dinglü-qi 定律器 [instrument for fixation of pitch]. There were two types of tuning instruments in ancient China, the string type and the pipe type. According to ancient records, representatives of early string-type tuning instruments were the *Junzhongmu* 均钟木 [lit. uniform bell wood], the *Zhun* 准 [lit. standard or norm] amongst others. According to current research, the Chinese had already invented a string-type tuning instrument for tuning and fixation of pitch in the sixth century B.C., for which the ancient name was *Junzhongmu* 均钟木.[6] However, because this tuning instrument was made of wood, it is not durable and unlikely to survive. Only when a 5-string instrument was found in the tomb of Lord Yi of the State Ceng (in the Warring States Period) 曾侯乙墓 [Cenghou Yimu] in Hubei Province, did we obtain a possible reference to deduce the real shape of the *Junzhongmu*. After Qin (221–206 B.C.) and Han period, this type of string-type tuning instrument was mostly called *Zhun* 准 [standard or norm], *Xianzhun* 弦准 [stringed norm] or *Lüzhun* 律准 [pitch norm]. There exists a fairly detailed record on string-type tuning instruments dating from the Han dynasty. In the *Lülizhi* 律历志 [Memoir on the calendar and acoustic calculations] of *Hou-Han-Shu* 后汉书 [Book of Later Han] they are clearly described: "The shape of a *Zhun* is similar to a *Se* 瑟 [translator's note: a Se, *great lute*, was an ancient type of lute extinct today], 1 *Zhang* 丈[7] in length, with thirteen strings. It had an interstice of 9 *Chi* 尺 and its *Huangzhong* 黄钟[8] [-string] was 9 *Cun* 寸 in length. Just below the string closest to the centre, graduations for the division of *Fen* and *Cun*, were engraved that served for the segmentation of the 60 notes. [准之状如瑟，长丈而十三弦，隐间九尺，以应黄钟之律九寸。中央

6 Dai Nianzu, *Zhongguo Wulixueshi Daxi – Shengxue Shi* 中国物理学史大系—声学史 [A History of Acoustics—History of Physics in China series] (Changsha, 2001), p. 10.

7 Translator's note: Traditional length measures and proportions in ancient China are: 1 Zhang 丈 (3,30 meter) = 10 Chi 尺; 1 Chi (one third of a meter) = 10 Cun 寸; 1 Cun = 10 Fen 分; 1 Fen = 10 Li 厘 (one third of a millimetre) etc.

8 Translator's note: *Huangzhong* 黄钟 [lit. yellow bell]. In ancient Chinese musical acoustics, this is the fundamental pitch taken as reference for the determination for all the other notes of the scale.

一弦，下有画分寸，以为六十律清浊之节。]" This passage from the *Hou-Han-Shu* describes the *Lüzhun* of Jing Fang 京房 (77–37 B.C.). Later, other new string-type tuning instruments continued to be designed, but most of them referred to the *Zhun* of Jing Fang.

Another important result of acoustics in the Han dynasty was the determination of the shape for a pipe-type tuning instrument, the ancient *Lüguan* 律管 (pitch-pipe), abbreviated *Guan* 管 [pipe]. In his *Yueling Zhangju* 月令章句 [Punctuated commentary on the monthly ordinances], Cai Yong 蔡邕 (132–192 A.D.) explained clearly and precisely: "The pitches are [length] proportions, and they are pipes of high and low tones [律，率也，清浊之管也]," and further: "Pitch is the method for the proportions of high and low tones, the measure for the height of tones are the length of pipes. [律者，清浊之率法也，声之清浊，以管之长短为度。]"[10] The pitch-pipes used in ancient China for tuning were usually made of twelve bamboo or copper pipes. One end was the mouth-piece; the other end was open. There were no sound holes in between the ends. The longest of the twelve pipes was the fundamental pitch and was called *Huangzhong* 黄钟. Actually, Sima Qian already stated in his *Shiji*: "As King Wu attacked Zhou (in order to overthrow the house of Shang), pipes were blown and their sound listened to [武王伐纣，吹律听声]", which indicates that pitch-pipes were probably utilised in even earlier periods. In the eleventh century B.C., when King Wu attacked the state *Zhou* 纣, pitch-pipes must have already been relatively widespread.

In ancient China, both string-type and pipe-type tuning instruments were used simultaneously in order to enhance their respective strong points and lessen their shortcomings. The strings were used to set the *Lü* 律 [pitch], and the pipes were used to set the *Yin* 音 [notes]. When the two were combined, it was possible to determine accurately the pitch of the fundamental tone as well by the use of pitch-pipes, and the pitches of all the other notes by using the strings.

9 *Houhan Shu – Lülizhi Shang (Zhuyin)* 后汉书 · 律历志上 (注引) [History of the Later Han dynasty, memoir on the calendar and acoustic calculations, part 1 (Annotations)].

10 Joseph Needham distinguishes *Sheng, Yin* and *Lü* as following: "Sheng has been translated as 'tones', in order to distinguish it from the word yin here interpreted as 'notes' [...] These two words seem at one time to have meant quite different sorts of sound. The former in its earliest written form suggests the sound produced when one of the ringing-stones is struck, and the latter that produced by blowing through a flute or pipe. [...] Moreover, the word lü (pitch) is also used as a synonym for 'note'. We find frequent references to the seven pitches at this time [i.e., Western Zhou dynasty (11th century–771 B.C.)], meaning the seven notes of a scale." In: Joseph Needham, *Science and Civilisation in China*, vol. 4, part 1 (Cambridge, 1962), p. 163.

Due to the lack of appropriate finds in the archaeological record, for a long time it was only possible to read about these two kinds of ancient Chinese compact tuning instruments, thus it was difficult to figure out their actual shape. Fortunately, among the many ancient sculptures collected in the Shanghai Museum, we found a set of tomb sculptures with a music theme from the Han dynasty, with the inventory numbers 75959 and 75960, respectively.[11] The complete set consists of two pieces made of pottery that have been preserved intact; the modelling is refined and of consummate craftsmanship. The set has been dated to the period of the Eastern Han dynasty (25–220 A.D.), precisely the period when tuning instruments of the Han dynasty were fully developed. This set of sculptures gives us material references quite similar to the historical original shape, invaluable for understanding the details of the essential shape and usage of the two main tuning instruments of the period. Thanks to the discovery of this set of sculptures, the basic shape and usage of string-type and pipe-type tuning instruments of the Han dynasty are no longer difficult to imagine.

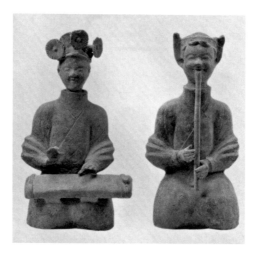

Fig. 2: A set of ancient sculptures, which can help us to envisage the musical tuning system structure during the Eastern Han dynasty of China (25–220 A.D.).

11 The graphical material originates from: Shanghai Museum, ed., *Zhongguo Gudai Diaosuguan* 中国古代雕塑馆 [Museum of ancient sculptures of China] *Huace* 画册 [Photo album], p. 5. q.v. Wang Zichu 王子初, *Zhonguo Yinyue Wenwu Daxi Shanghai Juan* 中国音乐文物大系上海卷 [Complete collection of Chinese cultural relics of music, volume on Shanghai] (Zhengzhou, 1996), p. 143.

Compared with the overwhelming number of records on the theory of the tone system in ancient China in the ancient Chinese classical records and literature, the amount of preserved ancient Chinese tuning equipment is as yet not very large. This set of tomb sculptures provides research on the history of ancient Chinese musical acoustics with a vivid image for reference. They are a precious piece of material historical data on ancient Chinese musical acoustics because of many aspects, including their historical age, their state of preservation, and the way they reflect reality.[12]

3. The First Scheme in Ancient China for Adjusting the Length of Pitch-pipes by Varying Pipe Diameters

Once one had an absolute pitch, a tuning method was still needed. Only then it was possible to determine a pentatonic (5-tone) or a heptatonic (7-tone) scale. This involves the overlap of mathematics, acoustics, and music. The ancient Chinese invention of *Sanfen Sunyi Lü* 三分损益律 [principle of superior and inferior generation][13] is just such a method to determine the notes of fixed pitch, simple and easy to learn, convenient to manipulate and to generate harmonic sound. To realise a pentatonic or a heptatonic scale on a stringed music instrument according to this method is easy and the result is pleasing to the ear. Therefore, the principle of superior and inferior generation had always occu-

12 Xu Fei and Xia Ji, Handai Yingao Biaozhunqi Xingzhi de zhongyao cankao 汉代音高标准器形制 的重要参考 [Important reference on shapes and making of musical tuning instruments in the Han dynasty], in: *Kexue Jishu yu Bianzhengfa* 科学技术与辩证法 [Science, technology, and dialectics] 20 [6] (2003): 72–73.

13 The principle of superior and inferior generation, *Sanfen Sunyi Lü* 三分损益律, is the system used for the calculation and generation of the different tones of the Chinese gamut of pitches. The translation "principle of superior and inferior generation" is Needham's: Needham, *Science and Civilisation*, vol. 4, part 1, pp. 173–174.

Translator's note: This system functions as follows: by reducing the length of a string of known length and pitch by one third (or multiplying it by 2/3), one produces a string five tones higher (described as "inferior generation"). By increasing the original string's length by one third (or multiplying it by 4/3), one produces a string three tones lower ("superior generation"). This process of multiplying by 2/3 or 4/3, whichever was required to keep the gamut within the compass of a single octave, started by a given fundamental pitch, the *Huangzhong*, and was continued up to the twelfth note, these being the twelve *Lü*. This ideal method by length proportions applies to stringed music instruments, but not to pipe music instruments due to the end-effect of pipes (see footnote 14 below).

pied a high status in ancient Chinese musical practice. However, this principle does not allow performance of musical transposition, and furthermore it creates difficulties when applied to pipe-type tuning instruments. A pipe whose length was made according to this principle does not sound the intended pitch. This raises the problem of length-correction of pipes.[14] Since this problem involves quite complicated physical phenomena, it is not possible to understand it exactly without carrying out one's own acoustic experiments.[15] Thus, the statements of past scholars were mostly opaque, even confused. According to the explanations of Jing Fang of the Western Han dynasty (206 B.C.–25 A.D.), one of the difficulties of the principle of superior and inferior generation is that pipes cannot be used (accurately) for tuning [竹声不可以度调].[16] What Jing Fang called "accurate tuning" expressed the hope of being able to realise the principle of superior and inferior generation on pipes so that they sound musical harmonics. Without carrying out length-correction, the pitch-pipes made according to this principle do not sound the same way as string-type tuning instruments made by the same principle. Moreover, even if the two *Huangzhong* 黄钟 and *Qing-huangzhong* 清黄钟[17] pipes have a 1:2 length ratio, they cannot sound an octave. Before the problem of length-correction was solved, ancient people could only use pipes to set the *Yin* 音 [notes], and strings to set the *Lü* 律 [pitches].[18] Until Shen Kuo 沈括 (1031–1095) of the Song dynasty (960–1279), people still used

14 Translator's note: The length-correction (of pipe), in Chinese: Guankou Fayin de Xiaozheng 管口发音的校正 [lit. correction of the sound emission from pipe-orifice], or Guankou Xiaozheng 管口校正 [lit. correction of pipe-orifice]. The length-correction (of pipe) is aimed at compensating the end-effect of pipes described in footnote 16 by adjusting one or several of the many factors responsible for variation in pitch, usually length and/or diameter, but also thickness of the walls of the pipe; see: Kenneth Robinson, *A Critical Study of Chu Tsai-yu's Contribution to the Theory of Equal Temperament in Chinese Music* (Wiesbaden, 1980), p. 69 and 118.

15 Translator's note: Needham explains: "The reason for the inaccuracy is that the effective length of a blown pipe is greater than the length of the pipe itself. The frequency of the note of a blown pipe with open ends equals the velocity of sound divided by twice the length of the pipe. But the effective length of the pipe, i.e. the length of its resonating air column, is its geometric length +0.58D, where D is the internal diameter. This is termed 'end-effect'. A vibrating string has no end-effect." In: Needham, *Science and Civilisation*, vol. 4, part 1, p.186, footnote d.

16 Fan Ye, *Houhan Shu. Lülizhi* 后汉书。律历志 [Memoir on the calendar and acoustic calculations, history of the Later Han dynasty]; *Wenyuange Siku Quanshuben* 文渊阁四库全书本 [Imperial collection of four from the Imperial Library in the Forbidden City], Song period of the Southern Dynasties (420–479), published 445.

17 Translator's note: *Qinghuangzhong* 清黄钟 literarily means "clear yellow bell". That is the half-length *Huangzhong* that sounds the higher octave of the *Huangzhong*.

18 For the differentiation between *Yin* 音 and *Lü* 律, see footnote 9 above.

the following tuning procedure: "Nowadays, in order to tune the strings, one must first use the *He* 合-note [so] of a pipe music instrument to define the *Gong* 宫 -string [do], because the *Gong*-string is used to generate the *Zheng* 征 [so] below it, [...] by [proceeding in this way] up and down they generate each other up to the *Shaoshang* 少商 [-string][19] [今之调弦，须先用管色 '合' 字定宫弦，乃以宫弦下生征，[...] 上下相生，终于少商。]."[20]

According to modern physics, for the acoustics of pipes it is essential to consider the length-correction, since the vibrating air column of a pipe of a specific length is actually longer than the pipe itself. Only by taking this factor into account in the making of pipes and by adopting an appropriate method for their length-correction can the sound of a pipe made according to the principle of superior and inferior generation be consistent with the sound of its corresponding string. But how the length-correction should be carried out is a complicated question in experimental physical acoustics. There are only two methods: one is the adjustment of the pipe's length, and the other the adjustment of its diameter. Since it was not in accordance with the principles and rules of tuning to carry out a further length adjustment once the length had been determined by the principle of superior and inferior generation, ancient people usually began by adjusting the diameter of the pipe. The first who tried to carry out length-correction by reducing the internal diameter of the pipe was Meng Kang 孟康 (ca. third century) of the Western Jin dynasty (265–316). Thanks to progress in modern physics, today we have mastered the theoretical principles involved in pipe length-correction and possess relatively reliable theoretical calculation formulas and experimental parameters for it; only the mathematical relation between today's length units and those of the Qin and Han periods have to be clarified. On the basis of the theoretical formula for the sound frequency of a pipe, we can carry out theoretical calculations of the frequencies of the sounds of Meng Kang's pitch-pipes with their varying diameters. Our studies prove that on the basis of the excellent and ingenious content of Meng Kang's annotations to the *Lülizhi Diyi Shang* 律历志第一上 [Memoir on the calendar

19 Shen Kuo, *Yuelü*, Juan 6 乐律, 卷6 [Music and temperament, vol. 6], in: *Mengxi Bitan* 梦溪笔谈 [Dream Pool Essays], Song dynasty (960–1279). The Dream Pool Essays were printed in the Yuan dynasty (1271–1368) (Beijing, 1975).

20 Translator's note: The five tones of the Chinese pentatonic scale are: *Gong* 宫 (in Western notation of 7-tone scale: do), *Shang* 商 [re], *Jiao* 角 [mi], *Zheng* 征 [so], *Yu* 羽 [la]. *Guanse* 管色 is a pipe music instrument. *He* 合 is a notational symbol in the traditional Chinese musical notation system and corresponds to "5" of the numerical notation (= so), and also is the *Zheng* 征-note. *Shaoshang* 少商 is the seventh string on the 7-string lute.

and acoustic calculations, part 1] of the *Qianhan Shu* 前汉书 [Book of Earlier Han], vol. 21, it is possible to obtain a complete scheme for pitch-pipes with varying diameters: The *Huangzhong* pipe measures 9 *Cun* in length, 9 *Fen* in circumference, and 3 *Fen* in diameter. The lengths and the diameters of the other pipes can all be obtained by mutual generation through the principle of superior and inferior generation. The scheme for pitch-pipes with varying diameters that Meng Kang proposed in his commentary to the *Lülizhi* 律历志 [Memoir on the calendar and acoustic calculations] of the *Qianhan Shu* is the seed of the idea that the ancient Chinese had to correct pipe acoustics systematically by altering the internal diameter of the pipe, which cleared the way for later generations to continue research to obtain an accurate scheme for pipe length-correction. Theoretical checks proved that the scheme for length-correction by the simultaneous reduction of the diameter and the length of pipe as proposed by Meng Kang produced results that already largely correspond to the string pitches. Apart from a single deviation of one musical cent,[21] the sound of every pitch-pipe was identical to the corresponding string pitches. According to the principles of musical acoustics, even a professional musician is only required to be able to sound out a usual tone deviation (22 cents). There are only very few people who can distinguish a deviation that is half the usual tone deviation.[22] The length ratio of two pipes is 1:2, and the theoretical frequencies of their sounds also correspond to a 1:2 ratio. It is possible to perform an octave interval.[23]

According to analysis of the ancient documents currently available, Meng Kang was the first in Chinese history to propose pipe length-correction by varying the diameters. This knowledge was of great significance in promoting further progress in the field of pipe acoustics.

21 Translator's note: A cent is equal to 1/100 of the tempered European semitone; see: Needham, *Science and Civilisation*, vol. 4, part 1, p. 216.

22 Miao Tianrui, *Lüxue, di 3 Ban* 律学, 第3版 [Study of the ritual tone system , 3 ed.] (Beijing, 1996), p. 19.

23 Fei Xu, *Xijin Meng Kang Yijing Lüguan Kaozheng* 西晋孟康异径律管考证 [Textual research on the pitch-pipes with varying diameters of Meng Kang from the Western Jin dynasty]. *Zhongguo Keji Shi Liao* 中国科技史料 [Material about the history of science and technology in China] 21 [3] (2000): 251–258.

4. The First Success of the Ancient Chinese Principle of Superior and Inferior Generation on Standard Pitch-pipe Flutes

Through their musical practice, the ancient Chinese discovered very early that "to halve and then double a tone results in just the same tone; however, its pitch sounds different to the ear. [夫声折半及倍加, 只是一声, 但清浊异耳。]"[24] The problem is that the pitches of stringed instruments, whose lengths are in 1:2 ratio, sound an octave, but with pipes this is not the case. Due to the end-effect of a pipe, the pitches of pipes with 1:2 length ratios do not sound an octave. This is similar to what Jing Fang of the Han dynasty said: "pipes cannot be used (accurately) for tuning [竹声不可以度调]." Since at that time Jing Fang did not know how to carry out the length-correction of pipes, he had to "make a *Zhun* tuning instrument similar to a *Se* 瑟 according to a fixed plan [作准以定数, 准之状如瑟]".[25] Therefore, if pitch-pipes that have been constructed by the use of the principle of superior and inferior generation are not adjusted, they will face two problems: first, apart from the *Huangzhong* pipe, the pitches of the rest of the twelve pipes are not exact; second, even if two pitch-pipes sounding an octave interval are artificially made to be in 1:2 length ratio, their sound still cannot form an octave.

To solve these two problems, ancient scholars diligently continued to work on this heritage after the decline of the Han dynasty. Due to the influence of the way of thinking predetermined by their able and virtuous ancestors *Liu Xin* 刘歆 (? –23), *Ban Gu* 班固 (32–92), and *Zheng Xuan* 郑玄 (127–200), many people believed that the length of pitch-pipe must follow the principle of superior and inferior generation, and also that the internal diameter must not change at all: "the measure of the circumference is neither increased nor decreased [惟大小围数无增减]".[26] Thus, throughout a long period of history, the length-correction of pipes was a big obstacle for the ancient Chinese to solve accurately the difficulty of pipe acoustics.

There are always people courageous enough to make breakthroughs to new creations. As mentioned above, in his commentary to the *Lülizhi* 律历志 [Mem-

24 Tian Wuze, *Lun Xiansheng Leibie* 论相生类别 [Discussion on types of mutual generation], in: *Yueshu Yaolu, Juan* 5 乐书要录, 卷5 [Selections from music books, vol. 5], Tang dynasty (618–907 A.D.)

25 *Houhan Shu—Lülizhi* 后汉书·律历志 [History of the Later Han dynasty, memoir on the calendar and acoustic calculations].

26 Tian Wuze, Lun Xiansheng Leibie 论相生类别 [Discussion on types of mutual generation], in: *Yueshu Yaolu, Juan* 5 乐书要录, 卷5 [Selections from music books, vol. 5], Tang dynasty (618–907)

oir on the calendar and acoustic calculations] of the *Hanshu*, Meng Kang of the Western Jin dynasty was the first to propose a scheme for the variation of the internal diameter of pipe—the nucleus of the idea that the ancient Chinese had to correct pipe acoustics systematically by changing the internal pipe diameter. Liu Zhuo 刘焯 (544–610) of the Sui dynasty (581–618) was the first to challenge the principle of superior and inferior generation and to propose a new tuning method. He initiated a tentative idea that humankind's understanding and thinking definitely had to pass through: to determine pitch by equal difference relations.[27] Failure was inevitable; nevertheless, it cleared the way for later generations to create a scientific equal temperament.

In the early eleventh century, the ancient Chinese principle of superior and inferior generation finally achieved success in the length-correction of pipes by Ruan Yi 阮逸 and Hu Yuan 胡瑗 of the Song dynasty on the basis of the great deal of hard work by their predecessors.

In the first year of the Jingyou period (1034–1038) of the reign of Emperor Renzong 宋仁宗 of the Song dynasty, the two musicologists Ruan Yi (ca. tenth to eleventh century) and Hu Yuan (993–1059) of the Song dynasty bequeathed to their descendants a precious diagram on the form and measures of pitch-pipes in the book *Huang-You Xin-yue Tu-Ji* 皇佑新乐图记 [New illustrated record of musical matters of the Huang-You reign-period]: It shows a set of pitch-pipes made according to the principle of superior and inferior generation. All together, there are sixteen pipes.[28]

The data system provided about this group of pitch-pipes is perfect in its form of presentation. The lengths conform strictly to the principle of superior and inferior generation. As to the diameters of the pipes, some finesse and interesting details are obviously also put in at random. "In the history of China, this is the first complete set of tuning instruments with varying diameters comprehensively recorded and described." Dai Nianzu 戴念祖 conjectures that "the numbers and values of the diameters of [the] pipes may have been defined by practice or experiments", but as to the question "if they are in perfect harmony with the stringed tuning instruments", he thinks that "there still needs reconstruction research to be done."[29] Analysis of

27 *Lülizhi* 律历志 [Memoir on the calendar and acoustic calculations], in: *Wei Zheng* (魏微), *Sui-Shu, Juan* 16 隋书, 卷16 [The Book of Sui, vol. 16], 636.

28 Ruan Yi and Hu Yuan, *Huangyou Lülütu di'er* 皇佑律吕图第二 [Illustration of the standard pitch-pipes in the Huangyou period], in: *Huangyou Xinyue Tuji, Juan Shang* 皇佑新乐图记, 卷上 [New illustrated record of musical matters of the Huang-you reign-period, vol. 1] 1034 A.D.

29 Dai Nianzu, *A History of Acoustics in China* (Shijiazhuang, 1994), p. 350.

Fig. 3: Ruan Yi's and Hu Yuan's pitch-pipes in varying diameters,
Song dynasty of China.

the data displayed in the diagram shows that the standards of the standardised lengths of this set of pitch-pipes conform to the principle of superior and inferior generation; however, for the first time it broke with the traditional dictum that "The *Huangzhong* pipe measures 9 *Cun* in length, 3 *Fen* in diameter, and 9 *Fen* in circumference; all the other pipes are gradually shortened, and the measure of the circumference is neither increased nor decreased. [黄钟之管长九寸, 孔径三分, 围九分, 其余皆渐短, 惟大小围数无增减。]"[30] Adjustments have been made to the internal diameters of the entire set of pipes, and, moreover, the two pipes forming the octave interval have a 1:2 length ratio. The data on lengths and internal diameters allow for the assumption that their length-correction was carried out by varying their internal diameters. This is the first complete set of pitch instruments with varying diameters in the history of China in which measurements are comprehensively described and recorded in the form of a diagram. Through theoretical calculations on this set of pitch-pipes, we know that this set by Ruan Yi and Hu Yuan was the first to present a diagram and complete data on pitch-pipes with varying diameters that conformed to the

30 Cai Yong, *Yueling Zhangju* 月令章句 [Punctuated commentary on the monthly ordinances], in: *Houhan Shu, Lülizhi, Zhu* 后汉书,律历志,注 [Annotations on the history of the Later Han dynasty, memoir on the calendar and acoustic calculations].

271

principle of superior and inferior generation, and it systematically solved the problem of the length-correction of pipes and the problem of perfect equality of the pitches of string-type and pipe-type tuning instruments. At the same time it realised perfectly the octave interval of two pipes in 1:2 length ratio and the ancient ideal that "pipes can be used (accurately) for tuning" by use of the principle of superior and inferior generation. The ancient Chinese principle of superior and inferior generation thus obtained a quite satisfactory scheme for resolving the tuning of both string-type and pipe-type tuning instruments.[31]

Because of the limitations of the principle of superior and inferior generation, this system of temperament has to be completely rejected if one wishes to perform musical modulation. Nevertheless, the successful construction of pitch-pipes with varying diameters by using the principle of superior and inferior generation, as initiated by Ruan Yi and Hu Yuan, was a significant inspiration for the thinking of later researchers in their exploration of pipe length-correction with new systems of temperament. These ideas directly influenced and enlightened the inventor of equal temperament Zhu Zaiyu, who explicitly cited Hu Yuan's set of pitch-pipes with varying diameters in the first volume of his *Lüxue XinShuo* 律学新说 [New account of the sciences of the pitch-pipes].

5. The Greatest Achievement of Ancient China in Combining Arts, Science, and Technology: The Invention of Equal Temperament by Zhu Zaiyu

The close relationship between arts and sciences can best be reflected by the research on equal temperament in musical theory and practice. The first ever to devise a scheme for its systematic solution was the brilliant researcher and artist Zhu Zaiyu. His outstanding, encyclopaedic contributions in many areas of arts and science are very rare both in the history of ancient China and the history of world civilisation. Zhu's most outstanding contributions are: he was the first in the history of humankind to solve the difficulty of musical transposition pursued in musical practice, he successfully found the mathematical computing method for equal temperament, and he wrote a book of music with equal temperament that allows free modulation. Especially worth mentioning

31 Xu Fei, *Songdai Ruan Yi Hu Yuan Yijing Guanlü Shengxue Chengjiu de Shuli Yanzheng* 宋代阮逸胡瑗异径管律声学成就的数理验证 [Physical analysis on the acoustical achievement of Ruan Yi's and Hu Yuan's pitch-pipes with varying diameters] *Ziran Kexue Shi Yanjiu* 自然科学史研究 [Studies in the history of natural sciences] 20 [3] (2001): 206–214.

is that he performed all his experiments by himself, and he invented physical tuning instruments that conformed to equal temperament—a new stringed tuning instrument and pitch-pipes of varying diameters. Zhu made his new string norm more than one hundred years before another musical instrument with a comparable principle was invented—the piano. Moreover, his unique pitch-pipes with varying diameters solved the problem of the length-correction of equal-tempered pipes at one stroke and became the highest achievement in the field of experimental physical acoustics in ancient China. Zhu Zaiyu made further outstanding contributions to the fields of the study of the ritual tone system, musicology, dancing, and many areas of the natural sciences such as physical acoustics, the astronomical calculation of calendars, the history of weights and measures, and the mathematics of calculation with the abacus. The famous history of science scholar, Joseph Needham (1900–1995), believed that "Chu Tsai-Yü's formulation of equal temperament may justly be regarded as the crowning achievement of China's two millennia of acoustic experiment and research."[32]

Zhu's invention of the theory and practice of equal temperament is a great contribution of ancient China to world civilisation. This contribution not only consists in the degree of accuracy in the calculation of the data for equal temperament to the twenty-fifth decimal place that Zhu Zaiyu has left us, but is found even more in his analytical thinking, which is rich in scientific logic and mathematical formulas, and in his perfect experimental verification under the guidance of theory. The following four illustrations show Zhu's main achievements in relation to his invention of twelve-tone equal temperament (12-TET), including his monumental work *Yuelü Quanshu* 乐律全书 [Collected works on music and the pitch-pipes], the book of music *Xuangong Heyuepu* 旋宫合乐谱 [Melodies for harmonious ancient music] written with equal temperament, and the pitch-pipes with varying diameters, as well as the new string tuning instrument—both made by 12-TET. Zhu Zaiyu accomplished the great invention of 12-TET from theoretical calculations, via tuning pipe and stringed instruments, up to the actual performance of music.

Many texts and books devoted to the study of Zhu Zaiyu have been published before.[33] This text does not intend to add a similar account, but briefly to dis-

32 Needham, *Science and Civilisation*, vol. 4, part 1, p. 224.

33 Needham, *Science and Civilisation*, vol. 4, part 1; Kenneth Robinson, *A Critical Study of Chu Tsai-yu's Contribution to the Theory of Equal Temperament in Chinese Music*; Dai Nianzu, *Zhu Zaiyu – Mingdai de Kexue he Yishu Juxing* 明代的科学和艺术巨星 [Zhu Zaiyu—A great star of science and

Fig. 4: A photocopy of Zhu Zaiyu's great book Collected Works on Music and Pitch-pipes.

Fig. 5: Book of music written with equal temperament by Zhu.

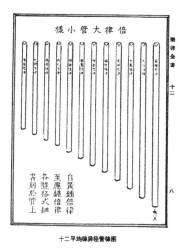

Fig. 6: Equally tempered pitch-pipes of varying diameters invented by Zhu.

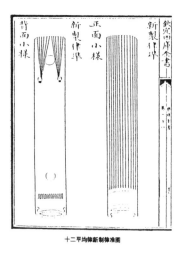

Fig. 7: Equally tempered strings tuner (pitch-strings) invented by Zhu.

Figs. 4–7: Overview of Zhu Zaiyu's achievements in twelve-tone equal temperament (12-TET).

cuss two aspects that so far have not received adequate attention. These are the unusual calculation instrument that helped Zhu Zaiyu to compute equal temperament—an ultra-long abacus—and the particular cosmology Zhu Zaiyu adhered to when he was inventing equal temperament.

In his book *Suanxue Xinshuo* 算学新说 [New account of the science of calculation in acoustics and music], Zhu writes: "For the study of extraction of roots, it is normally necessary to construct a large abacus whose length is 9 times 9 [rods] resulting in 81 digits; altogether it has 567 beads, thus roots can be extracted. Otherwise, if only ordinary abaci are available, join four or five into one to carry out the calculation. Then everything can [be calculated] too. [凡学开方，须造大算盘，长九九八十一位，共五百六十七子，方可算也。不然，只用寻常算盘，四五个接在一处算之，亦无不可也。]" Today's museum in memory of Zhu Zaiyu (*Zhu Zaiyu Jinianguan* 朱载堉纪念馆) exhibits a large 81-bit abacus constructed on the basis of recordings in Zhu's book.

Fig. 8: 81-bit abacus invented by Zhu and used in his calculation of equal temperament.

art in the Ming dynasty] (Beijing: 1986); Chen Wannai, *Zhu Zaiyu Yanjiu* 朱载堉研究 (Studies on Zhu Zaiyu) (Taipei, 1992); Xu Fei, *Dayin Xisheng – Zhu Zaiyu shi'er Pingjunlü Yanjiu* 大音希声—朱载堉十二平均律研究 [Great music is soft sound: Studies on Zhu Zaiyu's 12-tone equal temperament], in: *Zhongguoren Wenhua Shehui Kexue Boshi Shuoshi Wenku* 中国人文社会科学博士硕士文库 (哲学卷) [A dissertation library of Chinese doctor and master of social sciences and humanities, vol. philosophy] (Hangzhou, 2005).

Based on current documents concerning the history of mathematics in China, Zhu Zaiyu was the first who used an abacus to extract square and cubic roots. In his *Suanxue Xinshuo*, he gives detailed, pithy formulas [translator's note: i.e., mnemonic rhymes for calculation with an abacus] and adds detailed examples and explanations for the specific mathematical operation to extract square and cubic roots. Zhu accomplished the complicated task of computing equal temperament, resulting in a significant number accurate to the twenty-fifth decimal place, solely because he used the ultra-long abacus creatively. By the successive calculation of square and cubic roots he accomplished other complicated mathematical operations such as the extraction of the twenty-fourth square root of 2. Furthermore, he also successfully performed the computational task of solving geometric series step by step. In ancient times, when mathematics were not highly developed, the abacus was an advanced calculating tool and was a very important aid in helping Zhu to accomplish the complete reckoning of equal temperament.

The origin of the abacus in China cannot be later than the end of the Yuan dynasty (1271–1368), for in 1366 a description of the abacus appeared in Tao Zongyi's 陶宗仪 (1329– ca. 1412) Nancun Zhuigeng Lu 南村缀耕录 [Recordings on the Embellished Writings of the Southern Village]. The representative work for performing calculating operations with an abacus in ancient China is *Zhizhi Suanfa Tongzong* 直指算法统宗 by Cheng Dawei 程大位 (1533–1606) of the Ming dynasty. This book was written in 1592, and is generally regarded as the earliest account of the method for extraction of roots using the abacus. Zhu Zaiyu's *Suanxue Xinshuo* was written before 1581, so Cheng Dawei's book appeared at least eleven years later. This demonstrates that mathematics and the abacus are the two main scientific and technological means that Zhu employed to achieve his great invention of equal temperament. Zhu himself said: "The four *Xinshuo* 新说 [New Discourses] I have composed are: The first is *Lüxue* 律学 [Study of the ritual tone system], the second *Yuexue* 乐学 [Musicology], the third *Suanxue* 算学 [Mathematics], and the fourth *Yunxue* 韵学 [Phonology]. The former two are the radix of the book and the latter two its branches that the book uses as its wings. [臣所撰《新说》凡四种: 一曰《律学》, 二曰《乐学》, 三曰《算学》, 四曰《韵学》。前二者其书之本原, 后二者其书之支脉, 所以羽翼其书者也。]" Obviously, Zhu Zaiyu also saw mathematical tools, such as mathematical operations with the abacus, as the wings that helped him to complete equal temperament. This gives us a glance at a speck of the intrinsic relationship between the sciences and the arts. For apart from employing the abacus to complete calculation of the data of all the pitches of the 12-TET, Zhu also made use of the abacus to carry out the transformation of decimal places from the nonary (i.e., base-9) into the decimal (i.e., base-10) numeral system. This is also groundbreaking work in

the history of mathematics. Zhu Zaiyu's mathematical proofs and results demonstrate that the abacus is of unique superiority and convenience for transformation of different numerical systems. Figure 8 displays a new reconstruction of a large 81-digit abacus exhibited in the museum in memory of Zhu Zaiyu in today's Qinyang City in Henan Province. Just like the principle of today's computers of constantly increasing computing power, Zhu Zaiyu solved the algebraic problem of root extraction of large numbers at a stroke by increasing the number of the abacus digits. If this 81-digit abacus had not existed, and Zhu had had to rely on paper and pencil to carry out his calculations, the amount of work is unimaginable that would have been required to obtain a significant number to the accuracy degree of the twenty-fifth decimal place.

Zhu Zaiyu's systematic success in solving the problem of equal temperament is intrinsically tied to the scientific way of thinking and the scientific methods he applied accurately for exploring the arts. The construction of the huge abacus was undoubtedly of great use in improving this contemporary advanced technology, but we also have to concede that his unique way of freely interpreting the thoughts of his able and worthy predecessors demonstrates Zhu's rigorous exploration of cosmology. This mindset, that starts from the philosophical origins of nature in order to understand the world, is identical to the thinking adopted in today's sciences. Analysing and interpreting this logic in Zhu's thinking will help us to a fuller understanding of scientific thinking in ancient China. In theoretical and experimental comparative studies of the scholars of ancient China, Zhu is one of those who are closest to modern scientific thinking.

As is commonly known, the Doctrine of Yellow River Diagram and Luo River Calligraphy (*Heluo Zhixue* 河洛之学) is one quintessence of traditional Chinese culture. It deeply influenced the thinking of many generations of ancient Chinese scholars and their paradigm for the formulation of theories, and Zhu Zaiyu is no exception. As he was a remarkable representative of Chinese culture, it was a matter of course that he carried on the heritage of the Doctrine of Yellow River Diagram and Luo River Calligraphy. In his *Lüxue Xinshuo* Zhu then makes the book's purpose and main theme clear from the very beginning by pointing out:

"The Doctrine of Yellow River Diagram and Luo River Calligraphy is the origin of pitch-pipes and calendar-making, and the ancestor of mathematics. The sage rules the world, and his perfection and virtue moves Heaven and Earth. So Heaven is willing to give the doctrine and Earth is willing to give the treasure. So the phoenix arrived and the Yellow River Diagram appeared. The Book of Changes said: 'The Yellow River bears the Diagram and the Luo River bears the Calligraphy. The saint imitates them.' The so-called imitation is not limited to the two affairs of differentiating the eight trigrams and arranging in

categories, but up to pitch-pipes and calendar-making, everything is part of it without exception. Because nothing is separable from *Yin* 陰 and *Yang* 阳 as well as from the Diagram and the Calligraphy, the Doctrine of Yin and Yang is everything. The Yellow River Diagram was conveyed by the dragon-horse. It serves as connection to Heaven (乾 Qian) and gave the bud of Heaven. The Luo River Calligraphy was induced by the turtle. It serves to flow Earth (坤 *Kun*) and disclosed the symbol of Earth. The Yellow River Diagram is *Yang* 阳, and *Yang* is often abounding; the Luo River Calligraphy is *Yin* 陰, and *Yin* is often insufficient. Hence, the number of the Yellow River Diagram is 55, and is exceeding the *Dayan* 大衍 [= the number 50]; the number of the Luo River Calligraphy is 45, and is less than the *Dayan*. The Yellow River Diagram and Luo River Calligraphy together make one hundred. Like the connection of Yin and Yang, watching its male and female appearances, they are divided in two equal parts what gives two times the number *Dayan* [=2x50]. This is the highest natural principle of Heaven and Earth. Thus pitch-pipes and calendar-making rely on it to generate their numbers. So, when the *Huangzhong* pipe is 9 *Cun* in length, these 9 *Cun* are determined by the vertical millet-grain. Each *Cun* equals 9 *Fen*; thus, altogether this is 81 *Fen*, what is the result of the odd number of Luo River Calligraphy to the power of 2; this is the root of the pitch-pipes. When the *Huangzhong* pipe is 10 *Cun* in length, these 9 *Cun* are determined by the unit of horizontal millet-grain length. Each *Cun* equals 10 *Fen*; thus, altogether this is 100 *Fen*, what is the result of the even number of Yellow River Diagram to the power of 2; this is the mother of the measures. The pitch-pipes determined by the vertical millet-grain and those determined by the unit of horizontal millet-grain length are different in length. To combine them and to make them corresponding to each other is a creative ingenuity. Since thousands of years, there was nobody who knew this, what is very sad. The past official He Tang 何瑭 (1474–1543) said: 'The *Hanzhi* 汉志 says that the *Huangzhong* pitch-pipe is 9 *Cun* in length; adding 1 *Cun* results in 1 *Chi*. The measures and weights got their authority from the *Huangzhong*, therefore, it is of high value that [the *Huangzhong*] corresponds to the ethers of Heaven and Earth. If 1 *Cun* is added [to the length of the *Huangzhong*] to result in 1 *Chi*, then how it is possible that the measures and weights can still be based on the *Huangzhong*? Especially when it is not known that the length of the *Huangzhong* originally could not be decided by man. As for whether the pitch-pipe is 9 *Cun* in length or the [length unit of] *Chi* is 10 *Cun* in length, that is what man had decided. The *Hanzhi* did not understand to tell this. That is why there was the wish to add 1 *Cun* to the *Huangzhong* to be 1 *Chi* in length, but that is absurd! Today, according to the *Hanzhi*, 'the measures are based on the length of the *Huangzhong*'. That means

that when the length of the *Huangzhong* is 1 *Chi*, then the so-called lengths as 9 *Cun*, or 8 *Cun* one tenth and so on, are only ratios that have just been established by mathematicians.' This theory, regardless of whom, announces a secret that is thousands of years old, and will lay bare the doubts that lasted for a long, long time. Many Confucians of Tang and Song did not unveil that this is the most important point in *Lüxue*, the study of the ritual tone system. [夫河图洛书者, 律历之本源, 数学之鼻祖也。圣人治世, 德动天地。天不爱道, 地不爱宝, 故凤鸟至, 河图出。易曰：'河出图, 洛出书, 圣人则之。'所谓则之者, 非止划卦叙畴二事而已, 至于律历之类, 无不皆然, 盖一切万事不离阴阳图书二物, 则阴阳之道尽矣。河图龙发, 所以通乾而出天苞; 洛书龟感, 所以流坤而吐地符。河图阳也, 阳常有余; 洛书阴也, 阴常不足。故河图之数五十五, 视大衍而有余; 洛书之数四十五, 视大衍而不足。合河图与洛书共得百数, 若阴阳之交, 观牝牡之相, 衔均而分之, 得大衍之数者二, 此天地自然之至理, 故律历倚之而起数。是以黄钟之管长九寸, 九寸者, 纵黍为分之九寸也。寸皆九分, 凡八十一分, 洛书之奇自相乘之数也, 是为律本。黄钟之尺长十寸, 十寸者, 横黍为分十寸也, 寸皆十分也, 凡百分, 河图之偶自相乘之数也, 是为度母。纵黍之律, 横黍之度, 长短分齐, 交相契合, 此乃造化之妙也。而千载以来, 无一人识者, 殊可叹也。臣何瑭曰：'《汉志》谓黄钟之律九寸, 加一寸为一尺, 夫度量衡权所以取法于黄钟者, 盖贵其与天地之气相应也, 若加一寸以为尺, 则又何取于黄钟? 殊不知黄钟之长固非人所能为。至于九其寸而为律, 十其寸而为尺, 则人之所为也。《汉志》不知出此, 乃欲加黄钟一寸为尺, 谬矣! 今按《汉志》'度本起于黄钟之长', 则黄钟之长即是一尺, 所谓长九寸、长八寸十分一之类, 盖算家立率耳。'何氏此论发千载之秘, 破万古之惑, 律学第一要紧处, 其在斯欤, 此则唐宋诸儒之所未发者也。]"[34]

This wonderful essay clearly expresses that Zhu's basis of reasoning in his ideas on *Lüxue*, the study of the ritual tone system, is precisely the Doctrine of Yellow River Diagram and Luo River Calligraphy. Zhu Zaiyu traces back the root of the number of the pitch-measure [律数之本] to "the result of the odd number of Luo River Calligraphy to the power of 2 [洛书之奇自相乘之数]" and the mother of the measures [尺度之母] originates from "the result of the even number of Yellow River Diagram to the power of 2 [河图之偶自相乘之数]". Moreover, Zhu Zaiyu introduces the method of analysis by the units of vertical, horizontal, and diagonal millet-grain length, and in one fell swoop unites all the complicated and confusing disputes of the past about the length of *Huangzhong* within the copious framework of the Doctrine of Yellow River Diagram and Luo River Calligraphy. It was Zhu Zaiyu's opinion that the many

34 Zhu Zaiyu, *Jialiangpian di'er* 嘉量篇第二 [Fine measure and calculating manual, no. 2], in: *Lüxue Xinshuo, Juan* 4 律学新说, 卷4 [New account of the sciences of the pitch-pipes, vol. 4] (1584).

controversies among ancient scholars about the length of *Huangzhong* were all caused by their ignorance of the Doctrine of Yellow River Diagram and Luo River Calligraphy and by their lack of creative ingenuity.

By the definition of modern science, such an analytical method does not hit the point of nature's logic; however, in Chinese cultural tradition, it is an attempt at uniqueness and innovation. Seeking unity and simplicity of the knowledge about nature is theoretically the instinctive demand of almost any natural scientist. Zhu Zaiyu is no different. On the basis of the Doctrine of Yellow River Diagram and Luo River Calligraphy, he first hypothesised a unified interpretation of what the ancient scholars had said about the length of the *Huangzhong*. On this basis, he then built up a new, mature system for the theory of *Lüxue*—he later called this system the theory of equal temperament by the "New method for the calculation of circumference-diameter ratio".

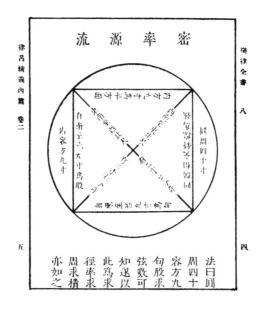

密率源流图

Fig. 9: Zhu's illustration of the source flow of equal temperament.

280

In the past, a certain number of studies criticising Zhu Zaiyu stated that it would not be fair and proper to adopt the Doctrine of Yellow River Diagram and Luo River Calligraphy. They could not figure out how Zhu Zaiyu could have been so brilliant to suddenly arrive at the concepts of intervals and musical cents by starting from geometric series and in this way achieve equal temperament. Even more unbelievable was that Zhu Zaiyu obtained his hypothesis merely by experimenting with millet-grains: "If I had not done experiments involving millet-grains, I don't think that I would have reached something as wonderful. [若不累黍亲验, 亦不信有如此之妙。]"[35] This shows that Zhu's equal temperament evolved progressively in a process full of assumptions, analysis, verifications, and experiments, like so many significant scientific discoveries and inventions in history, and in this process there was no lack of coincidences and opportunities.

Taking today's natural sciences as reference system, the Doctrine of Yellow River Diagram and Luo River Calligraphy appears to be a mathematical game; however, in ancient China, the strict, mathematically reasonable structure of this doctrine had been elaborated by scholars of Song and Yuan dynasties by deductive methods and was already a complete self-contained system in the Ming dynasty, which at the time shone in harmony together with the theories of five elements, *Taiji* and *Bagua* (i.e., the eight trigrams), and for Chinese scholars constituted the theoretical basis for the interpretation of everything. What we see today are mostly the negative effects of this science: it constrained Chinese scholars to explore thoroughly the principles of nature, and they often used one method to control everything. Hence, under the shadow of "the magic number of King Wen" [文王神数 *Wen-Wang Zhi-Shu*] Chinese scholars and science gradually fell behind the advances in other parts of the world. Yet in reality, there are two sides to everything. Zhu Zaiyu's invention of equal temperament is actually the rigorous result of a Chinese scholar applying the Doctrine of Yellow River Diagram and Luo River Calligraphy! Zhu Zaiyu's analytical process is not beyond reproach or approaching perfection, but the final result was the theory of equal temperament and that is completely on a par with modern scientific knowledge. Later generations of scholars, including today's, are moved to awe and praise confronted by equally tempered pitch-pipes whose lengths were corrected according to this theory. By this definition, the Doctrine of Yellow River Diagram and Luo River Calligraphy and other related traditional

35 Zhu Zaiyu, *Jialiangpian di'er* 嘉量篇第二 [Fine measure and calculating manual, no. 2], in: *Lüxue Xinshuo, Juan* 4 律学新说,卷 4 [New account of the sciences of the pitch-pipes, vol. 4] (1584).

doctrines and theories did indeed inspire the thinking of Zhu Zaiyu in his quest for equal temperament. It is not acceptable simply to believe that Zhu Zaiyu drew wrong conclusions by false analogy and by reading too much into something. We can go further into analysing this.

It is common knowledge that ancient scholars often changed the length unit of the fundamental tone *Huangzhong* 黄钟 out of convenience to calculate pitch-pipes. Some adopted 10 *Cun* for its length, others 9 *Cun*, and others 8 *Cun* and 1 *Fen*. The first problem Zhu Zaiyu faced was how to resolve these different units of length of *Huangzhong*. In order to unify these numbers that are found in the Chinese classics into the theoretical framework of the Doctrine of Yellow River Diagram and Luo River Calligraphy, Zhu Zaiyu took a distinctive attitude of his own and proposed an interpretation by means of length units of vertical, horizontal, and diagonal millet-grain, believing that the eighty-one units of vertical millet-grain in ancient measure of length corresponded to ninety units of diagonal millet-grain and to one hundred units of horizontal millet-grain.[36] Thus, he solved the contradictions and conflicts between the different lengths of *Huangzhong* in the ancient books in one fell swoop. Moreover, he related his interpretation to the Doctrine of Yellow River Diagram and Luo River Calligraphy and regarded it as a result of this doctrine. This is what he referred to when he stated "When the *Huangzhong* pipe is 9 *Cun* in length, [...] is the root of the pitch-pipes. [黄钟之管长九寸, [...] 是为律本]" and "When the *Huangzhong* pipe is 10 *Cun* in length, [...] is the mother of the measures. [黄钟之尺长十寸, [...] 是为度母]". The second problem was that during the calculation of the standard pitch-pipe flutes, inevitably one had to make use of the circumference–diameter ratio (Translator's note: i.e., π). To guarantee the rigor of his theoretical system, Zhu Zaiyu also had to adopt such a theoretical premise. Hence he proposed that "the arithmetic number of the square of the circumference–diameter ratio is calculated in the same way as the diameter to the power of two" "方圆密率算术, 周径幂积相求" and "there are the writings of Zhou Gong (the Duke of Zhou), but the mathematicians had forgotten its lore, and therefore it is made clear and demonstrated" "乃周公所撰, 而算家失其传, 故表而出之".[37] From today's point of view, although it would have been hard to avoid suspicions of "reading too much into something" (this was the criticism

36 Zhu Neipian 内篇, 卷4 [Internal manual, vol. 4], in: *Lülü Jingyi* 律吕精义 [The essential meaning of the standard pitch-pipes] (1596).

37 Zhu Zaiyu, *Jialiang Suanjing*, Shangjuan 嘉量算经, 上卷 [Fine measure and calculating manual, vol. 1].

levelled by Liu Fu 刘复 (1891–1934) at Zhu), Zhu Zaiyu's method whereby he built his edifice of theory is a method to find axioms, something that is rarely found among ancient Chinese scholars; that is, to start by the least primitive proposition, to bring all related problems together in the same theoretical system, and to unify, interpret, and describe them according to a certain logical principle. This is the only way for the natural sciences to proceed from the generalisation of experiences to rational deduction. And this point was precisely the weak link in the chain in ancient Chinese natural sciences. Yet when Zhu Zaiyu succeeded in making a breakthrough in this connection, he was able to realise his great achievement of equal temperament. That was the unavoidable in the contingency.

Zhu Zaiyu believed that all the secrets between Heaven and Earth could be comprehended entirely through the Doctrine of Yellow River Diagram and Luo River Calligraphy. He interpreted the 9 *Cun* length of *Huangzhong* by the unit of vertical millet grain length and linked it with the Luo River Calligraphy. This is why he believed that *Huangzhong* is the root of all pitch-measures. As to the *Huangzhong* length of 1 *Chi*, he availed himself of the unit of horizontal millet grain length for interpretation and linked it with the Yellow River Diagram. In so doing, he obtained a theoretical basis for the original norm of the *Huangzhong* measure. As Zhu Zaiyu had perfectly solved these theoretical problems, which had been confused and indistinct for a long period in history, his mood became extremely excited. Thus he was proud to say that "Since thousands of years, there was nobody who knew this, which is very sad [千载以来, 无一人识者, 殊可叹也]".

Even today, except that the units of vertical and horizontal millet grain length are assumptions, all his other interpretations are still true and at least logically perfect. Especially that Zhu Zaiyu was so clever as to use the diagram of "The internal square of 1 *Chi* [side length] and its outside circle [内方尺而圆其外]" from the Chapter *Lishi Weiliang* 粟氏为量 [Measures of the Li family] from the book *Zhouli* 周礼 [The Rites of Zhou] to calculate the key data of equal temperament is indeed "a mystery of ghosts and gods, impossible to understand [鬼神莫测, 虽百思不能到者也]".[38]

The *Measures of the Li family* from the *Zhouli* occupied a very high academic status in the eyes of ancient Chinese scholars. The perfect description of the Pythagorean theorem in the book caused many learned people in ancient times

38 Jiang Yong, *Xuwen* 序文 [Preamble], in: *Lülü Chanwei* 律吕阐微 [Detailed explanation of pitch-pipes].

to believe that this kind of doctrine would be everlasting and applicable everywhere. Even as Western sciences flowed east and European geometry and trigonometry spread to China, some scholars still affirmed that this teaching had already existed in China since ancient times, and that it would not be anything more than the doctrines of the Zhou Gong 周公 [Duke of Zhou] and Shang Gao 商高, etc. With such a cultural background, Zhu Zaiyu could not transcend the historical limits too far. Very naturally, he would also choose the principle diagram of "The internal square of 1 *Chi* [side length] and its outside circle from the *Measures of the Li family* from the *Zhouli*" and use it as geometric model to explain perfectly the truth of pitch-measure. Zhu Zaiyu believed that:

"The square resembles Earth, the circle models Heaven. Square and circle seek for this, the true proportion of Nature. Its measures come from the Doctrine of Yellow River Diagram and Luo River Calligraphy and are not man-made. The Yellow River is connected to Heaven, and its number is ten; the Luo River flows to Earth, and its number is nine. Combined, the two trigrams for Heaven [乾, Qian] and Earth [坤, Kun] form the hexagram for Peace [泰 Tai], and they mutually store their places of residence [i.e., the one is located within the other]. Therefore, nine represents Earth and ten represents Heaven. Heaven encircles Earth, Earth resides inside of Heaven. Heaven has four sides, every side is 10 *Cun* in length, and its circumference measures 4 *Chi* what is the circumference ratio of the circle. Earth has four sides, every side is 9 *Cun* in length, its diagonal is 1 *Chi* 2 *Cun* 7 *Fen* 2 *Li*[39] (one third of a millimetre) 7 *Hao* 毫, 9 *Si* 丝, 2 *Hu* 忽, 2 *Wei* 微 and a bit more in length. This is the diameter of the circle. The system of the standard measures of Zhou Gong already comprehends the art of circle measurement. [方者象地, 圆者法 天。方圆相求, 自然真率。其数出于河图洛书而非人所为也。河以通乾, 其数十; 洛 以流坤, 其数九。乾坤交泰, 互藏其宅。故九为地而十为天。天包地外, 地居天内。 天有四方, 每方十寸, 其周为四尺, 则圆之周率也。地有四方, 每方九寸, 其弦为一尺 二寸七分二厘七毫九丝二忽二微有奇, 则圆之径也。周公嘉量之制, 测圆之术盖已 具焉。]"[40]

39 Translator's note: In addition to footnote 6 more traditional length measures and proportions in ancient China are: 1 *Li* 厘 (one third of a millimetre) = 10 *Hao* 毫; 1 *Hao* = 10 *Si* 丝; 1 *Si* = 10 *Hu* 忽; 1 *Hu* = 10 *Wei* 微 and so on.

40 Zhu Zaiyu, *Milü qiuyuanmi diwu* 密率求圆幂第五 (The [calculation of the] circumference-diameter ratio requests the diameter to the power of two no. 5), in: *Lüxue Xinshuo, Juan* 1 律学新说, 卷 1 [A new account of the science of the pitch-pipes, vol. 1] (1584).

朱载堉算律理论图解

Fig. 10: Illustration of Zhu's theory of pitch-pipes: Zhu Zaiyu's cosmology and his deduction of π.

This passage contains a series of key concepts. The first is the belief that Heaven is round and Earth is square. "Nine represents Earth and ten represents Heaven [九为地而十为天]" is a basic principle of the Doctrine of Yellow River Diagram and Luo River Calligraphy. The so-called "true proportion of nature [自然真率]" is "not human-made [非人所为也]". The second key concept is that Heaven has four sides, and every side is 10 *Cun* in length. They are arranged in a circular form, thus the circumference of the circle must be 40 *Cun*. The third key concept is that Earth has four sides, which are arranged in a square form, and every side must be 9 *Cun* in length. Next, apply the method of using a right-angled triangle to find the length of the hypotenuse (i.e., Pythagoras' theorem), and thus, Heaven can be reached (i.e., the circle, the circle's diameter). Calculating the diagonal of the square is the same as calculating the diameter of the circle. Besides it is also possible to deduce the circumference–diameter ratio as being equal to $40/\sqrt{9^2+9^2}$. This is why there was the saying "[...] already comprehends the art of circle measurement [测圆之术盖已具矣]".

If, for a moment, we do not consider the erroneous belief that Heaven is round and Earth is square, compared to modern Western sciences—apart from not having adopted a formalised language—the methods of logical reasoning in such skilful theoretical "derivation" may be different in approach but

285

they achieve equally satisfactory results. All the strategies and methods from the mathematical theory of the Doctrine of Yellow River Diagram and Luo River Calligraphy up to the graph of the *Measures of the Li family* are suitable. Although they run counter to contemporary science, they have already become an organic unity, and extensively demonstrate cleverness and delight in intellectual theoretical discrimination to make statements consistent. The perfection or "elegance" of the theoretical system alone made Zhu Zaiyu deeply and doubtlessly certain about the algorithm for the circumference–diameter ratio which he had "derived" from them, and that the circumference–diameter ratio of Zu Chongzhi 祖冲之 (429–500) was not worthy of consideration.

Zhu Zaiyu not only made theoretical deductions, he also carried out every possible experimental test:

"The experimental method to apply is as follows: Use a large and a small piece of paper, apply the carpenter's square congruent to its sides, and compare the accurateness attentively so that the four sides are identical. Every side of the small [square] is 9 *Cun* [in length], and every side of the large [square] is 1 *Chi* and 3 *Cun* [in length]. Then put it on a flat surface, the small [square] on the large [square]. Fasten the spike [of the compass] in its centre and move the compass around passing by the outside of the four angles of the small [square]. Just the four corners are allowed, not the slightest bit more [translator's note: i.e., the pencil of the compass, that is the circle, must pass exactly through the four corners of the smaller square]. Draw the length of *Cun* on a paper strip and move it to measure the circumference. Then use a pinpoint to check the knowledge. It is neither more or less than just 40 *Cun*. [试验之法，用纸大小二幅，其方中矩，用意比对，四面相同。小者每面皆方九寸，大者皆方一尺三寸，置于平处，小者在大者上，中心定针，于小者四角外运规，仅容四角，丝毫不可多也。片纸作寸，移量圆周，针尖点识，恰好四十整寸。]"[41]

This experiment requires a square piece of paper of 9 *Cun* in side length and another one of 1 *Chi* and 3 *Fen* in side length; the latter is used as the square graph that is formed by the hypotenuses of the smaller 9 *Cun* square. Then a paper strip graduated by the length of *Cun* is moved around the circumscribed circle encompassing the 9 *Cun* square to measure its circumference. The result obtained by Zhu of the practical measurement is that the circumference of the circle encompassing the 9 *Cun* square is "exactly" 40 *Cun*. This is why Zhu Zaiyu believed with such a certainty in the *Measures of the Li family* from the *Zhouli*!

[41] Ibid.

With the hindsight of today's scientific knowledge, Zhu Zaiyu committed a historic error right here. Namely, that by such an experimental method the result is not at all a "real integer", but an approximate number that contains a certain deviation. The diagonal length of a square 9 *Cun* in side length inside a circle is $\sqrt{9^2+9^2} = 12.727922...$ *Cun*, while the circumference of the circle is 39.985946... *Cun*, and not 40 *Cun*. The difference between these two numbers is approximately 0.01405... *Cun*. We must note that Zhu Zaiyu was not able to perceive this error by measuring the circumference with pieces of paper, just as Isaac Newton (1642–1727) was not able to discern the curvature effect in rays in a field of gravitation. As we discuss this problem, we must start by looking at what history really looks like. It is positive and right that Zhu Zaiyu was able to make this scientific exploration, which merges theory and practice, by using the knowledge level and the operating methods available in his lifetime. Although his results contain certain errors because he carried out a large number of experiments alone and because of his empirical misunderstanding about the measurement of circumference, these errors are nevertheless within the permitted tolerance range for making pitch-pipes in practice. Hence, Zhu's standard pitch-pipe flutes of varying diameters represent a leap upwards to the highest level in history, and they realised the desire for "musical transposition" for the first time. So, is this another of the sciences that can potentially enable human civilisation to progress at the pace of space rockets and that solves the mysteries of nature? Similarly, Newtonian mechanics was also revealed to be not absolutely right after human powers of observation were boosted through advances in physics, such as microscopy, and was then continued and enhanced by Einstein's (1879–1955) theory of relativity. Even the Alfred Bernhard Nobel (1833–1896) prize committee has faced embarrassing situations when, several years after awarding the prize, the laureate's conclusions have later been identified as unreliable. Thus, we have no cause whatsoever to blame Zhu Zaiyu for his errors in the problem of circumference–diameter ratio.

Because Zhu had found the logic of the theoretical account, he was able to make extremely fluent calculations. Besides, he warned repeatedly: "Someone who sincerely calculates pitch-measures cannot ignore the true ratio of Nature of Heaven and Earth and Zhou Gong's general ratio of square and circle [天地自然真率及周公方圆总率, 算律之士, 诚不可忽]."[42] Due to space limitations, we shall not describe here in detail his calculations of length and internal and external diameters of every pipe in the set of pitch-pipes with varying diameters.

42 Ibid.

The historical process that took Zhu Zaiyu from adopting the *"Measures of the Li family"* and the Doctrine of Yellow River Diagram and Luo River Calligraphy as the logical starting point of his account on his "New method for calculating the circumference-diameter ratio" [*Xinfa Milü* 新法密率] to carrying out inductions and deductions based on experimentation, obtaining a series of accurate conclusions very far ahead of his time, and finally, accomplishing the great theory and practice of equal temperament is just a wonderful example of the combination of sciences and arts in ancient times and reflects the unremitting efforts of humankind to obtain accurate knowledge by uncovering the laws of nature.

Of course, Zhu Zaiyu also had to pay a certain price for his efforts to achieve this theoretical unification. While he was seeking to perfect his theory, besides sometimes even being suspicions of giving far-fetched interpretations, he also believed devoutly in the truth of prehistoric conventions, in Zhou Gong's general ratio of square and circle [*Zhou Gong Milü* 周公密率], and the Doctrine of Yellow River Diagram and Luo River Calligraphy [*Hetu Luoshu* 河图洛书]. These teachings are regarded as representative of Chinese culture until the present day, and we would not at all totally reject their significance and value simply because they are completely different to the Western sciences. That said, it is still a matter for regret that Zhu Zaiyu did not sufficiently understand the circumference–diameter ratio because his experiments were not precise enough due to lack of "analytical" mathematics. However, compared to many scholars on *Lüxue* and to Confucian classics in Chinese history, who only described other people's doctrines without adding any new ideas of their own, the scientific practice of Zhu Zaiyu is obviously particularly precious. When we look at the Ming and Qing dynasties, when "many books on *Yuelü* [the theory of the tone system in ancient China] [...] were retreating from reality [...] were extremely obscure and not able to resolve any problem at all [很多乐律著作 [...] 逃避现实 [...] 玄而又玄, 而毫不能解决什么问题]"[43]; when "the set of sixteen chime-bells in the Temple of Heaven made under the direct leadership of Emperor Kang Xi 康熙 (1654–1722) [康熙 (1654–1722) 皇帝直接领导之下所产生的一套十六个天坛编钟]" "were full of mistakes [错误百出]"[44]; when we make comparisons with some other great scientific works of Zhu's historical period like *Bencao Gangmu* 本草纲目 [Compendium of materia medica], *Tiangong Kaiwu* 天工开物 [Exploita-

43 Yang Yinliu, *Zhongguo Gudai Yinyue Shi Gao* 中国古代音乐史稿 [A draft history of music in ancient China] (Beijing, 1981), p. 1012.

44 Ibid., p. 1014.

tion of the works of nature], *Nongzheng Quanshu* 农政全书 [Complete treatise on agricultural techniques], *Jiuhuang Bencao* 救荒本草 [Herbals for the rescue from famine], and *Xu Xiake Youji* 徐霞客游记 [Diary of the travels of Xu Xiake], these are all still at a rather primary stage of development in natural science with regard to classification, comparison, and generalisation of experiences. Only Zhu Zaiyu's *Yuelü Quanshu* 乐律全书 [Collected works on music and the pitch-pipes] stands out as an exception. It merges theory and practice, begins with the Doctrine of Yellow River Diagram and Luo River Calligraphy, and closes with Zhu's book of music, which validates the results achieved. All his methods of research are extremely similar to today's sciences, and it is impossible not to feel a sense of awe that Zhu Zaiyu followed his peculiar way, but penetrated deep into the fields of analytical science, and started an exploration that seeks for axioms at a time when all the ancient Chinese sciences still adhered to the main guides of the accumulation of experiences and simple generalisations. Although this exploration was spontaneous and not conscious, all in all, it was a pioneering work unprecedented since several thousands of years. It was different from the minute and complicated textual research by the scholars of Confucian classics. It utilised illustrations with annotations for its explications, made use of real objects for its examinations, and used experiments as the final yardstick for all its conclusions. Therefore, great importance and esteem has to be accorded to the complete model for scientific research that Zhu Zaiyu developed: to use the Doctrine of Yellow River Diagram and Luo River Calligraphy as the theoretical foundation and a right triangle to calculate the length of the hypotenuse as the method for mathematical deduction, and to draw final conclusions by experimental tests.

Zhu Zaiyu's achievements in scientific epistemology and methodology evidence that the development of human civilisation is not sharply divided between East and West. If the conditions had been provided, it is feasible that the seed of modern science might have emerged in China, a country in the East. As to why the practical scientific revolution took place in the West despite China's ancient and earlier successes, this was Joseph Needham's "Grand Question".

Since historically Zhu's scientific methods went far beyond anything contemporary, for several hundred years one finds that hardly anyone understood him apart from Jiang Yong 江永 (1681–1762), Qing dynasty. With regard to a different aspect, we also finally found an answer to the question why Zhu's equal temperament was almost the only knowledge that entirely reached a level on a par with modern science: Since Zhu's theoretical methods were essentially based on the same principles as modern scientific methods, naturally, they are most suitable to obtain a conclusion in accordance with today's sciences. Although this

method was generally not understood in Zhu's period and even for a considerable time afterwards, once scientific and technical progress of the entire society has reached a certain level, people discover and are surprised by the scientific wonders deeply hidden under the dust of history.

Obviously, we cannot consider Zhu's quest for a perfect theory to be completely equal to Western sciences' systematic search for axioms. However, if we discuss in scientific methodology and epistemology about who was earliest and first, Zhu's work, with its perfect combination and application of precise experimental tests and theoretical systematic analysis, could possibly be another wonder of ancient Chinese science, the one in which the way of thinking is closest to Western modern sciences, as well as a great model for the perfect combination of art, science, and technology.

6. The Last Turn: The First Article
of a Chinese Scholar in the Magazine *Nature*

Zhu Zaiyu's multiple inventions in connection with equal temperament demonstrate the superiority of ancient Chinese traditional acoustics; the solid foundation that enabled it to generate continuously new achievements. Zhu's inventions also prove that seeking for creativity and innovation by reviewing the early history of art, science, and technology not only is a must, it can also be done. In this specific field, the ancient wisdom of humankind sometimes twinkles out at random like dazzling rays of light and enlightens keenly determined researchers, so that they never stop making new discoveries on their path of carrying on the heritage of the past, discarding old ideas, and bringing forth new ones. In China, such an academic tradition persisted throughout the ages until it merged with modern sciences, a long time after Western science had began to flow East.

Thanks to the important and irreplaceable function of ceremonial music as an institution in Chinese political administrations, research on *Lüzhi* 律制[45] and pitch-pipes continued unbroken until its modernisation. In the nineteenth century when Western sciences flowing East increased daily, the famous scholar Xu Shou studied the theory of the tone system in ancient China (*Yuelüxue* 乐律学) once again. As he had met the British missionary John Fryer (1839–1928),

45 Translator's note: *Lüzhi* is the mathematical method to fix the origin and the accurate pitch of every tone in a scale.

Xu Shou was not satisfied with Zhu Zaiyu's understanding of the length-correction of pipe, and hoped to find a more exhaustive physical reason instead. In 1874, his son Xu Jianyin 徐建寅 (1845–1901) translated and published in cooperation with John Fryer the masterpiece on *Sound* by the British physicist John Tyndall (1820–1893). Xu Shou discovered that the depiction of the sound of tuning pipes in this work was not in complete accord with the conclusion that had already existed in ancient China. Tyndall believed that "open pipe ought to be exactly halved to make it sound an octave higher".[46] Obviously this statement was not accurate enough. In June 1880, Xu Shou wrote a letter to Tyndall through Fryer asking for advice, investigation, and discussion. Xu also told Tyndall that experiences from his own experiments with bamboo pipes revise the data. Fryer sent the letter and its explanations simultaneously to Tyndall and to the British magazine *Nature*. On March 10, 1881, *Nature* contained an article on the topic "Acoustics in China", in which Xu's letter was published with the following additional comment by the editor: "It will be seen that a really scientific modern correction of an old law has singularly turned up from China, and has been substantiated with the most primitive apparatus."[47] The British acoustician W.H. Stone also wrote the following short commentary: "Mr. Fryer is perfectly correct in his observations.", "It is not a little interesting that a confirmation of this little-known fact [indicating the physical fact of the length-correction of pipe] should have come from so far off, and have been obtained by such simple experimental means." In fact, the first to present data on the length-correction of pipe in the West was Lord Rayleigh (1842–1919). He discussed this problem in his book *The Theory of Sound* compiled in 1877 and 1878. Tyndall's book *Sound*, published in 1875, puts special emphasis on general knowledge. For this reason he did not discuss in depth a problem as specific as the length-correction of pipe. This also explains why in the West, the question of length-correction of pipe did not receive as much long and sustained interest and research as in China. Xu Shou and other Chinese scholars could induce and deduce data on the length-correction of pipe from practice, but as yet were not able to find a better physical explanation. This is why Xu appealed in his letter: "I shall be glad if any foreign scientists can enable me to understand this interesting and important subject."[48] With the aid of Western modern physics' comprehensive development, Xu Shou was "desirous of having a scientific basis

[46] John Fryer and Xu Shou, Acoustics in China. *Nature* 23 (1880.11–1881.4), p. 448.

[47] Ibid.

[48] Ibid.

upon which a reformation [of the principles of length-correction of pipe] may be effected." Today, ancient Eastern traditional knowledge on the theory of the tone system *Yuelü* is already completely merged with modern Western knowledge of physics. In the same edition of *Nature*, Dr. Stone gave detailed theoretical answers to Xu Shou's inquiry, and highly praised Xu Shou's work in experimental physics. A few years ago, the author was invited to conduct research at the Needham Research Centre of Cambridge University. There, he chanced to find the 1881 edition of *Nature*, and faced with the slightly yellowed paper, could not help but feel awe at the thought of being connected to the academic exchange among the scientists Xu Shou, John Fryer, John Tyndall, and W.H. Stone through these few square inches of paper. After this publication, ancient China's unique tradition of *Yuelü* acoustics merged with the trend of modern physical knowledge. This first article of a Chinese scientist in *Nature* not only marks the end of the long overlapping and combination of Chinese sciences and arts, but also the self-evident start of Chinese sciences fully setting forth upon the trend towards modernisation.

Translated from Chinese by Jens Bleiber

Worldprocessor [#241]

ANTHONY MOORE

Transactional Fluctuations 1
Towards an Encyclopaedia of Sound

∘ ▫ ∘

On the Form of Fragments and
Non-existent Remains

When fragments are uncovered there is often a tendency to assume further pieces remain missing, that that which is discovered fills but part of a whole whose completeness is yet to be revealed. However, there are circumstances where no conclusive state can be expected, where nothing other than fragments will be found. Incompleteness as an authorial strategy may not have arisen in response to archaeology; rather, it may have pre-dated and indeed induced the origins of the subject! In addition, arriving at a state of completeness may also be thought of as undecidable (as in logical systems, notwithstanding that completeness and undecidability are different creatures), leaving infinite numbers of fragments that never sum up to a whole. Thus it is, in part, the nature of fragments to suggest they are both the beginning and end of all there is, and that Empedocles may have chosen to write—even to the extent of interrupting himself in mid sentence or word—in such a form. And yet again, there are situations where disclosed fragments form part of a work in progress, which is to say that that which seems to be missing never did or does not yet, and perhaps never will, exist. This is most likely the case in the following assemblage of texts, where we are clearly dealing with the primary stages of some sort of collection, encyclopaedia or fragmentary genealogy of acoustic phenomena and accompanying theories of movement that provide the watery fundament for a physics of sound.

"Fourier succeeded in proving a theorem concerning sine waves which astonished his, at first, incredulous contemporaries. He showed that any variation of a quantity with time can be accurately represented as the sum of a number of sinusoidal variations of different amplitudes, phases, and frequencies. The quantity concerned might be the displacement of a vibrating string, the height of the surface of a rough ocean, the temperature of an electric iron, or the current or voltage in a telephone or telegraph wire. All are amenable to Fourier's analysis."[1]

295

Studying the "edges" of fragments very closely, microscopically, the transition from presence to absence is bound to be blurred, becoming all the more so on zooming in. This creates a wonderful ambiguity between information retrieval and invention, where any attempted disentanglement of the observer becomes untenable (a condition equally true of this encyclopaedia, whose compiler can hardly be considered objective). Signs of just how much the world around us has become unverifiable are to be found commonly enough on the surface of our culture. Nevertheless, it is less than a century since, as a society, we were confronted in science with such inescapable uncertainties and undecidabilities—hardly time to be assimilated and therefore perhaps worthwhile reiterating, especially as such encounters with paradox and unpredictability open the world and, far from causing despair, offer fertile ground for creativity and profound thought. (The works of Emile Post, Kurt Gödel, Alonso Church, Alan M. Turing and, in physics, Werner Heisenberg along with many others less well-known, all emerged within about fifteen years of each other, 1921–1936, between the two World Wars).

"Karen Spärck Jones was Emeritus Professor of Computing and Information at the University of Cambridge and one of the most remarkable women in computer science. She made outstanding theoretical contributions to information retrieval and natural language processing, and built upon this theoretical framework through numerous experiments. She said, "My belief is that, intellectually, computer science is fascinating—you're trying to make things that don't exist."[2]

Partially decidable classes: "In classical computability, my favorite example of a partially decidable class is the class of Unsilent Machines as revealed in the form of the theorem that says that it is (only) partially decidable whether a Turing machine will print anything at all.

Movement: Yes, one of the amazing things about sound is that out of the superposition of perfectly periodic signals (themselves motion at some level, but stasis at a higher level—the sine wave as an eigenvector at rest) you can get first beats, then other senses of motion. The limitation of classical automata theory is that its discrete transitions suppress this important sense of continuous movement. That's why neural and quantum computations, for example, are more interesting. The thing about biological computation (or rather computation in evolvable material) is that that which gives living systems their evolvability is exactly what must fall through the cracks in any formal specification."[3]

Limit Processes and Leftovers

Leibniz discovered that pi divided by 4 is equivalent to one, minus a third, plus a fifth, minus a seventh, plus a ninth, minus an eleventh, and so on. At each step the output describes the limits of a swinging pendulum whose arc gradually decreases towards the solution without ever coming to a standstill. This restless action of the "limit process" shares with sound, and especially improvised music, the principle of unfolding through time, where approximation and probability replace certainty and resolution. Undecidable, partially decidable and even deterministic unfoldings of algorithmic calculation tell us more about the inseparable nature of mathematics and music than fixed relationships of pattern and proportion in exact harmonic division; notwithstanding that it is partly the inconsistencies revealed by combining these same patterns of low number ratios, thirds, and halves in circles of fifths and octaves, for example, that makes evident the feeling of time and movement permeating both calculation and music. The musical interval of a major third is expressed by the ratio 5:4, just as the doubling of frequency called an octave, is expressed as 2:1. There are three major thirds in an octave, C-E, E-Gs, Gs-C, but 5/4 times three (5/4 x 5/4 x 5/4) = 125/64 and not 128/64 or 2/1. Problems in tuning subdivisions of the octave, (the square root of two, the Pythagorean comma, and indeed the twelfth root of two), suggest that a dynamical systems approach may yet help to unfreeze such difficulties.

*Generative processes are measured by the differences they spawn as they splay and branch in all directions through multi-dimensional time-space. Due to the linearity of non-displacing waves and harmonic motions, the behaviour of sound provides a perfect metaphor for the negotiation of superposed differences. The ear is clearly an optimal tool for receiving such simultaneous information allowing for the unique perceptual possibility of one, the other, and both—either and both. Movement, difference and recollection are our tools for navigating and it is liberating to realise that difference does not depend simply on dualistic opposition. Difference in velocity is sufficient for the appreciation of motion (no need for the artificial construct of stillness). And therefore "Distinguishability Theory" arises as a concept of greater permeability than that offered by the pairs of opposites that drive binary logic. It is the duty of the theory "[...] to explore the distinction between difference and distinguishability in order to consider the appropriateness of unambiguous discontinuity in both our decoding and encoding of the world."**

"CAVEAT!!!

[...] about the possibility of linking undecidability with nature. I always have great difficulties with these questions because they are often ill-posed. Before starting from an a priori idea of a connection or no connection between

nature and formalisms, one should first better ask the question what it means practically for a system to be undecidable. What often annoys me in texts on this subject, is that undecidability is not considered as something interesting in itself, but as something which can be used to argue for something else and often completely different."[4]

Three Quotes from People
Whose Name Begins with the Letter "B"

The order of the next three quotes is both analphabetical and chronologically reversed. Thinking about historical time invites speculation that whilst with stones or material artefacts one might be lucky enough to uncover any number of fragments belonging to a similar period in history, the same cannot be hoped for in the archaeology of one's own thinking. Somewhat like memories that have become decoupled from their origins, thoughts float up onto the surface of consciousness from a time-line that has been so profoundly "cut and pasted" as to be entirely unrecoverable. As these fragments offer themselves up (the reality of the future is found in the will of objects and thoughts to become manifest—the archaeologist's desire to succeed is matched by the object's wish to be uncovered), they are inserted into the text. In this way the encyclopaedia expands from within, swelling rather than simply growing longer; and perhaps this is the dynamic of all compendia, dictionaries, and thesauri whose subsequent additions may be dropped in at any point along the course of the text.

"When I direct my attention inward to contemplate my own self [...] I perceive at first, as a crust solidified on the surface, all the perceptions that come to it from the material world. These perceptions are clear, distinct, juxtaposed or juxtaposable one with another; they tend to group themselves into objects. [...] But if I draw myself in from the periphery towards the centre [...] I find an altogether different thing. There is beneath these sharply cut crystals and this frozen surface, a continuous flux which is not comparable to any flux I have ever seen. There is a succession of states each of which announces that which follows and contains that which precedes it. In reality no one begins or ends, but all extend into each other."[5]

"The principle of the equality of action and reaction, when traced through all its consequences, opens views which will appear to many persons, most unexpected. The pulsations of the air, once set in motion by the human voice, cease not to exist with the sounds to which they gave rise. Strong and audible

as they may be in the immediate neighbourhood of the speaker; and at the immediate moment of utterance, their quickly attenuated force soon becomes inaudible to human ears. The motions they have impressed on the particles of one portion of our atmosphere, are communicated to constantly increasing numbers, but the total quantity of motion measured in the same direction receives no addition [...]. Thus considered, what a strange chaos is this wide atmosphere we breathe! Every atom, impressed with good and with ill, retains at once the motions which philosophers and sages have imparted to it, mixed and combined in ten thousand ways with all that is worthless and base. The air itself is one vast library, on whose pages are forever written all that man has ever said or woman whispered."6

"We have also sound-houses, where we practice and demonstrate all sounds, and their generation. We have harmonies which you have not, of quarter-sounds, and lesser slides of sounds. Divers instruments of music likewise to you unknown, some sweeter than any you have; together with bells and rings that are dainty and sweet. We represent small sounds as great and deep; likewise great sounds extenuate and sharp; we make divers tremblings and warblings of sounds, which in their original are entire. We represent and imitate all articulate sounds and letters, and the voices and notes of beasts and birds. We have certain helps which set to the ear do further the hearing greatly. We have also divers strange and artificial echoes, reflecting the voice many times, and as it were tossing it: and some that give back the voice louder than it came; some shriller, and some deeper; yea, some rendering the voice differing in the letters or articulate sound from that they receive. We have all means to convey sounds in trunks and pipes, in strange lines and distances."

On Active Perception

What is meant by "([...] the archaeologist's desire to succeed is matched by the object's wish to be uncovered)"? The intention here is to address the idea of "active perception". The ear is a marvel and serves very well as an analogy. One need look, or rather hear, no further than the phenomena of Oto-Acoustic Emissions (OAEs), measurable sounds emerging from the ear, to grasp that unless some action takes place on the part of the receiver, then incoming signals may remain unperceived. Due to the active, mechanical components that go to make up the physiology of the ear, it is possible to construct a hypothesis which proposes that certain physical aspects of hearing take place outside the body, at the entrance to the ear.

299

Although the traveling wave phenomenon discovered by von Békésy is believed to be the key element in the cochlea's analysis of sound, the initial observations of von Békésy revealed responses that were neither sharply tuned nor of sufficient sensitivity to respond to threshold levels of stimulation. The difficulty extrapolating from von Békésy's observations to real-life listening situations can be appreciated when one considers that his observations were confined to either cadaver ears or to mechanical models constructed to replicate conditions encountered in cadaver ears.

The discrepancies between the contemporary travelling wave demo stration and the tuning and sensitivity of the ear, were clearly described by Thomas Gold some 20 years after von Békésy's discovery. Gold suggested that parts of von Helmholtz' resonance theory were in keeping with the results of listening studies conducted with persons who had normal hearing (Gold, 1948). However, his ideas were not well accepted. Much effort was spent reconciling von Békésy's findings with later psychoacoustical findings by developing hypotheses regarding the "sharpening" effects of the peripheral and central nervous system.

Approximately fifty years after von Békésy's discovery, David Kemp reported that sound energy produced by the ear could be detected in the ear canal (Kemp, 1978). Called otoacoustic emissions (OAEs), these sounds offer evidence that the ear contains a source of energy and that the energy may fuel the sharp tuning and exquisite threshold sensitivity von Békésy was unable to see in his experiments.[8]

There are at least two theories occurring well over two thousand years apart that embrace the idea of "energetic" perception: the earlier, known as "The Theory of Pores", from the aforementioned Empedocles, and the more recent (1940) "Absorber Theory" from the remarkable pairing of John Wheeler and Richard Feynman. "The Theory of Pores", approximately 450 B.C., was significantly located between two alternative hypotheses of the day. One stated that objects emanated light that shone into the eye. The other concept was somehow the reverse, that the eye functioned like a projector, illuminating the object. Simply put, the thinking of Empedocles embraced both these notions with the proposition that the eye did indeed engage the object by casting its gaze upon it, but at the same time the object shone back toward the viewer. This meant that the perception of the object was located between the seer and the seen, at an interface, an ethereal skin of interference, outside the body where two streams of light came together.

Wheeler-Feynman Absorber Theory [1] was originally conceived as a time-symmetric alternative to conventional electromagnetism which, unlike the latter, imposes no ad hoc time direction on electromagnetic processes. It is essentially a set of boundary-condition rules arising from the requirement of time-symmetry which were restated in AT1 (The Arrow of Electromagnetic Time and Generalized Absorber Theory: Introduction) as follows: 1. The process of emission produces an electromagnetic wave consisting of a half-amplitude retarded wave and a half amplitude advanced wave which lie along the same four-vector but with opposite time directions; 2. The process of absorption is identical to that of emission and occurs in such a way that the wave produced by the absorber is 180° out of phase with the wave incident on it from the emitter; and 3. An advanced wave may be reinterpreted by an observer as a retarded wave by reversing the signs of the energy and momentum (and therefore the time direction) of the wave, and likewise an observer may reinterpret a retarded wave as an advanced wave.[9]

If we imagine the brain and consciousness of a human being on one side of this "ethereal skin of interference" or membrane, be it scopic or sonic, then desire or active perception is the motive force that drives the efferent flow out through the portals of the body to meet the afferent flow of incoming waves from the physical world. What happens when these flows of information pass through each other is, in a series of cancellations and amplifications, what we come to know of as the world we move through. In addition, the membrane itself is made up of no more than nodal concentrations of information, an encrustation of time that, in forming like some sort of crystal or accretion, would gradually render the membrane opaque were it not for the polishing action of the ego and its sense of difference, which sees itself as creative or capable of an imaginative disobediance towards the calculating Gods. However, the process is still reversible and the question remains as to on which side of the membrane the calculating or the imagining takes place. In certain societies the Gods are no more than playful children to be schooled and scolded by human beings.

The process of accretion through repetition and mirroring is similar to a standing wave, something that exists by virtue of time, distance, and reflection. A sound sends its impulse across a space, disturbing molecules as a pressure wave. Just as a wave in the ocean thuds against the harbour wall and then rebounds back out to sea to meet incoming waves, resulting in crests shooting up as if two giant hands had been clapped together in the water, so sound waves too bounce back from walls and surfaces of rooms. The same thing happens with the vibrating string of a guitar or violin. The impulse travels along the string, meets the bridge or nut at either end, and is reflected back along the string where it encounters the latency of itself. Due to timing differences or phase there results either an amplifica-

tion producing a crest known as a node, or a cancellation resulting in the opposite, known as an anti-node. So the mechanics of the metaphor function thus: As we interact with the world, actively perceiving by transmitting signals to decode incoming information so there is an instantaneous reflection that creates standing waves of perception.

How might Turing Machines be reconfigured with regard to active perception?—"I really need to have something like 'life' already existing in those individual cells on the infinite tape that skitters back and forth under the read/write head. What I mean by 'life' in the square, cell-like sections of the 'tape', is something like a 'consciousness of the other' for which it would be necessary to invent (or discover) a series of 3rd or 4th order logic gates that should be more satisfying than just a 'maybe' gate."*

"Each cell is separate but transparent and actively perceives. In other words it 'illuminates' its surroundings in order to receive information, just as deep sea creatures who have never seen the sun create light in order to see—a process in which the senses transmit in order to receive. The input is activated by the output and both run at the same time. This I would call 'feedthrough' rather than feedback or forward. And the information that is sent out and picked up is simple oscillation with each cell having its own infinitesimally slight difference of frequency brought about due to the fact that the big bang (if such a construct is to be believed) did not cause everything to exist simultaneously. Both the output and input are continuous. The interference of travelling differences in time and frequency cause ripples of sufficient density to manifest as apparent material on the delicate, active perceptors of each cell."*

Alphabets and Tape Recorders

It is with the quote (endnote 7) from Bacon that we begin to get a feeling for how sensitivity to the auricular domain may have diminished over the last two and a half thousand years in our European culture. His 380 year-old analogue for a recording studio, familiar to many musicians now living and working in these post-digital times, reminds us that the orality/literacy shift is still very much alive and well. The drift from the aural to the visual mapped out from the times of Homer (in our familiar Western culture), might also be thought of as a shift from "live" to recorded sound; that is, if you accept the abstraction that notation/writing is, in some sense, the recording of sound. Therefore, the invention of alphabets and writing as a way of preserving the sound of speech, poetry, and song was of some consolation. The Greeks were able to offer this technology with the inclusion of signs for vowels (rather than most early alphabets consisting only of mean little consonants, devoid of duration and pitch and constructed

simply to serve the mechanisms of merchants and bureaucrats). But scopic domination seems to grow and grow.

*"An abecedary (in some form): Regardless of whether the Greek alphabet was created by a 'reduction / substitution' operation using pre-existing Sumeric and other alphabets to which the vowels A E I O were introduced (Wachter), in my view this is simply comparable to increasing the storage capacity of a computer's memory. It is thinkable that some 3000 years ago or more, there was a shift towards the idea that knowledge could be moved around. Previously it was the people who would gravitate towards a place to receive information acoustically, as akousmata. To move information over significant distances you have to store it. At that time it would have been a lot simpler to invent storage systems for signs and symbols than to create the tape recorder for the purpose of storing duration as sound; hence a shift from hearing to vision (Röller). However, for the Greeks to be able to nurture and maintain the acoustic 'life' of the Homeric tradition, the hearable had to be preserved. So they introduced vowels into their alphabet in order to store sound (thus the alphabet becomes a technology). Even though the Mesopotamian alphabet may once have contained vowels which, in order to reduce the number of signs needed, were later removed (Wachter), this was nevertheless data compression gone too far. In order to store time you must have time. Consonants are percussive and practically take up no time at all, vowels simply take longer to articulate. Hence we can think of them as time-holders, as storage devices for the acoustic. Once stored, it might be thinkable that polyphony would follow, multi-voiced simultaneity, which was what indeed arose over the proceeding years in Western, classical music. Similarly, recording devices following on from the wax cylinder developed not only the potential to store longer and longer sequences of time, but also to expand the number of simultaneous recordable and playable channels. This enhancement of the vertical or parallel facilitated the reproduction of acoustic spaces. Therefore, the Greek alphabet with its expanded memory capacity in the form of vowels may be seen as a multi-channel tape recorder, a technical device for demonstrating harmony and the realisation of acoustic space. The similarity to tape is clearly seen when one recognises that ancient Greek had no groupings or spaces between words, no punctuation, just endless strings of letters, a pure ribbon of sound."**

to be continued …

*"Just as physics needs biology to describe dynamical systems, so too must the philosophy of time turn to music—the essential transdisciplinarity of the quadrivium rings true."**

∘ ◘ ∘

Endnotes:

1 John Robinson Pierce, *Symbols, Signals, and Noise. The Nature and Process of Communication* (Hutchinson, 1962), p. 31.

2 Taken from the obituary of Karen Spärck Jones, who died on April 4 2007 aged 71. The complete paragraphs from which the excerpts are edited read: "She was Emeritus Professor of Computing and Information at the University of Cambridge and one of the most remarkable women in computer science. She made outstanding theoretical contributions to information retrieval and natural language processing and built upon this theoretical framework through numerous experiments. Her work is among the most highly cited in the field and has influenced a whole generation of researchers and practitioners. Karen Spärck Jones thought it very important to get more women into computing. 'My slogan is: 'Computing is too important to be left to men',' she said. 'I think women bring a different perspective to computing; they are more thoughtful and less inclined to go straight for technical fixes. My belief is that, intellectually, computer science is fascinating—you're trying to make things that don't exist.'" The rest of the obituary comes from Cambridge University, cf. http://www.admin.cam.ac.uk/news/dp/2007040403

3 From private correspondance with Kevin G. Kirby, Evan-Stein- Professor of Biocomputing and Computer Science Program Director

4 From private correspondance with Dr. Liesbeth de Mol, member of the Centre for Logic and Philosophy of Science at Ghent University, Belgium.

5 Henri Bergson, *An Introduction to Metaphysics.* (London, 1913).

6 Charles Babbage, *The Ninth Bridgewater Treatise.* Cf. here: http://www.victorianweb.org/science/science_texts/bridgewater/b9.htm.

7 Francis Bacon, *New Atlantis*, written 1624, published in 1627. Cf. for example http://www.levity.com/alchemy/atlantis.html.

8 See Theodore J. Glattke, *Otoacoustic Emissions in 2002. Some Perspectives*, at http://www.audiologyonline.com/articles/article_detail.asp?article_id=334. Glattke is Professor for Speech and Hearing Sciences at the University of Arizona, Tucson, AZ.—In 1961, the Nobel Institute honoured Georg von Békésy, Ph.D., with the prize in Medicine and Physiology for his 1928 discovery of the mechanics of the standing waves in the cochlea. Central to his pioneering work was the development of nondestructive techniques for cochlear dissection and the creation of a mechanical model of the inner ear. Together they led to his most important revelations: how sound travels within the inner ear, and how specific discrete areas of the cochlea are stimulated, important for tuning and pitch perception. Von Békésy's seminal accomplishments eventually led to further discoveries about cochlear function. In 1978, David Kemp, Ph.D., found that in the process of receiving sound, our ears also emit sounds. Called otoacoustic emissions (OAEs), they can be detected with a sensitive microphone placed in the ear canal of a hearing person.

9 John G. Cramer, The arrow of electromagnetic time and Generalized Absorber Theory. *Foundations of Physics* 13 (1983): 887. Cf. http://www.npl.washington.edu/npl/int_rep/dtime/node2. html# SECTION00020000000000000000.

***** These passages not assigned numbers but contained within quotation marks are from myself. The "abecedary" for example is copied from my notes taken at the symposion, "Schrift, Zahl und Ton im Medienverbund. Archäologie, Ereignis und Grenzwerte des griechischen Vokalalphabets", organised at the Helmholtz Centre, Humboldt University Berlin, chaired by Prof. Dr. Friedrich Kittler.

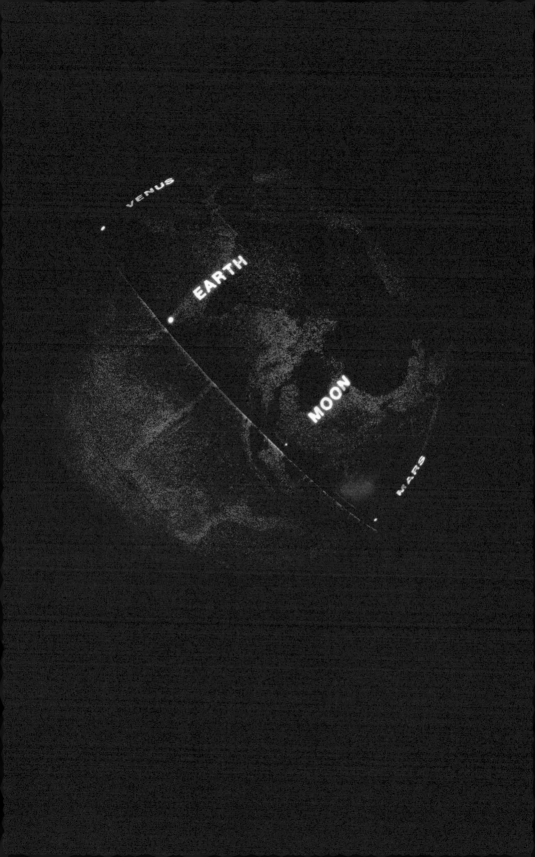

Worldprocessor [#170]

CLAUDIA SCHINK

Lux reflecta:
On Moonlight in Mythology
and Science

"In days gone by there was a land where the nights were
always dark, and the sky spread over it like a black cloth,
for there the moon never rose, and no star shone in the
obscurity."[1]

Throughout history moonlight has been a favourite light phenomena that
humankind has pondered on and observed intensely. In poetry and song moon-
light features prominently as well as in innumerable paintings. Systematic
observation of the moon and its light has been an important driver in the devel-
opment of science. In contrast to the violent, short-lived and blinding sensation
of a flash of lightning, soft moonlight provides the observer with a study object
that presents no danger.

The Earth's closest neighbour in space is its constant companion. As our near-
est cosmic source of light for many centuries the moon delineated the boundary
of the terrestrial domain and was held to be the mediator between this world
and the next. A diversity of theories about the origin of the moon's light and its
phenomenal spots led to various definitions of the form of the moon and the
nature of its surface. As reflected sunlight moonlight allows detailed observa-
tion of the moon with the naked eye. The reflected light rays have also spawned
philosophical reflections about the interstellar order of space in one direction,
and to metaphysical questions about the boundaries of terrestrial captivity in
the other.

1 Jakob and Wilhelm Grimm, The moon, in: *Grimm's Household Tales* (Project Gutenberg Online
Book: 7.1.2004), p. 549.

The Nocturnal Sun

The moon is humankind's favourite object in the starry heavens; its size and luminosity surpass all other celestial bodies that illuminate the night sky, which is why it is sometimes referred to as the "nocturnal sun".[2] With its unique light, the moon illuminates the dark Earth creating semi-clear, blurred shadows that suggest a strange and non-human world. The night and the moon are associated with what is secret, hidden, and special. The moon's mystical character derives from the fact that it changes constantly. The belief that mortal existence is dependent upon higher powers, and the experience that all life is subject to change, have always been very closely associated with this particular heavenly body.[3] On clear nights, the moon changes colour by the hour. When the moon rises above the horizon the low-angled rays of moonlight are reddish.[4] When it rises into the evening sky, it is orange, and then gold, then yellow; when it sets it is white, while the dawn sky in the east gets lighter and is illuminated with many colours. Through its changing phases, the moon also changes the appearance of the landscape at night. These different light phases gave the moon its reputation as a changeable star; medieval astrologers and popular beliefs attributed people's mood changes to the moon. The changeability of human existence seemed to be reflected in the moon's changes of colour and light intensity.[5] "How the moon changes me / Always murmuring blindly shimmering / It is a dervish in its changing dance."[6] The German word for mood, *Laune*, derives from the Latin for moon, *luna*, and the adjective from it, *launisch*, moody, means to be ruled by changeable moods. *Lunatismus* in German is a form of sleep-walking, and a lunatic is someone who is mad.[7] The New Testament describes sleepwalkers (by moonlight) as people possessed by demons.[8] Poetry, too, blames

2 Hanns Bächtold-Stäubli, *Handwörterbuch des deutschen Aberglaubens*, vol. 6 (Berlin, 2000), col. 482.

3 Bächtold-Stäubli, *Handwörterbuch*, col. 481.

4 During its long journey through the Earth's atmosphere the blue part of the spectrum of moonlight becomes much weaker than the red: it disappears almost entirely.

5 Bächtold-Stäubli, *Handwörterbuch*, p. 482.

6 "Wie mich der Mond umwandelt / Immer blindes Geschimmer murmelnd / Ein Derwisch ist er in seinem Wandeltanz." Else Lasker-Schüler (1869–1945), Der Letzte, in: *Das große deutsche Gedichtbuch*, ed. Karl Otto Conrady (Kronberg, 1977), p. 698.

7 Bächtold-Stäubli, *Handwörterbuch*, col. 483.

8 Matthew 17, 14–18, comp. 4, 24, in: *The Bible. New International Version*, ed. International Bible Society.

the moon for human problems: "Smooth mask, you fill the hearts of fools with delusions / You confuse children and the sick, sneer at drunkards, and make a fool of the wise".[9] People associated the changeability of the moon with anxiety about their personal fate. As such questions are generally addressed to the heavens as "the cosmic sphere far away from the Earth, they become attached to the phenomena that are visible in the sky, the stars and the largest object in the heavens, the moon."[10] The effect of moonlight on sleeping people, and the restlessness it induces in them, led to the belief that the moon possessed specific powers.[11] The spots visible on the moon's surface stimulated the imagination to all kinds of reveries. The moon's aspect was often described as the face of a man, who had been banished there as a punishment for his transgressions on Earth.[12] Dante associated the image on the moon's surface with the banishment of Cain to the moon, who had murdered his brother Abel: "But tell, I pray thee, whence the gloomy spots / Upon this body, which below on Earth / Give rise to talk of Cain in fabling quaint?"[13]

The moon glows, but its rays are not warm. In classical antiquity Anaxagoras attempted to interpret this with reference to the changing movements of the moon: "Men do not feel the warmth of the stars, because they are so far away from the Earth; and they are not warm in the way that the sun is, because they are in a colder region. [...] And the moon changes its course frequently because it is not able to master the cold."[14] The cold light glows for the dead, and endangers the living. The seamstress who sews by moonlight will make her

9 "Du füllst, glatte Maske, der Toren Herz mit Wahn / Du verwirrst Kinder und Kranke, höhnst Trinker und äffest die Weisen." Hans Schiebelhuth (1895–1944), An den Mond, in: *Das große deutsche Gedichtbuch*, ed. K.O. Conrady (Kronberg, 1977), p. 698.

10 Bächtold-Stäubli, *Handwörterbuch*, col. 483.

11 This power to cause emotional disorders is emphasised in superstitious rules of conduct; see: Bächtold-Stäubli, *Handwörterbuch*, col. 503.

12 "One night a man went out to steal some coal. 'Nobody can see me,' he said softly to himself. But then the moon came out and said, 'I can see you,' and took the man and his stolen coal away up to the moon. Ever since then, the man stands up there and all can see him." Bächtold-Stäubli, *Handwörterbuch*, col. 512.

13 Dante Alighieri (1265–1321), *The Divine Comedy* (Project Gutenberg Online Book, August 1997); cf. Notes to Paradise, Canto II, v. 52; cf. Notes to Hell, Canto XX, v. 123.

14 Anaxagoras, Fragments and commentary, in: *The First Philosophers of Greece*, ed. and trans. Arthur Fairbanks (London, 1898), p. 261. (Passages in the doxographers referring to Anaxagoras). That moonlight is in fact warm was only proved in the nineteenth century through advances in instruments; cf. Egon Lützeler, *Der Mond* (Cologne, 1906), p. 48.

own shroud, and the spinner will make linen for her own winding-sheet.[15] In antiquity, the moon goddess Selene was the protector of cemeteries and graves. In poetry and folk songs the connection between moonlight, cemetery and death also appears: "When moonlight shimmers down / Upon woodlands [...] / Thoughts of the grave of [my] beloved overshadow me / Once I delighted in it, oh you dead ones, with you!"[16] The moon seemed to share in the transience of human life, which is why it was also regarded as a comforting and magical star. The waxing and waning moon phases were an emblem of eternal recurrence and made the moon the star of hope for the dead. In Christian doctrine its symbolism of periodic renewal was transformed into an image of eternal life. Selene, the ancient goddess of the moon, became a metaphor for the church as the bride of Christ.

Light of Reflection

The Babylonian myth of creation contains a time plan, which is connected with observation of the moon phases.

"[Marduk] made the stations for the great gods; / [...] The Moon-god he caused to shine forth, the night he entrusted to him. / He appointed him, a being of the night, to determine the days; / Every month without ceasing with the crown he covered him, saying: / 'At the beginning of the month, when thou shinest upon the land, / Thou commandest the horns to determine six days, / And on the seventh day to divide the crown. / On the fourteenth day thou shalt stand opposite, the half.'"[17]

15 Old German folklore; cf. H. Bächtold-Stäubli, *Handwörterbuch*, col. 504.

16 "Wenn der Schimmer von dem Monde nun herab / In die Wälder sich ergießt [...] / So umschatten mich Gedanken an das Grab / Der Geliebten / [...] Ich genoss einst, o ihr Toten, es mit Euch!" Friedrich Gottlieb Klopstock (1724–1803), Die Sommernacht, in: *Das große deutsche Gedichtbuch*, ed. K.O. Conrady (Kronberg, 1977), p. 186.

17 The text that has survived is incomplete and continues: "When the Sun-god on the foundation of heaven [...] thee, / The [...] thou shalt cause to [...], and thou shalt make his [...] / [...] unto the path of the Sun-god shalt thou cause to draw nigh, / And on the [...] day thou shalt stand opposite, and the Sun-god shall [...] / [...] to traverse her way. [...]." Enûma Elîsh trad. since ca. 1100 B.C.; cf. The fifth tablet, in: Leonard William King, *The Seven Tablets of Creation*, (London, 1902). See also Paul Garelli and Marcel Leibovici: Enûma Elîsch, in: *La naissance du monde. Egypte ancienne, Laos, Tibet, Sumer, Akkad, Hourrites et Hittites, Chine, Turcs et Mongols, Israël, Cannan, Islam, Inde, Iran préislamique, Siam* (Paris: Deuil, 1959), cited from http://www.earlyworld.de/enuma_elish.htm?kbw_ID=71612002 (accessed March 2007).

As long as it was out of reach the moon was an object of pure observation: "In front of the eyes of all of Earth's inhabitants, our satellite repeats its eternal cycle; even in ancient times, without the help of any artificial optical or mechanical aids, the principal elements were known".[18] Before any human set foot on the moon, the only medium for researching the moon was its light. Whether the moon was viewed with the naked eye or through a telescope, or its surface transferred onto maps, it was the moon's rays that were captured by the human eye or optical devices. Moonlight was used in the calculation of astronomical size scales, and thus it became a medium for scientific reflection on the laws of the cosmos.

Unlike the sun, whose bright light blinds and damages the human eye, it is possible to observe the moon intensely in the nocturnal sky. Empedocles spoke of the scorching missiles of Helios, but Selene catches the burning sunrays and when she passes them on they are soothed:[19] "The sun lights upon us keen and violent (as Empedocles, too, not infelicitously renders the difference of the two: 'The sun keen-shafted and the gentle moon', referring in this way to her allurement and cheerfulness and harmlessness)".[20]

Ancient Greek emphasises the light aspect of the moon in the name of the moon goddess Selene, from which the root of the Greek word 'glowing' originates.[21] In the irregular appearances of the shining disk with its softly shaded areas, Greek poets recognised her gentle face of a young girl: "She gleams with fire encircled, but within / Bluer than lapis show a maiden's eye And dainty brow, a visage manifest."[22] According to early Pre-Socratic beliefs, the moon, sun, and stars were bodies that glowed like fire. "The moon is a fiery solid body."[23] It is known that the young Anaxagoras witnessed the fall and impact of a meteorite, which led him to develop the theory that all heavenly bodies are

18 Wilhelm Beer and Johann Heinrich Mädler, *Der Mond* [...] *oder Allgemeine vergleichende Selenographie* [Berlin, 1837], p. IV.

19 Helios was the name of the ancient Greek god of the sun and Selene was the goddess of the moon.

20 Plutarchos of Chaironeia (app. 45–125), *De facie in orbe lunae* [app. 75], engl.: Plutarch, *On the Face in the Moon* (Harvard: Loeb Classical Library edition, vol. XII, 1957), p. 37.

21 By contrast the root of the Nordic word is *ma-*, from latin *metiri*, to measure; cf. Bächtold-Stäubli, *Handwörterbuch*, col. 483) who thinks that the reason for these differences lies in the different clarity of the southern and the northern night sky.

22 Agesianax, cited by Plutarch, *On the Face in the Moon*, p. 39.

23 Anaxagoras, *Fragments and Commentary*, p. 255 (passages in the doxographers).

glowing stones.[24] Further, his observations of solar and lunar eclipses led him to realise that Earth's satellite was illuminated by the sun: "The moon does not have its own light, but light from the sun."[25] The Epicurean Lucretius, too, celebrated in verse the relationships of the cosmic light sources in his didactic poem *On the Nature of Things* "Look upward yonder at the bright clear sky / And what it holds [...] / The moon, the radiance of the splendour-sun."[26] Ancient Greek philosophers attempted to determine the distance between Earth and the moon through the rays of the moon and the positions of the planets. In the tradition of Anaxagoras Plato also felt challenged to pronounce on questions of astronomy: "And I thought that I would then go on and ask (Anaxagoras) about the sun and moon and stars, and that he would explain to me their comparative swiftness, and their returnings and various states, active and passive, and how all of them were for the best."[27] Earth's satellite was also a projection screen for fantasies; the possibility that it was an inhabited world especially fired the imagination. Even in the nineteenth century, there were expectations that lunar science would discover inhabitants of the moon. "Too often, authors that write about this subject of astronomy have given it over wholly to their imagination. [...] Some readers may even await impatiently the passage in this text where we shall tell them strange and exciting things about the moon-dwellers."[28] In the satire *Icaromenippus* by the Greek author Lucian the moon laments the lack of imagination of the ancient astronomers and philosophers:

"My patience is absolutely worn out by the philosophers, who are perpetually disputing about me, who I am, of what size, how it happens that I am sometimes round and full, at others cut in half; some say I am inhabited, others that I am only a looking-glass hanging over the sea, and a hundred conjectures of this kind; even my light, they say, is none of my own, but stolen from the Sun."[29]

24 Helmuth Gericke, *Mathematik in Antike und Orient* (Wiesbaden, 1994).

25 Anaxagoras, *Fragments and Commentary*, p. 261 (passages in the doxographers).

26 Titus Lucretius Carus (Lucretius) (ca. 94–49 B.C.) *On the Nature of Things* (Project Gutenberg Online Book: January, 1997), p. 178a–b.

27 Plato (428–349 B.C.), *Phaedo* (Project Gutenberg Online Book: March, 1999).

28 Beer and Mädler, *Der Mond*, p. V.

29 Lucian of Samosata (ca. 125–180), Icaromenippus. A dialogue [161], in: Lucian of Samosata, *Trips to the Moon* (Project Gutenberg Online Book: 2003), p. 178b.

Two Models of the World

Researching the moon was made even more difficult because of its static position in the geocentric model of world that had dominated scientific thinking since Ptolemy.[30] In this cosmology, Earth was the fixed centre, orbited by the moon; the space in between was filled by the sub-lunar sphere of the elements. Above this were the trans-lunar celestial spheres that carried the planets and fixed stars, which also circled the Earth. In this model of the world, the moon was the border, which separated the terrestrial substances from the cosmic ones: "Sun and moon and all the stars are fiery stones that are borne about by the revolution of the aether. And sun and moon and certain other bodies moving with them, but invisible to us, are below the stars. [...] The moon is below the sun and nearer us."[31] Although the Earth was supposed to be the centre of the universe, its material and space-time reality was marked by transience, and thus it was the most inferior part of the cosmic spheres. As swampy terrain and worst part of the universe the Earth might even conceal Hell underneath its surface.[32]

Already in antiquity the competing heliocentric model, which Aristarchus of Samos proposed on the basis of his calculations of the relative distance between sun and moon, was dismissed and fought against.[33] A fragment of the work of Archimedes survives that quotes from Aristarchus' proposal: Aristarchus believed that the fixed stars and the sun do not move, and that the Earth circles around the sun, which lies at the centre of Earth's orbit. The sphere of the fixed stars, whose centre lies in the middle of the sun, is so large, that the periphery of Earth's orbit relates to the distance to the fixed stars like the centre of the globe to its surface.[34] One's visual impression, however, suggests a cosmic model in which the heavenly bodies circle the earth. Great intellectual abstraction is necessary to explain the appearances in the sky with a diametrically opposed model. The geocentric model was supported by the writings of Plato and Aristotle:

30 Ptolemy (Claudius Ptolemaeus), (ca. 100–170). The Egyptian astronomer and mathematician created the philosophical foundations for the geocentric model of the world in his text *Mathematike syntaxis* (Mathematical Treatise), written 127–141.

31 Anaxagoras, *Fragments and Commentary*, p. 261 (passages in the doxographers).

32 Ulrich Kutschera, *Evolutionsbiologie* (Berlin, 2001), p. 10.

33 Aristarchus of Samos (ca. 310–230 B.C.), in: *Großes Werklexikon der Philosophie* 1, ed. Franco Volpi (Stuttgart, 2004), pp. 61–62.

34 Archimedes (ca. 287–212 B.C.), Arenarius, chapter 1, cited in Gericke, *Mathematik*, p. 329.

"Now the whole earth is a globe placed in the centre of the heavens, and is maintained there by the perfection of balance. That which we call the earth is only one of many small hollows, wherein collect the mists and waters and the thick lower air; but the true earth is above, and is in a finer and subtler element."[35] In the final dialogue of the *Politeia*, Plato creates an image of a completely harmonious world structure, which makes circular, rotating movements by means of spindles: "For this light is the belt of heaven, and holds together the circle of the universe, like the under-girders of a trireme. From these ends is extended the spindle of Necessity, on which all the revolutions turn."[36]

According to Aristotle, whom Ptolemy follows, the spherical Earth is the fixed centre of the universe, which is surrounded by crystal spheres. The innermost sphere carries the moon, the next ones are the seats of the sun and the various planets, and the fixed stars are attached to the outermost sphere of the heavens.[37] Beyond this sphere there is no space. Once a day, the fixed star sphere travels around the Earth; through the force of friction, it also moves the inner spheres, which lie next to each other without any space in between. The heavenly crystal spheres consist of a light and transparent medium, which render them eternal and everlasting: the ether. This distinguishes them entirely from the terrestrial world, which is made of the four elements earth, water, air, and fire. Aristotle's design gave a mechanical explanation for celestial phenomena, and provided a complete image of the world. It included both terrestrial and astral physics. In the years that followed, this complexity made it very difficult to overcome Aristotle's system because change to any one detail destroyed the whole system. In 1543 Nicolaus Copernicus published his most important work *De revolutionibus orbium coelestium*.[38] His observations led him to the insight that the motions of the planets could be explained more easily if the sun was the centre of the universe. Like Aristotle, Copernicus assumed the existence of crystal spheres whose revolutions set the planets on perfectly circular orbits, and he also made the heavenly spheres the boundary of the universe. However, the fact that the Earth now moved destroyed the great unity of the old world model. Copernicus' treatise, which contained complicated mathematics, at first

35 Plato, *Phaedo* (Project Gutenberg Online Book: March, 1999).

36 Plato, *The Republic* (Project Gutenberg Online Book: July 1994).

37 In his *Metaphysics* Aristotle gives a sum total of 47 spheres, the sun and the moon are not included; cf. Aristoteles, *Metaphysik* (Stuttgart, 1984), p. 318.

38 Nicolaus Copernicus, *De revolutionibus orbium colestium, libri sex* [Nuremberg, 1543] (facsimile, Leipzig, 1965).

only circulated amongst astronomers. The new theory raised many new questions, not all of which could be answered satisfactorily. [39] It was only through Galileo Galilei and Johannes Kepler that the import and problems of Copernicus' system became known to a wider circle of people. The Catholic church was strictly against the new way of thinking and put up resistance; to legitimise their anthropocentric view of the world, they cited the Old Testament, where the prophet Joshua makes the stars stand still and not the Earth. "Joshua said to the LORD in the presence of Israel: 'O sun, stand still over Gibeon, O moon, over the Valley of Aijalon.' So the sun stood still, and the moon stopped [...]. The sun stopped in the middle of the sky and delayed going down about a full day."[40]

Instruments for Seeing

Around the turn of the first century, the Arab natural scientist and astronomer Ibn al-Haytham designed an instrument that enabled moonlight to be studied when the moon was full. The device consisted of two rulers and movable slats, each with a hole or a slit. Mounted on an axle it could be turned on its four-cornered base, but required several people to operate it.[41] From various observations made with the instrument Ibn al-Haytham concluded that the visible light originates only from the moon. He wanted to prove that from every glowing point of the moon, light radiates to every point opposite to it.[42] The detailed descriptions of his observations establish Ibn al-Haytham as a co-founder of modern science. He stresses his empirical approach by repeatedly referring to the basis of his observations: "as far as sensory perception can reach".[43] Ibn

39 If the Earth rotated, wouldn't this cause terrible storms on the Earth? Why do bodies fall to the ground if Earth is not the center of the universe?

40 Joshua 10, 12–13, in: *The Bible* (International Bible Society). The church's ban on the Copernican system was only lifted in 1822; until then many universities officially taught the old system. See Jürgen Kremer, *Spezielle Relativitätstheorie* (http://ifb.bildung-rp.de/Faecher/Mathematik/SpezRelTheorie_neu.pdf (3/2007), p. 5.

41 Abu 'Ali al-Hasan ibn al-Hasan ibn al-Haytham (ca. 950–1040, atin: Alhazen), Arab physiologist and astronomer, described the principle of the *camera obscura*; see Karl Kohl, "Über das Licht des Mondes." *Sitzungsberichte der Physikalisch-medizinischen Societät Erlangen* 56/57 (1926): 333–335; Matthias Schramm, *Ibn al-Haythams Weg zur Physik* (Wiesbaden, 1963), pp. 146–157.

42 Ibn al-Haytham, Über das Licht des Mondes, p. 334.

43 Ibn al-Haytham, Über das Licht des Mondes, p. 331.

al-Haytham concluded that all stars emit their own light except for the moon because unlike the moon their appearance is not crescent-shaped.[44] In his early writings Ibn al-Haytham is of the opinion that the moon reflects sunlight because of its mirror-like surface; however, the treatise *Über das Licht des Mondes* describes the moon as an entity, which although it receives its light from the sun, still radiates light on all sides just like self-luminous stars. The diffusely reflected light of the moon is interpreted by the astronomer as a special property, which self-luminous bodies like the sun can bestow on other celestial bodies.[45]

Ibn al-Haytham expounds the background to his theory in his treatise *Optics* (Kitâb al manâzir), in which he distinguishes between "primary light" from the self-luminous bodies and "secondary light" from a body that receives light.[46] He also examines the influence of the astronomical refraction on the moonlight that falls onto Earth. Similar to Ptolemy, he conceives of refraction as the breaking of the rays from space when they reach the sphere of air, which was thought to be homogenous, and then the rays continue on in a straight line. His observations resulted in the discovery that the size of the angle of deflection is so small that moonlight cannot be explained as sunlight, which is reflected by a mirror-like surface. After intense research, Ibn al-Haytham refined his theory to the effect that only the moonlight that falls onto Earth, radiates in the same way as that from self-luminous bodies.[47] As long as the sun sheds light on the moon, it gives the moon a property, which lights up its substance, and with it its colour.

In Renaissance Italy Leonardo da Vinci experimented with lenses to observe the rising moon in the evening sky. The *Codex Leicester* contains his technical descriptions of these experiments.[48] "If you want to prove why the moon appears larger than it is, when it reaches the horizon, take a lens which is highly

44 It was not possible for the astronomer to observe the actual phases of planets like Venus or Mercury with the naked eye.

45 Averroes (1126–1198) and Roger Bacon (ca. 1214–1292) agreed with him in this: see *Rogeri Bacon Opera* (London, 1859), c. XXXVII, p. 118.

46 Ibn al-Haytham, Über das Licht des Mondes, pp. 397–398.

47 Ibn al-Haytham, Über das Licht des Mondes, pp. 397–398.

48 Leonardo da Vinci (1452–1519), *Der Codex Leicester* [1506–1510] (Berlin, 1999); *The Notebooks*, trns. Jean Paul Riehler [1888], vol. 2 (Project Gutenberg Online Book: Jan. 2004). The astronomical diagrams and notes are in the outermost margins of sheets of notepaper that Leonardo filled with his scientific notes between 1506 and 1510. The notes were published posthumously under the title of *Codex Leicester*.

convex on one surface and concave on the opposite, and place the concave side next the eye, and look at the object beyond the convex surface; by this means you will have produced an exact imitation of the atmosphere included beneath the sphere of fire and outside that of water; for this atmosphere is concave on the side next the earth, and convex towards the fire."[49] Approximately one hundred years later, the telescope revolutionised the observation of the bodies in the sky. In Italy, Galilei heard about the invention of the telescope in the spring of 1609, and on August 21 of the same year he already demonstrated his own instrument to Venetian patricians. Galilei's telescope had 20x magnification; to avoid annoying distortions, the outer parts of the lens were covered with a visor, which meant that the lens opening was only about 2 cm. This was enough though, to see clearly the uneven boundary between the moon's light and dark sides. In his notes, which were published in March 1610 as *Sidereus nuncius*, Galilei presented his observations of events involving the moon's light and shadow.[50] In addition to a description of lunar craters and mountain rings, the work contains undated drawings of Earth's satellite. The formations depicted in the first sketches are unclear and show the crater *Tycho*, the *Mare Imbrium*, the *Oceanus Procellarum*, and the *Alps*. The later drawings show detailed images of the craters *Purbach*, *Regiomontanus*, *Walter*, *Deslandres*, and *Albategnius*.[51] The existence of lunar mountains and valleys revealed that, like the Earth, heavenly bodies could also be structured, and are not perfectly round spheres.

Traces and Spots

Galilei was quite aware of the importance of his Starry Messenger, when he described the appearance of the moon. Especially his interpretation of the spots, which cover the surface of the moon "like clouds", caused trouble: "From observations of these spots repeated many times I have been led to the opinion and conviction that the surface of the moon is not smooth, uniform, and precisely spherical as a great number of philosophers believe it (and the other heavenly

49 Leonardo da Vinci, *Notebooks*, vol. 2, no. 909.

50 Galileo Galilei, *Sidereus nuncius* (Starry Messenger) [Venice 1610]. German edition: *Sidereus Nuncius* (Frankfurt am Main, 1980). Online English translation: http://www.bard.edu/admission/forms/pdfs/galileo.pdf. The drawings were probably done on the nights 1.–3. and 18.–19.12.1609 and 19.1.1610.

51 Bruno Deiss, *Historie der Mondkarten* (Frankfurt am Main: AstroLink, 1996–2006).

bodies) to be, but is uneven, rough, and full of cavities and prominences, being not unlike the face of the earth, relieved by chains of mountains and deep valleys."[52] Thus Galilei claimed that the moon was not perfect as heavenly bodies were supposed to be according to prevailing wisdom; instead, it appeared to be rather like the Earth.

The idea that the moon's essence was dark and earth-like had already been proposed by Anaxagoras: "I say the sun is a stone and the moon is earth."[53] "[Anaxagoras] said the moon is made of earth and has plains and valleys in it."[54] His explanation of the lunar spots was "that the unevenness of the composition (of the surface of the moon) is due to the mixture of earthy matter with cold, since the moon has some high places and some low hollows. And the dark stuff is mingled with the fiery, the result of which is the shadowy appearance; whence it is called a false-shining star."[55] However, none of the major Hellenic philosophical systems took over this "Earth theory". Plutarch was the first to attempt to prove the Earth-like nature of the moon in his treatise *De facie in orbe lunae*[56] "It is likely, however, that the moon has not a single plane surface like the sea but closely resembles in constitution the Earth."[57] He imagined landscapes on the surface of the moon, which exceeded those on Earth in their beauty: "It is in fact not incredible or wonderful that the moon, if she has nothing corrupted or slimy in her but garners pure light from heaven and is filled with width, which is fire not glowing or raging but moist and harmless and in its natural state, has got open regions of marvellous beauty and mountains flaming bright and has zones of royal purple with gold and silver not scattered in her depths but bursting forth in abundance on the plains or openly visible on the smooth heights. If through the shadow there comes to us a glimpse of these, different at different times because of some variation and difference of the atmosphere."[58] Plutarch interprets the dark spots on the moon's surface as canyons and valleys filled with water or air. Their darkness he explained with the shadows of the surrounding mountains. "Consequently let us not think it an offence to suppose

52 Galilei, *Sidereus Nuncius* (1980), pp. 87–88.

53 Anaxagoras, *Fragments and Commentary*, p. 246 (passages from Plato referring to Anaxagoras).

54 Anaxagoras, *Fragments and Commentary*, p. 261 (passages in the doxographers).

55 Anaxagoras, *Fragments and Commentary*, p. 255 (passages in the doxographers).

56 Plutarch, *On the Face in the Moon* (Classical Library edition, Vol. XII: 1957).

57 Ibid., p. 137.

58 Ibid., p. 141.

that she is earth and that for this which appears to be her face, just as our earth has certain great gulfs, so that earth yawns with great depths and clefts which contain water or murky air; the interior of these the light of the sun does not plumb or even touch, but it fails and the reflection which it sends back here is discontinuous."[59] The question about the spots on the moon Plutarch extends to the question about the substance of the moon, and furthermore, about the structure and meaning of the cosmos in general. In an excursion into cosmology, he refutes the traditional idea of concentric layers of elements, and proposes three alternative theories about the distribution of matter in the cosmos: "After all, in what sense is earth situated in the middle and in the middle of what? The sum of things is infinite; and the infinite, having neither beginning nor limit, cannot properly have a middle, for the middle is a kind of limit too but infinity is a negation of limits. He who asserts that the earth is in the middle not of the sum of things but of the cosmos is naïve if he supposes that the cosmos itself is not also involved in the same difficulties."[60]

Ibn al-Haytham reflects upon the views of the ancient world and his contemporaries with regard to the cause and characteristics of the spots on the moon:[61]

"Certain people", he wrote, "are of the opinion that the traces belong to the body of the moon; others believe that they are outside the moon, that is, between the body of the moon and the face of the observer; still others believe that they are a mirror image, because the surface of the moon is smooth and reflecting [...]. Thus there are also people who believe they are seeing a mirror image of the oceans on Earth; and others say they are the traces of the mountains and mountain ranges of our Earth; there are also people who believe that what they see is a figure that has been cut out of the reflecting rays that fall upon the Earth."[62]

However, Ibn al-Haytham's view was that the "traces" on the surface of the moon originate from the physical composition of the moon itself, especially its density: "The moon itself does not glow, but only when the sun's light strikes it. Therefore, the nature of the moon is precisely the opposite of all other stars. And if that is so, then it must be the case that even in its atoms there is a

59 Ibid., p. 143.

60 Ibid., p. 77.

61 Ibn al-Haytham, *Über die Natur der Spuren (Flecken), die man auf der Oberfläche des Mondes sieht*, ed. Carl Schoy (Hannover, 1925).

62 Ibid., pp. 2–3.

difference with regard to its nature, density, and luminescence." [63] Differences in reflectivity of light, the albedo, distinguishes the moon. The moon traces are "in truth a darkness on the body of the moon, which are caused by the fact that that part (the trace) does not absorb light sufficiently."[64] To Ibn al-Haytham the astronomer, the explanation lay in his theory of transparent and opaque bodies. A luminous body, which receives its light from a foreign source, is "permeated by light". This he sees as proven, because the whole of a transparent body is illuminated by a light source, not just the side facing the light, whereas on an opaque body there is no illumination on the side away from the light."[65] A compact body also absorbs light, but this only "lingers" on its surface: "No compact body, which is not also slightly transparent, allows light to enter its interior."[66] Thus if light falls on bodies of different density, "then the image (type, species) of the light is different, and this difference will correspond to their colour, smoothness or roughness and its greater or smaller density."[67] From this the astronomer deduces that there is no "optical homogeneity" of the regions of the moon."[68]

"The real nature of the traces is that in these places they hinder perfect absorption of light; whereas the other parts are free of this weakening of the light, these are in truth a light defect of the trace."[69] According to Ibn al-Haytham the colour of a body is also of importance because it has the effect of "darkening" the light. Colour is a result of density: "You will not find any colour without density, because a body that is extremely transparent is not dense and therefore it has no colour. For this reason we maintain that the colour of a body can be equated with its density."[70] He applies his assumptions to the moon, which "receives its light from the sun, which is in no part transparent, and which no light permeates."[71] From this he infers that "the entire body of the moon [possesses] the power to absorb light; only at the places where the traces

63 Ibid., p. 20.

64 Ibid., p. 21.

65 Ibid., p. 25.

66 Ibid., p. 24.

67 Ibid., p. 22.

68 Ibid., p. 23.

69 Ibid., p. 24.

70 Ibid., p. 28.

71 Ibid., p. 29.

are is this power imperfect."[72] In conclusion, Ibn al-Haytham draws a picture of the moon whose colour is "blackish". This is shown when there is an eclipse of the moon: "This colouring is dark; its nature is blackish and comparable to red."[73] The light that is visible as coming from the moon is only borrowed and its "luminosity conceals the dark colour which it actually possesses."[74]

Oceans and Swamps

Leonardo da Vinci also pondered the question as to whether the moon really is self-luminous. Like Plutarch, Leonardo listed ancient and contemporary theories about the about the dark spots on the moon in order to make his own position on this question clear. His list demonstrates what vivid interpretations the mysterious appearance of the moon gave rise to:

"Some have said that vapours rise from the moon, after the manner of clouds and are interposed between the moon and our eyes. [...] Others say that the moon is composed of more or less transparent parts; as though one part were something like alabaster and others like crystal or glass. It would follow from this that the sun casting its rays on the less transparent portions, the light would remain on the surface, and so the denser part would be illuminated, and the transparent portions would display the shadow of their darker depths; and this is their account of the structure and nature of the moon. And this opinion has found favour with many philosophers, and particularly with Aristotle, and yet it is a false view [...]. It has been asserted, that the spots on the moon result from the moon being of varying thinness or density [...]. Others say that the surface of the moon is smooth and polished and that, like a mirror, it reflects in itself the image of our Earth."[75]

Leonardo defends the mirror theory. In his opinion, the moon's surface acts like a spherical mirror: "Either the moon has intrinsic luminosity or not. If it has, why does it not shine without the aid of the sun? But if it has not any light in itself it must of necessity be a spherical mirror; and if it is a mirror, is it not proved in perspective that the image of a luminous object will never be equal

72 Ibid., p. 30.

73 Ibid., p. 31.

74 Ibid., p. 32.

75 Leonardo da Vinci, *Notebooks*, vol. 2, nos. 903, 904, and 905.

to the extent of surface of the reflecting body that it illuminates?"[76] Leonardo regarded the moon's surface as a mountainous landscape with lakes and seas, and he tried to draw the highly varied structure of the surface: "If you keep the details of the spots of the moon under observation you will often find great variation in them, and this I myself have proved by drawing them."[77] He imagined that there was a large amount of water on the moon and that it behaved similar to water on Earth. The water is evaporated by sunlight, which forms clouds that throw shadows on the moonscape: "And this is caused by the clouds that rise from the waters in the moon, which come between the sun and those waters, and by their shadow deprive these waters of the sun's rays. Thus those waters remain dark, not being able to reflect the solar body. [...] How the spots on the moon must have varied from what they formerly were, by reason of the course of its waters."[78] The light parts of the moon Leonardo interprets as waters, which reflect the rays of the sun like a mirror, whereas the dark parts are dry land, which does not reflect light:

"You see here the sun which lights up the moon, a spherical mirror, and all of its surface, which faces the sun is rendered radiant. Whence it may be concluded that what shines in the moon is water like that of our seas, and in waves as that is; and that portion which does not shine consists of islands and terra firma. [...] And in this way it can be proved that the moon must have seas which reflect the sun, and that the parts which do not shine are land."[79]

If the oceans on the moon did not produce any waves, then the light of the moon would be as bright as that of the sun: "The moon, with its reflected light, does not shine like the sun, because the light of the moon is not a continuous reflection of that of the sun on its whole surface, but only on the crests and hollows of the waves of its waters; and thus the sun being confusedly reflected, from the admixture of the shadows that lie between the lustrous waves, its light is not pure and clear as the sun is. [...] Having proved that the part of the moon that shines consists of water, which mirrors the body of the sun and reflects the radiance it receives from it; and that, if these waters were devoid of waves, it would appear small, but of a radiance almost like the sun."[80]

76 Leonardo da Vinci, *Notebooks*, no. 895.

77 Ibid., no. 906.

78 Ibid., no. 907.

79 Ibid., nos. 876, and 887.

80 Ibid., nos. 897, and 902.

Unlike Leonardo, Galilei thought that if any water existed on the moon, it would be in the darker parts: "If one should wish to revive the opinions of the Pythagoreans, namely, that the moon is actually a second Earth, then the luminous part would be land and the darker parts would be waters."[81]

The moon's "hollows and spots" described by Galilei Johannes Kepler imagined to be lunar wetlands in his dream journey *Somnium*.[82] In the moon craters Kepler saw large circular buildings that the moon's inhabitants (Endymionians) had erected to drain these "swamps", to protect them from the sun's rays, and perhaps as a defence against their enemies. In the middle of the space that was to be drained they first rammed in a stake to which was attached long and short ropes, the longest measuring five German miles. Then they took the rope as far as it went which was where the future wall would stand. Then moon-dwellers gathered in their masses to build the wall, which was how it got its circular form. The ditch was at least one German mile wide. At some sites they took out the material from the inside, at others partly from inside and partly from outside by constructing a double wall with a very deep ditch in the middle. Like a navel, the central point of the ditch is also the centre of such a moon city. Whenever the heat of the sun became a nuisance to the inhabitants, those that were in the centre withdrew to the shade of the outer wall, and others, who lived in the shady part of the ditch, away from the sun and the centre, withdrew to the shade inside. In this way, on the fifteen days when the sun was beating down on a particular place, the inhabitants follow the shade; they go round in circles and in this way they can bear the heat.[83]

In 1646, while Francesco Fontana was looking at the moon through a telescope, he discovered three craters with striking systems of radiating features, which he marked D to F on the map woodcut he made.[84] Ten years later, Johannes Hevelius, an astronomer from Danzig, published a more precise map of the moon on which he gave moon features the names of mountain ranges on Earth—Alps, Apennines, and Caucasus.[85] Named after the Greek moon goddess, the science and cartography of the physical features of the moon was

81 Galilei, *Sidereus nuncius*, p. 91.

82 Johannes Kepler (1571–1630), *Somnium seu opus posthumum de astronomia lunari* [1634]. German translation: Keplers Traum [Leipzig, 1895], cited in: Egon Lützeler, *Der Mond* (Cologne, 1906), p. 226.

83 See: Lützeler, *Der Mond*, p. 226.

84 Francesco Fontana, *Novae coelestium terrestriumq[ue] rerum observationes* (Naples, 1646).

85 Johannes Hevelius, *Selenographia* [1647] Digital Library (Wolfenbüttel, 2007).

christened selenography. The early technique was to depict the surface of the moon as though illuminated regularly from one side; thus, the result was forms that did not correspond to reality. Hevelius is considered as the founder of this technique, although he was certainly not the first person to draw the moon.[86] In 1651 William Gilbert published his ideas about the moon in *De mundo nostro sublunari*.[87] This work contained a map of the moon dating from 1600 and Gilbert called the lighter areas of the surface "seas" and the darker parts "land". To the regions known as the moon's face he gave the imaginative names *Regio Magna Orientalis*, *Regio Magna Occidentalis*, *Centinens Meridonalis*, *Insula Longa*, *Insula Borealis*, *Insula Medilunaria*, *Britannia*, *Promentorium Borealis*, *Mare Medilunarium*, *Sinus Orientalis*, *Cape Bicke*, and *Cape Longum*. However, both his map and Gilbert's first attempt at nomenclature did not become well known.

Together with Giovanni Francesco Grimaldi, Giovanni Battista Riccioli studied the moonscapes in Bologna. Published in 1651, the same year as Gilbert's book, Riccioli's *Almagestum novum* contained a detailed map of the moon.[88] In his *Astronomia reformata*, which appeared in 1665, Riccioli named the craters that Fontana had discovered *Tycho*, *Copernicus*, and *Kepler* and thus laid the foundations for the future nomenclature of the moon's craters.[89]

As a result of the assumption that the moon was a kind of small Earth, the term *mare* (Latin for sea, plural *maria*) became established as the designation for the large, dark spots, and the smaller ones were called *sinus* (bay), *lacus* (lake), or *palus* (swamp). By contrast the light-coloured, fissured high ground was named *terra* (land).[90] The erroneous belief that when the moon waxes there will be fine

86 All later maps of the moon used the method of illumination from the side. Unlike Hevelius modern moon cartography uses the illumination as seen at night. Illumination from a single source coming from one side is not simulated, for this would produce shadows of a length corresponding to the height of the objects. Instead the method of relief shading is used, which was developed in the early 1960s. Each physical feature is depicted as though it were illuminated by the sun from an angle corresponding to the elevation. Only the slopes not facing the light are covered in their own shadow and darker. With this method harsh shadows are avoided, such as those that appear on photographs; see Bruno Deiss, *Historie der Mondkarten* (Frankfurt am Main, 1996–2006).

87 William Gilbert (1540–1603), British physician and natural pilosopher, became famous for his book on magnetism (*De magnete*, 1600).

88 Giovanni Battista Riccioli, *Almagestum novum* [1651].

89 Giovanni Battista Riccioli, *Astronomia reformata* (2 vols.) [Bologna, 1665].

90 The sun did not appear to be a smooth, regular sphere either; the Jesuit mathematician and astronomer Christoph Scheiner (1575–1650) projected images of the sun onto a sheet of paper and observed the development of mysterious sunspots (latin *maculae*); cf. Christoph Scheiner, *Tres epistolae de maculis solaribus* (Augsburg, 1612). He entered into an acrimonious dispute with Galilei over who

weather and when it wanes the weather becomes overcast influenced the names given to the moon's maria. Apart from the *Mare Crisium* (Sea of Crises), in the days following full moon first maria with pleasant names appear: *Mare Fecunditatis* (Sea of Fecundity), *Mare Tranquillitatis* (Sea of Tranquility), *Mare Nectaris* (Sea of Nectar), and *Mare Serenitatis* (Sea of Serenity). After these come the less pleasant *Mare Vaporum* (Sea of Vapors), *Mare Imbrium* (Sea of Showers), *Sinus Aestuum* (Bay of Billows), *Mare Nubium* (Sea of Clouds), and *Oceanus Procellarum* (Ocean of Storms). It is possible with the naked eye to see a few bright spots on the moon, like the regions around the craters *Tycho* or *Copernicus*. Riccioli named the craters after philosophers and astronomers. Moon artists were fascinated by the diversity of colour in lunar landscapes:

"The whole *Mare Serenum*, except for the dark periphery, shimmers with a beautiful green. In *Mare Crisum* green is mixed with dark grey. In *Mare Humorum* the two colours are separate and green dominates the surface. A subdued, rather dirty yellowish green is characteristic for *Mare Frigoris*; the mysterious colour of *Palus Somnii*, a sharply contoured hilly landscape, seems to be a strange yellow, and in a few places there is a reddish shimmer."[91]

Ashen Light and a Black Horizon

One or two days after new moon a thin crescent appears as a new light in the night sky. During this moon phase it is also possible to make out the matt, dark portion of the moon next to the bright crescent.[92] The Earth illuminates the dark part of the moon with its light. The moon is in a position in which the side of the Earth that is in bright daylight reflects light back to the dark side of the moon. This configuration is present at the beginning of the moon's waxing phase, for the phases of moon and Earth are complementary and the Earth strongly radiates light toward the moon. The whole Earth is much larger in the night sky because its cloud layers and ice caps reflect sunlight better than land masses and oceans; the Earth reflects back into space almost one third of the sunlight that reaches it.

had discovered sunspots first; see the chapter Show and Hide (on projection) by Siegfried Zielinski in: *Variantology 1* (Cologne, 2005), pp. 81–100.

91 Beer and Mädler, *Der Mond*, p. 137, § 89.

92 The radius of the ash-grey moon disk looks a little smaller than the silvery crescent because bright objects appear larger than dark ones; this optical illusion is called "irradiation".

This *lumen cinereum*, "ashen light", was first depicted by Leonardo da Vinci.[93] With the aid of a geometric sketch Leonardo explained how the sunlight reflected by the Earth weakly illuminates the dark side of the moon:

"Some have thought that the moon has a light of its own, but this opinion is false, because they have founded it on that dim light seen between the hornes of the new moon, which looks dark where it is close to the bright part, while against the darkness of the background it looks so light that many have taken it to be a ring of new radiance completing the circle where the tips of the horns illuminated by the sun cease to shine. And this difference of background arises from the fact that the portion of that background which is conterminous with the bright part of the moon, by comparison with that brightness looks darker than it is; while at the upper part, where a portion of the luminous circle is to be seen of uniform width, the result is that the moon, being brighter there than the medium or background on which it is seen by comparison with that darkness it looks more luminous at that edge than it is. And that brightness at such a time itself is derived from our ocean and other inland-seas. These are, at that time, illuminated by the sun which is already setting in such a way as that the sea then fulfils the same function to the dark side of the moon as the moon at its fifteenth day does to us when the sun is set. And the small amount of light which the dark side of the moon receives bears the same proportion to the light of that side which is illuminated, as that [...]. If you want to see how much brighter the shaded portion of the moon is than the background on which it is seen, conceal the luminous portion of the moon with your hand or with some other more distant object."[94]

Galilei also puzzled over the "strange lustre" that he had observed:

"When the moon is not far from the sun, just before or after new moon, its globe offers itself to view not only on the side where it is adorned with shining horns, but a certain faint light is also seen to mark out the periphery of the dark part which faces away from the sun, separating this from the darker background of the aether. Now if we examine the matter more closely, we shall see that not only does the extreme limb of the shaded side glow with this uncertain light, but the entire face of the moon (including the side which does not receive the

93 "Leonardo's observations having hitherto remained unknown to astronomers, Moestlin and Kepler have been credited with the discoveries, which they made independently a century later"; cf. Owen Gingerich, Leonardos wissenschaftliches Vermächtnis, in: *Leonardo da Vinci. Der Codex Leicester*, p. 56.

94 Leonardo da Vinci, *The Notebooks*, vol. 2, no. 902.

glare of the sun) is whitened by a not inconsiderable gleam. [...] This remarkable gleam has afforded no small perplexity to philosophers, and in order to assign a cause for it some have offered one idea and some another. Some would say it is an inherent and natural light of the moon's own; others, that it is imparted by Venus; others yet, by all the stars together; and still others derive it from the sun, whose rays they would have permeate the thick solidity of the moon."[95]

Galilei suspected that the Earth's light was the source of this gleam:

"Now since the secondary light does not inherently belong to the moon, and is not received from any star or from the sun, and since in the whole universe there is no other body left but the Earth, what must we conclude? What is to be proposed? Surely we must assert that the lunar body (or any other dark and sunless orb) is illuminated by the Earth. Yet what is there so remarkable about this? The Earth, in fair and grateful exchange, pays back to the moon an illuminating similar to that which it receives from her throughout nearly all the darkest gloom of night."[96]

The "dark" side of the moon, the side turned away from Earth, was even more of a utopian place than the side of the moon that faced Earth. In general it was believed that it was similar to the moon's visible side, but it exerted an even greater fascination on the imagination:

"We know already that our travellers, as well as astronomers generally, judging from that portion of the dark side occasionally revealed by the Moon's librations, were—pretty certain—that there is no great difference between her two sides [...]. But [...] what if the atmosphere had really withdrawn to this dark face? And if air, why not water? Would not this be enough to infuse life into the whole continent? Why should not vegetation flourish on its plains, fish in its seas, animals in its forests, and man in every one of its zones that were capable of sustaining life? To these interesting questions, what a satisfaction it would be to be able to answer positively one way or another! For thousands of difficult problems a mere glimpse at this hemisphere would be enough to furnish a satisfactory reply. How glorious it would be to contemplate a realm on which the eye of man has never yet rested!"[97]

95 Galilei, *Sidereus nuncius*, pp. 101–102; English translation: http://www.bard.edu/admission/forms/pdfs/galileo.pdf.

96 Ibid., p. 103. In 1604 Johannes Kepler also presented his theory in his *Astronomiae pars optica*, pp. 254–255.

97 Jules Verne (1828–1905), *All Around the Moon* (Project Gutenberg Online Book: 6.8.2005) Chapter 14, A night of fifteen days.

Jules Verne's notion, that the moon is egg-shaped and the rounded end points towards the Earth while the pointed end is the side we do not see, was not confirmed by space exploration. On 12 September 1959, the Soviet moon probe Luna 2 made a crash landing on the moon and was followed a short time later by Luna 3, which sent back the first pictures of the dark side of the moon to Earth. It was a surprise that overall, this side of the moon was lighter and with less features than the side that faces the Earth; it lacks the characteristic great maria. Later space voyages to the moon confirmed what had been suspected in 1959: the side of the moon facing Earth is being gradually eroded by the Earth's gravitation.

The expression "dark side" of the moon for the side facing away from Earth is actually incorrect. In the course of its rotation both sides of the moon are illuminated alternately by the sun; when the moon is new, the "dark side" is completely illuminated.

One of the first recorded visions of an inhabitable moon on which animals and plants flourish, larger and more beautiful than on Earth, goes back to the Pythagoreans. The idea of a second, inhabited Earth developed into a favourite theme of fictional travel books. In his treatise on the moon Plutarch begins his concluding myth with a passage about possible moon dwellers. In Plutarch's opinion it makes no sense to create a planet that is uninhabited:

"I should like before that to hear about that beings that are said to dwell on the moon—not whether any really do inhabit it but whether habitation there is possible. If it is not possible, the assertion that the moon is an earth is itself absurd, for she would then appear to have come into existence vainly and to no purpose, neither bringing forth fruit nor providing for men of some kind an origin, an abode, and a means of life, the purposes for which this Earth of ours came into being."[98]

The idea of a world reversed preoccupied writers on astronomy long before earthlings were fascinated by photographs showing the Earth rising above the moon's horizon.[99] As the moon has no atmosphere to speak of, a blue sky does not exist there, and there is no dawn or evening. On the black horizon the bright sun suddenly comes up, and the blackness of the sky (i.e., space) renders

98 Plutarch, *On the Face of the Moon*, p. 157.

99 During the Apollo 11 mission in July 1969 photographs were taken of the Earth rising over the moon from the space capsule. This cannot be seen from the surface of the moon. Because the moon mainly turns the same side towards Earth, the Earth is either visible or not; cf. the "Earthrise" as seen from the moon, http://www.astronews.com. 3/2007.

its brightness even more stunning. "On the moon, where there is no haze that scatters light, the sky must be so black, or even blacker than we know from our loveliest moonless nights."[100] Jules Verne's adventurers in his time travel novel *Autour de la Lune* glide through the darkness of outer space in which a black moon is the metaphor for the silence of space vis à vis the perennial question of humankind:

"Great, therefore, as you may readily conceive, was the depression of our travellers' spirits, as they pursued their way, enveloped in a veil of darkness the most profound. [...] And certainly never before had astronomer enjoyed an opportunity for gazing at the heavenly bodies under such peculiar advantages. [...] For, candidly and truly speaking, never before had mortal eye revelled on such a scene of starry splendour. The black sky sparkled with lustrous fires, like the ceiling of a vast hall of ebony encrusted with flashing diamonds. [...] With what a soft sweet light every star glowed! No matter what its magnitude, the stream that flowed from it looked calm and holy. No twinkling, no scintillation, no nictitation, disturbed their pure and lambent gleam. No atmosphere here interposed its layers of humidity or of unequal density to interrupt the stately majesty of their effulgence. [...] For a long time [the travellers] continued to feast [their] eyes on all the glories of the starry firmament; but, strange to say, the part that seemed to possess the strangest and weirdest fascination for their wandering glances was the spot where the vast disc of the moon showed like an enormous round hole, black and soundless, and apparently deep enough to permit a glance into the darkest mysteries of the infinite."[101]

Translated from German by Gloria Custance

100 James Carpenter and James Nasmyth, *Der Mond* (Leipzig, 1876), pp. 138–139.

101 Verne, *All Around the Moon*, Chapter 14.

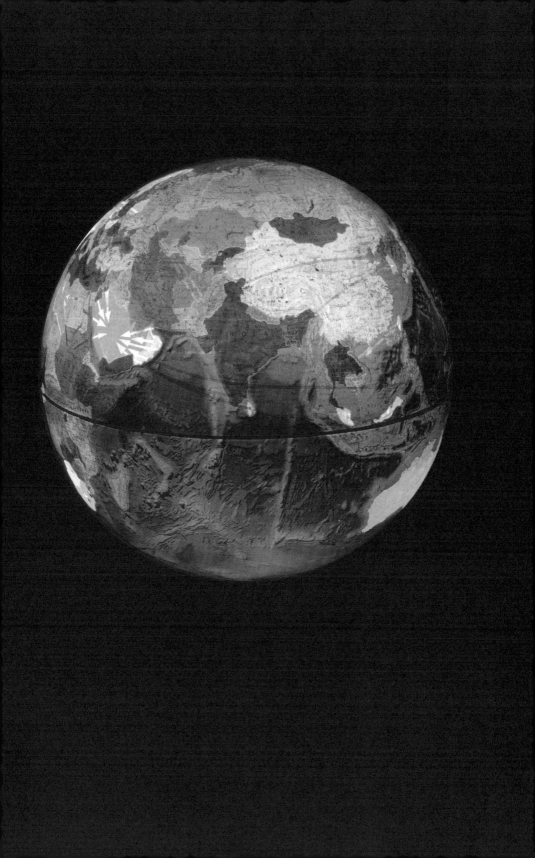

Worldprocessor [#166]

DHRUV RAINA

In Search of a Historiography
of Jesuit Science in Seventeenth and
Eighteenth-century India

The historical discourse on the expansion of modern European sciences into regions
designated as the non-West generally originates in a variety of descriptions of the
"Voyages of Discovery".[1] The majority of these histories are rooted in a fundamen-
tal asymmetry since they tend either to ignore or underplay any comparison with
the processes of transmission of so-called modern science within Europe itself.[2]
Furthermore, these histories tend to be anchored in a historiography that projects
a nineteenth-century reconstruction of European history of science[3] onto the non-
West in that they centre the conflict, first between "Western science" and religion,
and later between Western science and religions or in terms of the concomitant
dichotomies of reason and unreason, rationality and superstition, modernity and
tradition. Several components of this historiography have been interrogated over
the last three decades.[4] However, the historiography of interest in this chapter is
the one founded on the conflict of science and religion, and whose original myth
resides in the "trial of Galileo".[5] One of the most recent interrogations appears
in Heilbron's book entitled *The Sun in the Church*.[6] In this brief essay I shall dis-
cuss one aspect of an emerging area referred to as Jesuit science.[7] In particular,

1 William K. Storey, ed., *Scientific Aspects of European Expansion*, vol. 6 (Aldershot, 1996); George
Basalla, ed., *The Rise of Modern Science* (Lexington, MA, 1968).

2 Steve Fuller, Prolegomena to a world history of science, in: *Situating the History of Sciences. Dia-
logues with Joseph Needham*, ed. S. Irfan Habib and Dhruv Raina, (Oxford, 1999), pp. 114–151.

3 Rivka Feldhay, *Galileo and the Church* (Cambridge, 1995).

4 Storey, *Scientific Aspects*; Patrick Petitjean, Catherine Jami, and Anne Marie Moulin, eds., *Science
and Empires* (Dordrecht, 1992); Richard H. Grove, *Green Imperialism* (Cambridge, 1995); Michael
Adas, *Machines as the Measure of Men* (New Delhi, 1990).

5 Stillman Drake, *Galileo at Work* (Chicago, 1980); M.A. Finocchiaro, *Galileo and the Art of Reason-
ing* (Dordrecht, 1978); Pietro Redondi, *Galileo. Heretic* (Princeton, 1987).

6 John L. Heilbron, *The Sun in the Church* (Cambridge, MA, 1999).

7 Steven J. Harris, Transposing the Merton thesis. *Science in Context* 3 [1] (1989): 29–65.

I shall attempt to offer a narrative variant on the subject of Jesuit astronomers who arrived in India in the last decades of the seventeenth century, within the revised historiography of the expansion of modern science.[8]

Over the last few decades, in particular since the 1980s, the field of Jesuit history and Jesuit sciences, hitherto totally ignored, has become a rapidly growing field of study.[9] The central problematic for historians of science evidently is to examine the relationship between the missionary endeavours of the Jesuits and their scientific activity. Several of the histories of the Jesuit sciences authored by secular historians of science, portray Jesuits as the avant-garde of the Christian missionary efforts, as the pioneers of the so-called civilising mission. However, recently there has been a radical change in perspective within the Jesuit order in South Asia as deep reservations have been expressed about the civilising mission.[10] Notwithstanding other scholars have considered them as contributing to, if not inaugurating, a specific modernity and modern science.[11] Situated within this discourse or nebulous terrain of disciplinary modernity, there were several fields of Jesuit speciality: philology, astronomy, mathematics, and natural history. The study by Florence Hsia suggests that astronomy and hydrology were certainly predominantly Jesuit disciplines in seventeenth-century France.[12] Their overwhelming presence in these areas recommended them to Cassini as he was developing his project to draw up a map of the world. He found that the Jesuit presence in regions distant from Europe would prove particularly resourceful in furthering the goals of his scientific project. Cassini's proposal to involve the Jesuits in obtaining precious astronomical data in order to draw up the latitudes and longitudes of the world was resisted by several members of the Académie

8 Ines G. Županov, *Disputed Mission: Jesuit Experiments and Brahmanical Knowledge in Seventeenth-Century India* (Oxford, 1999); I.G. Županov, *Missionary Tropics: The Catholic Frontier in India (16th–17th Centuries)* (Ann Arbor, 2005); Sylvia Murr, Les conditions d'emergence du discours sur l'Inde au siècle des lumières. *Collection Purusartha* 7 (1983): 233–284; S. Murr, *L'indologie du Père Coeurdoux* (Paris, 1987); Dhruv Raina, *Images and Contexts* (Oxford, 2003).

9 Steven Harris, *Jesuit Ideology and Jesuit Science* (Ph.D. dissertation Madison, 1988); Županov, *Missionary Tropics.*

10 The work of Amaladass, Borges, de Sousa, and Clooney, which will be discussed below could be considered to fall within the ambit of this rethinking.

11 James M. Lattis, *Between Copernicus and Galileo* (Chicago, 1994); Joseph MacDonnell, *Jesuit Geometers* (St. Louis, 1989); William A. Wallace, *Galileo, the Jesuits, and the Medieval Aristotle* (Hampshire, 1991).

12 Florence Hsia, *French Jesuits and the Mission to China* (University of Chicago, Ph.D. dissertation, 1999).

des Sciences, and Colbert and others expressed reservations about the same.[13] In the end, however, Cassini's scientific agenda prevailed over the reservations of the members of the Académie and the Jesuits were enrolled into obtaining and sending astronomical reports to Cassini from China and India following an astronomical protocol drawn up by Cassini. The legendary Jesuit astronomer stationed at Beijing, Antoine Gaubil, more or less supervised the project in China, and the reports from India were sent to him before they travelled to Paris.[14]

A number of scientific projects in India and China between the sixteenth and eighteenth centuries were undertaken by European Jesuits who had set out on missionary activity. Nevertheless, these projects were marked by regional variations that in turn bore the imprint of the political climate and cultural diversity of Europe,[15] and strayed frequently along quite diverse paths. In other words, it would be difficult to find very many similarities between the Jesuit scientific pursuits in China and India, save for the astronomical project charted out in detail by Cassini.[16] Traditional historiography, on the contrary, draws up a portrait that is boringly homogeneous and restricted to the Jesuit religious project alone; but even that project, this historiography fails to recognise, was marked by an inner diversity. Further, the homogeneity of the portraiture of the Jesuit project arises in part from the disciplinary fragmentation characterising the efforts of scholars studying the Jesuit order or Jesuit sciences. This disciplinary fragmentation demarcates the Jesuit projects into the theological, linguistic, scientific, and ethnographic domains, and fails to reckon with the evolution of the relationship between the different modes and forms of Jesuit engagements with non-Western knowledge forms and cultural practices. In other words, their status as a religious order has drawn the attention of the majority of scholars to their missionary goals,

13 Hsia, *French Jesuits*.

14 *Observations physiques et mathematiques pour servir a l'histoire naturelle et à la perfection de l'astronomie et de la geographie. Envoyées des Indes et de la Chine à l'Académie Royale des Sciences à Paris, par les Pères Jesuites avec les reflexions de Mrs de l'Académie et les notes de P.Goüye, de la compagnie de Jesus* (Paris, 1692); de la Loubère, *Description du royaume de Siam par M. de la Loubère, envoyé extraordinaire du Roy auprès du Roy de Siam* (Amsterdam, 1714).

15 Catherine Jami, From Louis XIV's court to Kangxi's court. An institutional analysis of the French Jesuit mission to China (1688–1722), in: *East Asian Science*. Keizô et al., pp. 493–499; Županov, *Disputed Mission*.

16 Dhruv Raina, French Jesuit scientists in India. *Economic and Political Weekly* XXXIV (1999): 30–38; Colette Diény, Knowledge and appreciation of Chinese astronomy and history in eighteenth-century Europe, in: *East Asian Science*. Keizô et al., pp. 501–505; Han Qi, The role of French Jesuits in China and the Académie Royale des Sciences in the development of seventeenth- and eighteenth-century European science, in: *East Asian Science*. Keizô et al., pp. 489–492.

while overlooking the linkages and relative autonomy or inner workings of their scientific project so as to reveal to us the specificity of Jesuit science.

The entity that has come to be designated Jesuit science possibly originates in a variety of astronomy that emerged in Jesuit institutions in Italy in the seventeenth century and gradually blossomed into an active tradition of science practised amongst Jesuits in France in the eighteenth century.[17] The scientific output of these Jesuit scientists was fairly substantial for it has been pointed out that between the years 1600 and 1773, the year when the Society of Jesus was suppressed, Jesuit scientists had authored more than 4000 published works. About 600 journal articles appeared after 1700 and roughly 1000 manuscripts were available. The society's known publications include 6000 scientific works covering areas such as Aristotelian natural philosophy, medicine, philosophy, astronomy, and mathematics.[18] This scientific writing comprised textbooks and treatises on Euclidean geometry and mixed mathematics, treaties, opuscules and journal articles on observational astronomy, and academic publications on experimental and natural philosophy.[19] Discussions of the scientific revolution of the seventeenth and eighteenth centuries emphasise the changing role and function of "experience", wherein experiment was gradually ascribed the task of arbitrating over the status of hypotheses. This change was encountered in earlier Jesuit orders that were traditionally portrayed by historians as the bastions of reaction. The movement away from scholasticism towards the modern concept of experience was indicative of the character of early modern natural philosophical frameworks.[20] In fact, Gassendi's search for new foundations for certainty led him to anchor science in empiricism. His writings display scepticism that he employed as a tool to ridicule Aristotle, and argued that the necessary and final causes invoked by the Aristotelians were unknowable. Margaret Jacob writes: "Gassendi sought a synthesis of the scientific investigation of nature with a new ethical posture that offered support to monarchy and a strong central government provided they did nothing to inhibit the individual's free pursuit of his legitimate passions." This was the synthesis that Descartes was seeking.[21] It is interesting that the French traveller François Bernier, who visited the Moghul court in the seventeenth century, was a disciple of Gassendi.

17 Harris, Merton thesis, p. 41.

18 Ibid.

19 Ibid., p. 42

20 Peter Dear, Jesuit mathematical science and the reconstitution of experience in the early twentieth century. *Studies in the History and Philosophy of Science* 18 [2] (1987): 133–175.

21 Margaret C. Jacob, *The Cultural Meaning of the Scientific Revolution* (New York, 1988), pp. 43–50.

The important work of de Dainville on the education of the Jesuits traces the flowering of the Jesuit school of astronomy in France. The archives of Jesuit colleges reveal that towards the end of the sixteenth century there existed a centre of science in the region of Provence. The Jesuits interested in science and residing there were inspired by their contacts with the Italian universities. The Jesuit College at Tournon had a chair in mathematics in 1556.[22] Jesuit astronomy, it is suggested, then formally commences with Peiresc, and de Tonduti de Saint-Légier in the last decade of the sixteenth century at the College at Tournon. Both corresponded with Gassendi[23] and corrected the Rudolphine tables of Kepler. Scientists of repute such as Claude Richard, mathematician at the court of Philippe IV, and Lalouvere passed out of Tournon. Similar activity was initiated at Avignon. By 1616 the curriculum at Avignon included the study of treatises on mathematics, arithmetic, music, geometry, and an exposure to the science of astronomy that included recent developments in planetary theory including the system of Tycho Brahe.[24] Thus between 1620 and 1680 a great deal of astronomical and mathematical activity was initiated at Jesuit colleges in France. In the process they were responsible for the growth of the schools of provincial astronomy.[25] At these schools they carried out investigations to determine the meridians of the sun and the stars, observed eclipses of the moon, and the satellites of Jupiter that had just been discovered by Galilei. Furthermore, the correspondence between Kircher, Gassendi, Peiresc, Tonduti de Saint-Léger, and Mersenne reveals that a great deal of activity was generated around the problem of determining longitude. However, by 1660 in a major institutional movement, the centre for astronomy shifted from the provinces to the capital, Paris.[26] Thus it is hardly surprising that Cassini turned to the Jesuits when he conceived his larger project.

I shall very briefly summarise the genesis of my own exploration of the world of Jesuit science. One of the questions that evoked my interest in the Jesuit project was to trace the sources of Europe's knowledge of the mathematics and sciences of India. It has been pointed out by a number of scholars that the Jesuits in India were the first to engage with the sciences of India and to inform

22 François de Dainville. *L'éducation des Jésuites: (XVIe–XVIIIe)* (Paris, 1978), p. 311.

23 When speaking of the revival of astronomy in France under the Jesuits, it is Pierre Gassendi (1592–1655) who is considered the inaugurator.

24 De Dainville, *L'éducation*, p. 312.

25 Ibid., p. 314.

26 Ibid., p. 315.

Europe of the same.[27] Consequently, Jesuit scholarship belongs in a way to the pre-history of that narrative construction which Said has so eloquently portrayed for us as Orientalism.[28] So much so that there were claims following the official inauguration of Indology or Indianisme that the Jesuits were the true inaugurators of the field.[29] Naturally, historians of science would be led on to the related problem, which concerns understanding how these Jesuit accounts of the sciences of India shaped the subsequent development of the disciplinary history of sciences that was produced in the West between 1750 and 1850.[30] In order to explore this set of nested concerns and themes I was willy-nilly led to the world of the French Jesuits who landed on the coast of Pondicherry in the last decades of the seventeenth century.[31] However, the Portuguese Jesuits had been in India since the sixteenth century and the Jesuit writings from the early seventeenth century had an impact on the subsequent tradition of European travelogue writing on India as well as played a role in shaping French tastes.[32]

From among these French Jesuits would emerge a tradition of scientific, religious, and cultural commentary that provided Europe with a proto-ethnographical account of the knowledge-related practices of the Indian sub-continent.[33] This "discourse sur l'Inde" had its precedents in a narratology that had been rehearsed by the Jesuits since Ignatius of Loyola.[34] In this discourse on India,

27 Jean Filliozat, La naissance et l'essor de l'Indianisme, in: *Laghu-Prabandah. Choix d'articles d'Indologie*, ed, Jean Filliozat (Leiden, 1974), pp. 265–295; O.P. Kejariwal, *The Asiatic Society of Bengal and the Discovery of India's Past 1784–1838* (Delhi, 1988); Kate Teltscher, *India Inscribed: European Writing and British Writing on India* (Oxford, 1995).

28 Edward W. Said, *Orientalism* (London, 1978).

29 Dhruv Raina, *The French Jesuit Manuscripts on Indian Astronomy* (forthcoming); Francis X. Clooney, *Fr. Bouchet's India* (Chennai, 2005); Anand Amaladass, *Jesuit Presence in Indian History* (Anand, 1988).

30 Rachel Laudan, Histories of the sciences and their uses. A review to 1913. *History of Science* XXXI (1993): 1–34; A.C. Crombie, *Styles of Scientific Thinking in the European Tradition*, vols. I and III (London, 1994).

31 Adrian Duarte, *Les premières relations entre les Française et les princes indigènes dans l'Inde au XVIIᵉ siècle (1666–1706)* (Paris, 1932); Adrien Launay, *Histoire des Missions de l'Inde: Pondichéry, Maïssour, Coïmbatour*, vol. 1 (Paris, 1898).

32 Teltscher, *India Inscribed*; Jean-Marie Lafont, *Indika* (New Delhi, 2000); Jean Biés, *Littérature Française et Pensée Hindoue des Origines à 1950* (Paris, 1974).

33 Sylvia Murr, Les Jésuites et l'Inde au XVIIIᵉ siècle. Praxis, utopie, préanthropologie. *Revue de l'Université d'Ottawa* 56 [1] (1986): 9–27.

34 Županov, *Disputed Mission*; Teltscher, *India Inscribed*.

the Jesuits portrayed the systems of mathematical and astronomical knowledge that they encountered, and it is evident that they recognised there were several systems that were of great antiquity. This idea played a fundamental role in shaping the topos of Western accounts of the history of science in India that began to be crafted towards the end of the eighteenth century when the sciences in the West were entering their most intense phase of institutionalisation.[35] These narratives that appear to us in the form of letters that the Jesuits wrote home[36] and reports of astronomical expeditions and observations of astronomical events mailed to Cassini, Delisle, and others concerning the mathematical and astronomical knowledge of the region were not based on the textual interpretation of the "high Indian" tradition, but on conversations between Jesuits and informed almanac makers with little scholarly knowledge of Siddhantic astronomy.[37] Consequently, we have an account wherein a textual diachrony is absent, and this would continue to be the case until the last decades of the eighteenth century. Nevertheless, these proto-ethnographic reports served as resources for French astronomers and mathematicians from the middle of the eighteenth century to construct the histories of their disciplines, especially on matters relating to India. More specifically, the histories of Le Gentil, the master narrative of Bailly, and the professional history of Delambre, authored at the turn of the eighteenth and early nineteenth century were all indebted to Jesuit sources.[38] Thus these proto-ethnographic accounts metamorphosed into a history under the gaze of savants interested in producing an encyclopaedic history of science. Through these histories founded on secondary accounts of these historians of science, "l'Europe des sciences"[39] became acquainted with the legacy of the sciences of India. These encyclopaedic histories would further inspire British Indologists in their search for the original Sanskrit and Tamil sources of Indian

35 Dhruv Raina, *Nationalism, Institutional Science and the Politics of Knowledge* (Göteborgs Universitet, Institutionen för vetenskapsteori, report no. 201, 1999).

36 *Lettres Édifiantes et Curieuses. Memoires de l'Inde*, vols. 11–15. (Toulouse, 1810).

37 Dhruv Raina, The British Indological search for the origins of algebra and arithmetic in India (1780–1820), in: *Encyclopedia of the History of Science, Technology and Medicine in Non-Western Cultures*, ed. Helaine Selin (2008, forthcoming).

38 Jean-Sylvain Bailly, *Histoire de l'astronomie ancienne depuis son origine jusqu' à l'établissement de l'école d'Alexandrie* (Paris, 1775); Jean-Sylvain Bailly, *Traité de l'astronomie indienne et orientale* (Paris, 1787); Jean-Baptiste Joseph Delambre, *Histoire de l'astronomie ancienne*, Tome 1 (Paris, 1817); Jean-Baptiste Joseph Delambre, *Histoire de l'astronomie du moyen age* (Paris, 1819).

39 This happens to be the title of an important book by Michel Blay and Efthymios Nicolaïdes, eds., *L'Europe des sciences. Constitution d'un espace scientifique* (Paris, 2001).

mathematics.[40] Further, the Jesuit accounts on other aspects of Indian culture left a deep impression on the subsequent trajectory of French Indology and shaped the founding of French social science research on India.[41]

How are we to understand the variety of Jesuit intellectual activity in the South Asian region? In asking this question we are suggesting that the horizon of Jesuit activity in South Asia exceeded their missionary objectives even though the latter were intimately connected with the envisioning of this horizon. Second, the Jesuits who arrived in South Asia from Europe arrived from different regions of Europe and were repositories of different European cultural and intellectual traditions as well—it would be a gross error of reductionism to assume otherwise. And finally, the relationship between the Jesuit order and national centres of power within Europe were of paramount importance in shaping the contours of Jesuit activity in South Asia and East Asia. The rivalry within Europe between France, Spain, and Portugal splintered the consensus within the Jesuit order, and is revealed for us in the several disputes both within the missionary order and between missionary orders from Europe working in India.[42] In other words, what is being suggested is that the social roots of the diversity of the Jesuit imagination stems not merely from the exploration of a world that was foreign, new, and "other", but from an inner diversity swept into a unity that was called the missionary order.

The core of the explanation being proposed is that a nuanced geography of the European imagination is needed to explain this variety of Jesuit projects in South Asia. However, between the middle of the sixteenth and the end of the eighteenth centuries the Jesuit encounter in South Asia was by and large restricted to peninsular India, and in the case of the French Jesuits, from the end of the eighteenth century it was certainly restricted to what the geographers designated as "l'Inde Carnatic".[43] Thus the first wave of European Jesuits arrived on the western coast of India, stretching from Goa to Kerala, in the first half of the sixteenth century. This wave of missionary activity continued well into the seventeenth century, after which Portuguese power in South Asia and more generally in the sub-continent went into decline. Most of the Jesuits landing on the sub-continent during this period were of Portuguese origin, recruited under the *padraodo* system. But as the century rolled on Jesuits from

40 Raina, British Indological search.

41 Roland Lardinois, Louis Dumont et la science indigène. *Actes* 106–107 (1997): 11–26.

42 Županov, *Disputed Mission*.

43 Duarte, *Les premières relations*.

Italy, France, and Germany joined their ranks. This wave of Jesuits set out from Europe from Lisbon and the College of Saint Paul in Goa was the important seminary on the sub-continent.[44]

This wave is to be distinguished from the second wave of predominantly French Jesuits who landed on the coast of Pondicherry after their expulsion from Siam following a political uprising in the last decades of the seventeenth century.[45] Because of the changing political climate in Europe, these Jesuits set out from Lorient and not Lisbon. Between the last decades of the seventeenth century and 1750 there were about half a dozen practising French Jesuit astronomers sprinkled between Chandernagore and Pondicherry.[46] Unlike the Portuguese Jesuits before them the activities of the French and Italian Jesuits were not too closely linked with the French nation state. A relationship there was but it was limited to academic projects such as the scientific project of mapping the world and was so much in the nature of a political project. However, as post-colonial scholarship has revealed for us, the two are very difficult to separate—truth and power are constantly in conversation. And in the case of the French Jesuit project this becomes evident to us in the different optics the Jesuits employed when looking at the region[47].

At this point I would like to depart from the standard historiography of the Jesuit order in India and propose another one that is suited to understanding scientific discourses of the period. Thus in the Jesuit historiography the chronology of the order is partitioned between the arrival of Francis Xavier in the sixteenth century and the imposition of the ban on the Jesuit order in the last quarter of the eighteenth century, followed by the period commencing after the ban was lifted in the early nineteenth century.[48] In institutional terms this is reflected in the period between the formation of the first Madurai mission by Nobili in the early decades of the seventeenth century to the banning of the order in the third quarter of the eighteenth. The second period begins after the lifting of the ban on the order and the establishment of the second Madurai

44 Teotio R. de Sousa and Charles J. Borges, eds., *Jesuits in India: In Historical Perspective* (Instituto Cultural de Macau/Xavier Centre of Historical Research, 1992); see also Alden Dauril, *The Making of an Empire. The Society of Jesus in Portugal, Its Empire and Beyond: 1540–1750* (Stanford, 1996).

45 Zenobia Bamboat, Les voyageurs Français aux Indes aux XVIIᵉ et XVIIIᵉ siècles (Paris, 1933); Launay, *Histoire*.

46 Raina, British Indological search.

47 Murr, Les conditions.

48 Amaladass, *Jesuit Presence*; de Sousa and Borges, *Jesuits in India*.

mission. In this interregnum the Jesuit project had transformed substantially, but Jesuit science in South Asia had changed and did not come to an end.[49] This historiography certainly bears the signature of the institutionalisation of the order in Jesuit historical memory, but it also offers a portrait of the Jesuits in India and elsewhere as the vectors of modernity. However, the historiography from the perspective of the history of science or an intellectual history could well be based on different geographies of the imagination, as well as the variety of political projects that shaped the Jesuit project. This diversity on the liturgical front has been scrupulously documented for us by Županov in the debate on evangelisation of the Portuguese Jesuits and the *accommodatio* introduced by the French and Italian Jesuits on the Eastern coasts of India.[50] The point is further elaborated in the divergent historiography of the Jesuit orders in Latin America on the one hand, and India and China on the other.

On the other hand, despite its diversity there were themes around which Jesuit science did acquire coherence. The institutional and administrative organisation of Jesuit science was ensured through the disciplinary structures of the Society of Jesus that reinforced a "high level of group coherence and loyalty".[51] A comparison of Jesuit scientific activity in India and China suggests then that unlike the case of China, the Jesuits in India made little contribution to the growth of modern science. Such an assessment ignores the scale of the Jesuit project in India and China. Nevertheless, despite internal dissension within the Jesuit order witnessed both in India and China, the Jesuits inaugurated historical enquiry into ancient Indian astronomy as they did in China by providing both the impetus and material for French savants and astronomers to develop their *histoires de l'astronomie*. In the first half of the eighteenth century, we may in fact suggest that the efforts of French Jesuit astronomers in India and China mutually complemented each other.

The complexity and diversity of the Jesuit intellectual project has been the subject of much recent discussion. This complexity is partially to be understood in terms of "national traditions in colonial science", wherein the diversity of cultural and environmental contexts played itself out in different centres of scholarly activity involving European colleges, overseas mission stations, and the circulation of

49 In fact, the most recent conference of Jesuit scientists in South Asia was organised in the city of Pune in India in January 2007.

50 Županov, *Disputed Mission*.

51 Harris, Merton thesis, p. 39.

personnel and information.[52] Thus from the perspective of the history of science Jesuit science in South Asia could be visualised in terms of the evolution of an interwoven project along three technological axes: the technology of the body, the technologies of dialogue, and the technologies of the state. Thus the Portuguese Jesuits landing on the west coast of India had to find ways of surviving the tropical climate amidst a non-Christian people.[53] These circumstances initiated a number of Jesuit experiments, including significant ones involving local medical systems. The writings of Garcia de Orta provide us with the first instance of exchanges between European and Ayurvedic medical systems. Such encounters resulted in novel institutional, epistemological, and organisational innovations.

But this technology of the body was subordinate to the technology of dialogue that would have provided the optic for comprehending another knowledge system. As missionaries then engaged in proselytisation, the Jesuits were forced to acquire expertise in the local languages, and converse with both the high and low churches of the region. The problem of reconciling the other, separated by the dichotomies of us and them, interior and exterior, one and many, was a source of both frustration and creativity and crystallised into ways of addressing other cultures and ways of knowing; namely, the universalist and the ethnic.[54] The desire to image the other as oneself worked itself out in a universalism in Latin America that all but annihilated Amerindian practices and cultures. In regions where pagan civilisations were seen to be far more "resilient", the Jesuits went native. *Accomodatio* was propagated as a central liturgical sub-culture by Nobili in the seventeenth century.[55] Then Jesuits from Nobili, to Beschi, Hanxleden, and Pons, over a period of a hundred and thirty years acquired an expertise and deep scholarly appreciation of Sanskrit and the widely spoken languages of the southern peninsula. This was manifest in the publication and circulation of scholarly grammars, bilingual dictionaries, and lexicons.[56] Several of these scholars went on to compose poetry in the local languages. In any case, classical philology had

52 Steven J. Harris, Jesuit scientific activity in the overseas scientific missions, 1540–1773. *Isis* 96 (2005): 71–79.

53 C.R. Boxer, *Two pioneers of tropical medicine. Garcia d'Orta and Nicolas Monardes* (London, 1963); see chapters 3 and 6 in Županov, *Missionary Tropics*; see also John M. de Figueiredo, Ayurvedic medicine in Goa according to the European sources in the sixteenth and seventeenth centuries, in: Storey, *Scientific Aspects*, pp. 247–257.

54 Županov, *Disputed Mission*.

55 Ibid.

56 Clooney, *Fr. Bouchet's India*.

been an area of Jesuit competence, but this linguistic project in India has prompted a number of scholars to suggest that they were the first Indologists.[57] Depending upon the intellectual predisposition of either secular or hagio-biographers, several paternities have been ascribed to the origins of Indology as a discipline.[58] One reading that departs from the standard version wherein Anquetil Duperron and William Jones are considered the inaugurators of Indology, sees the French and Italian Jesuits of the seventeenth and eighteenth centuries as veritable and ignored founders of this discourse. Nevertheless, it is certain that beyond the question of priority, the secular inaugurators of Indology were treading upon a path that had been laid by these Jesuits and they were most certainly the inaugurators of the "discourse sur l'Inde".

However, this discourse was not independent of the Jesuit social technologies, but was framed by a literary template that for want of a better term I have elsewhere called the Jesuit narratology.[59] This frame was comprised of several representations of India. Of these three representations of India were quite marked: India was presented as similitude (as an other here), as radical alterity (India is signified as an elsewhere), and as exemplar (India is signified as Utopia).[60] The narratology itself centred a literary form referred to as cosmography. A century earlier Bacon had described cosmography as "a kind of history manifoldly mixed". This involved recounting the natural history of regions, the historic and civil account of habitations, the manners of people, discussions of mathematics in terms of the climates and the ordering of the heavens.[61] These cosmographic observations were to be blended with personal narrative. The primary cosmological question preoccupying the seventeenth and eighteenth century European imagination was that of the chronological origin of the Earth. Christian thought was preoccupied with the origins of the human race; and the dating of the book of Genesis. However, there was a related theological concern of situating a non-Christian people into the Christian conception of time.[62] This preoccupation stimulated the interest of the French astronomer-Jesuits in Indian theories of cosmology as

57 Raina, British Indological search.

58 Dhruv Raina, Jean-Baptiste Biot on the history of Indian astronomy (1830–1860). The nation in the post-Enlightenment historiography of science. *Indian Journal of History of Science* 35 [4] (2000): 319–346.

59 Raina, British Indological search.

60 Murr, Les conditions.

61 Teltscher, *India Inscribed*.

62 Murr, Les conditions.

well as the astronomical knowledge and practices prevalent on the Indian subcontinent. Their search led them to conversations with Tamil astronomers and astrologers, including an important dialogue with Jai Singh and the astronomers at his court.[63] The details of this encounter have come to us through Jesuit letters, as well as a variety of other historical material. It is often canonised as the first meeting of European and Indian astronomers, which it certainly was not. Historians of science have in any case conferred upon it the status of a central episode of the eighteenth century.

The last of these technologies had to do with defining the relationship between the Jesuit order in India and the patron state in Europe. Under the *padraodo* system, the Portuguese Jesuits were seen to be instruments in the hands of the Portuguese empire. However, the relationship was to undergo a sea-change over the next century with the French Jesuits who landed on the east coast in the last decades of the seventeenth century. This relationship between the Jesuit order, the French Academy, and the French state was woven around two distinct projects; one directly involving the state and the second worked out between the Jesuits and state on behalf of the Académie. The contributions of the French Jesuits in China to the emergence of French science has been carefully chronicled by Joseph Needham. These contributions included the determination of latitudes and longitudes for all of China, the observation of solar and lunar eclipses as well as of eclipses of Jupiter's satellites, and the passage of Mercury through the solar disc, to mention just a few. These Jesuit astronomers also initiated studies on ancient Chinese records and observations in order to analyse Chinese chronology. In fact, it was a similar interest that led them on to the study of Chinese, Indian, and Egyptian history. The astronomical observations made in China were often used to determine the accuracy of Chinese history, and hence these Jesuit scientists were the progenitors of Chinese historical astronomy.[64]

In India, on the other hand, in the first instance they were requested to collect the Sanskrit classics and ship them to Paris for the King's library.[65] Between

63 S.M. Razaullah Ansari, Introduction of modern Western astronomy in India during 18–19 centuries, in *History of Indian Astronomy*, ed. S.N. Sen and K.S. Shukla (New Delhi, 1985), pp. 363–402; Virendra Nath Sharma, The impact of eighteenth century Jesuit astronomers on the astronomy of India and China. *Indian Journal of History of Science* 17 [2] (1982): 345–352; Eric Forbes, The European astronomical tradition: Its transmission into India, and its reception by Sawai Jai Singh II. *Indian Journal of History of Science* 17 [2] (1982): 234–243.

64 Han Qi, The role of French Jesuits in China.

65 Jean Filliozat, L'Orientalisme et les sciences humaines. Extrait du *Bulletin de la Société des études Indochinoises* XXVI [4] (1951).

1700 and 1735 about three hundred Sanskrit classics were commissioned, copied and sent to the Bibliothèque Royale in Paris. These included works on literature, philosophy, jurisprudence, logic, metaphysics and a couple of karanas on astronomy and astrology.[66] Second, they were requested by the state at the instance of the Académie des Sciences to participate in the cartographic and astronomical project initiated by Cassini.[67] The Académie des Sciences' interest in India was restricted to that domain of knowledge that would serve the purposes of navigation, commerce, the transfer of particular techniques notably in the areas of textiles and pharmacopoeia, and diplomacy as and when France found the need to engage in military operations; the Jesuits stationed in Pondicherry were thus in constant communication with royal astronomers in Paris such as Delisle and Bailly. As scholars engaging with the Indian literary and philosophical traditions, their proto-ethnographic reports on the sciences of India contributed crucially to the historical and encyclopaedic discourses on the sciences of India. This phase of their engagement came to an end with the rise of secular scholarly interest in the sciences of India and China. Furthermore, the period coincides with the ban of the order in France, as well as with the rise of Indology proper. After the ban was lifted almost fifty years later, Oriental studies and Indology proper were institutionalised as academic disciplines outside the field of Jesuit inquiry, and the Jesuit contributions were delegated to the pre-history of the new disciplinary formations.

66 Lafont, *Indika*.

67 Harris points out in the case of the French Jesuits in China that "they skillfully fulfilled their twin scientific mandates by interweaving the interests of Versailles, the Forbidden City, the Académie Royale des Sciences, the republic of letters, and their general in Rome. In both the linguistic and Latourian sense, Jesuits were masters of translation"; cf. Harris, Jesuit scientific activity, p. 74.

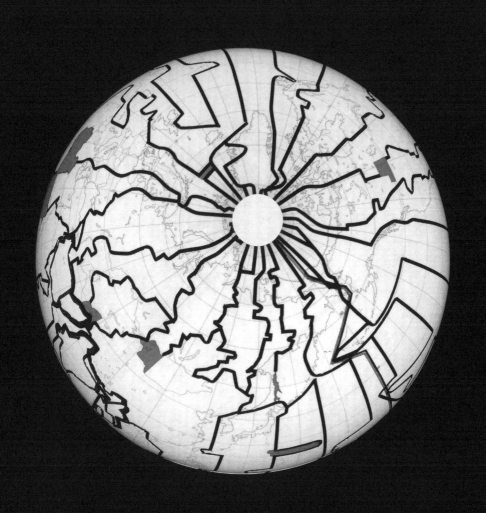

Worldprocessor [#274]

NILS RÖLLER

Thinking with Instruments:
The Example of Kant's Compass

In 1886 Friedrich Nietzsche called the German philosopher Immanuel Kant "the great Chinaman from Königsberg".[1] Looking back a century later Nietzsche assessed Kant's critical philosophy as an expression of a lack of the will to power. In fragments that have survived Nietzsche frequently characterises the Chinese as modest, conformist, and without the will to set themselves ends. Thus for Nietzsche Kant is a Chinaman; a great man but lacking the will to set ends and achieve them. This judgement is quite surprising considering the claims made for Kant's critical method. Comparison is made with the Copernican revolution and it styles itself as a movement of a new departure in philosophy. Kant makes calculated use of nautical terms, alluding to the attributes and aura of Columbus' discoveries, in order to classify his method as epoch-making. I shall demonstrate that Kant's reference to the compass, as the most important nautical instrument of the period, is specific.[2]

At the end of the eighteenth century the critical writings of Kant mark a change in the principles of European philosophy. This change gives rise to a different way of thinking about nature: nature is no longer conceived of as given, but as a system of laws. Concepts such as causality and matter are now construed as products of human subjectivity. This subjectivity develops in interaction with sensory data. Here critique means to make distinctions between things and the subjective cognition of things. The focus of subjectivity implies that an action of ethical value is no longer judged as striving for happiness or as orientation on ideas, but as authorship of the laws governing human will. In Kant's *Critique of Judgement* this leads to aesthetics no longer being conceived

1 Friedrich Nietzsche, *Beyond Good and Evil* [1886], trans. Helen Zimmern (New York, 1997; online: http://users.compaqnet.be/cn127103/ns/select.htm), VI, no. 210: "Even the great Chinaman of Königsberg was only a great critic." On Nietzsche's relationship to Kant see: Stephen Palmquist, How "Chinese" was Kant? *The Philosopher* 84 (1996): 3–9; online: http://www.hkbu.edu.hk/~ppp/srp/arts/HCWK.html.

2 On the inadequacy of Kant's Compass see: Jordan Howard Sobel, Kant's Compass *Erkenntnis* 46 (1997): 365–392.

of as the perception and organisation of beautiful sensations but as mediation between self-determination and heteronomy.

In Kant's texts the word "compass" appears frequently. Like "writing, counting, iron, gunpowder, glass," for Kant the compass is one of the arts "that can only be invented once".[3] Kant mentions this invention at significant points in the critical writings. These are points where the boundaries between familiar ways of thinking and the new critical thought are discussed. The word compass directs attention toward an aspect of critical philosophy that Nietzsche distances himself from.[4]

Nietzsche's assessment of Kant is not an exception; scathing judgements on Kant's thought are legion. Commentators question on principle Kant's distinctions between the world of experience (things, nature, sensibility) and the domain of reason (as the area of self-determined thought). This means, therefore, that it is also doubtful whether Kant's philosophy can contribute anything to reflections on and theories about humans in relation to media and technology. For it is indeed questionable whether a philosophy that makes a strict division between thought and the world can conceive of mediation at all. I shall pursue this question by looking at Kant and his dealings with the compass. A presupposition of this discussion is that in this period the relationship between means and ends had become problematic. One question was: to what end has nature endowed humankind with reason? This question rests on the assumption "that there will be found in the natural constitution of an organized being no instrument for some end other than what is also most appropriate to that end and best adapted to it."[5] Nature adapts everything according to its end; but why are humans endowed with reason? Self-preservation and well-being can be achieved more simply and easily without reason. Kant's ethics develop through deliberating this issue. His ethics try to determine the function of reason through constructing an analogy between means and ends in nature, and will and purpose in human actions. In this analogy the idea of being free of purposes is relevant. I shall demonstrate that in outlining this state of freedom Kant has the compass in mind. It will become clear that Kant thinks with this

3 Immanuel Kant, *Reflexionen zur Anthropologie* (Berlin, 1923), vol. XV/II, Part 2, no. 1423, p. 620.

4 Cf. *Kant-Konkordanz zu den Werken Immanuel Kants*, ed. Andreas Roser et al. (Hildesheim, 1993).

5 Immanuel Kant, *Groundwork of the Metaphysics of Morals* [1785], trans. Mary J. Gregor, in: *The Cambridge Edition of the Works of Immanuel Kant. Practical Philosophy*, ed. Mary J. Gregor (Cambridge, 2002), p. 50.

instrument and utilises it in a very precise manner to interrogate the theme of the limits of his method.

Kant as a Scientist?

Kant's scientific study of magnetism does not appear suited to remove reservations that are entertained about his critical differentiations. His relationship to science is characterised by Erich Adicke as "merely" dilettante.[6] Adicke edited Kant's papers of scientific notes for the Berlin Academy edition, and he also wrote a two-volume monograph with the title *Kant als Naturforscher* (Kant as a scientist). Here Adicke examines an aspect of Kant's biography and daily life that is not the basis for his renown, but is certainly of relevance biographically and from a systematic aspect. The theme of Kant and science is currently receiving much attention from British and American scholars.[7]

As part of his academic duties Kant lectured on mechanics, theoretical physics, and physical geography.[8] His lectures were based on existing textbooks. For example, Kant taught physics according to Johann Peter Eberhard's *Erste Gründe der Naturlehre* of 1753; for physical geography, though, he used his own "hand-written" text.[9] Initially, the titles with which Kant entered the academic sphere indicated an explicit scientific content. During various phases of his life,[10] and even when he was 70 years old, Kant pondered theories of magnet-

6 Erich Adicke, *Kant als Naturforscher* (Berlin, 1924–1925), vol. I, p. 5.

7 Michael Friedman writes in *Kant and the Exact Sciences* (Cambridge, 1992), p. XIIf.: "For, on the one hand, Kant had an astonishing grasp of the philosophical foundations of the exact sciences of his time—a grasp that we, with all our increase in purely scientific sophistication, have hardly been able to match vis-à-vis twentieth-century exact sciences. So Kantian thought stands as a model of fruitful philosophical engagement with the sciences. On the other hand [...] it is precisely because Kantian philosophy is so well adapted to eighteenth-century science—and not, therefore, to twentieth-century-science—that our present philosophical situation has the specific shape it does. A better understanding of Kant's thought within its eighteenth-century context is therefore most relevant indeed to our twentieth-century problems [...] Kant`s achievement consists [...] in adapting and radically transforming independently given philosophical and metaphysical ideas—ideas stemming largely from the Leibnizean philosophical tradition inherited—within the essentially new scientific context wrought by Newton."

8 Ernst Cassirer, *Kants Leben und Lehre* (Darmstadt, 1994), p. 41.

9 Ibid.

10 Immanuel Kant, *Handschriftlicher Nachlass*, vol. XIV, nos. 23, 25, 26, 28, 29 (Berlin, 1925), pp. 79–107.

ism.[11] In Adicke's opinion, "Magnetism and electricity are precisely the areas where he gives his imagination free rein." [12]

Free to fantasise in the area of physics? This stands in diametric opposition to Kant's efforts to achieve orientation in metaphysical concerns. A characteristic of Kant's entire intellectual development is that he undertakes great efforts to achieve orientation. His life's work was devoted to the question: "What does it mean to orient oneself in thinking?"[13] Ernst Cassirer sees this as Kant's basic question. To begin with Kant studies science following Leibniz and Newton. He reflects on whether natural processes are based on a *bauplan*. In the second phase he engages with the philosophical tradition. This is accentuated by an edition of hitherto unpublished texts by Leibniz that lead to a sharp differentiation between theories of physics as an area of factual truths or the sensible world (*mundus sensibilis*) and the area of reason as the intelligible world (*mundus intelligibilis*). In the area of reason necessary truths are examined, including propositions of mathematics and geometry. The third phase is the critical phase. Now, the relationship of ideas to phenomena in the world is questioned as a matter of principle. It is no longer the things of the world that are in the foreground but human cognitions about the things of the world. This is regarded as the "Copernican turn" in Kant's thought.

Is the compasss an instrument that Kant "fantasised' about, or does he use the compass in pursuance of his philosophical search for orientation? To answer this, I shall recapitulate relevant aspects regarding the history of the compass.

11 Immanuel Kant, Something on the influence of the moon on the weather condition [1794], trans. John Richardson, in: *Four Neglected Essays by Immanuel Kant*, ed. Stephen Palmquist (Hong Kong, 1994; online: http://www.hkbu.edu.hk/~ppp/fne/essay4.html).

12 Adicke, *Kant*, vol. II, p. 115.

13 Immanuel Kant, What does it mean to orient oneself in thinking? [1786], trans. Allen W. Wood, in: *The Cambridge Edition of the Works of Immanuel Kant. Religion and Rational Theology*, ed. A.W. Wood and George Di Giovanni (Cambridge, 2001).

History of the Compass

Joseph Needham[14] and Chen Cheng-Yih[15] both describe the development of the Chinese science of magnetism. They demonstrate that this proceeded independent of European developments until the sixteenth century, and many aspects took place earlier in China than in Europe. The utilisation of magnetism for spatial orientation, for example, was practised in China in the first century A.D.

Needham finds evidence that diviner's boards with magnetic spoons were probably in use in 83 A.D. In *Lung Hêng* by Wang Chung there is a passage that can be read as a reference to an early form of compass. These ritual instruments consisted of two boards: a square, which represented the Earth, and a circular one, which represented the heavens. On the round board, which rested upon a pivot, were marked 24 points of the compass. At its centre was etched a depiction of the constellation of the Great Bear (Ursa major).[16] Needham writes: "The 'tail' of the Great Bear may be unhesitatingly denominated the most ancient of all pointer-readings, and in its to transference to the 'heaven plate' of the diviner's board, we are witnessing the first step on the road to all dials and self-registering meters."[17] In the third century A.D. magnetic needles are mentioned. From the seventh century magnetic needles were used to align sun dials. In China the phenomenon of magnetic declination was already known in the ninth century. A text dating from 1044 states that magnetised iron strips are used in compasses. Compasses in this era were pieces of wood containing iron strips that floated in a water bath, or magnetised iron strips hanging in the air suspended on a string. Chen concludes: "From the existing records it is clear that by the early twelfth century both dry-pivoted compass and floating compass were in use on Chinese ships."[18]

In Europe knowledge about needles that pointed the direction only began to spread as of 1200. This information was probably brought to Europe by French

14 Joseph Needham, *Science and Civilisation in China*, vol. IV, Physics and Physical Technology, part 1 (Cambridge, 1962).

15 Chen (Joseph) Cheng-Yih, Magnetism in China, in: *Encyclopedia of the History of Science, Technology and Medicine in Non-Western Cultures*, ed. Helaine Selin (Dordrecht, 1997).

16 Needham, *Science and Civilisation*, vol. 4, part 1, p. 261f.

17 Ibid., p. 266.

18 Chen (Joseph) Cheng-Yih, *Magnetism in Chinese Civilization* (Manuscript, 2006), p. 8.

crusaders; the first literary sources are of French origin.[19] Magnetic needle and the depiction of a compass rose, *rosa dei venti*, were first combined around 1300 in the Mediterranean region, and is ascribed to Flavio Gioia from Amalfi.[20] Compasses greatly improved mariners' orientation on the seas, which made voyages safer and speeded up trade. The instruments were manufactured in regional centres, for example, in Danzig (now Gdansk) and Nürnberg. Seafarers were aware that they had to use different compasses in different regions. Maps of the Mediterranean could only be used with compasses customary to the area. The same applied to the Baltic, North Sea, and Atlantic Ocean. On his voyages of discovery Columbus carried various compasses with him from different manufacturers and regions. He found that 50 nautical miles west of the Azores the magnetic needles, which had pointed north-east up to this point, changed to north-west.[21]

Independently of Columbus, around 1500 the makers of sun dials in Nuremberg also discovered magnetic declination, also known as magnetic variation. When comparing the length of shadows they found that the shadow thrown when the sun was at its zenith, that is, when the sun indicated the geographic south, this was not identical with the magnetic south that a compass needle pointed to. As Nuremberg sun dials were prized artefacts and used in Rome and other places this led to the discovery of the geographic differences in magnetic declination. However, it was attributed to peculiarites of the instruments and of the magnetic stones used in their construction.[22] Nuremberg manufacturers of compasses and globes like Martin Behaim also worked for the Portuguese Crown and thus for navigation and expeditions of exploration.[23] The historian of astronomical instruments Ernst Zinner mentions that in sixteenth-century Nuremberg "compass" also referred to clocks, that is, devices for measuring time, for temporal orientation. This is explained through the linking of compasses and sun dials in the travelling sun dials of Nuremberg instrument makers and the fact that they were organised in the guild of the compass makers.[24]

19 Heinz Balmer, *Beiträge zur Geschichte der Erkenntnis des Erdmagnetismus* (Aarau, 1956), p. 50.

20 For research on Gioia see Amir D. Aczel, *The Riddle of the Compass* (New York, 2001).

21 Balmer, *Beiträge*, p. 79f.

22 Ernst Zinner, Die Fränkische Sternkunde im 11. bis 16. Jahrhundert, in: *XXVII. Bericht und Festbericht zum Hundertjährigen Bestehen der Naturforschenden Gesellschaft in Bamberg* (Bamberg, 1934), p. 65f.

23 Zinner, Fränkische Sternkunde, p. 84.

24 Ibid., p. 54.

Magnetic declination was used in an attempt to solve the problem of determining longitude, but proved unreliable. In Kant's day there already existed various maps of magnetic declination.[25] In 1683 Edmond Halley produced a chart with lines of identical declination, a result of measurements taken by himself and other seafarers. Halley assumed the existence of four magnetic poles as an explanation for the existence of the declinations.

Around 1544 in Nuremberg Georg Hartmann discovered the phenomenon of inclination of the magnetic needle. He reports on this discovery in a letter to Duke Albrecht of Prussia.[26] Robert Norman in London discovered the same phenomenon independently and published his findings in 1581.[27] Hartmann and Norman observed that an iron needle at equilibrium and balancing on a pivot is thrown off balance when it is magnetised; one end of the needle inclines toward the ground. This can be observed today when one looks at old Chinese compasses here in Europe. For example, Chinese needles in the Hellmann Collection,[28] held in Niemeck (Brandenburg), Germany, are blocked. The local inclination of the place where the collection is situated is 67° and thus greater than the inclination at the place in China where it is presumed that they were made.

William Gilbert studied what was known about declination and inclination systematically and in 1600 published his conclusions in *De magnete*.[29] Magnetism was a subject that philosophy engaged with in an epoch in which it was gradually beginning to separate itself from the scholastic tradition and the natural sciences. This is a very wide field that, for example, Athanasius Kircher and René Descartes treat in depth both in their writings and in experiments.[30]

25 The drawings were done by Alonso de Santa Cruz and Cristofo Borri. Leibniz drew on a portable globe a curve in which the declination is zero; cf. Balmer, *Beiträge*, p. 182.

26 Zinner, Fränkische Sternkunde, p. 66.

27 Balmer, *Beiträge*, p. 141.

28 Hans-Günther Körber, Katalog der Hellmannschen Sammlung von Sonnenuhren und Kompassen des 16. bis 19. Jahrhunderts im Geomagnetischen Institut Potsdam, in: *Jahrbuch 1962 des Adolf-Schmidt-Observatoriums für Erdmagnetismus in Niemegk* (1964), pp. 149–171. I should like to thank Dr. Hans-Joachim Linthe for the tour and for information about the Hellmann Collection.

29 William Gilbert, *De magnete*, [1600] trans. P. Fleury Mottelay [1893] (New York, 1958). The first large-scale chart of magnetic inclinations was published by Johann Carl Wilcke in 1768.

30 Through Marin Mersenne Descartes learned of English mathematicians and mathematical instrument makers; see René Descartes, *Oeuvres*, Tomus III, ed. Charles Adam and Paul Tannery (Paris, 1899), no. CLXXXVI, p. 51. Descartes excerpted from and criticised Athanasius Kircher's *De arte magnetica*; see Descartes, *Oeuvres*, op. cit. no. CCLXVII, p. 522, and R. Descartes, Excerpta

For an explanation of magnetic phenomena, particularly the vertical inclination of magnetic needles, in Kant's lifetime the Paris Academy instituted two prize questions in which Daniel Bernoulli and Leonhard Euler, who Kant held in high esteem, both participated and won prizes.[31]

Kant's Notes on Magnetism

Kant's scientific notes show that he was acquainted with the local declination and inclination of magnetic needles. He thought, for example, that the Earth was surrounded by a "universal magnetic atmosphere".[32] He calls this the "sphere of heterogeneous ether".[33] This sphere causes magnetic changes, and the declination and inclination of magnetic needles. In a sketch of his thoughts Kant concludes that therefore there are no magnetic poles on Earth that can be geographically located. This is his position on the question as to how many magnetic poles there are on Earth.

The polarity of a magnet is explained by Kant as an arrangement of particles, that have absorbed particles of the magnetic atmosphere in differing concentrations. These particles are attracted in varying degrees towards the centre of the Earth. Kant is trying to think through magnetism in a way that conforms to Newton's laws when he attempts to conceive of the effect of the magnetic sphere analogously to gravitation. He avoids supposing that there is a special magnetic force. In so doing Kant does not try to arrive at his own experimental results but rather to speculate on the basis of data that is known to him. He does not test this data in experiments, nor does he suggest making particular studies, as Leibniz had done before him. Kant's notes on these speculations induce Adicke to label Kant a "cosmic wanderer" and speculative architect:[34] unlike Kant, the scientist gathers a wide collection of experimental data before he constructs a theory.

Thus in comparison to his scientist contemporaries Edmond Halley, Johann Carl Wilckes, or Johann Albrecht Euler, Kant is written off by Adicke as a

ex P. Kircher De magnete, in: *Oeuvres*, Tomus XI, pp. 635–639. Descartes discusses magnetism in detail in *Principiorum philosophiae* [1644], in: *Oeuvres*, Tomus VIII, IV, pp. 275–311.

31 Balmer, *Beiträge*, p. 572f.

32 Kant, *Nachlass*, no. 26, p. 96.

33 Kant, *Nachlass*, no. 28, p. 99.

34 Adicke, *Kant*, p. 116.

dreamer. Kant ponders and speculates instead of poring over details of data and collecting facts exhaustively. He may have regarded the moon as a magnet, considered the movements of mountain ranges, and used all this to explain historical climate change, but his method disqualifies him as a scientist. Therefore, Kant's notes on natural science can only be regarded as the speculations of a natural philosopher. Adicke bases his judgement on the analysis of notes that Kant did not intend to be published. Michael Friedman's analysis is different. He works out the significance of the theory of ether for Kant's later work. The concept of ether is of central importance for Kant's deliberations on magnetism.[35] That contemporary theory of the magnetosphere of celestial objects, including Earth, does vindicate some aspects of Kant's ideas on magnetism I shall not expand on here. For our discussion of the compass it is sufficient that Kant knew about magnetic phenomena, such as polarity, declination, and inclination, and that in this era a coherent explanation of these phenomena was lacking.

In the passages in his writings where Kant mentions the compass that were published in his lifetime, he does not discuss magnetic phenomena in detail or specific points about how compasses were manufactured. For example, he writes that winds "pass through the entire compass in fourteen days".[36] In his scientific texts the compass is an instrument to aid spatial orientation, which is mentioned in addition to other possibilities such as the stars. When the word compass is mentioned it occurs within the framework of what was common knowledge in Kant's time, and does not indicate extensive knowledge of this navigation instrument.

Thus it is necessary to distinguish between Kant's preoccupations with the phenomenon of magnetism in his handwritten notes on scientific issues and the way he uses the compass in his published works on natural science. There, the instances when the compass is mentioned do not support the view that Kant is letting his imagination run away with him. And what about the critical writings? Does the compass set an accent there that makes the critical method stand out from the philosophical tradition?

35 Friedman, *Kant*, p. 290f.

36 Immanuel Kant, *Neue Anmerkungen zur Erläuterung der Theorie der Winde* [1756] (Berlin, 1910), p. 502; in this context see also: Immanuel Kant, *Von dem ersten Grunde des Unterschiedes der Gegenden im Raume* [1768] (Berlin, 1912), p. 380.

Philosophical References

In the history of philosophy there are innumerable references to the compass. I shall present two texts from the philosophical tradition pre-Kant because they mention the compass in the context of the question as to the freedom and self-determination of human beings.

In the 'Ion' dialogue Plato compares the poet Homer to an iron ring that is being attracted by a lodestone. The god who inspired Homer binds Homer like the magnetite binds an iron ring. A rhapsodist, however, who recites one of Homer's epics, is like an iron ring chained to another iron ring that is being attracted by the lodestone. The dialogue evaluates the rhapsodist as a being that has been chosen by the gods, from whom the philosopher disassociates himself. Magnetic attraction is here used as a rhetorical device to differentiate between poetic speech and philosophical speech. What is striking about this passage from Plato is that magnetism is mentioned in the context of a discussion of mental processes.[37]

Leibniz puts forward a contrary argument when in *Theodicy* of 1710 he declares the possibility of free will. First, he discusses the argument of Buridan's donkey. According to Buridan, a donkey who stands between two mounds of hay will starve to death because he is unable to decide which pile of hay to eat. Leibniz argues that a human being can never get into a situation in which two possible courses of action appear equal and a decision has to be made. The plan of the world is too complicated to admit such a possibility. It is precisely this complication that allows humans to determine their actions themselves. In the world plan God has already taken all possibilities of self-determined action into account.

A problem for Leibniz is that human beings do not possess any inward sensation for the freedom of their decisions. In this the human is like a magnetised needle that turns toward a pole without possessing any feeling for the direction. For we cannot always notice or imagine the causes upon which our decisions depend.[38] Magnetism serves Leibniz as an example to reconcile subjective freedom with the strict determination inherent in God's "best possible plan in

37 Plato, *Ion*, trans. Benjamin Jowet (New York, 1993; online: http://www.ellopos.net/elpenor/greek-texts/greek-word.asp#PLATO), 533d.

38 Gottfried Wilhelm Leibniz, *Theodicy*, trans. E.M. Huggard (Peru, Il., 1985; online: http://www.gutenberg.org/files/17147/17147-8.txt), § 50.

producing the universe".[39] In this case magnetism does not denote a difference between self-determination and divinely inspired action, but illustrates the idea of degrees of freedom within a well-considered world system.

Leibniz utilises the same French word "inclination" to describe both the magnetic needle and a mental attitude half-way between conscious volition and the inevitability of determination by fate.[40] Here Leibniz continues an established use of the Latin word, which was also used in astrology. Probably through knowledge and reception of Gilbert via Descartes, Leibniz articulates a new direction.

Before Gilbert, doctors and natural researchers had thought there was a connection between the stars and magnetism. They followed the ideas of the French scholar Petrus Peregrinus who wrote in 1269 in his *Epistola de magnete* that the stars determine the direction of magnetic needles. Then Gilbert stated that the reason for the orientation and inclination of magnetised needles was the poles of the Earth. According to Gilbert Marco Polo possibly introduced the compass to Europe.[41] He also considers the possibility that Gioia in Amalfi, Italy, invented it.[42]

Gilbert's critic Francis Bacon does not subscribe to this. He accuses Gilbert of allowing experiments to infect his imagination.[43] On the "acus nauticae" Bacon writes in *Novum organum* in 1620: "But we also note other discoveries of the kind which make us believe that mankind can pass by and step over outstanding discoveries even though they lie at our feet. For however much the discovery of artillery, silk thread, the mariner's compass, sugar, paper, or the like may seem to stand on certain hidden properties of things and nature, there is surely nothing belonging to the printer's trade which is not plain and pretty well obvious."[44]

That Kant was familiar with these thoughts is evidenced by a passage in *Anthropology from a Pragmatic Point of View*, where he considers the compass as an invention that humanity only needed to make once. Here invention is meant in

39 Gottfried Wilhelm Leibniz, The principles of nature and of grace, based on reason [1714], trans. Leroy E. Loemker, in: *Philosophical Papers and Letters*, ed. L.E. Loemker (Dordrecht, 1969), p. 639.

40 Gottfried Wilhelm Leibniz, An Nicolas Hartsoeker, 29 April 1715 [no. CXX, enclosure in a letter from Leibniz to des Bosses], in: *Philosophische Schriften*, vol. 2, ed. C.J. Gerhardt (Berlin, 1879), p. 497f.

41 Gilbert, *De magnete*, p. 7.

42 Ibid., p. 6.

43 Francis Bacon, *The New Organon* (Oxford, 2004), I, Aph. 64, p. 101.

44 Bacon, *Organon*, Bk. 1. no. 110, p. 160. Rees translates "acus nauticae" as "mariner's compass".

the sense of in contrast to discovery. Invention "brings into reality that which was not yet there",[45] whereas through discovery something becomes perceptible "that was already there, for example, America, the magnetic force directing to the poles".[46]

A passage in Voltaire's *Traité de métaphysique* of 1734 illustrates that the Enlightenment before Kant made use of nautical instruments. Voltaire writes of the compass of mathematics and the torch of experience that guided philosophers in the seventeenth century.[47] Here Voltaire draws a parallel between the cognitive faculty and the navigation instrument that had led to such groundbreaking discoveries. In his critical writings Kant follows this parallelisation of geographic discovery and philosophical activity. The philosophy of the Enlightenment develops through engaging with Leibniz. In the course of this the concept of reason changes. Initially reason is thought of as something bestowed upon humankind by God. By the end of the eighteenth century, for Kant reason has become a product that individuals and nation states as assemblies of individuals must first develop.

Navigation Instrument of Critique

Thought is moved by the winds of doubt. A philosopher like Hume "deposited his ship on the beach (of skepticism)". By contrast Kant promises to give the ship "a pilot, who, provided with complete sea-charts and a compass, might safely navigate the ship wherever seems good to him, following sound principles of the helmsman's art drawn from a knowledge of the globe."[48] In 1783 Kant

45 Immanuel Kant, *Anthropology from a Pragmatic Point of View* [1798], trans. Robert B. Louden (Cambridge, 2006), p. 144.

46 Kant, *Anthropology*, p. 144.

47 Voltaire (i.e. François Marie Arouet), *Traité de métaphysique* [1734], (Paris, 1826), p. 29f. Cited in: Ernst Cassirer, *Die Philosophie der Aufklärung* [1932] (Darmstadt, 2003), p. 12.

48 Immanuel Kant, Prolegomena to any future metaphysics that will be able to come forward as science [1783], trans. Gary Hatfield, in: *The Cambridge Edition of the Works of Immanuel Kant. Theoretical Philosophy after 1781*, ed. Henry Allison and Peter Heath (Cambridge, 2002), p. 58f.: "Hume also foresaw nothing of any such possible formal science, but deposited his ship on the beach (of skepticism) for safekeeping, where it could lie and rot, whereas it is important to me to give it a pilot, who, provided with complete sea-charts and a compass, might safely navigate the ship wherever seems good to him, following sound principles of the helmsman's art drawn from a knowledge of the globe."

speaks self-confidently of completeness. The region of metaphysics is charted and safe navigation of the ship is assured. Kant speaks as one that has brought to a conclusion ten years' work on the *Critique of Pure Reason* and is convinced that he has reliably mapped a new area of thought.

Soon, however, he no longer speaks of navigating charted waters. Navigation with compass and chart is possible in areas where other mariners have already been and recorded their positions. The domain of the metaphysics of morals is different: "Here, then, we see philosophy put in fact in a precarious position, which is to be firm even though there is nothing in heaven or on earth from which it depends or on which it is based."[49] At first Kant develops the *Groundwork* of critical ethics parallel to *Critique of Pure Reason*, which focuses on knowledge of nature. In *Groundwork of the Metaphysics of Morals*, which was published later, Kant refers to a principle that, like a compass, facilitates orientation in moral questions. It is an aid, for example, in deciding whether a person should lie or not. A decision can be reached by using one's common sense. One only has to ask oneself if one would like to be lied to or not. When the question is put in this manner the person will make the right decision. The application of the principle, whether one can conceive of one's actions as a law for others or not, is like a compass: "Here it would be easy to show how common human reason, with this compass in hand, knows very well how to distinguish in every case that comes up what is good and what is evil, what is in conformity with duty or contrary to duty...".[50]

The *Groundwork of the Metaphysics of Morals* clearly illustrates the difference between how reason was understood at the beginning of the Age of Enlightenment and the concept at the end of the eighteenth century. Reason can no longer refer conclusively—that is, according to objectively understandable rules—to a divine origin. At the same time it cannot refer to experience either. This means that reason is suspended in a precarious position between earthly experience and heavenly guarantee. Reason has to guarantee its relevance itself. It cannot be derived from praxis or from predetermination.

49 Kant, *Groundwork*, p. 77.

50 Ibid., p. 58.

To Orient Oneself in Thinking?

What is the critical method's attitude to religion? This is a question asked by Kant's contemporaries and enthusiastic readers. This question is also asked by the Prussian censor. Does critical philosophy admit the conception of a reason that is greater than human reason? That is, a divine reason that is able to arrange rationally the world, humankind, and earthly events? When human reason thinks like this, then it reflects upon its own limits and thus also upon the limits of Kant's method.

Kant takes up a position on this by speaking of rational faith. Reason can believe. This faith derives from a feeling of need to think of the world as ordered. Reason knows that it is limited. Its task is to formulate objective laws and with these to determine the will. Reason cannot think that it originates from a divine plan. It contradicts its essence of giving itself laws to think of itself as given by some other agency. Thus it is not the task of reason to reflect upon its own limits.

If, however, reason overtaxes itself with this burden, then it would be well-advised to follow a compass. The compass—and this what is specific about Kant's compass—is an instrument that offers orientation at the boundary between human and super-human abilities. As an instrument it is made by humans. It utilises forces that in Kant's era were imperfectly understood. Kant equates such an instrument with rational faith: "A pure rational faith is therefore the signpost or compass by means of which the speculative thinker orients himself in his rational excursions into the field of supersensible objects, but a human being who has common but (morally) healthy reason can mark out his path, in both a theoretical and a practical respect, in a way which is fully in accord with the whole end of his vocation; and it is this rational faith which must also be taken as the ground of every other faith, and even of every revelation."[51]

It is striking that Kant refers to navigation instruments when he is talking about the newness of the critical method. In this way he gives his critique the status of a discovery, and endows his arguments with the aura of a radical change. His thought is thus elevated to the same level and import as the discovery of new continents. Do his references to the compass, therefore, signify that he has let his imagination run away with him? Could Kant have chosen some other means of orientation? In its forays into speculative territory can reason orient itself on the sun or the "polestar"? Is rational faith comparable to a "plumb line",

51 Kant, What does it mean, p. 14.

or do mainsprings act within reason? Could numbers have been used to offer orientation to reason in its precarious situation?

Kant is acquainted with various means of spatial orientation. In some of his central arguments he mentions counting. Counting, for example, promotes decisively the thought of subjective consciousness. Kant mentions the plumb line frequently, for example, when he argues that reason determines the will. His references to the compass delineate an area where reason comes up against its limits. Reason finds itself in a speculative region and there it learns of its possibly restricted nature. Kant is so well-acquainted with the compass and magnetism that here he can use an equivalent for his argument. The compass is a product of human art. This art utilises principles that are not fully understood. In this the compass is similar to reason, which has first to develop in humans as a capacity for cognition. In this sense reason is a product of humans. At the same time reason feels a need; it senses dependencies that it does not comprehend. Rational faith is not a signpost that someone has put up, but a specific, a compass, that one has to take in hand oneself. And the compasses in Kant's day quivered a lot in the hand, as a visit to the Hellmann Collection today will confirm.

The comparison between mainsprings and the compass is a central element in what is specific about Kant's compass. Mainsprings are components of artefacts. They are a part of an organised whole. Kant thinks of nature as such a planned and organised whole. In *Groundwork* he calls it a machine.[52] In nature one finds no superfluous elements. Kant also mentions mainsprings when he speaks of subjective motives, when humans are thought of as machines and act like machines. The compass is not thought of with reference to the world machine. The laws according to which the compass functions cannot be deduced as part of the overall plan of nature. Thus the compass is an instrument which points to beyond the order of things that is understood. Kant thinks of the compass as an instrument in which reliability and infinity come together. Mainsprings, on the other hand, are a part of a strictly controlled system; their function is assigned to them by a superordinate whole that is conceived of as a machine. The compass functions as an aspect of an incomprehensibility that is nevertheless reliable.

Remarkably, in this realm of abstract arguments feelings and felt needs are spoken of. This is a zone of indeterminacy in which mainsprings, as a component of mechanical arts, are out of place. In "What does it mean to orient oneself in thinking?" the compass leads to a place where cool reason becomes sympa-

52 Kant, *Groundwork*, p. 87.

thetic—sympathetic in the sense that it guesses that it is possibly dependent on determinations. Reason enters into an accord with these determinations. Naturally this is not sympathetic for those, like Nietzsche, who philosophise with a hammer. To philosophise with a hammer instead of a compass means to want to hammer into the world the values one has set for oneself. This is something entirely different to adjusting concepts of orientation when confronted with the limits of one's own method.

Nietzsche and Kant did not write any treatises especially on China. In his Reflexions on Anthropology (*Reflexionen zur Anthropologie*) Kant mentions singularities of the Chinese people that are known to him. He does not differentiate among the different ethnic groups and languages; thus it can be assumed that Kant's knowledge of China was very limited. Nietzsche's comments on China are mainly found in unpublished material. Like Kant, he does not differentiate among the different ethnic groups and languages. Neither Nietzsche nor Kant refer to the compass as a Chinese invention.

There is, however, a structural difference in the general tendency of the two philosophers' remarks about China. Kant discusses Chinese aesthetic preferences and mentions that the Chinese have a partiality for small eyes and are fond of eating dogs as meat. Kant does not make any value judgements. Nietzsche, however, does. He ascribes to the view that different peoples are at different stages of evolution. At the top is the *Übermensch*, superman, who has liberated himself from Western metaphysics. He judges the Chinese as a human species that are not capable of this act of liberation. This is the difference between Kant's critical method and Nietzsche's philosophy of the will to power.

Kant develops his concept of reason as a faculty which humans utilise for self-determination. At the same time, by making use of the compass, he acknowledges that this faculty has its limits. Nietzsche also demands self-determination, but his notion of self-determination does not admit accord as a measure of ethical distinctions. For Nietzsche the goal of self-determination is the power-driven setting of own values. The striking difference is that Nietzsche does not reflect on the limits of his approach. Kant, however, does this when he speaks of the felt needs of reason. This is the point at which Kant acknowledges that there is something that reason cannot comprehend and cannot objectivise according to its maxims. It is to this area that Kant's compass leads: Kant perceives that there is is something unlimited, which reason believes and hopes that is similar to itself, yet does not know this for certain. Can such a compass make any contribution to the question of mediation? In the twentieth century it is used specifically by Cassirer, and as a nautical instrument it facilitates thinking through differences, which in the digital world of cybernautics become blurred.

Mediation

In the twentieth century a philosophical debate on Kant becomes pertinent. After the Davos debate between Martin Heidegger and Ernst Cassirer philosophy separates into one that is oriented on the natural sciences and one that distances itself from them.[53] Heidegger's position is that Kant's philosophy is philosophy about mortal, that is, finite existence. In the years that follow he studies Nietzsche. This can be interpreted as an attempt to transcend Kant. Cassirer agrees with Heidegger that Kant discusses the conceivableness of existence. However, Cassirer asserts that Kant believes that it is possible to open up human existence; this is, in his opinion, an open question.[54] In this context Cassirer examines the concept of symbols, including modern mathematical and scientific concepts of symbols. In this connection he speaks of concepts as compasses, which lead research to discovery of new aspects of reality. He demonstrates his argument with the example of the history of the concept of the atom.[55]

The as yet short history of media theory can be understood as the history of a discursive field. This field examines technological and scientific apparatus. Media theory reflects the interaction of these devices with culture in general and the specific cultures of the arts and philosophy. Within the field catchwords such as virtuality and cyberspace triggered debates. They suggested that computers have changed people's relationships to reality. In a Kantian context it is of relevance that computers operate with numbers. Kant links the constitution of subjectivity with the act of counting. When a person counts they do not just name number for number, but have to be aware that the numbers are connected. This connectedness is a form of synthesis. A computer links numbers without any human subject having to reconstruct the linkages, yet the links are the prerequisite for the operations that a person performs with the aid of a computer. The result is amalgamations of the abstract processes of a computer and human actions. In the 1980s these amalgamations gave rise to the popular idea of a novel reality. It was suggested that computers and networks enabled a new world in which the finiteness of humans would be neutralised.

53 Michael Friedman, *A Parting of the Ways. Carnap, Cassirer, and Heidegger* (Chicago, 2000).

54 Ernst Cassirer, Davoser Disputation zwischen Ernst Cassirer und Martin Heidegger [17 March–6 April 1929]. Anhang IV, in: Martin Heidegger, *Kant und das Problem der Metaphysik* (Frankfurt am Main, 1991), p. 278.

55 Ernst Cassirer, *Determinismus und Indeterminismus in der modernen Physik* [1937] (Darmstadt, 1957), p. 292.

Cyberspace was staged as a realm of unconditional freedoms in which many life forms could be anticipated through playing around. This in fact adapted certain feature of Kant's "intelligible world". A problematic aspect of the ideology of the unrestrictedness of cyberspace and virtuality is that it is unable to reflect its own limits. Reflection of the limited nature of something, however, is a chance to perceive differences. Cognition of one's own limits offers the opportunity to realise what is other, new, and non-restricted. The chance of realising such insights is marked by Kant's compass. It does not mediate; it offers the possibility of making corrections. Of the mariners of his time Kant demanded that they know the regions of the world at all times. That was the opinion of the "landlubber" thinker in his lectures on physical geography at the University of Königsberg. Seafarers can orient themselves "at any time" if they correct for the declination of a compass by regularly taking their bearings from the stars.[56] In conjunction with other reference systems the compass is useful. The same can be maintained of cyberspace. The value of this digital construction becomes clear in its difference to other worlds. It is not the mediation of two systems that is interesting but rather the difference between two systems. In navigation this offers orientation.

In Kant's compass is inscribed a basic insight into the limited nature of human cognition, and at the same time an insight into the fruitfulness of thinking the differences. This latter is an insight that acknowledgement of the limitedness of human cognition is reconcilable with structural openness. Until shortly before he died Kant thought about mediation between metaphysics and physics. He hoped to write a further major work that would elucidate the transitions between the intelligible world and the empirical world. The problem of mediation between the rational world and the sensible world remains. The Kantian approach is an invitation to identify differences and then to think of possible transitions and mediations. This is still a task to be done.

Translated from German by Gloria Custance

56 Immanuel Kant, *Physische Geographie* (Berlin, 1923), vol. 9, no. 81, p. 307.

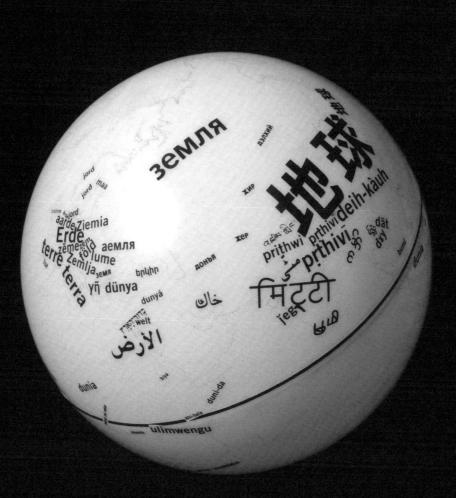

Worldprocessor [#66]

ROSSEN MILEV

The "World Script Revolution" in the Fourth Century: A Series of Coincidences and Typological Similarities, Interferential Influences, or an Unexplored Phenomenon of Parallelism?

"It is not that important to discover new things, most important is to create new links between already existing things."

Nam June Paik[1]

"It is in this striving after the rational unification of the manifold that science encounters its greatest successes, even though it is precisely this attempt which causes it to run the greatest risk of falling a prey to illusion."

Albert Einstein[2]

Introduction: A World Revolution in Writing as *summa summarum* of the Local and Regional "Script Revolutions" of this Epoch

Has there ever been a world revolution in the history of humankind? At the same time, all over the world? Perhaps the answer is yes: in the history of the script and of written culture.

In 2006, while conducting research on the Gothic alphabet[3], which was cre-

1 Nam June Paik, *Art for 25 Million People* (Berlin, 1984), p. 4.

2 Albert Einstein, Science, philosophy, and religion. Conference on Science, Philosophy and Religion in Their Relation to the Democratic Way of Life (New York, 1941), p. 13.

3 Rossen Milev, Svetlana Lazarova, About a 'virtual' letter-symbol in the Gothic alphabet. Th – a ligature, "Gothic cross", universal symbol of the Divine or an anagram of King Theoderic the Great? In: *Gotite/Goterna*, ed. Rossen Milev (Sofia, 2006), pp. 99–104.

ated for the translation of the Bible into the Gothic language by Bishop Wulfila (311–383) in the fourth century (ca. 360) in the Roman province of Moesia (present day Northern Bulgaria), our research team came across a very interesting, and thus far unresearched penomenon in fourth-century world culture. Astonishingly, when we placed Wulfila's invention in a world context, we discovered that in the fourth century, in all dominant cultures of the world there were "revolutionary" changes regarding the script plus transitions to a new manuscript book culture. In this period more than ten new alphabets and written languages were created—not only in Europe (in pagan and Christian cultures), but also in the Near East (in Jewish, proto-Arabic and Christian Syrian, Egyptian, and Ethiopian cultures), in Persia, in India, in China, Japan, Korea, and in a native American civilisation, the classical Maya in today's Mexico. Almost simultaneously, important changes in written culture or metamorphoses from oral to written expression took place in this period.

What is surprising is the fact that the process of reforms, new standardisation, codification, new aesthetic script ideas, recording or foundation of new writing systems encompasses different types of cultures world-wide that before had used phonetic alphabets, ideographic, or mixed writing. They all expressed different languages and traditions, each with a different and long history of writing. This appears to be a process independent of the differences and great geographic distances between civilisations. Further, almost everywhere the "script revolutions" were connected with some type of religious, sometimes also political and economic, expansion, crisis, or change. In many religions the "speechless speech" is a gift of God.[4] In their holy scriptures the individual characters plus the words, sentences, and manuscripts written using these characters are "sacred", "holy"; the materialisation of the Holy Spirit/Dharma/The Divine Will, etc. (the well-known "metaphysics" of religious books). If we look at this from a different point of view, writing, even before it was mechanised by Gutenberg, represented a mechanisation of the spirit.[5]

4 Виктория Андреева, Аркадий Ровнер, Алфавит (The Alphabet), in: *Егазаров, А. Иллюстрованная Энциклопедия символов* (Moscow, 2003), p. 41.

5 David Godfrey, Foreword, in: Harold A. Innis, *Empire and Communications* (Oxford, 1950) VIII.

China, Japan, Korea

The earliest written records in Chinese, with its typical logographic script system, were on oracle bones and date back to ca. 1400 B.C., which makes Chinese the world's oldest continuously developed script.

In the fourth century A.D., seventeen hundred years later, the writing system in China underwent important metamorphoses, a development connected chiefly with the work of two famous calligraphers, who were father and son. The father, Wang Xizhi (303–361), was considered "the greatest master of all time" for his contribution to the art of writing, and is the author of the first significant theoretical work on calligraphy: *Strategy of the Art of Writing of Lady Vai*[6]. The son, Wang Xianzhi (344–386), modernised Chinese cursive script. Generally speaking, so-called KYAÏ, "right writing" was introduced in China in the fourth century. This was also connected with the introduction and widespread use of paper (invented in China in the second century) and a new type of ink. For the first time, there were seal print for Daoist magic formulas. In China calligraphy became a recognised art form around 250 B.C., and because of this long tradition, the reform and the contribution to the art of writing by Wang Xizhi and Wang Xianzhi were recognised. In Europe, in the Christian world, writing also achieved calligraphic value and became an art in the fourth century.

Also in the fourth century, Chinese culture reached Japan and Korea, and it is during this period that the first script tradition began in these countries.[7] Further, the first state was founded in Japan at this time—the Yamato kingdom—and the so-called Kofun period (4th–8th century) in Japanese history began. In Korea, the first written documents were historical chronicles in the kingdoms of Paekche and Koguryo.

In contrast to Chinese civilisation and the Japanese, Korean, and other East Asian written cultures connected with it, where the logographic type of writing developed, the other great civilisations of the eastern hemisphere—Indian, Persian, Judean, Arabic, European (Greek-Roman-Christian)—developed alphabetic writing systems. These replaced earlier logographic systems. All of the alphabetic writing systems have a common origin—the "alphabet of alphabets"—the North Semitic Alphabet (Ugaritic alphabet). It was created around 1400 B.C. in the Syrian seaport of Ugarit through a metamorphosis of cuneiform characters.

6 Edoardo Fazzioli, *Chinese Calligraphy* (New York, 2005), p. 9.

7 Bruno Lewin, *Abriss der japanischen Grammatik* (Wiesbaden, 1975), p. 23; Kogen Mizuno, *The Beginnings of Buddhism* (Tokyo, 1980), p. 14.

A most interesting, but still unresearched phenomenon, is that the initial Chinese (Jiaguwen) written signs and the creation of this prototype of alphabetical scripts in the Near East emerged in approximately the same period as the Ugaritic alphabet. Could it be that, regardless of the great distances involved, there were contacts between these civilisations around 1400 B.C.? Or is this something entirely different, an instance of parallel development? The world's alphabetic and logographic writing systems are different in type and developed with different dynamics, but both surprise us seventeen centuries later, in the century when there was again a new universal period of writing derivations, expansion, and reform.

India

In western and northern India during the fourth century (320), the period of the Gupta Dynasty (golden age of India's Buddhist and Hindu cultures) began. This period witnessed a great flourishing of culture, and especially of writing and literature.[8] The Gupta alphabet, a new variant of the traditional Brahma script, was created. After a certain modernisation in later epochs up to the present day, this script is still the most popular one in India and is known as Devanagari script. The most vivid examples are the putting into writing of the Indian erotic epos *Kama Sutra*, and the ancient Indian *Mahabharata* and *Ramayana*. In central and southern India so-called box-headed script and Grantha script were created. The fourth century also saw the establishment of a new school of Buddhism, Vajrajana Buddhism (Tantric Buddhism, the Diamond Way), with its own script tradition, which introduced practices for faster attainment of enlightenment. Further, this is the period when the new Hindu religion (Hinduism) was created and codified; a new formulation of ancient faith traditions, and the Vedas (the ancient Indian sacred myths) were first recorded, which until then had been handed down from generation to generation by means of a unique oral mnemonic technique. Yoga, a practical system of physical and spiritual perfection which is now popular throughout the world, was also codified in this period time.[9]

The first "cave writings" (variations of Indian Grantha script) in Indonesia also date from the fourth century as well as the first inscriptions in the Champa language in Vietnam.

8 Julian Huxley, *Altertum und Mittelalter* (Klagenfurt, 1972), pp. 116–117.

9 Andreas Hilmer, Die Schüler des Siddharta. *GEO* 7 (2005): 39.

Persia

In the third and fourth centuries in Persia, the new ruling dynasty of the Sassanids undertook to codify the texts of the traditional religion of Zoroastrianism, which became the official religion. Its sacred book, the Zend-Avesta, was compiled in a new, Avestic alphabet. The Zend-Avesta consists of four parts: songs (Gathas), hymns (Jaschts), laws (Widewdat), and appeals (Wisprat). Also in the third and fourth centuries the Persian syncretistic dualist religion Manichaeanism (named after its founder Mani 216–277) spread to Central Asia, the Middle East, and Europe, and its sacred texts were written down in its own, Manichaean alphabet. Manichaeanism later influenced the medieval heresies of the Bogomils and Cathars in Europe.[10] Old Sogdian script, which was based on old Turkish runes, was also created in the fourth century.

Judea and the Middle East

The fourth century is the period in which radical changes in the script tradition of the Jewish people and culture take place: around the year 350 the Talmud—the compilation of Jewish oral law and rabbinical teachings in its Jerusalem version (Talmud Yerushalmi)—was edited and written down in book form.[11] The Nabateic script in the Middle East (Petra, today's Jordan) underwent a fundamental "modernisation" and became a proto-model for the later Arabic script.[12]

Europe and the Christian World

The fourth century is emblematic for the development of script cultures in Europe and the Christian world. Along with the Gothic alphabet of Wulfila, composed as a creative synthesis of Greek and Latin letters and Gothic runes, and the first longer textual inscription in the Gothic language and with Gothic runes on the Golden Ring of Pietroasa, (today in the National History Museum

10 Johannes Friedrich, *Geschichte der Schrift unter besonderer Berücksichtigung ihrer geistigen Entwicklung* (Heidelberg, 1966), p. 164.

11 Adin Steinsaltz, *The Talmud* (London, 1996), p. 37.

12 Carl Faulmann, *Schriftzeichen und Alphabete aller Zeiten und Völker* (Vienna, 1880), pp. 95–96.

of Romania),[13] only about fifty years later the great enlightener and missionary of the Armenian people Mesrob Mashtots (361–440) created three alphabets: the Armenian, the Georgian church script (Khucuri), and the alphabet of the Agavans (present-day Azerbaijan)[14]. The first two alphabets contributed to the Christianisation of the Armenian and Georgian peoples. The Armenian alphabet created by Mesrob Mashtots is still used today in Armenia.

In fourth-century Ireland the Celtic Ogham script[15] was created and developed (until the seventh century), a pagan writing system that was used not only in Ireland but also in Wales, Scotland, and the Isle of Man. This script expressed an archaic form of Gaelic and Pictish. The form of the signs was impressive: lines with notches on the left or right. Armenian, Georgian, and Ogham are "original" scripts;[16] they are not derivations from existing alphabets.

In the 330s Emperor Constantine the Great (280–337) began a major codification initiative in Constantinople for the Bible in which most of the biblical texts were collected and copied anew. A new style in Latin letters, so-called *Uncialis*, was developed at the same time. Ekphonetic notation for the Christian liturgies was introduced as well as individual "quiet reading", which partially replaced the reading aloud of the scriptures. In Greek and Coptic manuscripts decorated initial letters at the beginning of important texts are used for the first time, and the first illuminated books were produced. This is the beginning of Christian calligraphy.

According to historical sources, around the year 390 in the Roman province of Thrace (present-day Southern Bulgaria) Bishop Nicetas of Remesiana (335–414) translated the Bible into the language of the Thracians (of the tribe of Bessy), that is, he created a Thracian literary language. However, this translation has not survived and there is no written proof.[17]

It was also at the beginning of the fourth century that the first Christian monasteries in Egypt began to produce many manuscripts in the Coptic language—the Coptic alphabet had been created some time before. There were also new

13 Dorina Tomescu, Der Schatzfund von Pietroasa. in: *Goldhelm, Schwert und Silberschätze*, exhibition catalogue (Frankfurt am Main, 1994), p. 56. See also: Elisabeth Svärdström, Der Runenring von Pietroasa, ein à-propos, in: *Studia gothica*, ed. Ulf Erik Hagberg (Stockholm, 1972), pp. 117–119.

14 Александр Кондратов, *Книга о букве* (Moscow, 1975), p. 168.

15 Кирилла Королева, *(Ed.) История письма* (Moscow, 2003), pp. 367–368.

16 Harald Haarmann, *Geschichte der Schrift* (Munich, 2002), p. 116.

17 Klaus Gamber, *Die Liturgie der Goten und der Armenier* (Regensburg, 1988), p. 31.

Syrian translations of the Bible—Vetus Syra and the so-called Peschitta, with its own alphabet Estrangelo, as well as the Ge-ez Christian alphabet—the first truly original African writing system for the translation of the Bible into Ge-ez/Amharic in present-day Ethiopia.[18] For Goths, Armenians, Georgians, Egyptians, Syrians, and Ethiopians, as later for Bulgarians and other Slavic peoples, their own alphabet and their own literacy was an important factor in cultural genesis, and for their new Christian identity.

In the Christian world the fourth century was connected with changes in material media for the Bible manuscripts: the general transition from the roll (*volumen*) to the book (*codex*), from papyrus to parchment. On the order of Pope Damascus I (304–384) in 380 Christianity's earliest known library was created in the church of St. Lorenzo in Rome. From the end of the fourth to the beginning of the fifth, St. Jerome (Hieronymus, 347–420) created the *Vulgate*—a new translation of the Bible into the Latin which is still in use today.[19]

In addition to its use for religious purposes, the book turned out to be a very convenient form for compiling laws and in this way facilitated the development of jurisprudence in various empires and cultures; for example, in the fourth century the Katayayana, the compilation of Indian law, was compiled as well as the *Codex Hermogenianus*, an important collection of Roman law.

Interestingly, in the fourth century in present-day Mexico, the Maya culture flourished in the so-called classical period (4–9th century), and there was a new development of their own hieroglyphic form of writing (syllabic alphabet with ideographic component) and calendar.[20]

18 Pierre Du Bourguet, *Les coptes* (Paris, 1992), pp. 66–70. Svante Fisher, *Roman Imperialism and Runic Literacy* (Uppsala, 2005), p. 141. Christopher De Hamel, *Das Buch* (Berlin, 2002), p. 307.

19 De Hamel, *Das Buch*, p. 49. Steven Roger Fischer, *A History of Reading* (Wellington, 1998), p. 92.

20 Michael D. Coe, *Das Geheimnis der Mayaschrift* (Hamburg, 1996), pp. 4–13.

Intercultural Contacts between
Christianity and Buddhism

Over the course of script development there are indications of possible first contacts between Christianity and Buddhism in the fourth century; for example, the letter-symbol ħ [hti], which appears in Wulfilian Gothic Christian written records (*Codex Argenteus* and *Codex Ambrosianus*) and in Buddhist scripts as a letter/hieroglyph and a symbol.[21] In the Gothic and other European Christian cultures ħ, which Siegfried Zielinski has called "a virtual letter", is a letter, carrying phonetic value, and also a Christian symbol. It is also found in inscriptions as a symbol of the cross. Depending on the different versions of the grapheme of the letter—ħ or ħ—there are changes in the Christian symbolism. Sometimes the letter is similar to the inscription and symbolism of the Chinese hieroglyph ħ (Fang = square, direction, circle of life) and ħ (Ban, myriad, happiness, longevity)—a truly amazing fact.

This written similarity raises the question of intercultural communications and interactions between the civilisations in a new quality and new dimensions. It is in the fourth century that Christianity became an official religion of the Roman Empire (and the cross became an official Christian symbol, according to John Chrysostom (347–407),[22] one of the great theologians of the epoch), and Buddhism became the dominant religion in China.[23] The geographic expansion of these two religions led to contacts between them, mainly in the northern Black Sea region, the Balkans, and even Scandinavia,[24] where different peoples from Asia and Europe met and communicated. Such contacts were also observed along the Silk Road, especially in Dunhuang.[25] Christianity and Buddhism are religions of writing, of holy scriptures (like Judaism), and they largely replaced paganism and partially Hinduism, respectively. The pagan and Hindu religions are based mainly on the oral power of the priestly class.

21 Rossen Milev, Svetlana Lazarova, About a 'virtual' letter-symbol in the Gothic alphabet, in: *Gotite/Goterna*, ed. Rossen Milev (Sofia, 2006), p. 99–104.

22 Николай Марков, *Християнската символика* (Sofia, 2006), p. 11.

23 Derek Walters, *Chinese Mythology* (London, 1992), p. 28.

24 Axel Christophersen, Big chiefs and Buddhas in the heart of the Swedish homeland, in: *Thirteen Studies on Helgö*, ed. Agneta Lundström (Stockholm, 1988), pp. 51–59.

25 Thomas O. Höllmann, *Die Seidenstrasse* (Munich, 2004), p. 45.

Change of Paradigm
in Media History

About 1100 years before the invention of the printing press by Johannes Guten-
berg (ca. 1394–1468), in the fourth century there was a world-wide, global met-
amorphosis in the history of communication: a "world script revolution". To
date, this phenomenon remains unexplored in its totality and complexity. It is
an important stage in the development of human communication, from the cave
painting and first script systems to today's electronic mass media. In this period,
the book (*il codex*) became the dominant form of the written work in many cul-
tures, and is still a valid medium today, regardless of the changes in production
technologies that have been involved in its multiplication and dissemination over
the epochs.

From the point of view of media-historical studies, if we describe and analyse
this process we have the chance to discover "something new in the old" (to use
Siegfried Zielinski's expression[26]). To research this impressive parallelism, or
maybe this kind of global interrelation in an early stage of communication devel-
opment of different civilisations, is a new challenge for media history.

However, allow me to make one stipulation:

The cultural and communication development of different peoples, cultures,
and civilisations with all its parallelism and simultaneity in the fourth century is
not a sports contest, where the media historian stands as a referee with a chro-
nometer and notes whether the discoveries and innovations in different written
cultures fit exactly into the framework of the fourth century and where competi-
tors that leap slightly across its borders are out of the competition. Put different-
ly, I would just like to underline that some facts and events in different cultures
could precede or antedate the "astronomical" fourth century by some years (for
example, St. Jerome (Hieronymus) started his Latin translation of the Bible, the
Vulgate during the 380s of the fourth century and completed it at the beginning
of the fifth century. The period when the Armenian alphabet and the Armenian
translation of the Bible were created is similar; they were finally completed by
Mesrob in 410). More important is the fact that the process of changes in com-
munications took place almost simultaneously in many cultures across the entire
globe. We are talking of a period not exactly of 100 years, but of 120–130 years.

Undoubtedly the most interesting aspect of researching this phenomenon is
the question of the reasons why it happened. The sheer scale of the phenomenon

26 Siegfried Zielinski, *Deep Time of the Media* (Cambridge, MA, 2006), p. 3.

determines *a priori* the generalist approach, and also the high abstraction level in the interpretation of the initial source and reasons for this phenomenon—no matter how versatile the versions of an explanatory theory are. Put differently: the theme determines the type of methodology for its analysis.

A chain reaction of intercultural meta-communication and mutual influences? Equality of many peoples, races, cultures, and civilisations in their evolution? Early and spontaneous flow and order of world communications? A specific stage in development, in human evolution, reached at one and the same time almost everywhere in the culturally advanced world? A synchronous polygenesis of world writing systems? A global "democratisation of culture", "an age of spirituality"?[27] Also possible is an explanation of the phenomenon from the point of view of religious thinking: global divine will, a manifestation of the Holy Spirit for all? Various displays at the same time of a "world spirit", etc.? All these questions can actually be reduced to the quest for a general philosophical explanation of this human development. In other words: the analysis of the world script revolution in the fourth century demonstrates that media and communications history can actually touch upon and put questions concerning a general philosophical explanation of the world and of human civilisations.

Following the Tibetan Buddhist view, and also various ancient and modern European philosophies as well as the cultural anthropology approach, the history of humankind is in a certain way the history of human thinking, thoughts, notions, and ideas. In this theoretical and philosophical tradition, we can ask the question: Is the birth of so many analogous script phenomen in the fourth century around the globe perhaps the result of a series of similar thoughts and ideas of the elites and great spirits of an epoch that are independent of each other? Or cognitive transmission and exchange of brain waves? Is it perhaps a migration process, a copying and imitation of great ideas (*Ideenwanderung*) and innovations across cultures and continents?

The explanation of the spectacular analogies in the development of the written cultures of the world in the fourth century can only be a complex and interdis-

27 The term "democratisation of culture" as applied to the Late Roman, Christianised Empire was introduced by the Italian historian Santo Mazzarino in 1960 at the 11th International Congress of Historic Sciences in Stockholm: Santo Mazzarino, La democratizzazione della cultura nel "Basso Impero". In: *XI Congrès international des sciences historiques*, Rapports 2 Antiquité 1960, pp. 35–54, and became well known at an international congress in 2000 in Vercelli, Italy. The materials are published in the Paris review *Antiquitè Tardive*, 9 (2001). *Age of Spirituality* is the name of an exhibition on the art of Late Roman antiquity, organised in New York in 1977. Cf.: Kurt Weitzmann, ed., *Age of Spirituality*, Metropolitan Museum of Art (New York, 1977).

ciplinary one, and will include the answers, or rather the attempts at answers, to all these questions.

Let us not forget that similar analogies, although in more modest dimensions, can be found in recent and the most recent media history: For example, in 1895 simultaneously and independently of each other the Russian scientist Alexander Popov (1859–1906) and the Italian Guglielmo Marconi (1874–1937) made the first wireless transmissions of signals (the beginning of radio transmissions); in the same year, also independently of each other, the first film projections were made by the brothers Louis (1864–1948) and Auguste (1862–1954) Lumière in Paris and by Max Skladanovski (1863–1939) in Berlin (the beginning of cinema).

The world script revolution can be explained, at least partially, as a chain reaction of cultural interferences. The phenomenon of interference is described in physics as a mutual increase of the vibrations and effects of any kind of waves in their meeting and crossing, if they are of the same or similar frequency. Maximal increase can be observed if the waves also meet in the same phase. Following the laws of physics, interference is possible in all processes of wave character. If we assume that the world script revolution has a wave characteristic, what are the "frequencies" and what are the "phases"? "Frequencies" are perhaps similar efforts to create and/or perfect the writing systems of many peoples and cultures in the same period, which are in the same "phase" of their cultural development. Interference is also known in linguistics where it describes a kind of overlapping and influence of one language on a speaker or groups of speakers of another language in contact situations. Bearing in mind the interdependence between language and writing, we should not be afraid to formulate interference for the development of many writing systems in the fourth century, for example, by cultural contacts in the Roman world, or by clash, conflicts, and commercial and cultural exchange between empires and civilisations. However, in the case of the world script revolution, if we compare, for example, the development of the Maya culture in Central America on one hand with the expansion and reform of the Christian, Judean, Persian, and Indian writing systems on the other (between these civilisations of the two hemispheres at that time there were barely contacts, as far as the current state of knowledge is aware) we must ask ourselves the question: Is this a coincidence, a typological resemblance or some kind of unexplored parallelism at the same stage of human development? This question, of course, is open at this point in time and will require much additional serious interdisciplinary research. This also holds true in the concrete case—to what extent the world script revolution is a question of interferential influences and to what extent of typological similarities or another unexplored phenomenon of parallelism.

On the other hand, it is also productive to seek and consider small, ordinary explanations for some manifestations of this global phenomenon: The creation of new alphabets and writing systems, in the opinion of the French researcher Françoise Briquel-Chatonnet, is connected with the "affirmation of identities".[28] The new Christian alphabets and literacy in Late Antiquity are the reaction of peoples to Greek and Latin literacy who were in search of their own new identity, public display, and intellectual self-gratification. In most cases, the newly created alphabets integrated some written signs and symbols of older writing systems of these peoples—Wulfila, for example, integrated Gothic runes, the Copts ancient Egyptian letters, the Guptas in India parts of their Brahmin alphabet—the traditional was integrated into the new in order for it to be sustained and to survive in a new form. A phenomenon familiar to us from other periods of media and cultural development of humanity in general.

Impact and Importance
of the "World Script Revolution"

In the fourth century A.D., writing began to supplement oral speech in the most important sphere of social and cultural life of the period—religion. "By the close of the fourth century A.D. the written word's prestige overshadowed oral soothsaying and oracular pronouncements."[29] At the same time we should underline the fact that sacred books were used in liturgies and as the basis of oral homily, that is, the written word rather widened and enriched oral communication practices.

The global change to more writing and reading that gradually became established brought with it a new quality and new structure of human communication, an enlargement of the minds of the educated elites. Thanks to the new, expanded writing, humankind passed to a new stage in its social and intellectual evolution. This was also due to the personal achievements of numerous talented inventors: Wulfila, Mesrob, Hieronymus, Wang Xizhi, Wang Xianzhi, Kumarajira, and many other known and unknown intellectual revolutionaries. Most of these great people of the epoch were primarily priests and translators, and they were also multi-talented visionary personalities: polymaths, scholars, religious

28 Françoise Briquel-Chatonnet, Sur les traces d'un prince du Levant... *L'Express* 2873 (Paris 2006): 58–61.

29 Steven Roger Fischer, *A History of Reading* (Wellington, 1998), p. 86.

teachers, script reformers; bearers of intelligence, knowledge, wisdom, spirituality, and diligence. On a visit to Armenia for the Mesrob holiday, the Brazilian author Paulo Coelho called the work of the holy translators "the other side of the Tower of Babel" by association with the Biblical myth: "In response to the arrogant behaviour of the people, God destroyed the Tower of Babel and everyone started speaking a different language. But since His mercy is infinite, He also created a certain type of people who could again build the bridges, make possible the dialogue between people and the spread of human thought."[30] Very interesting and important yet still unresearched is the question as to what extent, at least among some of these intellectuals, for example, between Wulfila, Mesrob, and Jerome, did there exist contacts, a network, interactions?

It is evident from all these events that took place in the fourth century that the history of writing, of the script, although its evolution over the ages was long, it also had some very important revolutionary stages (e.g., Gutenberg's invention later) that catalyse and speed up its further development.

The reforms and expansion of writing in the fourth century is a reflection, but also a driving force, of an important social process: in this period, the world was a gigantic laboratory and scriptorium of faith, of social experiments, but also of the practical invention of new media materials and techniques (parchment in the Christian world, new type of ink in China, etc.).

The wide parallel polycentrism and synchronicity in the development of script in the fourth century looks unique, although it did create new possibilities for recording the memories and cultural identity of the peoples (along with its purely religious importance). We should not forget, however, that in the fourth century written communication all over the world was accessible only to the elites (religious and political). In contrast to the present day, global communication did not exist with its lingua franca and its own script (which today is the English language and the Latin alphabet), and that different civilisations lying far apart had practically no contact and no information about each other. Nevertheless, half of the alphabets used, transformed, or created in the fourth century continue to be used today, and the larger civilisations, although somewhat different and evolved, are approximately the same.

It does not matter that writing systems in the most developed cultures in different corners of the globe emerged at different times B.C., and exhibited different models of development and different dynamics of evolution. In the fourth century, almost simultaneously and symmetrically, radical changes and

30 Пауло Коельо, Другата страна на Вавилонската кула, *24 часа* (Sofia, 25.7.2005), p. 34.

modernisation occurred in the writing of all large civilisations around the world. Parallel to this development many peoples that lacked writing systems then created a script and attained literacy. This development, which spread practically all over the culturally advanced world, was not caused so much by some striving for perfection of the phoneme–grapheme relation and expressiveness of the writing systems, which is otherwise a major factor in their evolution. The driving forces of the mediamorphoses in the fourth century are rather the radical social and religious changes: the Great Migration of peoples (the Asian nomadic peoples reach and mix with the population not only of Europe but also of China), the beginning of the transition from slavery to feudalism in many countries, the expansion and adaptation to local conditions by the major religions, such as Buddhism, Christianity, Zoroastrianism, etc. In China, the modernisation of writing was connected with the widespread introduction in practice of a new media material—paper, invented as early as the second century, and of a new type of ink. Valid for this period to a great extent was the rule, formulated by the British researcher of alphabets D. Diringer in 1949, that "writing follows the religion",[31] and expanded by the Russian researcher I. Diakonov in the Russian edition of Diringer's book in 1963 with the specification that this rule is valid only for "historical epochs dominated by religions based on written dogmas", and more precisely, for the "age of feudal formations".[32]

This influence of religion over writing can be seen, for example, in the creation of ekphonetic musical notation script for recording Christian chants in the liturgies[33] in the fourth century in Constantinople, then the new capital of the Roman empire, and also in the beginning of individual quiet reading, instead of reading aloud, in the Christian world.[34]

The man of books acquired a new status and social role (he was often a translator, copyist, priest, writer, and reader, all in the same person): that of the intellectual of the Middle Ages. In spite of the fact that for some of the empires, namely the Roman and Chinese, the fourth century was a time of political and economic decline and crisis, it was the boom in writing that shows such periods of crisis can be productive for cultural development. Notwithstanding all specificities of the

31 David Diringer, *The Alphabet: A Key to the History of Mankind* (London, 1949), pp. 555 and 629.

32 Игорь Дьяконов О писмености. *Дирингер, Д. Алфавит* (Moscow, 1963), pp. 20 and 629.

33 Rossen Milev, *Europäische Medien- und Kommunikationsgeschichte in Daten und Fakten* (Graz, 2001), p. 39.

34 Hans H. Hiebel, Heinz Hiebler, Karl Kogler, Herwig Walitsch, *Die Medien* (Munich, 1998), p. 38.

various religious writing systems, such a simultaneity and also symmetry among the diversity in the world cannot be observed either earlier or later in the history of script culture. Only today, seventeen centuries later, can we can observe a similar phenomenon in the development of audiovisual media, of global electronic written communication via Internet, and also in the boom of print publications in different languages (a new book revolution).

Like any revolution the world script revolution was directly preceded and followed by events, in this case in written culture, that either presaged or continued the actual "revolutionary element". For example, in the second century in China paper was invented. Its gradual spread intensified in the third and fourth centuries, and it forced Chinese hieroglyphs to be reformed and modernised. Before the onset of the great series of inventing new Christian alphabets and translations of the Bible into these languages, in the third century in Egypt the Copts created a prototype first: the Coptic Christian alphabet.

The same holds true for the continuation of the revolution, as an evolution in writing over the next fifth and sixth centuries. This is quite evident all over the world; for example, soon after the Talmud was recorded in the fourth century, in the fifth century a system of vocalisation of Hebrew writing (a possibility for denoting the vowels was created using dots and for consonants using lines) was introduced. Also in the fifth century the new Syrian Christian Nestorian doctrine, with its own script and alphabet, spread from the Middle East through Central Asia and into China. In China in the fifth century, after the reform of writing, the compilation of phonetic dictionaries for the pronunciation of logograms/the words Jun-Fu began, constructed in correspondence with the sound and tone of the words. The general phonetic dictionary for northern China Tse-Jun[35] was completed in 601.

This list could continue. However, if we make a jump in chronology because of space limitations in this chapter, the second real revolution in script in Europe followed in the fifteenth century: the so-called printing revolution.[36] It began on the European continent and then spread all over the world. However, in spite of the deep social and cultural changes caused by book printing, initially it was not characterised by the same simultaneity and comprehensiveness as the world script revolution in the fourth century. The spread of printing to different cultures and regions of the world continued for hundreds of years. Moreover, in China, Korea, and Japan, printing had developed much earlier, in the eighth century.

35 Diringer, *The Alphabet*, p. 139.

36 Elizabeth Eisenstein, *The Printing Revolution in Early Modern Europe* (Cambridge, 1983), p. 7.

Without underestimating or forgetting the ancient history of world writing systems (Old European, Old Egyptian, Old Sumerian) let us acknowledge the fact that chronologically, the world script revolution divides into two approximately equal cycles of seventeen centuries: from the creation of the first phonetic alphabet, Ugaritic, and Chinese proto-hieroglyphs (Jiaguwen) created at approximately the same time in the fourteenth century B.C. to the third century A.D.; and from the revolution of the fourth century until the present day. Our era, in spite of the spread of audiovisual media and the Internet, is connected with a boom in of all kinds of books and publications on paper. Thus the French researcher Robert Escarpit back in 1965 correctly connected these facts with a new "book revolution" in a UNESCO publication.[37] He also presented a bold hypothesis: that the Russian (actually Bulgarian—Old Slav) word for book, *kniga*, is actually borrowed via the intermediation of some steppe Asian nations from the Chinese word *king*, where this word meant "classical book" and "silk thread"—the material media of Chinese books in that period.[38]

The world script revolution of the fourth century is actually the global introduction of the book as the dominant form for written records, and it is an impressive expression of the combination of science and art in the evolution of writing.

Regardless of the reasons for and roots of the world script revolution in the fourth century, from the point of view of modern analysis and generalisation this global process, in spite of the conflicts and unrest of these epochs, creates the impression of some kind of spontaneously emerging universal harmony in diversity, prosperity, and balance in the cultural development of all culturally advanced peoples of that time. In fact this is something that, in later epochs and up to the present day, avant-garde philosophers, rulers, public personalities, and groups have tried to construct as an idea and as praxis. Over the last, around 100 years, this is the main work of a number of international organisations. The realisation of this pursuit of harmony in diversity and prosperity remains one of the great challenges that humankind will face in the future as well.

Translated from Bulgarian by Svetlana Lazarova

This text is part of the author's preparation work for a World Script Museum and contains the following overview diagram:

37 Robert Escarpit, *La Révolution du livre* (Paris, 1965).

38 Escarpit, *La Révolution du livre*, p. 16.

New Writing Systems, Script Reforms, Codifications, and Records of the World in the Fourth Century A.D.

Empire, World Region, Contemporary Name	Religion	Writing Innovations and Inventors
EUROPE		
Celtic communities (Ireland, Wales, Scotland)	Paganism	Invention and initial stage of Ogham alphabet (Celtic)
Gothic Kingdom (Romania)	Paganism	First longer Gothic text with runes (Ring of Pietroasa)
Roman Empire (Bulgaria	Christianity	Creation by Bishop Wulfila (311–383) of the Gothic Christian alphabet and Gothic translation of the Bible
Roman Empire (Bulgaria)	Christianity	Translation of the Bible into the Thracian (Bessian) language by Nicetas of Remesiana
Armenian Kingdom (Armenia, Georgia, and Azerbaijan)	Christianity	Creation of Armenian, Georgian (Khucuri), and Agavanian Christian alphabets by Mesrob Mashtots (361–440)
Roman Empire (central, south European and Mediterranean countries)	Christianity	Codification politics and practice for new, canonical, selected record of the Bible by order of Emperor Constantine the Great (280–337) in Constantinople; Parchment becomes the main material medium for Christian writings; the roll (*il volumen*) is replaced by the book (*il codex*);

		Codification of Roman law in *Codex Hermogenianus*; Creation of *Uncialis* new style (Bible style) for the Latin letters in Christian and other scripts; Beginning of Christian calligraphy (art of penmanship): first painting of initial letters in Greek (*Codex Sinaiticus* and *Codex Vaticanus*) and Coptic manuscripts; first illuminated Christian books (*Vergilius Romanus*, *Vergilius Vaticanus*, etc.); Creation of the ekphonetic musical notation script for the record of Christian chants in the liturgy; Beginning of individual "quiet reading", which partially replaces reading aloud
MIDDLE EAST		
Roman empire (Israel)	Christianity	New translation of the Bible into Latin, *The Vulgate*, created by St. Jerome (Hieronymus) (347–420), still used today; First "media criticism": St. Jerome (Hieronymus) criticises the creation of luxury Bibles (written with golden and silver ink on purple parchment) as not corresponding to Christian modesty.

Roman Empire (Israel)	Judaism	Codification, record of Jerusalem Talmud (compilation of Jewish oral law and rabbinical teachings)
Roman Empire and nomadic communities (Jordan and Egypt)	Paganism	Creation of the proto-Arabic script on the basis of Nabateic and Proto-Sinaic (inscriptions of Namar)
Roman Empire (Syria and Lebanon)	Christianity	New Aramaic version of the Bible
Roman Empire (Syria)	Christianity	Two translation of the Bible into Syrian: *Vetus Syra* and *Peschitta*, new Syrian Christian alphabet Estrangelo
AFRICA		
Roman Empire (Egypt)	Christianity	Access to the writings of the sacred texts in the Coptic language and Coptic alphabet in the world's first Christian monasteries
Aksumerian Kingdom (Ethiopia)	Christianity	Translation of the Bible into the Ge-ez/Amharic language with its own alphabet
ASIA		
Sassanid Persian Empire (Iran)		Codification of the reformed Zoroastrian sacred texts in a new sacred book; *Zend-Avesta* with Avestic alphabet, founding of the college of Gundishapur, a famous centre of learning

Sassanid Persian Empire (Iran)		Access to the sacred texts of the dualistic religion of Mani (216–277) in its own alphabet in Central Asia and in the Roman Empire
Central Asia (Turkmenistan and Uzbekistan)	Paganism Zoroastrianism	Creation of the old Sogdian runic script (basis of old Turk runic script)
Gupta Empire (India)	Hinduism Buddhism	First record of the Vedas, the sacred books of Hinduism; Gupta literature with its own Gupta alphabet; First records of the erotic epos *Kama Sutra*, new records of the *Ramayana* and *Mahabharata*, literary renewal of Sanskrit; Codification of Yoga philosophy and practice; Codification of Vajrajana Buddhism; Codification of laws, Katayayana
Central and southern Indian kingdoms (India)	Hinduism Buddhism	Central Indian alphabet, 'box-headed script'; Southern Indian syllabic alphabet and literature Grantha; Alphabet of the Kingdom of Kadamba

Eastern Jin Dynasty Empire (China)	Daoism Buddhism	Reform of the Chinese writing by Wang Xizhi (303–361) and his son Wang Xianzhi (344–386); Introduction of KYAI, the 'right writing'; Widespread use of paper and a new type of ink, introduction of seal printing for copying of Daoistic magic spells, the great translator Kumarajira (334–413) translates Buddhist texts from Sanskrit into the Chinese language
Yamato Kingdom (Japan)	Shintoism Buddhism	First contacts with writing via Buddhism and Chinese culture
Paekche, Koguryo and Silla Kingdoms (Korea)	Buddhism	First contacts with writing via contacts with China, historical chronicles as first written works in the Kingdoms of Paekche and Koguryo
(Indonesia)	Hinduism Buddhism	Indonesian 'cave writing' (variation of Indian Grantha)
(Vietnam)	Buddhism	First inscription in Champa language and in a reformed Brahmin script
AMERICAS		
Maya Empire (Mexico)	Shamanism	Beginning of the Classical Maya culture with development of its own hieroglyphic script (syllabic alphabet with ideographic components)

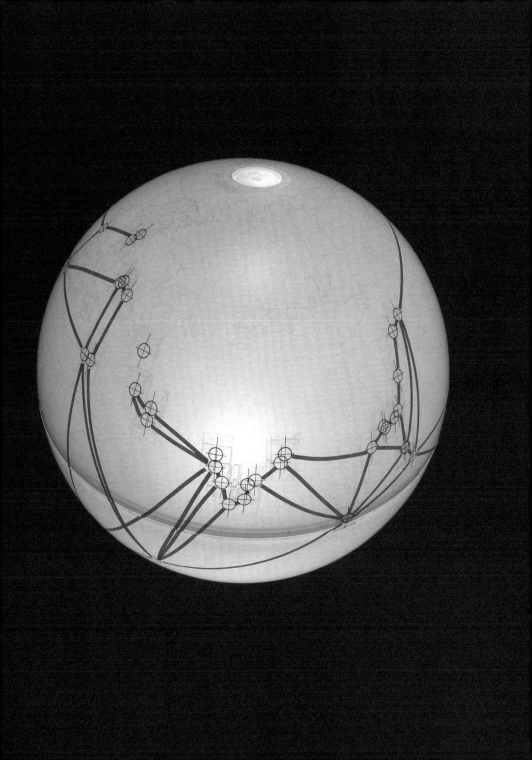

Worldprocessor [#245]

The Authors and Editors

Arianna Borrelli was born in Rome, Italy. After taking a degree in physics at Rome University (1988), she did research in theoretical high energy physics in Italy, England, and Switzerland. She then went on to study philosophy and history at the Technical University of Braunschweig (Germany), taking an MA in philosophy (2002) and a PhD in the history of science and technology (2006) with a thesis on medieval mathematical natural philosophy. In 2005, she was granted a two-year post-doc fellowship at the Max Planck Institute (MPI) for the History of Science (Berlin) for a project on heat, cold, and their degree of temperature. At present, she is post-doc fellow at the Fritz Haber Institute (FHI) of the Max Planck Society (Berlin), participating in a joint project of the FHI and MPI on the history of quantum mechanics. She is currently finishing a book on astrolabes and mathematical communication in high Medieval Latin Europe, to be published in 2008.

Francesca Bray is Professor of Social Anthropology at the University of Edinburgh. She was trained in Chinese studies and social anthropology at the University of Cambridge. On completing her BA she began work as a researcher at the East Asian History of Science Library (now the Needham Research Institute) at Cambridge, where she authored the volume on *Agriculture* in Joseph Needham's series *Science and Civilisation in China* (Volume VI, Part 2, Cambridge University Press, 1984). She spent several years at the Centre National de la Recherche Scientifique in Paris, and then taught for nearly twenty years at the University of California, first UCLA then UC Santa Barbara, before moving to Edinburgh in 2005. Her research focuses on the macro- and micro-politics of science, technology, and medicine, and on the politics of writing on these themes. She is especially interested in comparative approaches that offer alternatives to Eurocentric accounts of science and technology. She has published books like *Technology and Gender: Fabrics of Power in Late Imperial China.* (California University Press, 1997) or *The Rice Economies: Technology and Development in Asian Societies.* Blackwell, 1986), and subjects like critical history of science in China, public reactions to genetically modified crops in the USA and Europe, medicine and modernity in the People's Republic of China, and technologies of everyday life in California, including the flush toilet. *Graphics and Text in the Production of Technical Knowledge in China: The Warp and the Weft*, co-edited with Vera Dorofeeva-Lichtmann and Georges Métailié, was published by Brill in 2007.

Chen (Joseph) Cheng-Yih, born in Nanjing, China, received his PhD in Physical Chemistry from Notre Dame University in 1961. He did research at the Brookhaven National Laboratory and was elected as a fellow of the American Physical Society in 1965. In 1966, he joined University of California at San Diego as Professor of Physics. His research interest has been in atomic and molecular physics. He did pioneer work in vibrational excitations of molecules and in applying the Faddeev Equations to three-body atomic systems. He has been a visiting lecturer at Manchester University, England, a JILA Visiting Fellow at Joint Institute for Laboratory Astrophysics, a Nordita Visiting Professor at the Oslo University and the Nordisk Institute for Teoretisk Atomfysik, an OAS Visiting Scientist for the Multinational Project on Physics at the Centro Atomico Bariloche, Argentina. Chen's other research interest includes the history and philosophy of science. He is the editor of the Wei-Kung 為公 book series on the History of Science and Technology in East Asia and a faculty member of the UCSD Program in Chinese Studies. He was the 1988 Foundation Lecturer of the East Asian History of Science Foundation, Hong Kong. He was the Chairman of the International Conference on the History of Science in China (5th, 1988, San Diego, USA; 9th, 2001, Hong Kong), and the Vice Chairman of the International Conference on the History of Science and Technology of the Chinese Minorities held in China (1990, 1994). He served on the International Advisory Board for the International Conference on the History of Science in East Asia, ICHSEA (1993, Kyoto, Japan; 1996, Seoul, Korea; 1999, Singapore; 2007, Nanning, China); for the International Conference on the History of Science in China, ICHSC (1996, Shenzhen, China; 1998, Berlin, Germany), and on the Board of Directors for the International Colloquium on Mathematics (1998, Wuhan, China).

Dai Nianzu was born in Fujian Province, China. After graduating from the Department of Physics, Xiamen University in 1964, he worked at the Institute of History of Natural Science, Chinese Academy of Science (CAS) in Beijing; he became Research Professor in 1986. He was the director of the Department of the History of Physics and Chemistry of the Institute from 1986 to 1998 and the chairman of the History of Physics Committee, and the History of Science and Technology Society from 1989 to 1998. Since 2003 he is Lecture Professor of Beijing Capital Normal University. He is also vice-chief editor of Physics of the Chinese Encyclopaedia. Dai Nianzu has published more than ten books (e.g., A *History of Mechanics in Ancient China*, Shijiazhuang, 1988) and hundreds of articles on the history of science and technology. Dai also is the leading historian of Einstein's impact on China (e.g., "Einstein in China: On Einstein's

two trips via Shanghai during 1922 and 1923 and the impact of His Theory of Relativity in China", in *Commemoration on the Translated Collection of Einstein*, ed. Zhao Zhongli and Liangying Xu, Shanghai Science and Technology Press, 1979). He was awarded the CAS Honour for the expert with outstanding contributions in 1978 and 1996, and has received the CAS Natural Science Award many times.

Mareile Flitsch studied anthropology, sinology, and Chinese folklore at Münster, Paris, Shenyang/PR China, and in Berlin at the Freie Universität (FU) with Erling von Mende. MA thesis in Paris in Chinese anthropology, PhD at FU Berlin on the local cult of Ginseng seeking in Changbai mountain area, northeast China (1990). Assistant at FU Berlin on the research project "Liaoning province peasant everyday material culture" (1990–1994). Postdoctoral dissertation on the material culture of vernacular architecture and especially the heated brick platform *kang* in north and northeast China. Specialising in Chinese anthropology of technology with the Volkswagen Foundation-funded research project "History and Anthropology of Chinese Everyday Technologies" at the Technische Universität (TU) Berlin (2002–2005). Since 2005 head of the Study Group History and Philosophy of Chinese Science and Technology at the TU Berlin. Since 2004 steering committee member of the European Science Foundation programme EARTH. Extensive fieldwork in northeast, north, and northwest China. Publications and lectures on Chinese anthropology, everyday technologies, everyday knowledge, popular art and embodying knowledge, de-skilling and socio-technical change in China.

Eckhard Fürlus, born in Jever, Friesland. Studied philosophy and theology in Berlin at the Freie Universität, Technische Universität, and Kirchliche Hochschule (Divinity School). MA thesis in ecclesiastical history on *Sol invictus*. Assistant at the Staatliche Museen Preußischer Kulturbesitz SMPK; Deutscher Akademischer Austauschdienst DAAD; Akademie der Künste; and Landesmuseum Berlinische Galerie. 1993–2001 research assistant at the Berlinische Galerie for the archives of the estate of the artist Hannah Höch. Since 2001 editor of the online magazine *Tuxamoon*. Publications and lectures on fine arts, music, and literature. In 2006 artistic and scholarly research assistant at the Academy of Media Arts Cologne for archaeology and variantology of the media; since 2007 research assistant at the Berlin University of the Arts (UdK), Institute for Time Based Media.

Ramon Guardans graduated in biology from the University of Barcelona in 1974, worked from 1975 to 1977 in the Department of Applied Mathematics at the Weizmann Institute of Science, Rehovot (Israel), worked from 1978 to 1983 in the Chemical Physics Department of the Free University of Brussels (Belgium) collaborating with R. Margalef, I. Prigogine, K. Chemla, and F. Bray, amongst others. From 1983 to 1987 he worked at the Environmental Protection Service of the Catalan Regional Government in Barcelona; from 1987 to 2000 in the research group on Ecotoxicology of Air Pollution at the Research Centre for Energy, Environment and Technology (CIEMAT) in Madrid. From 1990 he has participated as Spanish delegate in the work of the UN under the 1979 Convention on Long-range Transboundary Transport of Air Pollution (LR-TAP); from 1993 to 2001 he served as Vice President of the Working Group on Effects, and as a member of the Implementation Committee in LRTAP. From 1997 to 2000 he was a member of the UN Joint Group of Experts on the Scientific Aspects of Marine Environmental Protection (GESAMP). In 2004 he was guest professor at the Interdisciplinary Centre on Cognitive Studies at Potsdam University, from 2004–2006 he worked on the development of the National Implementation Plan of the UN Stockholm Convention on Persistent Toxic Pollutants. Since 1977 Guardans has collaborated with electronic music and performing artists, including Etat Brut, La Fura Dels Baus, and The Electroacoustic and Computer Music Laboratory (EMEC) of the Instituto Superior de Arte (ISA) in Havana. He also worked in Medialab Madrid, including on the project Algorithmic Echolocation, developed with ZKM Karlsruhe and presented at SONAR2005 and Ars Electronica 2005.

Ingo Günther studied ethnology and cultural anthropology at Frankfurt University; 1978 Kunstakademie Düsseldorf (Prof. Schwegler, Prof. Uecker), MA 1983 (with Nam June Paik); in the same year, residency at P.S.1 in New York. Günther's sculptural works with video led him towards more journalistically oriented projects which he pursued in TV, print, and the art field. Since 1988, Günther has used globes as a medium for his artistic and journalistic interests (World Processor). In 1989, he founded the first independent TV station in Eastern Europe—Channel X, Leipzig, East Germany. Travels to refugee camps around the world became the foundation for Günther's Refugee Republic, a concept he has been working on since then. From 1990 to 1994, Professor at the Academy of Media Arts in Cologne; from 2001 to 2003 at the University for Media, Art, and Design in Zurich; 2006–2007 Visiting Professor at the Tokyo National University for Fine Arts and Music. Awards: 1988 Art Award Glockengasse (Cologne) and award of the BDI; 1996 Stankowski Award; 1997,

ZKM/Siemens Media Arts Award; World Economic Forum, Davos, 2000; Any Conference 1992 and 2000, Guggenheim Museum, New York; 2003 Sprengel Award, Hanover. Publications include: *Worldprocessor*, Chia-yi, ROC, 2005; *REPUBLIK.COM*, Stuttgart: Cantz, 1998; *Worldprocessor*, Tokyo: Shogakukan, 1991 (for more see: www.republik.com).

Rossen Milev is a Bulgarian historian of media and communications. He graduated in German studies at the Humboldt University of Berlin in 1985; PhD at Salzburg University in 1993. He was guest lecturer in European media and communications history at the Technical University Berlin (1995–1998), at Vienna University (1999–2002) and Zurich University (2001). In 1990 in Sofia, Bulgaria, he co-founded the BALKANMEDIA Association—the first international, independent, non-governmental Balkan organisation for media and cultural studies—and has been its President since then. Author of books and studies in various European languages, including *Media and Intercultural Communication in Europe* (Council of Europe, Strasbourg 2000), *Europäische Medien- und Kommunikationsgeschichte* (Blimp Verlag, Graz 2001), *Wulfila, the Goths, Europe* (Balkanmedia, Sofia, 2004). He is editor of the joint Bulgarian-Swedish publication on Gothic cultural history in Europe *GOTITE/GOTERNA* (Sofia 2006). He was research fellow of the Alexander von Humboldt Foundation in 1998 and in 2006 also of the Tercentenary Jubilee Foundation of the Swedish National Bank.

Nadine Minkwitz studied Mandarin at the Beijing Second Foreign Language Institute and artistic photography at the Academy of Arts and the Media Cologne (KHM) where she graduated in 2004. In addition to her work as an artist, her special interest is the relation between cultural studies, philosophy, and language. Since 2007 she has worked as a research assistant in the field of archaeology/variantology of the media at the University of Arts, Berlin.

Anthony Moore, born in London, composer, media artist, and professor at the Academy of Arts and the Media Cologne in the Department of Art and Media Studies where he works on the theory and history of sound. Numerous music pieces, songs, sound installations, and film compositions, which have received international prizes; 1972 founder of the band "Slapp Happy"; co-writer with the music group "Pink Floyd" during the recording of two albums working on concepts, sounds and lyrics; composer of the television opera "Camera", a commissioned work from Channel 4; Polygram recorded three albums of his work, "Pieces from the Cloudland Ballroom", "Secrets of the Blue Bag", and "Reed,

Whistle & Sticks", for voices, strings, woodwind, and percussion. 2000–2004 he was elected Principal of the Academy in Cologne. Initiator and art director of sound events, "per->SON". Besides lecturing he continues to write and compose. Moore lives in Arles (France).

Dhruv Raina is a faculty member at the School of Social Sciences, Jawaharlal Nehru University, New Delhi. His areas of research interest include the social history of science with special reference to modern South Asia, the historiography of sciences and particularly of mathematics, and the new social movements of science. With S. Irfan Habib he has co-edited books on the social history and historiography of sciences. Additionally, he has authored *Images and Contexts. The Historiography of Science and Modernity in India* (Oxford University Press, 2003), and co-authored *Domesticating Modern Science* (Tulika, 2004). He is currently working on the changing representations of non-European mathematics in the disciplinary histories of science.

Nils Röller, media theorist, 2003 lecturer on media and cultural theory, New Media Section, University of Applied Sciences and Arts Zurich; 1994–1999 assistant at the Academy of Arts and the Media Cologne, collaboration on conception and organisation of the *Digitale* festival with S. Zielinski; 2000 PhD dissertation on Hermann Weyl and Ernst Cassirer at the Bauhaus University, Weimar. Selected Publications: *Migranten: Jabès, Nono, Cacciar* (1995). *Medientheorie im epistemischen Übergang: Hermann Weyls Philosophie der Mathematik und Naturwissenschaft und Ernst Cassirers Philosophie der symbolischen Formen* (2002), *Absolute Flusser* (co-author and co-editor Silvia Wagnermaier) 2003, *Ahabs Steuer: Navigationen zwischen Kunst und Naturwissenschaft* (2005), Elektronische Blindheit, in: *ZappingZone*, ed. G.J. Lischka, Bern: Benteli, 2007 (www.roman-form.ch).

Dagmar Schäfer is Head of the Junior Research Group on Chinese Technology, 15th–19th Century, at the Max Planck Institute for the History of Science in Berlin. A native German speaker, she studied modern Chinese at the University of Würzburg and in China where she developed her interest in classical Chinese literature and history. Since receiving her PhD in sinology, japanology, and politics she has published numerous articles and books on the history of technology in China.

Claudia Schink, born 1960, philosopher and artist, MA in philosophy, masters exam in the free arts, post-graduate diploma of art and media in Cologne, PhD at the Humboldt University of Berlin; since 1987 international exhibitions of artworks. Selected publications: *Das Abendland (The Occident). The Legend. A literary project*, Cologne 1995; *Die Lehre der Architektur II, Scripts 1990–1999*, Cologne 2001; *Das Christentum. From the project "Das Abendland"* (catalogue), Cologne, 2002; *De Possest. From the project "Das Abendland"* (catalogue), Cologne 2004. Gallery representative: Aurel Scheibler, Berlin (www.aurelscheibler.de).

Simon Werrett has been Assistant Professor of History in the Department of History at the University of Washington in Seattle since 2002, after completing his PhD at Cambridge University. His research considers the history of the physical sciences as they relate to the arts, theatre, and performance, with a focus on Russia, Britain, and France. He has recently completed a manuscript *Philosophical Fireworks: Science, Art, and Pyrotechnics in Early Modern Europe*, currently under review. Werrett has been the recipient of awards from the Getty Research Institute in Los Angeles, and the Max Planck Institute for the History of Science in Berlin.

Xu Fei is Professor and chairman of the Department of Philosophy of Science at the University of Science and Technology of China (USTC). He graduated from USTC: Bachelor of geophysics (1983), Master of philosophy of science (1988), Doctor of history of science (1996). He was a Visiting Fellow (1997–1998) and Visiting Scholar (2002) at Harvard University and Visiting Professor at the Needham Research Institute in Cambridge (2005). He has published numerous books, essays and articles with focus on history and sociology of science as well as computer science. One of his major fields is the history of acoustics in ancient China, specifically on the subjects of pitch-pipe and musical archaeology. His current research interests include: history of science in ancient China, science and technology studies.

Siegfried Zielinski holds the chair for media theory: archaeology and variantology of the media at the Berlin University of Arts. He finished his dissertation on the history of the audiovisual time machine the videorecorder in 1984, and gave his inaugural lecture as a professor on high-definition television in 1989, both at the Technische Universität Berlin. From 1990–1993 he was professor for audiovisual studies at the University of Salzburg, where he developed the teaching and research department "Audiovisions". From 1994–2000

he was Founding Rector of the Academy of Arts and the Media in Cologne, and held its chair for media and communication studies (1993–2006). At the European Graduate School in Saas Fee he is the Michel Foucault Professor of media archaeology and techno-culture. He has published numerous books and essays focusing on the archaeology of the media. His most recent monograph in English is *Deep Time of the Media* (Cambridge MA, 2006), which also has been published in Chinese (Beijing, 2006) and Portuguese (Sao Paulo, 2006). In 2004 he founded the research unit *Variantology* which includes the publication of a five-volume book series under the same title. Zielinski is a member of the Academy of Arts Berlin-Brandenburg, the European Film Academy, and the Magic Lantern Society of Great Britain.

Bibliography

Acosta, Joseph de, *Historia natural y moral de las Indias* [1590], 2 vols. (Madrid: Ramón Anglés, 1894).

Aczel, Amir D., *The Riddle of the Compass. The Invention That Changed the World* (New York: Harcourt, 2001).

Adas, Michael, *Machines as the Measure of Men. Science, Technology, and Ideologies of Western Dominance* (New Delhi: Oxford University Press, 1990).

Adicke, Erich, *Kant als Naturforscher* (Berlin: de Gruyter, 1924–1925).

Adler, Joseph A., Response and responsibility: Chou Tun-i and Confucian resources for environmental ethics, in: *Confucianism and Ecology (The Interrelation of Heaven, Earth, and Humans)*, ed. Mary Evelyn Tucker and John Berthrong (Cambridge, MA: Harvard University Press, 1998), pp. 123–149.

Agrippa von Nettesheim, Henricus Cornelius, *De occulta philosophia libri tres* (Cologne: Johannes Soter, 1533).

Agrippa, Camillo, *Dialogo sopra la generatione de venti, baleni, tuoni, fulgori, fiumi, laghi, valli et montagne* (Rome: Bartolomeo Bonfadino & Tito Diani, 1584).

Albertus Magnus, *Opera omnia*, vol. 6, part 1. Meteora, ed. Paul Hossefeld (Münster: Aschendorff, 2003).

Alcamo, Joseph, Petra Mayerhofer, Ramon Guardans et al., An integrated assessment of regional air pollution and climate change in Europe. Findings of the AIR-CLIM Project. *Environmental Science & Policy* 5 (2002): 257–272.

Alekseeva, M.A., Yu.A. Vinogradov, Yu.A. Piatnitskii, and B.V. Levshin, eds., *Gravirovalnaia palata Akademii nauk XVIII veka: sbornik dokumentov* (Leningrad: Nauka, 1985).

Amaladass, Anand, *Jesuit Presence in Indian History* (Anand: Gujarat Sahitya Prakash, 1988).

Anaxagoras, Fragmente. Über die Natur, in: *Die Fragmente der Vorsokratiker*, Greek and German by Hermann Diels, 4th edition, vol. 1 (Berlin: Weidmannsche Buchhandlung, 1922), pp. 399–408.

Anaxagoras, Fragments and Commentary, in: *The First Philosophers of Greece*, ed. and trans. Arthur Fairbanks (London: K. Paul, Trench, Trubner, 1898), pp. 235–262.

Anonymous, *Apocryphal Treatise on the Spring and Autumn Annals. Investigation of the Strange and Extreme Penetration* 春秋纬考异邮 (Han Dynasty).

Anon., Crackers for the Fourth. *Massachusetts Ploughman and New England Journal of Agriculture* 58 (1899): 4.

Anon., *Disposition of the fireworks, ordered by the Honourable Artillery Company, to be displayed in the Artillery-Ground, on Tuesday night, August 12, 1783, on his Royal Highness George Prince of Wales, Captain-General of the Company, coming of age* (London, 1783).

Anon., Grand National Jubilee on the First of August, 1814. *Belle Assemblée, or Court and Fashionable Magazine* (September 1814): 88–95.

Anon. [Handbill], *Mr. Flockton's Theatre. At the* [hand-written White Lyen Highgate] *in this town. This present evening, will be exhibited His Grand Exhibition, in the same Manner as Performed before the Royal Family and most of the Nobility in the Kingdom.* (London, ca. 1780).

Anon. [Handbill], *Ranelagh. On Friday next, May 4, 1798, will be exhibited a grand fire-work. By Signors Rossi and Tessier. Order of firing* […] (London, 1798).

Anon., *San Fu Huang Tu* 三辅黄图, edition in the *Sikuquanshu*.

Anon., *The Nine-Heaven Mysterious Girl Blue-Bag Sea Angle Manual* 九天玄女青囊海角经, in: *Master Kuan's Geomantic Instructor, The Chapter of the Explained Middle*.

Ansari, S.M.Razaullah, Introduction of Modern Western Astronomy in India during 18–19 Centuries, in: *History of Indian Astronomy*, ed. S.N. Sen and K.S. Shukla (New Delhi: Indian National Science Academy, 1985), pp. 363–402.

Appier, Jean, dit Hanzelet, *La pyrotechnie de Hanzelet Lorrain où sont représentés les plus rares* [...] *secrets des machines et des feux artificiels propres pour assieger* [...] *toutes places* (Pont-à-Mousson, 1630).

Arbuckle, Gary, Inevitable treason: Dong Zhongshu theory of historical cycles and early attempts to invalidate the Han Mandate. *Journal of Asian and Oriental Society* 115 [4] (1995): 585–97.

Archimedes, *Archimedis Opera omnia cum commentariis Eutocii* (3 vols.), ed. J(ohan) L(udvig) Heiberg, (Leipzig, 1910–1915, reprint Stuttgart: Teubner, 1972).

Archimedes, Arenarius, in: *Archimedis Opera omnia cum commentariis Eutocii*, op. cit., vol. 2.

Aristoteles, *Metaphysik. Schriften zur Ersten Philosophie*, ed. Franz F. Schwarz (Stuttgart: Reclam, 1984).

Aristotle, *Meteorologica*, trans. Henry Desmond Pritchard Lee (Cambridge, MA: Harvard University Press, 1987).

Aristotle, *Problemata physica*, trans. Hellmut Flashar, in: Aristoteles, *Werke*, vol. 19 (Darmstadt: Wissenschaftliche Buchgesellschaft, 1975).

Arnigio, Bartolomeo, *Meteoria* (Brescia: Francesco Pietro Maria de Marchetti, 1568).

Arom, Simha, Marc Augé, Serge Bahuchet et al., *La science sauvage. Des savoir populaires aux ethnosciences* (Paris: Le Seuil, 1993).

Ascher, Marcia, *Mathématiques d'ailleurs. Nombres, formes et jeux dans les sociétés traditionnelles* (Paris: Le Seuil, 1998).

Babbage, Charles, *The Ninth Bridgewater Treaties*. http://www.victorianweb.org/science/science_texts/bridgewater/b9.htm.

Bächtold-Stäubli, Hanns, ed., *Handwörterbuch des deutschen Aberglaubens*, 10 vols. (Berlin: de Gruyter, 2000).

Bacon, Francis, *Historia ventorum*, in: F. Bacon, *Works*, ed. James Spedding, Robert Leslie Ellis, and Douglas Denan Heath, vol. 2 (London: Longman, 1859), pp. 13–78.

Bacon, F., *Neu-Atlantis* (Stuttgart: Reclam, 1982).

Bacon, F., *New Atlantis*. http://www.constitution.org/bacon/new_atlantis.htm.

Bacon, F., *The New Organon* [1620], trans. Graham Rees with Maria Wakely (Oxford: Clarendon Press, 2004).

Bacon, Roger, *Opera quaedam hactenus inedita*, ed. J[ohn] S[herren] Brewer (London, 1859; New York: Kraus Reprint, 1965).

Bacon, R., *The Opus Maius of Roger Bacon*, trans. Robert Belle Burke, 2 vols., [1928] (Bristol: Thoemmes Press, 2000).

Bailly, Jean-Sylvain, *Histoire de l'astronomie ancienne depuis son origine jusqu'à l'établissement de l'école d'Alexandrie* (Paris: Frères Delire, 1775).

Bailly, J.-S., *Traité de l'astronomie indienne et Orientale* (Paris: Debure, Librairie de la Bibliothèque du Roi et de l'Académie des Inscriptions et Belles Lettres, 1787).

Balbiani, Laura, *La 'magia naturalis' di Giovan Battista Della Porta. Lingua, cultura e scienza in Europa all'inizio dell'età moderna* (Bern: Peter Lang, 2001).

Ball, Terence, *Transforming Political Discourse: Political Theory and Critical Conceptual History* (Oxford: Blackwell, 1988).

Balmer, Heinz, *Beiträge zur Geschichte der Erkenntnis des Erdmagnetismus* (Aarau: H.R. Sauerländer, 1956).

Bamboat, Zenobia, *Les Voyageurs Français aux Indes aux XVIIᵉ et XVIIIᵉ Siècles* (Paris: Jouve & Cie., 1933).

Ban Gu, *Han Shu* 汉书, in: *Records of Five Elements*, vol. 96 (Beijing: Zhonghua Publishing House, 1962).

Ban Gu, *Qianhan Shu* 前汉书 [History of the Former Han Dynasty] (82 A.D.).

Barker, Peter, Stoic contributions to early modern science, in: *Atoms, "pneuma" and Tranquillity. Epicurean and Stoic Themes in European Thought*, ed. Margaret J. Osler (Cambridge: Cambridge University Press, 1991), pp. 135–154.

Barrow, John, ed., *Some Account of the Public Life, and a Selection from the Unpublished Writings, of the Earl of Macartney*, 2 vols. (London, 1807).

Barry, Fabio, Lux and Lumen. The Symbolism of Real and Represented Light in the Baroque Dome. *kritische berichte* 4 (Marburg, 2002): 22–37.

Basalla, George, ed., *The Rise of Modern Science. Internal or External Factors* (Lexington, MA.: D.C. Heath, 1968).

Baudry, Jean-Louis, Effets idéologiques produit par l'appareil de base. *Cinéthique* 7/8 (1970): 1–8.

Baudry, J.-L., Le dispositif: approches métapsychologiques de l'impression de réalité. *Communications*. Special issue *Psychanalyse et cinéma*, ed. École des Hautes Études en Sciences Sociales—Centre d'Études Transdisciplinaires 23 (1975): 56–72.

Beer, Wilhelm, and Johann Heinrich Mädler, *Der Mond nach seinen kosmischen und individuellen Verhältnissen oder allgemeine vergleichende Selenographie. Mit besonderer Beziehung auf die von den Verfassern herausgegebene Mappa Selenographica* (Berlin: Simon Schropp, 1837).

Benedetti, Giovanni Battista, *Diversarum speculationum mathematicarum et physicarum liber* (Turin: Heir of Nicola Bevilacqua, 1585).

Bergson, Henri, *An Introduction to Metaphysics*. Authorised translation by T.E. Hulme (London: Macmillan, 1913).

Bernard, H., Un correspondant de Bernard de Jussieu en Chine. Le Père Le Chéron d'Incarville, missionnaire français de Pékin. *Archives Internationales d'Histoire des Sciences* 6 (1949): 333–362 and 692–717.

Biés, Jean, *Littérature française et pensée hindoue des origines à 1950* (Paris: Librairie C. Klincksieck, 1974).

Biondo, Michele Angelo, *De ventis et navigatione libellus, in quo navigationis utilisima continetur doctrina cum pixide novo, et diligenti examine ventorum et tempestatum* (Venice: Comin da Trino, 1546).

Birdwhistell, Anne D., Medicine and history as theoretical tools in a Confucian pragmatism. *Philosophy East and West* 45 [1] (1995): 1–28.

Birdwhistell, A.D., ed., Shao Yung on knowledge and symbols of reality, in: *Shao Yung on Knowledge and Symbols of Reality* (Stanford: Stanford University Press, 1989).

Biringuccio, Vannoccio, *The Pirotechnia of Vannoccio Biringuccio. The Classic Sixteenth-century Treatise on Metals and Metallurgy*, trans. and ed. Cyril Stanley Smith and Martha Teach Gnudi [Venice, 1540] (New York: Dover, 1990).

Blay, Michel, and Efthimios Nicolaïdis, *L'Europe des sciences. Constitution d'un espace scientifique* (Paris: Le Seuil, 2001).

Blumenberg, Hans: Das Fernrohr und die Ohnmacht der Wahrheit, in: *Galileo Galilei. Sidereus nuncius (Nachricht von neuen Sternen); Dialog über die Weltsysteme (Auswahl); Vermessung der Hölle Dantes; Marginalien zu Tasso*, ed. Hans Blumenberg (Frankfurt am Main: Suhrkamp, 1980), pp. 7–75.

Blumenberg, H., *Die Vollzähligkeit der Sterne* (Frankfurt am Main: Suhrkamp, 2000).

Boas, Marie, Hero's Pneumatica. A study of its transmission and influence. *Isis* 40 (1949): 38–48.

Bodde, Derk, *Chinese Thought, Society, and Science* (Honolulu: University of Hawaii Press, 1991).

Bodin, Jean, *Universae naturae theatrum in qo rerum omnium effectrices causae, et fines contemplantur, et continuae series quinque libris discutiuntur* (London: Roussin, 1596).

Böker, Robert, Winde B. Die geographischen Windtheorien im Altertum, in: *Paulys Realenziclopädie der classischen Altertumswissenschaft* 8A2 (1958), cc. 2215–2265.

Bondi, Roberto, *Introduzione a Telesio* (Rome: Editori Laterza, 1997).

Boorsch, Suzanne, Fireworks on paper. Celebration of the "Glorious Peace", London 1814. *Art On Paper* 4 (2000): 54–59.

Borrelli, Arianna, The weatherglass and its observers in the early seventeenth century, in: *Philosophies of technology. Francis Bacon and its contemporaries*, ed. Claus Zittel, Gisela Engel, Nicole C. Karafyllis, and Romano Nanni (Leiden: Brill) (Intersections 11) [forthcoming].

Boxer, Charles R., *Two Pioneers of Tropical Medicine. Garcia d'Orta and Nicolás Monardes* (London: Wellcome Historical Medical Library, 1963).

Boysse, Ernest, *Le théâtre des Jésuites* (Paris: Henri Vatton, 1880).

Bracco, Patrick, and Elisabeth Lebovici, *Ruggieri. 250 ans de feux d'artifice* (Paris: Denoël, 1988).

Braithwaite, Richard Bevan, *Scientific Explanation* (Cambridge: Cambridge University Press, 1953).

Bray, Francesca, A deathly disorder: Understanding women's health in late imperial China, in: *Knowledge and the Scholarly Medical Traditions*, ed. Donald Bates (Cambridge: Cambridge University Press, 1995), pp. 235–250.

Bray, F., Agriculture. *Science and Civilisation in China* 6, Biology and biological technology Part II, ed. Joseph Needham (Cambridge: Cambridge University Press, 1984; Taipei: Caves Books, 1985).

Bray, F., Introduction: The powers of tu, in: *Graphics and Text in the Production of Technical Knowledge in China: The Warp and the Weft*, ed. Francesca Bray, Vera Dorofeeva-Lichtmann, and Georges Métailié (Leiden: Brill, 2007), pp. 1–78.

Bray, F., *Technology and Gender: Fabrics of Power in Late Imperial China* (Berkeley: University of California Press, 1997).

Brecht Bertold, *Gesammelte Werke*, vol. 18 (Schriften zur Literatur und Kunst 1) (Frankfurt am Main: Suhrkamp, 1967).

Breventano, Stefano, *Trattato delle impressioni dell'aere raccolto da varii autori di filosofie* (Pavia: Girolamo Bartoli, 1571).

Breventano, S., *Trattato dell'origine delli venti, nomi et proprieta' loro utile, et necessario a marinari et ogni qualità di persone* (Venice: Giovan Francesco Camotio, 1571).

Briquel-Chatonnet, Françoise, Sur les traces d'un prince du Levant… *L'Express*, no. 2873 (Paris, 2006): 58–61.

Brockey, Liam Matthew, *Journey to the East. The Jesuit Mission to China, 1579–1724* (Cambridge, MA: Belknap Press, 2007).

Brokaw, Cynthia J., *The Ledgers of Merit and Dementi: Social Change and Moral Order in Late Imperial China* (Princeton: Princeton University Press, 1991).

Brokaw, C. J., and Chow Kai-wing, eds., *Printing and Book Culture in Late Imperial China* (Berkeley: University of California Press, 2005).

Brook, Timothy, *The Confusions of Pleasure. Commerce and Culture in Ming China* (Berkeley: University of California Press, 1998; Taipei: SMC Publishing, 1998).

Burstyn, Harold L., Early explanations of the role of the Earth's rotation in the circulation of the atmosphere and the ocean. *Isis* 57 (1966): 167–187.

Cai Yong, *Yueling Zhangju* 月令章句 [Punctuated commentary on the monthly ordinances], in: *Houhan Shu, Lülizhi, Zhu* 后汉书,律历志,注 [Annotations on the history of the Later Han Dynasty, memoir on the calendar and acoustic calculations].

Cajori, Florian, *A History of Physics* (New York: Macmillan, 1919).

Camerarius, Joachim, Aeolia, in: J. Camerarius, *Opuscula aliquot elegantissima* (Basel: Balthasar Lasius & Thomas Platterus, 1536).

Campbell, Cameron D., Wang Feng, and James Z. Lee, Pretransitional fertility in China. *Population and Development Review* 28 (2002): 735–750.

Cardano, Girolamo, *De subtilitate*, ed. Elio Nenci, vol. 1 (Milan: Franco Angeli, 2004).

Cardano, G., *Opera omnia*. Faksimile-Neudruck der Ausgabe Lyon 1663, vol. 3 (Stuttgart: Friedrich Frommann, 1966).

Carpenter, James, and James Nasmyth, *Der Mond. Betrachtet als Planet, Welt und Trabant*. Mit Erläuterungen und Zusätzen von Hermann Josef Klein (Leipzig: Leopold Voss, 1876).

Cassirer, Ernst, Davoser Disputation zwischen Ernst Cassirer und Martin Heidegger [17 March–6 April 1929] Anhang IV, in: Martin Heidegger, *Kant und das Problem der Metaphysik* (Frankfurt am Main: Vittorio Klostermann, 1991), pp. 274–296.

Cassirer, E., *Determinismus und Indeterminismus in der modernen Physik: Historische Studien zum Kausalproblem* [1937] (Darmstadt: Wissenschaftliche Buchgesellschaft, 1957).

Cassirer, E., *Die Philosophie der Aufklärung* [1932] (Darmstadt: Wissenschaftliche Buchgesellschaft, 2003).

Cassirer, E., *Kants Leben und Lehre* [1918] (Darmstadt: Wissenschaftliche Buchgesellschaft, 1994).

Castells, Nuria, and Ramon Guardans, The development of multilateral environmental agreements (MEAs) on toxic chemicals and their roots in transdisciplinary cooperation, in: *Handbook of Transdisciplinary Research*, ed. Gertrude Hirsch Hadorn et al. (Berlin: Springer, 2007).

Cavazzi, Lucia, *"Fochi d'allegrezza" a Roma dal Cinquecento all'Ottocento* (Rome: Quasar, 1982).

Chambers, William, *A Dissertation on Oriental Gardening* [1772] (Dublin, 1773).

Chan Wing-tsit (trans. and comp.), *A Source Book in Chinese Philosophy* (Princeton: Princeton University Press, 1963).

Chao Yuan-ling, *Medicine and Society in Late Imperial China: A Study of Physicians in Suzhou* (unpublished Ph.D. thesis, Department of History, UCLA, 1995).

Chemla, Karine, and Guo Shuchun, *Les Neufs Chapitres. Le classique mathématique de la Chine ancienne et ses commentaires.* Édition critique bilingue (Paris: Dunod, 2004).

Chen (Joseph) Cheng-Yih, *Early Chinese Work in Natural Science* (Hong Kong: Hong Kong University Press, 1996).

Chen (J.) C.-Y., Magnetism in China, in: *Encyclopedia of the History of Science, Technology, and Medicine in Non-Western Cultures*, ed. Helaine Selin (Dordrecht: Kluwer Academic Publishers, 1997).

Chen Dingrong, and Xu Jianchang, The tomb of Song Dynasty in Linchuan county, Jiangxi province. *Archaeology* 4 (1988): 329.

Chen Guying, Xin Kouhao and Ge Rongjin, eds., *Ming Qing shixue sichao shi* 明情實學思潮史 [The History of the Trend of Practical Learning during the Ming and Qing Dynasties] (Beijing: Jilu shushe 1988).

Chen Shih-Chuan, How to form a hexagram and consult the *I Ching. J. Am. Oriental Society* 92 (1972): 237.

Chen Wannai, *Zhu Zaiyu Yanjiu* 朱載堉研究 [Studies on Zhu Zaiyu] (Taipei: The National Palace Museum Publication, 1992).

Chen Fan Pen Li, *Chinese Shadow Theatre. History, Popular Religion, and Women Warriors* (Montreal: McGill-Queen's University Press, 2007).

Cheng Yuanjing, *Guide through the Forest of Affairs* 事林广记 *Gui* 癸 *Collection*, vol. 12, *The Supernatural Beings and Necromancies* 神仙幻术 (Song Dynasty).

Chennevières, Henri de, Les Ruggieri. Artificiers, 1730–1885. *Gazette des beaux-arts* 36 (1887): 132–140.

Chi Ch'ao-Ting, *Key Economic Areas in Chinese History. As Revealed in the Development of Public Works for Water Control* (London: George Allen & Unwin, 1936).

Chi C., *Le zone economiche chiave nella storia della Cina* (Torino: Einaudi, 1972).

Chia, Lucille, *Printing for Profit: The Commercial Publishers of Jianyang, Fujian (11th–17th Centuries)* (Cambridge, MA: Harvard University East Asia Center, 2002).

Ching, Julia, and Willard Oxtoby, eds., *Discovering China. European Interpretations in the Enlightenment* (Rochester: University of Rochester Press, 1992).

Christophersen, Axel, Big chiefs and Buddhas in the heart of the Swedish homeland, in: *Thirteen Studies on Helgö*, ed. Agneta Lundström (Stockholm: Statens historiska museum, 1988), p. 51–59.

Chu Meng-ting, Wang Fuzhi lun Shi de wenxue tanyi 王夫之論《詩》的文學闡釋 [Wang Fu-Chih's Interpretation on "The Book of Odes"] *Dong Wu Zhongwen xuebao* 11 (5/2005): 191–220.

Chu Ze, *The Records in the Rock Chamber: A Taiqing Scripture*, vol. 1 太清石壁记 (Sui Dynasty).

Chu, Co-Ching, A preliminary study on the climate fluctuations during the last 5000 years in China. *Scientia Sinica* 16 (1973): 226–256.

Chu, C.-C., Climate pulsations during historic times in China. *Geographical Review* 16 [2] (1926): 274–281.

Ci-Shi-Zan 磁石赞 [The Amazing Lodestones] (ca. 300), Guo Pu 郭璞.

Claude, Roy, *La Chine dans un mirror* (Lausanne: Editions Clairefontaine, 1953).

Clooney, Francis X., *Fr. Bouchet's India. An 18th-Century Jesuit's Encounter with Hinduism* (Chennai: Satyam Nilayam Publications, 2005).

Clunas, Craig, Modernity global and local: Consumption and the rise of the West. *American Historical Review* 104 (1999): 1497–1511.

Coe, Michael D., *Das Geheimnis der Mayaschrift: Ein Code wird entschlüsselt* (Reinbek: Rowohlt, 1996).

Cohen, Joanna-Waley, *The Culture of War in China. Empire and the Military under the Qing Dynasty* (London: I.B. Tauris, 2006).

Cole, Michael, The demonic arts and the origin of the medium. *The Art Bulletin* 84 (2002): 621–640.

Conrady, Karl Otto, ed., *Das große deutsche Gedichtbuch* (Kronberg: Athenäum, 1977).

Copernicus, Nicolaus, *De revolutionibus orbium coelestium libri sex* [Nuremberg, 1543] (facsimile, Leipzig, 1965).

Cramer, John G., The arrow of electromagnetic time and Generalized Absorber Theory. *Foundations of Physics* 13 (1983): 887–902.

Crawford, David, Arranging the bones. Culture, time, and in/equality in Berber labor organization. *Ethnos* 68 (2003): 463–486.

Crombie, Alistair Cameron, *Styles of Scientific Thinking in the European Tradition. The History of Argument and Explanation especially in the Mathematical and Biomedical Sciences and Arts*, vol. 1 and 3 (London: Duckworth, 1994).

Cua, Antonio C., Practical causation and Confucian ethics. *Philosophy East and West* 25 [1] (1975): 1–10.

Cullen, Christopher, Patients and healers in late imperial China: Evidence from the Jinpingmei. *History of Science* 31 (1993): 91–150.

Cullen, C., Yi'an (case statements): The origins of a genre of Chinese medical literature, in: *Innovation in Chinese Medicine*, ed. Elisabeth Hsu (Cambridge: Cambridge University Press, 2001), pp. 297–323.

Cutbush, James, *A System of Pyrotechny* (Philadelphia, 1825).

d'Albert, Charles Philippe, duc de Luynes, *Mémoires du duc de Luynes sur la cour de Louis XV (1735-58)*, vol. 14 (Paris, 1864).

d'Elia, Pasquale M., ed. *Fonti Ricciane, Storia dell'Introduzione del Cristianesimo in Cina, 1597–1611*, vol. 2 (Rome, 1949).

d'Elia, P.M., *Galileo in China* (Cambridge, MA: Harvard University Press, 1960).

da Longiano, Fausto [Sebastiano], *Meteorologia* (Venice: Curzio Navo Troiani & Fratelli, 1542).

Dai Nianzu, *A Series of Books on History of Physics in China: A History of Electricity and Magnetism* (Changsha: Hunan Education Press, 2002).

Dai N., *Notes on Discovery and Application of Magnetic Phenomena in China. The Yellow River Culture Tribune, eleventh* (Taiyuan: Shanxi People's Publishing House, 2004).

Dai N., *Zhongguo Shengxue Shi* 中国声学史 [A history of acoustics in China] (Shijiazhuang: Hebei Educational Publishing House, 1994).

Dai N., *Zhongguo Wulixue Shi Daxi—Shengxueshi* 中国物理学史大系—声学史 [A history of acoustics; History of physics in China series] (Changsha: Hunan Educational Publishing House, 2001).

Dai N., *Zhu Zaiyu—Mingdai de Kexue he Yishu Juxing* 朱载堉—明代的科学和艺术巨星 [Zhu Zaiyu—A great star of science and art in the Ming Dynasty] (Beijing: People Publishing House, 1986).

d'Ailly, Pierre, *Tractatus super libros metheororum* (Leipzig: Jacobus Thanner, 1506).

Dante Alighieri, *Die Göttliche Komödie*, trans. Philalethes (Johann von Wettin, King of Saxony) (Leipzig: Knaur Nachf., n.d.).

Dante Alighieri, The Divine Comedy, trans. H.F. Cary (The Project Gutenberg Online Book, August, 1977) [EText-No. 10008]. Cf. http://www.gutenberg.org/etext/10008.

Dao-De Jing 道德經 [Canon of the Virtue of Dao] (ca. 4th century BCE). Attributed to Lao Zi 老子.

Dauril, Alden, *The Making of an Enterprise: The Society of Jesus in Portugal, its Empire and Beyond, 1540–1750* (Stanford: University Press, 1996).

Daxelmüller, Christoph, and Gundolf Keil, Prognose, Prognostik, in: *Lexikon des Mittelalters* 7 (2002), cc. 242–243.

de Dainville, François, *L'éducation des Jésuites XVIe–XVIIIe* (Paris: Les éditions de minuit, 1978).

de Faria e Sousa, Manuel, *The Portugues Asia or, The history of the discovery and conquest of India by the Portugues* [...], trans. Captain John Stevens [1666–1675] (London, 1695).

de Figueiredo, John M., Ayurvedic Medicine in Goa According to the European Sources in the Sixteenth and Seventeenth Centuries, in: *Scientific Aspects of European Expansion. An Expanding World - The European Impact on World History 1450–1800* 6, Variorum, ed. William K. Storey (1996): 247–257.

de Hamel, Christopher, *Das Buch. Eine Geschichte der Bibel* (Berlin: Phaidon, 2002).

de la Loubère, Simon, *Description du royaume de Siam par M. de la Loubère, envoyé extraordinaire du Roy auprès du Roy de Siam* (Amsterdam, 1714).

de Solla Price, Derek J., Automata and the origins of mechanism and mechanistic philosophy, *Technology and Culture* 5 (1964): 9–23.

de Sousa, Teotio R., and Charles J. Borges, eds., *Jesuits in India. In Historical Perspective* (Instituto Cultural de Macau / Xavier Centre of Historical Research, 1992).

de Waard, Cornelis, *L'expérience barométrique, ses antécédents et ses explications* (Thouars (Deux-Sèvres): Imprimerie Nouvelle, 1936).

de' Vieri, Francesco, *Trattato delle meteore* (Florence: Giorgio Marescotti, 1573).

Dear, Peter, Jesuit mathematical science and the reconstitution of experience in the early twentieth century. *Studies in the History and Philosophy of Science* 18 [2] (1987): 133–175.

Debus, Allen G., Chemistry and the quest for a material spirit of life in the seventeenth century, in: *Spiritus. IV° colloquio internazionale*, ed. Marta Fattori and Massimo Bianchi (Rome: Ed. dell'Ateneo, 1984), pp. 245–263.

Debus, A.G., Key to two worlds. Robert Fludd's weather-glass. *Annali dell'istituto e museo di storia della scienza di Firenze* 7 (1982): 109–143.

Debus, A.G., *The Chemical Philosophy: Paracelsian Science and Medicine in the Sixteenth and Seventeenth Centuries*, vol. 2 (New York: Science History Publ., 1977).

Debus, A.G., The Paracelsian aerial niter, *Isis* 55 (1964): 43–61.

Deiss, Bruno, *Historie der Mondkarten* (Frankfurt am Main, 1996–2006). Cf. http://www.astrolink.de/p012/p01207/p0120702001.htm.

Delambre, Jean-Baptiste Joseph, *Histoire de l'astronomie ancienne*, Tome 1 (Paris: Imprimeur Librairie pour les Sciences, 1817).

Delambre, J.-B.J., *Histoire de l'astronomie du moyen-âge* (Paris: Courcier, 1819).

Della Porta, Giambattista, *De aeris transmutationibus*, ed. Alfonso Paolella (Naples: Edizioni Scientifiche Italiane, 2000).

Della Porta, G., *Magiae naturalis sive de miraculis rerum naturalium libri IIII* (Anverse: Plantinus, 1560).

Della Porta, G., *Natural Magick [...] in Twenty Books* (London: Thomas Young, samuel speed, 1658).

Deng Yanfang, Mother's paper-cuts. *Women of China* 9 (1990): 29–31.

Der "Erdaufgang" vom Monde aus gesehen. Cf. http://www.astronews.com. 3/2007.

Dermigny, Louis, *La Chine et l'occident. Le commerce à Canton au XVIIIe siècle, 1719–1833*, 4 vols. (Paris: S.E.V.P.E.N., 1964).

Descartes, René, Excerpta ex P. Kircher De magnete, in: *Oeuvres*, Tomus XI, ed. Charles Adam and Paul Tannery (Paris: Léopold Cerf, 1909), pp. 635–639.

Descartes, R., *Le Méteores/Die Meteore, Faksimile der Erstausgabe 1637*, ed. Claus Zittel (Frankfurt am Main: Vittorio Klostermann, 2006).

Descartes, R., *Oeuvres*, Tomus III, ed. Charles Adam and Paul Tannery (Paris: Léopold Cerf, 1899).

Descartes, R., Principiorum philosophiae [Amsterdam 1644], in: *Oeuvres*, Tomus VIII, ed. Charles Adam and Paul Tannery (Paris: J. Vrin, 1905), pp.1–348.

Die Bibel. Die Heilige Schrift des Alten und Neuen Bundes (Freiburg im Breisgau: Herder, 1965).

Diény, Colette, Knowledge and appreciation of Chinese astronomy and history in Eighteenth Century Europe according to the writings of Antoine Gaubil S.J. (1689–1759), in: *East Asian Science: Tradition and Beyond*, ed. Hashimoto Keizô, Catherine Jami, and Lowell Skar (Osaka: Kansai University Press, 1995), pp. 501–505.

Dietrichson, Paul, Kant's criteria of universalizability, in: *Kant Foundations of the Metaphysics of Morals: Text and Critical Essays*, ed. Robert Paul Wolff (Indianapolis: Bobbs-Merrill, 1969), pp. 163–207.

Ding Yidong, *Yijing Xiangyi* 周易象義 [The Sense of the Phenomenon in the Zhou Yi]. *Siku quanshu*-edition.

Diringer, David, *The Alphabet: A Key to the History of Mankind* (London: Hutchinson, 1949).

Dodgen, Randall A., *Controlling the Dragon. Confucian Engineers and the Yellow River in Late Imperial China* (Honolulu: University of Hawaii Press, 2001).

Dong Zhongshu, *Chunqiu fanlu* 春秋繁露 [Abundant Dew, Interpretations of the Spring and Autumn Annals]. *Sibu beiyao*-edition.

Dotz, Warren, Jack Mingo, and George Moyer, *Firecrackers. The Art and History* (Berkeley, CA: Ten Speed Press, 2000).

Drake, Stillman, *Galileo at Work. His Scientific Biography* (Chicago: University of Chicago Press, 1980).

Drake, S., Giovanni Battista Benedetti. *Dictionary of Scientific Biography* 1 (1970): 604–609.

Drake-Brockman, Jennifer, The "perpetuum mobile" of Cornelis Drebbel, in: *Learning, Language, and Invention. Essays Presented to Francis Maddison*, ed. Willem D. Hackmann and Anthony J. Turner (Ashgate: Variorum, 1994), pp. 124–147.

Drebbel, Cornelis Jacobszoon, *Ein kurzer Tractat von der Natur der Elementen und wie sie den Wind, Regen, Blitz und Donner verursachen und war zu sie nutzen* (Leiden: Heinrich von Haestens, 1608).

Du Bourguet, Pierre, *Les coptes* (Paris: Presses Universitaires de France, 1992).

Du Halde, Jean-Baptiste, *The general history of China. Containing a geographical, historical, chronological, political and physical description of the Empire of China*, 4 vols. [1735] (London, 1741).

Duan Chengshi, *Miscellany of the Yu-Yang Mountain, Continuative Collectanea*, vol. 5, *Records on the Temples* 酉阳杂俎，续集卷5, 寺塔记 (Beijing: Zhonghua Publishing House, 1981).

Duarte, Adrian, *Les premières relations entre les Français et les princes indigènes dans l'Inde au XVIIe siècle (1666–1706)* (Paris: Jouve & Cie., Editeurs, 1932).

Ducos, Joëlle, *La météorologie en français au Moyen Age (XIIIe–XIVe siècles)* (Paris: Honoré Champion Éditeur, 1998).

Duden, Barbara, *The Woman Beneath the Skin: A Doctor's Patients in Eighteenth-century Germany* (Cambridge, MA: Harvard University Press, 1991).

Eamon, William, *Science and the Secrets of Nature: Books of Secrets in Medieval and Early Modern Culture* (Princeton: Princeton University Press, 1994).

Einstein, Albert, Science, philosophy, and religion, in: *Conference on Science, Philosophy and Religion in Their Relation to the Democratic Way of Life* (New York: published by the Conference on Science, Philosophy and Religion in Their Relation to the Democratic Way of Life, 1941).

Eisenstein, Elizabeth, *The Printing Revolution in Early Modern Europe* (Cambridge: Cambridge University Press, 1983).

Elman, Benjamin A., *On Their Own Terms: Science in China, 1550–1900* (Cambridge, MA: Harvard University Press, 2005).

Elvin, Mark, and T.-J. Liu, eds., *Sediments of Time: Environment and Society in Chinese History* (Cambridge: Cambridge University Press, 1998).

Elvin, M., *The Retreat of the Elephants: An Environmental History of China* (Yale: Yale University Press, 2004).

Enuma Elish: The Epic of Creation, trans. L. W. King (The Seven Tablets of Creation, London, 1902). Cf. http://www.sacred-texts.com/ane/enuma.htm (5/2007).

Erdberg, Eleanor von, Hand und Geste in der chinesischen Kunst, in: Eleanor von Erdberg, *Zur Kunst Ostasiens. Schriften und Vorträge* [1987] (Waldeck: Siebenberg-Verlag, 1998), pp. 151–172.

Escarpit, Robert, *La Révolution du livre* (Paris: UNESCO Publishing, 1965).

Etkin, Nina L., Cultural constructions of efficacy, in: *The Context of Medicine in Developing Countries: Studies in Pharmaceutical Anthropology*, ed. Siaak van der Geest and Susan R. Whyte (Dordrecht: Kluwer Academic Publishers, 1988), pp. 299–326.

Fan Ye, 后汉书.律历志 [Memoir on the calendar and acoustic calculations, history of the Later Han Dynasty], in: *Wenyuange Siku Quanshuben* 文渊阁四库全书本 [Imperial collection of four from the Imperial Library in the Forbidden City], Song Period of the Southern Dynasties (420–479), published 445.

Fang Hao, *Zhong-Xi Jiao-Tong-Shi* 中西交通史 [History of the Interrelation between China and the Western World], 5 vols. (Taipei: Huagang Publishing House, 1968).

Fang Jin-Qi, Establishment of a data bank from records of climatic disasters and anomalies in ancient Chinese documents. *International Journal of Climatology* 12 (1992): 499–519.

Fang Lüe, *Shangyou tang yian* [Medical cases from the Hall of Honoured Friendship], preface 1846 (Shanghai: Rare Books Press, 1983).

Fang Xualing, *Jin Shu* 晋书, vol. 27, in: *Records of Five Elements* 五行志 (Beijing: Zhonghua Publishing House, 1974).

Fang Yizhi, *Wuli Xiaoshi* 物理小识 (Ming Dynasty).

Faria e Sousa, Manuel de, *The Portugues Asia, or, The history of the discovery and conquest of India by the Portugues* [...], trans. John Stevens (London, 1695).

Faulmann, Carl, *Schriftzeichen und Alphabete aller Zeiten und Völker* (Vienna: Marixverlag, 1880).

Fazzioli, Edoardo, *Chinese Calligraphy: From Pictograph to Ideogram: The History of 214 Essential Chinese / Japanese Characters* (New York: Abbeville Press, 2005).

Feldhay, Rivka, *Galileo and the Church. Political Inquisition or Critical Dialogue* (Cambridge: Cambridge University Press, 1995).

Fierro, Alfred, *Historie de la météorologie* (Paris: Editions Denoel, 1991).

Filliozat, Jean, La naissance et l'essor de l'indianisme, in: *Choix d'articles d'Indologie*, ed. Jean Filliozat and Laghu-Prabandah (Leiden: Brill, 1974), pp. 265–295.

Filliozat, J., L'Orientalisme et les sciences humaines, Extrait du *Bulletin de la Société des Études Indochinoises*, XXVI [4] (1951).

Finocchiaro, Maurice A., *Galileo and the Art of Reasoning. Rhetorical Foundations of Logic and Scientific Method* (Dordrecht; Boston, MA., 1978).

Fischer, Steven Roger, *A History of Reading* (Wellington: Reaktion Books, 1998).

Fisher, Svante, *Roman Imperialism and Runic Literacy* (Uppsala: Uppsala University, 2005).

Flitsch, Mareile, *Der Kang. Eine Studie zur materiellen Alltagskultur bäuerlicher Gehöfte in der Manjurei* (Wiesbaden: Harrassowitz, 2004).

Flitsch, M., "Zeigt her eure Füße ...". Populärwissenschaftliche Verlage in China nehmen sich der untergehenden Kleinodien des Alltags an. *Das neue China* 1 (2003): 29.

Flitsch, M., Manjurische Scherenschnitt-Erzählungen. Bildergeschichten der Künstlerin Hou Yumei. *Deutsche Gesellschaft für Ostasiatische Kunst. Mitteilungen* 6 (1994): 15–24.

Flitsch, M., Papercut stories of the Manchu woman artist Hou Yumei. *Asian Folklore Studies* LVIII [2] (1999): 353–375.

Flitsch, M., Scherenschnitt-Künstlerin Hou Yumei, in: *Bertelsmann Lexikon Die Völker der Erde. Kulturen und Nationalitäten von A – Z*, ed. Inga Rogg and Eckard Schuster (Gütersloh; München: Bertelsmann Lexikon Verlag, 1992), pp. 228–229.

Fludd, Robert, *Integrum morborum mysterium* (Frankfurt am Main: Wolfgang Hofmann, 1631).

Fludd, R., *Philosophia sacra et vere christiana seu meteorologia cosmica* (Frankfurt am Main: de Bry, 1626).

Fontana, Francesco, *Novae coelestium terrestriumq[ue] rerum observationes, et fortasse hactenus non vulgatae* [1646] (Naples: Gaffarum, 1646).

Forbes, Eric, The European astronomical tradition. Its transmission into India, and its reception by Sawai Jai Singh II. *Indian Journal of History of Science* 17 [2] (1982): 234–243.

Forbes, Robert James, *Man the Maker: A History of Technology and Engineering* (New York: Schuman, 1950).

Frank, André Gunder, *Re-Orient: Global Economy in the Asian Age* (Berkeley: University of California Press, 1998).

Freiesleben, Hans-Christian, *Geschichte der Navigation*. 2. durchgesehene Auflage (Wiesbaden: Franz Steiner, 1978).

Friedman, M., *Kant and the Exact Sciences* (Cambridge, MA: Harvard University Press, 1992).

Friedman, Michael, *A Parting of the Ways: Carnap, Cassirer, and Heidegger* (Chicago: Open Court, 2000).

Friedrich, Johannes, *Geschichte der Schrift unter besonderer Berücksichtigung ihrer geistigen Entwicklung* (Heidelberg: Carl Winter Universitätsverlag, 1966).

Frisinger, H. Howard, *The History of Meteorology to 1800* (Boston: American Meteorological Society, 1983).

Froidmont, Libert, *Meteorologicorum libri sex* (Antwerpen: Balthasar Moretum, 1627).

Fryer, John, and Xu Shou, Acoustics in China. *Nature* 23 (1880.11–1881.4): 448–449.

Frytsche, Marcus, *Meteororum, hoc est, impressionum aerearum et mirabilium naturae operum item catalogues prodigiorum* (Nurnberg: Montanus & Neuberus, 1563).

Fu Daiwei, Higher taxonomy in scientific communities and higher incommensurability, in: *Mind and Cognition*, ed. Y.-H. Houng and J.-C. Ho (Taipei: Institute of European and American Studies, Academia Sinica, 1995), pp. 95–116.

Fulke, William, *A goodly gallery with a most pleasant prospect, into the garden of naturall causes of all kind of meteors (1563)*, ed. Theodore Hornberger (Philadelphia: The American Philosophical Society, 1979).

Fuller, Steve, Prolegomena to a world history of science, in: *Situating the History of Sciences. Dialogues with Joseph Needham*, ed. S. Irfan Habib and Dhruv Raina (New Delhi: Oxford University Press, 1999), pp. 114–151.

Furth, Charlotte, *A Flourishing Yin: Gender in China's Medical History, 960–1665* (Berkeley: University of California Press, 1999).

Furth, C., Concepts of pregnancy, childbirth, and infancy in Ch'ing dynasty China. *Journal of Asian Studies* 46 (1987): 7–35.

Furth, C., Introduction: Thinking with cases, in: *Thinking with Cases: Specialist Knowledge in Chinese Cultural History*, ed. Charlotte Furth, Judith T. Zeitlin, and Hsiung Ping-chen (Honolulu: Hawai'i University Press, 2007), pp. 1–27.

Furth, C., Producing medical knowledge through cases: history, evidence, and action, in: *Thinking with Cases: Specialist Knowledge in Chinese Cultural History*, ed. C. Furth, J.T. Zeitlin and Hsiung P. (Honolulu: University of Hawai'i Press, 2007), pp. 125–151.

Furth, C., Rethinking van Gulik: Sexuality and reproduction in traditional Chinese medicine, in: *Engendering China: Women, Culture, and the State*, ed. Christina K. Gilmartin, Gail Hershatter, Lisa Rofel, and Tyrene White (Cambridge, MA: Harvard University Press, 1994), pp. 125–146.

Furth, C., Judith T. Zeitlin, and Hsiung Ping-chen, eds., *Thinking with Cases: Specialist Knowledge in Chinese Cultural History* (Honolulu: University of Hawai'i Press, 2007).

Galilei, Galileo, *Dialogo sopra i due massimi sistemi del mondo tolemaico e copernicano*, ed. Ottavio Besomi and Mario Helbing, 2 vols. (Padova: Editrice Antenore, 1998).

Galilei, G., *Discourses Concerning Two New Sciences* (1638).

Galilei, G., *Sidereus nuncius* [Starry Messenger] (1610); http://www.bard.edu/admission/forms/pdfs/galileo.pdf.

Galilei, G., *Sidereus nuncius. Nachricht von neuen Sternen*, ed. and trans. Hans Blumenberg (Frankfurt am Main: Suhrkamp, 1980).

Gallagher, Louis J., S.J., ed., *China in the Sixteenth Century. The Journals of Matthew Ricci, 1583–1610* (New York: Random House, 1953).

Gamber, Klaus, *Die Liturgie der Goten und der Armenier* (Regensburg: Kommissionsverlag Friedrich Pustet, 1988).

Garcaeus, Joahnnes, *Meteorologia conscripta* (Wittenberg: Johann Schwertel, 1568).

Garelli, Paul, and Marcel Leibovici: Enûma Elîsch. Der mesopotamisch-altbabylonische Schöpfungsmythos nach der Übertragung aus dem Akkadischen ins Französische, in: *La naissance du monde. Egypte ancienne, Laos, Tibet, Sumer, Akkad, Hourrites et Hittites, Chine, Turcs et Mongols, Israël, Cannan, Islam, Inde, Iran préislamique, Siam* (Paris: Deuil, 1959), cited from http://www.earlyworld.de/enuma_elish.htm?kbw_ID=71612002 (3/2007).

Garin, Eugenio, Relazione introduttiva, in: *Spiritus. IV° colloquio internazionale*, ed. Marta Fattori and Massimo Bianchi (Rome: Ed. dell'Ateneo, 1984), pp. 3–14.

Gericke, Helmuth, *Mathematik in Antike und Orient. Mathematik im Abendland von den römischen Feldmessern bis zu Descartes* (Wiesbaden: Fourier, 1994).

Gerring, John, What makes a concept good? A criterial framework for understanding concept formation in the social sciences. *Polity* 31 [3] (1999): 357–393.

Gilbert, Otto, *Die meteorologischen Theorien des griechischen Altertums* (Leipzig: B.G. Teubner, 1907)

Gilbert, William, *De magnete* [1600], trans. P. Fleury Mottelay [1893] (New York: Dover Publications, 1958).

Gilbert, W., *De mundo nostro sublunari philosopha nova. Opus posthumus, ab authoris fratre collectum pridem et dispositum* (Amsterdam: Elzevir, 1651)

Gingerich, Owen, Leonardos wissenschaftliches Vermächtnis, in: *Leonardo da Vinci—Josef Beuys. Der Codex Leicester im Spiegel der Gegenwart*, catalogue, ed. Haus der Kunst Munich and Martin-Gropius-Bau Berlin (Düsseldorf: Richter, 1999), pp. 47–57.

Glahn, Richard von, *The Sinister Way: The Divine and the Demonic in Chinese Religious Culture* (Berkeley: University of California Press, 2004).

Glattke, Theodore J., *Otoacoustic Emissions in 2002. Some Perspectives.* http://www.audiologyonline.com/articles/article_detail.asp?article_id=334.

Gliozzi, Giuliano, Girolamo Cardano, *Dizionario biografico degli italiani* XIX (Rome 1976): 758–763.

Godfrey, David, Foreword, in: Harold A. Innis, *Empire and Communications* (Oxford: Oxford University Press, 1950).

Gofflot, L.V., *Theatre au Collège du moyen âge à nos jours* [1907] (New York: Franklin, 1964).

Golikov, Ivan Ivanovich, *Dopolneniia k Deianiam Petra Velikogo*, 18 vols. (Moscow: Moscow University Press, 1790–1797).

Gong, Gaota, and Sultan Hameed, The variation of moisture conditions in China during the last 2000 years. *International Journal of Climatology* 11 (1991): 271–283.

Goodenough, Ward, *Description and Comparison in Cultural Anthropology* (Chicago: Aldine, 1970).

Graham, Angus Charles, and Nathan Sivin, A systematic approach to the Mohist optics (ca. 300 B.C.), in: *Chinese Science*, ed. N. Sivin and Shigeru Nakayama (Cambridge, MA: MIT Press, 1973), pp. 105–152.

Graham, A.C., *Later Mohist Logic, Ethics and Science* (Hong Kong: The Chinese University Press, 1978).

Graham, A.C., *Two Chinese Philosophers: Cheng Mingdao and Cheng Yichuan* (London: Lund Humphries, 1958).

Grant, Joanna, *A Chinese Physician: Wang Ji and the "Stone Mountain Medical Case Histories"* (London: Routledge Curzon, 2003).

Grimm, Jakob, and Wilhelm Grimm, *Der Mond*, in: Projekt Gutenberg-DE (Hamburg, 2003). Cf. http://gutenberg.spiegel.de/grimm/maerchen/mond1.htm (3/2007).

Grimm, J. and W. Grimm, The Moon, in: *Grimm's household tales with the author's notes*, trans. Margaret Hunt (London: G. Bell & Sons, 1910) (The Project Gutenberg Online Book, 7.1.2004) [EText-No. 5314]. Cf. http://www.gutenberg.org/etext/5314, pp. 549–550.

Grove, Richard H., *Green Imperialism: Colonial Expansion, Tropical Island Edens and the Origins of Environmentalism, 1600-1860* (Cambridge: Cambridge University Press, 1995).

Gu Yan, *Zhengzai xiaoshi de yishu* 正在消失的艺术 [Arts that are about to disappear] (Shanghai: Shanghai yuandong chubanshe, 2001).

Guan Lu, Master Kuan's Geomantic Instructor, The Chapter of the Explained Middle 管氏地理指蒙, 释中, in: *Imperial Encyclopedia*, vol. 655 古今图书集成, 卷 655, 艺术典, 堪舆部记考, ed. Chen Menglei et al. (Qing Dynasty).

Guan Yinzi. Chapter Six 关尹子·六匕篇 (Jin Dynasty or Tang Dynasty).

Guang-Yang Za-Ji 廣陽雜記 [Guang-Yang Collected Miscellanea] Ming 明 (ca. 1695). Liu Xian-Ting 劉獻廷.

Guardans, Ramon, Estimation of climate change influence on the sensitivity of trees in Europe to air pollution concentrations. *Environmental Science & Policy* 5 (2002): 319–333.

Gui Gu Zi 鬼谷子 [Book of the Devil Valley Master] (ca. 4th century B.C.). Attributed to Su Qin 蘇秦.

Guidani, Francesco, *Dialogo nel quale a pieno si ragiona di tutte quelle cose, che nella supre-ma regione dell'aria si generano, appresso di quelle, che si fanno nella regione di mezzo, e poscia di quelle, che in questa ultima, e bassa regione si generano* (Venice: Domenico Farri, 1578).

Guo Qingfeng, *Zhiren ji. Huanghe liuyu minjian meishu kaocha shouji* 纸人记.黄河流域民间艺术考察手记 [Notes about paper figures. Diary about a research on the folk arts in the Yellow River area] (Shanghai: Shanghai sanlian shudian, 2006).

Guy, Basil, *The French Image of China before and after Voltaire* (Geneva: Institut et musée Voltaire, 1963).

Haarmann, Harald, *Geschichte der Schrift* (Munich: C.H. Beck, 2002).

Hakluyt, Richard, *Voyages and Discoveries. Principal Navigations, Voyages, Traffiques and Discoveries of the English Nation* [1599–1600] (London: Penguin, 1972).

Halley, Edmund, An historical account of the trade winds, and monsoons, observable in the seas between and near the tropicks, with an attempt to assign the physical cause of said winds. *Philosophical Transactions of the Royal Society* 16 (1686): 153–168.

Hamilton, Gary G., and Chang Wei-an, The importance of commerce in the organization of China's late imperial economy, in: *The Resurgence of East Asia: 500, 150 and 50-year Perspectives*, ed. Giovanni Arrighi, Takeshi Hamashita and Mark Selden (New York: Routledge, 2003), pp. 173–213.

Hannaway, Caroline, Environment and miasmata, in: *Companion Encyclopedia of the history of medicine*, ed. William F. Bynum and Roy Porter, 2 vols. (London: Routledge, 1993), here vol. 1, pp. 292–308.

Harcourt-Smith, Simon, An exhibition of Chinoiserie. *Burlington Magazine* 68 (1936): 90–92.

Harris, Marvin, History and significance of etie/emic distinction. *Annual Review of Anthropology* 5 (1976): 329–350.

Harris, Steven J., *Jesuit Ideology and Jesuit Science. Scientific Activity in the Society of Jesus, 1540–1773* (Ph.D. thesis; Madison: University of Wisconsin, 1988).

Harris, S.J., Jesuit scientific activity in the overseas scientific missions, 1540–1773. *Isis* 96 (2005): 71–79.

Harris, S.J., Transposing the Merton thesis. Apostolic spirituality and the establishment of the Jesuit scientific tradition. *Science in Context* 3 [1] (1989): 29–65.

Heilbron, John L., *The Sun in the Church. Cathedrals as Solar Observatories* (Cambridge, MA., Harvard University Press, 1999).

Hellmann, Gustav, Entwicklungsgeschichte des meteorologischen Lehrbuches, in: *Beiträge zur Geschichte der Meteorologie*, ed. G. Hellmann, vol. 2 (Berlin: Behrend & Co., 1917), pp. 1–134.

Hellmann, G., Wetterprognosen und Wetterberichte des XV. und XVI. Jahrhunderts. Facsimiliendruck mit einer Einleitung, in: *Neudrucke von Schriften und Karten über Meteorologie und Erdmagnetismus* 12 (Berlin: Kraus, 1969), pp. 7–26.

Hempel, Carl Gustav, *Aspects of Scientific Explanation* (New York: Free Press, 1965).

Hempel, C.G., *Fundamentals of Concept Formation in Empirical Science* (Chicago: University of Chicago Press, 1972).

Henderson, John B., *The Development and Decline of Chinese Cosmology* (New York: Columbia University Press, 1984).

Heninger, Simeon Kahn, jr., *A Handbook of Renaissance Meteorology. With Particular Reference to Elisabethan and Jacobean Literature* (Durham NC: Duke University Press, 1960).

Hero of Alexandria, *Opera omnia*, vol. 1. Pneumatica et automata, ed. Wilhelm Schmidt (Leipzig: B.G. Teubner, 1899).

Hevelius, Johannes, *Johannis Hevelii Selenographia. Sive, lunæ descriptio. Atque accurata, tam macularum eius, quam motuum diversorum, aliarumque omnium vicissitudinum, phasiumque, telescopii ope deprehensarum, delineatio* [1647], in: Digitale Bibliothek. Leibnizressourcen digital. Digitalisierung naturwissenschaftlicher, technischer und medizinischer Texte der Leibnizzeit, ed. Herzog August Bibliothek Wolfenbüttel (Wolfenbüttel, 2007). Cf. http://diglib.hab.de/drucke/2-5-astron-2f/start.htm.

Hiebel, Hans H., Heinz Hiebler, Karl Kogler, and Herwig Walitsch, *Die Medien. Logik-Leistung-Geschichte. Zu den Verfahren der Speicherung und Übertragung von Schrift, Bild und Ton* (Munich: Wilhelm Fink, 1998).

Hilmer, Andreas, Die Schüler des Siddharta. *GEO* 7 (2005): 39.

Hippocrates, *Airs, waters, places*, in: *Hippocrates*, vol. 1, trans. William Henry Samuel Jones (Cambridge, MA: Harvard University Press, 1962), pp. 65–137.

Hippocrates, *On breaths*, in: *Hippocrates*, vol. 2, trans. William Henry Samuel Jones (Cambridge, MA: Harvard University Press, 1967), pp. 226–253.

Ho Peng Yoke, Chinese science: The traditional chinese view. *Bulletin of the School of Oriental and African Studies, University of London* 54 [3] (1991): 506–519.

Höllmann, Thomas O., *Die Seidenstrasse* (Munich: C.H. Beck, 2004).

Hollister-Short, Graham, The formation of knowledge concerning atmospheric pressure and steam power in Europe from Aleotti (1589) to Papin (1690). *History of Technology* 25 (2004): 137–150.

Honour, Hugh, *Chinoiserie. The Vision of Cathay* (New York: Harper and Row, 1973).

Hou Yumei, *Bangchui gou: Renshen. Xiaji* 棒槌沟: 人参.下集 [The ginseng valley: Ginseng. Second volume] (Tonghua, 1989). Private collection Mareile Flitsch.

Hou Y., *Mao'er shan chuanqi: Bangchui guniang* 猫耳山传奇棒槌姑娘 [A legend from Cat-Ear-Mountain: The ginseng maiden] (Tonghua, 1990). Private collection Mareile Flitsch.

Hou Y., *Qiaoyu shengu* 巧遇参姑 [Accidental meeting with the ginseng maiden] (Tonghua, about 1989). Private collection Mareile Flitsch.

Hou Y., *Qiaoyu shengu: Dongbei minjian Manzu jianzhi lianhuan gushi* 巧遇参姑: 东北民间满族剪纸联欢故事 [Accidental meeting with the ginseng maiden: A north-east China Manchu paper-cut picture folktale] (Tonghua, 1985). Private collection Mareile Flitsch.

Houhan Shu—Lülizhi Shang (Zhuyin) 后汉书·律历志上 (注引) [History of the Later Han Dynasty, memoir on the calendar and acoustic calculations, part 1, Annotations].

Hsia, Florence, *French Jesuits and the Mission to China. Science, History, Religion* (Ph.D. dissertation, University of Chicago, 1999).

Hsiung Ping-chen, Facts in the tale: Case records and pediatric medicine in late imperial China, in: *Thinking with Cases: Specialist Knowledge in Chinese Cultural History*, ed. C. Furth, J.T. Zeitlin and Hsiung P. (Honolulu: University of Hawai'i Press, 2007), pp. 152–168.

Hsiung P., *A Tender Voyage: Children and Childhood in Late Imperial China* (Stanford: Stanford University Press, 2005).

Huang Shengwu, ed., *Zhongguo yixue baike quanshu. Zhongyi fukexue* [Chinese medical encyclopaedia. Traditional Chinese gynaecology] (Shanghai: Xinhua Press, 1983).

Hung Ho-Fung, Orientalist knowledge and social theories. China and the European conceptions of East–West differences from 1600 to 1900. *Sociological Theory* 21 (2003): 254–280.

Huxley, Julian, *Altertum und Mittelalter* (Klagenfurt: Buch und Welt, 1972).

Ibn Al-Haitham, *"Über die Natur der Spuren (Flecken), die man auf der Ober-fläche des Mondes sieht"*, ed. Carl Schoy (Hannover: Orient-Buchhandlung Heinz Lafaire, 1925), pp. 1–33.

Ibn Al-Haytham, *Optics, Books I–III*, On direct vision, trans. with introduction and commentary by Abdelhamid I. Sabra, vol. I: translation; vol. II.: introduction, commentary, glossaries, concordance, indices (London: The Warburg Institute, University of London, 1989).

Impey, Oliver, *Chinoiserie. The Impact of Oriental Styles on Western Art and Decoration* (London: Oxford University Press, 1977).

Intorcetta, Prosperus, *Sinarum scientia politico-moralis*, Latin translation of the book *Zhong Yong* 中庸 [Doctrine of the Mean] (1667).

Isidor of Sevilla, *Etimologie. Libro XIII: De mundo et partibus*, ed. and trans. Giovanni Gasparotto (Paris: Les Belles Lettres, 2004).

Jacob, Margaret C., *The Cultural Meaning of the Scientific Revolution* (New York: Alfred A. Knopf, 1988).

Jacobson, Dawn, *Chinoiserie* (London: Phaidon, 1993).

Jami, Catherine, From Louis XIV's court to Kangxi's court. An institutional analysis of the French Jesuit mission to China (1688–1722), in: *East Asian Science. Tradition and Beyond*, ed. Hashimoto Keizô, Catherine Jami, and Lowell Skar (Osaka: Kansai University Press, 1995), pp. 493–499.

Jarrell, Richard A., The latest date of composition of Gilbert's "De mundo". *Isis* 63 (1972): 94–95.

Jarry, Madeleine, *Chinoiserie. Chinese Influence on European Decorative Art, 17th and 18th Centuries* (New York: Vendome Press, 1981).

Ji Yun et al., eds., Jingyin wenyuan siku quanshu 景印文淵四庫全書 (Taipei: Taiwan Shangwu Yinshuguan, 1983–1986).

Jiang Jianmin, Zhang De'er, and Klaus Fraedrich, Historic climate variability of wetness in east China (960–1992): A wavelet analysis. *International Journal of Climatology* 17 (1997): 969–981.

Jiang Yong, *Lülü Chanwei* 律呂闡微 [Detailed explanation of pitch-pipes].

Jiangxi Tongzhi 江西通志, vol. 107, *Jixiang* 祥異 (1732).

Jiaxingfu Zhi 嘉興府志, vol. 35, *Xiangyi* 祥異 (1879).

Jin Shu 晉書 [History of the Jin Dynasty 265–420]. Tang 唐 635. Fang Xuan-Ling 房玄齡.

Jin Zhilin, *L'esthétique de l'art populaire chinois. La poupée porte-bonheur. Aesthetic features of Chinese Folk Art. The Good Luck Dolly* (Paris: Librairie You-Feng & Musée Kwok On, 1989).

Jin Z., *Zhonghua minzu de baohushen yu fanyan zhi shen – Zhuaji wawa* 中华民族的保护神于繁衍之神－抓髻娃娃 [The protection and fertility spirit of the Chinese people – Zhuaji wawa] (Beijing: Zhuongguo shehui kexue chubanshe, 1989).

Jones, Robert, *Artificial Fire-works* (London, 1765).

Jung, Carl Gustav, Synchronicity: An acausal connecting principle, in: *The Interpretation of Nature and the Psyche*, ed. C.G. Jung and W. Pauli (New York: Pantheon Books, 1955).

Kant, Immanuel, *Anthropology from a Pragmatic Point of View* [1798], trans. Robert B. Louden (Cambridge: Cambridge University Press, 2006).

Kant, I., Groundwork of the metaphysics of morals [1785], trans. Mary J. Gregor, in: *The Cambridge Edition of the Works of Immanuel Kant: Practical Philosophy*, ed. M.J. Gregor (Cambridge: Cambridge University Press, 2002), pp. 37–108.

Kant, I., *Handschriftlicher Nachlass*, vol. 14 (Berlin: de Gruyter 1925).

Kant, I., *Neue Anmerkungen zur Erläuterung der Theorie der Winde* [1756] (Berlin: Georg Reimer, 1910).

Kant, I., *Physische Geographie* (Berlin: de Gruyter, 1923).

Kant, I., Prolegomena to any future metaphysics that will be able to come forward as science [1783], trans. Gary Hatfield, in: *The Cambridge Edition of the Works of Immanuel Kant: Theoretical Philosophy after 1781*, ed. Henry Allison and Peter Heath (Cambridge: Cambridge University Press, 2002), pp. 49–160.

Kant, I., *Reflexionen zur Anthropologie* (Berlin: de Gruyter, 1923).

Kant, I., Something on the influence of the moon on the weather condition [1794], trans. John Richardson, in: *Four Neglected Essays by Immanuel Kant*, ed. Stephen Palmquist (Hong Kong: Philopsychy Press, 1994; online: http://www.hkbu.edu.hk/~ppp/fne/essay4.html).

Kant, I. *Universal Natural History and Theory of Heaven* [1755], trans. Ian Johnston, based on Georg Reimer's 1905 German edition of Kant's *Allgemeine Naturgeschichte* (online: http://www.mala.bc.ca/~johnstoi/kant/kant2e.htm).

Kant, I., *Von dem ersten Grunde des Unterschiedes der Gegenden im Raume* [1768] (Berlin: Georg Reimer, 1912).

Kant, I., What does it mean to orient oneself in thinking? [1786], trans. Allen W. Wood, in: *The Cambridge Edition of the Works of Immanuel Kant: Religion and Rational Theology*, ed. A.W. Wood and George Di Giovanni (Cambridge: Cambridge University Press, 2001), pp. 7–18.

Kao, Karl S.Y., Bao and Baoying: Narrative causality and external motivations in Chinese fiction. *Chinese Literature: Essays, Articles, Reviews (CLEAR)* 11 (1989): 115–138.

Kao, K.S.Y., Self-reflexivity, epistemology, and rhetorical figures. *Chinese Literature. Essays, Articles, Reviews (CLEAR)* 19 (1997): 59–83.

Kejariwal, O.P., *The Asiatic Society of Bengal and the Discovery of India's Past 1784–1838* (Delhi: Oxford University Press, 1988).

Kepler, Johannes, *Astronomiae pars optica* [Frankfurt am Main, 1604].

Kepler, J., *Opera Omnia*, ed. Christian Frisch, (Frankfurt am Main, 1870).

Kepler, J., *Somnium seu opus posthumum de astronomia lunari*, ed. Ludwig Kepler [Frankfurt am Main, 1634].

Kim Youngmin, Luo Qinshun (1465–1547) and his intellectual context. *T'oung Pao* 89 [4–5] (2003): 367–441.

King, Leonard William, *The Seven Tablets of Creation* (London: Luzac, 1902).

Kircher, Athanasius, *Ars magna lucis et umbrae, in decem libros digestae* (Rome: Hermann Scheus, 1645/1646).

Kircher, A., *China illustrata* (Amsterdam: Jansson van Waesberge, 1667).

Kircher, A., *Mundus subterraneus, in XII libros digestus*. 2 vols. in 1 (Amsterdam: Jansson van Waesberge, 1665).

Klier, Gerhardt, *Die drei Geister des Menschen. Zur sogenannten Spirituslehre in der frühen Neuzeit* (Stuttgart: Meiner, 2002).

Klopstock, Friedrich Gottlieb, Die Sommernacht, in: *Das große deutsche Gedichtbuch*, ed. K.O. Conrady (Kronberg: Athenäum, 1977), p. 186.

Knoblock, John H., *The Annals of Lü Buwei: A Complete Translation and Study*, trans. Jeffrey Riegel (Stanford: Stanford University Press, 2000).

Körber, Hans-Günther, Katalog der Hellmannschen Sammlung von Sonnenuhren und Kompassen des 16. bis 19. Jahrhunderts im Geomagnetischen Institut Potsdam. *Jahrbuch 1962 des Adolf-Schmidt-Observatoriums für Erdmagnetismus in Niemegk* (1964): 149–171.

Kohl, Karl, *"Über das Licht des Mondes". Eine Untersuchung von Ibn al Haitham*, in: Sonderabdruck aus den Sitzungsberichten der Physikalisch-Medizinischen Sozietät in Erlangen, vol. 56/57 (1924/25), (Erlangen: Kommission Max Mencke, 1926).

Kong Yingda, *The Zhouyi zhengyi* 周易正義 [Rectified Meanings of the Zhou Changes] (beginning period of the Tang Dynasty) (Beijing: Beijing University Press, 1999).

Kremer, Jürgen, *Spezielle Relativitätstheorie* (RheinAhrCampus Remagen, 26. Februar 2007). http://ifb.bildung-rp.de/Faecher/Mathematik/SpezRelTheorie_neu.pdf. (3/2007).

Krupp, E.C., *Echoes of the Ancient Skies* (New York: New American Library, 1983).

Kutschera, Ulrich, *Evolutionsbiologie. Eine allgemeine Einführung* (Berlin: Parey, 2001).

La Chenaye-Aubert, François-Alexandre de, *Dictionnaire historique des mœurs, usages et coutumes des Français*, 3 vols. (Paris, 1767).

La Porte, Joseph de, abbé de Fontenai, *Le voyageur françois, ou Le connoissance de l'Ancien et du Nouveau monde* (Paris, 1769).

Lach, Donald F., China in Western thought and culture, in: *Dictionary of the History of Ideas. Studies of Selected Pivotal Ideas*, ed. Philip P. Wiener, 4 vols. (New York: Charles Scribner's Sons, 1973), vol. 1, pp. 353–373.

Lafont, Jean-Marie, *Indika. Essays in Indo-French Relations, Manohar and Centre des Sciences Humanines* (New Delhi: Manohar and Centre des Sciences Humaines. 2000).

Lamberts, Ken, and David Shanks, eds., *Knowledge, Concepts, and Categories* (Cambridge, MA: MIT Press, 1997).

Lamouroux, Christian, Gestion de l'eau et organisation communautaire. L'exemple de la rivière Yeyu Shaanxi. *Bulletin de l'École Française d'Extrême-Orient* 85 (1998): 187–225.

Lang, Arend Wilhelm, *Seekarten der südlichen Nord- und Ostsee. Ihre Entwicklung von den Anfängen bis zum Ende des 18. Jahrhunderts* (Berlin: Gebrüder Borntraeger, 1968).

Langlois, Gilles-Antoine, *Folies, tivolis et attractions. Les premiers parcs de loisirs parisiens* (Paris: Délégation à l'Action Artistique de la ville de Paris, 1991).

Lao-Zi, Taishang ganying pian 太上感應篇 [Chapters on Action and Response According to the Most High], in: *The Texts of Taoism*, trans. James Legge, vol. 2 [1891] (New York: Dover, 1962), pp. 235–246.

Lao-Zi, Taishang ganying pian 太上感應篇 [Chapters on Action and Response According to the Most High], in: *Taoist Texts: Ethical, Political and Speculative*, trans. Frederic Balfour (London: Trubner, 1894).

Lao-Zi, Taishang ganying pian 太上感應篇 [Chapters on Action and Response According to the Most High], in: *Treatise on Response and Retribution*, trans. D.T. Suzuki and Paul Carus [1906] (La Salle, IL: Open Court, 1973).

Lao-Zi, Taishang ganying pian 太上感應篇 [Chapters on Action and Response According to the Most High], in: *Lao-tzu's Treatise on the Response of the Tao*, trans. Eva Wong (San Francisco: HarperCollins, 1994).

Lardinois, Roland, Louis Dumont et la science indigène. *Actes* 106–107 (1997): 11–26.

Lasker-Schüler, Else, Der Letzte, in: *Das große deutsche Gedichtbuch*, ed. Karl Otto Conrady (Kronberg: Athenäum, 1977), p. 698.

Lattis, James M., *Between Copernicus and Galileo. Christoph Clavius and the Collapse of Ptolemaic Cosmology* (Chicago: University of Chicago Press, 1994).

Laudan, Rachel, Histories of the sciences and their uses. A review to 1913. *History of Science* 31 (1993): 1–34.

Launay, Adrien, *Histoire des Missions de l'Inde. Pondichéry, Maïssour, Coïmbatour.* Tome Premier (Paris: Ancienne Maison Charles Doumol, 1898).

Lavely, William, and Wong R. Bin, Revising the Malthusian narrative: The comparative study of population dynamics in late imperial China. *Journal of Asian Studies* 57 (1998): 714–748.

Lavely, William, James Lee, and Wang Feng, Chinese demography: The state of the field. *Journal of Asian Studies* 49 (1990): 807–834.

Le Blanc, Charles, *Huai-nan Tzu: Philosophical Synthesis in Early Han Thought* (Hong Kong: Hong Kong University Press, 1985).

Le Blanc, C., Résonance: Une interprétation chinoise de la réalité, in: *Mythe et philosophie à l'aube de la Chine impériale*, ed. C. Le Blanc and Rémi Mathieu, (Montréal: Les Presses de l'Université de Montréal, 1992), pp. 91–111.

Le Chéron d'Incarville, Pierre Nicolas, A Letter from Father D'Incarville, of the Society of Jesus, at Peking in China, to the Late Cromwell Mortimer, M. D. R. S. Secr. *Philosophical Transactions of the Royal Society* 48 (1753): 253–260.

Le Chéron d'Incarville, P.N., Manière De faire les fleurs dans les Feux d'Artifice Chinois. *Mémoires de mathématique et de physique Présentés à l'Académie Royale des Sciences, par divers Savans, and lus dans ses Assemblées* 4 (1763): 66–94.

Le Chéron d'Incarville, P.N., Manner of making Flowers in the Chinese Fireworks, illustrated with an elegantly engraved Copper-Plate. From the fourth Volume [just published] of the Memoirs presented to the Academy of Sciences. *Universal Magazine* 34 (1764): 20–23.

Le Chéron d'Incarville, P.N., Mémoire sur les vernis de la Chine. *Mémoires de Mathématique et de Physique présentés à l'Académie Royale des Sciences* 3 (1760): 117–142.

Le Comte, Louis, *Memoirs and observations typographical, physical, mathematical [...] made in a late journey through the empire of China* [1696] (London, 1697).

Lee, James, Cameron Campbell, and Wang Feng, Positive check or Chinese checks? *Journal of Asian Studies* 61 (2002): 591–607.

Lee, J., and Wang Feng, *One Quarter of Humanity: Malthusian Mythology and Chinese Realities, 1700–2000* (Cambridge, MA: Harvard University Press, 1999).

Legge, James, *The Chinese–English Bilingual Series of Chinese Classics, Book of Changes: The Great Treatise* (Changsha: Hunan Publishing House, 1993).

Legge, J., trans., *The Texts of Confucianism*, part 2, *The Yi King* (Oxford: Oxford University Press, 1899).

Legge, J., trans., *Xiaojing* (New York: St. John's University Press, 1966).

Leibniz, Gottfried Wilhelm, An Nicolas Hartsoeker, 29 April 1715 [no. CXX: enclosure in a letter from Leibniz to des Bosses], in: *Philosophische Schriften*, vol. 2, ed. C.J. Gerhardt (Berlin: Weidmannsche Buchhandlung, 1879).

Leibniz, G.W., Explication de l'arithmetique binaire, in: *Mémoires de l'Academie Royale des Sciences* (Paris: 1703).

Leibniz, G.W., The principles of nature and of grace, based on reason [1714], trans. Leroy E. Loemker, in: *Philosophical Papers and Letters*, ed. Leroy E. Loemker (Dordrecht: D. Reidel, 1969), pp. 636–642.

Leibniz, G.W., *Theodicy: Essays on the Goodness of God the Freedom of Man and the Origin of Evil*, trans. E.M. Huggard (Peru, Illinois: Open Court Publishing, 1985; online: http://www.gutenberg.org/files/17147/17147-8.txt).

Leonardo da Vinci, Der Codex Leicester [1506–1510], trans. Marianne Schneider, in: *Leonardo da Vinci—Josef Beuys. Der Codex Leicester im Spiegel der Gegenwart*, catalogue, ed. Haus der Kunst Munich and Martin-Gropius-Bau (Düsseldorf: Richter, 1999), pp. 71–217.

Leonardo da Vinci, The Notebooks, 2 vols., trans. Jean Paul Richter [1888] (The Project Gutenberg Online Book, 2004) [EText-No. 5000]. Cf. http://www.gutenberg.org/etext/5000.

Lettres édifiantes et curieuses. Memoires de l'Inde. Tomes 11–15. (Toulouse: Noel-Étienne Sens, 1810).

Lewin, Bruno, *Abriss der japanischen Grammatik* (Wiesbaden: Otto Harrassowitz, 1975).

Li Bozhong, Duotai, biyun, yu jueyu: Song Yuan Ming Qing Jiangzhe diqu de jieyu fangfa jiqi yunyong chuanbo [Abortion, contraception, and sterilisation: Birth control methods and their dissemination in Song-Yuan-Ming-Qing Jiangsu and Zhejiang], in: *Hunying, Jiating yu Renkou Xingwei: Dongxi Bijiao* [Marriage, family formation, and population behaviour: East–West comparisons], ed. James Lee, Songyi Guo and Yizhuang Ding (Beijing: Beijing University Press, 2000), pp. 71–99.

Li B., Kongzhi zengchang, yi bao fuyu: Qingdai qianzhongqi Jiangnan de renkou xingwei [Controlling growth to protect wealth: Population behavior in Jiangnan during the early and mid Qing period]. *Xin Shixue* 5 (1994): 25–70.

Li Shizhen, *The Great Pharmacopoeia*, vol. 37, *The Part of Woods·Amber* (Beijing: People's Hygiene and Health Press, 1982).

Li Shuzeng, Sun Yujie and Ren Jinjian, eds., *Zhongguo mingdai zhexue* 中國明代哲學 [Philosophy in China during the Ming Dynasty] (Zhengzhou: Henan renmin chubanshe, 2002).

Li, Jingwei, ed. *Zhongyi Renwu Cidian* [Dictionary of Chinese physicians] (Shanghai: Shanghai Zishu Press, 1988).

Li Zehou, Some thoughts on Ming-Qing Neo-Confucianism, in: *Chu Hsi and Neo-Confucianism*, ed. Wing-Tsit Chan (Honolulu: University of Hawaii Press, 1986), p. 553.

Libbrecht, Ulrich, *Chinese Mathematics in the Thirteenth Century: The Shu-shu chiu-chang of Ch'in Chiu-shao* (Cambridge, MA: Science Series, vol. 1, 1973).

Ling, Wang, On the invention and use of gunpowder and firearms in China. *Isis* 37 (1947): 160–178.

Liu An, *Huainanzi* 淮南子 (Han Dynasty).

Liu A., *Huainan Wanbishu* 淮南万毕术 [The Ten Thousand Infallible Arts of the Prince of Huai-Nan Li Fang 李昉], *Tai Ping Yu Lan* 太平御览.

Liu Baonan, *The Lunyu zhengyi* 論語正義 [Rectified Meanings of the Analects] (Qing Dynasty) (Beijing: Zhonghua shuju, 1990).

Liu Xianting, *Guang Yang Zaji* 广阳杂记 (Beijing: Zhonghua Publishing House, 1957).

Liu Xie, chapters yuandao 原道 and lici 麗辭, in: *Wenxin diaolong* 文心雕龍, ed. Huang Shulin, (Shanghai: Gudian wenxue, 1958), pp. 1–235.

Liu Xingbang, Lun Wang Fuzhi de "Tianren zhi xue 論王夫之的 天人之學' [On Wang Chuanshan's Study of the Relation between Heaven and Man]. *Chuanshan xuekan* 3 (2004): 32–45.

Liu Yeeloo, Is human history predestined in Wang Fuzhi's cosmology? *Journal of Chinese Philosophy* 28 [3] (2001): 321–338.

Lü Buwei, *Lüshi chunqiu* 呂氏春秋 [Master Lü's Spring and Autumn Annals], ed. Chen Qiyou 陳 奇 猷 (Shanghai: Xuelin, 1995).

Lü B., *Master Lu's Spring and Autumn Annals (Compendium of Natural Philosophy)* 呂氏春秋, *chapter of the Proficiency* 精通篇. (Han Dynasty).

Lucian, *Trips to the Moon*, ed. Henry Morley, trans. Thomas Francklin (The Project Gutenberg Online Book, 2003) [EText-No. 10430]. Cf. http://www.gutenberg.org/etext/10430.

Lucian, *Zum Mond und darüber hinaus (Ikaromenippus)*, trans. Christoph Martin Wieland (Zurich: Artemis, 1967).

Lucretius, *On the Nature of Things*, trans. William Ellery Leonard (The Project Gutenberg Online Book, 1997) [EText-No. 150]. Cf. http://www.gutenberg.org/etext/150.

Lucretius, *Von der Natur der Dinge (Titus Lucretius Carus: De rerum natura)*. Trans. Hermann Diels. Philosophische Bücherei 12 (Berlin: Aufbau, 1957).

Luk, Bernard H.K., Abortion in Chinese law. *American Journal of Comparative Law* 25 (1977): 372–392.

Lülizhi 律历志 [Memoir on the calendar and acoustic calculations], in: Wei Zheng, *Sui-Shu, Juan 16* 隋书, 卷16 [The Book of Sui, vol. 16] (636 A.D.).

Lu-Lu Jing-Yi 律呂精義 [The Essence of Luology]. *Nei-Pian* 內篇, 10 vols.; *Wai-Pian* 外篇, 10 vols. Zhu Zai-Yu 朱載堉 (1536–1611).

Lun-Heng 論衡 [Discourse Weighed in Balance]. Wang Chong 王充 (27–97).

Lun-Yu 論語 [Analects]. Compiled by the disciples of Confucius (551–479 BCE).

Lü-Shi Chun-Qiu 呂氏春秋 [Master Lü's Spring-Autumn Annals], written and compiled by Lü Bu-Wei 呂不韋 and scholars patronised by him.

Lu-Shi 路史 [The Peripatetic History]. Song 宋. Luo Bi 羅泌.

Lützeler, Egon, *Der Mond als Gestirn und Welt und sein Einfluß auf unsere Erde* (Cologne: Bachem, 1906).

Lü-Xue Xin-Shuo 律學新說 [A New Account of Lüology]. 4 vols. Zhu Zai-Yu 朱載堉 (1536–1611).

MacDonnell, Joseph, *Jesuit Geometers. A Study of Fifty-Six Prominent Jesuits Geometers during the First Two Centuries of Jesuit History* (St. Louis: Institute of Jesuit Sources, 1989).

Macknight, Thomas, *The Life of Henry St. John, Viscount Bolingbroke, Secretary of State in the Reign of Queen Anne* (London, 1863).

Magalhães, Gabriel de, *Nouvelle relation de la Chine* (Paris: 1688).

Makra, Mary Lelia, and Paul K.T Sih., eds., *The Hsiao Ching* (New York: St. John's University Press, 1961).

Malthus, Francis, *A treatise of artificial fire-vvorks both for vvarres and recreation. With divers pleasant geometricall obseruations, fortifications, and arithmeticall examples* (London, 1629).

Manitius, Karl, *Amalgest. Des Claudius Ptolemäus Handbuch der Astronomie. Aus dem Griechischen übersetzt und mit erklärenden Anmerkungen versehen von Karl Manitius*, 2 vols. [Leipzig: Teubner, 1912–1913] Revised edition with corrections and commentary by Otto Neugebauer (Leipzig: Teubner, 1963).

Masson-Oursel, Paul, Études de logique comparée. *Revue de Métaphysique et de Morale* 20 (1912): 811; 23 (1916): 343.

Mazzarino, Santo, La democratizzazione della cultura nel "Basso Impero", in: *XI Congrès international des sciences historiques, Rapports 2 Antiquitè* (Stockholm: Almqvist & Wiksell, 1960), p. 35–54.

Medas, Stefano, *De rebus nauticis. L'arte della navigazione nel mondo antico* (Rome: L'Erma di Bretschneider, 2004).

Meinel, Christoph, Les "Meteores" de Froidmont et les "Meteores" de Descartes, in: *Libert Froidmont et les resisitances aux revolutions scientifiques*, ed. *Anne-Catherine Bernès* (Haccourt: Association des vieilles familles de Haccourt, 1988), pp. 105–129.

Merkel, Franz Rudolf, *Leibniz und China* (Berlin: de Gruyter, 1952).

Meurer, Wolfgang, *Commentarii meteorologici* (Leipzig: Valentin Vögelin, 1592).

Miao Tianrui 缪天瑞, *Lüxue, di 3 Ban 律学, 第 3 版* [Study of the ritual tone system, 3rd. ed.] (Beijing: People's Music Publishing House, 1996).

Middleton, Henry, *The Voyage of Henry Middleton to the Moluccas, 1604–1606*, ed. Sir William Foster (London: Hakluyt Society, 1943).

Mignini, Filippo, *Matteo Ricci. Europa am Hofe der Ming* (Milan: Mazzotta, 2005).

Milev, Rossen, *Europäische Medien- und Kommunikationsgeschichte in Daten und Fakten* (Graz: Blimp, 2001).

Milev, R., and S. Lazarova About a 'virtual' letter-symbol in the Gothic alphabet. ℔ – a ligature, "Gothic cross", universal symbol of the Divine or an anagram of King Theoderic the Great? in: *Gotite/Goterna. Current Aspects of the Gothic Historical and Cultural Heritage in Bulgaria*, ed. Rossen Milev (Sofia: Balkanmedia, 2006), p. 99–104

Miner, Earl, *Comparative Poetics: An Intercultural Essay on Theories of Literature* (Princeton: Princeton University Press, 1990).

Mizauld, Antoine, *Meteorologia* (Paris: Reginaldus Calderius, 1547).

Mizuno, Kogen, *The Beginnings of Buddhism* (Tokyo: Konsei, 1980).

Morel, A.M. Th[omas], *Traité pratique des feux d'artifice pour le spectacle et pour la guerre, avec les petits Feux de table, et l'Artifice à l'usage des Théâtres* (Paris, 1818).

Morrison, J.R., *A Chinese Commercial Guide* (Canton, 1848).

Moscati, Sabatino, The wind in Biblical and Phoenician cosmogony. *Journal of Biblical Literature* 66 (1947): 305–310.

Mote, Frederick W., *Intellectual Foundations of China* (New York: Alfred A. Knopf, 1971).

Mulsow, Martin, *Frühneuzeitliche Selbsterhaltung. Telesio und die Naturphilosophie der Renaissance* (Tübingen: Max Niemyer, 1998).

Mungello, David E., *Leibniz and Confucianism. The Search for Accord* (Honolulu: The University Press of Hawaii, 1977).

Murr, S., Les Jésuites et l'Inde au XVIIIᵉ siècle. Praxis, utopie, préanthropologie. *Revue de l'Université d'Ottawa* 56 [1] (1986): 9–27.

Murr, S., *L'indologie du Père Coeurdoux. Stratégies, apologétique et scientificité* (Paris: Ecole Française d'Extrême-Orient, 1987).

Murr, Sylvia, Les conditions d'emergence du discours sur l'Inde au siècle des lumières. *Collection Purusartha* 7 (1983): 233–284.

Needham, Joseph, *Science and Civilisation in China*, vol. 2, History and Scientific Thought (Cambridge: Cambridge University Press, 1956).

Needham, J., *Science and Civilisation in China*, vol. 3, Mathematics and the Sciences of the Heavens and Earth (Cambridge: Cambridge University Press, 1959).

Needham, J., Wang Ling, and Kenneth G. Robinson, *Science and Civilisation in China*, vol. 4, Physics and Physical Technology, part 1, Physics (Cambridge: Cambridge University Press, 1962).

Needham, J., Wang Ling, and Lu Gwei-Djen, *Science and Civilisation in China*, vol. 4, Physics and Physical Technology, part 3, Civil Engineering and Nautics (Cambridge: Cambrige University Press, 1971; Taipei: Caves Books, 1985).

Needham, J., *Science and Civilisation in China*, vol. 5, Chemistry and Chemical Technology, part 7, Military Technology: The Gunpowder Epic (Cambridge: Cambridge University Press, 1986).

Newton, David E., Wind, in: *Encyclopedia of air*, ed. D.E. Newton (Westport: Greenwood Press, 2003), pp. 208–213.

Ng On-Cho, Religious hermeneutics: text and truth in Neo-Confucian Readings of the Yijing. *Journal of Chinese Philosophy* 34 [1] (2007): 5–24.

Nichter, Mark, Of ticks, kings, spirits, and the promise of vaccines, in: *Paths to Asian Medical Knowledge*, ed. Charles Leslie and Allen Young (Berkeley: University of California Press, 1992) pp. 224–255.

Nietzsche, Friedrich, *Beyond Good and Evil: Prelude to a Philosophy of the Future* [1886], trans. Helen Zimmern (New York: Dover Publications, 1997; online: http://users.compaqnet.be/cn127103/ns/select.htm).

Nieuhof, Johannes, *An embassy from the East-India Company of the United Provinces, to the Grand Tartar Cham, Emperor of China deliver'd by their excellencies, Peter de Goyer and Jacob de Keyzer, at his imperial city of Peking* (London, 1673).

Obrist, Barbara, Wind diagrams and medieval cosmology. *Speculum* 72 (1997): 33–84.

Observations physiques et mathematiques pour servir a l'histoire naturelle et à la perfection de l'astronomie et de la geographie. Envoyées des Indes et de la Chine à l'Académie Royale des Sciences à Paris, par les pères Jesuites avec les Reflexions de M^rs de l'academie et les Notes de P.Goüye, de la compagnie de Jesus (Paris: L'Imprimerie Royale, 1692).

Ogden, Charles Kay, and Ivor Armstrong Richards, *The Meaning of Meaning* [1923] (San Diego: Harcourt Brace Jovanovich, 1989).

Ou Ming, *Chinese–English Dictionary of Traditional Medicine* (Hong Kong: Joint Publishing Press, 1988).

Owen, Stephen, *Readings in Chinese Literary Thought* (Cambridge, MA: Harvard University Press, 1992).

Padovani, Fabrizio, *Tractato duo alter de ventis alter perbrevis de terraemotu* (Bologna: Battista Bellagamba, 1601).

Paik, Nam June, *Art for 25 Million People – Bonjour, Monsieur Orwell – Kunst und Satelliten in der Zukunft* (Berlin: DAAD Galerie, 1984).

Palmquist, Stephen, How "Chinese" was Kant? *The Philosopher* 84 (1996): 3–9; online: http://www.hkbu.edu.hk/~ppp/srp/arts/HCWK.html.

Pan Lusheng, *Zhongguo minjian jianzhi tuji* 中国民间剪纸图集 [Collection of Pictures of Chinese Popular Paper-cuts] (Beijing: Beijing gongyi meishu chubanshe, 1992).

Pan, Jixing, On the origin of rockets. *T'oung Pao* 73 (1987): 2–15.

Pan, J., The origin of rockets in China, in: *Gunpowder: The History of an International Technology*, ed. Brenda J. Buchanan (Bath: Bath University Press, 1996), pp. 25–32.

Paracelsus (Theophrast von Hohenheim), *De meteoris*, in: Paracelsus, *Sämtliche Werke*, vol. 1, 13 (Munich: Oldenbourg Verlag, 1996), pp. 125–206.

Parfaict, Claude, and François Parfaict, *Dictionnaire des théâtres de Paris*, 7 vols. (Paris, 1767).

Partington, J.R., *A History of Greek Fire and Gunpowder* (Cambridge: W. Heffer and Sons, 1960).

Perrinet d'Orval, Jean-Charles, *Manuel de l'artificier* (Paris, 1757).

Persson, Anders O., Hadley's principle. Understanding and misunderstanding the trade winds. *History of Meteorology* 3 (2006): 17–42.

Peterson, Williard, Review of Henderson. *Harvard Journal of Asian Studies* 46 [2] (1986): 660.

Petitjean, Patrick, Catherine Jami, and Anne Marie Moulin, eds., *Science and Empires* (Dordrecht: Kluwer, 1992).

Pfister, Louis (Fei Lai-Zhi 費賴之), *Notices biographiques et bibliographiques sur les Jésuites de l'ancienne mission de Chine (1552 to 1773)*. 2 vols. (Shanghai: Mission Press, 1932), trans. into Chinese 在 (入) 華耶穌會士列傳 by Feng Cheng-Jun 馮承鈞.

Pierce, John Robinson, *Symbols, Signals, and Noise. The Nature and Process of Communication* (London: Hutchinson, 1982).

Pifferi, Francesco, *La sfera di Giovanni Sacrobosco, tradotta e dichiarata* (Siena: Salvestro Marchetti, 1604).

Plato, *Der Staat*, trans. Kurt Hildebrandt (Stuttgart: Kröner, 1955).

Plato, *Ion*, trans. Benjamin Jowet (New York: Simon and Schuster, 1993; online: http://www.ellopos.net/elpenor/greek-texts/greek-word.asp#PLATO).

Plato, Phaedo, trans. Benjamin Jowett (The Project Gutenberg Onine Book, 1994) [EText-No. 1658]. Cf. http://www.gutenberg.org/etext/150.

Plato, *Phaidon oder von der Unsterblichkeit der Seele*, revised and based on the translation by Friedrich Schleiermacher (Stuttgart: Reclam, 1981).

Plato, *The Republic of Plato*, trans. Allan Bloom (New York: Basic Books, 1991^2).

Plato, *The Republic* [Politeia, 360 B.C.], trans. William Ellery Leonard (The Project Gutenberg Online Book, 1997) [EText-No. 150]. Cf. http://www.gutenberg.org/etext/150.

Plinius, Gaius Secundus, *Historiae Naturalis libri XXXVII* [Venedig, 1469]. German edition: *Natürlicher History Fünff Bücher*, 12 vols. (Frankfurt am Main, 1781–1788).

Pliny the Elder, *Natural history*, trans. Harris Rackham, 10 vols. (Cambridge, MA: Harvard University Press, 1938–1964).

Plutarch, *Das Mondgesicht. De facie in orbe lunae*. Introduction, trans., and ed. by Herwig Görgemanns (Zurich: Artemis, 1968).

Plutarch, *On the Face in the Moon* (Harvard: Loeb Classical Library edition, 1957); cf. http://penelope.uchicago.edu/Thayer/E/Roman/Texts/Plutarch/Moralia/The_Face_in_the_Moon*/home.html (2007).

Pomeranz, Kenneth, *The Great Divergence: China, Europe, and the Making of the Modern World Economy* (Princeton: Princeton University Press, 2000).

Pontano, Johannes, and Vitus Amerbach, *Liber de meteoris cum interpretatione Viti Amerbachii*, (Strassburg: Crato Mylium, 1539).

Priesner Claus, and Karin Figala, eds., *Alchemie. Lexikon einer hermetischen Wissenschaft* (Munich: C.H. Beck, 1998).

Proudfoot, William Jardine, *Biographical Memoir of James Dinwiddie* [...] *embracing some account of his travels in China* (Liverpool, 1868).

Ptolemäus, Claudius, *Tetrabiblos*. Nach der von Melanchthon besorgten seltenen Ausgabe aus dem Jahre 1553 (Tübingen: Chiron, 2000).

Putscher, Marielene, *Pneuma, Spiritus, Geist. Vorstellungen vom Lebensantrieb in ihren geschichtlichen Wandlungen* (Wiesbaden: Franz Steiner, 1973).

Qi Han, The role of French Jesuits in China and the Académie Royale des Sciences in the development of the seventeenth- and eighteenth-century European science, in: *East Asian Science. Tradition and Beyond*, ed. Hashimoto Keizô, Catherine Jami, and Lowell Skar (Osaka: Kansai University Press, 1995), pp. 489–492.

Qian W.H, Chen D., Zhu Y., and Shen H.Y., Temporal and spatial variability of dryness/wetness in China during the last 530 years. *Theoretical and Applied Climatology* 76 (2003): 13–29.

Qiao Xiaoguang, ed., *Life and Arts of Folk Paper-cutting Genius Inheritors in China. Zhongguo minjian jianzhi tiancai chuanchengzhe de shenghuo he yishu* 中国民间剪纸天才传承者的生活和艺术 (Taiyuan: Shanxi renmin chubanshe, 2004).

Raina, Dhruv, French Jesuit scientists in India: Historical astronomy in the discourse on India (1670–1770). *Economic and Political Weekly* 34 (1999): 30–38.

Raina, D., *Images and Contexts. The Historiography of Science and Modernity in India* (Oxford: Oxford University Press, 2003).

Raina, D., Jean-Baptiste Biot on the history of Indian astronomy (1830–1860): The nation in the post-Enlightenment historiography of science. *Indian Journal of History of Science* 35 [4] (2000): 319–346.

Raina, D., *Nationalism, Institutional Science and the Politics of Knowledge. Ancient Indian Astronomy and Mathematics in the Landscape of French Enlightenment Historiography* (Göteborg: Göteborgs Universitet, Institutionen för vetenskapsteori, Rapport Nr. 201, 1999).

Raina, D., The British Indological search for the origins of algebra and arithmetic in India (1780–1820), in: *Encyclopedia of the History of Science, Technology and Medicine in Non-Western Cultures*, ed. Helaine Selin (Dordrecht: Kluwer Academic Publishers, forthcoming).

Raina, D., *The French Jesuit Manuscripts on Indian Astronomy. The Narratology and Mystery Surrounding a Late Seventeenth Early Eighteenth Century Project* (forthcoming).

Rao, Cesare, *I meteori, i quali contengon quanto intorno a tale materia si può disidirare. Ridotti a tanta agevolezza, cha da qual si voglia, ogni poco ne gli studi esercitato potranno facilmente e con prestezza esser intesi* (Venice: Giovanni Varisco & Co., 1582).

Rawski, Evelyn S., and Jessica Rawson, eds., *China: The Three Emperors, 1662–1795* (London: Royal Academy of Arts, 2005).

Rawson, Jessica, The Qianlong emperor: Virtue and the possession of antiquity, in: *China: The Three Emperors, 1662–1795*, ed. Evelyn S. Rawski and Jessica Rawson (London: Royal Academy of Arts, 2005).

Redondi, Pietro, *Galileo. Heretic* (Princeton: Princeton University Press, 1987).

Riccioli, Giovanni Battista, *Almagestum novum astronomiam veterem novamque complectens observationibus aliorum et propriis novisque theorematibus, problematibus ac tabulis promotam* (3 vols) [Bologna, 1651].

Riccioli, G.B., *Astronomia reformata* (2 vols.) [Bologna, 1665].

Riley, Matthew, Straying from nature: The labyrinthine harmonic theory of Diderot and Bemetzrieder's "Leçons de clavecin" (1771). *The Journal of Musicology* 19 [1] (2002): 3–38.

Robinson, Kenneth, *A Critical Study of Chu Tsai-yu's Contribution to the Theory of Equal Temperament in Chinese Music* (Wiesbaden: Franz Steiner, 1980).

Ronan, Charles E., and Bonnie B.C. Oh, eds., *East Meets West. The Jesuits in China, 1582–1773* (Chicago: Loyola University Press, 1988).

Roser, Andreas et al., eds., *Kant-Konkordanz zu den Werken Immanuel Kants* (Hildesheim: Olms-Weidmann, 1993).

Rousseau, Jean-Jacques, *Julie, or the New Heloise. Letters of Two Lovers Who Live in a Small Town at the Foot of the Alps*, trans. Philip Stewart and Jean Vaché (Hanover: Dartmouth College; University Press of New England, 1997).

Rowbotham, Arnold H., The impact of Confucianism on seventeenth-century Europe. *The Far Eastern Quarterly* 4 (1945): 224–242.

Ruan Yi, and Hu Yuan, *Huangyou Xinyue Tuji* 皇佑新乐图记 [New illustrated record of musical matters of the Huang-you reign-period] (1034).

Ruggieri, Claude-Fortuné, *Elémens de pyrotechnie* (Paris, 1801).

Ruggieri, C.-F., *Précis historique sur les fêtes, les spectacles et les réjouissances publiques* (Paris, 1830).

Ruggieri, C.-F., *Principles of Pyrotechnics*, trans. Stuart Carlton [1821] (Buena Vista: MP Associates, 1994).

Rulan Chao Pian, *Song Dynasty Musical Sources and Their Interpretation* (Cambridge, MA: Harvard-Yenching Institute, 1967; Hong Kong: The Chinese University Press, 2003).

Sabra, Abdelhamid I., trans. *The Optics of Ibn al-Haytham.* Books I, II, III: On Direct Vision. English translation and commentary, 2 vols. Studies of the Warburg Institute vol. 40 (London: The Warburg Institute, University of London, 1989).

Said, Edward W., *Orientalism* (London: Penguin, 1978).

Salatino, Kevin, *Incendiary Art. The Representation of Fireworks in Early Modern Europe* (Santa Monica: Getty Research Institute for the History of Art and Humanities, 1997).

Sarton, George, *Introduction to the History of Science*, vol. 3: Science and Learning in the Fourteenth Century (Baltimore: Williams & Wilkins, 1947).

Saussy, Haun, *The Problem of a Chinese Aesthetic* (Stanford: Stanford University Press, 1993).

Schafer, Joseph, *The History of North America*, vol. 10. The Pacific Slope and Alaska (Philadelphia: George Barrie, 1904).

Schaffer, Simon, Instruments as cargo in the China trade. *History of Science* 44 (2006): 217–246.

Scheiner, Christoph, *Tres epistolae de maculis solaribus* [Augsburg, 1612].

Schiebelhuth, Hans, An den Mond, in: Conrady, *Das große deutsche Gedichtbuch* (Kronberg: Athenäum, 1977), p. 846.

Schmitt, Charles B., Changing conceptions of vacuum (1500–1650), in: *Actes du XIe congrès international d'histoire des sciences*, vol. 3 (Wrocław: Ossolineum, 1968).

Schmitt, C.B., Experimental evidence for and against a void. The sixteenth-cenury arguments. *Isis* 58 (1967): 352–366.

Schneider-Carius, Karl, *Wetterkunde - Wetterforschung. Geschichte ihrer Probleme und Erkenntnisse in Dokumenten aus drei Jahrhunderten* (Freiburg: Karl Alber, 1955).

Schoy, Carl, ed., *Abhandlung des Schaichs Ibn Ali Al-Hasan Ibn Al-Hasan Ibn Al-Haitham, "Über die Natur der Spuren (Flecken), die man auf der Oberfläche des Mondes sieht"* (Hannover: Orient-Buchhandlung Heinz Lafaire, 1925).

Schramm, Matthias, *Ibn al-Haythams Weg zur Physik* (Wiesbaden: Franz Steiner, 1963).

Schwarze, R., Jodocus Willich. *Allgemeine Deutsche Biographie* 43 (1898): 278–282.

Semedo, Alvaro, *The history of that great and renowned monarchy of China wherein all the particular provinces are accurately described, as also the dispositions, manners, learning, lawes, militia, government, and religion of the people* [1642] (London, 1655).

Seneca, *Natural Questions*, trans. Thomas H. Corcoran, 2 vols. (London: William Heinemann, 1971–1972).

Sezgin, Fuat, *Geschichte des arabischen Schrifttums. Band 7: Astrologie—Meteorologie und Verwandtes bis ca. 430 H* (Leiden: Brill, 1979).

Shan-Hai Jing 山海經 [Classic of the Mountains and Rivers) Zhou 周 and Western Han 漢. Writers unknown.

Sharma, Virendra Nath, The impact of eighteenth century Jesuit astronomers on the Astronomy of India and China. *Indian Journal of History of Science* 17 [2] (1982): 345–352.

Shen Kuo 沈括, *Dream Pool Essays* 梦溪笔谈 (Song Dynasty).

Shen Kuo, Yuelü, Juan 6 乐律, 卷6 [Music and temperament, vol. 6], in: *Mengxi Bitan* 梦溪笔谈 [Dream Pool Essays], Song Dynasty (960–1279 A.D.); Dream Pool Essays printed in the Yuan Dynasty (1271–1368 A.D.) (Beijing: Cultural Relics Publishing House, 1975).

Shi-Suo Suan-Shu 釋鎖算書 [Mathematics Book on the Method of Unlocking by Binomial Coefficients] (ca. 1010, lost book). Jia Xian's 賈憲 (fl. 1010–1025).

Shuowen jiezi quanwen jiansuo shiban 說文解字全文檢索試版, http://shuowen.chinese99.com/index.php.

Qin Jiu-Shao 秦九詔 (1202–1261), *Shu-Shu Jiu-Sang* 數書九章 [Mathematics Treatise in Nine Chapters] (1247).

Sima Qian 司马迁, *Shi Ji* 史记, vol. 118, *Huainan Wang Zhuan* 淮南王传 (Beijing: Zhonghua Publishing House, 1959).

Simon, Gérard, *Der Blick, Das Sein und die Erscheinung in der antiken Optik. Mit einem Anhang: Die Wissenschaft vom Sehen und die Darstellung des Sichtbaren* [Le regard, l'être et l'apparence dans l'Antiquité, Paris: Seuil, 1988], trans. Heinz Jatho, ed. Gottfried Boehm and Karlheinz Stierle, Bild & Text series (Munich: Fink, 1992).

Simon, G., Science de la vision et représentation du visible. Le regard de l'optique antique. *Les Cahiers du Musée National d'Art Moderne*, special issue, *Visions* 37 (1991): 5–21.

Simon, Renèe, Voyage de P.N. Le Chéron d'Incarville en Chine sur le Jason 1740. *Archivum Historicum Societatis Iesu* XL, 80 (1971): 423–436.

Si-Shu 四書 [Four Classics], Zhou 周.

Sivin, Nathan, *Science in Ancient China. Researches and Reflections* (Aldershot: Variorium, 1995).

Sivin, N., *Science, Medicine, and Technology in East Asia*, vol. 2 (Ann Arbor: Center for Chinese Studies, 1988).

Sivin, N., Shen Kua: A preliminary assessment of his scientific thought and achievements. *Sung Studies Newsletter* 13 (1977): 31–56.

Sivin, N., and Shigeru Nakayama, eds., *Chinese Science: Explorations of an Ancient Tradition*, East Asian Science series (Cambridge, MA: MIT Press, 1973).

Zhu Shi-Jie 朱世傑, *Si-Yuan Yu-Jian* 四元玉鑑 [*Reflections in Mathematics up to Four-Variables*], (1303).

Sobel, Jordan Howard, Kant's Compass. *Erkenntnis* 46 (1997): 365–392.

Song Jie, Changes in dryness/wetness in China during the last 529 years. *International Journal of Climatology* 20 (2000): 1003–1015.

Song Lian 宋濂, *History of Yuan Dynasty* 元史, in: *Records of Five Elements*, vol. 51 (Beijing: Zhonghua Publishing House, 1976).

Song Yingxing, *Lun Qi*, in: *YeYi, Lun Qi, Tan Tian, Silan Shi* (Shanghai: Renmin chubanshe 1975).

Spence, Jonathan D., *The Chan's Great Continent. China in Western Minds* (London: Penguin, 1998).

Spence, J.D., *The Memory Palace of Matteo Ricci* (London: Penguin, 1985).

Stabile, Giorgio, Michelangelo Biondo. *Dizionario biografico degli italiani* 10 (1968): 560–563.

Stanhuf, Michael, *De meteoris libri duo* (Wittenberg: Creutzerus, 1554).

State Meteorological Administration of China, *Yearly Charts of Drought/Floods in China for the Last 500 Years (1470–1979)* (Beijing: Cartography Press of China, 1981).

Steinsaltz, Adin, *The Talmud: A Reference Guide* (London: Random House, 1996).

Stoichita, Victor I., *A Short History of the Shadow* (London: Reaktion Books, 1997).

Storey, William K., ed., *Scientific Aspects of European Expansion. An Expanding World—The European Impact on World History 1450–1800*, vol. 6 (Aldershot: Variorum, 1996).

Su Gong, *Notes on Pharmacopoeia of the Tang Dynasty* 唐本草注 (Tang Dynasty).

Sui Shu 隋書 [The History of the Sui Dynasty 581–617] (Tang 唐 636, annals and biographies; 656 monographs and bibliography). Wei Zheng 魏徵 et al.

Sun-Zi Suan-Jing 孫子算經 [Master Su's Mathematical Manual] (ca. 280 or later). Sun Zi 孫子 (Master Sun, full name unknown).

Svärdström, Elisabeth, Der Runenring von Pietroasa, ein à-propos, in: *Studia gothica*, ed. Ulf Erik Hagberg (Stockholm: Almqvist & Wiksell, 1972), p. 117–119.

Tang Shenwei, *Reorganized Pharmacopoeia*, vol. 4, *Yu Shi Bu* 证类本草, 卷4玉石部 (Song Dynasty).

Tao Zongyi, *Talks (at South Village) while the Plough is Resting* 南村辍耕录 (Yuan Dynasty).

Taub, Liba, *Ancient Meteorology* (London: Routledge 2003).

Taylor, Eva Germaine Rimington, *The Haven-finding Art. A History of Navigation from Odysseus to Captain Cook* (New York: Abelard-Schuman Ltd., 1957).

Taylor, F. Sherwood, The idea of the quintessence, in: *Science, Medicine and History. Essays on the Evolution of Scientific Thought and Practice Written in Honour of C. Singer*, ed. Edgar Ashworth Underwood, vol. 1 (London: Oxford University Press, 1953), pp. 247–265.

Taylor, F.S., The origin of the thermometer. *Annals of Science* 5 (1942): 129–156.

Telesio, Bernardino, *De his quae in aere fiunt*, in: B. Telesio, *Varii de naturalbus rebus libelli* (Venice: Felice Valgrisio, 1590).

Teltscher, Kate, *India Inscribed. European Writing and British Writing on India* (Oxford: India Paperbacks, 1995).

The Bible. New International Version, ed. International Bible Society. Cf. http://biblegateway.com/versions/?action=getVersionInfo&vid=31 (5/2007).

Thomas, Craig, Experience of the New World and Aristotelian revisions of the Earth's climates during the Renaissance. *History of Meteorology* 3 (2006): 1–16.

Thorndike, Lynn, *A History of Magic and Experimental Science*, 8 vols. (New York: Columbia University Press, 1923–1970).

Tian Wuze, Lun Xiansheng Leibie 论相生类别 [Discussion on types of mutual generation], in: *Yueshu Yaolu, Juan 5 乐书要录, 卷5* [Selections from music books, vol. 5] (Tang Dynasty 618–907).

Tierie, Gerrit, *Cornelis Drebbel (1572–1633)* (Amsterdam: Paris, 1932).

Tomai, Tomaso, *Dialogo meteorologico, nel quale brevemente e con piacevolezza si ragiona di molti maravigliosi effetti, dalla natura prodotti* (Ancona: Astolfo Grandi, 1566).

Tomescu, Dorina, Der Schatzfund von Pietroasa, in: *Goldhelm, Schwert und Silberschätze. Reichtümer aus 6000 Jahren rumänischer Vergangenheit*, ed. W. Meier-Arendt and L. Marinescu (Frankfurt am Main: cIMeC – Institutul de Memorie Cultural, 1994), p. 56.

Torricelli, Evangelista, *Lezioni accademiche* (Milan: Giovanni Silvestri, 1823).

Trigault, Nicolaus, *De Christiana expeditione apud Sinas* (Vienna: 1615).

Troitzsch, Ulrich, Technischer Wandel in Staat und Gesellschaft zwischen 1600 und 1750, in: *Mechanisierung und Maschinisierung. 1600 bis 1840*, ed. Akos Paulinyi and Ulrich Troitzsch (Berlin: Ullstein, 1997) (Propyläen Technikgeschichte 3), pp. 9–267.

Tsai Tai-Bing, *Yellow Sorrow and Pan Ji-xun's Water Management in Late Ming* (Taipei: Ler-Xue Bookstore, 1998).

Tu Weiming, *Confucian Thought: Selfhood as Creative Transformation*. SUNY Series in Philosophy (Albany: State University of New York Press, 1985).

Tu W., The continuity of being: Chinese visions of nature, in: *On Nature*, vol. 6, ed. Leroy R. Rouner (Paris: University of Notre Dame Press, 1984), pp. 113–129.

Tydeman, William, Glynne Wickham, John Northam, and W.D. Howarth, eds., *The Medieval European Stage 500–1550* (Cambridge: Cambridge University Press, 2001).

Tyndall, John, *Sound* [1875] (London: Longmans, Green & Co., 2005).

Valleriani, Matteo, From "condensation" to "compression": How Renaissance Italian engineers approached Hero's "Pneumatics", in: *Weight, Motion and Force: Conceptual Structural Changes in Ancient Knowledge as a Result of Its Transmission*, Max Planck Institute for the History of Science, Preprint 320 (Berlin: 2006), pp. 43–61.

Varey, J.E., Les spectacles pyrotechniques en Espagne (XVIe-XVIIe siècles), in: *Les Fêtes de la Renaissance*, ed. Jean Jacquot, 2nd edition, 3 vols. (Paris: Editions du Centre National de la Recherche Scientifique, 1975), vol. 3, pp. 619–634.

Vasil'iev, V.N., *Starinnye feierverki v Rossii (XVII- pervaia chetvert' XVIII veka)* (Leningrad: Izdatel'stvo Gos. Ermitazha, 1960).

Verbeke, Gérard, *L'évolution de la doctrine du pneuma du stoicisme á S. Augustin* (New York: Garland Publishing, Inc. 1987).

Vermeer, E.B., 'P' an Chi-hsün's solution for the Yellow River problems of the late 16th century. *T'oung Pao* 70 (1987): 33–67.

Vermeer, E.B., The rise and fall of a man-made lake: Training Lake in Jiangnan, China, 300–2000 A.D. (Nankai: Nankai Conference on China's Environment, 2005).

Verne, Jules, *All Around the Moon*, trans. Edward Roth (The Project Gutenberg Online Book, 2005) [EText-No. 16457]. Cf. http://www.gutenberg.org/etext/16457.

Verne, J., *Reise um den Mond* (Neu Isenburg: Metzler, 2005).

Vimercati, Francesco, *In quattuor libros Aristotleis meteorologicorum commentarii* (Rome: Bladus & Osmarinus, 1570).

Vitruvius, *On Architecture*, ed. and trans. Frank Granger, 2 vols. (Cambridge, MA: Harvard University Press, 1931–1934).

Volpi, Franco, ed., *Großes Werklexikon der Philosophie*, 2 vols. (Stuttgart: Kröner, 2004).

Voltaire (i.e. François Marie Arouet), *Traité de métaphysique* [1734] (Paris: Delanglie, 1826).

Waley-Cohen, Joanna, China and Western technology in the late eighteenth century. *American Historical Review* 98 (1993): 1525–1544.

Walker, Daniel Pickering, *Spiritual and Demonic Magic from Ficino to Campanella* (Leiden: Brill, 1958).

Wallace, William A., *Galileo, the Jesuits, and the Medieval Aristotle* (Hampshire, U.K.: Variorum, 1991).

Walters, Derek, *Chinese Mythology: An Encyclopedia of Myth and Legend* (London: Aquarian Press, 1992).

Wang Chong, *Lun Heng* 論衡 [Discourse weighed in balance]. Annotated full-text edition by Zheng Wen (1999).

Wang Fuzhi, *Jiang Zhai shihua* 姜斋詩話 [Poetry and prosa of Jiang Zhai] (Beijing: Renmin wenxue chubanshe 1981).

Wang Zhenduo, *Discovery and Application of Magnetic Phenomena in China. Collection of Science, Technology and Archaeology* (Beijing: Cultural Relics Publishing House, 1989).

Wang Zichu, *Zhonguo Yinyue Wenwu Daxi Shanghai Jiangsu Juan* 中国音乐文物大系上海江苏卷 [A series of books of Chinese musical relics, vol. on Shanghai and Jiangsu] (Zhengzhou: Henan Daxiang (Elephant) Publishing House, 1996).

Wang Risheng, Wang Shaowu, and Klaus Fraedrich, An approach to reconstruction of temperature on a seasonal basis using historic documents from China. *International Journal of Climatology* 11 (1991): 381–392.

Webb, John, *An historical essay endeavoring a probability that the language of the empire of China is the primitive language* (London, 1669).

Weitzmann, Kurt, ed., *Age of Spirituality. Late Antique and Early Christian Art, Third to Seventh Century* (New York: Metropolitan Museum of Art, 1977).

Weller, Robert, and Peter Bol, From heaven-and-earth to nature: Chinese concepts of the environment and their influence on policy implementation, in: *Confucianism and Ecology (The Interrelation of Heaven, Earth, and Humans)*, ed. Mary Evelyn Tucker and John Berthrong, (Cambridge, MA: Harvard University Press, 1998), pp. 313–342.

Wilhelm, Richard, *I Ging. Das Buch der Wandlungen* (Jena: Diederichs, 1924); English edition: *I Ching, or Book of Changes*, ed. H. Wilhelm, trans. C.F. Baynes (New York: Bollingen-Panthenon, 1950).

Willich, Jobst, *Isagoge in Aristotelis, Alberti Magni et Pontani meteora, per tres libros digesta* (Frankfurt am Main: Scivrus, 1549).

Wilpert, Clara B., *Schattentheater* (Hamburg: Selbstverlag, 1973).

Winter, Frank H., *The First Golden Age of Rocketry. Congreve and Hale Rockets of the Nineteenth Century* (Washington, D.C.: Smithsonian Institution Press, 1990).

Wolf, Arthur P., Is there evidence of birth control in late imperial China? *Population and Development Review* 27 (2001): 133–154.

Wolper, Roy S., The rhetoric of gunpowder and the idea of progress. *Journal of the History of Ideas* 31 (1970): 589–598.

Wong R. Bin, *China Transformed: Historical Change and the Limits of European Experience* (Ithaca: Cornell University Press, 1997).

Wong Sui-Kit, *Notes on Poetry from the Ginger Studio* (Hong Kong: Chinese University Press, 1987).

Wroth, Warwick, *The London Pleasure Gardens of the Eighteenth Century* (London: Macmillan, 1896).

Wu Yi-Li, Ghost fetuses, false pregnancies, and the parameters of medical uncertainty in classical Chinese gynecology. *Nan Nü* 4 (2002): 170–206.

Yang Hui 楊輝 (fl. 1261–1275). *Xiang-Jie Jiu-Zhang Suan-Fa* 詳解九章算法 [A Detailed Analysis of the Mathematical Methods in the 'Nine Chapters'] (1261).

Xiao jing zhu shu 孝經注疏 [Notes and Commentaries on the Classic of Filial Piety] Shisan jing zhushu fu jiaokan ji (1815; reprint, Beijing: Zhonghua, 1987).

Xiao Zixian, *Book of Southern Qi*, vol. 19, in: *Records of Five Elements* (Beijing: Zhonghua Publishing House, 1972).

Xie Zaihang, *Wu Za Zu* 五杂俎 (Ming Dynasty).

Xu Dachun, *Yilüe Liushu, Nüke Zhiyan* [Medical compendium in six books, experiences in gynaecology], first published eighteenth century (Beijing: Renming Weisheng Press, 1988).

Xu, Fei, Dayin Xisheng—Zhu Zaiyu shi'er Pingjunlü Yanjiu 大音希声—朱载堉十二平均律研究 [Great music is soft sound—Studies on Zhu Zaiyu's 12-tone equal temperament], in: *Zhongguoren Wenhua Shehui Kexue Boshi Shuoshi Wenku* 中国人文社会科学博士硕士文库 (哲学卷) [A dissertation library of Chinese doctor and master of social sciences and humanities, vol. on philosophy] (Hangzhou: Zhejiang Education Publishing House, 2005).

Xu F., Songdai Ruan Yi Hu Yuan Yijing Guanlü Shengxue Chengjiu de Shuli Yanzheng 宋代阮逸胡瑗异径管律声学成就的数理验证 [Physical analysis on the acoustical achievement of Ruan Yi's and Hu Yuan's pitch-pipes with varying diameters]. *Ziran Kexue Shi Yanjiu* 自然科学史研究 [Studies in the history of natural sciences] 20 [3] (2001): 206–214.

Xu F., Xijin Meng Kang Yijing Lüguan Kaozheng 西晋孟康异径律管考证 [Textual research on the pitch-pipes with varying diameters of Meng Kang from the Western Jin Dynasty]. *Zhongguo Keji Shi Liao* 中国科技史料 [Material about the history of science and technology in China] 21 [3] (2000): 251–258.

Xu F., and Xia Ji, Handai Yingao Biaozhunqi Xingzhi 汉代音高标准器形制的重要参考 [Important Reference on shapes and making of musical tuning instruments in the Han Dynasty]. *Kexue Jishu yu Bianzhengfa* 科学技术与辩证法 [Science technology and dialectics] 20 [6] (2003): 72–73.

Xu F., Xia Ji, and Wang Changsui, Jiahu Gudi Yinyue Shengxue Texing de xin Tansuo 贾湖骨笛音乐声学特性的新探索 [New research of acoustics characteristic of Jiahu bone flute]. *Yinyue Yanjiu* 音乐研究 [Music research] 112 [1] (2004): 30–35.

Xu Jiongxin, A study of long term environmental effects of river regulation on the Yellow River of China in historical perspective. *Geografiska Annaler. Series A, Physical Geography* 75 (1993): 61–72.

Xun Qing 荀卿 (313–238 BCE), *Xun Zi* 荀子 [The Book of Master Xun] (240 BCE).

Yang Weide, *Ying Yuan Zongmu* 茔原总录, vol. 1, *Zhu Shan Lun* 主山论 (Song Dynasty).

Yang Yinliu, *Zhongguo Gudai Yinyue Shi Gao* 中国古代音乐史稿 [A draft history of music in ancient China] (Beijing: People's Music Publishing House, 1981).

Yao Kuan, *Xixicongyu* 西溪丛语, vol. 1 (Song Dynasty).

Ye Gui, *Linzheng zhinan yi'an* [Medical records as a guide to diagnosis], preface 1776 (Taipei, Chongde Bookshop, 1984).

Yeh, Michelle, A new orientation to poetry: The transition from traditional to modern (in essays and articles), in: *Chinese Literature: Essays, Articles, Reviews (CLEAR)* 12 (1990): 83–105.

Yi Jing 易經 [Book of Changes], Zhou 周. Also known as *Zhou Yi* 周易. *Gui Cang* 歸藏. ; includes appendix additions from later periods, compilers unknown.

You Yi, *Latter Collection of the Problems on Astronomy, The Chapter of Universal Movement* 天经或问后集, 天转篇 (Qing Dynasty).

Yu Han, *Shanfang Jiyishu* 山房辑佚书, compiled by Ma Guohan 马国翰 (Qing Dynasty).

Yue Ji 樂記 []Record of Music] (5th century BCE). Incorporated in the *Li Ji* 禮記 in the first century B.C.

Yun-Ji Qi-Qian 雲笈七籤 [Yun-Ji Seven Tablets] (Song 宋 ca. 1019–1025). Zhang Jun-Fang 張君房.

Zeitlin, Judith T., The literary fashioning of medical authority: A study of Sun Yikui's case histories, in: *Thinking with Cases: Specialist Knowledge in Chinese Cultural History*, ed. C. Furth, J.T. Zeitlin, and Hsiung P. (Honolulu: University of Hawai'i Press, 2007) pp. 169–202.

Zeng Gongliang, *Collection of the Most Important Military Techniques*, vol. 15 武经总要前集卷 15 (Song Dynasty).

Zeng Zi 曾子 [The Book of Master Zeng] (5th century BCE). This is a book put together by the followers of Zeng Can 曾參 on some of his original teachings. According to the Yi-Wen Zhi 藝文志 section of the *Qian-Han Shu* 前漢書 [History of the Former Han Dynasty], the *Zeng Zi* has eighteen chapters, but subsequent mentions of the book found in later works all state that it has only ten chapters. Incorporated in the *Da-Dai Li-Ji* 大戴禮記 [Records of Rites] in the first century B.C. A commentary to the *Zeng Zi* was written in 1798 by Ruan Yuan 阮元.

Zhang Hua, *Bo Wu Zhi* 博物志, vol. 9 (Beijing: Zhonghua Publishing House, 1980).

Zhang Juzhong, Garman Harbottle, Wang Changsui, and Kong Zhaocheng, Oldest playable musical instruments found at Jiahu early Neolithic site in China. *Nature* 401 (1999): 366–368.

Zhang Qiu-Jian, *Zhang-Qiu-Jian Suan-Jing* 張邱建算經 [Zhang Qiu-Jian's Mathematical Book], written between 468 and 486.

Zhang Tingyu, et al., *Ming Shi* 明史, vol. 29, in: *Records of Five Elements* 五行志 (Beijing: Zhonghua Publishing House, 1974).

Zhang Zhou, *Ji Lei Pian* 鸡肋篇 (Song Dynasty).

Zhao Rukuo, *Records of Foreign Peoples* 诸藩志 (Song Dynasty).

Zhao Zhongwei, Fertility control in China's past. *Population and Development Review* 28 (2002): 751–757.

Zheng Wen, Lun Heng xiji 論衡析诂 [Analysis of the Discourse Weighed in Balance] (Chengdu: Bashu shuji 1999).

Zhong Rong, *Shipin* 詩品 [Pieces of Poetry], in: Zhong Rong, Sikong shipin 鍾嶸司空詩品 [Pieces of Poetry by Zhong Rong and Sikong (Tu)] (Shanghai: Zhonghua shuju 1936). See also *Sibu beiyao*-edition.

Zhong Yong 中庸 [Doctrine of the Mean] (4th century BCE), trans. into Latin by Prosperus Intorcetta (Yin Duo-Ze 殷鐸澤) with the title *Sinarum scientia politico-moralis* (1667).

Zhou Li 周禮 [The Book of Zhou Institutions]. Compiled in the second century B.C. Compilers unknown.

Zhu Bin, *Li ji xun cuan* 禮記訓纂 [Annotated Interpretation of the Book of Rites] (reprint, Beijing: Zhonghua shuju 1988, Shisan jing Qing ren zhushu series).

Zhu Yan, *Tao Shuo* 陶说 *The Theory of Pottery and Porcelain*, vol. 3, *Manufacturing Methods* (Tianjin: Tianjin Ancient Books Publishers, 1988).

Zhu Yu, *Pingzhou Table-Talk* 萍州可谈 (Song Dynasty).

Zhu Zaiyu, *Lüxue Xinshuo* 律学新说 [New account of the sciences of the pitch-pipes], (1584).

Zhu Z., *Jialiang Suanjing* 嘉量算经 [Fine measure and calculating manual].

Zhu Z., *Lülü Jingyi* 律吕精义 [The essential meaning of the standard pitch-pipes], (1596).

Zhu Z., *Suanxue Xinfa* 算学新说 [New account of the science of calculation in acoustics and music], (1603).

Zhu Z., *Xuangong Heyuepu* 旋宫合乐谱 [Melodies for harmonious ancient music], (1606).

Zhu Z., *Yuelü Quanshu* 乐律全书 [Collected works on music and the pitch-pipes], (1620).

Zhuang Zhou, *Zhuang Zi* 莊子 [The Book of Master Zhuang] (ca. 290 B.C.).

Zielinski, Siegfried, *Archäologie der Medien*, preface of Chinese edition, trans. Rong Zhenhua荣震华 (Beijing: The Commercial Press, 2006). German original: *Archäologie der Medien. Zur Tiefenzeit des technischen Hörens und Sehens* (Reinbek bei Hamburg: Rowohlt, 2002); English translation: *Deep Time of the Media, Towards an Archaeology of Hearing and Seeing by Technichal Means*, trans. Gloria Custance (Cambridge, MA: MIT Press, 2006).

Zinner, Ernst, Die Fränkische Sternkunde im 11. bis 16. Jahrhundert, in: *XXVII. Bericht und Festbericht zum Hundertjährigen Bestehen der Naturforschenden Gesellschaft in Bamberg* (Bamberg: Buch- und Kunstdruckerei J.M. Reindl, 1934), pp. 1–118.

Zuccolo, Vitale, *Discorso delle cose meteorologiche* (Venice: Paolo Megietti, 1590).

Zuoqiu Ming, *Zuo Zhuan* 左傳 [Master Zuoqiu's Commentary on the Spring-Autumn Annals] (ca. 5th century B.C.). Deals with the period 722–453 B.C..

Županov, Ines G., *Disputed Mission: Jesuit Experiments and Brahmanical Knowledge in Seventeenth Century India* (New Delhi; New York: Oxford University Press, 1999).

Županov, I.G., *Missionary Tropics: The Catholic Frontier in India (16th–17th Centuries)* (Ann Arbor: University of Michigan Press, 2005).

Андреева, Виктория./Ровнер, Аркадий Алфавит (The Alphabet), in: Егазаров, Альберт *Иллюстрованная Энциклопедия символов* (Moscow: Астрель, 2003).

Дьяконов Игорь,О писмености, in: *Дирингер, Д. Алфавит* (Moscow: Издательство иностранной литературы, 1963), p. 20 and 629.

Коельо, Пауло , Другата страна на Вавилонската кула, *24 часа* (Sofia, 25.07.2005).

Кондратов, Александр, *Книга о букве* (Moscow: "Советская Россия", 1975).

Королева, Кирилла (Ed.) *История письма* (Moscow: Terra Fantastica, 2003).

Марков, Николай, *Християнската символика* (Sofia: "Будител", 2006).

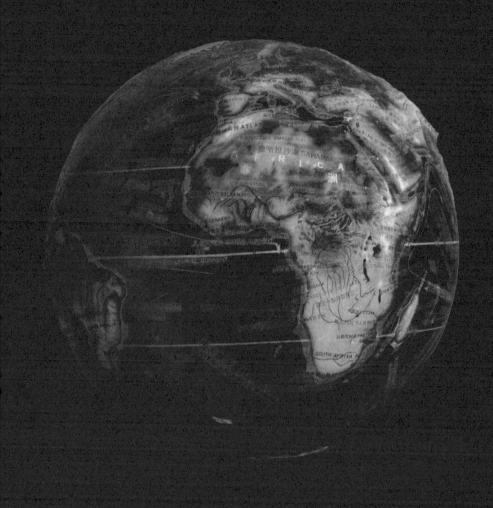

Worldprocessor [#10]

"Worldprocessor"—A Series of globes mapping planetary
conditions of the present and past. 1988–2008.

Many of the conditions and factors that we accept as constituents
of reality can be considered quantifiable, however, data sets do not
necessarily come in color or form and shape. The Worldprocessor
project—now on its 20th year is trying to give shape and dimension
to planetary phaenomena and conditions. At the same time it attempts
to be an as instant an interface to the world as possible. Leibniz is said
to have been the last man to hold the entire body of knowledge of his
time. Decades ago 'planetary technologies' as Heidegger called them,
empowered mankind beyond emotional, sensual, and moral capacities.
In 1492 Martin Behaim, German navigator based on the Azores,
completed the very first globe still in existence. It was a useful tool to
persuade German traders to invest in a Portuguese expedition to China.
Ironically, the globe became almost instantly obsolete as Columbus
discovered America the same year.

Index of Names

Many thanks to Franziska Latell for her great help.

Index of Places

Index of Subjects

VARIANTOLOGY 1

On Deep Time Relations of Arts,
Sciences and Technologies.

Edited by Siegfried Zielinski
and Silvia M. Wagnermaier.
230 x 155 mms, 384 pp., 29 color
and 21 b/w illus., paperback.
Kunstwissenschaftliche Bibliothek,
Vol. 31, edited by Christian Posthofen.

ISBN 3-898375-914-7, € 58,–

The work processes for VARIANTOL-
OGY try to react naively to a culture of
bloc formation and programmatic
standardisation. In contrast to the het-
erogeneous, with its ponderous oscilla-
tions in ontology and biology, we are
interested in the variant both method-
ologically and epistemologically as a
mode characterised by lightness and
ease. As such, the variant is equally at
home in experimental art, science and
media praxes. To vary something that
is established is an alternative to
destroying it—a strategy that played a
prominent role and was favoured by
many avant-garde movements in the
twentieth century.

VARIANTOLOGY 2

On Deep Time Relations of Arts,
Sciences and Technologies.

Edited by Siegfried Zielinski
and David Link.
230 x 155 mms, 450 pp.,
40 illus., paperback.
Kunstwissenschaftliche Bibliothek,
Vol. 35, edited by Christian Posthofen.

ISBN 978-3-86560-050-9, € 48,–

What does a 13th cent Majorcan mis-
sionary have to do with the logic by which
machines operate? Were medieval astro-
labes solely for calculating the orbits of
stars and planets or were they philoso-
phical instruments as well? Can com-
puters write love letters and where do
radar angels live? What do the origins
of the lottery and musical compositions
inspired by arithmetic have in common?
Was the first Russian avant-garde more
interested in Jesuit theory of affects or
in H.G. Wells' time machine? Our on-
going adventure of excursions into the
deep time of relations between the arts,
science, and technology engages with
such disparate themes as these.